Jasper Johns

Jasper Johns

A Retrospective

KIRK VARNEDOE

WITH AN ESSAY BY

ROBERTA BERNSTEIN

The Museum of Modern Art, New York

Published in conjunction with the exhibition
"Jasper Johns: A Retrospective," at The Museum of
Modern Art, New York, October 20, 1996–January 21,
1997, directed by Kirk Varnedoe, Chief Curator,
Department of Painting and Sculpture

This exhibition is sponsored by Philip Morris
Companies Inc.

Additional support is provided by the National
Endowment for the Arts. An indemnity for the exhi-
bition has been granted by the Federal Council on
the Arts and the Humanities.

This publication is made possible by a generous gift
from Emily Fisher Landau.

Produced by the Department of Publications
The Museum of Modern Art, New York
Edited by David Frankel
Designed by Bethany Johns Design, New York
Production by Amanda W. Freymann, Christina Grillo
Composition by Chelsea Arts Inc., New York
Printed and bound by Conti Tipocolor, Florence, Italy

Library of Congress Catalogue Card Number:
96-077360
ISBN: 0-87070-392-7

Published by The Museum of Modern Art
11 West 53 Street
New York, New York 10019

Distributed in the United States and Canada by
D. A. P./Distributed Art Publishers, Inc., New York
Distributed outside the United States and Canada by
Thames & Hudson Ltd, London

Cover: Jasper Johns. *Untitled*, 1992–95. See plate 242.
Endpapers: Jasper Johns. *Untitled* (details), 1995.
See p. 8. Frontispiece: Jasper Johns. *Painting Bitten
by a Man*, 1961 (actual size). See plate 82.

The presentation of this exhibition at the
Museum Ludwig, Cologne, was supported
by Ford Motor Company.

Printed in Italy

Contents

This publication is made possible

by a generous gift from

EMILY FISHER LANDAU

Flags, numbers, paintbrushes, handprints, the Mona Lisa: Jasper Johns has made all these, and other universal icons, part of the vocabulary of contemporary art. Depicting familiar signs and objects with subtle power and grace, Johns has won a broad global audience. "Jasper Johns: A Retrospective" is the most significant survey of the artist's work ever organized, a full and clear mapping of his four decades of exploration, traced in paintings, drawings, prints, and sculptures.

Philip Morris has been active in the arts for nearly forty years. Consistent with our special emphasis on the new and innovative, we sponsored Jasper Johns's first major retrospective, nearly twenty years ago. Since then, the artist's activity and pace have accelerated, and this new exhibition provides a fresh perspective on his achievements. We applaud The Museum of Modern Art for its crucial early support for Jasper Johns in the 1950s, and for its vision in creating this magnificent panorama of the artist's career. We also look forward to the exhibition's tours to Germany and Japan, where widespread appreciation for Johns's work has helped to make him one of the most influential artists of our time.

GEOFFREY C. BIBLE
Chairman and Chief Executive Officer
Philip Morris Companies Inc.

The endpapers of this book were designed
by Jasper Johns. They represent details of
the lithograph above: *Untitled*. West Islip,
N.Y.: Universal Limited Art Editions, 1995.
41 5/16 x 53 1/4″ (105.1 x 135.5 cm).
The Museum of Modern Art, New York.
Gift of Emily Fisher Landau.

Foreword

The Museum of Modern Art has long played two complementary roles in fostering contemporary creativity. Its great collection of early modern art, and its landmark historical exhibitions and catalogues, have been invaluable resources for generations of artists needing to learn from their forebears in the avant-garde. At the same time, the Museum's engagement with the immediate present, manifest in its programs of exhibiting and acquiring challenging contemporary art, has been instrumental in encouraging younger artists and making their work known. The relationship between Jasper Johns and this Museum illuminates precisely these twin aspects of the institution's mission. Johns first visited the Museum in 1949; it was, he recently recalled, "the first time I really saw the kinds of paintings that I had heard about." Since then (as this catalogue's essays and chronology emphasize), he has been a frequent visitor to both the Museum's collections and its exhibitions. Once, when asked what works of art had been most important to him, Johns listed two—Cézanne's *Bather* and Picasso's *Demoiselles d'Avignon*—that are among the prominent treasures of our Painting and Sculpture collection.

Happily, that collection also counts among its highlights a superb group of works by Johns himself. The Museum has supported his innovations since the very outset of his career. In January of 1958, less than ten years after Johns first visited The Museum of Modern Art, founding Director Alfred H. Barr, Jr., and Curator Dorothy Miller decided to back this young artist in the strongest and boldest way by purchasing three works (*Target with Four Faces*, 1955, plate 9; *Green Target*, 1955, plate 12; and *White Numbers*, 1957) from his first solo exhibition. Barr also persuaded Museum trustee Philip Johnson to acquire the seminal *Flag* of 1954–55 (plate 8); in 1973, Johnson donated this work to the Museum in Barr's honor.

Over the years, the collection has been enriched by several other superb Johns paintings, including two monumental canvases—*Between the Clock and the Bed*, 1981 (plate 183), and *Untitled*, 1992–95, which appears on the cover of this catalogue—given by the Museum's current President, Agnes Gund. Also, in addition to acquiring a fine representation of Johns's drawings, the Museum has been strongly committed to his exceptional work as a printmaker. The core of the Museum's collection in this area is an example of every print Johns made with the print workshop ULAE. Up until 1984, this policy of comprehensive acquisition was made possible by the generosity of Celeste and Armand Bartos; since then, Emily Fisher Landau has graciously supported this ongoing and crucial program. The collection has been further augmented by gifts from others, including the artist himself. In 1968–69, a major exhibition of Johns's prints, organized by the Museum, was shown in seven countries. It was Riva Castleman, however, recently retired Chief Curator of Prints and Illustrated Books, who was particularly instrumental in continuing the close relationship that Barr had initiated between Johns and this institution. "Jasper Johns: Lithographs," which she organized in 1970, traveled to six venues in the United States. In 1986 she organized and presented here the most comprehensive retrospective ever mounted of Johns's prints, and she also featured his work prominently in the "Seven Master Printmakers" exhibition of 1991. On the occasion of her retirement, the artist donated a beautiful untitled monoprint to the collection in her honor.

The present retrospective and its accompanying publications add another chapter to this history, and a particularly significant one. Here our engagement with Johns is impelled by the strong commitment of our Chief Curator of Painting and Sculpture, Kirk Varnedoe, who established this exhibition as one of his highest priorities from the moment he assumed his position at the Museum, in 1988. Preceded by Mr. Varnedoe's

retrospective exhibition of Cy Twombly and to be followed later in this decade by his retrospective exhibition of Jackson Pollock, "Jasper Johns: A Retrospective" is a centerpiece within a curatorial plan that commits the resources of the Museum to honoring and shedding new light on major creative forces of the second half of the twentieth century.

Elsewhere in this catalogue (pp. 10–11), Mr. Varnedoe acknowledges the numerous members of the Museum's staff, and the many others, who have contributed so generously to bring this project to fruition. The exhibition would not have been possible, however, without his own vision, energy, acumen, and intelligence. Mr. Varnedoe oversaw virtually every aspect of the project. To the present volume he contributes a perceptive introduction that discusses the richly textured meanings of Johns's work through an in-depth consideration of the Museum's most recently acquired painting, *Untitled*, 1992–95, among other works; a second essay transforms a series of interviews with artists into an analysis of Johns's influence as traced through these artists' own words. I also want to thank Roberta Bernstein both for the thoughtful essay she has contributed to the catalogue and for her role as a consultant throughout the development of the exhibition.

In ensuring that this landmark show reaches an international audience, we have been fortunate to work with the Museum Ludwig, Cologne, and its Director, Marc Scheps; and with the Museum of Contemporary Art, Tokyo, and its Director, Yasuo Kamon. Their participation in the exhibition's international tour has been an essential part of the project. I also wish to convey the Museum's tremendous gratitude to those who have made the exhibition and its accompanying publications possible through their invaluable support. The project could not have been realized without the support of Philip Morris Companies Inc., who have been partners with the Museum on this as on so many other, previous major projects. The publications—this catalogue; a companion volume of Johns's writings, sketchbook notes, and interviews; and a data-base publication of a complete bibliography and exhibition history—constituted an exceptionally ambitious project in themselves, and could not have been undertaken on this scale without the early commitment of a generous subvention by Emily Fisher Landau.

Our warmest thanks go to the many lenders, institutional and private, who have allowed us to borrow their paintings, graphic works, and sculptures by Jasper Johns. No one is more keenly aware than they are of the special quality, beauty, and (sometimes fragile or vulnerable) physical presence of Johns's creations; we laud appreciatively their willingness to part with the works for long enough to allow the exhibition's visitors the exceptional opportunity to see so much of the artist's wide-ranging production brought together. An extra measure of recognition should be expressed to those collectors, such as Robert and Jane Meyerhoff, Sally Ganz, and David Geffen, who have made exceptional sacrifices in agreeing to lend simultaneously several major masterworks, and to fellow institutions such as the Museum Ludwig, The Menil Collection, and the Öffentliche Kunstsammlung Basel, Kunstmuseum, who have made similarly special contributions.

Finally, I wish to express the Museum's great debt of gratitude to Jasper Johns himself. Beyond lending so many works from his own collection, Mr. Johns has been unfailingly patient with the many demands we have been obliged to place upon him, and unstintingly generous in the cooperation he has given to Kirk Varnedoe and to others on the Museum staff throughout this project. The Museum of Modern Art is pleased and proud to have been able to work with him to extend the particular history of commitment to his art that Alfred Barr began in 1958, and to reaffirm the larger traditions of support for the best of contemporary art that the Museum has embodied since its founding.

Glenn D. Lowry
Director
The Museum of Modern Art

Acknowledgments

Even with the gloomy certainty that I will almost certainly overlook many participants, I would like to express my gratitude to all those who made this exhibition and accompanying publication possible. Beginning by citing Glenn Lowry, Director of this Museum, for his strong backing of the project, I also reiterate his thanks to those whose financial support allowed the project to be realized, Philip Morris Companies Inc. and Emily Fisher Landau. I greatly appreciated the work of Michael Margitich and John Wielk for their help in securing and coordinating this support.

Numerous others on the Museum's staff have been key collaborators throughout the development of the exhibition and its publications. Richard L. Palmer has as always been magnificent in his command of the countless details and vast skeins of paperwork that hold together an endeavor of this scope. He will retire before this exhibition opens; it has been a privilege and a pleasure to work with him on this final project, and he will be greatly missed by all who have benefited from his meticulous eye and his calming spirit in times of stress. I would also like to thank those of his staff who made important contributions to keeping the Johns exhibition "on track": Eleni Cocordas, Maria DeMarco, and Rosette Bakish. Jennifer Russell helped see the ship into port in extremely helpful ways. For the exhibition's international tour, the coordination work was done in characteristic good fashion by Elizabeth Streibert. She joins me in praising the cooperation of the two institutions that will present this retrospective abroad, and colleagues there who have worked so well with us: Marc Scheps, Director, and Dr. Evelyn Weiss of the Museum Ludwig, Cologne; and Yasuo Kamon, Director, and Junichi Shioda of the Museum of Contemporary Art, Tokyo.

Lucille Stiger, Elena Amatangelo, and Pamela Neiterman-Graf have been in charge of coordinating the shipping and receiving of loans, and I have appreciated their efficient attention to these matters; credit is also due to Diane Farynyk for her supervision of all issues related to the movement and protection of these objects, and to Ramona Bronkar Bannayan, for her help with the project's beginning stages. In matters of conservation I have been fortunate to have had the excellent advice of James Coddington, who has been especially helpful with several delicate and time-consuming questions in this area, and of Patricia Houlihan, Lynda Zycherman, Karl Buchberg, and Erika Mosier. The handling of the artworks has also been the responsibility of Pete Omlor, whose team of preparators are working with their accustomed skill and caution to see that these works are received, installed, and redispatched with the greatest care. The design of the installation and its construction are the domain of Jerry Neuner and his staff. As so often in the past, I have profited enormously from his skilled advice and from his unrivaled ability to produce the best results under the most unreasonable pressures. In legal matters I have been fortunate to work with Beverly Wolff and Stephen Clark, who have proceeded with patience and much-appreciated expertise.

I am tremendously in the debt of Victoria Garvin, for countless extra hours spent assuring the continuity and stability of my own department, in the face of the project's exceptional demands; and of Alice Buchanan for her work toward these same goals. To these two people I owe much of my sanity and peace of mind in various moments of trial over the past two years. Still within my department, I would also like to extend special thanks to Kynaston McShine and Robert Storr, for the help they gave in nailing down crucial loans, and to Cora Rosevear.

In the Department of Prints and Illustrated Books, I am indebted to Deborah Wye, for making so many works available to me. She also supported the concept of holding a related exhibition of Johns's rarely seen working proofs concurrently with the larger retrospective, in the galleries of her own department. Installed in the Paul J. Sachs Gallery and Tatyana Grosman Gallery on the third floor, this exhibition, "Jasper Johns: Process and Printmaking," has been organized by Wendy Weitman with great knowledge and passionate commitment. Andrea Feldman has been very helpful to all of us who needed to gather information on Johns's prints, and I am also grateful for the assistance of Starr Figura, Deborah Dewees, and Charles Carrico. Similarly in the Department of Drawings, I thank Margit Rowell for loaning several works, and Kathleen Curry, who helped us with catalogue information.

In the Library, I thank particularly Eumie Imm Stroukoff, who helped with interlibrary loans, and in the Archives, Rona Roob, and her assistant Leslie Heitzman. The Department of Photographic Services and Permissions has been put under exceptional pressures by the demands of the catalogue, and I am very grateful for the helpful responses of Mikki Carpenter and Kate Keller as well as Erik Landsberg. Particularly in relation to the signage and brochure design that appear in the final stages of mounting the exhibition, we depend on the talents and spirit of Jody Hanson, Emily Waters, and Greg Van Alstyne in the Department of Graphic Design.

In the final stages of the exhibition, as the issues of spreading the word to the public, and of elucidating its contents for them, come more to the fore, the Departments of Communications and of Education play an important role. Elizabeth Addison has overseen all matters related to disseminating information to the press, and Mary Lou Strahlendorf has organized contacts with journalists efficiently and productively. Patterson Sims has worked with me on the public lectures and symposia accompanying the exhibition, providing the Museum's public, in several diverse ways, with both accessible and provocative commentaries on Johns's art.

All of these "in-house" efforts would be for naught, of course, were we unable to secure the cooperation of colleagues in other museums, and of important private collectors. The effort simply to locate certain works, and then to negotiate for their inclusion, often brought us to place heavy demands on friends throughout the museum field and in the art market. We constantly needed, and always received with exemplary generosity and good will, the help of Leo Castelli, in whose gallery we have also appreciated the help of Susan Brundage and MaryJo Marks. Among other art dealers or auction house personnel who were helpful, I would single out Lucy Mitchell-Innes, for her invaluable advice regarding valuations and other issues; Brooke Alexander, for parallel help with regard to prints; Jeffrey Deitch and Kate Ganz, for much-appreciated diplomacy in key loans; Robert Monk of Sotheby's; and Stephen Mazoh, for similar assistance. Museum colleagues were also of indispensable help in complex exchanges that led to loans being granted. I wish to thank in this regard Robert Bergman, Director, Cleveland Museum of Art, for special benevolence, as well as Robert Littman, Director, Centro Cultural Arte Contemporaneo, Mexico City. James S. Snyder was instrumental in concluding another such loan arrangement. For their help in certain communications with lenders, thanks are also owed to Nina R. Lenzer, of the law firm of Sullivan & Cromwell, and William M. Poppe, of the law firm of Poppe, Janiec, Mackasek & Bhouraskar. Finally, in this field of "brokerage" and special assistance, I thank Ronald Lauder, Chairman of the Board of Trustees of The Museum of Modern Art, for his generosity in making a key loan feasible.

More informally, I have also depended on the counsel and cooperation of several of Johns's friends, whose knowledge of his oeuvre has been invaluable. Gratitude goes out especially to David Whitney, who organized the great 1977 Johns retrospective at the Whitney Museum of American Art; I would also like to thank Mark Lancaster and Bill Katz. Foremost among my counselors, however, has been the person who agreed more formally to serve as a consultant to the project, and to contribute an essay to this publication, Roberta Bernstein. Her long association with the artist and her scrupulous scholarship have given her in an unrivaled knowledge of his work that she has shared with me and others at the Museum with tremendous good will and enthusiasm. Her contributions and criticisms have been of inestimable help; working with her has been among the most rewarding and pleasurable aspects of the entire project.

Among the institutions making important loans, I wish to recognize the special contributions of the Museum Ludwig, Cologne, The Menil Collection, Houston, and the Öffentliche Kunstsammlung Basel, Kunstmuseum. Each has lent multiple works of great importance, and I am deeply grateful to Marc Scheps, Paul Winkler, and Katharina Schmidt, directors of these three institutions respectively, for their support of our efforts. Thanks also to Nicholas Serota, Director, Tate Gallery, London; Richard Koshalek, Director, The Museum of Contemporary Art, Los Angeles; and Brenda Richardson, The Baltimore Museum of Art, for help involving loans from their institutions.

We have been obliged to deprive some museums of works loaned to them from Johns's own collection. For their gracious help in facilitating the inclusion of these works, I want to acknowledge Trevor Fairbrother, The Museum of Fine Arts, Boston; James Cuno, Director, Harvard University Art Museums; Madeleine Grynstejn, The Art Institute of Chicago; William S. Lieberman, The Metropolitan Museum of Art; Ann Temkin, Philadelphia Museum of Art; Allen Rosenbaum, Director, The Art Museum, Princeton University; Gary Garrels, San Francisco Museum of Modern Art; Jacquelyn Days Serwer, National Museum of American Art; and Brenda Richardson, The Baltimore Museum of Art.

The lenders to the exhibition are listed and acknowledged elsewhere in this book (see p. 407), but I should underline here my gratitude for their cooperation. I would especially like to thank those private lenders who made special sacrifices in letting us include multiple works from their collections. Chief among these are Robert and Jane Meyerhoff, who showed great patience and understanding for the many requests I made of them, and who allowed an exceptional number of their cherished paintings and drawings to appear in the retrospective. Sally Ganz, David Geffen, and the President of The Museum of Modern Art, Agnes Gund, also consented to the loan of important masterworks from their own collections, and I extend warm gratitude to them for this generous participation.

The preparation of the exhibition's catalogue and accompanying publications has been a project with its own significant demands, and has required the help of a great many friends throughout this country. Here, too, the aid of the Leo Castelli Gallery has been indispensable, and we owe special thanks to Allen Duffy for help with the gallery's archives and to Amy Poll for photographs. We have also received an extra measure of assistance from Larissa Goldston and Bill Goldston of Universal Limited Art Editions. Among the many others who supported our research endeavors, I would particularly cite Libby Rich, Columbia Museum of Art; David Vaughan, Cunningham Dance Foundation, Inc.; Laura Kuhn, John Cage Trust; Deborah Campana, John Cage Archives, Music Library, Northwestern University; Rachel Rosenthal; Calvin Tomkins; Francis Naumann; and Sidney B. Felsen and Nancy Erwin, Gemini G.E.L. For their help in securing transparencies for the best possible reproduction of Johns's work, thanks are also due to Frances Smyth and Sara Sanders-Buell, National Gallery of Art; to Laura K. Harden, Sotheby's; to Candace Worth, Christie's; and to Julie Bakke, The Menil Collection.

Within the Museum, the publications have been generally overseen by Osa Brown, and I have been grateful for her enthusiastic support of a complex undertaking. Harriet Bee has also helped to keep the project focused and organized, and both Marc Sapir and Cynthia Ehrhardt have played important roles. For the catalogue's texts, David Frankel has been asked to take on the Herculean task of coordinating, editing, and controlling the accuracy and consistency of a vast amount of material written by myself, Roberta Bernstein, and Lilian Tone. He has handled this task with skill, forbearance, and a much-appreciated sense of firm but flexible respect for quality. The visual elements and overall production of the book have been the task of Amanda Freymann. Despite the demands of many other projects, and the considerable challenges posed by unforeseen delays, she has kept the project on course, and has mediated excellently and with good spirit between desired ideals and pressing realities. The design of the book was entrusted to Bethany Johns, who, with her assistant Kathleen Oginski, did a wonderful job of accommodating the shifting demands of the visual material and the pressures of deadlines. The look of the volume you hold in your hands is the best evidence of

her success. It is difficult to imagine more valuable and dedicated collaborators than these; it has been a joy to work with them.

Christel Hollevoet has prepared the most complete bibliography to date of writing on Johns's work, with the help of Seiji Morimoto, Sophie Bowness, and the interns Isabel Duran, Stephanie Backe, Sabine Walli, Rosario Peiro, and Géraldine Dennys. A selected form of that massive document is included in this volume; the complete bibliography, along with a complete exhibition history compiled by Adrian Sudhalter, will be published by the Museum in electronic form for the use of libraries and scholars.

In drawing toward the conclusion of my acknowledgments, I have begun increasingly to concentrate on the "inner circle" of those who worked most closely with me to realize the twin projects of the exhibition and its publication. Beginning at home, I should express my most personal appreciation to my wife, Elyn Zimmerman, who tolerated the long hours of work on this project, and the disruptions in our life it inevitably entailed, and who encouraged, criticized, and guided me in all the right measures throughout the process. The last six months of the effort brought specially acute challenges that I could never have conquered without her loving support.

At the Museum, a small, very hard-working team of assistants aided Lilian Tone and myself. She joins me in thanking Adrian Sudhalter, who provided resourceful assistance in research related to my own texts as well as in a host of other tasks related to this catalogue, performed with her usual precision; Joe Martin Hill, who helped research Ms. Tone's chronology; Catherine Ruello, who assisted with photo research; and Raul Loureiro, Justin Garth White, and Beck Feibelman, interns who assisted Ms. Tone with myriad chores pertaining to the preparation of the exhibition plan and its documentation. For Lilian Tone herself, no expression of thanks can be truly adequate. She has been responsible for coordinating every aspect of this exhibition project, in work that required extralong days and nights for many months on end. She has been tireless, dedicated beyond measure, and passionately concerned for the accuracy and quality of everything she has done. How, in addition to fulfilling these responsibilities so well, she has been able to compile and write the unprecedentedly detailed chronology of Johns's life published here, must remain a source of my profound wonder and admiration.

Over more than two years of almost daily communication with Jasper Johns's studio, Ms. Tone and I have depended on the help and guidance of Sarah Taggart, the artist's assistant. Both of us find our vocabulary impoverished when it comes to seeking appropriate words with which to describe our gratitude for her aid, which has been unflaggingly patient, cooperative, discreet, and warm-spirited. She has been both an indispensable, loyal agent on behalf of the artist and an invaluable ally to us; no one could have performed this key bridging role with greater grace and effectiveness. I also wish to extend our thanks to Joanne Kriegel and James Meyer, also of Johns's studio, who helped our efforts all along the way.

Finally but obviously most importantly, I express deepest gratitude, personally and on behalf of The Museum of Modern Art and all the co-workers mentioned above, to Jasper Johns himself. This exhibition project has asked that he lend a tremendous number of works from his own collection, and it has also recurrently invaded his privacy, disrupted his schedule, and sapped time from his work. In the face of these and other annoying demands we have been obliged to place on him, he has been constantly and courteously responsive. Without ever presuming to exert pressure upon or interfere with the work of preparing the exhibition and publications, he has been an attentive and exacting participant in the entire process. To have had the chance to concentrate on his art so thoroughly in the past years, and to bring that art to the Museum's public, would already have been its own ample reward; to have worked with him in addition, and to have been able to spend time discussing his art with him, was an unforgettable education and an irreplaceable privilege. For the faults and failings of the exhibition and this catalogue, I assume ultimate responsibility; for all there is that is challenging, rewarding, and enriching in these endeavors, the ultimate debt is owed to his artistry and to him.

—KV

Introduction: A Sense of Life

KIRK VARNEDOE

In 1995, his sixty-fifth year and the beginning of his fifth decade as an artist, Jasper Johns completed a large untitled painting (fig. 1, plate 242). To describe this image is to probe archaeologically back down forty years of his art. Johns conceived the painting to replace another that had hung for ten years in his home on the island of Saint Martin, in the Caribbean; though taller and more square, the underlying structure of the new picture basically mirrors (hence reverses) the three sections of that earlier, 1984 composition (fig. 2, plate 195). Furthermore, in their horizontal panels labeled red-yellow-blue, their hand- and arm-prints, and their "scraped" half-circle motifs at the outer edges, those 1984 sections themselves reiterate motifs Johns had used in the early 1960s, in works such as *Diver* and *Periscope (Hart Crane)* (plates 98 and 103). The half-circles in *those* paintings are linked to *Device Circle* of 1959 (plate 49), which in turn refers backward yet again, to Johns's earliest images of targets (plates 9, 10, and 12), from 1955.

Onto this already stratified foundation of reversal and multiple reprise in the 1992–95 *Untitled*, Johns added layers of more recent imagery: the tilted cross-form on the right, for example, derives from an etching of 1990 (plate 227), and assembles

Fig. 1. Jasper Johns. *Untitled*. 1992–95 (see plate 242) Oil on canvas 78 x 118″ (198.1 x 299.7 cm) The Museum of Modern Art, New York. Promised gift of Agnes Gund

elements—a ladder, a child's silhouette overlaid with geometric forms, and the shadow of the artist himself, in ghostly ethereality—that originated in the *Seasons* paintings of 1985–86 (plates 204–7). The large stick figure, with tendons and limbs protruding from a globular head, first appeared in Johns's work in 1992, as a quote from Pablo Picasso; but the three smaller stick figures below began appearing in drawings a decade earlier, and the wide *X* to their left has been a "signature" mark in

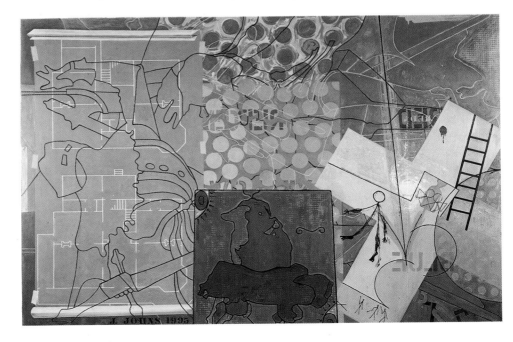

Untitled (detail, actual size). 1992–95 (see plate 242)

13

Fig. 2. Jasper Johns. *Untitled (Red, Yellow, Blue)*. 1984
(see plate 195)
Encaustic on canvas (three panels)
Overall: 55 ¼ x 118 ½" (140.3 x 300.9 cm): each panel: 55 ¼ x 39 ½" (140.3 x 100.3 cm)
Collection the artist

numerous images of Johns's since the early 1970s. The splatter of paint on the upper right of the cross form, carried over in the same locale from the 1984 composition, is a familiar Johns mark, implying a general sardonic reference to the "accidents" of spontaneity in painting (and likely bearing specific reference to the ejaculatory "shots" in Marcel Duchamp's *Bride Stripped Bare by Her Bachelors, Even (The Large Glass)*, 1915–23.[1] This literal, material mark then has its ethereal and Romantic counterpoint in the spiral galaxy floating over the cross's center, a motif in Johns's work from the late 1980s and early 1990s, with an astral lineage that goes as far back as his flag paintings of the mid-1950s.

Into the lower center of the new composition, as if on a separate canvas leaning back against this one,[2] Johns inserted a picture-within-a-picture. Its image is one he devised in 1990, by combining a map- or puzzlelike motif (based on a tracing from an unidentified source) with a rectangular "face" of cartoonlike eyes, lips, and nostrils that he had begun using in the mid 1980s (e.g., plates 203, 208, 217). Finally, the left third of this *Untitled* is "covered" by a blueprint, rendered in trompe l'oeil fashion as taped up and furled at the ends—a plan of one of Johns's childhood homes that he reconstructed from memory and began including in paintings in the early 1990s (plates 235–37, 241). Overlaying that document, and carrying across the upper half of the picture, is a motif he introduced in 1982 and has employed frequently since: a linear tracery taken from the two upended soldiers below the tomb of the resurrected Christ in Matthias Grünewald's Isenheim Altarpiece.

There is still more to inventory here, but we can already see that the painting is a palimpsest of Johnsian motifs early and late. It provides a broadly inclusive "retrospective" of his subjects, marks, and manners, and seems to constitute not only a "manifest," in the sense of a shipboard inventory, but also a "manifesto," in another—a chart of voyages made and a key to present location, shaped by the apparent desire for a cumulative self-summation that has also seemed to spur the other large, synthetic assemblage-paintings such as *According to What* of 1964 (plate 105) Johns has produced to mark previous points in his development. So much to see, so many references, such fullness—and yet, too, such perplexity in the aggregate. The unchristened bounty of images, styles, and themes, running the gamut of representation from cave-painting pictographs to a photo of deep space, begs an equal wealth of questions about what to make of it—not just what meanings to ascribe to these references and their particular layerings here, but what larger lessons their conjunction might teach about the long and complex career in art that they encode. At one level, the picture surely emphasizes the densely woven continuities that have governed Johns's development, and reaffirms his consistent practice of making new art while progressing through a chain of variant self-repetitions whose play of recurrence and reconsideration has been called an analogue, in the manner of Proustian memory, for the fullness of consciousness itself.[3] Yet our sampling

makes us equally aware of the many sharp fissures and discontinuities in this same artistic evolution. A gulf, after all, would seem to divide this painting's esoteric appropriations and private symbols from the common, flat signs of flags, targets, and numbers with which Johns began in the mid- and late 1950s (e.g. plates 6–14). Thinking about how we might articulate a meaning for this picture inevitably draws us then into broader questions of how, on the occasion of a retrospective exhibition, we should reckon with issues of coherence and "legibility" in an art so densely armored and internally complex—how legitimately we might try to put so many disparate pieces and phases together, to balance their often seemingly contradictory demands, and to look through them to understand the body of work and the career whose history we see embedded there. Where and how should we begin to say what, or how, such an art means?

We could begin at a basic level, with the impact the art has on us before we label our pleasures or organize our questions—the particular blend of stimulations, irritations, and rewards that we sense as a personality or character in the presence of this and other Johns-made objects, with their yes-no rhythms of fast and slow, thick and thin, liquidity and dryness, intimacy and implacable chilliness, the literal and the inexplicable in fusion. Johns has been at various times the wielder of a cool, smoothly anonymous touch, and at others the author of some of the densest and most caressed surfaces in contemporary painting; in turn a master of monochrome whites and grays, a strict practitioner of primary and secondary hues only, and then a painter who runs the chromatic scale, from body colors—the pinks of flesh and lips, sanguine crimson—through orchid tints to fauve fireworks. The 1992–95 *Untitled*, with its extended range of cool and earth-inflected grays set off by deep passages of dried-blood and rouge hues, signals a period of increasing richness in the material life of his painting, and—after some exceptionally open and airy works in the early 1990s—of mounting density in his pictorial constructions. Through every mode and in all mediums, though, Johns's art has consistently conveyed a sense of virtuosity, sometimes called erotic in its appeal.[4]

That quality has had little to do with suave figuration in an academic sense, nor with any facile choreography of the medium. In fact it most characteristically involves a willful impersonality in lines and marks,[5] a lack of conventional bravura that speaks instead of other gifts and ambitions. Johns has dealt with the world almost exclusively by treating found images, and as models for drawing he has given pride of place to plans, maps, stencils, and other devices (such as linear tracing) that reduce the world's variety to an apparently objective, flattened form. Representing without describing, these schemas combine a maximum of transformation with a seeming absence of subjective stylization.[6] They are functional, concrete modes of encoding ideas, and they offer, as Johns's early targets also did most succinctly, nonabstract forms of abstraction. Johns has not wanted to be either an abstract or an illusionist artist, but as a constant literalist he has at times been both, and has often purposefully walked the line. Declared admirer of both John F. Peto and Barnett Newman, he has favored in his own work abstractions that can be read as depictions (*Green Target*, 1955, for example; plate 12) and depictions schematized to the point of abstraction (the masking-tape rectangles, Cubist nails and wood grain, and cartoon facial features of the past decade or so).

Though Johns has often adopted an intentionally staid, Magritte-like manner of depiction, his more declarative "handwriting" in all mediums has been independent of the normal techniques of pictorial rendering. Since the slow compilations of encaustic strokes in his first paintings, he has cultivated a combination of programmed disciplines (such as filling in stripes or backgrounds or puzzle segments) and unexpected intensities (underscaled or outsized units of touch applied with exhaustive density or seemingly untoward breadth) that wields a dislocated expressive power over the work's nominal subjects. Even at the most basic level of making marks and applying medium to surface, he has wrought his "signature" manner from techniques that work against any familiar code of self-expression. Indeed his most "expressionist" gestural brushstrokes, seen in works of the late 1950s and early 1960s, seem by willful contrariness self-consciously generic and often openly repetitive (plates 52, 54, 77, 78), and there has been an equal muzzling of the usual indices of spontaneously released energy, whether lyric or angry, in his repertoire of dry, wet, and viscous material effects—scraping, smearing, pressing, melting, puddling, etc. Yet, by personal alchemy, he has orchestrated this vocabulary into a compelling and influential sense of craft. Typically blending, in illogical or uncanny proportion, elements of crisply controlled exactitude, obsessiveness, and partial liberation of a material's inherent physicality, this craft often seems repressed and ironic in its refusals; but it remains unmistakably alive, emotively and psychically as well as tactilely and optically.

Raising the issue of slippage between form and handling, however, reminds us how barren any isolated delectation of Johns's surfaces and lines must quickly become. If we are to grasp his ambition as an artist—to understand both its singularity and its relation to modern traditions—we should attend simultaneously to his subjects, and to what he has said about them. Johns has wanted his subjects, like his schematic models for drawing, to come ready made. He has also long favored those that have arrived involuntarily, through chance encounters or uncontrolled circumstance—fleeting glances, unexpected gifts from friends, suggestions made by others, or even, in the case of the first *Flag*, 1954–55 (plate 8), a dream. This is clearly not, however, a belated case of the Surrealist courtship of chance and the unconscious mind, which meant so much to the generation of American artists immediately preceding Johns's. What came to him from his initial dreams and serendipities were not primal icons beyond civilization's reach, or exotic eccentricities, but everyday images shaped by convention and culture. The prime gift, the dream of painting the American flag, was prime precisely because it provided the most conventional of conventions, a wholly public symbol.

It was in acting on that dream that Johns found his way, and decided that through such seemingly self-evident subjects his art could deal in fundamental issues of seeing. More precisely, he was concerned with relations of thought and sight— "the idea of knowing an image rather than just seeing it out of the corner of your eye." To work in that area he needed subjects that had acquired an "invisibility"[7] by virtue of being too well-known to be truly seen, or conversely by being so often seen that they were not truly thought about. He famously referred to his first choices—the flag, target, and numbers—as "things the mind already knows,"[8] and also (because the mind, knowing them too well, ignores them) as things that were "seen and not looked at, not examined."[9]

The unexpected mental spasm those first objects induced—is this a flag, a painting, or both?—was meant to cause a shift in attention that would enliven awareness on a much wider front. Though critics immediately associated Johns's conundrums with the antiart pranks of Dada, he had other aims and broader roots. He had inherited the notion, familiar at least since Romanticism, that knowledge blinds us to experience. More particularly—and true to a specifically modern variant of the notion—he embraced the credo that *unreflective* knowledge, of the kind that entrenches itself in habit, was the most sinister problem; and that self-aware knowledge—the kind of intent attention provoked by challenging art— was the best solution.

It was a common tenet of early modern thought that a poem or a picture, by disrupting our habitual ways of seeing, could snap awake the senses and heighten our consciousness of being alive. Without such derailing challenges, it was felt, people succumbed to taking things for granted, and risked moving numbly though their days without truly living.[10] Showing common things in unexpected ways— taking the familiar and "making it strange," or "making it new"—was one way for art to effect this life-enhancing jolt. This is the program we hear echoed in Johns's 1969 recollection that he had chosen to paint "things people knew, and did not know" because "I wanted to make them see something new."[11] When asked what he meant by that expression, he elaborated, "When something is new to us, we treat it as an experience. We feel that our senses are awake and clear. We are alive."[12] Later, discussing an old interview, Johns reaffirmed his statement: "I think that one wants from painting a sense of life.…One wants to be able to use all of one's facili-ties, when one looks at a picture, or at least to be aware of all of one's facilities in all aspects of one's life.…like we were saying a while ago, a surprise. You may have to choose how to respond and you may respond in a limited way, but you have been aware that you are alive."[13]

Earlier modern theorists had proposed that art achieved the effect of surprise, or "making new," when it disrupted accepted conventions of representation and forced a recognition of their confining artificiality. In the visual arts of the time, linear perspective, with its illusion of transparent "naturalness" and its rationalized hierarchy of visual relationships, was the obvious convention to be attacked, and a logical strategy was to dismantle the fixity of the single viewpoint on which it depended. By the time Johns was a student, it was a matter of received wisdom that Paul Cézanne and then the Cubists had defeated one-point perspective in this fash-ion, by including in each picture many different views taken from changing van-tages over time. Indeed, in his first written statement on his art, published in 1959, Johns nodded toward this dictum by listing first among the "three academic ideas" that he said had "been of interest" to him "what a teacher of mine (speaking of Cézanne and cubism) called the 'rotating point of view.'"[14]

This notion of a mobile viewpoint implied (as Johns also doubtless heard from his teachers) a superior grasp on objective truth: by synthesizing many vantages into one representation, it was said, Cézanne and the Cubists had gotten into their art a fuller, less subjectively limited account of reality. (Picasso's frequent attempts to show the front and back of a figure simultaneously are a prime instance of this mod-ern chimera of an all-encompassing, all-possessing picture of the world of sensory

experience.[15]) In the same 1959 statement, Johns expressed what might seem a parallel ambition not to be pinned to one static viewpoint: "At every point in nature there is something to see," he said. "My work contains similar possibilities for the changing focus of the eye."[16] Yet he meant something very different. His references to the "eye" and to "focus" involved a metaphoric ideal of agilely shifting mental attentiveness, and his ambition was to present reality not as more integrally complete, but as more fragmented and discontinuous.

Annulling the issue of perspective in the early flat subjects allowed Johns to escape the limitation of a single vantage, but equally to avoid any implications of some higher synthesis of different views. He later said he preferred his work to present "not just one relationship or even a number of them, but constantly chang-ing and shifting relationships to things in terms of focus."[17] This mobility, more thoroughgoing and permanently unresolved than that of Cubism, seemed to him to correspond to a truer and fuller experience of life. As he explained once when asked what he meant by "changing focus," "I mean it in the sense of undefined, or what I consider an undecided situation, one that offers more possibilities to examine a situation. I think an undecided situation—something conditional—leads to a broader spectrum of facts."[18] It is clear, too, that for Johns this avoidance of fixed relations concerned not only sight and thought, but attitude and emotions as well. When asked by David Sylvester, in 1965, about the "mood" one could feel in his work, he responded, "I'm not interested in any particular mood. Mentally my preference would be the mood of keeping your eyes open and looking, without any focussing, without any constricted viewpoint."[19]

The early subjects were chosen as "depersonalized, factual, exterior elements"[20] in part to answer this felt need for emotional disengagement. We know from sev-eral accounts that in 1954, Johns decided to reinvent himself; destroying everything he could of his work to that point, and taking what he saw as more adult respon-sibility for what he was doing, he drastically ratcheted up his level of artistic ambi-tion.[21] A central component of this drive involved an imperious self-repression, a willed emotive shutdown. Much later, he said this "had to do more or less with how I felt about myself, than towards painting. I had withdrawn into myself, I was avoid-ing psychology or emotions. But I lived through the work….When one is young, one imposes limits on oneself, often very harsh ones…one needs to be exact with oneself."[22] In Johns's choice of subjects as in every stroke of his brush, this stance hammered a spike into the heart of the existentialist call for decisive engagement and self-expression that had been associated with a sense of epiphany and catharsis in the dominant art movement of his youth, Abstract Expressionism. The singular, compressed power of his early paintings, the sense of life one gains from them, seems to have been fueled by an intense, self-conscious will channeled through a draconian self-policing.

Though Johns's use of the term "focus" might superficially suggest a connection to the cinematic mobility of vantage that was so important to early modern aes-thetics, his dead-on stare, in *Flag* or *Target with Plaster Casts*, 1955 (plates 8 and 10), was clearly as far from the filmmaker's or photographer's strategy of "making new" by eccentric distortion as it was from utopian ideals of higher knowledge. Such activist heroics were replaced in his early world view by the belief that impassivity—

the fixed gaze of uncertain focus—could effect a subtler but more devastating subversion of habits of mind, and force a sharper awareness of experience in the present tense. It was on these grounds that Johns broke with the modern tradition as it had been taught to him, and found his kinship with Duchamp.

In 1960, when Johns praised Duchamp's use of willful indifference as a tool for bringing awareness into the here and now, he echoed his own ideals. Reviewing the publication that year of the notes for Duchamp's masterwork, *The Large Glass*, Johns praised the work for "allowing the changing focus of the eye, of the mind, to place the viewer where he is, not elsewhere."[23] He was to amplify this sense of identification in 1968, when he lauded the same work for the ways its "cross-references of sight and thought, the changing focus of the eyes and mind, give fresh sense to the time and space we occupy."[24] Appropriately, then, after the "rotating point of view," the second "academic idea" Johns cited in his statement of 1959 was Duchamp's: the "suggestion 'to reach the Impossibility of sufficient visual memory to transfer from one like object to another the memory imprint.'"[25] The passage Johns referred to here, from the notes for *The Large Glass*, reads in full:

<u>To lose the possibility of identifying/recognizing</u>
<u>2 similar objects</u>—
 2 colors, 2 laces
2 hats, 2 forms whatsoever
to reach the Impossibility of
 sufficient <u>visual</u> memory
to transfer
from one
 like object to another
the <u>memory</u> imprint
—Same possibility
with sounds; with brain facts[26]

The idea of losing memory, like that of defeating habits of thought, had long tantalized the modern imagination as a way to regain a freshness of experience—hence Paul Valéry's dictum, "Seeing is forgetting the name of the thing one sees." Again, however, what Johns seems to have admired was something more subtle, and more discomfiting, than this dream of unprejudiced holistic purity. For Duchamp's concern in his note is not with some rejuvenation of experience per se, but with our synthesizing ability to see two like things as instances of a single category. His ambition is to defeat that generalizing mechanism, which facilitates the continuity of normal consciousness, in order to foster an extreme nominalism in which there are no universals and in which each separate experience, no matter how resembling or repeated, must be attended to on its own terms, as unique.

Johns likely came upon this note after his first, 1958 exhibition, but he clearly felt it fit with what he had been doing.[27] Its implications for him become clearer in the enthusiasm he later expressed for the "Wilson-Lincoln system," a strategy Duchamp described in his notes but never used, which had to do precisely with the intertwining of perspective and memory.[28] The system was named for a trick

device (presumably a piece of political advertising) that presented Woodrow Wilson's likeness when seen from one vantage and Abraham Lincoln's when seen from another. Duchamp envisioned a geometric drawing of two figures based on this principle for *The Large Glass*: from the right, it would offer a square viewed from the front, while from the left, it would present the same square in perspectival projection.[29] With each viewpoint showing the figure via a different optic, there would have been no constant form at the center; each experience of it would be separate and incommensurable with the other, for even if we could present the views simultaneously, each would show us something as different as Wilson is from Lincoln.

This notion delighted Johns, by virtue of the same predilection that has informed his later attraction to the trick images of perceptual psychology—the duck/rabbit drawing, for example, that we can see as one of these creatures or the other, but never stably as both, or as anything "in between." (Johns has used this image in a number of works; see, for example, plate 207.) "I like to create an image that when looked at becomes something else and there's no in between," he has said as recently as 1990. "That aspect of seeing or knowing…offer[s] equal access to two possibilities. I'm fascinated by that kind of thing and other kinds of material that make possible that either/or situation where things become slurred and uncertain….Not knowing exactly is something I find fascinating. Whatever the basis, it probably moves one to see life in an ambiguous way."[30] The dream of permanent indecision in the Wilson-Lincoln system is the negative döppelganger of Picasso's desire to possess front and back simultaneously, and it dovetailed precisely with Johns's feeling that representations which force awareness of the discrete separateness of every viewpoint—and thus of the irremediable fragmentation, variability, and discontinuity of experience—were truer to life.

Such considerations have limited power to illuminate any particular picture, but they do help to define some of the paradoxical relations between Johns's intentions and his strategies over his whole career. Just as we have seen that the fixed, static format of the earliest work was born from a desire for mobility of mind, so Johns's practice of constant repetitions turns out to be informed by a strong belief in inconstancy. On the Wilson-Lincoln principle, the passage of time divides an ostensibly stable form into a sequence of discrete moments or states that are separate unto themselves. By thwarting the mental habits that give our consciousness an unthinking, fluid wholeness, art can promote keener attention to those separate integrities—an active awareness that will not allow the easy confluence of the past into the present, but instead holds the two apart in mutually vivifying juxtaposition. "I am concerned with a thing's not being what it was," Johns has said, "with its becoming something other than what it is, with any moment in which one identifies a thing precisely and with the slipping away of that moment."[31] Repetition, in the early grids of alphabets and numbers or in the constant recyclings since, has been a (perhaps consciously contrary) way for him to embody this concern for the unrepeatable. Reiterating a prior motif naggingly requires that Johns—and the viewer—each time recall and surmount the habits of a previous or habitual mode of approach. For an artist so committed to avoiding familiar ideals of resolution and wholeness, this repeated exercise of attending to and remaking the past becomes an integral part of a constant effort to sharpen a sense of being in the present—

within the process of covering a canvas, or at particular moments in the course of a developing life.

This consideration in turn suggests how central the concept of remembering has been throughout Johns's work. From the outset he has seen art's goal as that of making life memorable—of impressing vividly on the mind things one might otherwise look at and forget.[32] In the late 1960s and 1970s, his art was almost completely taken up with work on abstract patterns—flagstones and hatch-mark clusters—reconstructed from mental images of things he had glimpsed fleetingly in passing and never seen again (e.g., plates 123 and 153–62); and since 1982 his work has often seemed to function almost wholly as a kind of recollection system, including the evocation, through house plans, family photos, and other references, of his own earliest memories. It seems not at all unnatural that an artist concerned with detached mobility, discontinuity, and fragmentation as the necessary conditions of life should eventually become reflective about the sense of transience that may follow as the cost of such freedoms; and that he should then activate memory, not as the enemy of new experience, but as an agent against loss. From the *Flag* of 1954–55 to the plan of his grandfather's house that he introduced in 1992, the ambition remains constant: to use art as a way to pique the mind's active and reflective powers against the silent deadening that steadily works to truncate human experience.

But do such considerations bring us any closer to a reading of the meaning, or meanings, of the art? Given what Johns has said over the years, such speculations about his notions of knowing and seeing may have some truth on their own terms. None of this, however, is what the art is *about* in any literal sense. Even if we could confirm that they shaped his intentions, these notions would matter only inasmuch as they prodded Johns toward painting; they offer no master key to the results. "The problem with ideas," he has said, "is, the idea is often simply a way to focus your interest in making a work….a function of the work is not to express the idea…. The idea focuses your attention in a certain way that helps you to do the work."[33]

Johns has argued forcefully against the fallacy that initial intentions define final meanings, and has made it clear how little stock he puts in the premise that his art ever "makes a statement."[34] Yet the literature remains dense with interpretations that read his pictures as exactly realized expressions of carefully plotted (though concealed) programs concerning formalist issues, commentaries on art-historical traditions, sexual identity, and more.[35] The common image of this artist is that of a delphic, cerebral strategist who understands at all times exactly what he is doing and what his works mean (but usually chooses to keep it secret). His admiration for Duchamp, the canny cerebral schemer and secrets-keeper par excellence, encourages this assessment; the publication of his fragmentary sketchbook notes to himself, which speculate and instruct in the manner of Duchamp's notes, has helped reinforce it. Johns's (absence of) public life and his personal demeanor, legendarily marked by a cautious reserve and an often cryptic thoughtfulness, have been taken as further confirmation. And on this view, what really matters to him, and to us, is the preconceived intellectual structure of his works, theoretical or philosophical; the rest is at best a vehicle, at worst a seductive distraction.

Many American critics, sympathetic to Duchamp's rejection of art's sensuality but uncomfortable with the easy dandyism and aristocratic elegance of his play, have

found this more earnest concept of seriousness congenial. In its light, Johns's work is seen as encrypting therapeutic philosophical demonstrations, particularly concerning the nature of art, in difficult codes that demand an initiate's reading. Properly understood, these lessons ostensibly recommend to us such morose virtues as skepticism, irony, fatalism, and disillusionment. Johns has been extolled in this fashion not only as Wittgenstein in paint but even as an ascetic moral exemplar for whom "it is more important to pursue the truth than to follow a spurious esthetic progress."[36] Yet this model of how he works, and of how the art works, risks overstatement in what it claims, and may even more grievously miss the mark in what it scants.

There are other ways to be intelligent, and other ways to be serious. To state the obvious, Johns is a first-rank artist, not an ersatz philosopher. He has been by all evidence strongly interested in certain philosophical questions, but these interests may in the long run be like Seurat's science or Turner's poetry, invaluable for propelling the artist to the easel but impoverished or irrelevant as a standard for assessing the result.[37] The devices from perceptual psychology that have attracted Johns's interests, for example—the duck/rabbit, the drawing that is both young girl and old woman, and so on—are common things at the call of undergraduates; and the original Wilson-Lincoln device was a cheap-trick political toy. It takes either a special creative mind or an overearnest pedantry to see such things as the emblems of something broad and profound; this is a good "mistake" when Johns or Duchamp makes it but a bad one for an art historian to remake.

If what Johns offered us intellectually were only such chestnuts and their familiar "messages" about perception, what an impoverished, didactic art his would be. The trick images are standard as instructions about the mind in general but peculiar and more interesting as tokens of Johns's own. His attraction to them as talismans of broader situations—of ambiguity, for example—is of a piece with his fascination for reductive schemas, and with his practice of joining the literal to the abstract and vice versa. It is that particular abstract-literal splice in the wiring of Johns's temperament that informs his fruitful cross-references between seeing, thinking, and making, or between inherent matters of art and broader matters of life. The sense of life in his art, which is its most basic vehicle of meaning, depends less on concepts or props than on the distinctive, often uncanny character of these unexpected linkages, and on the original expressions he finds for them in the nonverbal language of space, scale, line, color, and materials.

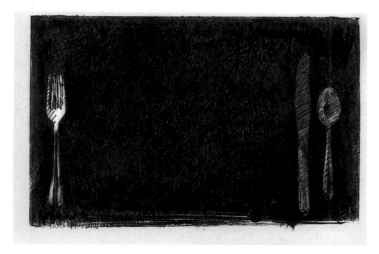

Fig. 3. Jasper Johns. Illustration for the book *In Memory of My Feelings*, by Frank O'Hara (New York: The Museum of Modern Art, 1967) Graphite pencil and graphite wash on plastic 12 ½ x 19″ (31.7 x 448.2 cm) (irreg.) The Museum of Modern Art, New York. Gift of the artist

Interviewers often comment on Johns's interest in taking words literally, through a sophisticatedly stubborn refusal to admit nuance; and he is at the same time someone who can, like an anthropologist in an alien culture, see every concrete thing in terms of its place in a system of abstract relationships. When asked his thoughts on the knives and spoons in a group of drawings from 1967 (fig. 3), his answer moved directly through the kitchen to the cosmos: "cutting, measuring, mixing, blending, consuming— creation and destruction moderated by ritualized manners."[38] In self-deprecation he once remarked,

"My thinking is perhaps dependent on real things and is not very sophisticated abstract thinking";[39] but it is precisely the nature of those connections to real things—not the ideas themselves, as items on a syllabus—that seems crucial to his art. Along the same line as the cutlery, Johns early on speculated in a sketchbook note that "'Looking' is and is not 'eating' and 'being eaten.'"[40] This may or may not be the "text" for the disturbing and utterly personal little work *Painting Bitten by a Man*, 1961 (fig. 4, plate 82), but both text and painting reflect the back-and-forth traffic between Johns's speculations on matters of art, perception, and language and his engagement with materials, physical expression, and the appetites and mortality of the body.

Johns's seriousness as an artist is often linked to his pessimistic cast of mind, but the negative energy of a work like *Painting Bitten by a Man* is both horrifically bleak and something more. It involves a peculiar and disturbing psycho-physical impact that is worth thinking about in terms of the concept, at least, of the comedic. There are certain kinds of ideas that we never imagine being taken literally, and many objects we never expect to see as the vehicle for certain lofty ideas. When Johns bit a hunk out of a painting, or slowly and obsessively painted a target, he short-circuited those expectations, using the gag of inappropriate decorum the way Samuel Beckett used slapstick. He also drew on the languages of comedy when, in the 1980s, he fashioned a purposefully cartoonish style of depicting wood, nails, and so on (fig. 5, and, e.g., plates 188, 189, 193–94, 201–3). In discussing this style, however, Johns cited the late paintings of Philip Guston as evidence that such simplifications have more uses than only merriment.[41] And it was as he moved farther into that vein, toward what he sees as the infantile bases of representation, that he produced the cocktail-olive eyes (fig. 6) and other features of the unfunny funny-face in the recent work, where an air of loopy innocence is inseparable from a Surrealist sense of derangement and dismemberment. The lines typically radiating from those eyes—ambiguously either lashes or comic signs for sight—have evoked both first light and final darkness, miming sperm cells hovering around an egg and also nails clustered beside their distended target.

There are also more obviously dark signs in Johns's art, skulls being the most blatant (e.g., plates 104, 193–94). But these seem conventionally Romantic in comparison to the morbidity of some of the *Skin* drawings of the early 1960s and early-to-mid 1970s (fig. 7, plates 91–94, 148–50), the elegiac quality of the *Diver* charcoal of 1963 (plate 101), and the agitated nocturne

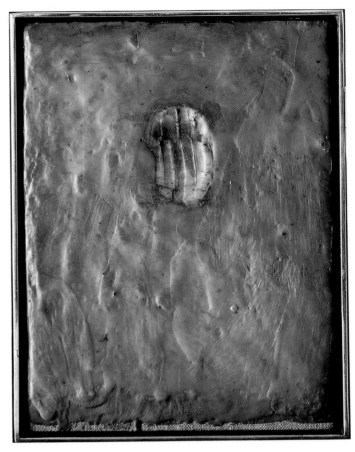

Fig. 4. Jasper Johns. *Painting Bitten by a Man*. 1961 (see plate 82) Encaustic on canvas mounted on type plate 9 ½ x 6⅞″ (24.1 x 17.5 cm) Collection the artist

Fig. 5. Jasper Johns. *Untitled (M. T. Portrait)* (detail). 1986 (see plate 208)

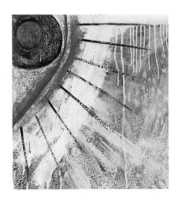

Fig. 6. Jasper Johns. *Green Angel* (detail). 1990 (see plate 226)

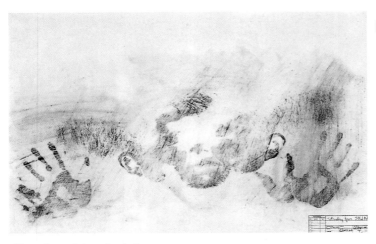

Fig. 7. Jasper Johns. *Study for Skin I*. 1962 (see plate 91) Charcoal on drafting paper 22 x 34″ (55.9 x 86.4 cm) Collection the artist

of *Perilous Night* of 1982 (plate 189), works in which the physical immediacy conveyed by body imprints or casts collides with the ambiguity of the pictorial space to conjure dark struggles within imprisoning voids. And the more original language of those images arises from the same concrete/abstract frame of mind that can impart a frozen power to ideas that might otherwise be one-liners, as in *The Critic Sees II*, 1964 (fig. 8, plate 112), or *Painted Bronze* (ale cans), 1960 (fig. 9, plate 66). In a lesser artist, jokes like these, and Johns's various puns (*4 the News*, *Painting with Two Balls*), might be just trivial. But everything depends on the delivery, and in his downbeat deadpan they come off as a bridge between Duchamp's smutty French-schoolboy *blagues* and Bruce Nauman's "stupid" word games and poke-in-the-eye black humor. The joke in *The Critic Sees II*, for example, lands on us like the brick it is, and the evident sight/mouth conflation may have less to do with the piece's long-term bite than does the uncomfortable incongruity (often ignored in reproductions) between the light jest and the sullen gray lump of this fake-metal ingot. *Painted Bronze* (ale cans) originated in Johns's characteristic impulse to take a flip jibe literally and make it concrete; the cans' diligent rendering, and the surplus particularity of their separate weights and details, have a parallel kind of mordant unfunniness that borders on pathos. The gap is miles between the swift, surgical wit of Duchamp's readymades and the seemingly flat-footed, slow-burn emotive complexity of such an object; Johns's works can be at their most serious when they and their premises are this dumb, in the double sense of the word.

It does not deny the intelligence of Johns's work, either, to insist on the crucial role played in it by impulse, obsession, stubbornness, and the rote labor of simply "worrying" the object—in short, by the willful *un*thinking that adds so crucially to its presence. One of his sketchbook notes recommends,

> *Take an object.*
> *Do something to it.*
> *Do something else to it.*
> " " " " "
>
> *Take a canvas*
> *Put a mark on it*
> *Put another mark on it*
> " " " " "42

These exhortations do not constitute an intellectual strategy, but something more like an antidote to intellectual strategies; they encourage just getting at it, and imply trusting the two-way interchange between thinking and doing. The same is true even when—or especially when—Johns has carefully preplotted his path. Both

in the grid systems of alphabet or number sequences he took up early on and in the complex patterning that underlies many of the cross-hatch abstractions of the 1970s (e.g., plates 154, 158), a rigid, preassigned matrix freed him to focus on units of execution, and on the variations of material, color, touch, etc., in each zone of work. The rest would take care of itself. It was the steady accumulation of minor "imprecisions" of the hand, at least as much as the mental ordering, that gave the resulting pictures their quality. Though the schemes underlying the cross-hatch works were sophisticated, Johns also liked the "mindless," labor-intensive aspect of the motif; he would later remember the force of that appeal for him even when he first saw the hatch pattern, on a passing car: "I only saw it for a second, but knew immediately that I was going to use it. It had all the qualities that interest me—literalness, repetitiveness, an obsessive quality, order with dumbness and the possibility of complete lack of meaning."[43]

In the execution of these works as elsewhere, the sense of mind in Johns's art may owe less to thoughtful preprogramming than to his enforced suspension or suppression of what he knows in order to focus on what he is doing. (An affinity with Zen procedures, and Johns's close relationship with the composer John Cage's exposition of Eastern thought, doubtless inform this apparent emptying-out and attention to process.) In the mid-1960s he told David Sylvester he believed that "in a painting, the processes involved in the painting are of greater certainty and of, I believe, greater meaning, than the referential aspects of the painting. I think the processes involved in the painting in themselves mean as much or more than any reference value that the painting has."[44] Matter, making, and meaning are as necessarily interconnected for Johns as body, eye, and mind. His bent for cross-breeding the literal and the abstract receives its most consequential outlet when broad intellectual concerns spur an original investment in particular physical aspects of his craft, and when that investment in turn pays complex surplus dividends. Thinking hard about painting—about the fundamental interlock of what can be seen (the surface) and what may be known (implied space in front of, behind, and around the surface, including the perception of one's own body)—has yielded for Johns a series of actions, images, and orders that have informed a central spine of meaning in his work. This is far from "formalism" as many critics of the late 1950s and 1960s understood the term; Johns seems to have had little interest in the shibboleth of pure flatness that then governed so much talk of the picture plane. Yet he was strongly concerned to emphasize the concrete, nonillusionist materiality of his work, and the tension between that imperative and the desire still to include matters of time, motion, and space in the art drove him to concentrate on a series of quite literal aspects of his process as an artist, and to enlist them as metaphors, in ways that have bound several different phases of his work together. The basic elements in question—a physical world, an imagined space, and a canvas—are almost ludicrously self-evident as any painter's givens; as with simple ideas and cheap-trick optical puzzles, it took a special fixation of attention and concern to find these "merely formal" conditions of body, mind, and eye problematic, and fraught with potential cognitive challenge and emotional valence. (As Johns noted in a sketchbook jotting, "Some have problems/which are not seen/as problems by others/[and which are not/seen by others].")[45]

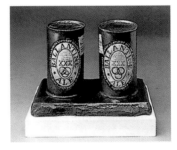

Fig. 8. Jasper Johns. *The Critic Sees II*. 1964 (see plate 112) Sculp-metal on plaster with glass 3 ¼ x 6 ¼ x 2 ⅛″ (8.2 x 15.8 x 5.3 cm) Collection the artist

Fig. 9. Jasper Johns. *Painted Bronze*. 1960 (see plate 66) Oil on bronze Overall: 5 ½ x 8 x 4 ¾″ (14 x 20.3 x 12 cm); two cans: each 4 ¾ x 2 ¹¹/₁₆″ diameter (12 x 6.8 cm diameter); base: ¹³/₁₆ x 8 x 4 ¾″ (2 x 20.3 x 12 cm) Museum Ludwig, Cologne

In the earliest works, Johns's schemes for making meanings manifest in physical terms were aggressively literal and direct. He originally intended to put panels like large piano keys atop his first target painting, for example, drawing viewers to come push them in order to hear a sound—and thus enforcing physically the kind of shift in viewing distance he felt was important for "the changing focus of the eye."[46] And, in order to convey the temporal sense we discussed, of the separate integrity of each moment of looking, he adopted fast-drying encaustic, so that individual brushstrokes would remain discrete and the time between each consecutive mark would become palpable.[47] Operating with ideals of the mind's mobility and a heightened consciousness of the present, he decided to advance labor (patient and modular) as a metaphor for thought (focused and attentive).[48]

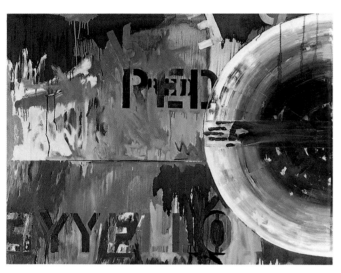

Fig. 10. Jasper Johns. *Periscope (Hart Crane)* (detail). 1963 (see plate 103)

After 1960, Johns moved beyond painting designs like the flags or numbers and into the sphere of pictures that had "no references outside of the actions which were made." The pictures then became for him less "intellectual," as the viewer could respond more "directly to the physical situation." When he said that this work was also "involved with the nature of various technical devices,"[49] he likely referred to motifs like the pivoting boards that produced scraped half-circles in paintings such as *Device*, 1961–62, and *Periscope (Hart Crane)*, 1963 (fig. 10, plates 87 and 103). These brought the drafting practices behind the target pictures to the foreground as physical events in their own right, indices of actions made and potential carriers of altered meanings.

Just as Johns can see cutlery under the aegis of creation and destruction, so he appears to have found in such measuring tools a distinct vein of associations, tied up with the basic processes of breaking a whole into parts and subsuming disparate things under a single order of standard, conventional increments. For Johns, gauging size is an act of definition akin to naming, and the first measuring devices appeared as subjects in his work near the same time he began to feature—in *False Start*, 1959 (plate 54)—the inherent conventionality of names for colors.[50] The presence of rulers, thermometers, color charts, and makeshift compasses as instruments of hard quantification within the ostensibly unmeasurable ambiguities of the pictorial field produced a collision he found interesting.[51] In *Periscope (Hart Crane)*, for example, the half-circle blurs and confuses the surface in the act of clarifying and ordering it, simultaneously evoking an absent, past act and emphasizing the paint's immediate, nonreferential physicality. The "arm's length" measure made explicit by the limb print also seems to speak less of rational parceling than of the pinioned delimitation of a human reach. Circularity as an abstract order of wholeness is here transformed into a physical metaphor of futility, turning constantly without getting anywhere. Barbara Rose has been sensitive to the implied pessimism of such circle motifs in Johns's art of the period, and has connected them to the onanistic self-enclosures of rotary motion in the "bachelors" section of Duchamp's *Large Glass*.[52]

Beginning thus as a device of physical demarcation and assuming a set of implied emotive meanings, the circle expanded within Johns's art as that art changed, eventually becoming associated less with a visible act of measurement than with the concept of rotation in implied space, and hence of continously revolving return. This happened after 1961, as part of a broader shift that saw Johns begin to focus on issues of space as much as on those of materiality, and to seek direct, nonillusionistic ways of mediating between a fully dimensional world and a flat plane. This new bent prompted his attention to different kinds of schematic designs governed by topological codes, as in the *Map* images of 1962–63 (plates 96 and 97) and especially in the global dymaxion map Johns painted in 1967 (and repainted from 1968 to 1971; plate 146). But before and after adopting these found topological projections, Johns explored both more immediately physical and more abstrusely conceptual ways of representing three dimensions in two. On the one hand he began printing forms directly onto the plane of the paper or the canvas, to create a trace impression, and on the other he began devising purely mental codes, like that of implied cylindricality, to suggest spatial structures beyond the surface. Each process yielded a different potential for metaphor and meaning.

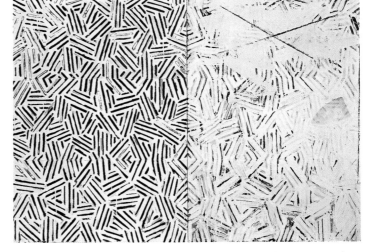

Fig. 11. Jasper Johns. *Corpse and Mirror.* 1974 (see plate 155) Oil, encaustic, and collage on canvas (two panels) 50 x 68 ⅛″ (127 x 173 cm) Collection Sally Ganz, New York

Johns may have first gotten the notion of printing with objects from Robert Rauschenberg, who used this method as an effortless way of drawing.[53] Like life casting, it offered an ideally impersonal way to transfer found imagery into his work on exact scale. From 1960 on, too, Johns's own work in printmaking further attuned him to (among other things) overlay, delay, surface resistance, mirror reversal, the modular partition of wholes into parts, and figure/ground separation. Richard Field has explained in depth how Johns understood and articulated these conditions and procedures as vehicles of meaning in his prints;[54] they also carried over into painting.[55] The mirroring and variation effects of print transfer—which dovetailed with Johns's interest in basic matters of identity, repetition, and change—could for example translate into diptychs that made a new whole out of two mirrored parts, or that juxtaposed a crisp pattern with its degraded or muddled "blot," suggesting a change of state with overtones of decay or death (e.g., *Corpse and Mirror*, 1974, fig. 11, plate 155).

When it came to representing three dimensions on a flat surface, direct printing of an object could also provide an automatically denatured and reductive trace that took on an independent life. In the case of Johns's own face and body, rationalized mapping gave way to splayed distortions in the *Study for Skin* drawings of 1962, where he continuously rolled out the surface of his form into one flat sheet across the surface (fig. 12). These steamrollered images of the body corresponded to another unrealized project of the early 1960s in which Johns had planned to cast a head in rubber in order to create a "hide" stretched flat.[56] But the macabre connotations of flaying that would have resulted from this sculpture seem more predictable than the complex metaphor of ghastly imprisonment that arose directly in making

Fig. 12. Jasper Johns.
Skin II. 1973 (see plate 149)
Charcoal on paper
25 ½ x 40 ¼″ (64.8 x 102.2 cm)
Collection the artist

Fig. 13. Jasper Johns.
Fool's House (detail). 1962
(see plate 90)

Fig. 14. Jasper Johns.
Sketchbook notes (detail)

the studies: the pressure against the front of the paper suggested, in the imprinted image, a figure trapped and desperately pushing forward from a space behind the surface (fig. 7).

Simultaneously with these disturbing images, Johns was devising an apparently more detached and covert code for space "behind" or "within" his images—and returning to the motif of circularity, now reconceived as a rotation in three-dimensional space. In *Fool's House* of 1962 and many subsequent paintings, titles or patterns are painted partially cropped by the works' right and left edges, in such a way that these edges would join in seamless continuity were the surface rolled around an imaginary cylinder (fig. 13). Pushing this idea of an encoded topological referent still further, Johns then introduced a much more complex mathematical system, and a more ambitious concept of represented space, in many of the cross-hatch paintings. Dividing their surfaces into modules of different color, stroke, direction, etc., he imposed rules of sequencing that, when decoded, corresponded conceptually to the track of one or more spiraling motions through space (fig. 14).

Here again, considerations of formal structure seem to have been directly conjoined with those of meaning, in an altered nexus of spatial, temporal, and emotional implications. These spiral systems dominate the numerous late-1970s and early-1980s works entitled *Usuyuki*, meaning "light snow" in Japanese but implying also the notion of "fleeting beauty" (plates 167, 168, 174, 180). That series might be taken to represent the opposite pole of the interest in measurement and circularity that began with the concrete physicality and immediate process reference of *Device Circle*.[57] Instead of a fixed circle scribing or smearing the matter of the surface, now an implicit movement through time and space, encoded in an intangible and barely intuited rhythmic pattern, underlies the rustling evanescence and atmospheric variety of the cross-hatch fields. Concrete literalism has thus segued into something more like metaphysical romanticism: within the restlessly blooming and buzzing sensory experience of the plane lurk intimations of a controlling order at work in another dimension.

In plotting these patterns, Johns, who would likely have known of Duchamp's interest in the early modern notion of a fourth dimension and in *n*-dimensional mathematics, may in fact have been thinking more neutrally of the intersection of separate spatial dimensions.[58] But the implied spiritual metaphor of a higher, invisible order of cycling return, sensed behind the ephemeral and apparently fragmented beauty of the physical plane, seems inescapably attached. If there is any justice to finding such metaphoric meaning, then it may not be coincidental that in the last phase of the cross-hatch period Johns took up (in the *Cicada* works; see plate 175) the theme of a locust whose short life

in the open air is but the brief visible moment in a years-long cycle of generation below ground; nor that he almost simultaneously turned his attention (in the *Tantric Details* pictures of 1980–81, plates 182 and 185–87) to an Eastern emblem of destruction and regeneration clasped in a permanent dance of copulation, a dance that makes and unmakes all life.[59]

Circle to cylinder to spiral: from flat, static geometric devices Johns found his way stepwise to the idea of a cosmic order of time, and from acute concern with immediate physicality he moved to themes of the infinite and transcendental. The disrupted physicality of the surface, imprinted imagery of the flesh, and sense of pessimistic futility and constraint that locked together in the half-circle of *Periscope* all seem dispersed by the time Johns's long work with abstraction begins to wind down, in the later 1970s. *Periscope*'s half-circle then is recalled as a "clock" motif in the *Seasons* paintings of the mid-1980s (fig. 15, plates 204–7). There, however, the dominant bodily presence is not a pressing imprint but a weightless cast shadow, and the primary rotation is that of a wheel, turning no longer in frustrated self-enclosure but as one gear, like the phases of the year, in a broader cycling of incessant decline and regeneration. What was a matter of form has become a matter of life and death.

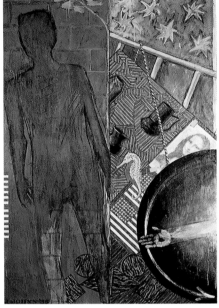

Fig. 15. Jasper Johns. *Summer.* 1985 (see plate 204) Encaustic on canvas 75 x 50″ (190.5 x 127 cm) Collection Philip Johnson

The impersonal, formal issues of topology—of mapping three dimensions onto two—has developed in this fashion into a vehicle of complex meaning for Johns. And there is no doubt that the most persistent topological motif in his work—the one in which concerns for the painting's surface and for the space on either side of it most directly connect both to immediate physicality and to metaphor—lies in the body, and, more precisely, in skin. The practice we have seen again and again, of tenaciously grounding the cognitive in the physical, and then conversely of metaphorizing from the physical toward larger issues of time and spirit, seems especially connected to the artist's intense interest in skin, which was apparent at an early date. The third and final "academic idea" that Johns cited in his 1959 text for The Museum of Modern Art was "Leonardo's idea ('Therefore, O painter, do not surround your bodies with lines....') that the boundary of a body is neither a part of the enclosed body nor a part of the surrounding atmosphere."[60] From early on, clearly, Johns was fascinated by skin as the body's literal boundary between internal life and the impress of sensations from without, a malleable sheath stretched over the human frame; and his viewers as well as he understood the analogy between that stretched membrane and the canvas on which he painted. Max Kozloff once remarked that Johns made the surface of his paintings seem like an erogenous zone, to be repeatedly caressed, and Barbara Rose noted in 1963 that Johns's loving use of encaustic "calls attention to the surface, which is both veined and suave, almost like skin over membrane, rather than harsh and rough like the surfaces of the abstract expressionists."[61]

In 1962, a visit to Madame Tussaud's wax museum in London renewed Johns's fascination with the properties of skin, and this directly fed into his work on the cast-wax legs in *Watchman*, 1964 (plate 108), and *According to What* (plate 105).[62] Later, as he approached sixty, his fascination with the cicada locust seems in part to have centered on the way it split its shell—shed its skin—to emerge from its long

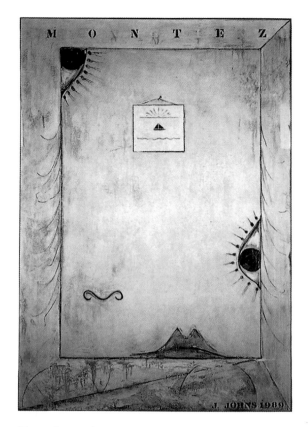

Fig. 16. Jasper Johns.
Montez Singing. 1989
(see plate 224)
Encaustic and sand on canvas
75 x 50″ (190.5 x 127 cm)
Collection Douglas S. Cramer

underground gestation into its short life in the light; and at least a part of his subsequent interest in the detail of a demon from the *Temptation of Saint Anthony* panel of the Isenheim altarpiece also involved skin.[63] (The altar was originally commissioned for a hospital, and several of its figures—including especially this scabrous troll—display epidermal pathologies in clinically grotesque detail.[64]) In recent years, Johns has been more overt in his association of the painter's canvas with skin, frequently using a Caucasian flesh tone in depictions involving the dislocated "face" that has been a favorite motif (fig. 16, plate 224). As the "face" connects with Johns's interest in the drawings of children, so this more explicit skin/canvas connection seems similarly tied to his heightened interest in bringing forward the primal, infantile impulses that he feels lie at the origins of art. When we compare the face with the "unrolled" *Study for Skin* of thirty years previous (fig. 7), we find both a continuity of thought and a shift of mood from nightmare to dream. The bodily envelope of sensation, so often sensed as the fabric of mortality and anxiety in earlier works, seems now to be a screen of projection for the fantastic deformations of primal sensual experience.

The flayed body or *écorché* figure has a complex history in European art as a symbol both of human mortality and of the power of science, beyond the limits of normal vision, to lay bare that truth; it has traditionally been used as the emblem simultaneously of knowledge and death. But these properties it has by the absence of its skin, the barrier that conceals inner structure from view. By contrast, Johns's haunting 1974 self-portrait as a hide (fig. 17, plate 150) vests the spirit in the shell, situating life—and, through uncanny suggestions of the Holy Shroud of Turin, death also—on the surface. The rigorous insistence of all of this art on spurning illusion and dealing with the complex through the schematic, the intangible in terms of matter, the abstract through the literal, and the spiritual through the physical, constitutes a different kind of insistence on truth; and for this artist the limiting envelope of flesh, pressed to maximum presence on the flat plane of representation, is perhaps the most compelling self-image. Its more recent correlate is the image of the empty pair of trousers hung up in the center of the "bathtub" pictures of the mid-1980s (fig. 18)—a melancholy, hollow husk of the self that in shape and in self-vilifying implications offers a distant echo of Michelangelo's self-portrait as a flayed sack, in the *Last Judgment* fresco in the Sistine Chapel (fig. 19).

This is a self-presentation fraught, too, with overtones of suffering and physical mortification. In the emotional compression of the early, "neutral" subjects, it was already evident that Johns's art drew some of its best powers from ruthless exclusions and deliberate restraints. The stern valence of much of his subsequent work stems in part from similar repressions and negations. He has made it clear that any "public" motivation for art—the idea of making a picture to please an audience or answer a social demand—is anathema to him, and that the private impulse he seeks is one born from self-denials and throttlings of will; these refusals are to yield at the end a "helpless situation" of exhausted, involuntary fatality, beyond judgment and beyond

pleasure, from which true originality can emerge.[65] Ideals of passivity and acceptance, rather than constructive will and shaping force, have governed Johns's aesthetic territory. In part they belong to the aspects of Zen self-effacement he shared with his late friend Cage, but his particular commingling of these Eastern ideals with a more American stoicism of self-discipline and stubborn refusals has forged a darker, notably unserene alloy of affirmation and abnegation in the physical immediacies of his art.[66]

Prime among Johns's refusals has been a refusal of meaning—or, more precisely, an insistence on distancing himself from the enterprise of interpreting what he has achieved. In his ideal of an artist's action, the energies invested in the making of a work should leave none remaining for its analysis or explication. Aside from the commentary or critique implied in the next work he or she makes, the creator then leaves the meaning of a given creation to emerge from its uses or abuses at the hands of its viewers. If there is one key point of congruity between Johns's interest in the language of painting and his broader interest in linguistics, it is this antiessentialist notion—often associated with Ludwig Wittgenstein—that the meaning of something derives from the way in which it is used. Rather than simply resigning himself to this condition, Johns has actively sought to respect it as a central precept of his art. Remarking to Sylvester that "intention involves such a small fragment of our consciousness and of our mind and of our life," he added, "I think a painting should include more experience than simply intended statement. I personally would like to keep the painting in a state of 'shunning statement,' so that one is left with the fact that one can experience individually as one pleases; that is not to focus the attention in one way, but to leave the situation as a kind of actual thing, so that the experience of it is variable." And when Sylvester tried to turn this position itself into a statement, Johns further demurred, by making a key distinction. "In other words," he was asked, "if your painting says something that could be pinned down, what it says is that nothing can be pinned down, that nothing is pure, that nothing is simple." "I don't like saying that it says that," Johns corrected. "I would like it to *be* that."[67]

Yet the pursuit of a fundamental or secure meaning in this art has proved, and still proves, irresistible. More perhaps than any other artist of his time, Johns has from the outset of his career given rise to a tremendous literature of explication, often aiming to fix his work to an originating intention. There has been, for example, a powerful recurring urge to show that his early signs of common culture are actually recondite selections with historical or personal meanings that can only be unlocked by specialists; and the elusive, layered imagery of more recent work has been read as if it offered a rebus illustrating some programmatic private narrative. In the early literature, there were warnings about the error of merely enjoying Johns's pictures as luscious optical experiences,[68] but it may wind up being these converse seductions, of explanation, that are the more irresistible and more misleading.

Fig. 17. Jasper Johns. *Skin*. 1975 (see plate 150) Charcoal and oil on paper 41 ¾ x 30 ¾" (106 x 78.1 cm) Collection Richard Serra and Clara Weyergraf-Serra

Fig. 18. Jasper Johns. *Racing Thoughts* (detail). 1983 (see plate 193)

The dilemma of the 1992–95 *Untitled* painting, with which we began, is exemplary in this regard. Johns's art, especially now that it has accreted such a rich history of reception and exegesis, offers so much to analyze and explain, and contains so many references and cross-references, that a large labor is invited simply to set down the knowable facts. We began with only the simplest sketch of that one painting, and there would be vastly more to say about the skein of connections it provides to the histories of schemas and measurement, circles and space, seeing and memory, that we have touched on since. Yet at the end of the endeavor, after potential pages more of citation and explication of the particulars, we would still be "beside" the picture. Having amassed a parallel information bank that might have little or nothing to do with the experience that drew us to the work in the first place, or with its final qualities and impact as a synthesis of all these things, we would risk implying that such an ennumerative "explanation" could account, with some spurious thoroughness, for the meanings in the art. And we would have invited the false implication that this picture, or the art in general, can only speak truly to an informed initiate, armed with a decoding apparatus of hermetic knowledge.

This path to explanation seems in part unavoidable, yet in totality unfruitful; for by taking it we betray the very point about meaning that we most centrally associate with this artist. We cannot, without some fundamental hypocrisy, go on mouthing obeisance to Johns's (or Wittgenstein's) insights into the irresolvable ambiguities of all communication and at the same time insist on how clearly and definitively Johns's art encapsulates these messages to us. If what the artist is telling us is that meaning is not a matter of private intention and intrinsic essence, but of socially tempered conventions and of usage, then certainly this must apply to the meanings of his art as well. And this implies that we must deflect the seduction to continue "reading" the particulars of the art as if they ultimately embodied a fixed, narrative text, and instead pursue the issues of Johns's meanings by other routes.

The publications produced to accompany Johns's retrospective at The Museum of Modern Art will seek to further that effort in several different ways. First, the core of the present volume offers the most thorough visual documentation to date of Johns's production in all mediums. It divides this visual record into nine chronological units, each representing a particular phase of Johns's career; the points of division are determined by what seem marked shifts in mode of representation or in favored motifs. Each section is introduced by a brief text that takes an overview of the salient characteristics of Johns's art during the period in question, and by a chronology that summarizes all the publicly available information about his life and work in these years. A companion volume, *Jasper Johns: Writings, Sketchbook Notes, Interviews*, supplements this record with an anthology of the artist's own words, including many interviews and sketchbook notes previously unavailable in English. In addition, the selected bibliography in the present volume is also to be supplemented by a full bibliography and an exhibition history, published electronically for use as a computer data base. It is our hope that these presentations of more complete visual and textual documentation will provide an enduring foundation for any future reckoning with Johns and his art.

In the realm of broader commentary on that art, because the literature on the artist is already well supplied if not oversupplied with ambitious attempts to decode his pictures like puzzles, item by item, from the inside, the present catalogue will, in the essays that follow, approach the work from the outside in. It will consider Johns's work from two complementary aspects—by the Wilson-Lincoln system, one might say. First, Roberta Bernstein will examine what artists of the past have meant to Johns; then I will consider what Johns has meant to artists of the present.

Neither essay will be about "influence" in the limited sense of the word. In the course of his work, Johns has created a discernible pantheon of artists he may cite in his titles or quote in his imagery. Some of these, along with certain writers and musicians, have helped form his sense of the possibilities of art; others are bound to him by "elective affinities," discovered as his life and art evolved. Taken together, they constitute Johns's invention of a personal tradition that belies the schisms in earlier modern art—as for example between Picasso and Duchamp—as certainly as it confounds the very line between modernity and postmodernity that his work is sometimes held to embody.

On the other side of that purported line, in avant-garde art since 1960, Johns's own impact has been no less diverse and filled with apparent contradiction. Beyond the well-recognized, immediate impact of the early paintings and sculptures as a generative source for the art of the early 1960s, Johns has provided ongoing inspiration for generations of peers and younger artists, of widely differing aesthetic persuasions. By studying his work through their responses to it, we can extend our sense of the uses to which that work has been put—and hence of the potential meanings it has carried. With this examination of what radiates outward and with Bernstein's consideration of what flows in, the hope is to bracket Johns's art within a pair of complementary contexts that will help expand and enrich, rather than only reduce and define, our understanding of it—that will map more of its topology, and also suggest, perhaps, something more of what its skin encompasses.

Fig. 19. Michelangelo. *The Last Judgment* (detail). 1534–41
Fresco
Sistine Chapel, The Vatican, Rome

Notes

1. In his most explicit homage to Marcel Duchamp, the 1964 *According to What*, Johns juxtaposed this splatter-drip mark directly with the profile of Duchamp, on the small hinged canvas at the lower left of the large work (see fig. 5 of Roberta Bernstein's essay in the present volume). The mark's sprayed or splattered character may refer to the way Duchamp fired paint-tipped matchsticks from a toy cannon at the surface of *The Large Glass* to mark the futile spurts of the Bachelors toward the upper realm of the Bride.

2. The device of the perspectival picture-in-picture, first used in *In the Studio*, 1982, is in fact based on the experience of seeing a canvas leaning back in the studio. "I had seen an empty canvas propped against a painting in my studio, and that accounts for the sort of empty rectangle that goes in a slight perspective." Johns, speaking in Rick Tejada-Flores's film *Jasper Johns: Ideas in Paint*, 1989. Earlier, Johns had inserted

seemingly external panels into his works as two-dimensional overlays, as in the long passage of screenprinted newsprint in *According to What*, or the *Usuyuki* composition inserted diagonally into one version of *Between the Clock and the Bed*, 1981 (plate 184).

3. Barbara Rose has compared Johns's work with Marcel Proust's *Remembrance of Things Past*, which she sees as pursuing the goal of "the representation of the totality of consciousness." "Johns's commitment to the exposé of the whole content of consciousness is necessarily bound to the perpetuation of the continuity of memory." Rose, "Decoys and Doubles: Jasper Johns and the Modernist Mind," *Arts* 50 no. 9 (May 1976): 68.

4. Characteristic responses to this quality in Johns's work include Rose's remark "Jasper Johns seems to me in love with his paintings.... Only a lover could lavish the kind of care and consideration Johns gives the surfaces of his paintings"; see her "Pop Art at the Guggenheim," *Art International* 5 no. 7 (May 25, 1963): 22.

John Cage similarly observes, "Looking closely helps, though the paint is applied so sensually that there is the danger of falling in love," in his "Jasper Johns: Stories and Ideas," in Alan R. Solomon, *Jasper Johns*, exh. cat. (New York: The Jewish Museum, 1964), p. 25. And Max Kozloff writes, "In Johns' vision...the sensuous properties and pleasures of art are accentuated....It is, if one wishes, a self-canceling use of seduction," in his *Jasper Johns* (New York: Harry N. Abrams, Inc., 1969), p. 10.

5. Rose writes, "We have seen how Johns often displaces elements from one context to another. Depriving color of its conventionally expressive role as well as disregarding the associative possibilities of objects, he displaces a great deal of the expressive burden of his work to technique. This is especially true of his prints....But the technical brilliance of Johns's works on paper is surprisingly not the result of his facility as a draftsman....His expressiveness arises rather out of an ability to create analogs of emotional experience in the tempo,

regularity and irregularity of stroke, firmness or openness of contour and sensitive bleeding or dripping wash passages." Rose, "The Graphic Work of Jasper Johns: Part II," *Artforum* 9 no. 1 (September 1970): 69–70. Rose's suggestion of "analog" techniques, however, makes Johns sound too much like an expressionist in the accepted sense of the word. What is more remarkable is the willed impersonality of his marks, most especially in the *w* and *m* marks that we find beginning in the painterly works of 1959–60, but also in the patterns of hatching and scrubbing that often make up his drafts-manship. One might compare these latter tech-niques with the gestural language of Robert Rauschenberg's early transfer drawings, in which he used solvent to rub off printed imagery onto his drawing sheets; the combination of precise, ready-made imagery and artless, task-oriented freehand scrubbing strokes may have left its mark on Johns's procedures in rendering his flag and target images.

6. In a 1990 interview, Johns discussed his lack of training as a draftsman, his techniques, and his predilection for "found" schemas. He allowed that "perhaps I'm more confident work-ing with images of a schematic nature or images that lend themselves to schematization than with things that have to be established imagina-tively," and stated: "Images that can be mea-sured, traced, copied, etc. appeal to me, and I often enjoy that my finished work should con-tain the suggestion that I have used such proce-dures." Johns, quoted in Ruth E. Fine and Nan Rosenthal, "Interview with Jasper Johns," in Nan Rosenthal and Ruth E. Fine, with Marla Prather and Amy Mizrahi Zorn, *The Drawings of Jasper Johns*, exh. cat. (Washington, D.C.: National Gallery of Art, and New York and London: Thames and Hudson, 1990), p. 70.

Johns's tracings of figures from Grünewald's Isenheim Altarpiece are noteworthy in this regard, as they commingle his acceptance of what he finds with his processes of self-editing and independent determination. Johns drew the linear schema of the toppling soldiers from a folio sent to him by a friend, using a plate that showed a detail of the larger work; gravure printing had already transformed the image into a play of grays, and Johns accepted as a given the way the detail cropped Grünewald's compo-sition. When he decided to trace the contours of the demon in the Saint Anthony panel, how-ever, he determined his own croppings, as no isolated detail of this figure appears among the reproductions in the folio; see figs. 55 and 56 acccompanying Roberta Bernstein's essay in the present volume, p. 85. Johns also tried tracing other plates from the folio, but chose not to pursue them.

Beginning with *Souvenir* in 1964 and con-tinuing in the 1970s, Johns has occasionally admitted photographs and photo-reproductions as a nonlinear, tonal variation of the kind of "styleless" but encoded translation of visual information he liked in earlier, more evidently abstract schemas.

7. Johns, quoted in Grace Glueck, "No Business like No Business," *New York Times*, January 16, 1966, Section II, p. 26x.

8. Johns, quoted in "His Heart Belongs to Dada," *Time* 73 (May 4, 1959): 58.

9. Johns, quoted in Walter Hopps, "An Interview with Jasper Johns," *Artforum* 3 no. 6 (March 1965): 34.

10. This notion is primarily associated with the school of literary criticism known as Russian Formalism; its prime exponent in that area was Viktor Shklovsky. See Victor Erlich, *Russian Formalism History-Doctrine* (New Haven and London: Yale University Press, 1965), pp. 176–77. Erlich comments, "It is this inexorable pull of routine, of habit, that the artist is called upon to counteract. By tearing the object out of its original context, by bringing together disparate notions, the poet gives a *coup de grâce* to the verbal cliché and to the stock responses atten-dant upon it and forces us into heightened awareness of things and their sensory texture" (p. 177). Erlich also notes that this general ideal of the purposes of poetry was shared more broadly among those who saw modern artistic creativity as a last line of defense against the numbing automatization of experience. He cites remarks by Jean Cocteau on "the role of poetry": "It takes off the veil, in the full sense of the word," Cocteau wrote. "It reveals…the amazing things which surround us and which our senses usually register mechanically. Get hold of a commonplace, clean it, rub it, illuminate it in such a fashion that it will astound us all with its youth and freshness, with its primordial vigor, and you will have done the job of the poet." From Cocteau's *Le Rappel à l'ordre*, quoted in ibid., p. 180. Given the young Johns's intense interest in poetry, it seems likely that he encountered some version of this ideal of art's purposes and strategies through readings in modern poetry and literary criticism.

11. Johns told a Danish reporter in 1969, "In the earlier paintings you refer to, I looked for subject matter that was recognizable. Letters and numbers, for example. These were things people knew, and did not know, in the sense that everyone had an everyday relationship to numbers and letters, but never before had they seen them in the context of a painting. I wanted to make them see something new. I am interested in the idea of sight, in the use of the eye. I am interested in how we see and why we see the way we do." Johns, quoted in Gunnar Jespersen, *"Møde med Jasper Johns,"* *Berlingske Tidende* (Copenhagen), February 23, 1969, p. 14. Translated from the Danish by Scott de Francesco.

12. Ibid.

13. In 1975, Yoshiaki Tono conducted an interview with Johns in which he asked the artist to reread and comment upon the text of an interview between Johns and David Sylvester ten years previous (see note 19 below). The quote cited here is taken from the original English-language tape of the 1975 Tono inter-view. Both the Sylvester and the Tono interview are published in the companion volume to this catalogue, *Jasper Johns: Writings, Sketchbook Notes, Interviews.*

14. Johns, ["Statement"], in Dorothy C. Miller, ed., *Sixteen Americans*, exh. cat. (New York: The Museum of Modern Art, 1959), p. 22.

15. See Leo Steinberg's examination of Picasso's lifelong obsession with the notion of visually "possessing" a figure from dorsal and frontal views simultaneously in his "Algerian Women and Picasso at Large," *Other Criteria* (New York: Oxford University Press, 1972), pp. 125–34, and in his "Philosophical Brothel," *October* no. 44 (Spring 1988): 55–57.

16. Johns, ["Statement"], in Miller, p. 22.

17. Johns, quoted in G. R. Swenson, "What Is Pop Art? Part II," *Artnews* 62 no. 10 (February 1964): 43.

18. Johns, quoted in Annelie Pohlen, *"Inter-view mit Jasper Johns,"* *Heute Kunst* (Milan) no. 22 (May–June 1978): 21. Translated from the German by Ingeborg von Zitzewitz.

19. Johns, in an interview with David Sylvester, recorded in the spring of 1965 and first broadcast, in England by the BBC, on October 10, 1965. Published as "Interview with Jasper Johns" in *Jasper Johns Drawings*, exh. cat. (London: Arts Council of Great Britain, 1974), p. 11. See also Johns's statement in Swenson, p. 43: "I've taken different attitudes at different times. That allows different kinds of actions. In focusing your eye or mind, if you focus in one way, your actions will tend to be of one nature; if you focus another way, they will be different. I prefer work that appears to come out of a changing focus."

20. Johns, in Sylvester, "Interview with Jasper Johns," p. 7.

21. Johns has said, "After the army, I won-dered when I was going to stop 'going to be' an artist and start being one. I wondered what was the difference between these two states, and I decided that it was one of responsibility.… I could not excuse the quality of what I did with the idea that I was going somewhere or that I was 'going to be something.' What I did would have to represent itself. I would be responsible to it now, in the present tense, and though everything would keep changing, I was as I was and the work was as it was at any moment. This became more important to me than any idea about 'where things were going.'" Johns, quoted in Sylvia L. McKenzie, "Jasper Johns Art Hailed Worldwide," *Charleston (S.C.) News and Courier*, October 10, 1965, p. 13-B.

22. Johns, quoted in Demosthène Davvetas, *"Jasper Johns et sa famille d'objets,"* *Art Press* no. 80 (April 1984): 11–12. Translated from the French by Christel Hollevoet.

23. Johns, "Duchamp," *Scrap* (New York) no. 2 (December 23, 1960): [4].

24. Johns, "Marcel Duchamp (1887–1968)," *Artforum* 7 no. 3 (November 1968): 6.

25. Johns, ["Statement"], in Miller, p. 22.

26. Duchamp, a note for *The Large Glass*, published in *The Bride Stripped Bare by Her Bachelors, Even: A Typographic Version by Richard Hamilton of Marcel Duchamp's Green Box*, trans. George Heard Hamilton (New York: George Wittenborn, Inc., 1960), n.p.

27. In a later sketchbook note, Johns referred back to the Duchamp quote as follows:

Distinguishing one thing from another (Duchamp's "2 like objects")

 none has existed
Making distinctions where none
has been said to exist
 none has been made
 ?
How does the (eye) make such distinctions
Linguistically, perhaps, the verb is important.
But what about such a case in painting?

Author's transcription from an undated page in Johns's sketchbook notes. See this catalogue's companion volume, *Jasper Johns: Writings, Sketchbook Notes, Interviews*.

28. Johns, in his "Duchamp" review of 1960 (see note 23 above), refers to "the beautiful Wilson-Lincoln system."

29. Duchamp's description of the Wilson-Lincoln system appears in the following passage of his notes, in George Heard Hamilton's translation in *The Bride Stripped Bare by Her Bachelors, Even* (n.p.):

Oculist's charts—Dazzling of the splash

by the oculist's charts.

Sculptures of drops (points) which
 the splash forms
after having been dazzled across the
oculist's charts, each drop acting
as a point and sent back mirrorically
to the high point of the glass to meet
the 9 shots =
 Mirrorical return—Each drop
will pass the 3 planes at the horizon
between the perspective and the geometrical
 drawing of 2 figures which will be
indicated on these 3 planes by the Wilson-
 Lincoln system (i.e.
like the portraits which seen from the left show
Wilson seen from the right show Lincoln—)

seen from the right the figure may give a square
 for example
from the front and seen from the right it could
 give the same
square seen in perspective—
 The mirrorical drops not the
 drops themselves
but their image pass between these 2 states
of the same figure (square in this example)
 (Perhaps use prisms stuck behind
 the glass.)
 to obtain the desired effect)

Note: 'seen from the right' (7th line from the bottom) is my error and should read—seen from the left. MD 59

30. Johns, quoted in W. J. Weatherby, "The Enigma of Jasper Johns," *The Guardian* (London), November 29, 1990, p. 29. Just after the section quoted, Johns added, "There may be an infantile foundation to it, a kind of sensitivity, a predisposition towards that way of seeing."

31. Johns, quoted in Swenson, p. 43.

32. In Roberta J. M. Olson, "Jasper Johns: Getting Rid of Ideas," *Soho Weekly News* 5 no. 5 (November 3, 1977): 24, Johns remarks, "What unites things like the flags and flagstone pattern which I once fleetingly saw on a Harlem wall is that in both cases one does not examine the objects very closely. You could easily identify them, without looking very closely. One would ordinarily respond to them visually by looking at them quickly and then forgetting them."

33. Johns, quoted in Katrina Martin, "An Interview with Jasper Johns about Silkscreening," in *Jasper Johns: Printed Symbols*, exh. cat. (Minneapolis: Walker Art Center, 1990), p. 61. Johns has begun by saying, "Well, you mean meaning of images? I don't like to get involved in that because I—any more than I've done—I tend to like to leave that free."

34. In 1964, Johns said, "There is a great deal of intention in painting; it's rather unavoidable. But when a work is let out by the artist and said to be complete, the intention loosens. Then it's subject to all kinds of use and misuse and pun. Occasionally someone will see the work in a way that even changes its significance for the person who made it; the work is no longer 'intention,' but the thing being seen and someone responding to it." Later in the same interview he continued, "Basically, artists work out of rather stupid kinds of impulses and then the work is done. After that the work is used.... Publicly a work becomes not just intention, but the way it is used. If an artist makes something—or if you make chewing gum and everybody ends up using it as glue, whoever made it is given the responsibility of making glue, even if what he really intends is chewing gum." Johns, quoted in Swenson, p. 66.

In 1975, when asked by Tono to review his 1965 interview with Sylvester (see note 19 above), Johns elaborated, "When you begin to work with the idea of say, suggesting a particular psychological state of affairs, you have eliminated so much from the process of painting that you make an artificial statement, which is, I think, not desirable.... if you can say that painting can be interpreted in such a way, you have to realize that you are limiting the meaning of the painting, that the painting doesn't really mean what you say. Because saying means what you say and painting means something else. Though one might agree that what you say is a reasonable thing to say, it may be the best description you can make of the painting, but it is not the painting." He continued, "I think that most art which begins to make a statement fails to make a statement because the method used [is] too schematic or too artificial. And that is simply to reverse what I just said. That I think if you set out, in painting, to say something you could say, you would have been better to say it, rather than to paint it. Painting has a nature which is not entirely translatable into verbal language. I think painting is a language, actually. It's linguistic in a sense, but not in a verbal sense." See this catalogue's companion volume, *Jasper Johns: Writings, Sketchbook Notes, Interviews*.

35. For one instructive example, we might want to consider the ways in which Johns's work has been compared to that of the American Precisionists. Kozloff, writing in 1969, saw the prime basis of the connection between Johns's early use of the figure 5 and Charles Demuth's *Figure Five in Gold* of 1928, for example, to lie in the realm of certain formal traditions of modernism. Rose, also writing in 1969, saw the connection between Precisionism and New York Dada, by contrast, more in terms of history and culture, as a testimony to the continuity of American ideals of pragmatism and indigenous aesthetic traditions. Most recently Kenneth E. Silver has reconsidered Johns's ostensible quotation from or reference to Demuth's *Figure 5* as having to do with homosexual identity. See Kozloff, pp. 11–12; Rose, "Problems of Criticism V: The Politics of Art, Part II," *Artforum* 7 no. 5 (January 1969): 44–49; and Silver, "Modes of Disclosure: The Construction of Gay Identity and the Rise of Pop Art," in Paul Shimmel and Donna De Salvo, eds., *Hand-Painted Pop: American Art in Transition, 1955–62*, exh. cat. (Los Angeles: The Museum of Contemporary Art, 1992), pp. 179–203, especially pp. 186–88.

36. Rose writes, "Taking the clues Johns provides in his statements, notes and titles, we are led straight back into his personal philosophy, as it relates to art as well as to life. Tracking these meanings we find that Johns is no Dada 'pataphysician' as he has been unsympathetically pictured, but perhaps the only artist operating today in the dimension of a mental physics, that is of a true metaphysic. We infer that Johns sees no separation between decisions made in art and those made in life. His decisions have unmistakable moral implications, for he is among those artists for whom the activity on the canvas is the exemplar of his understanding of right human conduct.

"In Johns's case, morality is, purely and simply, an effort at picturing the way things are. His method of working is consequently his morality. He is forced to make endless painful revisions and corrections, to smudge and correct, because this effort does not represent an esthetic, but a moral position. His stylistic change was not a matter of choice but of moral necessity. He can no longer, after a certain

point, picture a stable world of fixed definitions, closed boundaries and a single point of view because it does not seem to him 'accurate,' that is, true. And for Johns, it is more important to pursue the truth than to follow a spurious esthetic progress. There are no advances in a morality of questioning and opposition. To maintain that we exist on shifting ground with no fixed poles of orientation is more difficult than to provide assurances of stability and order. It may, in fact, make the viewer as anxious as the artist who perceives the world this way." Rose, "The Graphic Work of Jasper Johns: Part II," p. 74.

37. In 1988, Johns said: "During the sixties, I concerned myself intensively with Wittgenstein. That his theory is reflected in my work has always been clear only to the art historians, never to me." Johns, quoted in Irene Vischer-Honegger, *"Ich bringe nichts mehr in meinen Kopf,"* *Bilanz* (Zurich), June 1988, p. 96. Translated from the German by Ingeborg von Zitzewitz.

38. Johns, quoted in Fine and Rosenthal, p. 82.

39. Johns, quoted in Sylvester, "Interview with Jasper Johns," p. 15.

40. These notes were published in Johns, "Sketchbook Notes," *Art and Literature* (Lausanne) no. 4 (Spring 1965): 185. See also this catalogue's companion volume, *Jasper Johns: Writings, Sketchbook Notes, Interviews.*

41. Discussing the depiction of wood in some works done around 1990, Johns told Amei Wallach, "It's the wood from anywhere, it's just a symbol for wood [laughs]. It's just a cartoon of wood." When Wallach asked what the "cartoon quality" was about, Johns replied, "I don't know. I think it's just that way of an image being recognizable and having not much other quality, and recognition is that, I don't know what you call that." After Wallach then suggested that a cartoon generally portends something "pleasant or silly," Johns responded, "Not necessarily, think of Guston's late works which have a cartoon quality and they are not very amusing." From a previously unpublished tape recording of an interview held on February 22, 1991, generously provided by Wallach. Parts of the interview were published in Wallach, "An American Icon: Jasper Johns and His Visual Guessing Games," *New York Newsday*, February 28, 1991, Part II, pp. 57, 64–65. See also this catalogue's companion volume, *Jasper Johns: Writings, Sketchbook Notes, Interviews.*

42. Author's transcription from an undated page in Johns's sketchbook notes, previously published in Johns, "Sketchbook Notes." See also this catalogue's companion volume, *Jasper Johns: Writings, Sketchbook Notes, Interviews.*

43. Johns, quoted in Sarah Kent, "Jasper Johns: Strokes of Genius," *Time Out* (London), December 5–12, 1990, p. 15.

44. Johns, quoted in Sylvester, "Interview with Jasper Johns," pp. 13–14.

45. Author's transcription from an undated page in Johns's sketchbook notes.

46. Johns, quoted in Jerry Tallmer, "A Broom and a Cup and Paint," *New York Post*, October 15, 1977, p. 20. Another passage in the article reads, "Originally, [Johns] said, he'd put into his pictures 'elements that I thought would have to make anyone looking at them change position.' Over the plaster casts on those early target paintings, for instance, he'd put little wooden lids. 'One has to come near to open and close them. That kind of activity interests me, and still does.'"

Johns has also said, "The first *Target* originally was to have been a sort of piano. The lids of the boxes would have been keys prepared in such a way that touching them caused noises from behind the painting.... At some point it changed and the wooden keys became lids covering the boxed casts. In both plans, and in the *Target with Four Faces*, it was necessary that one come near the painting to manipulate the keys or lids. This aspect has been lost now that the pictures have become more museumized, but it was important at the time. I thought that what one saw would change as one moved toward the painting, and that one might notice the change and be aware of moving and touching and causing sound or changing what was visible. In such a complex of activity, the painting becomes something other than a simplified image." Johns, quoted in Bernstein, "An Interview with Jasper Johns" [January 18, 1980], in *Fragments: Incompletion and Discontinuity*, ed. Lawrence D. Kritzman, *New York Literary Forum* vol. 8–9 (1981): 287.

47. When asked by Davvetas in 1984 why he first used encaustic, Johns replied, "I was working on a painting, it wasn't dry, and I did not want to blur what I had put on the canvas by adding something else. I had read something on encaustic. So I bought some wax and I set to work: I was right. Everything I did became more clear. Encaustic preserves the character of every stroke of the brush. This coincided with my thirst to use everything that was discrete. These were the ideas of a young man who wanted to do something important, something dynamic. Today I melt any kind of material and let it drip." Johns, quoted in Davvetas, p. 12.

Johns has also said, "For my first flag pictures, I used slow-drying paint, and I didn't want to wait between brushstrokes. So I became impatient, but I didn't want the pigments to blend. What I was striving for was a feeling for the time between consecutive brushstrokes. I wanted each of these gestures to remain separated from the next. It was at that time that I heard or read about the encaustic technique and somehow I saw it as a solution to my problems, bought wax and continued with that technique." Johns, quoted in Pohlen, p. 22.

Edward J. Sozanski writes and quotes Johns, "In those early paintings, Johns would make images that showed his errors, 'all the

adjustments I had made. Everything could be sensed by looking. One thing this does is give a sense of time passing.'" Sozanski, "The Lure of the Impossible," *The Philadelphia Inquirer Magazine*, October 23, 1988, p. 30.

48. In 1963, discussing the role of reworking as a process in his early works, Johns made a comparison with more recent, less reworked pieces, and in these remarks touched on the way insistent activity yields unplanned results, linking ritual acts of task-oriented labor to images with unpredictably charged emotional coloration: "There isn't the constant attempt to do something over and over and over in the more recent works. Like drawing a straight line—you draw a straight line and it's crooked and you draw another straight line on top of it and it's crooked in a different way and then you draw another one and eventually you have a very rich thing on your hands which is not a straight line.

"If you can do that then it seems to me you are doing more than most people. The thing is, it is very difficult to know oneself whether one is doing that or not, whether you mean what you do; and there is the other problem of the way you do it and whether sometimes you do more than you mean or you do less than you mean. It's very good if you can establish a language where it's clear that that is what you are doing—that you do what you mean to do." Johns, in an interview with Billy Klüver, published as a 33 ⅓ r.p.m. record included in the catalogue *The Popular Image* (Washington, D.C.: Washington Gallery of Modern Art, 1963). Extracts from this interview appear in Klüver, *On Record: 11 Artists 1963, Interviews with Billy Klüver* (New York: Experiments in Art and Technology, 1981), where the quotation above appears on pp. 15–16. See also this catalogue's companion volume, *Jasper Johns: Writings, Sketchbook Notes, Interviews.*

49. Johns, quoted in Klüver, *On Record*, pp. 13–14.

50. When asked by Tono in 1964 whether it was true that he had restricted himself to the three primary colors and the alphabet, Johns responded, "Yes, I have. Anyhow I am interested in measuring the size of things and naming them. I am also interested in picking up some circumstances and name them 'x' [and he went on to discuss the conventional, consensual basis for the use of the word 'red']." Tono, "[I Want Images to Free Themselves from Me]," *Geijetsu Shinco* (Tokyo), August 1964. Reprinted in Tono, *Tsukuritetachino Jikan* (Tokyo: Iwanami-Shaten, 1984), p. 135. Translated from the Japanese by Tadatoshi Higashizono.

51. When asked about the presence of rulers, etc., in his work, Johns replied, "I suppose that has to do with an interest in the idea of measurement and with the play of what measures against that which can or cannot be measured." Johns, quoted in Bryan Robertson and Tim Marlow, "The Private World of Jasper

Johns," *Tate: The Art Magazine* issue 1 (winter 1993): 46.

52. Rose writes, "The paintings and prints related to the circular image of *Device* are particularly pessimistic in this respect because they picture the future as only the repetition of the past. As the stick has moved to the position we see it in, so it will retrace its fixed course. The image recalled is Duchamp's 'vicious circle,' one of the repetitious litanies of the bachelors." Rose, "The Graphic Work of Jasper Johns: Part II," p. 71.

53. Talking about Happenings of the late 1950s, Johns told David Vaughan, "Once, in 1959, [Allan] Kaprow picked Bob Rauschenberg and me from his audience and asked that we work on opposite sides of a suspended piece of muslin. One of us was told to paint circles and the other straight lines. With a brush, I nervously drew unsteady verticals on my side of the cloth and, as Bob's circles bled through the material, I was again impressed by his brilliance. He, having discarded his brush, simply dipped the top of a jar into paint and then printed it onto the fabric." Johns, quoted in Vaughan, "The Fabric of Friendship: Jasper Johns in Conversation with David Vaughan," in *Dancers on a Plane: Cage, Cunningham, Johns* (first published 1989, reprint and enlarged ed. New York: Alfred A. Knopf, with Anthony d'Offay Gallery, London, 1990), p. 139.

54. See Richard Field's introduction to *The Prints of Jasper Johns 1960–1993: A Catalogue Raisonné* (West Islip, N.Y.: Universal Limited Art Editions, 1994).

55. Johns talks about the effect of his early printmaking experience on his painting in Christian Geelhaar, "Interview with Jasper Johns" [October 16, 1978], in *Jasper Johns: Working Proofs* (Basel: Kunstmuseum Basel, 1979). He makes a further statement on painting and printmaking in Robertson and Marlow: "I suppose painting and printing contribute to each other in largely unnoticed ways. That the print is the reverse of the image drawn on the stone must impress even novice printmakers. In the shop, one is always conscious of these mirror images, and this awareness has influenced my paintings in which images are sometimes mirrored or deliberately reversed. The procedures of painting and printing are different, part of the life of any painting being in the weight of the paint, its unique thickness or thinness. Printmaking is more indirect and more social.

Painting is an isolated activity for me, but printmaking involves and requires the presence of other people to accomplish the work. You want them to be pleased with what they are doing, so there are needs of economy" (p. 47).

56. On a sketchbook page containing notes about the 1964 sculpture *High School Days*, Johns proposed to himself, "Make a plaster negative of whole head. Make a thin rubber positive of this. Cut this so that it can be (stretched) laid on a board fairly flatly. Have it cast in bronze and title it *Skin*." Author's transcription from an undated page in Johns's sketchbook notes. Quoted, in Japanese, in Tono, "[Jasper Johns in Tokyo]," *Bijutsu Techô* (Tokyo), August 1964, p. 270. See also this catalogue's companion volume, *Jasper Johns: Writings, Sketchbook Notes, Interviews.*

57. Smaller circular imprints, the size of the bottom of one ale can, or occasionally the size of the Savarin coffee can from *Painted Bronze*, 1960, appear on the surfaces of many of the cross-hatch paintings, as markers for scale and as a kind of surrogate signature.

58. On the broader subject of *n*-dimensional ideas and their connection to the work of Marcel Duchamp and other early modern artists, see Linda Dalrymple Henderson, *The Fourth Dimension and Non-Euclidean Geometry in Modern Art* (Princeton: Princeton University Press, 1983).

59. On these paintings, see Rose, "Jasper Johns: The *Tantric Details*," *American Art* 7 no. 4 (Fall 1993): 47–71.

60. Johns, ["Statement"], in Miller, p. 22.

61. Rose, "Pop Art at the Guggenheim," p. 22.

62. In Tono's diary notes dealing with Johns's trip to Japan in 1964 (published in "[Jasper Johns in Tokyo]," p. 272, "[I Want Images to Free Themselves from Me]," and *Tsukuritetachino Jikan*, p. 132), Johns is recorded as having told a reporter, "When I visited the Wax Museum in London two years ago, I realized that human skin is strange. I have been thinking for two years of how to use it in my works. At first, I planned to use a child's leg and place a chair at the bottom of the canvas in the ordinary way. Then I intended to use a woman's leg. But eventually, after a flight from Honolulu to Tokyo, I changed the plan again into what you see now [in *Watchman*, 1964]." Translated from the Japanese by Tadatoshi Higashizono.

63. When asked by an interviewer whether this detail stemmed from the Saint Anthony panel of the Isenheim Altarpiece, Johns remarked, "Yes, but it's skin." Johns, quoted in Jill Johnston, "Tracking the Shadow," *Art in America* 75 no. 10 (October 1987): 132.

64. Because of his terrible skin condition, this demon has often been read as a reference by Johns to AIDS (which is often accompanied by skin lesions). While Johns has acknowledged that he sees how such a connection might be made given our preoccupation with the syndrome, there seems no convincing reason to believe that the demon motif was originally selected with this reference in mind.

65. The locus classicus for Johns's explanation of this attitude in his work is in Sylvester, "Interview with Jasper Johns": "I think one has to work with everything and accept the kind of statement which results as unavoidable or as a helpless situation. I think that most art which begins to make a statement fails to make a statement because the methods used are too schematic or too artificial. I think that one wants from painting a sense of life. The final suggestion, the final statement, has to be not a deliberate statement but a helpless statement. It has to be what you can't avoid saying, not what you set out to say. I think one ought to use everything one can use, all of the energy should be wasted in painting it, so that one hasn't the reserve of energy which is able to use the thing. One shouldn't really know what to do with it, because it should match what one is already; it shouldn't just be something one likes" (p. 14).

66. Illuminating his way of creating by acts of denial and exclusion, Johns once proposed in an interview that, since "the mind is working with all sorts of things" at a given moment, "it might be a good rule to avoid anything one knows, and still act....I don't see any point in simply stating something that is easily available. But then that may just be my own psychology, a kind of negative position." He continued the same thought a little later, arguing about approaching a new situation that "if you can avoid everything you know about that situation, and still make an action....you must be making a positive action, even though your means are negative. You say 'no' to this and 'no' to that, and so forth, and you get somewhere." Johns, on the Klüver record in the catalogue *The Popular Image.*

67. Johns, quoted in Sylvester, "Interview with Jasper Johns," p. 19. Author's italics.

68. Kozloff, p. 10.

"Seeing a Thing Can Sometimes Trigger the Mind to Make Another Thing"

ROBERTA BERNSTEIN

> *Seeing a thing can sometimes trigger the mind to make another thing. In some instances the new work may include, as a sort of subject matter, references to the thing that was seen. And, because works of painting tend to share many aspects, working itself may initiate memories of other works. Naming or painting these ghosts sometimes seems a way to stop their nagging.*
>
> —Jasper Johns, 1982[1]

Among the most fascinating and consistent features of Jasper Johns's art is his use of imagery "triggered" by his response to other artworks. He refers to these sources in a variety of ways—through names, initials, titles, imprints, copies, and tracings; whether the references are obvious or cryptic, they are integral to the visual, conceptual, and expressive dimensions of his work. Knowing which artists, which works, and which details Johns uses, and examining how these references function, enrich our understanding of his art. Johns's dialogue with art history is part of his ongoing inquiry into how images carry meaning, and how meanings shift in changing contexts. The imagery that he adapts also serves as a catalyst for change, propelling his work into new territory.

Allusions to Johns's artistic predecessors first appear in his art in the early 1960s, and become increasingly important as his own achievement is recognized. His references include Leonardo da Vinci, Matthias Grünewald, Hans Holbein, Giovanni Battista Piranesi, Paul Cézanne, Edvard Munch, Pablo Picasso, Marcel Duchamp, René Magritte, and Barnett Newman. By making these artists' imagery the source of a large share of his own, Johns affirms his roots in the tradition of Western art, and positions his work alongside that of the artists in that tradition who most stimulate and challenge him. But the range of art that inspires and influences him is broader than the European and American canon. Asian art, for example, is a long-standing interest of Johns's. His creative process may also be triggered not only by masterpieces, or by the minor works of famous artists, but by lesser-known images including illustrations, children's art, and crafts. In the late 1970s, when asked to identify works by modern artists he admired, Johns named Picasso's *Demoiselles d'Avignon*, 1907 (fig. 75), Duchamp's *Bride Stripped Bare by Her Bachelors, Even*

Figures 19–84 of this essay, all by artists other than Johns, appear on pages 76–91.

(The Large Glass), 1915–23 (fig. 29), Cézanne's *Bather*, c. 1885 (fig. 21), and the paintings of Robert Rauschenberg. He then added, "These might be considered great, but in one's working, things not great often have equal or deeper meaning. One isn't just attached to great things."[2]

In mining imagery from art history, Johns's work fits within much of the art of our time. The use of art-historical sources by contemporary artists has been well documented, for example in the exhibition "Art about Art," held at New York's Whitney Museum of American Art in 1978.[3] Among Johns's closest peers, Rauschenberg, Roy Lichtenstein, and Cy Twombly have made extensive use of art references in their work. And during the 1980s the use of quotations from earlier art was central to a new generation of artists, including Sherrie Levine, David Salle, and Philip Taaffe, who used appropriation to present a postmodern view of history.[4] Johns's approach to art history both parallels and differs from that of artists of his own and younger generations. Like his contemporaries and the modernists who preceded him, he uses art-historical references in part to call attention to the problematic of the avant-garde's relation to tradition. His primary focus, however, is not on the issues of 1960s Pop: a satirical revisionism, or art's susceptibility to mass reproduction. Nor is he engaged with current ideas about the diminishing aura of the art object, or the end of artistic originality.

When asked, in the early 1970s, if he believed new art was a criticism of old, Johns replied, "I think art criticizes art, I don't know if it's in terms of new and old. It seems to me old art offers just as good a criticism of the new as new art offers of old."[5] In assuming this kind of dynamic interaction between present and past, Johns rejects the modernist idea of progressive change. Harold Bloom, in *The Anxiety of Influence: A Theory of Poetry*, describes how poets engage in "creative misreadings," deliberately misinterpreting their predecessors to "clear imaginative space for themselves,"[6] and Johns's use of preexisting art involves a similar kind of creative revision, a transformation of his sources into the elements of his own pictorial language. But where Bloom sees this process as tied to the "creative mind's desperate insistence on priority,"[7] Johns's dialogue with art history is both more casual and more reverential. His "creative misreadings" involve not a vying for priority but an ongoing process of self-criticism that keeps stimulating and reviving his own artistic voice. He himself has explained how the process works: "One thing shows what another thing isn't, and what it itself is."[8]

> *I find all use of space emotionally affective....But there's no intention on my part to achieve that—then you lead people on. There's a Leonardo drawing that shows the end of the world, and there's this little figure standing there, and I assume it's Leonardo. For me, it's an incredibly moving piece of work—but you can't say that, in any way, was an interest of Leonardo's.*
>
> —Jasper Johns, 1977[9]

From the time he painted his first *Flag*, in 1954–55 (plate 8), to his first solo exhibition, at the Leo Castelli Gallery, New York, in 1958, Johns concentrated on establishing his own artistic identity. If his work of this period looked like anyone else's,

he has said, he stopped doing it and did something else.[10] He reacted to Abstract Expressionism, then the prevailing style of painting, by making images of things that were vividly real, and by avoiding gestural, expressionist paint-handling.

By 1959, however, with his own identity secured, Johns began to acknowledge the artists whose works inspired his own, and with whom he recognized a shared artistic sensibility. In an important statement of that year, on the occasion of the "Sixteen Americans" exhibition at The Museum of Modern Art, he named Leonardo, Cézanne, Cubism, and Duchamp as sources for ideas about perception that remain central to his art:

> Sometimes I see it and then paint it. Other times I paint it and then see it. Both are impure situations, and I prefer neither.
>
> At every point in nature there is something to see. My work contains similar possibilities for the changing focus of the eye.
>
> Three academic ideas which have been of interest to me are what a teacher of mine (speaking of Cézanne and cubism) called "the rotating point of view" (Larry Rivers recently pointed to a black rectangle, two or three feet away from where he had been looking in a painting, and said "…like there's something happening over here too."); Marcel Duchamp's suggestion "to reach the Impossibility of sufficient visual memory to transfer from one like object to another the memory imprint"; and Leonardo's idea ("Therefore, O painter, do not surround your bodies with lines…") that the boundary of a body is neither a part of the enclosed body nor a part of the surrounding atmosphere.
>
> Generally I am opposed to painting which is concerned with conceptions of simplicity. Everything looks very busy to me.[11]

Johns's engagement with Leonardo, Cézanne, and Duchamp plays an important role in his generation of imagery and serves as a touchstone for his art. When he began to use the human figure during the early 1960s, he did so in ways that can be related to these artists' works. (Johns had used the figure earlier, in a few constructions from 1954–55; see plates 5, 9, and 10.) In the four *Study for Skin* drawings of 1962 (plates 91–94), the *Diver* painting of 1962 (plate 98), the *Diver* drawing of 1963 (plate 101), and the 1963 paintings *Land's End* (plate 102) and *Periscope (Hart Crane)* (plate 103), he uses imprints of his head, hands, and feet to depict figures that allow various interpretations. The figure in both the *Diver* works—indicated through handprints, footprints, and arrows showing movement—may be viewed as making a swan dive from a diving board, or, more dramatically, as taking a suicidal leap.[12] The extended arm in *Land's End* may be seen as a detail of the diver's right arm (there are the same repeated superimposed handprints in this painting as in *Diver*), or as the outstretched arm of a drowning figure. In *Periscope (Hart Crane)* the diver's arm becomes a device used to trace a semicircle; it suggests both the arm of the diver, sweeping through space, and the extended arm of the "drowning" figure in *Land's End*.

Johns's conception of the figure in the *Diver* group brings to mind Leonardo's famous drawing *Human Figure in a Circle, Illustrating Proportions*, c. 1485–90 (fig. 19),[13]

in the way that the figure, as an active and monumental presence, is shown measuring and defining space. At the same time, the sense of emotional and physical vulnerability in Johns's "divers" recalls the view of human fragility and powerlessness that Leonardo presents in his *Deluge* drawings (fig. 20). The agitated surfaces of this group of Johns's works suggest a turbulent sea, engulfing the figures, and Johns has said that the title *Land's End* had to do with his "arriving at a point where there was no place to stand."[14] After visiting Windsor Castle in 1964 to see Leonardo's *Deluge* drawings, Johns said he admired them "because here was a man depicting the end of the world and his hands were not trembling."[15] The swirling cloud formations found in Leonardo's drawings may have provided a model for a range of expressive imagery in Johns's art of this period. One of his sketchbook notes from the early 1960s reads, "An object that tells of the loss, destruction, disappearance of objects. Does not speak of itself. Tells of others. Will it include them? Deluge."[16] Later, in 1967, a reproduction of one of Leonardo's *Deluge* drawings hung on the wall of Johns's studio.[17]

Cézanne's solitary male bathers provided another model for Johns's figures. Johns saw the Cézanne exhibition at New York's Metropolitan Museum of Art in 1952, and from then on Cézanne was the artist whose pictures he studied with more attention than any other's.[18] During the 1960s, Johns thought of copying *The Bather* of c. 1885 (fig. 21) in gray, but he did not want to work directly from Cézanne's painting (which is in the collection of The Museum of Modern Art), nor could he find reproductions large enough to realize the idea.[19] It was possibly during this time that he conceived *Diver*, devising a monumental figure of his own instead of copying or tracing the Cézanne figure directly.[20]

Cézanne's bathers, including *The Bather* and *Bather with Outstretched Arms*, c. 1883 (a work Johns owns; fig. 22), seem relatively static and contemplative, but they are linked in their themes and expressive qualities to Johns's more active divers. Awkwardly posed and introspective, Cézanne's figures convey emotional vulnerability rather than heroic monumentality. Meyer Schapiro, who was among the first art historians to bring a psychological interpretation to Cézanne's work, describes *The Bather* as projecting the "drama of the self";[21] for Theodore Reff, *Bather with Outstretched Arms* is a projection of the artist, "an image of his own solitary condition."[22] Johns's interest in Cézanne's bathers in the early 1960s may suggest a need on his part to find a type of figure that could be read as anonymous and at the same time enabled him to introduce his own experiences into his work.

Arrive/Depart, 1963–64 (plate 104), has the emotionally charged quality of the *Diver* works, though a solitary handprint at the upper right is the diver's only vestige. The dominant figurative presence is a skull, printed in black on white at the painting's bottom right, with the inscription "Arrive/Depart" below it. The skull transforms the entire painting into a *vanitas*, a work reflecting upon life's brevity, while the title suggests the cycle of birth and death. A screenprinted image of a sign reading "Handle with Care—Glass—Thank You" reinforces the sense of life's fragility. The skull is a *vanitas* symbol with which Johns would have been familiar from many sources. The most direct antecedents of the skull in *Arrive/Depart*, however, are Cézanne's *Boy with Skull*, 1896–98 (fig. 26), and the still lifes with skulls that Cézanne painted throughout his career.[23]

While Leonardo and Cézanne provided Johns with models for figuration, the artist he addressed most directly during the 1960s was Duchamp. His works are full of Duchampian references, some intentional, others the result of the two artists' shared concerns. The "Handle with Care" sign in *Arrive/Depart*, for example, alludes to Duchamp's *Large Glass*, of which Johns has written, "Duchamp's *Large Glass* shows his conception of work as a mental, not a visual or sensual, experience in which one thing can mean another. With Duchamp language has primacy, and the *Glass* is a pun on opaque meaning and transparent material. He presents in literal terms the difficulty of knowing what anything means—you look through the glass and don't see the piece itself."[24] The statement contains two ideas that have been integral to Johns's work since the time of his engagement with Duchamp: an expanded emphasis on the conceptual aspects of art, and the importance of recognizing how meanings shift.

As early as 1957, critics had made a connection between Duchamp's ready-mades and Johns's works, which they labeled "Neo-Dada." The term inspired Johns's curiosity.[25] He read about Dada and Duchamp, and he and Rauschenberg visited the extensive Duchamp collection in the Philadelphia Museum of Art. In early 1959, the critic Nicolas Calas brought Duchamp to see Johns's and Rauschenberg's work at their Front Street studios.[26] By 1960, Johns had begun collecting Duchamp's art, and he further familiarized himself with the artist's ideas by reading the notes for *The Large Glass*, which had recently become available in English for the first time, in a book-format edition of the collection of notes Duchamp reproduced in the *Green Box*, 1934.[27]

In a short review of this edition that Johns published in 1960 in the New York periodical *Scrap*, he remarked on its "revelation of the extraordinary qualities of Duchamp's thinking." He also described Duchamp as "one of this century's pioneer artists [who] moved his art…into a field where language, thought and vision act upon each other."[28] More important to Johns than the similarities critics had initially recognized between his paintings and sculptures of familiar objects and Duchamp's readymades was the wide range of interests and values he shared with Duchamp concerning the nature of art and the artist's role. While his contact with Duchamp's ideas was expansive for him, it also crucially affirmed what was distinct about his own work, particularly his commitment to visual sensation, and to exploring the eye's relation to the mind.

It may have been the mechanical forms in Duchamp's paintings (such as *Coffee Mill*, 1911, fig. 28), readymades, and sculptures that inspired Johns to introduce rotating objects into his art, beginning with the painting *Device Circle*, 1959 (plate 49). The different kinds of measures in his works, including *Thermometer*, 1959 (plate 57), and *Painting with Ruler and "Gray"*, 1960 (fig. 1), reflect a response to Duchamp's interest in "the shifting weight of things, the instability of our definitions and measurement."[29] In *False Start*, 1959 (plate 54), Johns inaugurated a more intensified and Duchampian interest in language by introducing the names of colors to elicit contradictory perceptual responses. By the early 1960s he was keeping "Sketchbook Notes," their style modeled on the notes Duchamp collected in the *Green Box*. In 1968, Johns paid tribute to Duchamp by basing his elaborate set for Merce Cunningham's dance *Walkaround Time* (Chronology, pp. 234–35) on *The Large Glass*.[30] That

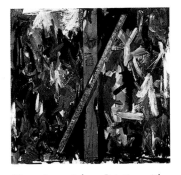

Fig. 1. Jasper Johns. *Painting with Ruler and "Gray"*. 1960. Oil and collage on canvas with objects. 32 x 32 x 2″ (81.2 x 81.2 x 5 cm). The Estate of Frederick R. Weisman, Los Angeles, Calif.

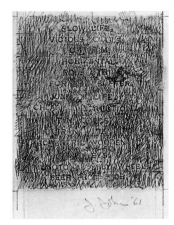

Fig. 2. Jasper Johns. *Litanies of the Chariot*. 1961. Pencil and graphite wash on paper. 4⁵⁄₁₆ x 3½" (10.9 x 8.8 cm) sight. Private collection.

same year, he used a decal of the Mona Lisa in the *Figure 7* lithographs from the *Black Numeral Series*, 1968 (plates 128–37), and *Color Numeral Series*, 1968–69, referencing both Leonardo's masterpiece and Duchamp's irreverent revisions of it in *L.H.O.O.Q.*, 1919 (fig. 31), and *L.H.O.O.Q. Shaved*, 1965.[31]

Johns's small drawing *Litanies of the Chariot*, 1961 (fig. 2), is his first direct appropriation of another artist's work: the "Chariot" is a section of Duchamp's "Bachelor Apparatus" in *The Large Glass*, and the "Litanies" are his invocations regarding its movement. These "Litanies" (fig. 30), from the *Green Box*, are an odd mixture—the "cheap" materials to be used for the chariot's construction ("Junk of life"), and suggestions of emotional and erotic stasis ("Slow life," "Vicious circle," "Onanism," "Monotonous fly wheel"). In his notes, Duchamp crossed out the "Litanies" with a large *X* and followed them with the instruction: "(to be entirely redone)."[32]

Johns's reworking of Duchamp's "Litanies" reveals the central difference between the two artists: what is pure concept for Duchamp results with Johns in a drawing with a richly handworked graphite surface. Indeed all the paintings and sculptures by Johns that incited the critics' comparisons to Duchamp are made by hand, from artist's materials. When found objects appear, they are always incorporated into a painting rather than presented on their own. And as in Johns's many

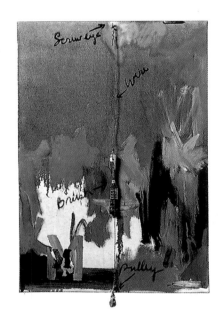

Fig. 3. Jasper Johns. *M*. 1962. Oil on canvas with objects. 36 x 24" (91.4 x 60.9 cm). Sezon Museum of Modern Art, Tokyo.

works based on alphabets and numbers, words and letters function pictorially. In *M*, 1962 (fig. 3), Johns includes objects that refer to the "Junk of life" from Duchamp's "Litanies"—the "iron wire" and "Eccentric wooden pulleys." (The title *M*, repeated twice in the work, may refer to "Marcel.") There is also, however, a paintbrush, calling attention to painting as Johns's medium of choice.

Johns's deep involvement with Duchampian ideas in the early 1960s coincided with an abrupt change in his work from an impersonal tone to the projection of a restrained but intense emotional condition. Titles, included in the works as inscriptions, reinforce these paintings' mood of anger and loss: *Disappearance II* (plate 79), *Good Time Charley* (plate 80), *No* (plate 81), *Painting Bitten by a Man* (plate 82), *Water Freezes* (plate 83), *In Memory of My Feelings—Frank O'Hara* (plate 84), *Liar* (plate 85), all 1961. In *No*, Johns has used Duchamp's bronze sculpture *Female Fig Leaf*, 1961 (fig. 32), to make an imprint in the canvas's upper left.[33] The sculpture is explicitly sexual in title and suggestively erotic in form, appearing to have been cast from female genitalia. In *No*, however, it reads as an esoteric shape, its source perhaps impossible to identify if Johns had not revealed it. Once known, the erotic connotations of the *Female Fig Leaf* imprint add to the emotional charge suggested by the word "No." Characteristically, though, Johns presents this form as he does the rest of his images—in such a way as to encourage multiple readings. The *Female Fig Leaf* imprint appears again in *Field Painting*, 1963–64 (plate 107), and in *Arrive/Depart*, where it continues to add suggestive if ambiguous content.

For Johns, the process he uses to alter a source and to integrate it into his work is as important as the content that may carry over from it. In the early 1960s, he was exploring ways of marking surfaces with imprints of his own body and of different kinds of objects, including stencils, stretcher bars, and cans. Heating the

underside of Duchamp's sculpture and pressing it into
the encaustic surface of *No*, he made it another means of
leaving the trace of a three-dimensional form on the
canvas. In doing so he was possibly inspired by the instructions in Duchamp's *Musical Erratum*, 1913, from the *Green
Box*: "To make an imprint mark with lines a figure on a
surface impress a seal on wax." In *Passage*, 1962 (fig. 4),
Johns similarly used an iron to "impress a seal on wax"—
the painting's encaustic surface.[34] The work's title refers
to Duchamp's *Passage of the Virgin to the Bride*, 1912, a
painting, in the artist's biomechanical Cubist style, that is
related to the erotic machinery of *The Large Glass*.

Features of *According to What*, 1964 (plate 105), recall
Duchamp's final oil painting, *Tu m'*, 1918 (fig. 33).[35] At the
same time, the work affirms Johns's own artistic identity
by providing a summary of motifs that were already established in his work by 1964. With typical irony, Duchamp's
swan song to painting is a brilliant anthology of the
various means of presenting or representing reality in art.
In *According to What*, which echoes the horizontal format
of *Tu m'*, Johns uses a repertory of motifs that similarly
call attention to painting's mediation between art and life through the interplay
between objects and various modes of representation. Both Duchamp and Johns
use illusions or simulations in a tongue-in-cheek, fool-the-eye manner: in *Tu m'*,
a painted rip in the canvas is held together by real safety pins; in *According to What*,
a diagonal swath of newspaper looks like collage but is actually screenprinted
onto the canvas. A spoon attached to a bent-coat-hanger-and-wire construction in
Johns's painting has associations with both artists. Johns had first used a spoon
in *In Memory of My Feelings—Frank O'Hara*, where he likely intended
it to refer to Duchamp's *Locking Spoon*, 1957 (fig. 34), a readymade of
a spoon attached backwards to the lock on the artist's apartment
door, which Johns saw when he visited Duchamp shortly after first
meeting him.[36]

At the lower left corner of *According to What* is a small canvas,
hinged to hang down from the rest of the work. Hinges too have
both a Duchampian source and a history in Johns's own art. Their
first appearance in his work was in his 1955 targets with moveable
lids. The hinges in *In Memory of My Feelings—Frank O'Hara* (plate 84)
reference Duchamp's *Green Box* note, "Perhaps make a <u>hinge picture</u>.
(folding yardstick, book...) develop the <u>principle of the hinge</u>." When
the canvas in *According to What* is open (fig. 5), it reveals Duchamp's
initials and a distorted tracing of his *Self-Portrait in Profile* (fig. 35),
made in 1958 out of paper torn by hand around a metal template. *Self-
Portrait in Profile* is complex and fascinating in the ambiguity it creates between
figure and ground. Like Johns's body imprints and casts, it is an image taken directly
from the figure, probably traced from a photograph. As Richard Shiff explains,

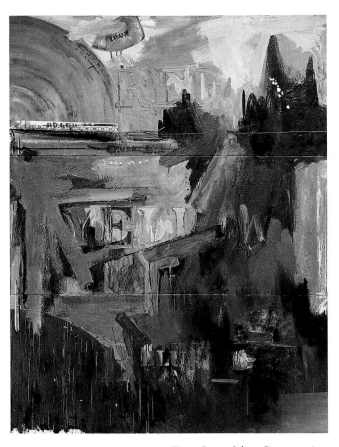

Fig. 4. Jasper Johns. *Passage*. 1962.
Encaustic and collage on canvas
with objects (three panels). 54 x
40″ (137.1 x 101.6 cm). Museum
Ludwig, Cologne.

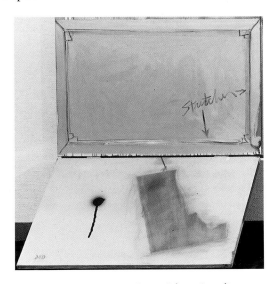

Fig. 5. Jasper Johns. *According to
What* (detail; see plate 105). 1964.
Oil on canvas with objects (six
panels). 7′4″ x 16′ (223.5 x 487.7
cm). Private collection.

"This representation remains 'true' in that it retains a claim to indexicality—it can be physically linked back to the real presence of Marcel Duchamp."[37]

Johns traced the Duchamp self-portrait from a 1959 print of the image in his collection.[38] He later explained the process, and why he chose to place the image on a hinged canvas: "Duchamp did a work which was a torn square (I think it's called something like *Myself Torn to Pieces*). I took a tracing of the profile, hung it by a string and cast its shadow so it became distorted and no longer square.... There is in Duchamp a reference to a hinged picture, which of course is what this canvas is."[39] In using this procedure to transform the Duchamp work, Johns engaged in the same process of tracing objects' distorted shadows that is so important in *Tu m'*.

Self-Portrait in Profile is one of Duchamp's several depersonalized, self-parodying portraits, a group that includes *Wanted/$2000 Reward*, 1923, *Monte Carlo Bond*, 1924, and *My Tongue in Cheek*, 1959. *Wanted/$2000 Reward*, which appeared on the poster for Duchamp's retrospective at the Pasadena Art Museum in 1963 (Johns owns a signed copy of this poster; fig. 36), may have inspired Johns to include his photograph on the plates in his two *Souvenir* paintings from 1964 (plates 109 and 110). Johns was to refer to *Self-Portrait in Profile* and *My Tongue in Cheek* when he wrote a tribute to Duchamp in 1968: "The self attempts balance, descends. Perfume—the air was to stink of artists' egos. Himself quickly torn to pieces. His tongue in cheek."[40]

Like *According to What*, the painting *Decoy*, 1971 (plate 144), provides a kind of catalogue of the images that Johns had been repeating and revising during the preceding years. It contains the final incarnation of the upside-down seated figure from *According to What*, now presented as a screenprinted photographic image. The ale can in the painting's center stands as a memento of one of the 1960 *Painted Bronze* works, which appears again, reproduced alongside other sculptures, in the row of pictures across the bottom. Names of colors, in the form of a convoluted spectrum of words, zigzag across the picture space. What critics once saw as Duchampian, "Neo-Dada" devices here stand transformed into imagery firmly identified as Johns's own.

Voice 2 (plate 145), completed the same year as *Decoy*, reaffirms the importance to Johns of establishing his own "voice" after a decade-long engagement with Duchamp's art and thought. It includes a reference to Duchamp's *Female Fig Leaf* in the form of the imprint of a chair frame, a shape that reminded Johns of the Duchamp sculpture. Also in 1971, Johns made a series of lithographs, *Fragments—According to What*, that isolate details of his 1964 Duchampian homage. One of these, *Fragment—According to What—Hinged Canvas* (fig. 6), includes Duchamp's *Self-Portrait in Profile* as Johns transformed it in the earlier painting. When asked about the crossed-out signature in this lithograph, Johns said, "Well, I didn't cross it out. The cross was there before I signed it, but I planned to sign it that way. I have deliberately taken Duchamp's own work and slightly changed it, and thought to make a kind of play on whose work it is, whether mine or his."[41] Recently, asked if he still feels affinities with the spirit of Duchamp, Johns answered, "Yes, but he has qualities that are foreign to my nature. I think he's more cheerful in his skepticism and more detached."[42]

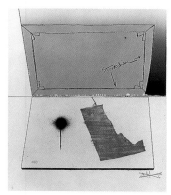

Fig. 6. Jasper Johns. *Fragment—According to What—Hinged Canvas*, from the series *Fragments—According to What*. Los Angeles: Gemini G.E.L., 1971. Lithograph. 36 1/8 x 29 3/4" (91.7 x 75.8 cm). The Museum of Modern Art, New York. John B. Turner Fund.

I suppose Cubism is one of the two great "isms" for people of my generation.
The other is Surrealism, of course. Cubism and Surrealism were strong indica-
tors of directions that one might move in. They were liberating, and in a way
instructive. Not only did they free you, they made certain kinds of rules apparent.

—Jasper Johns, 1989[43]

In the leftmost panel of the four-part *Untitled*, 1972 (plate 153), Johns introduced
a new motif that simultaneously suggests Cubist planar structure, the decorative
patterning of Henri Matisse, and the allover compositions of Abstract Expressionism.
The design, often referred to as "hatchings" or "cross-hatchings," was based on a
fleeting glimpse of a colorful pattern painted on a car that drove past him on a New
York State highway, the Long Island Expressway. In this respect it relates to the
two center panels of *Untitled*, which show a flagstone pattern that was likewise an
image seen briefly in passing and reproduced from memory—a painted wall Johns
also saw while driving.[44]

The rightmost panel of *Untitled* contains seven wax casts of fragmented body
parts: face, torso, feet (with green shoes), leg, buttocks, knee, and a curious cast
combining a hand, foot, and sock on a wooden floor. The presentation of cast body-
parts recalls Johns's early *Target with Four Faces* (plate 9) and *Target with Plaster
Casts* (plate 10), both 1955, where he aligned plaster casts of anatomical parts like
objects in compartments. Initially the casts in *Untitled* look like a female figure
broken into pieces, but when they are examined closely it is evident that they were
made from more than one model, male and female. Placed on an irregular frame-
work of boards, they are more graphically realistic than the earlier casts, and their
effect is more psychologically jarring. Their disturbing quality makes one think
of the violated "bride" in Duchamp's *Étant Donnés: 1e La Chute d'Eau; 2e Le Gaz
d'Éclairage*, 1946–66 (fig. 37), a major work revealed only after the artist's death,
in 1968. Johns had visited this work in the Philadelphia Museum of Art more than
once by the time he completed *Untitled*.[45]

While Johns was not citing any specific work or artist in *Untitled*, 1972, or in
the earlier *Target* works, Dada and Surrealist precedents for his fragmented figures
provide clues to their possible meanings.[46] A particularly significant one is the
conceptualized Surrealism of Magritte. Johns was first exposed to Magritte's paint-
ing in an important exhibition at the Sidney Janis Gallery, New York, in 1954.[47]
And there were major Magritte exhibitions and publications closer to the date of
Untitled, among them a 1970 monograph by Suzi Gablik that included a discussion
of the relationship of Johns's and Magritte's art.[48] The two artists' shared concerns
with issues of reality and illusion have generated a number of uncanny resemblances,
such as that between the juxtaposed head and target in Magritte's *Hall of Arms
(The Shooting Gallery)*, 1925/26 (fig. 39), and Johns's 1955 *Target* works.

In Magritte's *One-Night Museum*, 1927 (fig. 40), a disembodied hand is one of
a group of objects in separate compartments, much as Johns's *Target* works display
painted-plaster body parts as objects in niches. In both cases the results are unex-
pected and unsettling. Several of Magritte's paintings combine fragmented figures
with boards or stone walls, as Johns does in the 1972 *Untitled*. And both artists
use the female nude to evoke erotic and psychologically disturbing effects, while

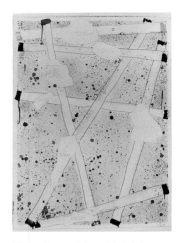

Fig. 7. Jasper Johns. *Untitled (From Untitled 1972)*. 1973. Oil paint and graphite pencil on paper. 41 ¼ x 29 ½" (104.7 x 74.9 cm). Collection David Whitney.

Fig. 8. Jasper Johns. *Face*, from the series *Casts from Untitled*. Los Angeles: Gemini G.E.L., 1974. Lithograph. 30 ¾ x 22 ¾" (78.1 x 57.8 cm). Courtesy Universal Limited Art Editions.

reminding the viewer of the fragment's fictive status as representation (see, for example, Magritte's *Eternally Obvious*, 1930; fig. 42). In *A Courtesan's Palace*, 1928 (fig. 41), Magritte presents the torso of a female nude as a framed picture hanging on a wall made of boards. And in *The Acrobat's Rest*, 1928 (fig. 43), he shows an eccentrically fragmented nude embedded in a stone wall.

The Literal Meaning, 1929 (fig. 44), is one of a number of paintings in which Magritte substitutes words for images; here the words "*femme triste*" (sad woman) are shown inscribed on an oddly shaped canvas that leans against a stone wall with a board running across it. In several drawings and prints related to the 1972 painting *Untitled*, Johns uses words in place of images in a similar manner: in the drawing *Untitled*, 1973 (fig. 7), and the lithograph *Face* (fig. 8) from the 1974 series *Casts from Untitled*, for example, irregular shapes traced from photographs of the casts are labeled with their names. This practice goes back to Johns's earlier use of words as labels for colors and objects, which in turn has precedents in Magritte's series *The Interpretation of Dreams*, one of which Johns owns (fig. 45).[49]

In the phase of his art ushered in by *Untitled*, 1972, Johns eliminated graphic representations of the figure from his paintings and focused on abstraction, using variations on the cross-hatching design. Unlike *Untitled*, however, most of the abstractions that follow have titles suggesting sensory or emotional content: *Scent, Corpse and Mirror, Weeping Women, The Dutch Wives, The Barber's Tree, Céline, Usuyuki, Cicada, Between the Clock and the Bed, Dancers on a Plane, Tantric Detail*. While Johns concentrated on abstraction, the figure remained a central preoccupation for him. Although casts disappeared from his work between 1972 and 1982 (when he reintroduced them in *In the Studio*, plate 188, and *Perilous Night*, plate 189), he continued to use body imprints in drawings and prints during the 1970s, among them the drawings *Skin I* and *II*, 1973 (plates 148 and 149), *Skin*, 1975 (plate 150), and drawings and prints made after *Periscope (Hart Crane)* (the 1977 drawing of the same title, plate 164) and *Land's End*. Even in his abstractions, moreover, Johns sometimes suggested figurative presences through his manipulation of the cross-hatching design, and through his titles, several of which allude to art-historical sources.

The word "corpse" in the title of *Corpse and Mirror*, 1974 (plate 155), for example, both interjects a morbid figurative presence and underscores Johns's links to Surrealism by referring to the Surrealists' game of "Exquisite Corpse," in which, as Thomas Hess writes, "a collective drawing is accomplished as each player works on a piece of paper that is folded under, step by step."[50] The titles of two of Johns's paintings and several drawings and prints of 1974–75 (the paintings were *Corpse and Mirror* and *Corpse and Mirror II*, 1974–75, plate 158) have to do with the game's process, and with the psychological implications of the disjointed images, often of nudes, that resulted from these chance collaborations. (See, for example, *Figure* [exquisite corpse], 1926–27, by Yves Tanguy, Joan Miró, Max Morise, and Man Ray; fig. 46).

The cross-hatching works are related to Dada and Surrealist art in visual terms as well as linguistic ones. The imprint of an iron in the right panel of *Corpse and Mirror*, for example, provides an iconographic link with earlier works of Johns's (the panel of cast body fragments in *Untitled*, 1972, where the iron appears in the lower left, and *Passage*, fig. 4) that themselves recall Duchamp's injunction to "impress a

seal on wax," and his *Passage of the Virgin to the Bride*. Johns painted the three sections of the left panel of *Corpse and Mirror* without reference to each other except at the edges, as in the Exquisite Corpse game, and in *Corpse*, a drawing of 1974–75 (plate 161), he produced the cross-hatching pattern through the use of folded paper, imitating the Surrealists' process even more closely. This predetermined system triggered ideas for other ways of relating disjointed parts to each other in the cross-hatching abstractions that followed. In many of these abstractions, what initially appear to be continuous designs with random elements are in fact intricately arranged patterns that repeat at intervals and mirror each other.[51]

Weeping Women, 1975 (plate 160), marks the point at which Picasso shifts toward center stage in Johns's dialogue with his artistic predecessors. The title was inspired by Picasso's etching and aquatint *Weeping Woman*, 1937 (fig. 76), which Johns saw in Paris while working on etchings of his own, for a collaboration with the playwright Samuel Beckett.[52] Picasso's work had interested Johns since early in his career, but it was only in the 1970s that he began to acknowledge that interest in his art and published statements. He recently said that the first real painting he ever saw was a Picasso, at a New York gallery, and "I thought it was the ugliest thing I'd ever seen…I didn't realize I would have to revise my notions of what painting was."[53] He has also named Picasso's *Demoiselles d'Avignon*, 1907 (fig. 75), among the twentieth-century paintings most important to him, remarking that it "has a kind of coarseness that's interesting. It makes available different kinds of qualities that are meaningful to me."[54] His first visual references to Picasso appear in the lithographs *Cups 4 Picasso*, 1972 (fig. 9), and *Cup 2 Picasso*, 1973, both inspired by a request that he contribute to a portfolio honoring Picasso's ninetieth birthday. In both works, mirror-image profiles of Picasso double as goblets; these are Johns's first use of ambiguous figures based on illustrations in books on the psychology of perception.[55]

Though some viewers have discerned three figures in the cross-hatching patterns of *Weeping Women*, one in each panel, Johns has said that his intention in the cross-hatched paintings was not to depict abstracted figures but "to create *spaces* that suggest a connection to physical presences."[56] He achieves this in *Weeping Women* through his manipulation of the cross-hatching design and through the sensory and emotional content conveyed by the work's title. Specific visual clues link Johns's painting to Picasso's image: the four prominent imprints of an iron in the central panel are strikingly similar in shape to the pointed fingernails of Picasso's figure.[57] Johns also appears to be crisscrossing his pattern of stripes in a similar manner to the cross-hatchings in the Picasso etching, particularly in the area of the figure's handkerchief. In the right-hand panel of Johns's work, the imprints of cans, with paint dripping from them, make a visual pun on the weeping eyes of Picasso's figure.

The 1937 *Weeping Woman* etching is one of a series of works so titled that have been called "perhaps the most emotive of Picasso's human figures."[58] Moved by his reaction to the bombing of Guernica and by turmoil in his personal life, Picasso worked on the theme obsessively that year, producing nearly sixty pictures in a variety of mediums.[59] By using Picasso's title, Johns alludes to the psychologically expressive content of Picasso's images. Any personal associations that may exist for Johns himself, however, remain undisclosed.

Fig. 9. Jasper Johns. *Cups 4 Picasso*. West Islip, N.Y.: Universal Limited Art Editions, 1972. Lithograph. 22 ¼ x 32 ¼" (56.5 x 81.9 cm). The Museum of Modern Art, New York. Gift of Celeste Bartos.

The title *Between the Clock and the Bed*, which Johns gave to several works of the early 1980s, refers to *Self-Portrait between the Clock and the Bed*, 1940–42 (fig. 50), by the Norwegian Symbolist Edvard Munch. In 1981, a friend of Johns's, having noticed the similarity between the striped bedspread in the Munch work and Johns's cross-hatchings, sent him a postcard of the painting.[60] As in *Weeping Women*, the title conjures vivid images and content, even if one doesn't know the work to which it refers. The words become even more charged, however, when the connection is made to their source.

In Munch's symbolic self-portrait, one of the two major paintings of his last years, the artist stands passively between his clock and his bed, his studio visible behind him. On the wall beside the bed hangs a picture, a female nude, bringing the theme of sexuality into Munch's meditation on the passage of time and the inevitability of death.[61] Johns had recently turned fifty when he began the *Between the Clock and the Bed* series, and since then he has increasingly directed himself to examinations of human mortality. While avoiding the confessional, autobiographical quality of Munch's art, the series shows Johns's willingness to "drop the reserve" and allow his own psychological and emotional state to be more openly acknowledged in his work.[62]

This direction is explored in a group of graphic works of the late 1970s and early 1980s in which Johns uses the image of one of his *Painted Bronze* works of 1960, the Savarin can holding paintbrushes (plate 69), as a surrogate self-portrait. Several of these drawings and prints contain hand- or arm prints, which stand in for the artist's own creative hand (as in an *Untitled* drawing of 1977, plate 165). The lithograph

Fig. 10. Jasper Johns. *Savarin*. West Islip, N.Y.: Universal Limited Art Editions, 1978. Monotype. 27¼ x 19⅝″ (69.2 x 49.8 cm). Courtesy Universal Limited Art Editions.

Savarin, 1977–81 (plate 181), includes the initials "E.M." next to an arm imprint, referring to Munch and specifically to his lithograph *Self-Portrait*, 1895 (fig. 49). This print, with its skeletal arm along the bottom edge, has been variously interpreted to suggest the youthful artist haunted by death or the fear of artistic and sexual impotence.[63] By using his own arm in place of Munch's skeletal arm, and his paintbrushes in place of Munch's face, Johns suggests that he identifies himself with the tools of his craft.[64] In a 1978 *Savarin* monotype (fig. 10), he makes the relationship to Munch's self-portrait even more explicit by drawing a skeletal arm below the paintbrushes.

During this same period in which he was both recycling imagery from his own 1960s work and exploring Munch's psychologically charged symbolism, Johns found another source of ideas, one that would eventually lead him from abstraction back to an art of objects and figures: tantric art. Crucial to the groups of works titled *Dancers on a Plane*, 1979–82 (plates 176 and 177), and *Tantric Detail*, 1980–81 (plates 185–87), is the seventeenth-century Nepalese painting *The Mystical Form of Samvara with seventy-four arms embracing his sakti with twelve arms* (fig. 51). This symbolic picture representing "the absolute unification of all duality"[65] inspired imagery that enabled Johns to address themes of procreation, transformation, and death. In the 1960s, he had turned to Duchamp's *Large Glass* as a source of cryptic

erotic imagery. Now he turned to another complex, ritualized rendering of sexual union, but one created from a very different philosophical frame of reference.

Specific images from tantric art first appear in Johns's work in a band of sketches below the abstract cross-hatching in the 1979 watercolor *Cicada* (plate 175). These sketches offer an intimate glimpse of the evolution of a new Johnsian iconography. The title keys into drawings of cicadas in different stages of their life cycle, which Johns copied from a text on entomology. Another important sketch is the skull and crossbones, which is shown next to the words "Pope Prays at Auschwitz/Only Peace"—a quotation from a newspaper clipping about Pope John Paul II visiting the former concentration camp. Smaller, schematically rendered skulls are based on tantric sources. Between the cicadas and the skull and crossbones is a sketch of fire in a vessel, copied from an eighteenth-century Indian painting of a cremation pyre. Other sketches scattered throughout are done after tantric renderings of the phallus (lingam) and vulva (yoni).[66]

The title *Dancers on a Plane* refers most directly to the choreographer Merce Cunningham, whose name is printed and scrolled along the bottom edge of two of the three paintings in this series.[67] The "dancers" also refer to the embracing and copulating deities in *The Mystical Form of Samvara*. The compositional structure of the *Dancers on a Plane* works echoes that of the tantric painting: all are symmetrically divided along a vertical central axis, with each side mirroring the other. Three-dimensional forks, spoons, and knives framing the sides of the first two *Dancers on a Plane* paintings allude to the ritual objects that the deities hold in their hands in *The Mystical Form of Samvara*. According to Johns, these motifs, familiar from some of his 1960s paintings, are here intended as "symbols of creation and destruction."[68] The 1980 *Dancers on a Plane* (plate 177) includes a schematic image of copulation, a lingam and yoni sculpted in relief as part of the top and bottom of the bronze frame. A dotted line (inspired by beaded ornaments in the tantric painting) leads the eye along the painting's midsection, visually linking the separated halves.

Johns's references to imagery from *The Mystical Form of Samvara* are even more explicit in the three *Tantric Detail* paintings: he specifically points to a detail in the tantric work's lower center (fig. 52) that reveals strings of beads, skulls ornamenting the deities' clothing, and Samvara's "prominently displayed testicles."[69] These details are transformed and integrated into a cross-hatched abstraction that recalls the "Corpse" section of *Corpse and Mirror*.[70] The format of the *Tantric Detail* works, divided into three stacked horizontal rectangles, and the placement of the testicles also recall Johns's *Painting with Two Balls*, 1960 (plate 62), in which two wooden balls are inserted between the upper and middle panels— in part, an ironic pun on the masculinist idea that a good painting has to have "balls."[71] Now Johns puns on his own earlier work, while also introducing content that is at once personal and universal. Mark Rosenthal has observed that by making the skull and testicles alone indicate a human presence, "Johns makes the twin themes of death and eros the most evocative aspects of the human condition."[72] Johns was to continue to develop these themes in his next group of works, in which he turned to Christian iconography for sources of images and ideas.

I'm interested in the way forms can shift their meanings. I had marveled at the Grünewald painting when I saw it in Colmar; and later, I was given a portfolio containing large sized details from the work. Looking at these, I became interested in the linear divisions, the way forms were articulated, and I began to make tracings of the configurations. It was a little like my work with the flag—the work one does with a given structure alters its character.

—Jasper Johns, 1989[73]

After a decade of working nearly exclusively with abstraction in his paintings, in the early 1980s Johns chose to explore the vividly representational imagery of the Isenheim Altarpiece. The work was painted by the German artist Mathis Gothart Nithart, known as Matthias Grünewald, in around 1512–16, on commission from the Antonite monastery and hospital in Isenheim, in Alsace.[74] Comprising a group of dramatic scenes from the lives of Christ and Saint Anthony, it is one of the great masterpieces of the period, and its brilliant iconographic and formal inventiveness and powerful expressive qualities have been influential throughout the twentieth century (figs. 53 and 54). Johns visited it in its installation in Colmar, France, in 1976, and again in 1979. In 1981, he began using it as a source of imagery.[75]

Through a process of tracing, transferring, reversing, and reorienting details from the altarpiece, Johns examines how meaning is conveyed through structure—how images function when "drained of illusionism, reduced to pattern."[76] He told Michael Crichton, "I found the [Grünewald] details so interesting and handsome, that as I looked at them I had the feeling there was something in the way these things are structured that was important, and free of the information that the images convey....I felt there was some aspect that seemed to be 'underneath' the meaning—you could call it composition—and I wanted to trace this, and get rid of the subject matter, and find out what it was."[77]

After tracing several details of the Isenheim Altarpiece from reproductions, Johns selected two that he has used in numerous paintings, drawings, and prints since 1982. These are the forms of the diseased demon in *The Temptation of Saint Anthony* (fig. 56) and of the sleeping soldiers guarding the tomb in the Resurrection, one of them prone, like the demon in *The Temptation* (fig. 55). Andrée Hayum has noted the similarity of the poses of the demon and the most prominent of the soldiers in the *Resurrection*, "the one bearing witness to bodily torture, the other attendant to bodily transcendence."[78] This reclining soldier is one of the most striking figures in the altarpiece, as he reacts in a twisted posture to the miracle of Christ's transcendence over death. The gesture of his raised arm echoes the outstretched arms of the risen Christ.[79] These in turn evoke the extended arms, and the arms tracing circles, that have recurred in Johns's works since the *Diver* of 1962 (plate 98).

This detail of the soldiers guarding the tomb appears twice in *Perilous Night*, 1982 (plate 189): turned ninety degrees and reversed, it fills the painting's entire left panel, and it appears again in the right panel, here smaller and "correctly" oriented. In his cross-hatching works from *Corpse and Mirror* through *Between the Clock and the Bed*, Johns had implied figurative presences through manipulations of abstract form and his use of titles. Here he reverses the idea, introducing expressive figures

but rendering them abstract. He does, however, keep enough of the original imagery to maintain the connection to the source. The closer one looks, the more recognizable features emerge—the soldier's costume, sword, halberd, and so on—and the more one senses that there is something there to be identified.

With *Perilous Night* and *In the Studio*, 1982 (plate 188), Johns introduces a kind of picture space new to his work: illusionist devices and assemblage are used to depict a wall with pictures or objects attached. In the right panel of *Perilous Night*, the Grünewald tracing, a cross-hatching abstraction, and a handkerchief are represented as fixed to a wall with nails. These trompe l'oeil devices are in turn juxtaposed with three-dimensional objects: a stick is attached to the panel's right edge by a hinge, and three casts of arms are suspended from hooks. The Grünewald detail and its reference to the *Resurrection* panel (a night scene) play into the emotional resonance evoked by the title *Perilous Night*, which comes from an early John Cage composition (the title page and score are screenprinted in the upper right of the Johns work) that Cage said tells of the "loneliness and terror that comes to one when love becomes unhappy."[80]

The body of the demon in *The Temptation of Saint Anthony* embodies the themes of illness and healing that pervade the altarpiece, which, in its original setting in a hospital, served those suffering from Saint Anthony's fire, a disease causing painful internal symptoms and external deformities.[81] Discussing Johns's use of this figure in his 1980s work, Hayum writes, "What precisely the figure signifies for Johns one can only speculate on....One thing is certain, however: in coming to rest on this embodiment of suffering, Johns (perhaps unintentionally) has evoked the context that originally provided the Isenheim Altarpiece with its reason for being."[82] Hayum notes the relevance of the Isenheim Altarpiece in the age of AIDS, which has affected individual and public consciousness in our time as the plague of Saint Anthony's fire did in Grünewald's. Johns has commented that while he did not intend to connect his use of the Grünewald demon to AIDS, "As concerned with the disease as our society is, it is easy to have such a thought."[83]

The deformed demon plays a central role in Johns's art of the mid-1980s. The critic Jill Johnston, the first to identify it, describes it as "too distinctive,

Fig. 11. Jasper Johns. *Untitled*. 1983. Encaustic and collage on canvas with objects. 48 1/8 x 75 1/8" (122.2 x 190.8 cm). Private collection.

too particularized, too human not to imagine that the artist made some strong emotional identification with it."[84] Grünewald's demon first appears in the left panel of *Untitled*, 1983 (fig. 11), where it is turned upside-down, rendered in outline, and given stripes and colors that further disguise it. As with the nearly indecipherable soldier, however, details remain visible: the demon's webbed foot and bent knee can be seen in the panel's upper left, and its head appears near the right edge. The demon's advent in Johns's art coincides with

the first use of the bathroom of his home in Stony Point, New York, as a setting. Bathtub fixtures depicted in the lower right corner of the painting indicate the vantage from which the artist contemplates the objects illusionistically proposed as hanging on the wall in front of him. These include a warning sign for avalanches, with a skull and crossbones, symbolizing danger and death. Between the sign and the demon, a three-dimensional cast arm hangs above the *Painted Bronze* image, which is used as a surrogate self-portrait, in a variation of the *Savarin* lithograph of 1977–81 (plate 181). In conjunction with the demon, these images continue Johns's preoccupation with mortality, here combined with the body's vulnerability to accident and illness.

In *Racing Thoughts*, 1983 (plate 193), and *Untitled*, 1984 (plate 202), Johns again combines a tracing of Grünewald's demon with the skull-and-crossbones sign. The other objects depicted are all things Johns owns, and carry autobiographical associations. In *Racing Thoughts*, Johns's trousers hang on his bathroom door, where the demon's image merges with the surface patterning of stripes and wood graining. A jigsaw puzzle made from a photograph of Johns's dealer, Leo Castelli, as a young man is a reminder of their long-standing association. A reproduction of the Mona Lisa has been made from the same iron-on decal that Johns used fifteen years earlier for his *Figure 7* lithographs; it is one of many women's faces that now begin to appear in his art with increasing frequency. Besides this double homage to Leonardo and Duchamp, Johns includes his first direct reference to an admired predecessor from the Abstract Expressionist generation, a lithograph by Barnett Newman (*Untitled*, 1961; fig. 66).

Johns's accelerating interest in images taken from art history coincided with the appearance of appropriationists of a younger generation during the late 1970s and early 1980s, and with a growing interest in theorizing strategies of appropriation. He shares with these artists an interest in how images saturated with meaning change as their context shifts, but his use of images taken from art or from the wider culture differs significantly from the postmodernist, deconstructionist enterprise. Johns's primary aim is neither direct cultural critique nor revision of the art-historical canon. He is not concerned with art's status as commodity, or with the role of reproductions in creating an "unbridgeable distance from the original."[85] Rather, he uses references to art history to enrich his pictorial vocabulary with images yielding a range of resonant personal and cultural associations. Unlike many recent appropriationists, Johns avoids a simulationist approach to his sources; his processes of copying images, even when he uses photographic techniques (the Mona Lisa, Castelli portrait, and Newman lithograph in *Racing Thoughts* are photo-screenprints), involve his own transformations of the found image. In general his attitudes toward visual images, fine art or otherwise, are shaped by his own historical frame of reference. Johns himself has described how his use of earlier art differs from the younger artists' appropriations: "The difference is probably the spirit of the artists involved.…My work offers one context; theirs another.…The role of images is very different for people say thirty years old or younger than for someone of my age. You realize there wasn't any TV in my childhood. There was very little plane travel. These things have made the world quite different, so that the basis for thought with particular regard to images has changed."[86]

In *Untitled*, 1984 (plate 202), the collagelike presentation of items illusionistically taped or nailed to a wall becomes more complex. In the left-hand panel, Johns combines a tracing of the Grünewald demon with abstracted tracings of casts from his lithograph series *Casts from Untitled* (fig. 8). The right-hand panel introduces an image that he used repeatedly during this period: "My Wife and My Mother-in-Law," an illustration of 1915 by W. E. Hill, which appears in books on the psychology of perception.[87] Depending on where the observer's eye rests, the image shifts from a young woman, seen in a disappearing profile, to the profile of an old woman, with a large nose and a projecting chin. Also new to Johns's repertory, having begun with *Racing Thoughts*, are the pieces of pottery on the wicker hamper next to the tub. One is a porcelain vase that was made to celebrate the Silver Jubilee of Queen Elizabeth II, and that forms profile portraits of the Queen and Prince Philip in its negative space. The other is a piece by the turn-of-the-century American ceramist George E. Ohr.

These paintings create a disturbing uncertainty about whether the things depicted hang before us on a wall, are reflected in a mirror, or constitute a stream of images racing through the artist's mind. In creating his own brand of unorthodox illusionism, Johns mixes elements of Cubism, Surrealism, and trompe l'oeil still life. His earliest paintings relied on a rigorously literal conception of space. In his paintings since 1982, however, he shifts his position, devising a new kind of picture space that allows for an illusionist frame of reference even as it cancels out any consistent spatial reading.

Cubist still life and collage remain important touchstones for Johns's ideas about representation. An example is Juan Gris's *Table*, 1914 (fig. 57), which features a newspaper in which the headline *"Le Vrai et le faux"* (The true and the false) underscores the play on reality and illusion that comes from the use of various and contradictory modes of representation, from collage to pseudo–trompe l'oeil to Cubist abstraction. Magritte's Surrealist inquiries into the distinction between an object and its image are equally crucial precedents for Johns's fictive pictures-within-pictures in the works since *Perilous Night*. Especially important in this regard are Magritte's series *The Treason of Images* and *The Human Condition*, examples of which are in Johns's own collection: *"Ceci n'est pas une pipe"*, 1965 (fig. 48), and *The Human Condition*, 1948 (fig. 47).

In *Ventriloquist*, 1983 (plate 200), Johns uses the bathtub vantage-point to contemplate images that suggest his roots in American art and culture. The work's title shows his continued preoccupation with the idea of the artist's voice, a theme invoked in the titles of the earlier paintings *Voice*, 1964–67, and *Voice 2*, 1968–71 (plates 122 and 145). A ventriloquist speaks in such a way that his or her voice appears to come from some other source.[88] What the title *Ventriloquist* suggests and the work's imagery confirms is the increasing importance of motifs taken from other art in stimulating Johns's own creative expression.

The double *Flags* "taped" to the bathroom wall (one of them cropped at the left edge) refers back three decades to Johns's own signature *Flag* from 1954–55, and to its numerous variations, such as *Two Flags*, 1962 (plate 95). It also sets the tone for the emphasis in *Ventriloquist* on American imagery. The presence once again of Newman's 1961 lithograph *Untitled*, also seen in *Racing Thoughts*, pays specific

homage to this long-admired artistic predecessor, but also acknowledges Johns's connections with Abstract Expressionism: the pairing of his *Flags* with this print suggests a visual and historical link between Newman's "zips" and the stripes of Johns's *Flags*.[89] By reversing Newman's lithograph, Johns draws attention to the importance of mirroring in the process of printmaking, an aspect of his graphic work that has become integral to his concept of composition and picture space.

The illusionist details (nails, tape, hinges) of *Ventriloquist* and other paintings, and these works' manner of displaying objects, reflect the importance of American trompe l'oeil still life as a precedent for Johns's art. Like Johns, the artists who worked in this genre chose to show familiar objects that are flat, or are shown hanging from walls or cupboard doors in shallow relief, as in William Harnett's *Still Life—Five Dollar Bill*, 1877 (fig. 58), and *Still Life—Violin and Music*, 1888 (fig. 60). The paintings of John F. Peto are particularly close to Johns's in their pictorial concerns and the types of imagery they use. The two artists' common interest in the painting as a constructed object, for example, results in the coincidental similarity between Johns's *Canvas*, 1956 (plate 20), and Peto's *Lincoln and the Phleger Stretcher*, 1898 (fig. 59).

In the early 1960s a friend of Johns's gave him a reproduction of Peto's *Cup We All Race 4*, c. 1900 (fig. 61), having noted its similarity in imagery and mood to his own painting *Good Time Charley*, 1961 (plate 80), with its overturned Sculp-metal cup.[90] In an experimental print, *Cup We All Race 4*, 1962 (fig. 12), Johns processed the imagery in the Peto work by highlighting and transforming its details. That year he also inscribed Peto's name along the bottom edge of the painting *4 The News* (fig. 13), between the title and his own name, acknowledging the two artists' shared

Fig. 12. Jasper Johns. *Cup We All Race 4*. West Islip, N.Y.: Universal Limited Art Editions, 1962. Lithograph. 15¾ x 19⅞" (40 x 50.5 cm). Courtesy Universal Limited Art Editions.

visual, conceptual, and expressive concerns. Peto's depictions of things attached to walls and doors provide models for the display of different kinds of information and imagery in a shallow picture space. Both his *Old Souvenirs*, 1881 (fig. 63), and *Ordinary Objects in the Artist's Creative Mind*, 1887 (fig. 62), include an array of items that introduce referential and autobiographical content: *Old Souvenirs* shows a photograph of Peto's daughter as a young girl, and *Ordinary Objects...* displays instruments of his artistic life—his cornet, his palette, and a small still life of his, as well as reproductions of works by other artists.[91]

The seven pots in the left-hand panel of *Ventriloquist* are from Johns's collection of pieces by Ohr (fig. 64), known as the "Mad Potter of Biloxi" for his eccentric personality and unique approach to the craft of pottery.[92] Asked in the late 1980s if he was interested in ceramics generally or just in Ohr's, Johns replied, "I think Ohr especially but there is something interesting about such a primitive way of making forms, something touching in its fragility. It's all about labor and skill."[93] This interest in the craft aspect of art-making is also reflected in Johns's comment that his interest in Peto had to do with the "workmanship" involved in that artist's trompe l'oeil still lifes.[94] *Ventriloquist* shows the Ohr pottery floating in space, in a way that contradicts the illusionism of the bathroom setting. Another image embedded in the stripes that

Fig. 13. Jasper Johns. *4 the News*. 1962. Encaustic and collage on canvas with objects. 65 x 50" (165.7 x 127 cm). Kunstsammlung Nordrhein-Westfalen, Düsseldorf.

fill this left-hand panel is an outline of a whale, from a wood engraving by Barry Moser illustrating Herman Melville's *Moby Dick* (fig. 65).[95] Johns's choice of an image from one of the great American novels affirms both this painting's focus on the American roots of his art and the long-standing importance of literature to his creative process.

In the four paintings together entitled *The Seasons*, 1985–86 (plates 204–7), Johns examines the passage of time through the lens of his own experience. The references in these works to both his own art and that of his predecessors encapsulate his artistic history. The imagery of each painting reinforces the series' overlapping themes—the four seasons, the stages of life, and particularly the activity of the artist, which is seen in the context of a cyclic view of existence. Most striking is Johns's new mode of presenting the figure: in the form of a shadow, which he traced from a template of his own shadow cast on the ground. An imprint of an arm tracing a circle appears with the shadow in each canvas of *The Seasons*, directly linking the series to *Diver* (plate 98), *Land's End* (plate 102), and *Periscope (Hart Crane)* (plate 103). The outstretched arms of the divers and of the shadow also recall Cézanne's solitary male bathers (*The Bather*, fig. 21, and *Bather with Outstretched Arms*, fig. 22).[96] As in Johns's earlier works, Cézanne serves as a model for presenting the figure as simultaneously a projection of the self and a universal type.

The Seasons makes a more direct allusion to Cézanne through the varied configurations of circles, triangles, and squares that appear in each painting. These geometric figures, which are new to Johns's art in this series, reminded him of Cézanne's advice to "treat nature by the cylinder, the sphere and the cone."[97] They also refer to a nineteenth-century brush painting, *Circle, Triangle, and Square* (fig. 69), by the Japanese Zen master Sengai Gibon (1750–1838), which Johns saw reproduced on a postcard.[98] He was interested in the free-form geometry of Sengai's renderings of shapes that Western art more often treats as perfect forms, as illustrated in Leonardo's drawing of a figure inscribing a circle and a square (fig. 19).

At this time Picasso's art became a central source for triggering Johns's images and ideas, providing models for imagery full of both autobiographical details and general themes to do with the creative life of the artist. Two works of Picasso's were important sources for *The Seasons*: *The Shadow*, 1953 (fig. 77), and *Minotaur Moving His House*, 1936 (fig. 79), both of which Johns saw reproduced in David Douglas Duncan's book *Picasso's Picassos*.[99] Duncan's text accompanying these paintings includes biographical anecdotes and comments from Picasso. Adjacent to *Minotaur Moving His House*, Duncan writes, "Minotaur, half man, half beast…appeared in the Pantheon of Picasso's world when his personal life was in turmoil, when there must have seemed no way out."[100] In the same passage he notes that Picasso had recently moved: "In the Maestro's new home, sparsely furnished with a few old things that had traveled with him from the start, the tide of life had caught him on its crest and was carrying him forward once more." In Duncan's text for *The Shadow*, Picasso affirms that the shadow cast is his own shadow, and the bedroom is the one he shared with his lover Françoise Gilot, who had recently left him.[101]

Minotaur Moving His House shows a minotaur pulling a cart full of possessions across a landscape. Johns has said that he was attracted to Picasso's painting more for its subject matter than for its structure: "More than most of his paintings, the

catalog of things is very layered.... And, of course, it was very odd to see the cart before the horse: the Minotaur is pulling the cart, and on it is a horse giving birth. There was something very wonderful, very interesting in an unexpected way. It's not the pursuit of logic. I thought, how did he have that thought? I wouldn't have that thought."[102] To incorporate details from *Minotaur Moving His House*, Johns used a different process from his adaptations of Grünewald: instead of transforming the Picassos by tracing and reworking them, he selected from them specific iconographic details that he adapted and reconfigured in his own hand. Each of the *Seasons* paintings has an animated background of stars inspired by the landscape in Picasso's painting, as well as a ladder, rope, canvas, and tree branch borrowed from the minotaur's cart. The arm tracing a circle suggests the cart's wheel. And the sea horse strategically located in *Summer* is a revealing substitute for the horse that the virile minotaur carries among his possessions. In Picasso's painting, the minotaur stands for the artist; the horse giving birth represents his lover Marie-Thérèse Walter, who had recently given birth to their daughter, Maya. Since the sea horse is one of the few species in which the male bears offspring, Johns's visual pun may suggest that he is questioning gender-based stereotypes about sexuality and creativity.[103]

Johns originally conceived *Summer* as an independent work inspired by the circumstances of his life when he began it: he was moving into a new home in New York City, and was also living in several other places, including Saint Martin, in the Caribbean. Basing his composition on the Picasso paintings, he showed himself with his possessions, reminiscing on his past and contemplating his future. Then, while working on a project for an edition of Wallace Stevens poems, Johns was inspired by Stevens's poem "The Snowman" to do a series on the seasons of the year. As the idea for a series of works developed, he expanded the theme from his own personal history to an allegory of the cycle of life, tapping into the long-standing artistic and literary traditions of the four seasons, the four times of day, and the four ages of man.[104]

The shadow moves to different locations in each painting in the series, but retains the same form, implying a permanent core of the self weathering the seasons' changes. In *Spring* (plate 207), Johns adds the shadow of a young boy, pointing to childhood as the stage of life in which the psyche is formed and perceptions are awakened. Reinforcing this idea are the various pictures of visual puzzles that have fascinated Johns in his readings on the psychology of perception.

In *Summer*, the mature self emerges and creativity flourishes. Here the canvas within the canvas contains images from *Racing Thoughts* and *Ventriloquist*, the works immediately preceding this one: the *Two Flags* and the Mona Lisa, images that were designed by others but that have become Johns's own as they have played out in his art over time. The Mona Lisa confirms the continued importance of Leonardo and Duchamp as inspirations for his work. The sexual ambiguity of Leonardo's portrait (sometimes interpreted as a veiled self-portrait), which is made explicit in Duchamp's *L.H.O.O.Q.*, accords with the questioning of gender stereotyping that seems to have interested Johns in his response to *Minotaur Moving His House*. More recent additions to Johns's lexicon of art references are the Grünewald demon and Ohr pots.

In *Fall*, the figure splits in two and the skull and crossbones appears, warning of death. Johns inserts another reminder of Duchamp by including that artist's *Self-Portrait in Profile* as an image within the fictive canvas. The adjacent spoon reaffirms the connection to Duchamp and his *Locking Spoon*, and alludes to the many incarnations of dinnerware in several decades of Johns's art. Near the work's lower edge, the *Cup 2 Picasso* goblet appears among Ohr pots, which seem to be falling as the ladder breaks, the rope snaps, and the arm descends. Finally, *Winter* conveys the elegiac mood of the final stage of nature's cycle. A childlike drawing of a snowman is a reference to the Stevens poem that sparked Johns's idea of expanding *Summer* into a series on the seasons.[105]

> *It's hard to know what leads to what. Does art lead to art? What happens in art makes art change, but what happens outside art also prompts changes. Not that one can always make distinctions.*
>
> —Jasper Johns, 1989 [106]

While working on *The Seasons*, Johns devised an image of a woman's face with eyes, nose, and lips that gravitate outward toward the edges and corners of a rectangular field. The face evokes contradictory responses: it is at once generic, curiously bland, and, at the same time, personal and mesmerizing. The intensity of the eyes' gaze is particularly engaging. Most of the works that feature this image have a sparse, light, lyrical quality, notably different from the densely packed imagery of *Racing Thoughts*, *Ventriloquist*, and *The Seasons*. With this shift in style, Johns pursued his investigations into the workings of the eye and mind by more openly exploring the influence of the subconscious. And he continued to deal with issues of identity, sexuality, and mortality, emphasizing the formative years of early childhood and drawing upon his own memories.

The source that triggered this schematic rectangular face was Picasso's surrealistic *Woman in Straw Hat* (also known as *Straw Hat with Blue Leaf*, among other titles), 1936 (fig. 78), which Johns found, like *The Shadow* and *Minotaur Moving His House*, in Duncan's *Picasso's Picassos*. The psychic impact of Johns's haunting face in part results from the fragmentation and isolation of facial features found in the Picasso, and also in many Surrealist works, such as Magritte's *White Race*, 1937 (fig. 70). Another important aspect of Johns's image is the ambiguity of its spatial reading: besides sometimes appearing as a solid surface, to which objects are attached with trompe l'oeil nails or tape, it doubles as an abstracted landscape or seascape, the lips being readable as mountains, the eyes as the sun. Again, there are precedents for this in Surrealist art, which similarly transforms facial features into landscape elements, or sets them mysteriously in landscapes, as in Magritte's *Every Day*, 1966 (fig. 72), and Man Ray's *Observatory Time—The Lovers*, 1932–34 (fig. 74).[107]

Woman in Straw Hat is one of many Picassos that push "disarticulation of the human likeness to the extreme."[108] Its ambiguity appealed to Johns, who has described it as appearing "very simple, arbitrary, and thoughtless, and yet it's full of interesting thoughts. It's a still life with a book and a vase, but the head can be seen as a [fruit hanging from] a branch. It's rich in a kind of sexual suggestion and

extremely complicated on that level, but it seems so offhand."[109] The eroticism Johns found in the Picasso comes from the imagery's multiple readings: the face is shaped to double as breasts, and the eyes as nipples; the purple vase that serves as the woman's neck transforms into a phallus, with the rounded forms on her blue dress simulating both breasts and testicles.

Describing what caught his attention about this work, Johns has said, "It became extremely poetic, something that conveys many meanings at once. While looking at it, it interested me that Picasso had constructed a face with features on the outer edge. I started thinking in that direction, and it led me to use the rectangle of the paper as a face and attaching features to it."[110] Johns was interested in the idea that a face could be depicted through the simplified and schematically rendered features Picasso had used. He purposely did not copy the Picasso, but devised his own variation:[111] he retained the vertical orientation of the eyes and their placement at different heights on the face, while changing the schematic line that Picasso had used for the nose, and inventing his own lips.

When this rectangular face first appeared in his art, in works produced between 1984 and 1988, Johns used it in combination with the diseased demon traced from the Grünewald altarpiece and with a watch hanging by its wristband from a nail.[112] By using this symbol, Johns integrated into these works the themes of aging and mortality with which he was concurrently engaged in *The Seasons*. In a pair of paintings respectively from 1985 and 1986, *Untitled (A Dream)* (plate 203) and *Untitled (M. T. Portrait)* (plate 208), he reverses the figure/ground placement of the demon and the face, treating the former like a picture nailed to the wall and the latter like the wall's surface.

When Johns began using the rectangular face, he associated it with the "first images or forms of a child."[113] He had in mind a drawing he had seen years earlier, but could not recall in detail; he remembered, though, that he had come upon it in an issue of *Scientific American* when he was in the army in the early 1950s. In 1991, when Johns finally looked up the drawing, finding it in a 1952 article by Bruno Bettelheim, he was astonished at its similarity to the Picasso-inspired face he had first painted over thirty years later.[114] Bettelheim had reproduced a series of drawings by a girl who had developed schizophrenia after losing both her parents. He had described the drawing Johns remembered, *The Baby Drinking the Mother's Milk from the Breast* (fig. 73), as showing "a pictorial world that consisted only of the mother's breasts and just above them what the nursing infant sees—mouth and eyes. As if to emphasize the primitive sensations, she put fingerprints all around the border."[115]

Once Johns found the girl's drawing, he acknowledged its connection to his work in a series of untitled paintings from 1991–94 (plates 229–31) in which he copied it within the frame of the larger rectangular face. Even before researching the Bettelheim article, he had made a connection between the face and a maternal figure in his own life: in 1989, he had begun a series entitled *Montez Singing* (plate 224), a name that refers to his step-grandmother (his paternal grandfather's second wife), who had raised him between the ages of two and nine. These works' schematic rendering of a sailboat and a sunset on the ocean refers to Johns's memory of Montez playing the piano and singing "Red Sails in the Sunset."[116]

This is the first of the explicit references to Johns's childhood that now begin to appear with increasing frequency in his art.

Several untitled works (including a drawing from 1986, plate 217, a painting from 1987, plate 219, and a painting from 1991, plate 232) combine Johns's rectangular face with its model, the biomorphic face from Picasso's *Woman in Straw Hat*, and also with the ambiguous W. E. Hill figure that shifts between young woman's and old woman's profile. These images present various female types (maternal and erotic, attractive and repulsive, infantile and sophisticated), but they are too eccentric to read as stereotypes, and their repetitions and transformations impress them in one's memory. The faces in the untitled painting of 1987 are made still more iconic through their association with the veil of Saint Veronica. Earlier, in the prints, drawings, and painting named *Untitled (Red, Yellow, Blue)*, 1984 (plate 195), Johns had shown hanging cloths with the word "blue" written on them. *Untitled*, 1987 (plate 219), uses similar cloths to display faces, an idea triggered by the *Veil of Saint Veronica* paintings (fig. 71) by the seventeenth-century Spanish Baroque artist Francisco de Zurbarán, two of which Johns saw in an exhibition at the Metropolitan Museum of Art in 1987.[117] The cloths provided a varied surface on which to display the faces, and one that allowed for the effect of transparent layers. (See an untitled drawing of 1988, in watercolor and ink, plate 218, and an untitled painting of 1991–94, plate 231.)

An untitled painting of 1988 (plate 221) is one of those that combine Picasso's ambiguous, erotic *Woman in Straw Hat* with Grünewald's diseased demon, and also with the Stony Point bathroom. Picasso's image seems to be dissolving, an effect created by making the wax-based encaustic medium melt and drip. Johns has related this manipulation of the image to two stories about Picasso: "One anecdote Paul Brach told me: that Picasso, when he first saw a painting by de Kooning, turned to someone and said, 'Melted Picasso.' Then I read a book of Cocteau's in which he writes that Picasso said he was always amazed, when he took a bath, that he didn't melt like a cube of sugar. That image stuck in my mind, and I decided I wanted to use an image of a melting Picasso. Finally I put it together with the [Stony Point] bath."[118] Picasso's *Woman in Straw Hat*, the Stony Point bathtub, and the Grünewald demon appear again in an untitled watercolor from 1988 (fig. 14). To this work Johns has added his signature *Flags*, the skull-and-crossbones avalanche warning sign, and a page from the *New York Times* with the headline "Spread of AIDS Abating, But Deaths Will Still Soar." Created for an AIDS benefit auction, this drawing makes explicit the connection of Grünewald's diseased demon with sexuality and death in the age of AIDS, a link that in other works is one of many possible meanings.[119]

Another source that Johns returned to in the mid-1980s was Duchamp's "erotic machinery." In 1986, he produced eight untitled tracings (plates 209–16) from an aquatint of 1930 by Jacques Villon (fig. 38), copied from Duchamp's 1912 painting *Bride*. The Duchamp work itself is a highly abstracted biomechanical rendering of the human form, and Johns's tracings from Villon's reproduction of it further abstract it, while retaining its vestigial sense of figuration. Johns, who owns a copy of the Villon print, was intrigued that Villon

Fig. 14. Jasper Johns. *Untitled*. 1988. Watercolor, ink, and graphite pencil on paper. 31 3/8 x 47 3/8" (79.7 x 120.3 cm). Collection Jeanne Lang Mathews.

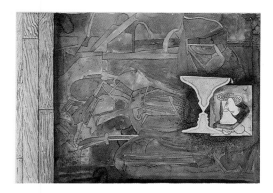

Fig. 15. Jasper Johns. *Untitled*. 1988. Watercolor and graphite pencil on paper. 21 3/8 x 29 3/4″ (54.3 x 75.6 cm) sight. Collection Barbaralee Diamonstein and Carl Spielvogel.

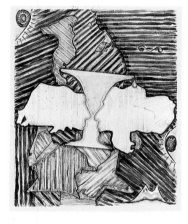

Fig. 16. Jasper Johns. *Untitled*. 1990. Watercolor and graphit pencil on paper. 22 1/4 x 17 3/4″ (56.5 x 45 cm). Private collection.

(Duchamp's brother) did not try to replicate the Duchamp painting, but purposely took liberties with it.[120] An untitled drawing of 1988 (fig. 15) combines Duchamp's and Picasso's suggestive images; Johns has copied Villon's aquatint and Picasso's *Woman in Straw Hat* freehand, reversed them both, and turned the Duchamp on its side. The Picasso "cup" (originally from the 1972 *Cups 4 Picasso*, fig. 9), so full that a drop of liquid spills over the rim, is superimposed on these appropriated images. The work documents Johns's affinity with the two modernist artists who have most stimulated and inspired his work—artists who are thought to represent opposite poles of twentieth-century art. The way he reworks their imagery, invests it with new meanings, and integrates it into his own body of work shows an approach to appropriation that differs from the straightforward quotations of other artists working with art-historical sources during this period.[121]

In 1990, Johns combined the rectangular face/landscape with a cryptic image, probably traced from a reproduction of an artwork, that he has so far refused to identify and whose source remains unknown.[122] The form suggests one figure holding another, but its identity is so obscured by the way Johns has traced it that any reading as figure or object remains speculative. The first painting to use this image was given an intriguing title, *Green Angel*, 1990 (plate 226), that may or may not provide a clue to the image's source.[123]

Just as he did with the Grünewald tracings, Johns has worked myriad modifications on this image, showing it reversed and upside-down in various multicolored, striated, and monochromatic configurations (plates 225, 226, 240–42; fig. 16). Throughout these processes of transformation, however, the aura of its origins as a representational image is retained. That the image's source remains unknown is a crucial factor in Johns's use of it to further his inquiry into how images convey meaning. His concealment of the source is not an end in itself, but a way to explore the complex responses generated by something that remains cryptic. Johns has said, "If something is a tracing…does knowing [what it is] affect your perception of the work?…And if you don't know what it is, do you see it completely differently…or not?"[124]

Tracing has remained a significant means for Johns to "reread" images from art history with which he makes a connection.[125] Two other works he has taken as sources, one by Holbein and one by Cézanne, show the range of his uses of this process, and how he pays homage to the artists whose work he appropriates while at the same time making their images his own. In 1989, the year before he adopted the unidentified image in *Green Angel*, Johns began a series of tracings after a Holbein drawing, *Portrait of a Young Nobleman Holding a Lemur*, c. 1541, that he had seen in Basel in 1988 (fig. 80).[126] While in some of these tracings Johns pushes the Holbein close to abstraction, he has never hidden that work as their source (see *After Holbein* and *After Hans Holbein*, both 1993, plates 243 and 244).

The idea of using the Holbein came to Johns when Riva Castleman, then Director of the Department of Prints and Illustrated Books at The Museum of Modern Art, remarked that she wished he would do a picture about a person with a pet. At the time, Johns was passing the Holbein every day, in the form of a poster from the Basel exhibition that hung in the hallway of his New York townhouse.[127]

Portrait of a Young Nobleman Holding a Lemur was the first drawing Johns had used for a tracing. He may have been interested in working from a drawing then because a retrospective of his own drawings was in the planning stages at the National Gallery of Art in Washington, D.C., where it would open in 1990. The Holbein also corresponded to the several images in Johns's work from this period that focus on childhood. And the resemblance of the boy's pet, variously identified as a monkey and a lemur, to the marmosets Johns himself had kept for many years may have sparked a personal association with the Holbein, which Johns has said made a vivid impression on him when he first saw it in Basel.[128]

Significantly, Johns's first tracing from another artist's work was derived from one of Cézanne's paintings of bathers—the *Bathers* of 1900–1906 (fig. 25), in the National Gallery of Art in London, which he traced from a postcard in 1977. He had seen the painting that year in an exhibition of Cézanne's late work at The Museum of Modern Art. While Cézanne's bathers have a connection to *Diver* and to *The Seasons*, until the small *Tracing*, 1977 (fig. 17), Johns had made no direct reference to a specific Cézanne, and none appeared again until the series of six *Tracings* from 1994, all in ink on plastic (plates 245–50). In 1989, Johns had traveled to Basel to see the comprehensive exhibition of Cézanne's images of bathers held that year at the Kunstmuseum. By that time he had started collecting Cézannes, and in fact he loaned two works to that show: *Bather with Outstretched Arms* (fig. 22) and *Studies for Bathers*, c. 1877–80 (fig. 27).

Part of Johns's interest in the *Bathers* seems to have had to do with the way Cézanne used and transformed the same motifs over a long career. When asked in 1989 about his recycling of images, Johns replied, "I doubt that I understand the underlying mechanism if there is one, that causes one to return to images that have already been used....one can state why one does something of that sort. But it becomes a difficult mystery if, say, you think of the way Cézanne used the same poses of the bathers over and over again."[129] But what set the stage for Johns's engagement with Cézanne's *Bathers* in his 1994 *Tracings* was his involvement with issues of sexuality, seen, for example, in the explicit eroticism of his *Tantric Detail* works, and in the imagery he has taken from Grünewald, Picasso, and Duchamp.

The *Tracings* derive from *Nudes in Landscape*, 1900–1905 (fig. 23), in the Barnes Foundation, Merion, Pennsylvania. One of Cézanne's three late *Large Bathers*, *Nudes in Landscape* is generally seen as the most expressive of the group: the nudes have been said to "posture and gesture with a nearly manic theatricality."[130] Johns made his tracings from the reproduction on a poster for the traveling exhibition "Great French Paintings from the Barnes Foundation," which he saw at the National Gallery of Art, Washington, D.C., in 1993. He had seen the painting in Merion years before, but the idea of making the tracings was inspired by the impact of seeing it again in the National Gallery show.

Johns has said that in the course of tracing the Cézanne, he began to interpret its figure leaning against a tree as a "dreaming" figure "fantasizing" the other bathers. As he traced the image, he transformed this female figure into a sexually aroused male one.[131] While Johns may have been the first to interpret this particular figure in this way, Cézanne's *Bathers* contain many figures of ambiguous sexual identity. Theodore Reff has pointed out compositions in which "male bathers appear in

Fig. 17. Jasper Johns. *Tracing.* 1977. Ink on plastic. 10⅞ x 13" (27.6 x 33 cm) sight. Collection David Shapiro.

poses originally invented for female bathers…they raise interesting questions about the mingling of the sexes in pictures thought to be clearly differentiated and, with other figures of a hermaphroditic character, about their sexual identity altogether."[132] Cézanne's recurring figure of a male bather raising his arms over his head, for example, is adapted from the pose of female bathers fixing their hair. This pose, in which the figure looks as if he were displaying his body for a desiring observer (fig. 27), appears frequently in Cézanne's studies and paintings of bathers, including two that Johns owns. (Johns has described Cézanne's *Bather*, fig. 21, as having "a synesthetic quality that gives it a great sensuality—it makes looking equivalent to touching."[133]) It is also the pose of the standing figure in *Nudes in Landscape*, and of a second figure in that work whose body and facial features are more obviously female.

In reference to his tracings after Cézanne, Johns has noted his interest in interpretations of Cézanne's work that identify the artist as present in his scenes of female bathers.[134] Probably an important source of these ideas for Johns was Mary Louise Krumrine's essay on the series' development in the catalogue of the Basel exhibition. Krumrine stresses that while male and female figures usually appear in different canvases, "The sex of the bathers is often difficult to determine."[135] In her analysis of *Nudes in Landscape*, which she sees as "the most personally revealing" of the final three *Large Bathers*, she interprets an early version of the striding bather at the left as a Cézanne self-portrait, in which he casts himself "as an Olympian god in the company of seven *baigneuses*."[136] Although Cézanne ultimately made the figure more abstract and more female, Krumrine argues that he is still present in it, if in a concealed role.[137] In her conclusion Krumrine asserts that the main issue of all three *Large Bathers* is "the sexual identity of the artist, of both the male and female characteristics in his nature."[138]

Interpreting *Nudes in Landscape* through his *Tracings*, Johns did not follow the specific details of Krumrine's inquiry into the bathers' indeterminate sexual identities, but her discussion of Cézanne's presence among them may have influenced him. Whether he himself identified with the fantasizing male bather must remain a point of speculation. The personal rereading he brings to the Cézanne through his *Tracings*, however, affirms his close identification with Cézanne's art throughout his career. And Johns's recent acquisition of a number of Cézanne works, including the drawing *Self-Portrait*, c. 1880 (fig. 24), attests to Cézanne's continued importance as the artist with whom he most profoundly identifies.[139]

> *Painting can be a conversation with oneself and, at the same time, it can be a conversation with other paintings. What one does triggers thoughts of what others have done or might do….This introduces a degree of play between the possible and the necessary, which can allow one to learn from other artists' work that might seem otherwise unrelated or irrelevant.*
>
> —Jasper Johns, 1989[140]

Johns's works of the 1990s are characterized by an increasingly complex spatial layering and a growing number of references to his childhood. His "conversations" with

both his own and other artists' previous works escalate in intensity as he continues his inquiry into perception as a means of examining the larger questions of existence.

The oil painting *Mirror's Edge*, 1992 (plate 236), sparks an intricate interplay of images through the pictures it illusionistically sets on a sheet of paper with curled corners. These pictures include a spiral galaxy (an increasingly prominent form in Johns's iconography), which adds a cosmic perspective to the work—a telescopic view into space and time. To its right, the familiar Silver Jubilee vase stands on the wicker hamper from the bathroom of Johns's Stony Point home. The two black-and-white Barnett Newman drawings at the paper's upper edge are visually and thematically linked to the spiral galaxy, since Newman's works deal with the concept of the void, and his titles often reinforce the images' sense of cosmic space. (A Newman painting of 1949 is specifically titled *Galaxy*.[141]) These untitled drawings from 1960 (figs. 67 and 68), both in Johns's collection, are from a group of twenty-two brush-and-ink works relating to Newman's painting series *The Stations of the Cross*, 1958–66.[142] Johns has reversed both drawings, and turned the left-hand one upside-down.

The colorful background for these two black-and-white images is the detail of the soldiers guarding the tomb from Grünewald's Isenheim Altarpiece, which returns as a major image here and in other works in the *Mirror's Edge* group. The detail is turned vertical and reversed, so that the pinwheel pattern of the reclining soldier's costume stands out, echoing the swirling galaxy. Through his presence at the Resurrection, the soldier introduces the ideas of spiritual transcendence and triumph over death, reinforcing the themes of timelessness and cyclic change. The juxtaposition of the Newman drawings and the Grünewald detail contrasts late-twentieth-century abstract art and High Renaissance illusionist art, two very different pictorial languages that both deal with spiritual themes.[143]

The paper with curled corners on which all these images appear is illusionistically taped to a second layer of imagery—a 1990 etching of *The Seasons*, in which that series' four panels are arranged in a cruciform configuration (plate 227). Besides its obvious religious symbolism, the shape suggests the circularity and continuous flow of a wheel, with no fixed beginning or ending. When Johns first exhibited *The Seasons*, in 1987, the paintings' arrangement encouraged a linear reading, beginning with *Spring* (plate 207) and ending with *Winter* (plate 206). In a series of etchings, of which this is the final one, Johns transformed the concept into the idea of a continuous cycle, first by moving the position of the seasons to end with spring instead of winter, and finally through the cross/wheel format.[144]

An important image enters the *Seasons* iconography in the etching of 1990: the group of stick figures at the bottom of the cross. These three figures, which are schematic renderings of artists wielding brushes, had first appeared in the 1982 ink-on-plastic version of *Perilous Night* (plate 190), where they may stand for the persistence of creativity even in doubt and despair. In the *Seasons* etching they indicate the continuity of the artist's activity in the changing cycle of life. Although they appear to be Johns's invention, they bear a striking resemblance to the animate stick figure waving a brush in Paul Klee's *Wander-Artist (A Poster)*, 1940 (fig. 84).

In *Mirror's Edge*, Johns focuses on only a few key motifs from the 1990 *Seasons* etching. In addition to the stick figures, the boy's shadow from *Spring* features

prominently, telescoping back in time to the artist's formative years. The ladder from Picasso's *Minotaur Moving His House* also appears, reading as a metaphor for passage through time and space. Another Picasso image, first used in the *Seasons* etchings, adds an important figurative element to *Mirror's Edge*, and to Johns's paintings that follow. This is the curious figure near the upper right, with arms and legs fanning out from a featureless head, making a linear body with little detail except toes, fingers, and some musculature. The figure derives from Picasso's *Fall of Icarus*, 1958, a large mural commissioned by UNESCO for its Paris headquarters (fig. 82). Johns first saw the image in a Picasso biography.[145] He himself was working with the Klee-like stick figures at the time, and he was interested in how Picasso could make a schematic figure that was still so expressive and rich with content.

The *Seasons* etchings and *Mirror's Edge* show Picasso's figure emerging out of the man's shadow (here only faintly traced) that is repeated in all the *Seasons* as a stand-in for the artist as an "everyman" weathering the changes of life. In Picasso's mural, Icarus appears "plunging into the water like a bird or airplane while bathers

Fig. 18. Jasper Johns. *Sketch for Montez Singing.* 1988. Ink on paper. 12 ¼ x 19 ¾" (31.1 x 50.1 cm). Collection the artist.

watch from the beach."[146] He is simultaneously a diver by the seashore and the Icarus of classical legend whose tragic flaw of "hubris and imagination" leads to his demise.[147] In *Sketch for Montez Singing*, 1988 (fig. 18), Johns draws Picasso's Icarus on the same page with the rectangular face and sailboat of *Montez Singing*, suggesting that he may originally have intended to link that work with the theme of Icarus falling into the sea. Johns likely made the connection between the diving Icarus and his own diver figures dating back to the 1960s.[148]

Another new motif in *Mirror's Edge*, almost covered by the cruciform *Seasons* and taped picture, is the ground plan of Johns's grandfather's house in Allendale, South Carolina. Allendale is Johns's home town, where he spent his early childhood, living first with his parents and then, after their separation and divorce, with his grandfather and Montez. When Johns painted *Mirror's Edge*, his grandfather's house had recently been torn down, and he had not visited it in many years. So he reconstructed it from memory, after consulting relatives who still lived in the area.[149] By using a reference to his own childhood, Johns contrasts the specificity of the circumstances of his life with the universal themes implied by other images in *Mirror's Edge*—the *Seasons* etching and the spiral galaxy.

Similarly, in an untitled watercolor of 1993 (plate 239) based on *Mirror's Edge*, Johns pairs one of Newman's drawings with a copy of a family photograph showing Johns's father, William Jasper Johns, as a child seated on his father's knee. The photograph also shows Johns's grandmother, aunts, and uncle. This grandmother, Evaline, who died before Johns was born, was the only other artist in Johns's family. Johns has mentioned paintings of hers that he saw in relatives' homes when he has described his childhood ambition to be an artist.[150] This document of his paternal family roots coincides with his continued use of maternal references in the pictures using Bettelheim's child's drawing (fig. 73) and the rectangular face/landscape based on Picasso's *Woman in Straw Hat* (fig. 78).

Mirror's Edge 2, 1993 (plate 237), is an encaustic variation on the oil *Mirror's Edge*—the elements are nearly identical, but they are rearranged. Most notably, the cross/wheel *Seasons* image is rotated, so that the figures are upside-down. The

Icarus figure now appears to fall through space, like the diving figure in Picasso's painting. In the taped picture-within-the-picture, Johns has replaced the Grünewald soldiers with the diseased demon as the background for the galaxy and the Newman drawings, and an Ohr pot substitutes for the Silver Jubilee vase. The Grünewald soldiers remain present, however, in an additional layer behind the plan of Johns's boyhood home.

The layered, shifting perceptions in the *Mirror's Edge* works continue Johns's preoccupation with space as both an expressive and a perceptual element of art. He has said that the trompe l'oeil wooden strip at one edge of each *Mirror's Edge* painting was meant to evoke a part of a mirror's frame, functioning like similar devices in other works of his to underscore the fiction of the paintings' complex illusionism.[151] For Johns, the importance of the mirror as a metaphor for the work of art may go back to Leonardo's *Treatise on Painting*, an important source for Johns's theories on art dating back to the 1950s. Leonardo writes that "the mind of the painter must resemble a mirror."[152] He calls the mirror the painter's master, advising that "when you want to see if your picture corresponds throughout with the objects you have drawn from nature, take a mirror and look in that at the reflection of the real things, and compare the reflected image with your picture....You should take the mirror for your guide...because on its surface the objects appear in many respects as in a painting."[153] By building on Cubist and Surrealist concepts of how reality is "mirrored" in art, Johns brings a late-twentieth-century perspective to Leonardo's concept of painting as a mirror of nature.

Both the encaustic *Untitled*, 1992–94 (plate 241), and the oil *Untitled*, 1992–95 (plate 242), provide an eloquent synthesis of Johns's work of the previous decade. Here Johns merges imagery from *Mirror's Edge* and from *Untitled (Red, Yellow, Blue)* (plate 195), using the latter's tripartite structure. The rectangular face and the unidentified tracing appear as images on a fictive canvas leaning against a wall. Rendered as pure outline, a multiple tracing of Grünewald's soldiers acts as a filigree spanning the breadth and depth of the picture space; what was a cryptic embedded form in *Perilous Night* (plate 189) and *Untitled*, 1984 (plate 201), now emerges, superimposed on the floor plan of Johns's grandfather's house, with the clearly recognizable features of its source.

The differences between the two *Untitled* paintings are mainly the results of changes in color and medium, but a minor variation in iconography involves the sheets of paper on which the house floor plan is drawn. In the *Untitled* of 1992–95, instead of giving these papers curled corners to create the trompe l'oeil effect, Johns takes folded and rolled edges from a Piranesi engraving of architectural details, *Del Castello Dell'Acqua Giulia*, 1761 (fig. 81). Not only Piranesi's trompe l'oeil devices but the way he suggests layers of images coincided with the interests of Johns's art at the time. In a 1993 interview with Mark Rosenthal, Johns commented on his interest in Piranesi's illusionism: "At first glance the Piranesi seemed to represent architectural studies. Later, I saw another level of representation, suggesting that the studies were on several unrolled sheets or pages. This complication, this other degree of 'reality' or 'unreality,' interested me."[154]

In *Nothing At All Richard Dadd*, a drawing of 1992 (plate 235), the cross/wheel *Seasons* intersects the floor plan of Johns's childhood home. The Icarus figure, with

its unmistakable musculature and digits, appears to step out of these intersecting planes. At the upper edge, the work's title is repeated three times. The reference is to the nineteenth-century English painter Richard Dadd, whose fascinating and disturbing biography may have interested Johns: when Dadd was twenty-six, he believed himself possessed by spirits, and on their instructions he murdered his father. He spent the rest of his life in an asylum for the criminally insane, where he produced "fantastic pictures of fairies painted in obsessional detail and crammed with hordes of tiny figures."[155] The "Nothing At All" inscription may allude to a poem Dadd wrote about his masterpiece, *The Fairy Feller's Master Stroke*, 1855–64 (fig. 83). After a lengthy exegesis of the painting's imagery, Dadd ends the poem by denying the validity of his own explanations: "But whether it be or be not so/You can afford to let this go/For nought as nothing it explains/And nothing from nothing nothing gains/'Can you make no use of nothing, nuncle?' 'Why no,/boy; nothing can be made out of nothing.'"[156]

Patricia Allderidge writes of Dadd's "total commitment to, and understanding of his own creative power, which enabled him to keep on working and grow and develop in isolation, knowing he could never win any more recognition or response from the world outside his asylum than if he had been literally dead."[157] Dadd's persistence in making art suggests a belief in art's necessity for the artist and for society even when its purpose is in doubt. This idea fits with Johns's linking of his own work to the art of the past, as an affirmation of his commitment to the viability of painting as a way of speaking to issues about the human condition that have continued to obsess artists and engage viewers.

Johns's use of images taken from other artists is connected to his long-standing practice of using forms designed by others as a starting point, rather than forms invented in his own imagination. While the images *as found* belong to others, Johns transforms them into something of his own, without severing their connections to their sources. Of his first painting of an American flag, Johns has said, "Using this design took care of a great deal for me because I didn't have to design it. So I went on to similar things like targets—things the mind already knows. That gave me room to work on other levels."[158] Of his flagstones, first used in *Harlem Light*, 1967 (plate 123), Johns has said, "If I could have traced it, I would have felt secure that I had it right. Because what's interesting to me is the fact that it isn't designed but taken. It's not mine."[159] By now the "things designed by others" include a wide repertory of images taken from other artists—a Piranesi engraving, Grünewald's soldiers, Picasso's *Minotaur Moving His House*, a child's drawing, Sengai's *Circle, Triangle, and Square*, an unidentified tracing, Cézanne's bathers, and Duchamp's brides. They have become elements in Johns's complex and layered pictorial vocabulary, part of his ongoing conversation with his own previous art, the art of the past, and the myriad other sources that impinge upon his consciousness, generating new images and ideas.

I want to express my gratitude to Kirk Varnedoe for inviting me to write this essay; to Lilian Tone, Christel Hollevoet, and David Frankel for their research and editorial assistance; to Jasper Johns for his thoughtful responses to my questions and for checking the accuracy of my information; and to Johns's assistant, Sarah Taggart, and Joanne Kriegel for locating material in his archives. Finally, I want to thank my family and friends, especially Sally Ganz and Viki Sand, for their support.

Notes

1. Jasper Johns, quoted in Richard Francis, *Jasper Johns* (New York: Abbeville Press, Modern Masters Series, 1984), p. 98.

2. Johns, quoted in Grace Glueck, "The 20th-Century Artists Most Admired by Other Artists," *Artnews* 76 no. 9 (seventy-fifth anniversary issue, November 1977): 89. Glueck asked a number of contemporary artists, "What specific work(s) of art—or artist(s)—of the past 75 years have you admired or been influenced by—and why?"

Part of Johns's response to Glueck's question—the point that he is not "just attached to great things"—recalls the relationship of his imagery to mass media or popular culture. Although this is an important aspect of his work (see, for example, Kirk Varnedoe and Adam Gopnik, *High & Low: Modern Art and Popular Culture*, exh. cat. [New York: The Museum of Modern Art, 1990], pp. 330–33), the present essay focuses primarily on his use of references to the traditional fine-arts mediums, particularly painting.

Within the fine arts, another important source for Johns's imagery is literature. His use of authors' names, and of references to their writings, dates back to his 1958 painting *Tennyson*, and includes allusions to Frank O'Hara, Hart Crane, Ted Berrigan, Samuel Beckett, Louis Ferdinand Céline, Herman Melville, and Wallace Stevens. This area has been addressed elsewhere by myself and others; see, for example, *Foirades/Fizzles: Echo and Allusion in the Art of Jasper Johns*, exh. cat. (Los Angeles: The Grunwald Center for the Graphic Arts, Frederick S. Wight Art Gallery, University of California, 1987), and Roberta Bernstein, *Jasper Johns' Paintings and Sculptures 1954–1974: "The Changing Focus of the Eye"* (Ann Arbor: UMI Research Press, 1985). A comprehensive study of the subject, however, has not yet been done.

Although Johns may look outside the fine-arts canon for "things not great," the artists (and writers) whose works he references are primarily well-known, male artists in the Western tradition. While this point needs to be acknowledged, it is not central to this essay; unlike many contemporary appropriationists, Johns is not involved with a critical reassessment of the canon. His choice of primarily old and modern "masters" as sources for imagery, however, does not mean that his artistic influences or interests are not more inclusive. For example, his collection includes works by women artists he admires, among them Diane Arbus, Käthe Kollwitz, Marisol Escobar, and Bridget Riley.

3. See Jean Lipman and Richard Marshall, *Art about Art*, exh. cat. (New York: E. P. Dutton, in association with the Whitney Museum of American Art, 1978). Leo Steinberg, in his introduction to this catalogue, traces the long-standing and diverse practice of art about art, and writes, "There is as much unpredictable originality in quoting, imitating, transposing, and echoing, as there is in inventing. The ways artists relate their works to antecedents—and their reasons for doing so—are as open to innovation as art itself" (p. 25). Works by Johns were included in this exhibition and are represented in the catalogue.

4. See, for one example in what is now a large literature, *Endgame: Reference and Simulation in Recent Painting and Sculpture*, exh. cat. with essays by Yve-Alain Bois, Thomas Crow, Hal Foster, et al. (Boston: The Institute of Contemporary Art, 1986).

5. Johns, quoted in Vivien Raynor, "Jasper Johns: 'I have attempted to develop my thinking in such a way that the work I've done is not me,'" *Artnews* 72 no. 3 (March 1973): 21.

6. Harold Bloom, *The Anxiety of Influence: A Theory of Poetry* (New York: Oxford University Press, 1973), p. 5.

7. Ibid., p. 13.

8. Johns, quoted in Ruth E. Fine and Nan Rosenthal, "Interview with Jasper Johns," in Nan Rosenthal and Ruth E. Fine, with Marla Prather and Amy Mizrahi Zorn, *The Drawings of Jasper Johns*, exh. cat. (Washington, D.C.: National Gallery of Art, and New York and London: Thames and Hudson, 1990), p. 76.

9. Johns, quoted in Mark Stevens with Cathleen McGuigan, "Super Artist: Jasper Johns, Today's Master," *Newsweek* 90 no. 17 (October 24, 1977): 78.

10. Steinberg has written of Johns's early decision to stop making abstract collages when it was pointed out to him that they looked like the work of Kurt Schwitters. See Steinberg, "Jasper Johns: The First Seven Years of His Art," *Other Criteria: Confrontations with Twentieth Century Art* (New York: Oxford University Press, 1972), p. 21. Paul Clements has also quoted Johns as follows: "In work I did earlier I deliberately tried to avoid doing work that could be compared to another artist. It was part of establishing my identity and my idea of making art. I tried to make something that would not be someone else's. Of course I used images that already existed, non-art images. Later I was less concerned that I was I and not someone else." See Clements, "The Artist Speaks," *Museum & Arts Washington* 6 no. 3 (May/June 1990): 79.

11. Johns, ["Statement"], in Dorothy C. Miller, ed., *Sixteen Americans*, exh. cat. (New York: The Museum of Modern Art, 1959), p. 22. Johns's teachers at the University of South Carolina, Columbia, where he studied art for three semesters during 1947–48, were Catharine Rembert, Augusta Wittkowsky, and Edmund Yaghjian. He may have been referring to one of them as the teacher who made the remark about the "rotating point of view" in regard to Cézanne and Cubism.

12. See Bernstein, *Jasper Johns' Paintings and Sculptures*, pp. 103–12.

13. See Nan Rosenthal, "Drawing as Rereading," in Rosenthal and Fine, p. 30.

14. Johns, quoted in Michael Crichton, *Jasper Johns* (first published 1977, revised

and expanded edition New York: Harry N. Abrams, Inc., in association with the Whitney Museum of American Art, 1994), p. 48.

15. Johns, quoted in Max Kozloff, *Jasper Johns* (New York: Harry N. Abrams, Inc., 1969), p. 38.

16. Johns, quoted in John Cage, "Jasper Johns: Stories and Ideas," in Alan R. Solomon, *Jasper Johns: Paintings, Drawings and Sculptures 1954–1964*, exh. cat. (New York: The Jewish Museum, 1964), p. 22.

17. Bernstein, *Jasper Johns' Paintings and Sculptures*, p. 60.

18. See Christian Geelhaar, "The Painters Who Had the Right Eyes: On the Reception of Cézanne's Bathers," in Mary Louise Krumrine, *Paul Cézanne: The Bathers* (Basel: Museum of Fine Arts, and Einsiedeln: Eidolon, distributed by Harry N. Abrams, Inc., New York, 1989), p. 298. See also Bernstein, *Jasper Johns' Paintings and Sculptures*, pp. 68–74.

19. See Geelhaar, p. 298.

20. Fourteen works in different mediums from Fernand Léger's *Diver* series of 1940–45 were exhibited in New York in 1962, in the exhibition "Fernand Léger: Five Themes and Variations," at the Solomon R. Guggenheim Museum. Johns's *Diver* works may have a connection to this series, but their emotional content is closer to Cézanne.

21. Meyer Schapiro, *Paul Cézanne* (New York: Harry N. Abrams, Inc., The Library of Great Painters, 1952), p. 68.

22. Theodore Reff, "Cézanne's Bather with Outstretched Arms," *The Gazette des Beaux-Arts* 6th series no. 59 (March 1962): 174. Reff is referring to a larger, 29-by-23 ⅝-inch version of Cézanne's *Bather with Outstretched Arms*, from c. 1885.

23. See Bernstein, *Jasper Johns' Paintings and Sculptures*, p. 111.

24. Johns, quoted in Glueck, p. 87.

25. The first use of the term "Neo-Dada" in connection with Johns's art was in Robert Rosenblum, "Castelli Group," *Arts* 31 no. 8 (May 1957): 53, a review of a group exhibition at the Leo Castelli Gallery in which Johns showed *Flag*, 1954–55. The composer John Cage knew Duchamp's work during the 1940s, and transmitted his ideas to Robert Rauschenberg and others on the New York art scene in the 1950s. By late in that decade Duchamp's work had become widely known, so that Johns's concern with him was part of a widespread interest in his art and thought, both in the United States and abroad. Duchamp continues to have a major impact on avant-garde art, as several recent publications have documented. See, for example, Bonnie Clearwater, ed., *West Coast Duchamp* (Miami Beach: Grassfield Press, 1991); Susan Hapgood, *Neo-Dada: Redefining Art, 1958–62*, exh. cat. (New York: The American Federation of Arts in association with Universe Publishing, 1994); and *Ubrigens Sterben Immer Die Anderen: Marcel Duchamp*

und die Avantgarde seit 1950, exh. cat. (Cologne: Museum Ludwig, 1988).

26. See Kozloff, p. 24, and Rosalind Krauss, "Jasper Johns," *Lugano Review* 1 no. 2 (1965): 84. The books Johns has mentioned reading are Robert Motherwell, ed., *The Dada Painters and Poets: An Anthology* (New York: Wittenborn, Schultz, 1951), and Robert Lebel, *Marcel Duchamp*, trans. George Heard Hamilton (New York: Grove Press, 1959). Johns's copy of the editioned book *Lettre de M Duchamp (1921) à Tristan Tzara*, published in 1958, contains a personal inscription from Duchamp to Johns dated January 30, 1959. This could possibly be the date of their first meeting. Johns's relationship with Duchamp has been discussed by many authors, beginning with Kozloff's essay "Johns and Duchamp," *Art International* 8 no. 2 (March 1964): 42–45.

27. *The Bride Stripped Bare by Her Bachelors, Even: A Typographic Version by Richard Hamilton of Marcel Duchamp's Green Box*, trans. George Heard Hamilton (New York: Wittenborn and Company, 1960). Johns owns a copy of the 1934 edition of the *Green Box* with the inscription "To Jasper Johns, Sybille des cibles, Affectueusement, Marcel 1960" (To Jasper Johns, sibyl of targets, affectionately, Marcel 1960).

28. Johns, "Duchamp," *Scrap* no. 2 (December 23, 1960): [4].

29. Johns, "Thoughts on Duchamp," *Art in America* 57 no. 4 (July–August 1969): 31.

30. Johns was engaged in all aspects of designing and fabricating the set for *Walkaround Time*. The program credit, which, at his insistence, reads "After Marcel Duchamp's The Large Glass in the Philadelphia Museum of Art, supervised by Jasper Johns," does not acknowledge how instrumental he was in the project. As the Merce Cunningham Dance Company's artistic advisor from 1967 to 1978, Johns arranged for sets to be produced by other artists, and sometimes designed costumes. This is the only set he made himself. See Bernstein, *Jasper Johns' Paintings and Sculptures*, pp. 67–68. See also the interview "Jasper Johns," in *Merce Cunningham*, ed. James Klosty (New York: E. P. Dutton & Co., Inc., 1975), pp. 85–86; and Francis, "'If Art Is Not Art, Then What Is It?,'" in *Dancers on a Plane: Cage, Cunningham, Johns* (London: Anthony d'Offay Gallery, 1989), pp. 30–31.

31. In the 1960s and 1970s, works inspired by *L.H.O.O.Q.* were among the most obvious and widespread manifestations of Duchamp's impact. Especially after the art world's rediscovery of Duchamp in the late 1950s, many artists followed his lead in altering a reproduction of Leonardo's masterpiece. Johns first used a Mona Lisa reproduction as a small collage element in a *Figure 2* painting of 1962. For the lithographs of 1968–69, he ironed a decal of the Mona Lisa onto the lithograph stone, a process in line with his interest in imprinting images. Interviewed in 1969, Johns remarked,

"The Mona Lisa is one of my favorite paintings, and da Vinci is one of my favorite artists. Duchamp is also one of my favorite artists, and he painted a mustache on a reproduction of the Mona Lisa. Also just before I came to work at Gemini someone gave me some iron-on decal 'Mona Lisas' which you would get from sending in something like bubblegum wrappers and a quarter. With the decals all one has to do is iron the decal on cloth and one makes his own 'Mona Lisa.' I had some of these decals when I came to Gemini, and I thought I would use the Mona Lisa decal because I like introducing things that have their own quality and are not influenced by one's handling of them." Johns, quoted in Joseph E. Young, "Jasper Johns: An Appraisal," *Art International* 13 no. 7 (September 1969): 53. Lil Picard, in "Jasper Johns," *Das Kunstwerk* 17 no. 5 (November 1963), which this author read in an unpublished translation in the Leo Castelli Archives, notes seeing a print of Duchamp's "famous Mona Lisa parody" hanging on Johns's studio wall.

32. On the adjacent page of the 1960 translation is another list of litanies (also crossed out, but more faintly). This may be Duchamp's revision of the list Johns used in his drawing.

33. Johns probably acquired *Female Fig Leaf* in Paris in June–July 1961, when an exhibition of his was held at the Galerie Rive Droite, which that year also issued Duchamp's bronze *Female Fig Leaf* sculptures in an edition of ten. In 1977, Johns acquired the original galvanized-plaster *Female Fig Leaf* from 1950. Fred Orton, in *Figuring Jasper Johns* (Cambridge, Mass.: Harvard University Press, 1994), pp. 60–61, has discussed the metonymic function of *Female Fig Leaf* in *No*—as a reference to access, to a particular object of desire (female genitalia), and to circumstances surrounding Johns's acquisition of the bronze version of the work. Johns's collection also contains related erotic sculptures by Duchamp: *Objet-Dard*, 1962, and *Wedge of Chastity*, 1963, both of which he acquired in the 1960s.

34. In his *Scrap* review Johns mentions Duchamp's proposal for a reciprocal readymade, "Use a Rembrandt as an ironing board," as an example of Duchamp's "mind slapping at thoughtless values." Another reference may be to Man Ray's Duchamp-inspired readymade *Gift/Cadeau*, 1921, a replica of which Johns owns.

35. Many studies have compared Johns's *According to What* to Duchamp's *Tu m'*. See John Tancock, "The Influence of Marcel Duchamp," in Anne d'Harnoncourt and Kynaston McShine, eds., *Marcel Duchamp*, exh. cat. (New York: The Museum of Modern Art, and Philadelphia: Philadelphia Museum of Art, 1973), pp. 165–66; Barbara Rose, "Decoys and Doubles: Jasper Johns and the Modernist Mind," *Arts* 50 no. 9 (May 1976): 68–73; and Francis M. Naumann, *Jasper Johns: According to What & Watchman*, exh. cat. (New York: Gagosian Gallery, 1992).

36. Arturo Schwarz, in *The Complete Works of Marcel Duchamp* (New York: Harry N. Abrams, Inc., 1969), p. 531, notes that *Locking Spoon* was on the door of the apartment at 327 East 58th Street that Duchamp occupied until 1960. See James Cuno, "Jasper Johns," *Print Quarterly* 4 no. 1 (March 1987): 91.

37. Richard Shiff, "Anamorphosis: Jasper Johns," in *Foirades/Fizzles: Echo and Allusion in the Art of Jasper Johns*, p. 151. In making his point about the indexicality of the Duchamp self-portrait, Shiff assumes the profile was traced from a shadow. It is more likely, however, that it was traced from a photograph. Johns, in a conversation with the author on March 9, 1996, also assumed it was traced from a photograph.

38. Duchamp originally produced *Self-Portrait in Profile* as an edition to be included in numbered copies of Robert Lebel's monograph *Sur Marcel Duchamp* (Paris and London: Éditions Trianon; New York: Grove Press; and Cologne: DuMont Schauberg Verlag, 1959). Johns owns a 1959 serigraph edition of the work (8/40), made to celebrate the publication of Lebel's book. *Self-Portrait in Profile* was reproduced in several publications and on a second poster closer to the date of *According to What*. A full-scale replica of the original was also published in twenty-five numbered copies of Ulf Linde's *Marcel Duchamp* (Stockholm: Galerie Buren, 1963), and a color reproduction appeared in Schwarz's *Marcel Duchamp readymades, etc. (1913–1964)* (Milan: Galleria Schwarz, and Paris: Le Terrain vague, 1964), both also owned by Johns. See Schwarz, *The Complete Works of Marcel Duchamp*.

39. Johns, quoted in John Coplans, "Fragments according to Johns: An Interview with Jasper Johns," *The Print Collector's Newsletter* 3 no. 2 (May–June 1972): 30. Johns outlined his plans for this project in one of his "Sketchbook Notes" from the early 1960s: "Profile? Duchamp (?) Distorted as a shadow? Perhaps on falling hinged section." See Johns, "Sketchbook Notes," *Art and Literature* (Lausanne) 4 (Spring 1965): 185. Johns mentioned the title *Myself Torn to Pieces*, he recently explained, because he believed that the title of this work was *Marcel déchiravit*, and that the English translation of this phrase was *"Myself"* or *"Marcel Torn to Pieces"*. Johns, in conversation with the author, March 9, 1996.

40. Johns, "Marcel Duchamp (1887–1968): An Appreciation," *Artforum* 7 no. 3 (November 1968): 6.

41. Johns, quoted in Coplans, p. 41.

42. Johns, quoted in Bryan Robertson and Tim Marlow, "The Private World of Jasper Johns," *Tate: The Art Magazine* issue 1 (Winter 1993): 42.

43. Johns, quoted in Dodie Kazanjian, "Cube Roots," *Vogue* no. 179 (September 1989): 729.

44. Johns derived the flagstone motif, which he first used in *Harlem Light*, 1967, from a painted wall that he saw while driving through Harlem on his way to the airport. When he returned to photograph the wall so that he could copy it, he could not find it, and assumed it had been demolished. See Bernstein, *Jasper Johns' Paintings and Sculptures*, pp. 128–29.

45. Roni Feinstein has discussed the connections of *Untitled*, 1972, to Duchamp's *Étant Donnés*, and also to his *Large Glass*; see her "Jasper Johns's *Untitled* (1972) and Marcel Duchamp's *Bride*," *Arts* 57 no. 1 (September 1982): 86–93.

46. In a conversation with the author on November 11, 1995, Johns said he was not alluding to any specific art reference.

47. See Bernstein, "An Interview with Jasper Johns," in *Fragments: Incompletion and Discontinuity*, ed. Lawrence D. Kritzman, *New York Literary Forum* vol. 8–9 (1981): 287.

48. See Suzi Gablik, *Magritte* (Greenwich, Conn.: New York Graphic Society, Ltd., 1970), pp. 94–95. Johns visited the 1965 retrospective of Magritte's work at The Museum of Modern Art, New York, and soon after that began acquiring works by Magritte for his collection (see figs. 45, 47, 48). There were Magritte exhibitions at the Byron Gallery, New York, in 1968, and at the Tate Gallery, London, in 1969; Johns owns the catalogues for these and other Magritte exhibitions.

49. Johns acquired his *Interpretation of Dreams* in 1965, the year of the Magritte retrospective at The Museum of Modern Art (Jasper Johns Archives). In this painting (similar to the other works in the series except that the words are in English rather than French), three of the four words bear no connection to the objects they label. Johns, on the other hand, always labels his objects with words associated with them, underscoring the presence of the object itself, or of an imprint or tracing from the object.

50. Thomas B. Hess, "On the Scent of Jasper Johns," *New York* 9 no. 6 (February 9, 1976): 66. Hess was the first to point out the connection between Johns and the Exquisite Corpse game. The name itself comes from a collective poem, the result of one of these games, that yielded the following phrase: "The exquisite corpse—shall drink the young—wine." See Crichton, p. 58.

51. See Crichton, p. 58.

52. See Riva Castleman, *Jasper Johns: A Print Retrospective* (New York: The Museum of Modern Art, 1986), p. 45.

53. Johns, quoted in Stevens with McGuigan, pp. 73 and 77.

54. Johns, quoted in Glueck, p. 31.

55. The goblet/faces display Johns used as a model for the Picasso prints is called a "figure-ground reversal," and is found in studies on the psychology of perception. First used by Danish psychologist Edgar Rubin around 1920, such figures have come to be known as "Rubin's figures." Johns most likely encountered them in books on perception that he read during the 1960s and 1970s, including James J. Gibson, *The Senses Considered as Perceptual Systems* (Boston: Houghton Mifflin, 1966), and R. L. Gregory, *Eye and Brain: The Psychology of Seeing* (London: Weidenfield and Nicolson, 1966) and *The Intelligent Eye* (New York: McGraw-Hill, 1970).

56. Johns, in conversation with the author, November 12, 1995. Both Francis, in *Jasper Johns*, p. 90, and Mark Rosenthal, in *Jasper Johns: Work since 1974* (Philadelphia: Philadelphia Museum of Art, and New York: Thames and Hudson, Inc., 1988), pp. 27–28, detect figures in the cross-hatching patterns of *Weeping Women*. Krauss, in "Jasper Johns: The Functions of Irony," *October* 2 (Summer 1976): 96–97, suggests that *Weeping Women* refers to proto-Cubist works of Picasso's that explore figures "by means of a crude and insistent hatching by which Picasso declared that the language for depicting depth was to be the major problematic of a modern style." She writes that Johns is also evoking later works of Picasso's in which "broad and violent hatching" is used to "far more psychologically expressive ends than in the early standing nudes."

57. Francis, *Jasper Johns*, p. 90, says the iron impressions are reminiscent of the breasts in Picasso's *Woman Seated in an Armchair*, 1913, which Johns saw in the collection of his friends the Ganzes; he sees the paint-can marks in the right panel as breasts. Mark Rosenthal, in *Jasper Johns: Work since 1974*, p. 29, notes Johns's remark that while he was working on the painting he was struck by its connection to Edgar Degas's laundresses. Cuno sees an allusion to Picasso's *Woman Ironing*, 1904; see his "Voices and Mirrors/Echoes and Allusions: Jasper Johns's *Untitled*, 1972," in *Foirades/Fizzles: Echo and Allusion in the Art of Jasper Johns*, p. 104.

58. Judi Freeman, *Picasso and the Weeping Women: The Years of Marie-Thérèse Walter & Dora Maar*, exh. cat. (Los Angeles: Los Angeles County Museum of Art, 1994), p. 18.

59. See ibid., p. 14. The series is thoroughly illustrated and discussed in Freeman's catalogue. Its figures have qualities attributable to the women in Picasso's life at the time—Marie-Thérèse Walter, Dora Maar, and his estranged wife, Olga Koklova.

60. See Crichton, p. 63. Johns's interest in Munch dates to an exhibition he saw at The Museum of Modern Art, New York, in 1950. Johns, in conversation with the author, March 9, 1996.

61. See Ragna Stang, "The Aging Munch: New Creative Power," trans. Solfrid Johansen, and Arne Eggum, "Munch's Self-Portraits," trans. Erik J. Friis, both in *Edvard Munch: Symbols and Images*, exh. cat., with an introduction by Robert Rosenblum (Washington, D.C.: National Gallery of Art, 1978).

62. Johns, quoted in Peter Fuller, "Jasper Johns Interviewed Part II," *Art Monthly* no. 19 (September 1978): 7. The full quotation reads: "In my early work, I tried to hide my person-

ality, my psychological state, my emotions. That was partly due to my feelings about myself and about painting at the time. I sort of stuck to my guns for awhile but eventually it seemed like a losing battle. Finally one must simply drop the reserve. I think some of the changes in my work relate to that."

63. See Eggum, "Munch's Self-Portraits," and Trygve Nergaard, "Despair," trans. Einar Petterson, in *Edvard Munch: Symbols and Images*, pp. 20 and 135 respectively.

Richard S. Field, who has written extensively on Johns's prints, informed me in a recent conversation that he had included an early Johns lithograph, *Skin with O'Hara Poem*, 1963–65, and Munch's *Self-Portrait* in an exhibition called "Images of Death," held at the Davison Art Center, Wesleyan University, Middletown, Conn., in 1975. In his catalogue essay for that exhibition, Field places both prints in a section titled "Fear of Death," grouping them with other works in which artists' self-portraits also contain skulls or other emblems of death, and discussing these images in terms of the dread of the artist's own death and "the loss of his power to create." See Field, *Images of Death*, exh. cat. (Middletown, Conn.: Davison Art Center, Wesleyan University, 1975), p. 16. Field remembers discussing the Munch print with Johns at the time.

64. See Judith Goldman, *Jasper Johns: 17 Monotypes*, exh. cat. (New York: Whitney Museum of American Art, and West Islip, N.Y.: Universal Limited Art Editions, 1982), n.p. Goldman suggests that Johns's *Weeping Women* refers to Munch's 1906 painting *Weeping Woman* as well as to Picasso's etching of 1937. She also notes that the spermatozoal shapes from Munch's lithograph *Madonna*, 1895, appear in monotypes nine and eleven in her catalogue.

65. Caption for the reproduction of the adjacent plate of a painting on the same theme as *The Mystical Form of Samvara* in Ajit Mookerjee, *Tantra Art: Its Philosophy and Physics* (New Delhi, New York, and Paris: Kumar Gallery, 1966, reprint ed. Basel: R. Kumar, 1971), p. 30. It was in this book that Johns found the reproduction of the painting that he used in his works. See Rosenthal and Fine, pp. 255–56. Mark Rosenthal, in *Jasper Johns: Work since 1974*, p. 44, writes that for Johns, the sexual union of the deities shown in this image represents "the interpenetration of constructive and destructive forces." Robert A. F. Thurman, in "Wisdom and Compassion: The Heart of Tibetan Culture," in Marilin M. Rhie and Thurman, *Wisdom and Compassion: The Sacred Art of Tibet*, exh. cat. (San Francisco: Asian Art Museum of San Francisco, and New York: Tibet House, in association with Harry N. Abrams, Inc., 1991), p. 17, discusses the variations on this image, found in many examples of tantric art, as showing the Buddha "in father-mother union form, in an aspect that is electrifyingly physical." He goes on to write, "The

father-mother union is a manifestation of the Buddha's highest spiritual essence, of enlightenment as the union of wisdom and compassion. More than metaphorical, to the devout Tibetan, this image is concrete evidence of the existence of great spiritual attainment."

66. The details and sources of *Cicada* are thoroughly discussed in Rosenthal and Fine, pp. 247–48. See also Orton, pp. 164–65.

67. For a complete description of these works and a discussion of their relationship to Cunningham, see Rose, "Jasper Johns: The *Tantric Details*," *American Art* 7 no. 4 (Fall 1993): 47–71. See also *The Tate Gallery 1980–82: Illustrated Catalogue of Acquisitions* (London: The Tate Gallery, 1984), pp. 145–46.

68. Johns, quoted in *The Tate Gallery 1980–82*, p. 146. See also Fine and Rosenthal, pp. 81 and 82. In the literature on Tibetan art, the objects held by Samvara and his sakti are interpreted as symbolizing the triumph over ignorance and evil. See Rhie and Thurman, p. 217.

69. Rosenthal and Fine, p. 252.

70. See ibid., pp. 255–56. The skull recalls the skull imprints in Johns's works of the 1960s and 1970s, particularly the drawing *Skull*, 1971. Mark Rosenthal ties *Tantric Detail* to *In Memory of My Feelings—Frank O'Hara*, in which an overpainted skull has been revealed by X rays. See his "Dancers on a Plane and Other Stratagems for Inclusion in the Work of Jasper Johns," in *Dancers on a Plane: Cage, Cunningham, Johns*, p. 129.

71. See Mark Rosenthal, *Jasper Johns: Work since 1974*, p. 48.

72. Mark Rosenthal, "Dancers on a Plane and Other Stratagems for Inclusion in the Work of Jasper Johns," p. 129.

73. Johns, quoted in Ann Hindry, "Conversation with Jasper Johns/*Conversation avec Jasper Johns*" (in English and French), *Artstudio* no. 12 (Spring 1989): 14.

74. See Ruth Mellinkoff, *The Devil at Isenheim: Reflections on Popular Beliefs in Grünewald's Isenheim Altarpiece* (Berkeley: University of California Press, 1988).

75. See Jill Johnston, "Tracking the Shadow," *Art in America* 75 no. 10 (October 1987): 132. Johns's first work after Grünewald was a 1981 ink-on-plastic tracing of a detail from the *Crucifixion* showing John holding the Virgin Mary. He dedicated the drawing to the art dealer and publisher Wolfgang Wittrock, who had sent him a book of Grünewald reproductions, Ostar Hagen's *Grünewalds Isenheimer Altar in neun und vierzig Aufnahmen* (Munich, 1919). See Rosenthal and Fine, p. 45 (note 37) and p. 82.

76. Johns, quoted in Fine and Rosenthal, p. 75.

77. Johns, quoted in Crichton, p. 64. In an interview in 1993, Johns said, "I was attracted to the qualities conveyed by the delineation of the forms [in Grünewald's paintings] and I

wanted to see if this might be freed from the narrative. I hoped to bypass the expressiveness of the imagery, yet to retain the expressiveness of the structure. In some tracings this seemed to happen, but not in others." Johns, quoted in Robertson and Marlow, p. 43.

78. Andrée Hayum, *The Isenheim Altarpiece: God's Medicine and the Painter's Vision* (Princeton: Princeton University Press, 1989), p. 40. See also Nan Rosenthal, "Drawing as Rereading," pp. 37–38. Grünewald depicts the soldiers in a state of unconsciousness. They react physically to the trembling of the earth that occurs simultaneously with the Resurrection, and seem to be responding psychically to the Resurrection itself, even though, according to Scripture, they did not actually witness it. John Yau, in "Target Jasper Johns," *Artforum* 24 no. 4 (December 1985): 85, links the soldiers to the "watchman" mentioned in a well-known passage of Johns's "Sketchbook Notes" relating to the painting *Watchman*, 1964 (plate 108). He writes of the soldiers, "They represent the watchman fallen 'into' the trap of looking. When they wake up they will take no information away." In Robertson and Marlow, p. 43, Johns describes these figures as having "collapsed in awe."

79. See Hayum, pp. 108–11, for a discussion of the "range and force of the gestural repertory" in the Isenheim Altarpiece.

80. Cage, quoted in Calvin Tomkins, *The Bride and the Bachelors: Five Masters of the Avant-Garde*, 1965 (reprint ed. Hamondsworth and New York: Penguin Books, 1981), p. 97. Francis says that Cage's *Perilous Night* is meant to tell a story of the dangers of the erotic life and of the misery of "something that was together that is split apart"; see his "'If Art Is Not Art, Then What Is It?,'" p. 26. See also David Revill, *The Roaring Silence. John Cage: A Life* (New York: Arcade Publishing, 1992), p. 85.

81. In Grünewald's time the cause of Saint Anthony's fire was unknown; in 1597 the disease was found to be alimentary in origin, stemming from the consumption of rye affected by the ergot fungus. See Hayum, pp. 20–21. Some interpreters see the figure in *The Temptation of Saint Anthony* not as a demon but as a human suffering from Saint Anthony's fire; see Joris-Karl Huysmans, *Grünewald* (New York: E. P. Dutton, 1976), p. 9.

82. Hayum, p. 148.

83. Johns, quoted in Fine and Rosenthal, p. 82. In the same book, p. 40, Nan Rosenthal mentions the demon's relation to AIDS, specifically citing a drawing Johns did in 1988 for an auction held to benefit the Supportive Care Program of St. Vincent's Hospital and Medical Center, New York, in May of that year.

84. Johnston, "Tracking the Shadow," p. 142.

85. Douglas Crimp, "The Photographic Activity of Postmodernism," *October* 15 (Winter 1980): 94. See also Harold Rosenberg, "The Mona Lisa without a Mustache: Art in

the Media Age," *Artnews* 75 no. 5 (May 1976): 47–54.

86. Johns, quoted in Fine and Rosenthal, p. 77.

87. W. E. Hill's image was first published as an illustration in the English humor magazine *Puck* (London) no. 78 (November 6, 1915): 11, with the caption, "My wife and my mother in law/They are both in this picture—find them." Johns most likely saw it in books on the psychology of perception. It is reproduced, for example, in Gregory's *Intelligent Eye*, which notes that it was first used as an example of a perceptually ambiguous figure by the American psychologist E. G. Boring. Like the original caption of Hill's image, Gregory's description relies on stereotypes: "It looks sometimes like a charming young girl, sometimes like a frightening old woman; looking completely different in the alternative perceptions. As a young lady she is in profile, the lashes of one eye showing at her cheek. She wears a black band around her neck. As an old lady, the chin becomes a hideous huge nose; the black band around the charming neck becomes the cruel mouth of a hag" (pp. 38–39). See Nan Rosenthal, p. 33, and Rosenthal and Fine, p. 294.

88. See Francis, *Jasper Johns*, p. 106. For a detailed description and discussion of *Ventriloquist* see also Nan Rosenthal, p. 44 (note 9).

89. *Untitled*, 1961, is one of three lithographs Barnett Newman did that year at the Pratt Graphic Art Center, New York. See Hugh M. Davies with an essay by Castleman, *The Prints of Barnett Newman* (New York: The Barnett Newman Foundation, 1983). Johns owns other prints and drawings by Newman. His use of the 1961 lithograph acknowledges the two artists' shared experience of working at Tatyana Grosman's Universal Limited Art Editions workshop, West Islip, New York, during the 1960s. Johns owned this Newman print at least as early as 1967, when this author saw it in his Riverside Drive apartment. Bernstein, unpublished journal entry, May 1, 1967.

90. Art dealer Ileana Sonnabend gave Johns the reproduction. Johns has said he did not see Peto's *Cup We All Race 4* in person at the time, nor did he see other Peto works. Johns, in conversation with the author, November 11, 1995.

91. See John Wilmerding, *Important Information Inside: John F. Peto and the Idea of Still Life Painting in Nineteenth Century America*, exh. cat. (Washington, D.C.: National Gallery of Art, 1983), pp. 217–19 and 158–59. Johns's interest in Peto at the time of *Ventriloquist* may have been revived when he saw this exhibition at the National Gallery. Other discussions of the relationship between Peto's and Johns's work include Yau's interesting observations in "Target Jasper Johns," pp. 81 and 83.

92. See Garth Clark, Robert A. Ellison, Jr., and Eugene Hecht, *The Mad Potter of Biloxi:*

The Art & Life of George E. Ohr (New York: Abbeville Press, Inc., 1989). Johns presently owns twenty-eight pieces by Ohr (Jasper Johns Archives).

93. Johns, quoted in Hindry, p. 14.

94. Johns, quoted in Robert Saltonstall Mattison, *Masterworks in the Robert and Jane Meyerhoff Collection: Jasper Johns, Robert Rauschenberg, Roy Lichtenstein, Ellsworth Kelly, Frank Stella* (New York: Hudson Hills Press, 1995), p. 30.

95. The image comes from an edition of Melville's novel published by The Arion Press, San Francisco, in 1979. After Johns used the book illustration in making *Ventriloquist*, he acquired a copy of the engraving itself.

96. See Mark Rosenthal, *Jasper Johns: Work since 1974*, pp. 96 and 107 (note 79).

97. Paul Cézanne, quoted in, e.g., Herschel B. Chipp, ed., *Theories of Modern Art* (Berkeley: University of California Press, 1971), p. 19. See also Bernstein, "Jasper Johns's The Seasons: Records of Time," *Jasper Johns: The Seasons*, exh. cat. (New York: Brooke Alexander Editions, 1991), p. 13 (note 7).

98. Castleman, *Seven Master Print-Makers: Innovations in the Eighties*, exh. cat. (New York: The Museum of Modern Art, 1991), p. 87.

99. David Douglas Duncan, *Picasso's Picassos* (New York: Harpers & Brothers and Ballantine Books, 1968).

100. Ibid., p. 67.

101. Ibid., p. 145. Johns had also seen *The Shadow* in the exhibition "Picasso: Oeuvres réçues," at the Grand Palais, Paris, in 1979–80. See Mark Rosenthal, *Jasper Johns: Works since 1974*, p. 107 (note 61). Marie-Laure Bernadac, in *Picasso Museum Paris: The Masterpieces* (Munich: Prestel, 1991), writes that in *The Shadow* Picasso presents himself as a shadow looking at a nude woman, who could be an "imaginary model" or his lover Françoise (p. 180). See also Steinberg, "Picasso's Sleepwatchers," in *Other Criteria*, which reproduces the two versions of this Picasso painting, done the same day, under the title *The Artist's Bedroom*.

102. Johns, quoted in Crichton, p. 68.

103. Both Rose, in "Jasper Johns: The Seasons," *Vogue* no. 177 (January 1987): 259, and Mark Rosenthal, in *Jasper Johns: Work since 1974*, p. 107 (note 74), make the association between Johns's sea horse and Picasso's horse in *Minotaur Moving His House*.

104. See Cuno, "Reading the Seasons," in *Jasper Johns: Printed Symbols* (Minneapolis: Walker Art Center, 1990), pp. 83–89. The fact that the four seasons are important subjects of Asian art was of interest to Johns in suggesting a broad, universal scope. Another important precedent was Cage's composition *The Seasons*, 1945, the concept of which is based on the cycles posited in Indian philosophy: "spring symbolizing creation; summer, preservation; fall, destruction; and winter, quiescence." See Tomkins, p. 105.

105. See Bernstein, "'Winter' by Jasper Johns," *Sotheby's Preview* 7 no. 6 (November 1995): 12–14.

106. Johns, quoted in Fine and Rosenthal, p. 76.

107. Mattison also mentions Magritte's *False Mirror*, 1929, and, discussing the relationship of Johns's face image to features of color and view in Saint Martin, calls it a "Seascape/Face." See Mattison, p. 38 and pp. 36–37 respectively. Johns has said that the face can be a landscape as well as a seascape, and notes that he made his first image of it not in Saint Martin but in Stony Point. Johns, in conversation with the author, November 12, 1995.

108. Bernadac, p. 136. *Woman in Straw Hat* was included in the 1980 Picasso retrospective at The Museum of Modern Art, and was reproduced in the catalogue in black and white under the title *Lady in a Straw Hat*. Johns has said he does not remember seeing it in that exhibition, and that it first came to his attention in Duncan's book. Johns, in conversation with the author, November 12, 1995.

109. Johns, quoted in Amei Wallach, "Jasper Johns: On Target," *Elle* (New York), November 1988, p. 154. In conversation with the author on May 21, 1996, Johns revised this quotation to agree more closely with his intention.

110. Johns, quoted in Crichton, p. 70. Johns's first use of the face was in an untitled drawing of 1984. See Rosenthal and Fine, p. 298.

111. Johns, in conversation with the author, November 12, 1995.

112. In each work in which the watch appears, Johns shows it in the same style, changing only the color of the watchband. Watches recur in his paintings, and may perhaps be connected to one of the few stories he has told about his childhood. When he was about five years old, he has said, he was told that he could have his father's watch when he grew up. Soon after, deciding that he *had* grown up, he went to his father's house (his parents had divorced, and lived apart) and took the watch. When Johns's father found out he was angry and took the watch back (see Crichton, p. 20). Johns had said that he never thought of this when he painted the watch in these pictures (see Wallach, p. 154). Yet the possible unconscious association between the watches in his painting and this story is noteworthy, especially given the turn his work takes at this point toward using childhood memories as sources of imagery. Johnston, in "Trafficking with X," *Art in America* 79 no. 3 (March 1991): 164, links the presence of the watch in these works to the fact that when Johns produced them he was approaching the age his father had reached when he died.

113. Johns, quoted in Wallach, p. 154. See also Crichton, pp. 71–72.

114. Johns has said that the child's drawing was in the back of his mind from the very first. Although he did not remember that it had been

reproduced to illustrate an article by Bruno Bettelheim, he decided to track it down shortly after he read Bettelheim's obituary. Johns, in conversation with the author, November 11, 1995. The article is Bettelheim, "Schizophrenic Art: A Case Study," *Scientific American* vol. 186 (April 1952): 31–34. See also Crichton, p. 71, and Jonathan Fineberg, *Mit dem Auge des Kindes: Kinderzeichnung und moderne Kunst*, exh. cat. (Munich: Leinbachhaus, Kunstbau, and Bern: Kunstmuseum, Verlag Gerd Hatje, 1995), pp. 229 and 232–34.

115. Bettelheim, p. 34.

116. See Johnston, "Trafficking with X," p. 110.

117. See ibid., p. 164, where Johns says that he was impressed with these paintings but wished they didn't have Christ's face; Johnston reproduces Zurbarán's 1658 painting from the Museo Nacional de Escultura in Valladolid. See also Jeannine Baticle, *Zurbarán*, exh. cat. (New York: Metropolitan Museum of Art, distributed by Harry N. Abrams, Inc., 1987), cat. nos. 54 and 65. The imprinted faces in the Zurbarán paintings recall Johns's *Study for Skin I–IV*, 1962 (plates 91–94). Given the iconic power of the women's faces in Johns's work from this period, he may have been interested in the idea of Veronica's veil as the venerated *veron ikon*—"true image" in Greek (see Baticle, p. 273)—even as he disavowed any interest in Zurbarán's religious subject matter.

Another trigger for the image of the hanging cloths in the *Untitled* of 1987 was Duchamp's "3 Draft Pistons," which appear in *The Large Glass* within the painted cloud—the "Cinematic Blossoming"—at the work's top (fig. 29). To determine the shapes of these three transparent squares, Duchamp used a chance procedure: he hung a piece of cloth, one meter square, above a radiator and photographed it at different times as it moved in the warm-air currents. Johns, in an unrecorded conversation with the author.

118. Johns, quoted in Wallach, p. 154.

119. See Rosenthal and Fine, pp. 40 and 300, and Johnston, "Trafficking with X," p. 165 (note 6). This is the drawing that was done for "Contemporary Art: A Benefit Auction for the Supportive Care Program of St. Vincent's Hospital and Medical Center of New York," held at Sotheby's, New York, in May 1988. In 1990, the drawing was reproduced as a poster for another AIDS benefit.

120. Johns had done a single tracing from Villon's print in 1978. For the 1986 untitled tracings, he used a book reproduction of Duchamp's *Bride* to revise the Villon tracing with free-hand additions. Johns, in conversation with the author, November 12, 1995. According to Rosenthal and Fine, pp. 274–77, Johns's tracings after *The Bride* were made to be used as the bases for gravure illustrations in a series of books of John Cage's mesostics, *The First Meeting of the Satie Society*, published by Osiris Editions, New York.

121. A relevant example is Mike Bidlo's series of eighty paintings, collectively titled *Picasso's Women, 1907–71*, copied from reproductions in art books. These were exhibited at the Leo Castelli Gallery in 1988, the date of Johns's drawing and of other works using Picasso's *Woman in Straw Hat*. Bidlo did handmade facsimiles of works by other modernist masters, including Johns, that fit with the postmodernist rejection of the concept of originality and individual style.

122. See Johnston, "Trafficking with X," pp. 107 and 165.

123. Johnston, in ibid., p. 165, mentions that "Green Angel" is written on the back of an untitled drawing of 1990, in watercolor, charcoal, and pencil. This is one of twelve drawings Johns did for a calendar published by the Anthony D'Offay Gallery, London, in 1991, several of which use tracings from the same unidentified image. The one with "Green Angel" written on the back is used for the December calendar page. See *Jasper Johns: A Calendar for 1991* (London: Anthony D'Offay Gallery, 1990).

124. Johns, quoted in Johnston, "Trafficking with X," pp. 108–109. Johnston links "X" to Johns's need for privacy, and to his response to the art community's curiosity about his work. See also Wallach, p. 154, Crichton, p. 72, and Barbaralee Diamonstein, *Inside the Art World: Conversations with Barbaralee Diamonstein* (New York: Rizzoli International Publications, Inc., 1994), p. 119.

125. The title of Nan Rosenthal's essay in Rosenthal and Fine, *The Drawings of Jasper Johns*, is "Drawing as Rereading." Rosenthal uses the word "rereading" to emphasize that Johns's drawings are "varied interpretations" of his own paintings (p. 43). The term is useful in understanding his interpretations of images taken from other artists as well.

126. Johns had seen *Portrait of a Young Nobleman Holding a Lemur* in the exhibition "Zeichnungen Hans Holbein d.J. aus der Sammlung I.M. Königin Elizabeth II in Windsor Castle und aus der Öffentlichen Kunstsammlung Basel," held at the Kunstmuseum Basel in June–September 1988. For information on this work, see Christian Muller, *Hans Holbein d.j.: Zeichnungen aus dem Kupferstichkabinett der Öffentlichen Kunstsammlung Basel*, exh. cat. (Basel: Kunstmuseum Basel, 1988). The traditional identification of the sitter as Edward, the Prince of Wales in the mid-sixteenth century, is no longer accepted, and the sitter's identity and even nationality remain unknown. See Kate Ganz, *Heads and Portraits: Drawings from Piero Di Cosimo to Jasper Johns*, exh. cat. (New York: Kate Ganz, Ltd., 1993), pp. 78–80.

127. See Crichton, p. 72. The present author saw the poster in Johns's townhouse on several occasions in 1989–90.

128. Johns, in an unrecorded conversation with the author.

129. Johns, quoted in Fine and Rosenthal, p. 79.

130. Joseph J. Rishel, *Great French Paintings from the Barnes Foundation: From Cézanne to Matisse*, exh. cat. (New York: Alfred A. Knopf, in association with Lincoln University Press, Philadelphia Museum of Art Edition, 1995), p. 162. The title of *Nudes in Landscape*, and the date for it that I have used here, come from this catalogue; the work is also known as *The Large Bathers*.

131. Johns has said that although this idea only came to him in the process of making the tracings, once he had made the interpretation he saw it easily in the poster reproduction. Having viewed the painting again in 1995, when the Barnes exhibition was installed at the Philadelphia Museum of Art, he felt that nothing he saw in the painting itself contradicted his interpretation. Johns, in conversation with the author, November 12, 1995.

132. Reff, "Cézanne's Late Bather Paintings," *Arts* 52 no. 2 (October 1977): 119. Reff notes that some of the bathers in *Nudes in Landscape* are "overtly sensual in posture," but he does not discuss the ambiguous sexuality of the figure leaning against the tree.

133. Johns, quoted in Glueck, p. 87.

134. Johns, in conversation with the author, November 12, 1995.

135. Krumrine, p. 33.

136. Ibid., p. 208. Rishel discusses the changes Cézanne makes in this figure, including the Brancusi-like abstraction of the neck and head, but does not speculate that it was a male figure. He identifies the figure leaning against the tree as female, "her gender emphasized by black sketched lines on her belly and her thigh" (p. 162).

137. Ibid., p. 210. Krumrine does not point out that in abstracting the striding figure, Cézanne created a phallus from its breast, neck, and featureless head.

138. Ibid., p. 241.

139. Johns acquired *Self-Portrait* in September 1995 (Jasper Johns Archives).

140. Johns, quoted in Hindry, p. 13.

141. See Mattison, p. 46.

142. See Hess, *Barnett Newman* (New York: The Museum of Modern Art, 1971), p. 97, and Brenda Richardson, *Barnett Newman: The Complete Drawings 1944–1969* (Baltimore: The Baltimore Museum of Art, 1979), p. 158.

143. See Mark Rosenthal, "Interview with Jasper Johns," in *Artists at Gemini G.E.L.: Celebrating the 25th Year*, exh. cat. (New York: Harry N. Abrams, Inc., in association with Gemini G.E.L., Los Angeles, 1993), p. 63. When asked in this interview about the connection between Grünewald and Newman, Johns replies, "One thing that's interesting about art—about painting—is that we accept so many different kinds of things as painting. And certainly these seem superficially to suggest two poles."

144. See Bernstein, "Jasper Johns's The Seasons: Records of Time," pp. 9–13.

145. The book in which Johns first saw *The Fall of Icarus* was Arianna Stassinopoulos Huffington, *Picasso: Creator and Destroyer* (reprint ed. New York: Avon Books, 1989; first published by Simon & Schuster, New York, in 1988). Johns, in conversation with the author, November 12, 1995. The book reproduces a detail of the work (commissioned for UNESCO's delegates' lounge in the fall of 1957) with the caption, "Picasso beneath the Fall of Icarus, the despairing mural he created in 1958 for the headquarters of UNESCO, an organization dedicated to hope. Was it, many wondered during the unveiling, a masterpiece or a giant doodle?" See also ibid., pp. 422–23.

146. Jane Fluegel, "Chronology," in William Rubin, ed., *Pablo Picasso: A Retrospective* (New York: The Museum of Modern Art, 1980), p. 418.

147. Jean S. Boggs, "The Last Thirty Years," in Roland Penrose, ed., *Picasso in Retrospect* (New York: Praeger, 1973), pp. 213–14. Mary Mathews Gedo, in *Picasso: Art as Autobiography* (Chicago: University of Chicago Press, 1980), reads *The Fall of Icarus* as a pessimistic work in which Picasso is preoccupied with survival (p. 231).

148. Denis Hollier has argued that Picasso's Icarus represents the artist facing the canvas in isolation and anxiety. He makes the point that "Icarus is born of the fusion of the figures of the painter and the diver, as part of the allegorical identification of the diving board and the canvas, both instruments of a leap into the void." Hollier, "*Portrait de l'artiste en son absence (Le peintre sans son modèle)*," *Les Cahiers du Musée national d'art moderne* no. 30 (Paris: Centre Georges Pompidou, Winter 1989): 19. I thank Kirk Varnedoe for pointing out to me the link from Johns to Picasso's Icarus and the Hollier article.

149. See Mattison, p. 45. Johns discusses the floor plan of his grandfather's house in Diamonstein, p. 114.

150. See, for example, Deborah Solomon, "The Unflagging Artistry of Jasper Johns," *The New York Times Magazine*, June 19, 1988, p. 23, and Diamonstein, p. 114.

151. Johns, in conversation with the author, November 12, 1995. See also Mattison, p. 46. Mark Rosenthal, in *Jasper Johns: Work since 1974*, p. 73, quotes Johns to the effect that the purple strip at the right edge of *Ventriloquist* is a "a way to suggest something real, such as a frame or mirror, that is, some aspect of a place outside the world of the painting."

152. Leonardo, in Pamela Taylor, ed., *The Notebooks of Leonardo da Vinci: A New Selection* (New York: New American Library, 1960), p. 57.

153. Ibid., pp. 58–59.

154. Johns, quoted in Mark Rosenthal, "Interview with Jasper Johns," p. 58. A friend had given Johns the Piranesi engraving in 1990.

155. See *Richard Dadd (1817–1886): A Loan Exhibition*, exh. cat., with an introduction by Patricia Allderidge (New York: Davis & Langdale Co., Inc., 1994), n.p.

156. Richard Dadd, quoted in P. Allderidge, *The Late Richard Dadd: 1817–1886* (London: The Tate Gallery, 1974), pp. 125–29.

157. Allderidge, p. 9.

158. Johns, quoted in "His Heart Belongs to Dada," *Time* 73 (May 4, 1959): 58.

159. Johns, quoted in Edmund White, "Enigmas and Double Visions," *Horizon* 20 no. 2 (October 1977): 53.

Figures 19–84 of Roberta Bernstein's essay constitute an "imaginary museum" of works she discusses by artists other than Johns. Many of these works Johns has certainly seen; some inclusions, however, are speculative. Full captions for the works appear below; the figures appear on the pages following.

Fig. 19. Leonardo da Vinci. *Human Figure in a Circle, Illustrating Proportions.* c. 1485–90 Ink on paper, c. 13 ½ x 9 ⅝″ (34.3 x 24.5 cm) Galleria dell'Accademia, Venice

Fig. 20. Leonardo da Vinci. *Deluge.* c. 1516–18 Black chalk on paper, 6 5/16 x 8 ⅛″ (16.1 x 20.7 cm) The Royal Collection © Her Majesty Queen Elizabeth II

Fig. 21. Paul Cézanne. *The Bather.* c. 1885 Oil on canvas, 50 x 38 ⅛″ (127 x 96.8 cm) The Museum of Modern Art, New York. Lillie P. Bliss Collection

Fig. 22. Paul Cézanne. *Bather with Outstretched Arms.* c. 1883 Oil on canvas, 13 x 9 7/16″ (33 x 23.9 cm) Collection Jasper Johns

Fig. 23. Paul Cézanne. *Nudes in Landscape.* 1900–1905 Oil on canvas, 52 ⅜ x 81 ½″ (133 x 207 cm) The Barnes Foundation, Merion, Pennsylvania

Fig. 24. Paul Cézanne. *Self-Portrait.* c. 1880 Pencil on paper, 12 ⅝ x 5 ¾″ (32.1 x 14.6 cm) Collection Jasper Johns

Fig. 25. Paul Cézanne. *Bathers.* 1900–1906 Oil on canvas, 51 ¼ x 76 ¾″ (130 x 195 cm) The National Gallery, London. Reproduced by courtesy of the Trustees of The National Gallery, London

Fig. 26. Paul Cézanne. *Boy with Skull.* 1896–98 Oil on canvas, 51 ¼ x 38 ¼″ (130.2 x 97.3 cm) The Barnes Foundation, Merion, Pennsylvania

Fig. 27. Paul Cézanne. *Studies for Bathers.* c. 1877–80 Pencil on paper, 4 ⅝ x 7 ¾″ (11.7 x 19.6 cm) Collection Jasper Johns

Fig. 28. Marcel Duchamp. *Coffee Mill.* 1911 Oil on cardboard, 13 x 5″ (33 x 12.7 cm) Tate Gallery, London

Fig. 29. Marcel Duchamp. *The Bride Stripped Bare by Her Bachelors, Even (The Large Glass).* 1915–23 Oil and lead wire on glass panels, 109 ¼ x 69 ⅛″ (277.5 x 175.6 cm) Philadelphia Museum of Art. Bequest of Katherine S. Dreier

Fig. 30. Page from *The Bride Stripped Bare by Her Bachelors, Even: A Typographic Version by Richard Hamilton of Marcel Duchamp's Green Box,* trans. George Heard Hamilton (New York: Wittenborn and Company, 1960)

Fig. 31. Marcel Duchamp. Replica of *L.H.O.O.Q.* 1919 Collotype hand-colored with watercolor, 7 ⅝ x 4 13/16″ (19.4 x 12.2 cm) Philadelphia Museum of Art. The Louis and Walter Arensberg Collection

Fig. 32. Marcel Duchamp. *Female Fig Leaf.* 1961 Bronze, edition of eight, 3 ¾ x 5 ½ x 5″ (9.5 x 13.9 x 12.7 cm) Collection Jasper Johns

Fig. 33. Marcel Duchamp. *Tu m'.* 1918 Oil on canvas with bottle brush, three safety pins, and one bolt, 2′ 3 ¼″ x 10′ 3″ (69.8 x 313 cm) Yale University Art Gallery, New Haven. Gift from the Estate of Katherine S. Dreier

Fig. 34. Marcel Duchamp. *The Locking Spoon.* 1957 Semireadymade of spoon fixed to a lock, 9 ⅞ x 7 ⅛″ (24 x 18 cm) Original lost. Photograph courtesy Arturo Schwarz, Milan

Fig. 35. Marcel Duchamp. *Self-Portrait in Profile.* 1958 Paper, 13 1/16 x 9 13/16″ (33.2 x 25 cm) Arturo Schwarz Collection, Milan

Fig. 36. Marcel Duchamp. Poster for exhibition at Pasadena Art Museum. 1963 34 ½ x 27″ (87.6 x 68.6 cm) Collection Jasper Johns

Fig. 37. Marcel Duchamp. *Étant Donnés: 1e La Chute d'Eau; 2e Le Gaz d'Éclairage.* 1946–66. Interior view Mixed media assemblage Philadelphia Museum of Art. Gift of the Cassandra Foundation

Fig. 38. Jacques Villon. *The Bride.* 1930 Aquatint, 19 ½ x 12 1/16″ (49.5 x 30.7 cm) Courtesy of the Fogg Art Museum. Harvard University Art Museums. Gift of Theodore Stebbins in honor of Jakob Rosenberg

Fig. 39. René Magritte. *Hall of Arms (The Shooting Gallery).* 1925/26 Oil on canvas, 30 x 24 ½″ (77 x 63 cm) Courtesy Galerie Christine et Isy Brachot, Brussels

Fig. 40. René Magritte. *The One-Night Museum.* 1927 Oil on canvas, 19 11/16 x 25 ⅜″ (50 x 64.5 cm) Courtesy Galerie Christine et Isy Brachot, Brussels

Fig. 41. René Magritte. *A Courtesan's Palace.* 1928 Oil on canvas, 21 ¼ x 28 ¾″ (54 x 73 cm) The Menil Collection, Houston

Fig. 42. René Magritte. *The Eternally Obvious.* 1930 Oil on five separately stretched and framed canvases mounted on Plexiglas. Plexiglas: 63 ¼ x 11 ½″ (160.6 x 29.2 cm) The Menil Collection, Houston

Fig. 43. René Magritte. *The Acrobat's Rest.* 1928 Oil on canvas, 21 ¼ x 28 ¾″ (54 x 73 cm) Courtesy Galerie Christine et Isy Brachot, Brussels

Fig. 44. René Magritte. *The Literal Meaning.* 1929 Oil on canvas, 28 ⅞ x 21 ½″ (73.3 x 53.3 cm) Collection Robert Rauschenberg

Fig. 45. René Magritte. *The Interpretation of Dreams.* 1935 Oil on canvas, 16 ¼ x 10 ¾″ (41.3 x 27.3 cm) Collection Jasper Johns

Fig. 46. Yves Tanguy, Joan Miró, Max Morise, and Man Ray. *Figure.* 1926–27 "Exquisite Corpse" composite drawing in pen and ink, pencil, and colored crayon on paper, 14 ¼ x 9 ⅛″ (36.2 x 22.9 cm) The Museum of Modern Art, New York. Purchase

Fig. 47. René Magritte. *The Human Condition.* 1948 Gouache on paper, 13 3/16 x 18 5/16″ (33.4 x 46.5 cm) Collection Jasper Johns

Fig. 48. René Magritte. *"Ceci n'est pas une pipe".* 1965 Ballpoint pen on paper, 6 ⅞ x 10 ⅜″ (17.4 x 26.3 cm) Collection Jasper Johns

Fig. 49. Edvard Munch. *Self-Portrait.* 1895 Lithograph, printed in black, 23 1/16 x 16 11/16″ (58.5 x 42.3 cm) The Museum of Modern Art, New York. Gift of James L. Goodwin in memory of Philip L. Goodwin

Fig. 50. Edvard Munch. *Self-Portrait between the Clock and the Bed*. 1940–42
Oil on canvas, 58 ¾ x 47 ½" (149.2 x 120.6 cm)
Munch Museum, Oslo

Fig. 51. *The Mystical Form of Samvara with seventy-four arms embracing his sakti with twelve arms*.
Nepal. Seventeenth century
Gouache on cloth, 28 x 19" (71.1 x 48.3 cm)
Formerly collection Ajit Mookerjee, present location unknown

Fig. 52. *The Mystical Form of Samvara with seventy-four arms embracing his sakti with twelve arms* (detail)

Fig. 53. Matthias Grünewald. *Resurrection*.
Panel from the Isenheim Altarpiece. c. 1512–16
Oil on panel, 98 ¼ x 36 ¼" (249 x 92 cm)
Musée d'Unterlinden, Colmar, France

Fig. 54. Matthias Grünewald. *The Temptation of Saint Anthony*. Panel from the Isenheim Altarpiece. c. 1512–16
Oil on panel, 98 ¼ x 36 ¼" (249 x 92 cm)
Musée d'Unterlinden, Colmar, France

Fig. 55. Matthias Grünewald's *Resurrection*, in a detail reproduced in Ostar Hagen, *Grünewald's Isenheimer Altar in neun und vierzig Aufnahmen* (Munich, 1919), p. 39
Collection Jasper Johns

Fig. 56. Matthias Grünewald's *Temptation of Saint Anthony*, from Ostar Hagen, *Grünewald's Isenheimer Altar in neun und vierzig Aufnahmen* (Munich, 1919), p. 44 (detail)
Collection Jasper Johns

Fig. 57. Juan Gris. *The Table*. 1914
Colored papers, printed matter, and charcoal on paper mounted on canvas, 23 ½ x 17 ½" (59.6 x 44.4 cm)
Philadelphia Museum of Art.
A. E. Gallatin Collection

Fig. 58. William Michael Harnett. *Still Life—Five Dollar Bill*. 1877
Oil on canvas, 8 x 12 ⅛" (20.3 x 30.8 cm)
Philadelphia Museum of Art. The Alex Simpson, Jr., Collection

Fig. 59. John Frederick Peto. *Lincoln and the Phleger Stretcher*. 1898
Oil on canvas, 10 x 14" (25.4 x 35.6 cm)
New Britain Museum of American Art, Connecticut, Charles F. Smith Fund, 1966.5

Fig. 60. William Michael Harnett.
Still Life—Violin and Music. 1888
Oil on canvas, 40 x 30" (101.6 x 76.2 cm)
The Metropolitan Museum of Art. Catherine Lorillard Wolfe Fund, 1963. The Catherine Lorillard Wolfe Collection. (63.85)

Fig. 61. John Frederick Peto. *The Cup We All Race 4*. c. 1900
Oil on canvas and wood boards with brass plates, 25 ½ x 21 ½" (64.7 x 54.6 cm)
The Fine Arts Museums of San Francisco. Gift of Mr. and Mrs. John D. Rockefeller 3rd, 1979.7.80

Fig. 62. John Frederick Peto. *Ordinary Objects in the Artist's Creative Mind*. 1887
Oil on canvas, 56 x 33" (142.2 x 83.8 cm)
Shelburne Museum, Shelburne, Vermont

Fig. 63. John Frederick Peto. *Old Souvenirs*. 1881
Oil on canvas, 26 ¾ x 22" (67.9 x 55.8 cm)
The Metropolitan Museum of Art. Bequest of Oliver Burr Jennings, 1968. (68.205.3)

Fig. 64. George E. Ohr. Five ceramic pieces
All collection Jasper Johns

Fig. 65. Barry Moser. *Sperm Whale*
Wood engraving, 10 ⅜ x 6 ½" (26.4 x 17.3 cm)
From Herman Melville, *Moby-Dick, or The Whale*, 1851 (San Francisco: The Arion Press, 1979), p. 357

Fig. 66. Barnett Newman. *Untitled*
New York: the artist, 1961
Lithograph, 30 ¹⁄₁₆ x 22 ⅛" (76.3 x 56.1 cm)
The Museum of Modern Art, New York.
Gift of Mr. and Mrs. Barnett Newman in honor of René d'Harnoncourt

Fig. 67. Barnett Newman. *Untitled*. 1960
Ink on paper, 12 x 9" (30.4 x 22.8 cm)
Collection Jasper Johns

Fig. 68. Barnett Newman. *Untitled*. 1960
Ink on paper, 12 x 9" (30.4 x 22.8 cm)
Collection Jasper Johns

Fig. 69. Sengai Gibon. *Circle, Triangle, and Square*. Nineteenth century
Ink on paper, 11 ⅛ x 19" (28.4 x 48.1 cm)
Idemitsu Museum of Arts

Fig. 70. René Magritte. *The White Race*. 1937
Gouache on paper, 10 ¼ x 10 ¼" (26.4 x 26.4 cm)
Courtesy Sotheby's, New York

Fig. 71. Francisco de Zurbarán. *The Veil of Saint Veronica*. c. 1635
Oil on canvas, 41 ⅜ x 32 ⅞" (105 x 83.5 cm)
Museo Nacional de Escultura, Valladolid, Spain

Fig. 72. René Magritte. *Every Day*. 1966
Oil on canvas, 19 ¾ x 28 ¾" (50 x 73 cm)
Private collection

Fig. 73. Anonymous (schizophrenic child).
The Baby Drinking the Mother's Milk from the Breast
Drawing used as an illustration in Bruno Bettelheim, "Schizophrenic Art: A Case Study," *Scientific American* vol. 186 (April 1952). By permission of Raines & Raines, New York

Fig. 74. Man Ray. *Observatory Time— The Lovers*. 1932–34
Oil on canvas, 39 ⅜ x 98 ⁹⁄₁₆" (100 x 250.4 cm)
Private collection

Fig. 75. Pablo Picasso. *Les Demoiselles d'Avignon*. 1907
Oil on canvas, 96 x 92" (243.9 x 233.7 cm)
The Museum of Modern Art, New York.
Acquired through the Lillie P. Bliss Bequest

Fig. 76. Pablo Picasso. *Weeping Woman*. 1937
Etching and aquatint, 27 ½ x 19 ½"
(69.2 x 49.5 cm)
Musée Picasso, Paris

Fig. 77. Pablo Picasso. *The Shadow*. 1953
Oil on canvas, 51 x 38" (129.5 x 96.5 cm)
Musée Picasso, Paris

Fig. 78. Pablo Picasso. *Woman in Straw Hat*. 1936
Oil on canvas, 24 x 19 ¾" (61 x 50 cm)
Musée Picasso, Paris

Fig. 79. Pablo Picasso. *Minotaur Moving His House*. 1936
Oil on canvas, 18 ⅛ x 21 ⅝" (46 x 54.9 cm)
Estate of Pablo Picasso

Fig. 80. Hans Holbein the Younger. *Portrait of a Young Nobleman Holding a Lemur*. c. 1541
Chalk and watercolor on paper, 15 ¾ x 12 ¹⁄₁₆"
(40 x 30.7 cm)
Öffentliche Kunstsammlung Basel, Kunstmuseum

Fig. 81. Gian Battista Piranesi. *Del Castello Dell'Acqua Giulia*. 1761
Engraving, 21 ¼ x 16 ⅛" (53.9 x 40.9 cm)
Collection Jasper Johns

Fig. 82. Pablo Picasso. *The Fall of Icarus*. 1958
Mural, 26' 2 ¹⁵⁄₁₆" x 32' 9 ¹¹⁄₁₆" (800 x 1000 cm)
Palace of UNESCO, Paris

Fig. 83. Richard Dadd. *The Fairy Feller's Master Stroke*. 1855–64
Oil on canvas, 21 ¼ x 15 ¼" (54 x 39.4 cm)
Tate Gallery, London

Fig. 84. Paul Klee. *Wander-Artist (A Poster)*. 1940
Colored paste on paper,
12 ³⁄₁₆ x 11 ½" (31 x 29.2 cm)
Private collection, Switzerland

Fig. 19. Leonardo da Vinci.
Human Figure in a Circle, Illustrating Proportions. c. 1485–90

Fig. 20. Leonardo da Vinci. *Deluge.* c. 1516–18

Fig. 21. Paul Cézanne. *The Bather.* c. 1885

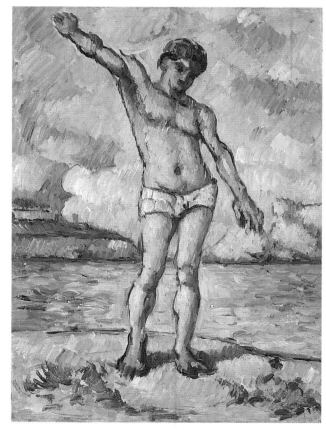

Fig. 22. Paul Cézanne. *Bather with Outstretched Arms.* c. 1883

Fig. 23. Paul Cézanne. *Nudes in Landscape*. 1900–1905

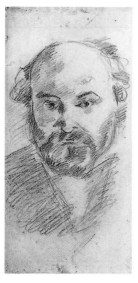

Fig. 24. Paul Cézanne.
Self-Portrait. c. 1880

Fig. 25. Paul Cézanne. *Bathers*. 1900–1906

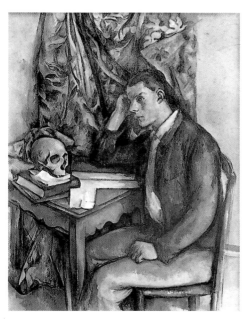

Fig. 26. Paul Cézanne. *Boy with Skull*. 1896–98

Fig. 27. Paul Cézanne. *Studies for Bathers*. c. 1877–80

Fig. 28. Marcel Duchamp.
Coffee Mill. 1911

Fig. 30. Page from *The Bride Stripped
Bare by Her Bachelors, Even: A Typographic
Version by Richard Hamilton of Marcel
Duchamp's Green Box*

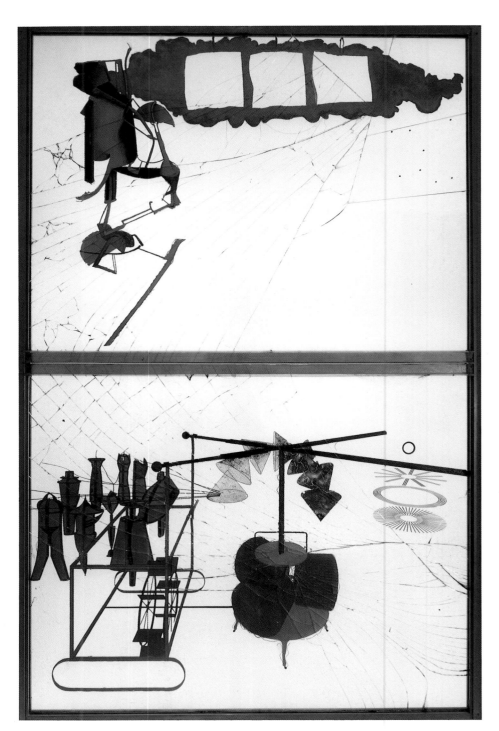

Fig. 29. Marcel Duchamp. *The Bride Stripped Bare by Her Bachelors, Even (The Large Glass)*. 1915–23

Fig. 31. Marcel Duchamp.
Replica of *L.H.O.O.Q.* 1919

Fig. 32. Marcel Duchamp. *Female Fig Leaf*. 1961

Fig. 33. Marcel Duchamp. *Tu m'*. 1918

Fig. 34. Marcel Duchamp.
The Locking Spoon. 1957

Fig. 35. Marcel Duchamp.
Self-Portrait in Profile. 1958

Fig. 36. Marcel Duchamp.
Poster for exhibition at Pasadena Art Museum. 1963

Fig. 37. Marcel Duchamp.
Étant Donnés: 1e La Chute d'Eau; 2e Le Gaz d'Éclairage. 1946–66

Fig. 38. Jacques Villon. *The Bride*. 1930

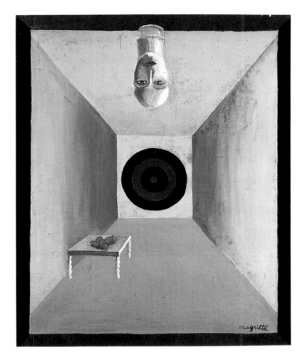

Fig. 39. René Magritte.
Hall of Arms (The Shooting Gallery). 1925/26

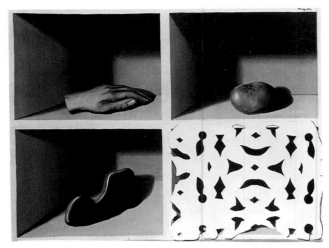

Fig. 40. René Magritte. *The One-Night Museum*. 1927

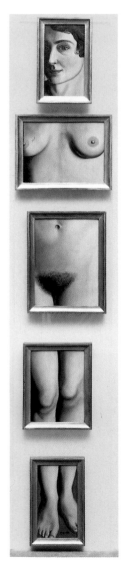

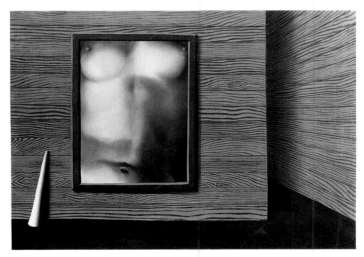

Fig. 41. René Magritte. *A Courtesan's Palace*. 1928

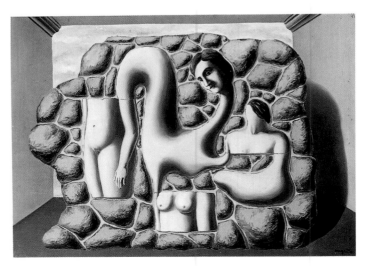

Fig. 43. René Magritte. *The Acrobat's Rest*. 1928

Fig. 42. René Magritte.
The Eternally Obvious. 1930

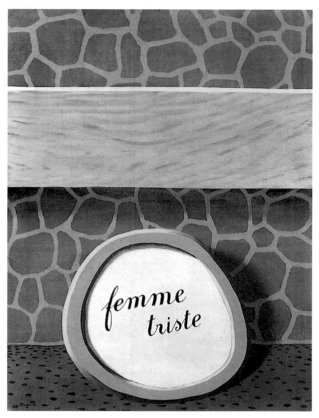

Fig. 44. René Magritte. *The Literal Meaning*. 1929

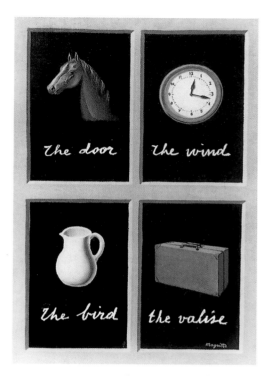

Fig. 45. René Magritte. *The Interpretation of Dreams*. 1935

Fig. 46. Yves Tanguy, Joan Miró, Max Morise, and Man Ray. *Figure*. 1926–27

Fig. 47. René Magritte. *The Human Condition*. 1948

Fig. 48. René Magritte. *"Ceci n'est pas une pipe"*. 1965

Fig. 49. Edvard Munch. *Self-Portrait*. 1895

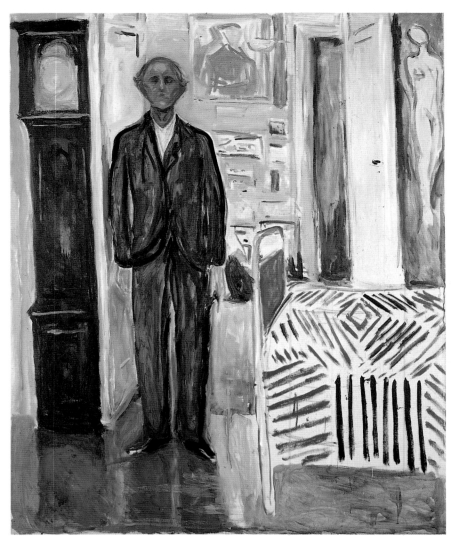

Fig. 50. Edvard Munch. *Self-Portrait between the Clock and the Bed*. 1940–42

Fig. 51. *The Mystical Form of Samvara with seventy-four arms embracing his sakti with twelve arms*. Seventeenth century

Fig. 52. *The Mystical Form of Samvara with seventy-four arms embracing his sakti with twelve arms* (detail)

Fig. 53. Matthias Grünewald. *Resurrection*.
Panel from the Isenheim Altarpiece. c. 1512–16

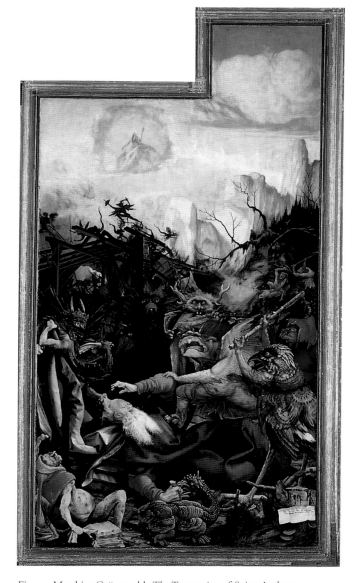

Fig. 54. Matthias Grünewald. *The Temptation of Saint Anthony*.
Panel from the Isenheim Altarpiece. c. 1512–16

Fig. 55. Matthias Grünewald's *Resurrection*, in a detail reproduced in
Ostar Hagen, *Grünewald's Isenheimer Altar in neun und vierzig
Aufnahmen* (Munich, 1919)

Fig. 56. Matthias Grünewald's *Temptation of Saint Anthony*,
from Ostar Hagen, *Grünewald's Isenheimer Altar in neun und
vierzig Aufnahmen* (Munich, 1919) (detail)

Fig. 57. Juan Gris. *The Table*. 1914

Fig. 58. William Michael Harnett. *Still Life—Five Dollar Bill*. 1877

Fig. 59. John Frederick Peto. *Lincoln and the Phleger Stretcher*. 1898

Fig. 60. William Michael Harnett. *Still Life—Violin and Music*. 1888

Fig. 61. John Frederick Peto. *The Cup We All Race 4*. c. 1900

Fig. 62. John Frederick Peto.
Ordinary Objects in the Artist's Creative Mind. 1887

Fig. 63. John Frederick Peto. *Old Souvenirs*. 1881

Fig. 64. George E. Ohr. Five ceramic pieces

Fig. 65. Barry Moser. *Sperm Whale*.
Published 1979
From Herman Melville, *Moby-Dick,
or The Whale*, 1851

Fig. 66. Barnett Newman. *Untitled*. 1961

Fig. 67. Barnett Newman. *Untitled*. 1960

Fig. 68. Barnett Newman. *Untitled*. 1960

Fig. 69. Sengai Gibon. *Circle, Triangle, and Square*. Nineteenth century

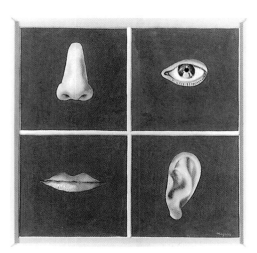

Fig. 70. René Magritte. *The White Race*. 1937

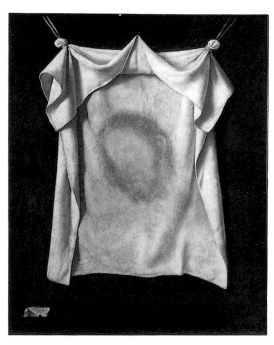

Fig. 71. Francisco de Zurbarán. *The Veil of Saint Veronica*. c. 1635

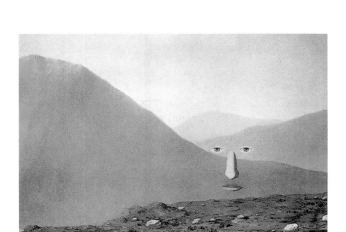

Fig. 72. René Magritte. *Every Day*. 1966

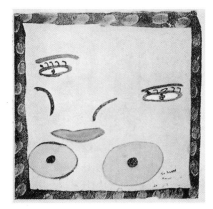

Fig. 73. Anonymous (schizophrenic child). *The Baby Drinking the Mother's Milk from the Breast*. Published 1952

Fig. 74. Man Ray. *Observatory Time—The Lovers*. 1932–34

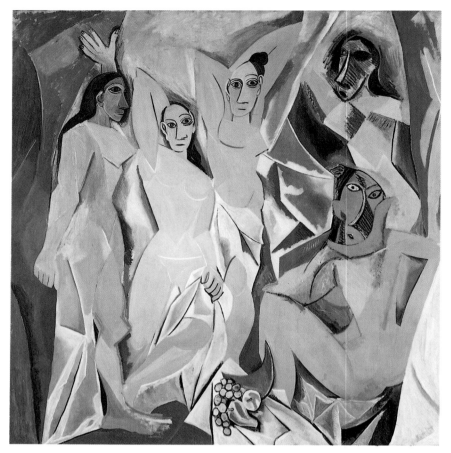

Fig. 75. Pablo Picasso. *Les Demoiselles d'Avignon*. 1907

Fig. 76. Pablo Picasso. *Weeping Woman*. 1937

Fig. 78. Pablo Picasso. *Woman in Straw Hat*. 1936

Fig. 77. Pablo Picasso. *The Shadow*. 1953

Fig. 79. Pablo Picasso. *Minotaur Moving His House*. 1936

Fig. 80. Hans Holbein the Younger.
*Portrait of a Young Nobleman Holding
a Lemur.* c. 1541

Fig. 81. Gian Battista Piranesi. *Del Castello
Dell'Acqua Giulia.* 1761

Fig. 82. Pablo Picasso. *The Fall of Icarus.* 1958

Fig. 83. Richard Dadd. *The Fairy Feller's
Master Stroke.* 1855–64

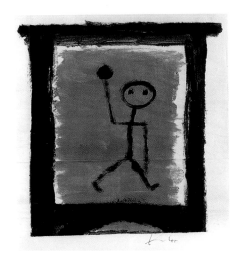

Fig. 84. Paul Klee. *Wander-Artist (A Poster).* 1940

Fire: Johns's Work as Seen and Used by American Artists

KIRK VARNEDOE

In 1960, just turning thirty and only two years into a public career already marked by extraordinary success, Jasper Johns wrote a book review that praised an eccentric, one-off masterwork completed in 1923—*The Bride Stripped Bare by Her Bachelors, Even (The Large Glass)*—and its 73-year-old creator, Marcel Duchamp, who as far as anyone knew had barely made a work of art since. As if to preempt criticism of such an idiosyncratic legacy, Johns added in a footnote, "In reviewing this book, I searched for the cartoon whose caption was, 'O.K., so he invented fire—but what did he do after that?' but could not find it."[1] The cartoon in question, which had appeared in *The New Yorker* that summer (fig. 1), satirized society's fickle demand that an innovator keep besting even his most consequential creations, and pointed up the burden of great beginnings. Johns could hardly have imagined then, before Minimalism had a name or a single comic image or soup can had yet appeared on a New York gallery wall, that this same jibe might ever be thrown back at him. Yet histories of postwar American art have typically tended to choose this exact moment, around 1960, as the point at which to freeze Johns's flame, and to consign to him a lustrous but straitjacketed historical role as progenitor and man of transition for all that followed—the fuse-lighter of a different future.

Johns clearly saw how Duchamp's case belied such simpleminded notions of art's progress; more important, his own innovations decisively scuttled the standard chronologies of modern art that had marginalized Duchamp's ideas and misgauged the open-ended potentials of their subversiveness. Some lessons, however, seem to need relearning with each new generation. In dealing with Johns himself, the inadequacies of narrow historical niches should be all the more apparent. Yet critical thinking about his forty-year career of invention—arguably the most compelling life-course in the art of our time—continues to suffer from a will to box him into some one fixed role or moment of glory within a spurious pass-the-torch-type tale of progress in contemporary art. The death of Abstract Expressionism and the genesis of the art of the 1960s, the closure of modernism and the advent of postmodernism—these and other grand critical constructs have been used to accord Johns an apparently prestigious singularity within a shorthand schema of avant-garde art in the second half

Fig. 1. Cartoon by Robert Kraus. *The New Yorker*, July 30, 1960

"*Oh, I give him full credit for inventing fire, but what's he done since?*"

of this century. But this throne is procrustean: it ignores the fuller complexities of his work, and discourages any comprehensive treatment of his developing life as an artist.

Johns's "perfect fit" within potted histories of postwar art has in fact taken him out of history. For four decades now he has been both more responsive to his time, and more broadly meaningful to his contemporaries, than any such account has allowed. And taken in overview, with all its internal integrities and self-reinventions, his art speaks far more powerfully of continuities and sustaining forces within contemporary culture than it does of the neat chains of novelty and obsolescence on which so many narratives of postwar art depend. We could at least open onto a possible alternative way of thinking about what Johns's art has offered if we tried to sidestep received categories and niches, and attended more directly to those who have followed that art most closely and continuously—his fellow artists. As Johns himself has often asserted, and as writings on him ritually reaffirm, the meaning of art, or of any other human expression, ultimately derives from the ways in which it is used by others; and it is other artists who have, in the most direct and consequential senses, put to use what he has created. Accordingly, in what follows, my own views will punctuate and give shape to a series of observations drawn (unless otherwise noted) from personal interviews with artists in the winter of 1996, in which we discussed all the things that Johns has meant and continues to mean to them. My conclusions will try to honor the complexity they describe.[2]

Fig. 2. Philip Guston.
Painting. 1954
Oil on canvas
63 ¼ x 60 ⅛" (160.6 x 152.7 cm)
The Museum of Modern Art,
New York. Philip Johnson Fund

Fig. 3. Sari Dienes. *Tomb.* 1950
Collage and ink on paper
36 x 24" (91.4 x 60.9 cm)
Collection Sari Dienes
Foundation, Inc.

Stories of American art often make Jasper Johns the bridge between Abstract Expressionism and the 1960s: like an ideal "missing link" fossil, his 1955–58 paintings of flags, targets, and numbers seem neatly to meld the vestigial (post–Abstract Expressionist, allover, painterly surfaces of spaceless flatness) with the germinal (proto-Pop public images and proto-Minimal literalness). But in biology the "missing link" is a chimera, never to be found, because the linear progress it presumes is not the way evolution actually works; and a like model of cultural change will inevitably mistreat Johns. From the first *Flag* to now, his art has never been either a residual or an emergent state of anything else. At each point it has always had a personal completeness that can make its apparently progressive followers seem merely reductive, and that can wait decades to be more fully apparent and influential.

It is partly because Johns's art has seemed so sui generis in its rhythms of development that we have such faulty notions of its broader connections to its time. His effacement of his artistic beginnings, for example (he destroyed much of his earliest work), leaves little specific context for the new sensibility that seems to appear full-blown in the 1954–55 *Flag*. Yet the tender, butter-pat brushstrokes of Philip Guston's mid-1950s paintings (fig. 2) can be seen to have a distinct affinity with Johns's first encaustic surfaces—as Guston's later art also does with Johns's more recent imagery (see below). An approach to found public imagery through iconic formal configurations was also available as an immediate climate to the young Johns, in examples ranging from less-known work, such as the rubbings and

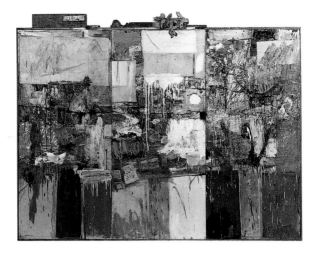

collages of Sari Dienes (fig. 3), to the essential presence of Robert Rauschenberg. Well beyond the particular visual affinities of pieces like the striped *Yoicks* of 1953 (fig. 4), or *Collection* of 1953–54, with its bold color bars (fig. 5), it was doubtless Rauschenberg who provided Johns with the most powerful and affecting model of what being an artist meant. Even after their close personal relationship ended, in the early 1960s, works like *According to What* of 1964 (plate 105) show how Rauschenberg's remarkable way with assemblage and juxtaposition—not to mention his characteristic slow-dripping sludge-stroke gesture across the canvas, his blueprints of the body, his monochrome paintings over newspaper, his white works (e.g. fig. 6), and his adoption of screenprinting—left lasting impressions.[3]

Johns's early work was of its time in broader ways as well. In Europe and America in the late 1950s, countless artists were looking for a way to transform the freedoms of gestural abstract painting into something less airy, more concrete, and more in touch with quotidian realities. One solution toward which many of them converged was monochrome coupled with a toughened surface and a more self-consciously impersonal gesture; in this sense Johns's white and gray paintings of the period have a rough congruency with contemporary work by Piero Manzoni (figs. 7 and 8), Yves Klein, Lucio Fontana, and Cy Twombly. One might also be able to sketch a general intellectual atmosphere in which Johns's distinctive interests would appear less isolated. The displacement of Sartre's Existentialism by Merleau-Ponty's phenomenology, the challenges of Continental gestalt psychology to Anglo-Saxon empiricism, the weakening of behaviorist thought in the face of new ideas of language as paradigmatic for understanding cognition and culture—all these intellectual phenomena of the late 1950s provide a surrounding backdrop for Johns's particular pressure on the intersections between seeing and knowing as a central matter of his art, and for the broadly attentive public reception of his self-conscious interplay of the retinal and the mental.

This art did not just echo its environment, however; to the contrary, it condensed available potentials in a way that revealed and irrevocably remade that world of possibilities. Johns's first paintings were not made to fit in, but to be rigorously different; and so they appeared—often with stunning force—when they were first seen. Ed Ruscha says of a reproduction of *Target with Four Faces* that he came upon in his early twenties, "It was the atomic bomb of my education." By the late 1950s the community of artists who espoused the artistic imperatives of Abstract Expressionism was strongly bonded; its adherents were in control of art instruction not

Fig. 4. Robert Rauschenberg.
Yoicks. 1953
Oil, fabric, and paper on canvas
96 x 72″ (243.8 x 182.9 cm)
Whitney Museum of American Art, New York. Gift of the artist

Fig. 5. Robert Rauschenberg.
Collection. 1953–54
Oil, paper, fabric, and metal on wood
80 x 96 x 3 ½″
(203.2 x 243.9 x 8.9 cm)
San Francisco Museum of Modern Art. Gift of Harry W. and Mary Margaret Anderson

Fig. 6. Robert Rauschenberg.
Crucifixion and Reflection. c. 1950
Oil, enamel, water-based paint, and newspaper on paperboard attached to wood support
47 ¾ x 51 ⅛″ (121.3 x 129.9 cm)
The Menil Collection, Houston

Fig. 7. Piero Manzoni.
Achrome. c. 1958
Kaolin on squares of canvas
51 3/16 x 31 3/8" (130 x 79.7 cm)
Staatsgalerie Stuttgart

Fig. 8. Piero Manzoni.
Alphabet. 1958
Ink and kaolin on canvas
9 13/16 x 7 1/16" (25 x 18 cm)
Courtesy Galleria Blu, Milan

just at Chouinard in Los Angeles, where Ruscha studied, but across the country. The pressure to conform to their ideals was enormous. "They could all be misunderstood together," Roy Lichtenstein remembers, "which of course everybody liked." In retrospect their second-generation version of gestural abstract painting may appear to have been ripe for overthrow, but to contemporary eyes it seemed flourishing, and its expansive success made Johns stand out as, in Ruscha's words, "so contrary at such a vibrant time."

The contrariness that "completely flabbergasted" Ruscha was not the image content of the work, but its formal structure. Nothing his teachers had told him allowed the possibility of a painting that could be symmetrical, and could bring together two separate surfaces—one solid hue next to another—in stripes like the *Flag*, or in rings like the *Target*. More impressive still was the basic idea that a painting could be premeditated. Ruscha, Frank Stella, Brice Marden, Chuck Close, and other artists stress how they were inculcated as students with the idea that one discovered oneself in the act of painting. What snapped them all to attention was Johns's implied proposition that you could decide in advance what your work was going to be— and by implication who you were—and then make it so. As Bruce Nauman put it, "I loved de Kooning's work, but Johns was the first artist to put some intellectual distance between himself and his physical activity of making paintings."[4] It was the particular combination of evident physicality (which the more obviously cerebral or planned work of, say, Josef Albers lacked) with this self-conscious control that was striking, and affecting. The word "deliberate" resonates through several testimonies to Johns's effect at the time: not only the given structures of his images but also his palette denied the faith, central to so much of Abstract Expressionism, in improvisational or undetermined choices. Johns simultaneously put the artist back in conscious control and subjected him to the discipline of a fixed image and a priori decisions. Marden paid direct homage to this instruction in a painting he made in 1970, *3 Deliberate Greys for Jasper Johns* (fig. 9).[5]

The Johnsian principles of control and self-restriction tied technical implications to moral ones. The Abstract Expressionists' insistence on mess and movement had discredited care and craft; by reclaiming the artist's older responsibility of carefully defining what he wanted to say, Johns made their followers seem to be, in Stella's words, "simply pouring out the water so that they could see their own image." Many young painters felt, furthermore, that their teachers' imperative of self-revelation, and the angst-freighted notion of the world that accompanied it, were irrelevant to them. They wondered, as Mel Bochner puts it, "Where is your true self at age 23?," and felt, as Close says, that the call to bear witness to bloody suffering and man's inhumanity to man made less sense for them than it had for a generation directly marked by World War II. Amid the hothouse pressures to affect a heart-on-the-sleeve subjectivity, early Johns arrived for such beginners as cool fresh air. Whether one felt, as Stella did, that Abstract Expressionism seemed to take up so much room that there was no space left, or conversely sensed, like Elizabeth Murray, that the "unreal romanticism" of the New York School was too narrow and left out too much of life, Johns offered a different way both into the activity of painting and out into the broader world.

For most of these artists, exposure to Rauschenberg's work and to Johns's came near simultaneously, and for many of them Rauschenberg seemed both more shockingly avant-garde (in combine works like the goat-and-tire *Monogram*, 1955–59) and easier to "use." By his disdain for the cuisine of art and his active engagement with assemblage, performance, etc., he was a great permission-giver.[6] Yet many artists felt then, or have come to feel since, that Rauschenberg's aesthetic was at base more continuous with the gestural heartiness of Willem de Kooning and others, and that Johns's seeming conservativism was in fact more deeply subversive. Rauschenberg had for them the grace of a great natural athlete, imbued with an extraordinary gift for pulling disparate things together into one convincing image or pictorial space; when he made a gesture it seemed authoritative and unhesitant. What was moving about Johns, on the contrary, was his sense of un-natural, willful bearing down on the task, wherein every inch was hard fought and every gesture remade again and again. In John Baldessari's words, Rauschenberg was a "horizontal scanner" and Johns a "vertical scanner," boring in on a single image or task. On those occasions when Johns set out to work in Rauschenberg's accustomed territory, as in *Diver*, 1963, or *According to What*, the relationship of parts to whole came out as more additive than synthetic, and the space read as discontinuous. It was, however, precisely an aspect of this resistance to synthesis—a clear concern for the shifting dialogue between something taken as a whole and then as a part, or vice-versa—that would spur the interest of artists as diverse as Nauman, Close, and Baldessari.

One of the earliest labels applied to Johns's art was "Neo-Dada," but neither performative absurdity nor political subversion—true Dada spirits that blossomed in other art of the late 1950s and early 1960s—had any part in his enterprise. It was with Duchamp particularly that he formed a bond, and in an original and transformative way. Arguably, Duchamp would not have had so broad an impact on American art since 1960 were it not for the personal "translation" that Johns provided. Nauman, for example, remembers that Johns offered him a "door into Duchamp" in a way that was "sort of like learning about Freud by reading Faulkner — it's there, but *in use*."[7] Though Johns's occasional explicit references to and quotations from Duchamp would find echoes in countless "appropriations" in the 1980s, they were less important than his transformation of Duchamp's way of not making art into a way of making art. Johns turned an abstemious elegance of thought into hands-on physicality, and remade a deft wit into a darker and more troubling psychology.[8] This mirrored the Europe-to-America exchange of the 1940s, when the Parisian Surrealism of Max Ernst, André Masson, et al., had been purged of its sophistication and remade by the younger New York School painters into a more earnest, immediate way of wrestling the unconscious onto the canvas. But to counter the robustly expansive, Whitmanesque reach of "action painting" that had emerged then, and that Rauschenberg continued, Johns now proposed an ironized materialism that, with brooding, Eakins-like tenacity, would subdue the physical world in the grasp of thought.

Fig. 9. Brice Marden. *3 Deliberate Greys for Jasper Johns*. 1970 Oil and beeswax on canvas Three panels; each panel 6′ 1/8″ x 4′ 2 1/16″ (183.2 x 127.1 cm); overall 6′ 1/8″ x 12′ 6 11/16″ (183.2 x 382.8 cm) National Gallery of Canada, Ottawa

If we compare Johns's *Painted Bronze* (ale cans), 1960, to a Duchamp ready-made like the *Bicycle Wheel*, the distinctly American quality of Johns's laboriously handmade trompe l'oeil seems patent. It is ironic, then, that this element of touch, especially in the facture of the paintings, was precisely what made Johns seem, to European artists of Gerhard Richter's generation, too allied with a Cézanne-based tradition of painting they found oppressive.[9] Such attitudes partly explain why Andy Warhol—whose flat screenprints better satisfied European notions of America's impersonally industrial, violent glamor—had a broader impact in Europe than Johns. (The potency of Johns's influence in Britain and Japan, by contrast, was evident by the early 1960s.) Yet at the outset of Johns's career, no one was more fascinated by him (or at least by his success and fame) than Warhol was.

Johns, in fact, is often regarded as the "father of Pop," but as the artist himself has said, "If you make chewing gum and everybody ends up using it as glue, whoever made it is given the responsibility of making glue."[10] It would be obtuse to deny that he and Rauschenberg instigated Pop; where Duchamp had put found things on a pedestal, Stella remarked, these two took the incidental and the day-to-day world into their art with a striking immediacy and made it functional, finding new relationships between things and forcing unexpected congruities. Certainly, too, as Bochner attests, Johns's use of a prime cultural symbol, the U.S. flag, helped open up for countless artists the whole issue of culture and its critique; and the sculptures he made of commonplace objects—beer cans, flashlights, light bulbs, etc.— doubtless helped catalyze the Pop artists' attention to items of commerce. Yet he stopped making those objects just as Pop ascended, and in retrospect we can easily see how the studio conjured by these pieces of workshop clutter (and by the broom and cup in *Fool's House*, 1962) remains bohemian and solitary—dirty floorboards, used brushes, bare light bulbs, a life of alcohol and caffeine—in contrast to the socializing embrace of mass fabrication and mercantile publicity that informed Warhol's Factory or Claes Oldenburg's Store.

Johns seems at first to have sought in American public life a set of symbols that would be timelessly neutral and unvarying. But he did so precisely in a period when political and especially consumer life in this country sped up: the flag got more stars, labels and logos were redesigned, long-steady brand names died or were remade. This sense of accelerated inconstancy, which seems to have figured in his decision to shift away from making a private iconography of "common things" by extracting items of public commerce,[11] is in part what occasioned the deep vein of nostalgia in Pop art—the bitterly shrill keening for waning commonplaces like soup cans with fifty-year-old label designs, Coca-Cola bottles in an age of canned Coke, and crude little pulp advertisements in the full-color heyday of Madison Avenue. Meanwhile, Johns's rigorously same-scale objects had a private, taciturn nature that never fit with Pop's tendency to enlarge art's rhetoric, and his cessation of commercial imagery after only two essays (the Ballantine and Savarin cans) kept him aloof from the tabloid blend of irony and sentiment that the Pop artists favored. Pop's objects spoke of transaction, while Johns's retained a crucial dimension of possession.

Johns's fatherhood to Pop is typically paired with his parenting of Minimalism, dividing those artists who were marked by the image of *Flag* from those who were taken with the way that image was treated. The former saw it as all subject, the

latter as all object; for them, pushing the image forward to take up the canvas's entire surface seemed to obliterate normal representation. As Robert Morris wrote in 1969, "Johns took painting further toward a state of non-depiction than anyone else. The Flags were not so much depictions as copies....Johns took the background out of painting and isolated the thing. The background became the wall. What was previously neutral became actual, while what was previously an image became a thing."[12]

 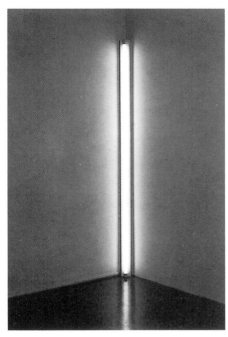

Fig. 10. Frank Stella.
Die Fahne Hoch. 1959
Black enamel on canvas
10′ 1 ½″ x 6′ 1″ (308.6 x 185.4 cm)
Whitney Museum of American Art, New York. Gift of Mr. and Mrs. Eugene M. Schwartz and purchase, with funds from the John I. H. Baur Purchase Fund; the Charles and Anita Blatt Fund; Peter M. Brant; B. H. Friedman; the Gilman Foundation, Inc.; Susan Morse Hilles; The Lauder Foundation; Frances and Sydney Lewis; the Albert A. List Fund; Philip Morris Incorporated; Sandra Payson; Mr. and Mrs. Albrecht Saalfield; Mrs. Percy Uris; Warner Communications Inc. and the National Endowment for the Arts

Fig. 11. Dan Flavin. *Pink out of a Corner—To Jasper Johns.* 1963
Pink fluorescent light in metal fixture
96 x 6 x 5⅜″ (243.8 x 15.2 x 13.6 cm)
The Museum of Modern Art, New York. Gift of Philip Johnson

This immediate presence and autonomous wholeness, with no reference to an illusory space, was sharply stimulating to a broad variety of people. Perhaps the most direct transfer was from the stripes of *Flag* to Stella's black paintings of 1959 (fig. 10),[13] but Johns had a parallel impact on early-1960s sculptors such as Donald Judd and Dan Flavin, who were seeking to expunge internal compositional relationships and directly activate surrounding space (fig. 11). As Pop took off from Johns's intimate, slow surrogates of common things into a speedy public brassiness, so these other artists leaped from his art of cognitive ambiguities into one of empirical certainties. Stella's classic assertion about his stripes, that "what you see is what you see," implied, as another artist put it, a "brilliant misreading" of Johns, one that confidently obviated the subtler tensions between eye and mind his work explored.[14]

In this strict Minimalist sense, Johns could be seen as encouraging a clear-thinking demystification of art's processes—even though, when probed more attentively, his superficially straightforward certainties were laced with ironies and doubt. Morris recently recalled these issues in relation to his own work:

> On one level it would have been the structural considerations in J.J.'s paintings that were of interest: the "found" image generating the painting's internal divisions as well as its limit (flags, targets, numbers). This resonated to my a priori strategy of following the rules of straightforward construction methods for generating the sculpture ([my] early plywood works). One could say (if one were an art historian perhaps) that Minimalism could not have existed without J.J.'s assertion of the a priori as method. But for me J.J.'s method went deeper. It was the inexorable, progressive "logic" built into the kind of a priori chosen that was profound. What does it mean, Wittgenstein asks, when the subject says "I know how to go on." A great deal is at stake in this game of "following a rule" (see p. 201 of the *Investigations*). The skeptical and the ironic begin to emerge here. Anyway I felt an affinity both to Duchamp and J.J. in the skepticism and the ironies that informed my early plywood works.

Fig. 12. Robert Morris.
Metered Bulb. 1962
Light bulb, ceramic socket with
pull chain, and electricity meter,
mounted on painted wood
17¾ x 8 x 8¼″
(45.1 x 20.3 x 21 cm)
Collection Jasper Johns

Fig. 13. Robert Morris.
Swift Night Ruler. 1963
Sliding ruler and wood, painted
10 x 28½ x 1″
(25.4 x 72.4 x 2.5 cm)
Collection Leo Castelli

Morris was among the first artists, in the early 1960s, to be so directly in sympathy with a constellation of aspects of Johns's work—its intense intellectual engagement with Duchamp, its morbid corporeality, and most especially the distinctive sensuality of its surfaces—that were scanted by many of the Pop and Minimal artists (see for example figs. 12 and 13). He felt "a strong affinity with J.J.'s surfaces and materials....Perhaps the pathos in J.J. is embedded in his surfaces and comes from all those caresses trapped within his rule following." Even Stella, who would seem to have bypassed this part of Johns's art, thought the work "all surface," and found himself drawn to the unique properties of Johns's encaustic, which he felt coated the canvas rather than painted it, with a "colloidal" quality "like skin." In Stella's 1959 black paintings, the layering of strokes of enamel on the raw duck fabric was tied to a self-conscious desire to emulate this richness.

After Johns's retrospective exhibition at the Jewish Museum in 1964, a more attentive reading of these sensual components of his work, and a different feel for the possible meanings of his methods, emerged in a new generation of painters and sculptors. The artist who had helped create Minimalism offered these aspirants a way beyond it. Marden, for example, worked as a guard at the Jewish Museum at the time of the show. Already committed as an abstract artist, and "totally indoctrinated" in the ethos of the New York School, he came to Johns out of a study of the grays of Goya and Manet, and via an admiration for the intense realism of Zurbarán. Studying the grayed-down hues of Johns works like the 1962 *Map* (plate 96), Marden also admired the rule-bound nature of Johns's choices. These works made it easier for him to accept and concentrate on the activity of "painting the rectangle," and showed him how the structure of a work could emerge, as it did in Cézanne's work, from the way the artist painted.

What struck Marden powerfully, in consonance with Morris's observation about the "image becoming a thing," was the potent *realism* of Johns's work. Johns made the thing he was presenting—not himself, or his actions—seem of primary importance. For Marden, however, this was a matter not of clinically clarifying the certainties of objecthood but of creating an experience of emotionally colored ambiguities and fruitful confusion. In the paper he submitted as part of his M.F.A. thesis in 1967, Marden wrote,

With Johns there was an advance in illusionistic realism, or the depiction of things, because he made the things himself. Other Pop artists painted pictures of pictures but Johns's paintings are actually the thing elevated, through the use of traditional plastic means, to a higher, or aesthetic state. He has imbued his objects or things, his subject matter with a new mystery. (Painting is also a main part of his subject matter, paint and painting.) The flag remains a flag yet becomes art, capable of awakening the spirit in a more moving way than flags ordinarily do....[My] paintings are blatantly simple color shape statements, but then go very confusing, as do the simple Johns flag paintings, and the object becomes a playground of contents, mysteries, and questions.[15]

Another aspect of Johns's work—the practice of reiteration in his numbers and alphabet pictures, and his larger habit of painting variant versions of the same motif—encouraged a notion of art as a serial, ongoing activity. While for several younger artists this dovetailed with a renewed appreciation for Monet's series paintings, or for Brancusi's frequent reconsideration of near-identical forms or motifs, on a larger scale it held the promise that one need not continually invent anew but could return again and again to the same motif, and by shifting inflections draw something new from it each time.[16] Marden felt that such "fine thinking" about slight differences embodied the truest "minimalist" spirit, by showing how complex a simple thing could be. He sensed a Zen spirit here, and he similarly saw Johns's repetitions of his own gestures as a meditative way of deeply absorbing the mind in the task at hand, in order to get "to another place." This was one of several ways in which Johns's involvement with John Cage and with Eastern aesthetics was sensed by fellow artists as a calmer, more centered and accepting alternative to the supposedly epiphanic inspirations—also sometimes linked to Japanese aesthetics—that were implied in the calligraphic gestures of artists such as Robert Motherwell or Franz Kline. Johns's less spontaneously elegant, more dogged approach to making his works suggested a route to creation through insistent, task-oriented process, and this stubborn attentiveness appealed to artists like Nauman. "What I tend to do is see something," Nauman has said, "then re-make it and re-make it and re-make it and try every possible way of re-making it. If I'm persistent enough, I get back to where I started. I think it was Jasper Johns who said, 'Sometimes it's necessary to state the obvious.'"[17]

Close speaks in similar terms of admiring how Johns apparently gave himself over to process in order to see where it led; to use Close's analogy, he seemed to work as if knitting, in that the existence of the determined pattern allowed disregard for the totality and greater concentration on making each constituent stitch, or gesture. The results put the viewer in a condition of oscillating attention between the dominant subject and its parts, the local or discrete concentrations of charged physicality across the declaredly artificial surface—an aspect of Johns's work that was and remains crucial for Close's huge gridded portrait heads (fig. 14). And Richard Serra likewise admired Johns's implicit assertion that "how the thing is made gives you another kind of

Fig. 14. Chuck Close. *Keith*. 1972
Mezzotint
50 ¹⁵/₁₆ x 41 ¹³/₁₆" (129.4 x 106.2 cm)
The Museum of Modern Art,
New York. John B. Turner Fund

meaning." The demonstration lay for him in the evident way Johns passed no value judgments as he worked, but displayed an "aggressive indifference" that refused to distinguish between major and minor activities, instead concentrating on all parts simultaneously, "tightening down from the big mark to the detail, paying attention to the dot." Johns's denial of himself as subject, and his lesson that the process of making would carry the art "if you paid attention to it...millimeter by millimeter, second by second," was for Serra "a huge relief."

That patient absorption in labor implied a self-constraint to which the post-Minimalist generation was emotively attuned. Both Marden and Close, for example, liked Johns's work for what was held back—for its intense feelings of reticence, denial, or repression. They saw this energy of exclusions and self-imposed prohibitions as ultimately positive, and felt that the stricter the parameters preset for a Johns work, the more freedom and energy his labor on it conveyed. In the political and social climate of the 1960s, where rules seemed to be dissolving, such discipline apparently seemed salutary, even liberating, for artists in their twenties. Far from being simply ascetic, Johns's facture suggested, for Serra, a pleasure in making that was "very different from the 'puritanism' of Judd." Yet Serra also felt that Johns's way of "finding a representation through the process of painting" was not fed by the popular culture from which the ostensible subjects were drawn, but by Johns's "thinking about his emotional state in relation to painting." This put him in a position of "concentrated vulnerability," in Serra's words, so that "his anxiety in making is much deeper than most other people out there." That anxiety, and the evident force of repression that accompanied it, fused inextricably with the palpable sense of pleasure in making to give the work much of its complex psychological potency.

Such "lessons" yielded an influence that did not respect boundaries of style or medium. During Close's and Serra's postgraduate years at Yale, Johns's *White Flag* of 1955 was on extended loan to the Yale Art Gallery, and helped push each of them in their respective directions, toward a heightened form of realist painting and a more immediate kind of abstract sculpture. "For me," Serra says, "the *White Flag* was enormous; it just forced you to look at it forever." After Jackson Pollock, he feels Johns was the artist who most affected him; and certainly the thrown-lead piece he made for Johns in 1969–70 in the artist's Houston Street studio is unthinkable without both predecessors (fig. 15). The throwing of liquefied lead was a quasi-industrialized homage to Pollock, but the systematic, repetitive collisions against the constraining corner and the extraction of parallel cast strips reflected Johns's methods, just as the (paradoxically elegant, Whistler-esque) silver gray of the lead itself seemed connected to Johns's palette and feel for materials. As a blue-collar replay of Duchamp's *3 Standard Stoppages* of 1913–14, Serra's piece vividly embodies Johns's transmission of Duchamp's ideas—in this case, ideas about measurement and systems of chance—into physical, and specifically American, terms. Around 1968, in the dying hour of hopes for a left-wing political union of workers and students—of steel mill and Ivy League, to pick the poles of Serra's own biography—the fusion of the muscular with the mental, violently enacted here, took

Fig. 15. Richard Serra. *Splash Piece: Casting.* 1969–70 Lead 3′ 9 1/8″ x 15′ x 9′ 3/8″ (114.6 x 457.2 x 275.2 cm) Installation at Jasper Johns's studio, Houston Street, New York. Now in the collection of the San Francisco Museum of Modern Art, under the title *Splash Piece: Casting (Gutter Cast—Night Shift),* 1969–70/1995. Gift of Jasper Johns

on a special valence. As the cheap expedient of industrial house paints had fit
with the working-man ethos of the New York School, what one artist called Johns's
"philosophy of labor," with its ability to combine sophisticated thought, intent
craft, and a visceral feel for the erotics of materials, held a powerful appeal for this
college-trained, self-consciously intellectual crop of art workers, as they scoured
Canal Street for industrial scrap with paperbacks of art theory in their back pockets.

Serra's work here and elsewhere also suggests how Johns's influence, instead
of simply subverting and invalidating Abstract Expressionism, could fuse with
Pollock's in the work of artists marked by both the 1964 Johns retrospective and
the 1967 Pollock retrospective at The Museum of Modern Art. Far from canceling
or superseding Pollock's legacy, as he is often held to have done, Johns provided
for many artists, at this juncture in the late 1960s, a key set of options that allowed
Pollock's innovations to be expanded upon and put to fresh use without being
merely diluted by unthinking imitation. The sculptures and drawings of Eva Hesse
would be a prime case in point. When Bochner first met Hesse, around Christmas
of 1965 (well before her Pollock-inspired "cobweb" hanging pieces of c. 1970), his
first words to her—thinking of the sculpture *Ishtar*, which opened her exhibition of
that year (fig. 16)—were "I see you're into Jasper Johns"; to which she replied "Yes."
But Hesse's response to Johns was, as Bochner recounts it, of a very different nature
from Serra's; it centered on "that point where the formal and the perverse come
together." For Bochner (and, he feels, for Hesse as well) the "secret power of Johns's
work" lies in the way he sexualizes inanimate objects, by "the tender eroticism
with which he handles materials." Not only the "touch" of Johns's paintings but his
way of "turning everything inside out," and his practices of "peek-a-boo" conceal-
ment and implied suppression—the boxes atop the *Targets*, the covering flaps in
Shade, Highway, and *Disappearance II*—seemed to Bochner to have an "erotic volt-
age," which he feels Hesse apprehended directly (fig. 17).

Several writers have remarked how Johns's early aesthetic, in its apparently
cool diffidence or even "feminine" craft aspects, was subversive to the demonstrative
masculinity of New York School action painting. Less remarked are the ways in
which this same work—which had spurred the impersonal, supercontrolling logic
and geometries of Minimalism a few years earlier—nourished the organicist aes-
thetic of feminist object-making that emerged in Hesse's sculpture, as well as the
symphonic lyricism of Jennifer Bartlett's systems-based art of the
same period, and also the very different painting of Murray (fig. 18).
For Murray, in fact, Johns's orientation toward process was a bridge
that allowed her a point of entry into the work of male contempo-
raries such as Serra and Marden, and helped her draw something
from their art. She also found that the way "a structure, a thought
process is already there in the image" in Johns's work resonated with
her growing understanding of the power of Cézanne, and helped
her to focus and ground her painting. Recognizing an "incredible
sarcasm, down to the toes," in Johns's art from the moment she first
encountered it, Murray saw him as "a deep doubter" who "raised
questions on every level." Yet at the same time she also found the
work "so utterly beautiful, and physical, to explore." Ultimately, it

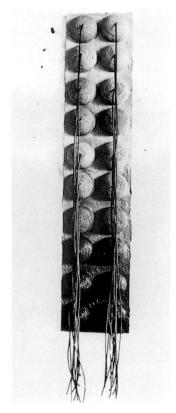

Fig. 16. Eva Hesse. *Ishtar.* 1965
Twenty cord-bound and painted
hemispheres with black plastic
cords protruding from their centers,
mounted on heavy paper stapled
and nailed to wood, paper gessoed
and painted with acrylic
42 ½ x 7 ½ x 2 ½"
(107.9 x 19 x 6.3 cm)
Collection Florette and Ronald B.
Lynn, New Jersey

Fig. 17. Eva Hesse. *Circle Drawing
(with Plastic Thread).* 1968
Pencil, ink wash, and plastic
thread on paper
15 ⅛ x 15 ⅛" (38.4 x 38.4 cm)
Collection Sally Ganz

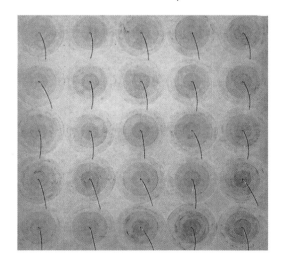

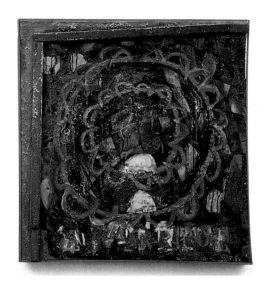

Fig. 18. Elizabeth Murray.
A Mirror. 1963
Oil on canvas with glass, paper,
and wood
32 ½ x 28 ¾" (82.5 x 73 cm)
Collection the artist

was the "melding of the idea or the mental with the physical"
in Johns's art that was most fundamentally impressive to her, as it
seems to have been to all her contemporaries, of both genders.

That melding opened a universe of possibilities. It might seem,
for example, that of all those maturing in the late 1960s it was
Bochner who was most attentive to the mental, or logical, side of
Johns's work as a stepping-off point for Conceptual art. He did
in fact see *False Start*, 1959, and Johns's other works with words as
signaling the end of painting, by stressing that images and state-
ments were incommensurable. Yet he was more broadly moved by
the "impurities" in Johns's art, and it was his reading of these that
informed the collision in his own work between a priori conceptual
systems—language, number, measurement—and the reality of
immediate physical experience (figs. 19 and 20).[18] For Bochner, the "Nietzschean"
combination of the pleasurable and the painful or tragic in Johns's sensuality was
inseparable from, and every bit as meaningful as, the work's skeptical cognitive
inquiry. Sharing Robert Smithson's interest in entropic systems, Bochner was atten-
tive to the fact that encaustic was a material that changed state—that lost heat
and solidified—rather than merely dried; and he saw a temporal pathos in the way
Johns embalmed newspaper shreds, the most fragile of daily ephemera, in this most
ancient of mediums. Bochner also found that effect consonant with the energy-
denying, downward-pulling heaviness of the characteristic *M*-shaped, almost generic
brushstroke that Johns used widely.[19]

If the 1960s opened with a variety of artists taking from Johns the cue for,
respectively, a heartily ironic exploitation of popular culture and an empirical abso-
lutism, the decade closed with Bochner and others focusing on the intense doubt,
nihilism, and negative energies they found in his art. At a moment when not just
the idealism of modern painting, but individualism and materialism more generally,
were under severe critique, this aura of deeply guarded emotive and intellectual
concentration gave his individual touch and his investment in the physicality of
materials its saving, impressive authenticity. In this period, Johns's art gave sustenance
both to those who thought painting passé and to those who sought to sustain it.
When Serra looked at a picture such as *Painting with Two Balls*, 1960, for example,
he hardly thought at all of the work's color, or of its other painterly aspects,

Fig. 19. Mel Bochner.
Actual Size (Hand). 1968
Polaroid photograph, rephoto-
graphed, enlarged, and mounted
22 x 17 ¾" (55.8 x 45 cm)
Collection the artist

Fig. 20. Mel Bochner.
Language Is Not Transparent. 1970
Chalk on paint on wall
72 x 48" (182.8 x 121.9 cm)
Installation in "Language IV"
exhibition, Dwan Gallery,
New York, 1970

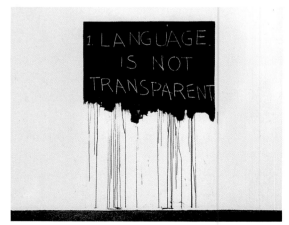

but saw primarily the powerful effect of compression. *Painting with Two Balls*, Serra feels, is a deep metaphor for matters sexual and psychological (utterly independently of the often-cited verbal pun about "ballsy" painting); for him, though, the references for its tension lie clearly beyond painting, with principles of leverage and other aspects of the mechanical culture of the world. Yet even while such aspects of physical immediacy spoke to the concerns of sculptors, and while Johns's use of language also spurred Conceptual artists, his continuing interest in imagery simultaneously encouraged painters like Murray, and his imagery-effacing handling of paint fed still others like Marden.

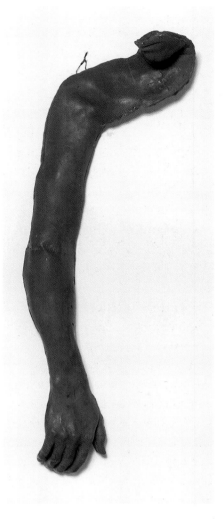

In the 1960s, this variety in Johns's influence seemed to flow from the deeply fused paradoxes of his early work, and to a lesser extent from its evident internal disjunctions, such as the splice of sculpture and painting in the *Target* assemblages. By the early 1970s, however, the situation became far more complicated. Not only had Johns's own production grown more various and multifaceted, but many areas of his formerly private terrain had been colonized and developed by younger artists. Visiting galleries and reading art magazines as he turned forty, he would have been confronted with a wide array of work that was extrapolated from aspects of his own, and that moved in directions he himself had not explored. Thus, for example, when he returned to cast body-parts in the rightmost section of the large four-panel *Untitled* of 1972, he would inevitably have been recovering his own *Target with Plaster Casts* or *Watchman* not only through the lessons of Duchamp's body simulacrum in *Étant Donnés...*, posthumously revealed in 1969, but also through the filter of Nauman's work with wax life-casts and body templates in the late 1960s (figs. 21 and 22). Perhaps in a willful effort to break out of these incestuous circles of exchange and find more completely fresh terrain, the other two motifs in this 1972 *Untitled*, the flagstone and "cross-hatch" devices, were taken neither from traditional art nor from the commercial mass culture on which Pop had drawn, but from outside the art world altogether, in the domain of anonymous "street art"; and it was in their direction that Johns's art veered after 1973.

Still, when Johns used the cross-hatch pattern he did so not just in ways that confronted the legacy of Pollock's allover abstractions, but also in terms of underlying numerical and topological systems that suggest his attention to the systems-oriented work of artists like Bochner and Sol LeWitt in the later 1960s. The lessons of his own number and letter grids, expanded and linked by others to areas such as music and set theory, returned in this way to underpin his (resolutely contrary)

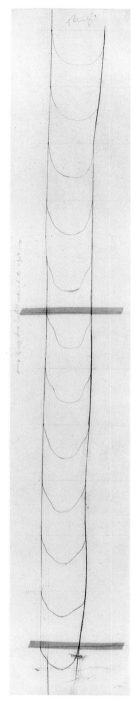

Fig. 21. Bruce Nauman.
From Hand to Mouth. 1967
Beeswax over cloth
28 x 10 1/8 x 4″
(71.1 x 25.7 x 10.2 cm)
Hirshhorn Museum and Sculpture Garden, Smithsonian Institution, The Joseph H. Hirshhorn Purchase Fund, Holenia Purchase Fund, and Museum Purchase, 1993

Fig. 22. Bruce Nauman.
Six Inches of My Knee Extended to Six Feet. 1967
Pencil and collage
73 1/2 x 12 1/2″ (186.6 x 31.7 cm)
Collection Jasper Johns

adherence to painting in the decade of the dematerialized art object. For a young painter maturing in the 1970s like Terry Winters, the cross-hatch paintings "quantified and measured the space that is in Pollock." He saw that they were not beholden to the Greenbergian formalist notions that had led to the dead-end decorativeness of Color Field abstraction, nor allied to "bloodless conceptual painting, which had no touch, no biography, no reference outside the work itself." In an era when Serra, Judd, and so many other artists were involved in the brushless "literalization of what Pollock did," Winters felt Johns's abstractions remade Pollock in a fashion that kept both the mind and body in the image and allowed abstract painting to go forward. Stepping aside from his long twinned relationship with Rauschenberg, Johns now seemed for Winters to demand comparison instead with Cy Twombly, whose greatest, gray-ground, "blackboard" paintings of the early 1970s also faced Pollock's legacy head-on, and similarly made it newly accessible in terms that reckoned with the objectifying challenges of Minimalism. After 1970, as Rauschenberg's expansive inclusiveness seemed increasingly the forerunner of multimedia work, performance, etc., Twombly and Johns became the key father figures for artists who sought to keep faith with painting but at the same time to engage with the issues of language, measurement, and de-Romanticized self-awareness that separated their epoch from that of Abstract Expressionism.

For Winters, the "distillation and concentration" of the cross-hatch paintings seemed to have "reconciled all the issues about abstraction and representation." He felt that works like the *Corpse and Mirror* pictures arrived at a figural reference without being mimetic—that Johns had proposed a way to "feed in abstract information and get out a picture...in the way that fractal geometries can produce [the contours of] a mountain range." With their evocative titles (*Dutch Wives, Weeping Women*), each of these paintings seemed to have its own "story," and to maintain a resonance with the outside world while keeping the subject in abstraction. Winters also admired, however, Johns's break with this kind of abstract work, in the early 1980s, as indicative both of a laudable willingness to understand when a personal vein has been exhausted and of a parallel will to avoid a long-term "signature style."

Johns's turn toward illusionistic imagery in the early 1980s seemed to many a drastic, surprising, and anomalous development. The post-1982 works seem as different from Johns's early period, Winters suggests, as Wittgenstein's *Philosophical Investigations* (a text of great interest to Johns) is from his early *Tractatus*. In retrospect, though, Johns's work of the 1980s seems closely connected to currents of the time. American art in that decade underwent a delayed "post-Pop" experience that played off against the 1970s dominance of post-Minimalist aesthetics. Not just figuration but also issues of the interplay between abstract art and commercial culture returned, while found imagery and illusionistic space, such as appeared in Johns's work, emerged as elements of the lingua franca of younger painters as well. Specific elements of "post-Pop" also appeared in Johns's apparent relation to the work of Roy Lichtenstein. Over the past two decades these two have shown, aside from their mutual demonstrations of interest in Pablo Picasso, several common elements of both theme and style, including the striped-puzzle-piece arrangement of motifs (fig. 23) and the trope of reassembling the artist's own past for new imagery (fig. 25). In some of his still lifes of the 1970s, Lichtenstein also drew on

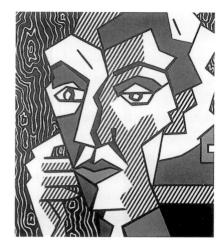

the American trompe l'oeil tradition of William Harnett and John F. Peto that Johns had acknowledged in his early work, and caricatured the devices of the tackboard—shadow-casting nails, fake tape, Cubist-like *faux-bois* wood grain (fig. 24)—in a way that seems to prefigure aspects of Johns's paintings of the 1980s.[20] (Works by Johns are in turn sometimes pictured, in satirically reductive homage, in Lichtenstein's later interior views.)

More generally, though, Johns's return to figuration, and the explicitly cartoonlike rendering that appears frequently from the *Tantric Detail* pictures of 1980 onward, seems connected to a previous apostate from abstraction, Philip Guston. Guston's brutal renunciation of the atmospheric, impressionist graces of his abstract painting, and his adoption of a tragicomic manner of revisiting his earlier realism, was one of the most perplexing and moving dramas of dogged private motivation in the art of the 1970s. His death in June of 1980, and the retrospective exhibition that came to New York the following summer, may have helped catalyze Johns's departure from his cross-hatch work shortly after. Certainly for the maker of the *Painted Bronze* sculptures of beer cans and dirty brushes in a coffee tin, Guston's conjurings of a solitary, smoking-and-drinking studio life lit by light bulbs on cords must have touched a point of poetic affinity (fig. 26). As opposed to the upbeat impersonality of Lichtenstein's 1970s work, Guston's later imagery also has an element of self-lacerating pain and melancholia that may be truer to the spirit of Johns's "bathtub" imagery of the 1980s.

Murray, herself a strong admirer of Guston's later work, finds these bath scenes (e.g. plates 193, 194, 200–202, et al.) among the "saddest images I've ever seen," as they imply the artist lying in the tub alone and naked, "reviewing everything about fears and hopes and failures." For her, Johns's recent paintings have become both "more emotional and more ethereal," and their evocations of memory, time, and eros seem to connect with the feel of Nabokov stories such as *Ada* and *Speak, Memory*. Other artists also remark on the "novelistic" quality of these recent works, and Baldessari uses a filmic analogy: he sees Johns as a creator in the mold of Orson Welles or Ingmar Bergman, who used the same actors again and again "as material to do what they wanted," and he now has the sensation of watching Johns's mind come to a point "where everybody's coming on stage again for some grand finale." Moreover, where in early life Johns had been intent on purging from his art any

Fig. 23. Roy Lichtenstein.
Expressionist Head. 1980
Oil and Magna on canvas
70 x 60″ (177.8 x 152.4 cm)
Robert and Jane Meyerhoff,
Phoenix, Maryland

Fig. 24. Roy Lichtenstein.
*Trompe l'Oeil with Léger Head
and Paintbrush*. 1973
Oil and Magna on canvas
46 x 36″ (116.8 x 91.4 cm)
Private collection

Fig. 25. Roy Lichtenstein.
Mural with Blue Brushstroke.
1984–85
Acrylic on canvas
68′ ¾″ x 32′ 5 ¼″ (2074.5 x 988.6 cm)
Collection The Equitable Life
Assurance Society of the U.S.

Fig. 26. Philip Guston.
Head and Bottle. 1975
Oil on canvas
65 ½ x 68 ½″ (166.3 x 173.9 cm)
Private collection; courtesy McKee
Gallery, New York

Fig. 27. Vija Celmins.
Galaxy (Cassiopeia). 1973
Graphite on acrylic sprayed ground
12 x 15″ (30.4 x 38.1 cm)
The Baltimore Museum of Art;
Gertrude Rosenthal Bequest
Fund; courtesy McKee Gallery,
New York

trace of resemblance to the work of others, he now includes among his troupe, and quotes directly, admired forebears such as Picasso and Barnett Newman, a distant "expressionist" in Matthias Grünewald, and an unexpected interloper from craft, the American potter George Ohr. In this fashion, whereas the early work focused on anonymous, given designs, the recent paintings honor what Winters calls the "morphogenetically invented," whether in the eroticized deformations of Picasso or in abstract imagery wrested more directly from the properties of materials and processes, as in the Newman lithograph and drawings Johns owns and began to depict in 1983 (e.g. plates 193, 194, 236, 237, et al.).

If Johns since 1982 has been strongly involved with the theme of memory, he has been so in a specifically contemporary way. Winters, for example, sees these "accumulation" pictures as reinventing the notion of collage for painting in an era of digital information. Whereas Rauschenberg was the master of what Leo Steinberg called the "flat-bed picture plane," which received as a landing surface the disparate fragments of a world,[21] Johns now seems engaged with what Winters calls a "vertical collage" of window images suspended in a shallow, nonspecific space more closely related to the computer screen. There are of course more mundane linkages to the contemporary scene as well, as Johns continues both to appreciate and to influence younger artists. His long acquaintance with Vija Celmins's drawings and paintings of star-speckled night skies, for example (fig. 27), might well stand behind his recent use of the imagery of a spiraling galaxy (e.g. plates 236, 237, 239, et al.), and there are numerous elements of affinity that link Johns's "vertical collage" to artists emerging in the 1980s, such as Salle. Though Salle has obviously filtered his view of Johns through numerous other worlds of imagery inside and outside art, several aspects of his early-1980s paintings—not least the large citation of the word "Tennyson" in a 1983 painting—speak directly of Johns's model. And by 1990, the complex backgrounds and floating "window" images in Salle's imagery (fig. 28), as well as the frequent appearances of idiosyncratic pottery (fig. 29), had confirmed an unmistakable connection with more recent Johns works such as *Ventriloquist*, 1983, and the "three-handkerchief" untitled paintings of 1987.

Such particular look-alike instances may of course be ultimately of little consequence, but they help point up the enduring, and multifaceted, nature of Johns's impact. As early as the *Target* paintings of 1955 (plates 9 and 10), it was clear that his work presented a fruitfully unresolved tension between iconic wholeness and disjunctive fragmentation. As has long been evident, many artists of the early 1960s found that the head-on, iconic aspects of those early Johns works helped catalyze their art's engagement with the larger-than-life imagery and mechanically hard-edged rhetoric of American advertising and industry. But another vein of feeling extended from the mute splicing of flat sign and dismembered body in the *Targets*, and it was reinforced by the additive structures of works like *According to What* and *Untitled*, 1972. It was this latter language of disrupted fragmentation and unsettling juxtaposition that spoke so strongly to Nauman, to Baldessari, and eventually—especially through the overlapping structures of the "fragmentary" lithographs Johns derived from the *Untitled* of 1972—to Baldessari's student at CalArts, Salle.[22]

Through this deeper and broader channel, as well as by the more evident look of his 1980s paintings, Johns's essentially private aesthetic once again came to underpin a style held to evoke the rhetoric of American public life—only now, in the 1980s, the language he helped shape was no longer one of sharply defined icons and rationalized systems of production, but a converse expression that used overlaid and colliding snatches of disparate styles and levels of visual culture to evoke the Babel of media overload in the information age. In roughly the same way that the hermetic studio ruminations of Picasso's and Georges Braque's Cubism could simultaneously underpin the Constructivist vision of a newly rationalized modern order and also give Expressionism a language for modernity's explosively anarchic energies, Johns's personal inventions have been essential in our time to the generation of basic, and basically different, artistic metaphors for contemporary social experience.

Fig. 28. David Salle.
Mingus in Mexico. 1990
Acrylic and oil on canvas
8′ x 10′ 3″ (243.8 x 312.4 cm)
Collection Douglas S. Cramer

Fig. 29. David Salle.
Coming and Going. 1987
Acrylic and oil on photosensitized canvas (four joined panels)
Overall (four panels):
8′ x 11′ 1 ⅝″ (243.8 x 339.4 cm)
National Gallery of Art, Washington, D.C. Robert and Jane Meyerhoff Collection

Our awareness of this ongoing potency of Johns's art need not be limited to strict chains of "influence" nor be based on arguments of direct causation. One of the prime effects of new art and fresh viewpoints may be to awaken us to neglected potentials in the past, with or without demonstrable lines of filiation. (Johns's art, to cite a prime instance, changed awareness of Duchamp prior to, and often irregardless of, any direct or conscious connection). The originality of Nauman's art, for example, and the special contemporaneity of his work in video and installation formats, is evident; yet the large acclaim recently given to his work must have as one consequence a renewed appreciation of the not-yet-exhausted fertility of Johns's early work with words, his hybrid forms of painting and sculpture, and his basic, skeptical, and even painful combinations of the mental and the physical. As Stella points out, at a time when Johns himself has now returned to the interior of the rectangle of the painting, where he has taken up an often dreamlike illusionistic space, it is the more literal excrescences and attachments of his early paintings—the corporeal chunks, chairs, mirrors, and so on—that seem, partly through the optic of Nauman's current influence, to be of renewed importance for contemporary art. More generally, it is Johns's ability to address emotively or psychically charged and often deeply personal subjects without lapsing into a traditional romanticism or subjective expressionism

that seems now to become clearer than ever as a basis for his relevance to a wide field of creativity. And Nauman has been explicit about the lessons Johns's work gave him in this regard, citing the crucial model Johns provided for objectifying personal experience without resorting to conventional autobiographical devices.[23]

In more particular terms, the theme of the body offers one key point of connection between Johns's work and specifically contemporary concerns. Since the mid-1980s, in a period when a new consciousness of sexuality has been affected by AIDS, and when sex and gender have been put under intense scrutiny as matters of the mind and of society as well as of biology, the singularly fraught store of morbid sensuality that Johns long ago began investing in corporeal imagery seems revivified. The object-body interchanges that mark Robert Gober's art, for example— his combination of homages to Duchamp and veristic segments of torsos and limbs—move back onto territory Johns broached in the early 1960s. Similarly, Kiki Smith's sacks of flayed flesh (fig. 30), and her splayed deformation of her face (fig. 31), reawaken the climate of feeling that surrounded Johns's *Study for Skin* drawings—at the same moment when Johns himself, in the stretched and dislocated "face" he derived from Picasso and from a child's drawing, is reexploring this very terrain of epidermal distension and pyschically decentered dissociation. For Murray, these new stretched faces in Johns's work evoke a child's fascination with pulling and stretching his or her body as a possession to be tested and discovered; pushing toward that inside-outside attitude, they pass through the adult repugnance that buries such instincts and cloaks the body in clothes and willed forgetfulness. Even beyond the Freudian linkages of early pleasures and adult sufferings in this explicit "infantilism," Murray senses that such seemingly innocent trompe l'oeil devices as the standing nails and pieces of masking tape in the recent imagery may evoke "the pain of the body" and a compulsive, Band-Aid–like covering of the flesh.

Here again, we seem confronted with an instance in which a long-standing element of Johns's private and personal poetics has waited, across generations, to find a newly shared or public resonance in an altered social context. Stella observes that the sense of the body in Johns's work was distinctive and disjunctive from the first: where action painting had an element of the balletic, through which one always sensed a bodily movement continuous with a painted stroke, in Johns the hand seemed to have been disfunctionally detached from the body—literally, in the imagery of fragmentation, and more generally in the sense of a touch generated

Fig. 30. Kiki Smith.
Untitled. 1992
Latex and glass
Lifesize
Collection J. B. Speed Art
Museum, Louisville, Ky.
Gift of New Collectors
and Museum Purchase

only from the elbow down. In this way, Stella feels, Johns translated some of the disjunctions of modern choreography he saw in Merce Cunningham (and particularly in Cunningham's most unorthodox dancer, Viola Farber) into his new psychology of the body's explicit and implicit roles in painting and sculpture. More even than the evident fragments in his work, or the macabre distortions of the recent face, it is this fundamental and long-standing feel for the body as the intimate yet also objectified—and, by implication, alienated—base of all social experience that seems to speak with a fresh, undated force to a now altered consciousness of sexuality and gender. Moreover, as Bochner suggests, little that has been produced in the ostensibly sex-obsessed art of the 1990s appears to have transcended the combination of directness and disturbing fleshiness that Johns evoked by rubbing oil on his body, printing it, and dusting the stain with charcoal powder, in the early 1960s.

Fig. 31. Kiki Smith. *My Blue Lake.* 1995 Photogravure and lithograph printed in color 43 ¹¹⁄₁₆ x 54 ¾″ (110.9 x 139 cm) The Museum of Modern Art, New York. Gift of Emily Fisher Landau

At this stage of Johns's extraordinary career, in any event, it seems impossible to assess one aspect, early or late, without acknowledging the larger sense in which the personal and private quality of his decisions as an artist—whether evidently and widely influential, as in the first works, or less well understood and more seemingly hermetic, as in some of the recent imagery—has in itself established a remarkable and broadly respected model within contemporary creativity. Artists especially, regardless of their feeling for one or another phase of Johns's development, express near-unanimous respect for the way Johns has remained, as Julian Lethbridge puts it, "indifferent to the expectations or appetites" of a public. Exceptionally successful at an early age, he has formed every aspect of his art—his adoption and then peerless command of printmaking, his experiments in assemblage, his choices of new modes or new motifs—under a withering spotlight of public scrutiny. Yet the resulting body of work, as remarkable for its control and unity as it is for its scissions and variety, seems consistently controlled by a strongly grounded internal regulator. Murray admires the fact that Johns "has never claimed an ideology of any kind, or a school"; instead "he has operated alone, and invented his own place," creating an influence that "cannot—as even Pollock's can—be reduced to the decorative." Whatever its shifts in mode, and its responsiveness to change, this art has never conveyed a concern with a succession of styles—it's "not in the fashion curve," as Winters says—but has more consistently communicated the sense that, in each of its phases, "he is painting something that he needs to be painting." As Marden puts it, Johns is "the most public of painters, whose work remains the most private."

This difficult achievement has set a formidable example for Johns's peers and juniors. While many may feel, like Bochner, that the potentially debilitating stresses of his relentlessly examined career and consequent isolation should not be wished on one's worst enemy, they also feel, as Nauman does, that the experience of watching him grow and change has been a gift, of tremendous help in showing a way to go on. Seen across the years, Johns is, as Serra puts it, "a feast," a font of "colliding thoughts, a huge, continual, revolving process, picking up the pieces and dovetailing as it moves along, an evolution that like Brancusi can go back to the same problem twenty years later, a person who hasn't closed the sequence." When asked

what about Johns has meant most to him, Baldessari replies, "The high seriousness of his work"; he likens that work to Giacometti's, in the sense that an incessant and often self-repeating attack on the problem at hand seems fueled, in both cases, by a drive to get at some "essentiality." Baldessari adds, "There are very few people I have ever thought so believe that art can do something, that something can be found." Close in turn speaks both personally and in echo of Baldessari and so many others when he asserts, "More than any single artist, Jasper Johns is the model for me of how you function as an artist and have a career." Not the least aspect of this is the recognition that, in the mid-1990s, "the search is still on; he's still moving."

These are hardly just testimonials to earnest persistence. To a degree that still needs further clarification, and certainly broader awareness, Johns's presence can be felt at or near the origin point of virtually every generative idea of importance in avant-garde painting and sculpture in America for four decades. Since, as Lethbridge puts it, "the doing of one thing almost always sets up the condition of not doing it" for someone else to explore, it seems almost impossible for one artist to "cover so many bases" as Johns has. Part of his ability to do so, and for so long, may stem paradoxically from what Barbara Rose has stressed as the insistently "conservative" aspect of his work.[24] In an age of fast takes and boundary-breaking experiment in diverse mediums, he has worked to slow perception down, defeating the quick read and rewarding the up-close, contemplative view. Whether working with bronze and encaustic or incorporating the illusion of pictorial space, Johns showed painters like Marden and Winters how one could produce works of potent sophistication and contemporary impact while remaining in touch with venerable traditions. Yet "conventions," as Stella recognizes, "are not necessarily conservative," and Johns is "like a bulldog: he won't give up until he explodes it. He turned painting inside out." In Stella's analysis, Johns's ongoing centrality these past forty years is grounded in the basic formal concerns of his art. Since Pollock, Stella believes, the prime dilemma for art has centered on the relationship of literalism and illusionism: "The literal is very compelling, but without some illusion it's dead. Illusionism defines pictoriality, it's a physical thing that generates power and presence; the literal is just a structure." Johns, he feels, "is the one who has leaned hardest on this problem." Bochner's view, while more differentiated and concerned as well with subject focus, leads to a similar conclusion. Bochner sees three prime streams of activity, or driving principles, in art since the mid-1950s: a literalist emphasis; a focus on popular culture or on culture itself as a subject, in Conceptual art as well as in Pop; and a language-based art. (When prodded, he adds a fourth: the body, and especially the "dark side" of eros.) For all these streams, he feels, "when you trace back, you run out of water at Johns. It goes into the ground there; that's the source."

Within a tradition of modern art seemingly based on notions of revolution and the constant overthrow of the past, there may be no more fundamental problem for individual innovators than that of finding a way to evolve and grow. What seems demanded is a potent originality, a distinctive "signature" manner or strategy or gamut of materials, subjects, and actions that belong to oneself alone; but a matching and merciless requirement is that, under pain of marginalization or gentle

obloquy, one never be confined by such singularity to mere stasis or repetitiveness, but remain responsive to one's time and to unceasing change. This was in one sense the dilemma of public perception suggested by the little fire cartoon Johns saw in 1960. But the problem may appear under a very different aspect for the modern artist himself or herself: how is one—in disregard for public validation if need be—to sustain a career of creativity, remaining true to one's private sense of art and one's finest early ambitions, without declining into self-imitation or a comfortably varied tilling of familiar soil? Two years after the quip that caught Johns's eye in regard to Duchamp, the same cartoonist returned to the subject in a way perhaps even more pertinent to Johns, and to the larger issues his fellow arists raise in discussing him. This time the inventive caveman himself speaks, no longer smugly reclining on his laurels but anxiously toting fuel logs, and airing a primal anxiety: "Now that I've discovered it," he says to the awestruck onlooker, "I keep worrying that the damn thing will go out" (fig. 32).

Some have argued, and loudly, that it has been our fate to live in an age of extinctions, and that what Johns ignited when he sparked Pop and Minimalism was the beginning of the great burn-down of modernism, a process by which all the former ideals and exclusivities of the age of Picasso, Henri Matisse, Pollock, et al. went up in smoke, leaving us eventually in a postmodern endgame of polyglot and decentered pluralisms with no sustaining core of heat. Whatever truth this view may bear for the epoch, however—and I suspect it is little—it seems absurdly inappropriate for Johns, one of the period's central figures. As a beacon or *phare*, in Baudelaire's sense of the term, Johns has illuminated a new understanding of the possibilities of earlier modern art, not simply by reviving the previously marginalized legacy of Duchamp, but by showing that this strain of inquiry—supposedly so antithetical to and incommensurable with the more traditional mainstream lineage of Cézanne and Picasso—can be grafted together with its apparent opposites to produce a hybrid of potent fertility. By a range of such personal fusions and reinventions, Johns has opened up new avenues of growth and development for these achievements of the past, transforming not only our sense of what they contained but of what they might still yield. When I reinstalled the permanent-collection galleries of painting and sculpture in The Museum of Modern Art in 1993, I arranged a room in which Duchamp's *Bicycle Wheel* was juxtaposed with Picasso's sheet-metal *Guitar*, and Duchamp's *3 Standard Stoppages* faced off against a group of Picasso's collages. I did this not simply because these objects are in fact contemporaneous (all dating from 1913) but because it seemed, since the advent of Johns's art and its influence, no longer possible to think of the early roots of modernism without recognizing that this early confrontation—this bifurcated, constantly challenging argument of differences— is both central to what modern art was at its outset and a necessary precondition for the ongoing arguments and innovations of its traditions as we have experienced them in our time. In thus altering the traditional MoMA installation that had isolated Cubism from Dada, I was aware then and acknowledge now that, in no simple or facetious sense, Johns "made me do it."

Fig. 32. Cartoon by Robert Kraus. *The New Yorker*, September 8, 1962

"Now that I've discovered it, I keep worrying that the damn thing will go out."

More important than revisions of history, though, have been Johns's immensely varied consequences in the present. The essential domains of contemporary feeling that have been germinated, catalyzed, or sustained by this artist's work are amazing in their breadth and their contradictory variety—the languages of public life and private meditation, the voices of authority and doubt, the poetries of sensuality and suffering, the imperatives to thought and feeling alike. How much, then, all these varied markers suggest we still have to learn about this still-young old master of contemporary creativity, and how much more may yet come from him. What's peculiar about fire is that it's always been a social matter, not just a personal one. Its tending and its scattering may thus be complementary, not opposed; for the more it's used, the more there is that's burning, and the more that's taken from it, the greater its incandescence.

Notes

1. Jasper Johns, "Duchamp," *Scrap* (New York) no. 2 (December 23, 1960): [4] (note).

2. I held discussions for this article with the following artists: John Baldessari, Mel Bochner, Chuck Close, Julian Lethbridge, Roy Lichtenstein, Brice Marden, Elizabeth Murray, Bruce Nauman, Ed Ruscha, Richard Serra, Frank Stella, and Terry Winters. Only Serra's remarks were taped; the other quotes are taken from notes. I also communicated with Robert Morris via telefax, and his remarks are transcribed as written.

3. See Roni Feinstein, "Random Order: The First Fifteen Years of Robert Rauschenberg's Art, 1949–1964," unpublished Ph.D. dissertation, Institute of Fine Arts, New York University. See especially chapter 5, "Rauschenberg and Johns," pp. 234–69.

4. Nauman, quoted in Coosje van Bruggen, *Bruce Nauman* (New York: Rizzoli International Publications, Inc., 1988), p. 23.

5. In a text published in *Art Now: New York* 3 no. 1 (1971), n.p., Marden wrote of this painting:

When I talk with my son he often asks "are you still painting those grey rectangles?"
Canvas size and shape taken from Johns' *Screen Paintings*
I have worked with many greys, not studying them, using them. Greys move around within themselves as they tend toward other colors. These greys don't, they had to stay grey. The problem was to get color using only these stone cold greys; values. It was a bitch because it kept being value and not going to color. It finally went to color. When it got up on a wall it made me very happy to see it.
Jasper Johns paintings showed me paint dispersed on a surface being a surface, much about Cézanne, and has me always asking about realities.
I find it difficult to paint. It is harder not to paint but even harder to paint when you aren't painting.

Painting says pain in it.
Never dare think you're on top of grey.

6. Rauschenberg offered "a lot of ideas about the outside world," as Stella puts it, whereas the ideas Johns offered were "more about making art in the studio."

7. This quotation is Nauman's remark to me, but he made the same analogy, in slightly expanded form, in his earlier discussion with van Bruggen, who writes, "The influence of Duchamp on Nauman was channeled through his understanding of the work of Jasper Johns. As Nauman puts it: 'It's sort of like my understanding of Freudian philosophy, which is probably a very American version of it coming through [William] Faulkner. It's no longer from Freud, but digested and rearranged.'" Van Bruggen, p. 23.

8. Discussing Nauman's early body-cast pieces in relation to Duchampian precedents, and drawing on direct conversations with Nauman, Neal Benezra has written, "Although Nauman scarcely knew the work of Marcel Duchamp at this point, the spirit and essential character of pieces such as [Duchamp's] *With My Tongue in My Cheek* (1959) were conveyed to the young artist indirectly through Jasper Johns. Nauman was fully conversant with Johns' work; pieces such as *Target with Plaster Casts* (1955), with its small, fragmented body parts, were of great importance for him. While Duchamp is often credited as a crucial influence on Nauman, the lighthearted intellectual gamesmanship of the French artist was, in fact, much less important than the restrained psychological tension underlying Johns' work at this point." From Benezra, "Surveying Nauman," in Joan Simon, ed. *Bruce Nauman*, exh. cat. (Minneapolis: Walker Art Center, 1994), p. 24.

9. Gerhard Richter, for example, has said, "Johns retained a culture of painting, which also has something to do with Paul Cézanne, and I rejected that. That's why I even painted photos, just so that I would have nothing to do with *peinture*: it stands in the way of all expression that is appropriate to our times." Richter, quoted in Benjamin Buchloh, "Interview with Gerhard Richter," trans. Stephen P. Duffy, in Roald Nasgaard, *Gerhard Richter: Paintings*, exh. cat. (Chicago: Museum of Contemporary Art, and Toronto: Art Gallery of Ontario, 1988), p. 18.

10. Johns, quoted in G. R. Swenson, "What is Pop Art? Part II," *Artnews* 62 no. 10 (February 1964): 66.

11. In 1965 Johns told David Sylvester that "one also thinks of things as having a certain quality, and in time these qualities change. The Flag, for instance, one thinks it has 48 stars and suddenly it has 50 stars; it is no longer of any great interest. The Coke bottle, which seemed like a most ordinary untransformable object in our society, suddenly some years ago appeared quart-sized: the small bottle had been enlarged to make a very large bottle which looked most peculiar except the top of the bottle remained the same size—they used the same cap on it. The flashlight: I had a particular idea in my mind what a flashlight looked like—I hadn't really handled a flashlight, since, I guess, I was a child—and I had this image of a flashlight in my head and I wanted to go buy one as a model. I looked for a week for what I thought looked like an ordinary flashlight, and I found all kinds of flashlights with red plastic shields, wings on the sides, all kinds of things, and I finally found one that I wanted. And it made me very suspect of my idea, because it was so difficult to find this thing I had thought was so common. And about that old ale can which I thought was very standard and unchanging, not very long ago they changed the design of that....it turns out that actually the choice is quite personal and is not really based on one's observations at all." Interview with Sylvester first broadcast on the BBC on October 10, 1965, and published in *Jasper Johns Drawings* (London: Arts Council of Great Britain, 1974), pp. 7–8.

12. "More even than in Pollock's case, [Johns's] work was looked at rather than into and painting had not done this before. Johns took painting further toward a state of non-depiction than anyone else. The Flags were not so much depictions as copies, decorative and fraudulent, rigid, ridiculous counterfeits. That is, these works were not depictions according to past terms which had, without exception, operated within the figure-ground duality of representation. Johns took the background out of painting and isolated the thing. The background became the wall. What was previously neutral became actual, while what was previously an image became a thing." Morris, "Notes on Sculpture, Part 4, Beyond Objects," *Artforum* 7 no. 8 (April 1969): 50. Quoted in *Robert Morris: The Mind Body Problem*, exh. cat. (New York: Solomon R. Guggenheim Museum, 1994), p. 132.

13. Stella told me that the connection between his striped paintings and Johns's *Flag* was first driven home to him by a painting teacher, who inscribed "God Bless America" across the top of one of Stella's paintings in progress.

14. Stella remarked "What you see is what you see" on a radio program on WBAI-FM, New York, in 1964. The text of the program is printed in Lucy R. Lippard, "Questions to Stella and Judd," *Artnews* 65 no. 5 (September 1966): 55–61. It also appears in Gregory Battcock, ed., *Minimal Art: A Critical Anthology* (Berkeley, Los Angeles, and London: University of California Press, 1968), p. 158. The artist who talked of Stella's "brilliant misreading" of Johns with me was Mel Bochner.

15. Marden, "Statement and Photographs Submitted in Partial Fulfillment of the Requirements for Master of Fine Arts Degree," May 1, 1963, unpublished. Courtesy Brice Marden.

16. See Bochner, "Serial Art Systems: Solipsism," *Arts* 41 no. 8 (Summer 1967): 39–43, and "Serial Attitude," *Artforum* VI no. 4 (December 1967): 28–33. "Serial Art Systems" is reprinted and revised in Battcock, pp. 92–102.

17. Nauman, in Simon, "Breaking the Silence: An Interview with Bruce Nauman," *Art in America* 76 no. 9 (September 1988): 142, quoted in Kathy Halbreich, "Social Life," in Simon, ed., *Bruce Nauman*, p. 95.

18. For several references to Johns's impact on Bochner, see Richard S. Field, *Mel Bochner: Thought Made Visible 1966–1973* (New Haven: Yale University Art Gallery, 1995). In his introductory essay to this catalogue, Field writes, "Not only had Johns's 1964 exhibition at the Jewish Museum made an indelible impression on the young Bochner, but so too did the unfolding of Johns's character and its attendant moral imperatives. It was Johns's deep skepticism, his intractable commitment to 'impure situations' where one kind of idea played against another, his attraction to rudimentary subjects and systems ('things the mind already knows'), his fascination with language and the impossibility of describing visual situations accurately, his shifting the burden of meaning onto the viewer, and his constant challenges to received ideas about painting and sculpture, that make Bochner his true progeny" (p. 9). Farther on, Field notes, "Throughout Bochner's work there is a fascination with the idea of discontinuity, an incongruity between concept (language) and experience; it is an idea Bochner found to be central to Jasper Johns's work, as well" (p. 49). In an appended note (p. 72), Field expands: "There is a sketchbook of 1966–68 that is filled with notes for an essay on Jasper Johns, specifically on his drawing *0 Through 9*. In essence it aimed to record Bochner's debt to Johns's notion of discontinuity. 'The parameters of what is there to be seen are pre-set by the procedures necessary for realization…We are unconsciously forced into perceiving it with the techniques usually reserved for reading. The image is neither flat nor spatial. The numbers being "not objects" we are at a loss to place them in context or view them as depictions.…Johns employed in an art context, I believe, "reading" of images along with the entire set of implications of retrievable *a priori* logic patterns.'"

19. In her essay "Language Is Not Transparent," in Field, Jessica Prinz notes that Bochner made a "portrait" of Johns that reflected his notion of this negativity in Johns's methods of execution: "Related to Bochner's thesaurus portraits is a meditation on Jasper Johns that combines words and drawing [*Untitled (Portrait of Jasper Johns)*, 1966–67]. The squiggle in Bochner's drawing is a reference to Johns's ubiquitous and 'entropic' M-shaped brushstroke (e.g. *Map*, 1961). Establishing a relationship between image and word, Bochner labels the squiggle's first appearance 'meaningless'; stated a second time, it becomes 'gratuitous'; stated the third time, it is 'repetitious'; and by the fourth time, it is 'redundant.' The whole drawing is crossed out by a large X in an hommage to Johns's own nihilism (*No* and *Liar*, 1961)" (p. 197). Prinz goes on to note the reference of the dripping elements in Bochner's *Language Is Not Transparent* wall drawing to the facture of Johns's painting.

20. See Mark Rosenthal, *The Robert and Jane Meyerhoff Collection: 1945 to 1995*, exh. cat. (Washington, D.C.: National Gallery of Art, 1996), p. 113.

21. See Leo Steinberg, "Other Criteria," *Other Criteria: Confrontations with Twentieth-Century Art* (New York: Oxford University Press, 1972), pp. 55–91.

22. For a discussion of Salle's interest in Johns's prints, see Lisa Liebmann, *David Salle*, ed. David Whitney (New York: Rizzoli International Publications, Inc., 1994), pp. 18–19.

23. Nauman was particularly informed by Johns's *According to What*, which was for many years in a private collection in Los Angeles. Van Bruggen writes, "Nauman cites especially the inclusion of a cut-open, upside-down chair with a cut-open cast of a human leg sitting on it in Johns's painting *According to What*, 1964. In this work the interior of the cast and the inside of the chair face the viewer. According to Johns, 'if the chair were in the position with which we usually associate it, what would be absent would be too important in the fragment of the figure.' The act of making that kind of displacement in order to focus one's attention differently, as well as Johns's idea that 'through thought or through accumulation of other thoughts, something that's very charged can lose its charge, or vice versa,' confirmed for Nauman his use of the tension between what is told and what is deliberately withheld, as well as his own attempts to objectify his experiences rather than leave autobiographical traces in the work." Van Bruggen, p. 23.

24. In the context of debts to old masters, subject matter, and structure, Barbara Rose concludes that Johns "is essentially a very conservative artist." Rose, "To Know Jasper Johns," *Vogue*, November 1977, p. 323.

Jasper Johns's early childhood was spent in a small-town environment in the South during the Great Depression of the 1930s. His parents' marriage dissolved shortly after his birth, and he grew up primarily in the homes of relatives. A penchant for drawing brought him welcome attention, and—with virtually no reinforcement from contact with any actual paintings or painters—the fantasy of a life in art began to appeal to him as something wonderfully remote from his own circumstances. Throughout his early education (during which he also developed a strong affinity for poetry), Johns aimed at becoming an artist. In New York City after army duty, at the age of twenty-four, he resolved to cease becoming, and instead to *be*, an artist. He then destroyed virtually all his prior work, and set out to expunge from his art any trace of resemblance to the styles of other artists. The few surviving objects from 1954 suggest waning affinities with the art of Kurt Schwitters and Joseph Cornell, but also announce an original alloy of methodical logic and private compulsion. A gridded system of close-variant forms,[1] collage covered with paint, a cast face, an iconic sign—all these Johnsian elements had already appeared before he made his breakthrough painting, *Flag*, in 1954–55.

Flag entailed a layered overpainting of collaged strips of newspaper. In the course of making it, Johns switched from enamel house paint to a wax-based encaustic that dried more quickly, allowing him to overlay strokes in swift succession and still keep each distinct. With this method, Johns went on to paint other flags, then targets and single numbers—all flat signs of common public occurrence that appealed to him, he said later, as "pre-formed, conventional, depersonalised, factual, exterior elements,"[2] "things which are seen and not looked at, not examined."[3] Johns described the densely worked surfaces of these pictures as "a sum of corrections." They showed, he felt, a concern with "accuracy"[4]—the work of "a young person who wanted to do something worthwhile, something with more rigor to it."[5] By making some *Flag* images in three separate panels, and by painting the side edges of several works, Johns stressed the paintings' physical presence as objects. This emphasis combined with the intellectual and perceptual dilemma posed by the coidentity of the depictions and the things depicted to produce a sensually

compelling and mentally jarring experience. Some of the flags and targets showed the expected primary colors, but others were monochrome green, gray, or white, increasing the degree of abstraction and the sense of an elusive, embedded image.

An air of Surrealism surrounded the colored plaster-cast body fragments set in lidded boxes atop the first two target pictures, then dispersed as Johns focused more exclusively on flat signs. But at the same time he started making enigmatic little sculptures—a flashlight, a light bulb—in Sculp-metal. And he made the paintings more complex in other ways: situating flags within expanded fields, and treating alphabetic and numeric sequences in grids, he introduced implications of space and time. Actual objects inserted in the paintings annexed the area in front of the canvas, and sometimes—as with a drawer, or reversed painting stretchers—also showed a preoccupation with the space behind. These elaborations expanded into another sphere when Johns began including words ("Tango," in 1955, "The," in 1957) in his pictures. *Tennyson*, of 1958, encompasses some of the rapid-fire changes: the canvas flap over the two panels suggests occlusion, while the bare strip at the bottom insists on the layered artifice of the surface; and the poet's name colors the gray monochrome with literary, elegiac associations.

For three years, this evolution was observed only by Robert Rauschenberg, who was closest to Johns, and by a few other artist friends. In January 1958, however, Johns had his first solo exhibition at the fledgling Leo Castelli Gallery. A target painting appeared on the cover of *Artnews*, The Museum of Modern Art acquired three of his works, and his art became widely discussed. It was seen as a revival of Dada, and analyzed as both the extension of and an attack on the formal strategies of Abstract Expressionism.

In *Numbers in Color*, begun that year and finished the next, we can see the taciturn solidity of the early imagery begin to come apart. The disparate colors often used in individual numbers, and the signs of a more general dissociation of color from structure, make for a jumpily fragmented, optically bewildering image field, where the dilemma of dominance between figure and ground, or between delineating touch and abstract stroke, becomes more extreme.

—*KV*

Chronology

COMPILED BY LILIAN TONE

This chronology compiles and consolidates information published in the Jasper Johns literature. Whenever possible, it also brings forth new information and attempts to resolve inconsistencies by reconciling these secondary sources with primary documentation available in the Leo Castelli Gallery Archives, New York; the Universal Limited Art Editions Archives, West Islip, New York; the John Cage Archive, Music Library, Northwestern University, Evanston, Illinois; and elsewhere. Johns's own files were unavailable for consultation, and the information presented here is limited to whatever could be gathered without access to them.

An attempt has been made to list every painting produced during each year of Johns's career through 1995, providing information on their dates of completion whenever possible. The principal source for the sequence of the works' completion was Roberta Bernstein's "Chronological List of Johns's Paintings and Sculptures, 1954–1974," published in her *Jasper Johns's Paintings and Sculptures 1954–1974: "The Changing Focus of the Eye"* (Ann Arbor: UMI Research Press, 1985). Also instrumental were the Leo Castelli Gallery Registry and Johns's records. Information on where each painting was made was generously and patiently provided by the artist. Drawings are listed whenever details could be determined beyond their year of completion; more precise dates, including month, day, and place of execution, are based on the artist's inscriptions on the works.

Many of Johns's works share titles or are untitled. To help the reader to identify them, works mentioned in the chronology may be identified by a plate number, if they are reproduced in the present volume's plate section; by an "LC" number, in reference to the registry numbers used by Johns's gallery, the Leo Castelli Gallery, New York; or, in the case of prints, by a "ULAE" number, corresponding to the catalogue number in *The Prints of Jasper Johns 1960–1993: A Catalogue Raisonné* (West Islip: Universal Limited Art Editions, Inc., 1994). Works that are clearly identifiable by title and date are not classified in any of these ways.

General information, including the dates of completion of Johns's works, that cannot be dated precisely within a given year appears listed at the beginning of that year. The spans of the seasons are understood as follows: winter, January–March; spring, April–June; summer, July–September; and fall, October–December. When a date or span of dates is enclosed in square brackets, it is speculative, and remains unconfirmed by substantive documentation. Approximate dates are preceded by "c.", for "circa."

Quotations in italic type are Johns's.

Exhibitions are listed only selectively. A full exhibition history, compiled by Adrian Sudhalter, is forthcoming as an electronic publication.

In the plate section, information on title, date, medium, and dimensions is given as in Johns's records, unless corrected or complemented by the artist, by the work's current owner, or, for some works on paper, by updated information found in Nan Rosenthal and Ruth E. Fine, with Marla Prather and Amy Mizrahi Zorn, *The Drawings of Jasper Johns*, exh. cat. (Washington, D.C.: National Gallery of Art, and New York and London: Thames and Hudson, 1990). Dimensions are given in inches (or, when they include a measurement over ten feet, in feet and inches), followed by centimeters in parenthesis; unless otherwise noted, height precedes width, followed, when applicable, by depth. For drawings and prints, the dimensions correspond to the size of the support, rather than to the size of the composition, unless followed by the word "sight."

1930

May 15: Birth of Jasper Johns, Jr., in Augusta, Georgia. Only child of William Jasper Johns (1901–57), a farmer and former lawyer,[1] and Jean Riley Johns (1905–92, born Meta Jeanette Riley, in Barnwell, South Carolina), who live in an apartment on School Street in Allendale, South Carolina.[2] Johns is born in Augusta probably *because it was the hospital nearest Allendale.*[3]

1932

In 1932 or 1933, Johns's parents divorce, and he is sent to live with his paternal grandfather,[4] William Isaac Johns (1869–1939, born in Ehrhardt, South Carolina), a Baptist farmer who lives with his second wife, Montez B. Johns, on Main Street in Allendale.[5] Johns remains there for the next five years or so, in an environment he later describes as *entirely Southern,*

small-town, unsophisticated, a middle class background in the Depression years of the thirties.[6] His father, who continues to live in Allendale, sees him sporadically.

[My grandfather] had a number of crops. I remember cotton, melons, asparagus....Occasionally I'd drive with my grandfather to look at his fields, and I was completely mystified how he would know what this green stuff was. He would be very excited about the cotton or melons or rye just coming up, and I couldn't understand how he could tell one thing from another.[7]

I had had a grandmother who died before I was born who had made some pictures, and these were in homes of various relatives. They were like swan on a creek, or crane standing in water, or cow in meadow...something like that, and I have the suspicion that they were copied, but I don't know. Those were the only paintings I ever saw, real paintings, as a child.[8]

Left, left to right: Johns's uncle Wilson, father William Jasper, grandfather W. I., aunt Gladys, grandmother Evaline, and aunt Eunice, in a family portrait. Above: W. I. Johns's house in Allendale, S.C.

1933

I started drawing when I was three, and I've never stopped.[9]

1934

April 17: Johns's mother marries Robert Earl Lee, later an Internal Revenue Service agent.[10] Johns continues to live with his grandfather.

1935

I'd wanted to be an artist from age five. No one in my immediate family was involved with art (I had a grandmother who painted, though I never knew her), but somehow the idea must have been conveyed to me that an artist is someone of interest in a society. I didn't know artists, but at an early age I realized that in order to be one I'd have to be somewhere else.[11]

Once an artist came through Allendale and boarded, I suppose, with my grandparents. He decorated the mirrors of the Greek restaurant with birds and flowers. I stole some paints and brushes from his room. It didn't occur to me that he could miss the things I took—he had so much! But he did. Not knowing that oil paint wouldn't mix with water, I made a mess before his materials were returned to him by our cook.[12]

January 31: Birth of half-sister Alexandra Lee (later Wells).

1936

I do remember being six, and having a party in my grandfather's garden, behind the house.... After the cake and things, we all went to the movies [where children under 6 were admitted free]. For the first time, I got to pay....Lots of guests couldn't.[13]

[Summer]: Enrolls in Allendale Elementary School, where his aunt Eunice Johns Warren (later Mrs. J. Carl Kearse) is principal.[14]

Sometime between 1936 and 1938, Johns's father remarries.[15]

1937

In 1937 or 1938, spends about a year living in Allendale with uncle Wilson R. Johns and his wife, Lib, who have twins, Betty and Bill, the same age as Johns.[16] Then he returns to his grandparents,[17] with whom he remains until 1939.

1938

February 14: Birth of half-sister Owen Riley Lee.

1939

May 7: Johns's grandfather dies in Allendale, of coronary thrombosis, at age seventy-one. Burial takes place the following day.[18] To his widow (Montez Johns) and children (Wilson R. Johns, Allendale; William Jasper Johns, Allendale; Gladys Johns Shealy, Lexington; Eunice Johns Warren, Allendale; Martha James, Greenwood; and Virginia Johns, Columbia, all in South Carolina), he leaves several thousand dollars in "livestock, farming implements, etc."[19]

After his grandfather's death, Johns lives in Columbia for a year with his mother, stepfather, and half-sisters. Attends A. C. Moore Elementary School.[20]

1940

[Summer]: After finishing the school year, Johns moves in with aunt Gladys Johns Shealy (Mrs. Francis W. Shealy), who lives near Lake Murray, South Carolina, in an isolated section called The Corner (now part of Batesburg-Leesville).[21]

It was very rural—no telephone, no electricity at first. I had no sense of the world, and still have very little of it.[22]

Johns will remain in The Corner until his senior year in high school. During this time, his mother will move from Columbia to Rock Hill, then to Orangeburg, and then to Sumter, South Carolina.[23]

Fall: Attends a two-room school called Climax, where his aunt teaches all grades.[24]

1942

In Savannah, Georgia, in a park, there is a statue of Sergeant William Jasper. Once I was walking through this park with my father, and he said that we were named for him. Whether that is in fact true or not, I don't know. Sergeant Jasper lost his life raising the American flag over a fort.[25]

Fall: Still living with his aunt, enrolls in Batesburg-Leesville Consolidated High School, in Batesburg (now Batesburg-Leesville). He will remain a student there until spring 1946.

1943

September 14: Birth of half-brother Robert Earl Lee, Jr.

As a teenager, c. 1946–48.

1946

[Summer]: Moves to Sumter (401 W. Hampton Avenue) to live with his mother, stepfather, and half-siblings.

Fall: For high school senior year, enrolls at Edmunds High School, Sumter (now Sumter High School),[26] where he will take courses on mechanical drawing and on art, each for one semester.

1947

June: Graduates from Edmunds High School as valedictorian.[27]

Color guard at Edmunds High School, Sumter, S.C., c. 1946–47, with Johns at left.

[Summer]: Moves back to Columbia, where he lives by himself. While there, he makes one visit each to his father and to his mother.[28]

September: Starts attendance at the College of Arts and Sciences, University of South Carolina, Columbia.[29] Studies art under Catharine Phillips Rembert,[30] Augusta Rembert Wittkowsky Walsh, and Edmund Yaghjian, who will encourage him to move to New York. During these "early days, in Columbia," Rembert later recalls, "Jap [Jasper] came every night to help cook supper. He was writing poetry."[31] She also remembers, "Anywhere you saw Jap he was sketching. We went to the beach on a trip with several other students and found Jap sketching on the beach."[32]

1948

December: Quits University of South Carolina before graduation, after three semesters there. According to Catharine Rembert, "He left for New York because he wanted to study more art and he had exhausted what USC had to offer.... Friends recall that his uncle gave him a large sum of money the night before he was to leave for New York in the late 1940s. He went to the S.C. State Fair and mysteriously lost the money."[33]

Moves to New York, living off the sale of some land inherited from his grandfather.[34] His first address is at 126th Street and Riverside Drive in Manhattan.[35] Not long after, he moves to Long Island, then back to Manhattan—first to a hotel near Columbus Circle, then to the West 60s.[36]

1949

I remember the first Picasso I ever saw, the first real Picasso....I could not believe it was a Picasso, I thought it was the ugliest thing I'd ever seen. I'd been used to the light coming through color slides; I didn't realize I would have to revise my notions of what painting was.[37]

Visits the annual exhibitions at the Whitney Museum of American Art (then at 10 West 8th Street), and for the first time sees works by Jackson Pollock, Isamu Noguchi, and Hans Hofmann.[38]

[January–June]: Attends Parsons School of Design.[39] His classes include life drawing, anatomy, color theory, and design.[40]

[Summer]: Interrupts his studies at Parsons due to financial difficulties.

> Then I went broke and needed a scholarship. The head of the school said [s]he'd give me one because a teacher of mine from the University had recommended me. "But you don't deserve it," [s]he told me. So I turned it down. The head of the school said: "If you refuse this, you'll never be a painter."[41]

[Summer 1949]–May 1951: Works as a messenger boy and a shipping clerk.[42]

In Columbia (?), S.C., c. 1951–52.

1950

Between June 30 and August 13: Visits the exhibition "Edvard Munch," at The Museum of Modern Art.[43]

Between October 24 and November 11: Visits an exhibition of Jacob Lawrence's *Hospital* paintings at the Downtown Gallery (32 East 51st Street), New York.[44]

Between November 28 and December 16: Visits a Jackson Pollock exhibition at Betty Parsons Gallery (15 East 57th Street), New York.[45]

1951

Between April 23 and May 12: Visits Barnett Newman's one-person show at Betty Parsons Gallery, New York.[46]

May 25: Drafted into the army.[47] Is inducted in Columbia, South Carolina, and is later transferred to nearby Fort Jackson, where he will remain stationed for about a year and a half. Here he develops

In Pawleys Island, S.C., c. 1951–52.

an art exhibition program for the soldiers. Visits New York whenever possible.[48]

November: According to the *Columbia Museum of Art News*, "Private Jasper Johns…has activated a cultural center at the Fort by organizing a series of art exhibits by Columbia artists at the Cultural Center in Carlisle Hall. The first has been a show of smashing paintings of John Rast."[49]

December: The Columbia Museum of Art, which has opened in March of the previous year, makes the facilities of its Richland Art School available to Fort Jackson personnel: "The need for the services the Museum has to offer to soldiers in the vicinity of Columbia is evidenced in their constant attendance and requests. The Museum, consequently, proposes to extend those services by offering…its Richland Art School facilities on the weekends for creative talents."[50]

The Museum also creates a Fort Jackson Gallery, dedicated to the display of art produced by Fort

Johns, standing at right, in Fort Jackson, S.C., c. 1951–52. U.S. Army photograph.

Jackson personnel: "As the first instance of this type of a city museum making available to members of the armed forces an art gallery devoted to their sole use, your Museum has marked another milestone and established a national precedent. The small blue room to the right at the top of the staircase has been freshly lighted, and bi-weekly exhibits of the art work of Fort Jackson's soldiers will be shown there."[51] Major General Harold John Collins, commander of the Eighth Infantry Division at Fort Jackson, asks Johns to run this gallery. During his time here, Johns will organize numerous exhibitions of painting, architecture, ceramics, sculpture, photography, landscape architecture, and theater design.[52]

1952

Produces his earliest recorded works, of which two drawings survive: *Idiot* (now in the Columbia Museum of Art) and *Tattooed Torso* (now in the Philadelphia Museum of Art).

February: From that month's *Columbia Museum of Art News*: "One of the most active groups to use [the Richland Art School] are the soldiers from Fort Jackson. Space and materials have been theirs for the asking; and they form one of our most congenial groups, mixing with other students and generally 'feeling at home.' Many of the exhibits in their Fort Jackson Gallery have been created at the School, often in the wee hours of the weekend mornings. Here are some of the soldier artists whose works have been on view recently:...Pvt. Jasper Johns, Sumter, S.C."[53]

April: Bruno Bettelheim's article "Schizophrenic Art: A Case Study" is published in *Scientific American*, featuring drawings by a child. Almost forty years later, Johns will start using a drawing that Bettelheim reproduces, "The Baby Drinking the Mother's Milk from the Breast," in paintings and prints.[54]

Between April 4 and May 18: Visits the exhibition "Cézanne: Paintings, Watercolors and Drawings," at the Metropolitan Museum of Art, New York.[55]

[December 1952–May 1953]: During the Korean War, is stationed in Sendai, Japan, about 200 miles north of Tokyo. Assigned to Special Services, he makes posters to advertise movies and to educate soldiers on how to avoid sexually transmitted diseases. He also works on decorations for a Jewish chapel begun by another soldier.[56]

While based in Sendai, Johns visits a Tokyo exhibition of works by Dada- and Surrealist-inspired Japanese artists. *It was very entertaining. One work I remember was a woman's glove hanging from a pedestal, held in place by a preserved elephant's foot that rested on one finger of the glove.*[57]

Yoshiaki Tono will later write that during this stay in Japan, Johns "happened to find [an Edgard Varèse] record in a local coffee shop, and listened to it on every day off, until the record was worn out."[58]

1953

May 5: Is discharged from the army in Fort Jackson, with the rank of private first class.[59]

[Summer]: Moves back to Manhattan, where he lives on East 83rd Street in a *tiny railroad apartment...painted egg-yolk yellow.*[60]

Meets the artist Sari Dienes, who has a studio at 57 West 57th Street. He occasionally helps Dienes with her work of "urban frottage": *She went around making rubbings of the streets in the early hours of the morning with sheets of paper twelve feet or longer. They were rubbings of manhole covers and things like that.*[61]

Sari Dienes, *Marcy*, 1953, ink on fabric, 72 x 36". Collection Sari Dienes Foundation, Inc.

[September]: Enrolls at Hunter College on the G.I. bill. Quits after first day of classes.[62]

When I came back I thought I really didn't know much, so I'd go to school on the G.I. bill. I enrolled at Hunter and assumed I was going to the Park Avenue branch. But no—that was only for girls then, and I had to go up to the Bronx. The first day I had a class in Beowulf, then a French class in which I couldn't understand a word and then an art class in which a handsome, red-haired lady in a hat told me I drew a "marvelous line." Near home, I passed out on the street. I was rescued and stayed in bed for a week and that ended my career in higher education.[63]

[Fall]: Works as a night-shift clerk at Marboro Books, on West 57th Street near Carnegie Hall.[64]

Late fall, or early January 1954: Just after work one night, on the corner of Madison Avenue and 57th Street at around ten or midnight, Johns runs into the writer Suzi Gablik, one of the few people he then knows in New York, with another writer and Robert

Rauschenberg, whom Gablik had met at Black Mountain College, in North Carolina.[65] For Johns, Rauschenberg is to become *the first person I knew who was a real artist*.[66]

1954

Makes graphite drawings based on dried oranges (see plate 2).[67]

[Winter]: Moves from East 83rd Street to East 8th Street and Avenue C.[68] Meets Rauschenberg again, and for the first time the composers John Cage and Morton Feldman, during parties at Dienes's studio.[69] While still working at Marboro Books, continues to paint in his spare time, and starts to help Rauschenberg make objects for use in store-window displays.[70]

January 20: Attends a performance of the Merce Cunningham Dance Company at the Brooklyn Academy of Music. The program consists of Christian Wolff's *Suite by Chance*, Pierre Boulez's *Fragments*, Erik Satie's *Septet*, Louis Moreau Gottschalk's *Banjo*, and David Tudor's *Dime a Dance*, a selection of nineteenth-century piano music. After the performance, meets Cunningham for the first time.[71]

After January: Meets Rachel Rosenthal, a student of Cunningham's who has recently arrived from Paris. Rosenthal will recall, "We did all kinds of things together—meetings in John [Cage]'s studio or in Sari [Dienes]'s large studio…trips to the country to visit Fance Stevenson and her husband."[72] At East 8th Street, using a cast of Rosenthal's face, makes *Untitled* (plate 5), the first time he has employed a cast body-fragment in his work.

Probably later that year makes *Untitled* (plate 1), his first work to use a gridlike structure: *I was working in a bookstore, and you had little rectangular pads of paper to write orders on. I used to fold these sheets and then tear them, so that when they were opened the tears made a symmetrical design. The idea was to make something symmetrical that didn't appear to be symmetrical.*[73]

Between March 1 and 20: Visits "Magritte: Word vs. Image," an exhibition including twenty-one paintings of 1928–30, at the Sidney Janis Gallery (15 East 57th Street), New York. In the 1960s, Johns will collect Magritte's work.[74] Johns also sees works by Joseph Cornell at about this time.[75]

Summer: Moves to a loft at 278 Pearl Street, one floor below Rachel Rosenthal's. Robert Rauschenberg is living nearby, on Fulton Street. Rosenthal will recall, "That summer…Jap and Sari [Dienes] and I decided

Jasper Johns—NYC 1955. Photograph: Robert Rauschenberg. © Untitled Press.

to get lofts downtown. Almost nobody had them then, except for Bob [Rauschenberg]….So we spent that summer looking for lofts, and found an incredible brick building on Pearl Street. It had been condemned by the city. It had only two lofts, and I'm sorry to say that Jap and I cut Sari out and took those two. I had the top floor, Jap had one below….There were four or maybe five floors, and a huge old pulley to pull stuff in and out of the windows of the printers on the second floor, and holes in the floors for the ropes to go through. The rent was something like $50 a month for mine. I spent some money and put in a tub and hot water. Bob's loft on Fulton was just a block away."[76]

Rosenthal will also recall, "Jap was an artist but he didn't yet consider himself a serious artist. He had hardly any time to paint, and had been living in a tiny apartment. What he'd been doing were collages that he would totally paint over in enamel paint. Also a lot of drawings. So when he moved into the loft he felt he was going to open up and really work."[77]

Around this time, Johns leaves his job at Marboro Books to devote himself to painting. To support himself, he does freelance window-display work with Rauschenberg. According to Rosenthal, "Bob at that time was earning his living making window displays. He talked Jap into quitting his job and going in with him on the displays. At first, Jap was very apprehensive. But the two of them started to go around to stores. Bob did the talking, and he could always talk anybody into anything, so they got plenty of jobs.

With Robert Rauschenberg at Pearl Street, New York, c. 1954.
Photograph: Rachel Rosenthal.

For every job, they would use Jap's loft to work in—Bob's was for serious work."[78]

At Pearl Street, Johns makes a painting in the shape of a cross (probably no longer in existence). Rosenthal subsequently commissions from him a painting in the shape of a Jewish star, which results in *Star*.[79] It is also probably around this time that he makes *Construction with Toy Piano*.

[Fall]: Destroys all the work of his that remains in his possession.[80] According to Rosenthal, "One day he destroyed everything, all the old work. It seemed as if his whole new conception was created in his mind—it was not a work process. As soon as he got a handle on his esthetic he destroyed everything. Right after that, he started working with encaustic. He had a big book from Marboro's on artist's techniques, and he got it out of that. It was as though the whole thing were already created in his head before he did it."[81]

In the early fifties I was going to be an artist, and I kept meeting people who were artists, and I thought, "Here I am, still going to be an artist." What was different? What needed to be changed, so that I would be, rather than going to be? It was then I decided I would only allow myself to do what I couldn't not do, and whatever I did would have to represent myself as an artist. There was a change in my spirit, in my thought and my work, as well as some doubt and terror.[82]

Late fall: Sometime toward the end of the year, prompted by a dream, begins his first *Flag* (plate 8).[83]

One night I dreamed that I painted a large American flag, and the next morning I got up and I went out and bought the materials to begin it. And I did. I worked on that painting a long time. It's a very rotten painting—physically rotten—because I began it in house enamel paint, which you paint furniture with, and it wouldn't dry quickly enough. And then I had in my head this idea of something I had read or had heard about: wax encaustic.

In the middle of the painting I changed to that, because encaustic just has to cool and then it's hard and you don't blur it again; with enamel you have to wait eight hours. If you do this, you have to wait eight hours before you do that. With encaustic you can just keep on.[84]

December 8: First performance of Merce Cunningham's *Minutiae*, at the Brooklyn Academy of Music, Brooklyn, New York, with music by John Cage (*Music for Piano 1 through 20*) and set and costume design by Robert Rauschenberg. Johns helps Rauschenberg construct the set.

December 20, 1954–January 20, 1955: *Construction with Toy Piano* is exhibited at the Tanager Gallery (90 East 10th Street), New York, in a group show that includes eighty-one painters and sculptors, among them Rauschenberg and Rachel Rosenthal. In his review of the show, Fairfield Porter spots Johns among the newcomers: "Exhibitors who are new to this reviewer are: Johns, showing something like a music box...."[85]

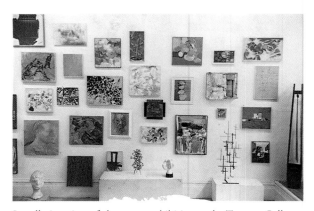

Installation view of the group exhibition at the Tanager Gallery, December 1954–January 1955, Johns's first show in New York.

1955

January 9: First performance of James Waring's *Little Kootch Piece*, at Henry Street Playhouse (466 Grand Street), New York, performed by Marian Sarach and Sheldon Ossosky, with music by Olivier Messiaen and costumes designed by Johns.

[Winter–spring]: Completes *Flag*.[86] Also paints *Target with Plaster Casts*, his first target painting, and *White Flag* (plate 11).

March 15–16: Performances of Marian Sarach's dance *Naskhi*, at the Master Institute Theater, New York, with sixteenth-century music; set and costume design are by Johns. The set includes a plaster object, harp-like but without strings, and the costume features a

bird-head piece.[87] *Naskhi* will also be performed on June 5, 1955, at the Master Institute Theater.

April 26–May 21: Robert Rauschenberg exhibits in the "Fourth Annual Exhibition of Painting and Sculpture," Stable Gallery (924 Seventh Avenue), New York. Works shown include *Short Circuit*, 1955, which incorporates a painting by Susan Weil and a small flag painting by Johns (13 ¼ x 17 ¼").[88]

Summer: Having gone to California to attend her father's funeral, Rachel Rosenthal decides to stay there, and Rauschenberg rents her studio.[89] Over the next six years, he and Johns see each other on a daily basis, exchanging ideas about their work. Rauschenberg will later say of Johns, "He and I were each other's first serious critics. Actually, he was the first painter I ever shared ideas with, or had discussions with about painting. No, not the first. Cy Twombly was the first.... But Jasper and I literally traded ideas. He would say, 'I've got a terrific idea for you,' and then I'd have to find one for him."[90]

> It's true that I painted a Rauschenberg. Actually, I made two Rauschenbergs. I made the gold leaf painting and I made a later-period Rauschenberg, because I thought I understood them so well that I could make them. But they were missing something. So they were turned over to Bob, who completed them. I believe they were both sold, as Rauschenbergs.[91]

With Rosenthal away in California, Johns makes *Target with Four Faces*, using casts of the face of his friend the potter and poet Fance Stevenson.[92] Other works probably produced at Pearl Street around this time are *Flag above White* and *Flag above White with Collage*.

[After summer]: Johns and Rauschenberg create Matson Jones, the commercial name by which their window-display business becomes known. "Matson" comes from the maiden name of Rauschenberg's mother, and "Jones" is a near homophone of "Johns." Rauschenberg writes to Rosenthal in Los Angeles, "Our ideas are beginning to meet the insipid needs of the business [so] that our shame has forced us to assume the name of Matson Jones—Custom Display."[93]

[Fall]: At Pearl Street, creates the first four paintings of individual numbers, all in the same size and in encaustic and collage on canvas: *Figure 1*, *Figure 2*, *Figure 5*, and *Figure 7*. Also paints *Green Target* and *Tango*.

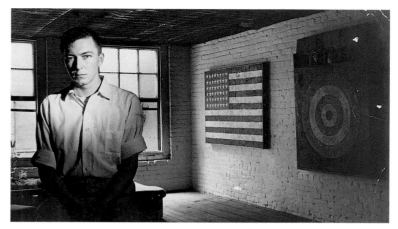

At Pearl Street in 1955, with *Flag*, 1954–55, and *Target with Plaster Casts*, 1955, in the background. Photograph: George Moffet.

October 15: Attends performances of the Merce Cunningham Dance Company and of John Cage, Harold Coletta, and David Tudor, at Clarkstown High School in New City, Rockland County, New York. Here he meets Lois Long and Emile de Antonio, chairman of the Rockland Foundation and the event's producer. The program includes Cunningham's *Solo Suite in Space and Time*, *Minutiae*, and *Springweather and People*, and Cage's *34′46.776″ for 2 Pianists and a String Player*.[94]

During this period, Johns and Rauschenberg become close to Cage and Cunningham, and the group gathers frequently at the Cedar Tavern or in other downtown bars. Cage will remember, "We called Bob and Jasper 'the Southern Renaissance.' Bob was outgoing and ebullient, whereas Jasper was quiet and reflective. Each seemed to pick up where the other left off. The four-way exchanges were quite marvelous. It was the *climate* of being together that would suggest work to be done for each of us. Each had absolute confidence in our work, each had agreement with the other."[95]

December 19, 1955–January 4, 1956: *Flag*, 1955 (plate 14), is included in a group exhibition of drawings at the Poindexter Gallery (46 East 57th Street), New York. This seems to be the work Johns is referring to when he later remarks, *I once painted an American flag that had 68 stars [sic; actually 64]. Didn't find it out for months, until I looked at it in a display and counted the stars. No one else had noticed either.*[96]

1956

At Pearl Street, makes his first alphabet painting, *Gray Alphabets* (plate 19).

Paints *Canvas*, the first work in which he attaches stretcher bars to the painting's surface, as he will in many later works, including *Fool's House*, 1962, *According to What*, 1964, *Portrait—Viola Farber*, 1961–62, and *Slow Field*, 1962. *Canvas* is also Johns's first monochromatic gray painting: *The encaustic paintings were done in gray because to me this suggested a different kind of literal quality that was unmoved or unmovable by coloration and thus avoided all the emotional and dramatic quality of color. Black and white is very leading. It tells you what to say or do. The gray encaustic paintings seemed to me to allow the literal qualities of the painting to predominate over any of the others.* [97]

Other paintings completed at Pearl Street include the small-scale *Flag* and *Green Target*.

January 31–February 7: *White Flag*, 1955–58, is shown in its first state in the window of the Bonwit Teller department store (721 Fifth Avenue at 56th Street) as part of a display created by Gene Moore. In his work as display director for Bonwit Teller and, later, for Tiffany's, Moore frequently uses props built by Matson Jones: "I'd tell them what I wanted, and they'd go off and make it. I never knew which one of them did what, they worked so closely together, even sharing the same joint pseudonym, Matson Jones....They started using that name when they began to get recognition as artists—they didn't want their commercial work confused with what they considered their real art." [98] Once a year, Moore includes in his windows artworks by the artists he has hired, in order to give them visibility.

Over the year, Matson Jones will create windows showing, respectively, a mushroom field (February 14, Bonwit Teller); tilted paint-cans appearing to pour paint on the floor (August 7, Bonwit Teller); "Cave scenes" (August 30, Tiffany's); a moon in the background (November 5, Bonwit Teller); "Recreations in dimension of eighteenth-century still lifes" (November 9, Tiffany's); [99] and "Christmas.... forest with trees" (Tiffany's, November 29). [100]

Between February 6 and March 4: Visits the exhibition "Recent Paintings by Philip Guston," at the Sidney Janis Gallery, New York. [101]

May 30: Performance of Marian Sarach's *Triglyphos*, at the Master Institute Theater, New York, with music by John Cooper and set and costume design by Johns.

1957

At Pearl Street, creates his first painting of a series of numbers, *White Numbers*, and paints *Gray Numbers*, *Gray Rectangles*, *Drawer*, *Gray Flag*, *Flag* (LC# 30), *Study for Painting with Two Balls*, *Book*, *Flag* (LC# 1), *Numbers*, *Gray Target*, *Target*, *Figure 4*, *Newspaper*, *Flag on Orange Field*, *The*, and *White Target*.

Sometime this year, meets the poet Frank O'Hara. [102]

Flag on Orange Field, 1957, is shown in Bonwit's window, as *White Flag* was in 1956.

In *Drawer*, *Book*, and *Newspaper*, Johns continues to incorporate objects into his paintings, as he did

with a toy piano, a music box, and stretcher bars in earlier works.

Invites the art dealer Betty Parsons to visit his studio. She declines the invitation, saying that she already works with more artists than she can show.[103]

[Winter]: The artist Allan Kaprow brings Horace Richter, who sits on the Administrative Committee of the Jewish Museum, New York, to Johns's and Robert Rauschenberg's studios: *Allan Kaprow came to see us, saying that he was guiding Horace Richter around studios in New York to select an exhibition for the Jewish Museum. Bob and I thought wrongly that he was the Dadaist Hans Richter.*[104]

January 31: Tiffany's window: "Valentine's Day." Later in the year Matson Jones will do three more windows for Tiffany's: "Landscapes" (June 20), "Webs" (August 29), and "Piles of leaves and falling leaves" (October 10).[105]

February–March: *Target with Four Faces*, 1955 (plate 9), is reproduced in an issue of *Print* magazine conceived and designed by Bob Cato. This is the first time a Johns work appears in a periodical.[106]

February 10: First performance of Paul Taylor Dance Company's *The Tower*, at Kaufmann Concert Hall, New York, with choreography by Taylor, set design by Rauschenberg, music by John Cooper, and costumes by Johns.

March 7: "Artists of the New York School: Second Generation," a twenty-three-artist exhibition opening shortly at the Jewish Museum (March 10–April 28), receives a preview. There is a catalogue with an introduction by Leo Steinberg. After initially sending *Target with Plaster Casts*, 1955, *White Flag*, 1955, and possibly *Tango*, 1955, to be included in this exhibition, Johns has ended up exhibiting *Green Target*, 1955.[107]

Attending this preview, the art dealer Leo Castelli sees a work by Johns for the first time.[108] Just a month or so earlier, on February 1, Castelli has opened a gallery, on the fourth floor of 4 East 77th Street, New York, with an exhibition of well-known European and American artists.

March 8: At 9 P.M., Morton Feldman brings Castelli, his wife, Ileana (later Ileana Sonnabend), and Ilse Getz, a young friend who is working at the gallery, to Rauschenberg's studio to look at recent work.[109] When Rauschenberg mentions that he has to go downstairs to get ice for drinks (he and Johns share a refrigerator), Castelli connects Johns's name with the *Green Target* at the Jewish Museum, and asks to meet him.

In Johns's studio, the Castellis see *Flag*, 1954–55, *Target with Plaster Casts*, 1955, *Target with Four Faces*, 1955, *White Flag*, 1955, *Gray Alphabets*, 1956, and other works.[110] Ileana Castelli buys *Figure 1*, 1955, and Leo Castelli offers Johns an exhibition at his gallery.

March 10: Johns's father dies, in or near Charleston, South Carolina.[111]

May 6–25: Exhibits *Flag*, 1954–55, in "New Work: Bluhm, Budd, Dzubas, Johns, Leslie, Louis, Marisol, Ortman, Rauschenberg, Savelli" at the Leo Castelli Gallery. Referring to Johns in a review of this show, Robert Rosenblum uses the term "Neo-Dada," which later gains widespread usage: "Take Jasper Johns's work, which is easily described as an accurate replica of the American flag but which is as hard to explain in its unsettling power as the reasonable illogicalities of a Duchamp ready-made. Is it blasphemous or respectful, simple-minded or recondite? One suspects here a vital Neo-Dada spirit."[112]

Possibly prompted by this review, Johns reads Robert Motherwell's *The Dada Painters and Poets: An Anthology*,[113] and shortly thereafter visits the Philadelphia Museum of Art with Rauschenberg to see Marcel Duchamp's works in the Arensberg Collection.[114]

October 20: First performance of Paul Taylor's *Seven New Dances* (*Epic, Events I, Resemblance, Panorama, Duet, Events II, Opportunity*), at Kaufmann Concert Hall, New York, with music by John Cage and costume and set design by Johns and Rauschenberg, who are listed in the program as artistic collaborators.

November 30: With Leo Castelli, attends Merce Cunningham Dance Company's first performances of *Labyrinthian Dances, Changeling,* and *Picnic Polka,* at the Brooklyn Academy of Music, Brooklyn, New York.[115]

December 16, 1957–January 4, 1958: Johns's work is included in "Collage in America," an exhibition at the Zabriskie Gallery, New York. The exhibition will travel through 1959, and is sponsored by the American Federation of Arts.

1958

Johns is given a copy of Duchamp's *Box in a Valise* by collectors Donald and Harriet Peters, at about the time they acquire the painting *Tennyson*, 1958.[116] Over the years, Johns will collect several other Duchamp works.[117]

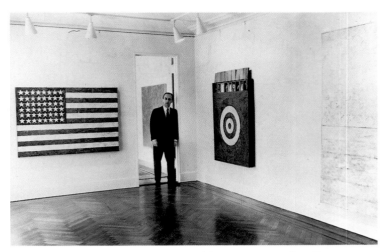

Leo Castelli at "Jasper Johns: Paintings" exhibition, Leo Castelli Gallery, New York, January–February 1958. Photograph: Rudolph Burckhardt.

Produces his first sculptures, *Flashlight I* and *Light Bulb I*, in Sculp-metal, a material made of vinyl resin mixed with aluminum powder, which he also uses in the painting *Target* of the same year.

Johns's stepfather dies, in Sumter.[118]

[Winter]: At Pearl Street, before he moves to Front Street in March, Johns paints his first *0–9*, in white, along with *Gray Target*, a *Target* in red, yellow, and blue (LC# 54), a *White Target*, and probably a small *Green Target*.

Other paintings completed this year, either at Pearl Street or at Johns's subsequent studio, at Front Street, are a Sculp-metal *Target*, *Flag on Orange Field II*, *Gray Numbers*, *White Numbers* (plate 38), *Flag*, and *White Flag*, 1955–58.

January: *Target with Four Faces*, 1955 (plate 9), is published on the cover of *Artnews* magazine.

> *Fairfield Porter came to my studio before the show opened, and did a criticism for* Artnews. *Tom Hess, who was then the editor, decided on the basis of that, I believe, to put a painting of mine on the cover. That again was something quite unprecedented, that someone no one had ever heard of had a picture on the cover of* Artnews. *Especially as Tom's primary interest was Abstract Expressionist painting.*[119]

Makes the drawing *Target with Four Faces* (LC# 32) by tracing the reproduction on the magazine cover, a process he will employ repeatedly from the 1970s onward using his own works and works by Matthias Grünewald, Paul Cézanne, and other artists.

January 20–February 8: Johns's first solo exhibition, "Jasper Johns: Paintings," is held at the Leo Castelli Gallery, where his new work will be exhibited from this date on. Included in the show are the paintings *Flag*, 1954–55, *Target with Plaster Casts*, 1955, *White*

Flag, 1955, *Target with Four Faces*, 1955, *Figure 1*, 1955, *Figure 5*, 1955, *Green Target*, 1955, *Figure 7*, 1955, *Canvas*, 1956, *White Target*, 1957, *White Numbers*, 1957, *Drawer*, 1957, *Flag*, 1957 (LC# 30), *Book*, 1957, *Flag on Orange Field*, 1957, *Gray Target*, 1957, *Numbers*, 1957, and *Green Target*, 1958, as well as the drawings *Target with Four Faces*, 1958 (LC# 32), and *Sketch for Numbers*, 1957 (LC# 31).

The exhibition receives much attention from the press. By the time it closes, only two paintings remain unsold: *Target with Plaster Casts* (which Castelli acquires) and *White Flag* (kept by the artist).[120]

Willem de Kooning comes to see the exhibition, and is introduced to Johns.[121]

[January 25]: On this Saturday morning, Alfred H. Barr, Jr., of The Museum of Modern Art, visits the Leo Castelli Gallery. From there he calls curator Dorothy Miller, asking her to come down right away. They spend an hour discussing which paintings to buy for the Museum, settling on *Flag*, 1954–55, *Target with Four Faces*, 1955, *Green Target*, 1955, and *White Numbers*, 1957. Miller will remember, "It wasn't a question of one picture, we chose four pictures. They were inexpensive and they were just so remarkable."[122] Barr is also interested in *Target with Plaster Casts*, but is worried about the possible reaction to the box containing a cast of a penis. He asks Johns, who happens to be at the gallery, if the work can be displayed with the box closed. Johns replies that the lid can be kept closed "some of the time, but not all of the time."[123]

Johns's former teacher Catharine Rembert has a dinner date with Johns that evening, and he is late. But on arriving, "he picked her up and danced her around the room."[124]

February 17: Castelli writes to Barr: "In accordance with our agreement I am sending you on approval the following paintings by Jasper Johns: 'Flag', 1954, Encaustic on newsprint and canvas, 42″ x 60″ $1000.00; 'Green Target', 1955, Encaustic on newsprint and canvas, 60″ x 60″ $1000.00; 'Target with Four Faces', 1955, Plaster casts; encaustic on newsprint and canvas, 30″ x 26″ $700.00; 'White Numbers', 1957, Encaustic on canvas, 34″ x 28″ $450.00."[125] Barr acquires *Green Target*, *White Numbers*, and *Target with Four Faces*. Afraid that the Museum's Acquisitions Committee will find *Flag* unpatriotic, Barr persuades Philip Johnson to acquire it, and it is given to the Museum in 1973, in Barr's honor.[126]

February 27–April 6: *Figure 1*, 1955, is exhibited in "Collage International: From Picasso to the Present," at the Contemporary Arts Museum, Houston.

[March]: With the Pearl Street building slated for demolition, Johns and Robert Rauschenberg move to the third and second floors, respectively, of 128 Front Street. An author has described Johns's studio here: "Johns paints in a large studio with a relatively low ceiling. His paintings are never higher than the height of the room whose ceiling the painter, with outstretched arms, can just reach with his fingertips. The studio is located on the third floor of a three-story house. On the street floor is a coffee shop… with counter, jukebox, cigarette slot machine, a few tables and chairs."[127]

At Front Street, Johns paints another *Target* (LC# 39), his first major painting in oil. He has previously used oil only in occasional small-format works: *Untitled*, 1954 (plate 1), two *Flag* works of 1957 (LC# 1 and LC# AA), and *Numbers*, 1957.[128] Other paintings completed later in the year at Front Street are *Three Flags*, *Tennyson*, *Painting with a Ball*, *Alley Oop*, and probably *White Numbers* (plate 26).

March 31: *Newsweek* announces that "both [Johns] and Rauschenberg now live on their sales."[129] But the artists continue to do display work for Gene Moore: "Dimensional cutouts of birds" (September 8, Tiffany's) and "Forests with tree stumps, rakes, squirrel, tree" (September 25, Tiffany's),[130] probably Matson Jones's last window-display project.

May 15: A "25-Year Retrospective Concert of the Music of John Cage," conceived and produced by Impresarios Inc.—Emile de Antonio, Rauschenberg, and Johns—is held at Town Hall, New York. The date coincides with Johns's twenty-eighth birthday. George Avakian's recording of the performance is later released as a boxed set of records. In addition to ticket sales, the concert is financed by contributions of $1,000 each from the three producers.[131] In conjunction with the concert, some of Cage's scores are exhibited at the Stable Gallery, New York.

June 14–September 30: Johns's work is shown in Europe for the first time, at the XXIX Venice Biennale, in an exhibition organized by the International Program of The Museum of Modern Art, New York. Works included are *Flag*, 1954–55, *Green Target*, 1955, and *Gray Alphabets*, 1956.

[Early August]: To New London, Connecticut, to attend a series of Merce Cunningham Dance Company performances at the Eleventh American Dance Festival, Connecticut College, New London. Here, on August 14, Cunningham's *Antic Meet*, 1958, is performed for the first time, with music by Cage and

set and costume design by Rauschenberg. Johns has helped Rauschenberg with the costumes. Cunningham's *Summerspace*, performed for the first time on August 17, with music by Morton Feldman (*Ixion*), also has set and costume design by Rauschenberg; Johns has helped Rauschenberg paint the backdrop.[132]

Before September 20: Paints *Tennyson*.[133]

October 21–November 20: A drawing by Johns is shown in the exhibition "*Le Dessin dans l'art magique*," at the Galerie Rive Droite (23, Faubourg Saint-Honoré), Paris. There is a catalogue, with poems by André Verdet and Henri Michaux.

November 20, 1958–January 4, 1959: "A Decade of Contemporary Drawings 1948–1958," at the Contemporary Arts Museum, Houston, Texas, includes *Target*, 1958 (plate 41).

December 3: Receives a telegram from Gordon Washburn, director of the Carnegie Institute, Pittsburgh: "Your painting Grey Numbers has received award of $500 international congratulations looking forward to seeing you at the opening."[134] *Gray Numbers*, 1958, has been awarded the "Anonymous Donation to Foster Good Will through the Arts" of the Carnegie's 1958 Pittsburgh Bicentennial International Exhibition of Contemporary Painting and Sculpture (December 5–February 8, 1959). It is the only painting by an American artist to receive an award. The jury is composed of Mary Callery, Marcel Duchamp, Vincent Price, James Johnson Sweeney, Raoul Ubac, and Lionello Venturi.[135]

December 29, 1958–January 24, 1959: "Beyond Painting," an exhibition at the Alan Gallery (766 Madison Avenue), New York, includes *Three Flags*, 1958.

Left to right: Merce Cunningham, Robert Rauschenberg, John Cage, M. C. Richards, and Johns, 1958.
Photograph: Bob Cato. Courtesy George Avakian.

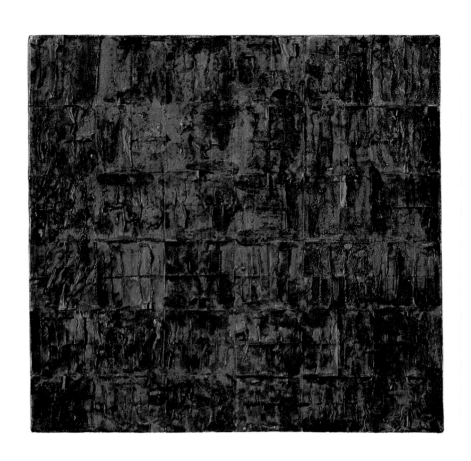

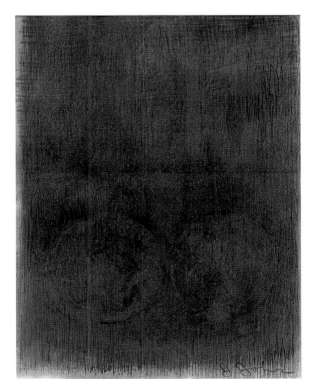

1. **Untitled**. 1954
Oil on paper mounted on fabric
9 x 9″ (22.9 x 22.9 cm)
The Menil Collection, Houston

2. **Untitled**. 1954
Graphite pencil on oil (?) stained paper
8 ¼ x 6 ⁹⁄₁₆″ (21 x 16.7 cm) sight
Collection Robert Rauschenberg

3. **Construction with Toy Piano**. 1954
Graphite and collage with toy piano
11 9/16 x 9 1/8 x 2 3/16″ (29.4 x 23.2 x 5.6 cm)
Öffentliche Kunstsammlung Basel,
Kunstmuseum

4. **Star**. 1954
Oil, beeswax, and house paint on newspaper,
canvas, and wood with tinted glass, nails,
and fabric tape
22 ½ x 19 ½ x 1 ⅞″ (57.2 x 49.5 x 4.8 cm)
The Menil Collection, Houston

132

5. **Untitled**. 1954
Construction of painted wood, painted
plaster cast, photomechanical reproductions
on canvas, glass, and nails
26 ¼ x 8 ⅞ x 4 ⅜″ (66.7 x 22.5 x 11.1 cm)
Hirshhorn Museum and Sculpture Garden,
Smithsonian Institution. Regents Collection
Acquisitions Program, with Matching Funds
from the Thomas M. Evans, Jerome L.
Greene, Joseph Hirshhorn, and Sydney and
Frances Lewis Purchase Fund, 1987

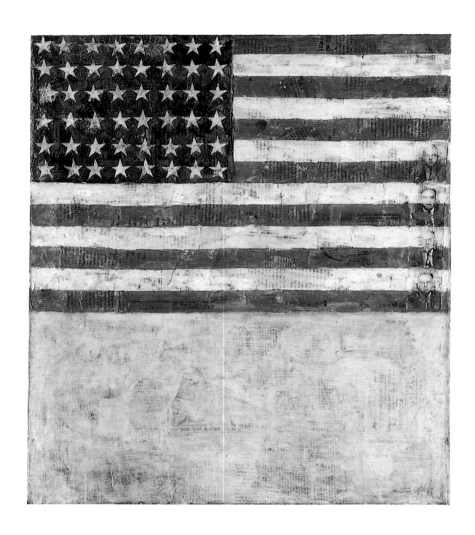

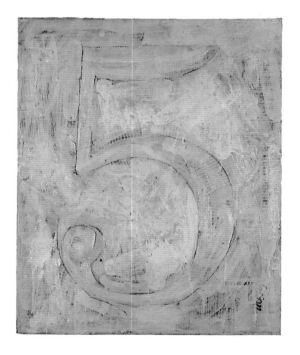

6. **Flag above White with Collage**. 1955
Encaustic and collage on canvas
22 ½ x 19 ¼″ (57.2 x 48.9 cm)
Öffentliche Kunstsammlung Basel, Kunstmuseum.
Gift of the artist, in memory of Christian Geelhaar

7. **Figure 5**. 1955
Encaustic and collage on canvas
17 ½ x 14″ (44.5 x 35.6 cm)

Collection the artist

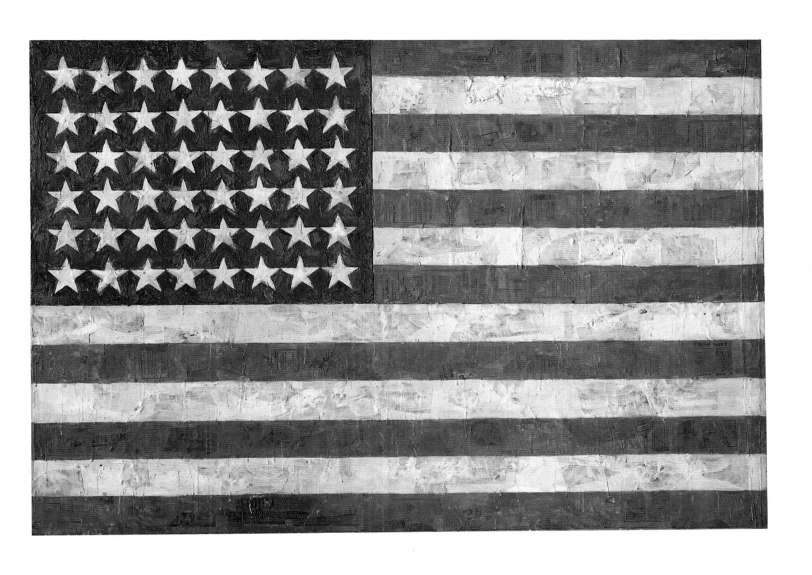

8. **Flag**. 1954–55
Encaustic, oil, and collage on fabric
mounted on plywood (three panels)
42 ¼ x 60 ⅝″ (107.3 x 154 cm)
The Museum of Modern Art, New York.
Gift of Philip Johnson in honor of
Alfred H. Barr, Jr.

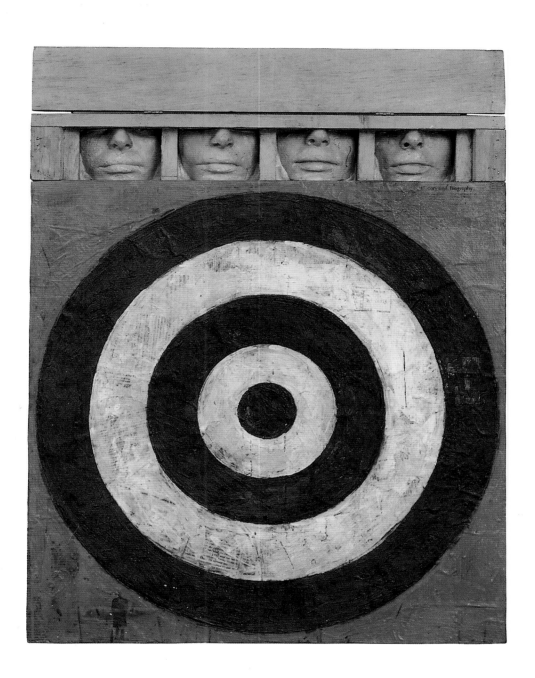

9. **Target with Four Faces**. 1955
Encaustic on newspaper and cloth over
canvas surmounted by four tinted-plaster
faces in wood box with hinged front
Overall, with box open: 33 ⅝ x 26 x 3″
(85.3 x 66 x 7.6 cm); canvas: 26 x 26″
(66 x 66 cm); box (closed): 3 ¾ x 26 x 3 ½″
(9.5 x 66 x 8.9 cm)
The Museum of Modern Art, New York.
Gift of Mr. and Mrs. Robert C. Scull

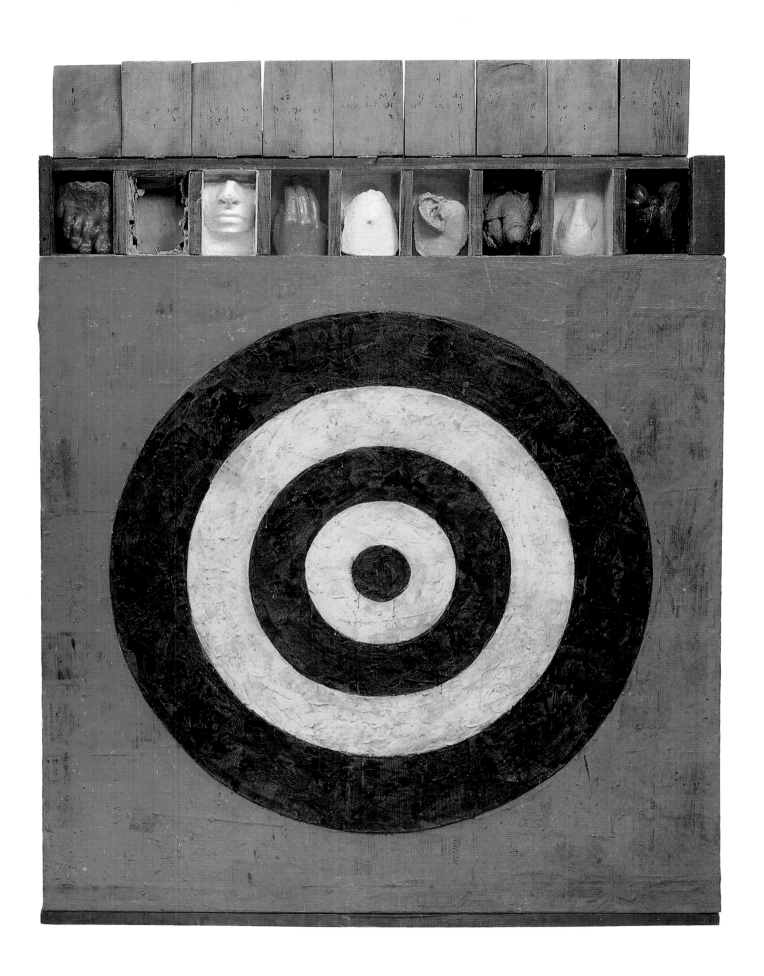

10. **Target with Plaster Casts**. 1955
Encaustic and collage on canvas with objects
51 x 44 x 3 ½″ (129.5 x 111.8 x 8.8 cm)
Collection David Geffen, Los Angeles

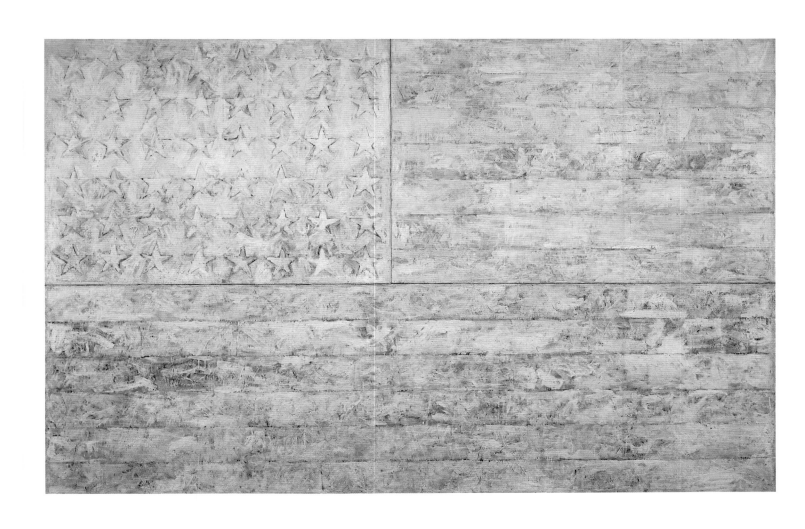

11. **White Flag**. 1955
Encaustic and collage on canvas (three panels)
6′ 6 5/16″ x 10′ 3/4″ (198.9 x 306.7 cm)
138 Collection the artist

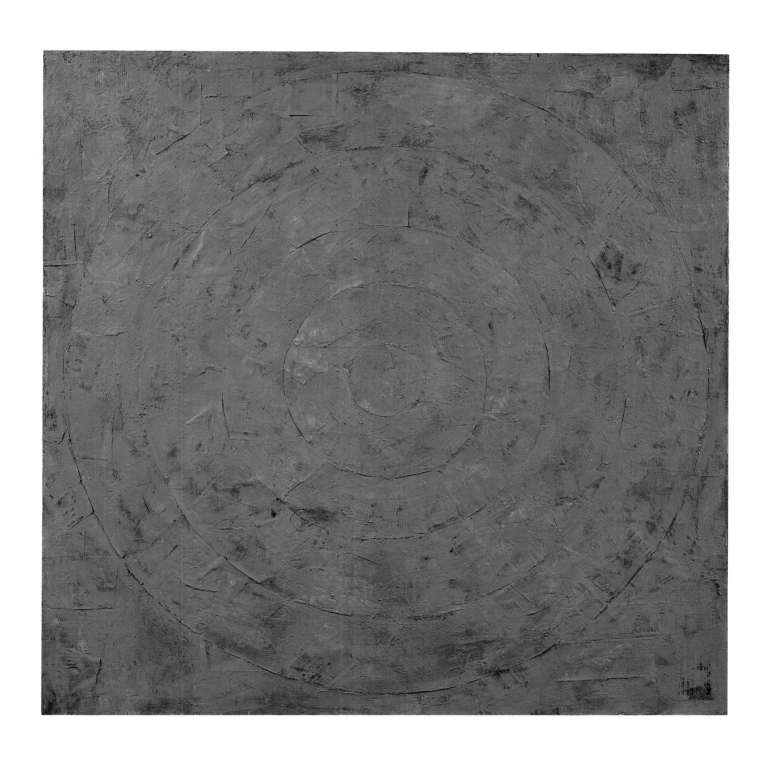

12. **Green Target**. 1955
Encaustic on newspaper and cloth over canvas
60 x 60″ (152.4 x 152.4 cm)
The Museum of Modern Art, New York.
Richard S. Zeisler Fund

13. **Target with Four Faces**. 1955
Graphite pencil and pastel on paper
9 ¼ x 7 ⅞″ (23.5 x 20 cm)
Collection the artist

14. **Flag**. 1955
Graphite pencil and lighter fluid (?)
on paper
8 ½ x 10 ⅛″ (21.5 x 25.7 cm)

Collection the artist

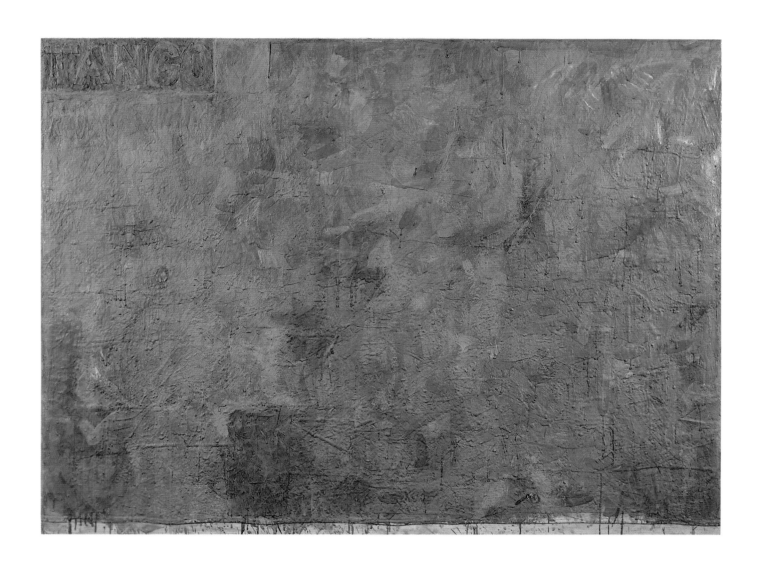

15. **Tango**. 1955
Encaustic and collage on canvas
with music box
43 x 55″ (109.2 x 139.7 cm)
Ludwig Collection

16. **Flag**. 1957
Graphite pencil on paper
10 ⅞ x 15 ⁵⁄₁₆″ (27.6 x 38.8 cm)
Collection the artist

17. **Drawing with 2 Balls**. 1957
Graphite pencil on paper
10 x 8 ¹³⁄₁₆″ (25.4 x 22.4 cm)
Mrs. Lester Trimble

18. **Alphabets**. 1957
Graphite wash, graphite pencil, ink, and
collage on paper
23 ¾ x 18 ⅛″ (60.3 x 46 cm)

Collection Jane and Robert Rosenblum

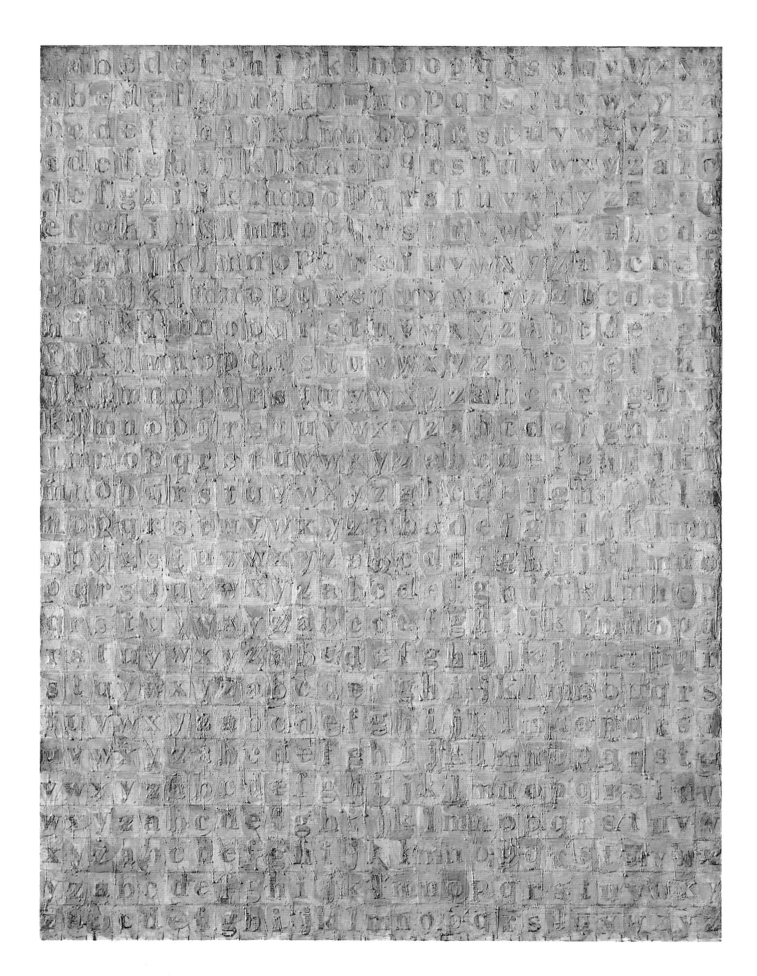

19. **Gray Alphabets**. 1956
Beeswax and oil on newsprint and
paper on canvas
66 ⅛ x 48 ¾″ (168 x 123.8 cm)
The Menil Collection, Houston

20. **Canvas**. 1956
Encaustic and collage on wood and canvas
30 x 25″ (76.3 x 63.5 cm)
Collection the artist

21. **The**. 1957
Encaustic on canvas
24 x 20″ (61 x 50.8 cm)
Mildred and Herbert Lee Collection

22. **Drawer**. 1957
Encaustic on canvas with objects
30 ½ x 30 ½″ (77.5 x 77.5 cm)
Rose Art Museum, Brandeis University,
Waltham, Mass.; Gevirtz-Mnuchin
Purchase Fund

23. **Book**. 1957
Encaustic on book and wood
10 x 13″ (25.4 x 33 cm)
Margulies Family Collection, Miami, Fla.

24. **Gray Rectangles**. 1957
Encaustic on canvas
60 x 60″ (152.4 x 152.4 cm)
146 Collection Mr. and Mrs. Barney A. Ebsworth

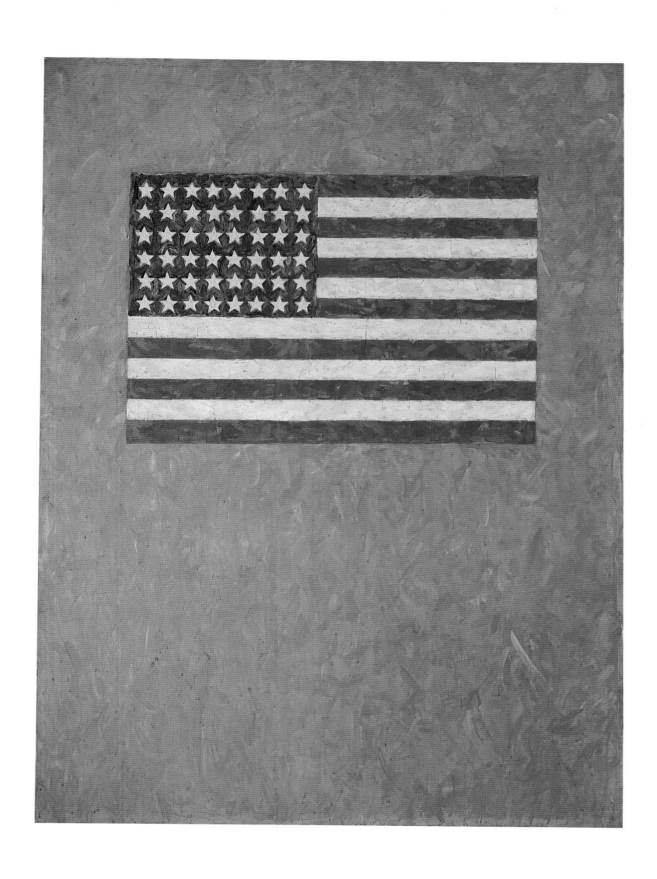

25. Flag on Orange Field. 1957
Encaustic on canvas
66 x 49″ (167.6 x 124.5 cm)
Museum Ludwig, Ludwig Donation, Cologne

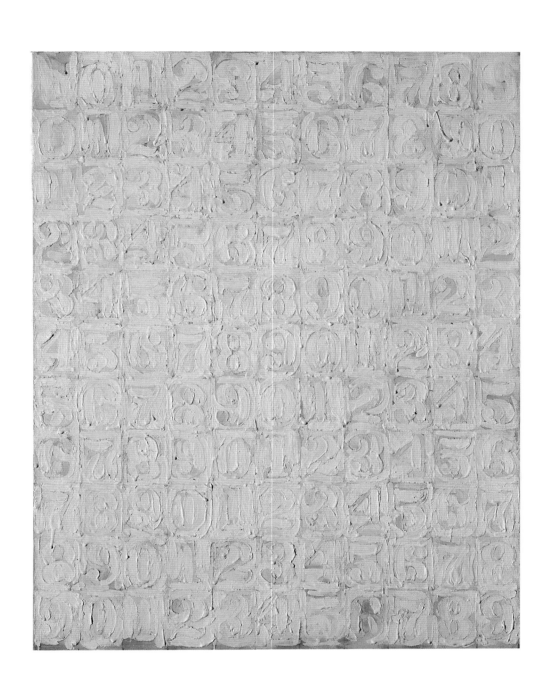

26. **White Numbers**. 1958
Encaustic on canvas
28 x 22″ (71.1 x 55.8 cm)
Mildred and Herbert Lee Collection

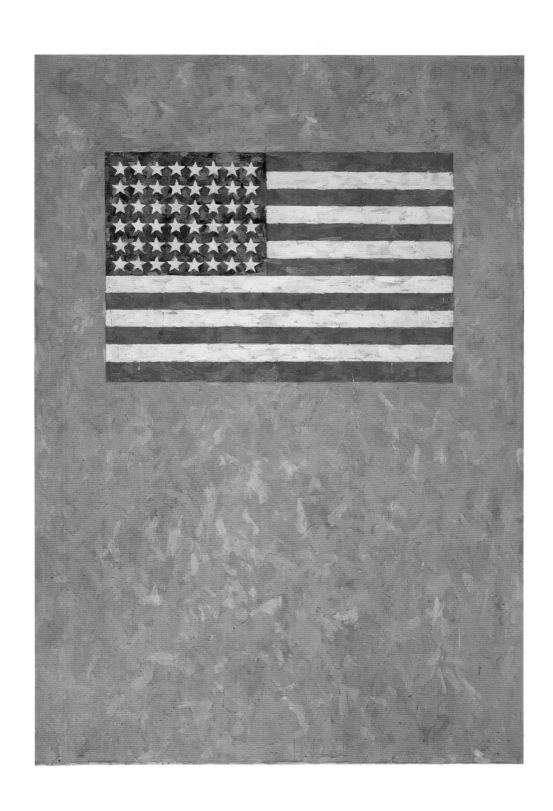

27. Flag on Orange Field II. 1958
Encaustic on canvas
54 x 36 ¼″ (137.1 x 92 cm)
Private collection

28. Study for "Painting with a Ball".
1958
Conté crayon on paper
20 x 18″ (50.8 x 45.7 cm)
Collection the artist

29. Flag. 1958
Graphite pencil and graphite wash on paper
9 ⅞ x 12″ (25 x 30.4 cm)
Collection Leo Castelli

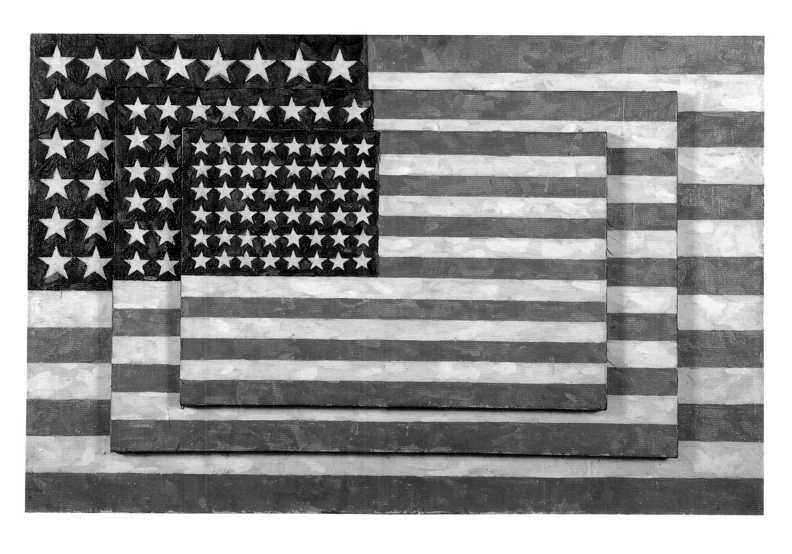

30. **Three Flags**. 1958
Encaustic on canvas
30 ⅞ x 45 ½ x 5″ (78.4 x 115.6 x 12.7 cm)
Whitney Museum of American Art.
50th Anniversary Gift of the Gilman
Foundation, Inc., The Lauder Foundation,
A. Alfred Taubman, an anonymous donor,
and purchase

31. **Alley Oop**. 1958
Oil and collage on cardboard
23 x 18″ (58.4 x 45.7 cm)
Collection Mr. and Mrs. S. I. Newhouse

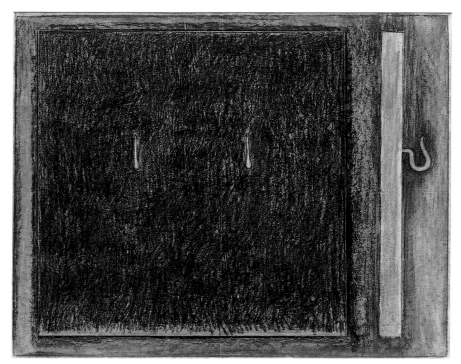

32. **Coat Hanger**. 1958
Conté crayon on paper
24 ³⁄₈ x 21 ⁵⁄₈″ (61.9 x 54.9 cm) sight
Private collection

33. **Hook**. 1958
Crayon, charcoal, and chalk on paper
18 ¹⁄₈ x 23 ³⁄₄″ (46 x 60.3 cm)
Sonnabend Collection

152

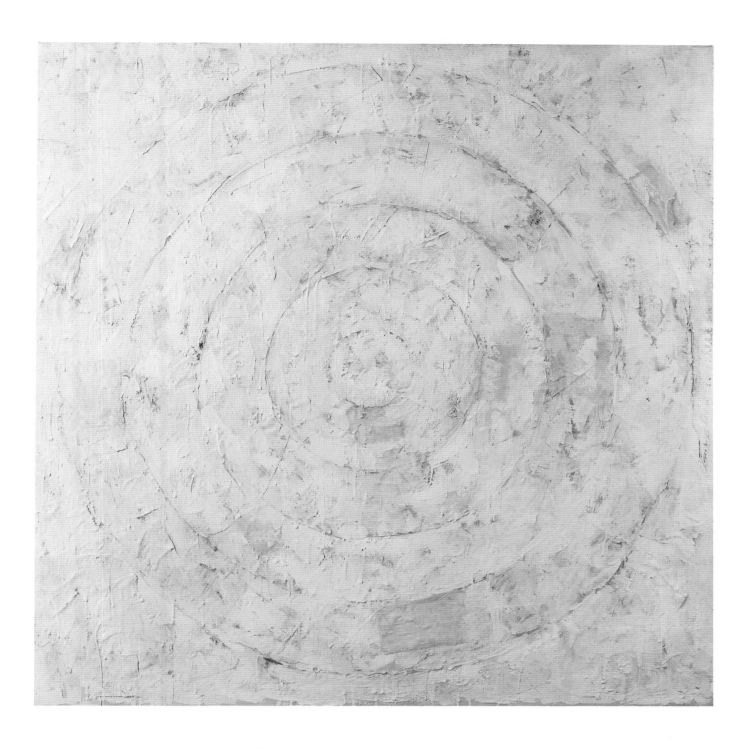

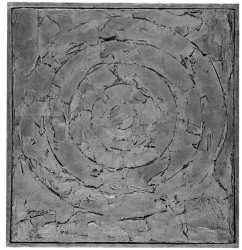

34. **White Target**. 1958
Encaustic and collage on canvas
41 ⅝ x 41 ⅝" (105.7 x 105.7 cm)
Private collection

35. **Target**. 1958
Sculp-metal and collage on canvas
12 ⅛ x 10 ¾" (30.7 x 27.3 cm)
Addison Gallery of American Art,
Phillips Academy, Andover, Massachusetts

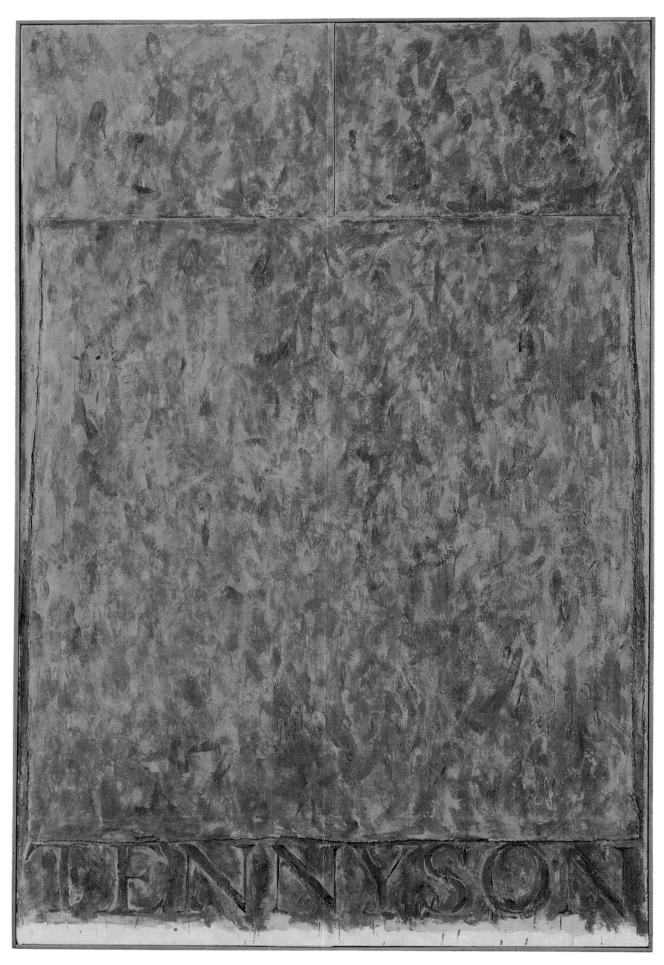

36. **Tennyson**. 1958
Encaustic and collage on canvas
73 ½ x 48 ¼" (186.7 x 122.6 cm)
Purchased with funds from the Coffin Fine Arts Trust, Nathan
Emory Coffin Collection of the Des Moines Art Center, 1971

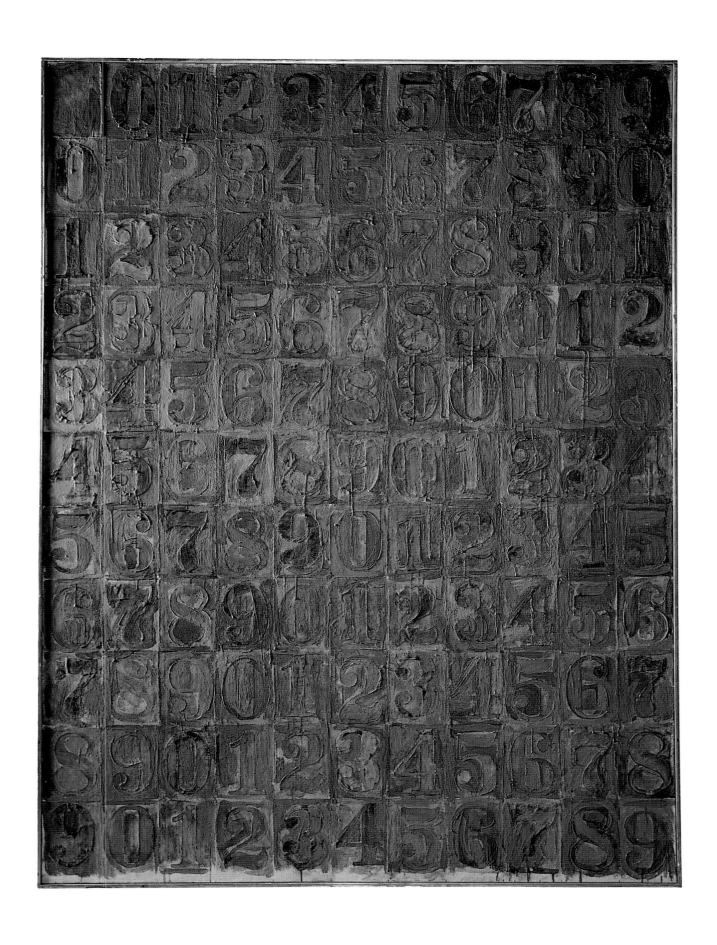

37. **Gray Numbers**. 1958
Encaustic and collage on canvas
67 x 49 ½″ (170.2 x 125.7 cm)
Private collection

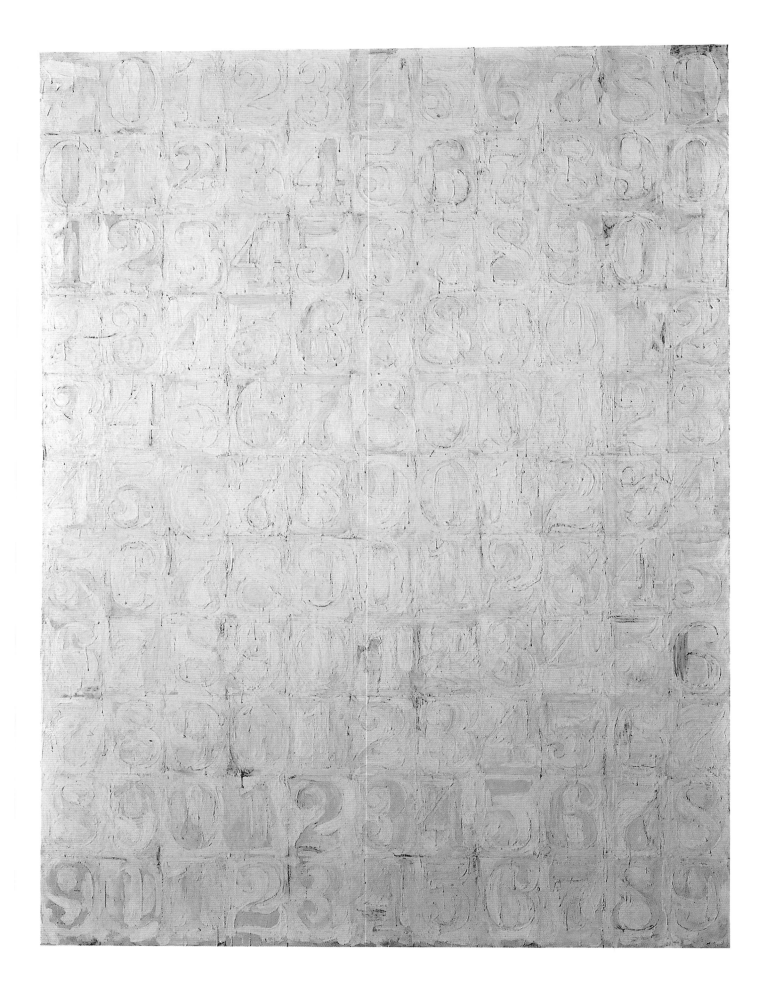

38. **White Numbers.** 1958
Encaustic on canvas
67 x 49 ½″ (170.2 x 125.7 cm)
156 Museum Ludwig, Ludwig Donation, Cologne

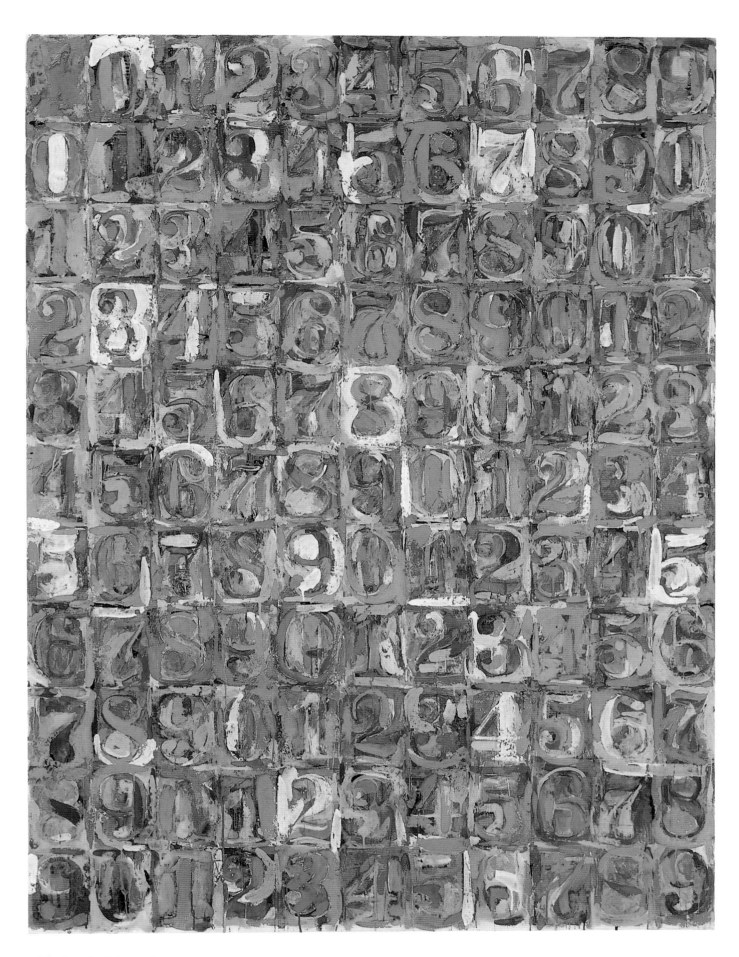

39. **Numbers in Color**. 1958–59
Encaustic and newspaper on canvas
66 ½ x 49 ½" (168.9 x 125.7 cm)
Albright-Knox Art Gallery, Buffalo, New York.
Gift of Seymour H. Knox, 1959

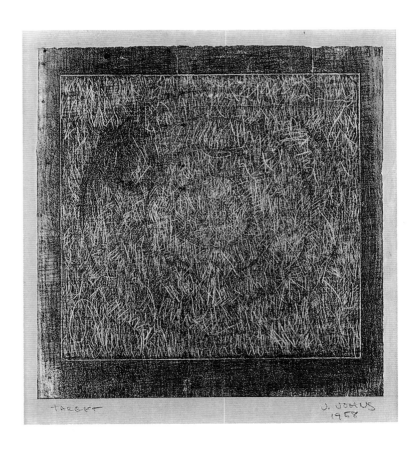

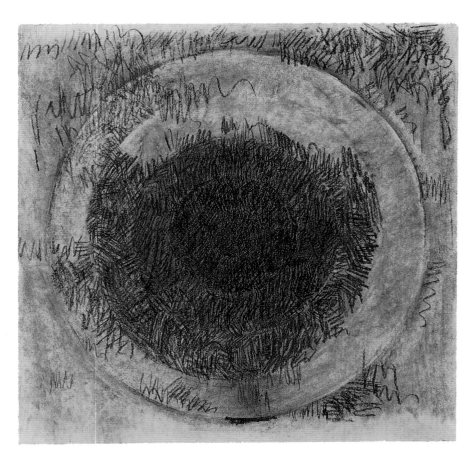

40. **Target**. 1958
Pencil, graphite wash, and collage
on paper mounted on cardboard
15 x 13 ⅞″ (38.1 x 35.2 cm)
Modern Art Museum of Fort Worth,
Museum Purchase, The Benjamin J.
Tillar Memorial Trust

41. **Target**. 1958
Conté crayon on paper
16 ⅛ x 16 ⅛″ (41 x 41 cm)
Collection Denise and Andrew Saul

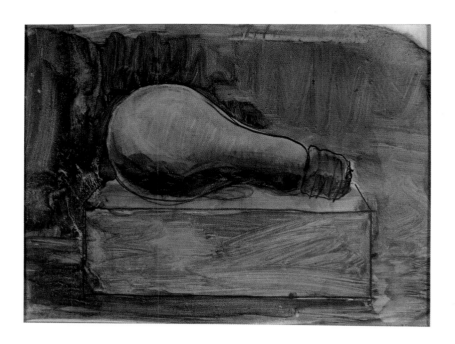

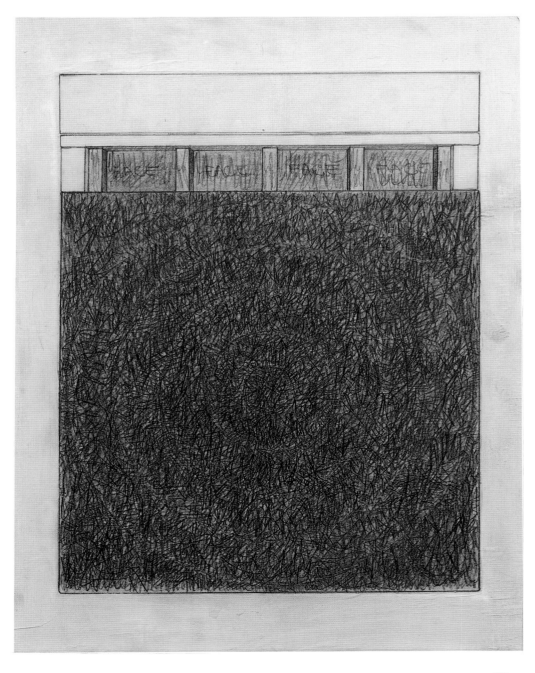

42. **Light Bulb**. 1958
Graphite pencil and graphite
wash on paper
6 ¾ x 8 ¾″ (17.1 x 22.2 cm) sight
Private collection

43. **Target with Four Faces**. 1958
Pencil and gouache on tracing
paper mounted on board
16 ¼ x 12 ½″ (41.3 x 31.7 cm)
Collection David Whitney

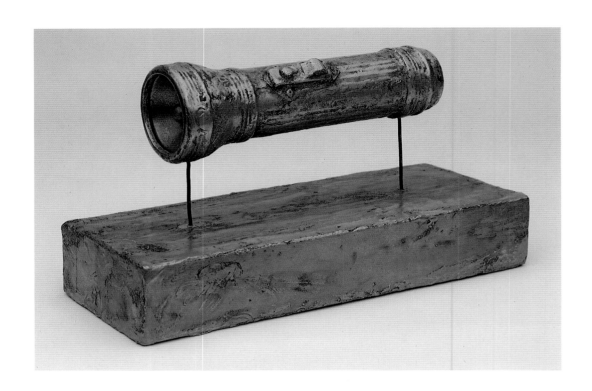

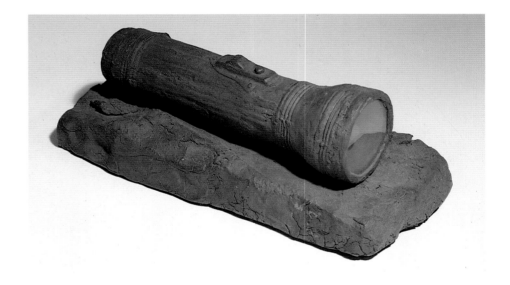

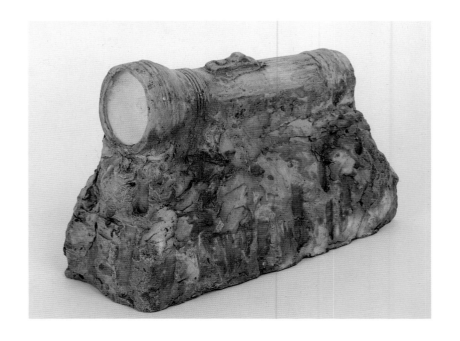

44. **Flashlight I**. 1958
Sculp-metal on flashlight and wood
5 ¼ x 9 ⅛ x 3 ⅞″ (13.3 x 23.2 x 9.8 cm)
Sonnabend Collection

45. **Flashlight II**. 1958
Papier-mâché and glass
4 x 8 ¾ x 3″ (10.2 x 22.2 x 7.6 cm)
Collection Robert Rauschenberg

46. **Flashlight III**. 1958
Plaster and glass
5 ¼ x 8 ¼ x 3 ¾″ (13.3 x 20.9 x 9.5 cm)
Collection the artist

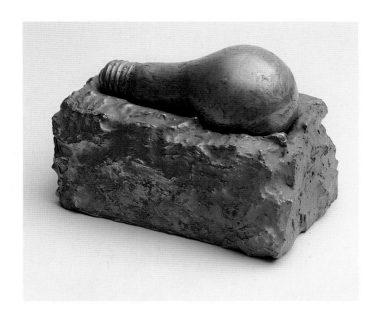

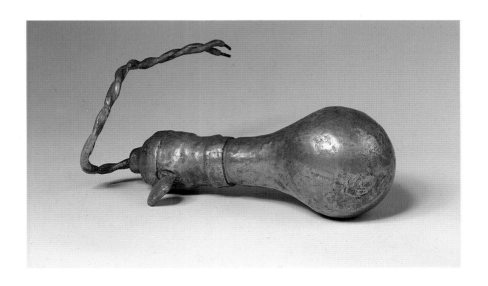

47. **Light Bulb I**. 1958
Sculp-metal
4 ½ x 6 ¾ x 4 ½″ (11.5 x 17.1 x 11.5 cm)
Private collection

48. **Light Bulb II**. 1958
Sculp-metal
5 x 8 x 4″ (12.7 x 20.3 x 10.2 cm)
Collection the artist

In the wake of his gallery debut, Johns almost immediately ceased painting in the way that had won him acclaim. In 1959 he covered the pictorial field, now often imageless, with aggressive brushstrokes and stroke clusters, in white, black, and gray and also in the three primary hues, red, yellow, and blue, and their immediate secondaries (a palette as "found" and prelimited as the schema of a flag or target). These new rocket-burst patches had a splashy "expressionist" intensity, in contrast to the deadpan reticence of his previous paintings; and though a deliberate dryness and self-contained isolation distanced such strokes from the "action" painting that had emerged in New York in the 1950s, several 1960s observers still saw the new manner as regressing to Abstract Expressionism, against the grain of contemporaneous trends toward hard-edged art or evident imagery (trends that Johns's earlier work had fostered). Alfred H. Barr, Jr., of The Museum of Modern Art, who had been one of the artist's most ardent early champions, was apparently bewildered and sharply disappointed by the new work.[1] Only with the passage of time has it become possible to differentiate the unforeseen varieties of pictorial energy—muted or pyrotechnic, airy or choked—that this abstract manner permitted to enter Johns's art.

As opposed to the rigorous flatness of the images up to 1958, the new paintings introduced a sense of open, layered space—even in *Shade*, where a covering flap sealed off the picture's "window." The previous, gridded sequences of integers, for example, were replaced by a new series of paintings in which all the numbers from zero through nine were rendered one atop the other, as in a palimpsest: a logical parade of figures became an archaeology of confusions. As Roberta Bernstein describes this shift, "The self-containment and fixed structure of his earlier work were replaced by compositions that suggest incompleteness and a breakdown of order."[2]

Johns insisted perhaps even more strongly, though, on literalness. The act of painting and the physical properties of the picture, more than any motif brought in from common experience, became the central subjects and primary sources of imagery for the art. As opposed to the earlier targets, for example, *Device Circle* of 1959 exposed the process of its own making, and referred only to itself (and to the general concept of measurement), not to any conventional external sign; for the first time, even its descriptive title—like that of *Painting with Two Balls* the following year—was included in the image. Near simultaneously, however, Johns began to assign referential, nondescriptive titles (*False Start*, *Out the Window*, *Highway*) to his paintings. Such pictures brought to the fore new issues of language, naming, and "signature" marks, as well as introducing (in *Painting with Two Balls* and *Out the Window*) a format of three stacked and abutting horizontal panels that was to become a favored stratagem.

The conceptual wholeness of earlier works gave way also to a greater concern with the mutable nature of physical intensities (the calibration of *Thermometer*) or forms (the wedging in *Painting with Two Balls*). At the same time, deception and contradiction were newly courted: in *False Start*, Johns set perceptual and linguistic cues at odds by inducing discordance between colors and the words that conventionally name them, and in sculpture he made painted-bronze trompe l'oeil re-creations of found objects. *Painted Bronze* (Savarin can), a metal memorial of frozen brushes crowded into a recycled coffee container of paint solvent, was also the first explicit image of studio life in Johns's art.

Johns's focus on matters of making and craft also received a new impetus from his entry into printmaking. His first essays there, following his practice as a draftsman, returned to a tight group of signature motifs; and the three versions of the *Flag* lithograph introduced a strategy of making chains of closely related variations on familiar images. This and other aspects of printmaking's capacities for reiteration, reversal, and sequential development would come to affect Johns's work in paint as well, reinforcing a tendency begun in 1959, when the use of doubled motifs in a single work first emerged as a compositional strategy. While not serialized in any systematic way, Johns's initial imagery—targets, flags, numbers, etc.—now became, through such recyclings, less the common public markers they had initially been, and more evidently the private touchstones of an artistic progress henceforth to be marked equally by sharp, unexpected breaks and by layerings of continuous recurrence. The practice that developed in these years, of painting in a new mode while simultaneously attending to earlier motifs in graphic works, would become a signal part of Johns's complex evolution.

—*KV*

Chronology

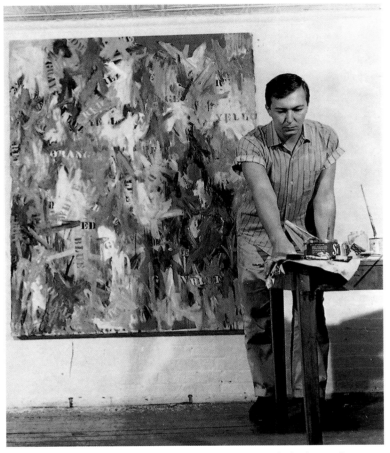

At Front Street, New York, in 1959, with *False Start*, 1959, in the background.

1959

At Front Street, paints *Numbers in Color*, 1958–59; *Colored Alphabet*; a number of small works of single figures—*Figure 4* (LC# 64), *Figure 8* (LC# 77), *Figure 8* (LC# 72), *Figure 0* (LC# 82), *Figure 4* (LC# 57), *Figure 7*, and *Figure 0* (LC# DD); *0–9* (LC# 58); *Device Circle*; *Reconstruction*; *False Start*; *Jubilee*; *Highway*; *Out the Window*; *Thermometer*; *Shade*; *Small Numbers in Color*; *Two Flags*; *Coat Hanger*; *White Numbers*; and *Black Target*.

 Device Circle is the first painting to incorporate a "device," usually a ruler or stretcher bar used to trace a semicircle on the painting's surface.[1] It also foreshadows Johns's references to studio activity.[2]

Includes names of colors in some paintings: *False Start*, *Jubilee*, and *Out the Window*. The latter work is the first in which he divides the painting into three horizontal bands; each bears the name of a primary color.[3]

Working in Sculp-metal, makes his first sculpture on the theme of the critic, *The Critic Smiles*.[4]

Begins the drawing *Study for "0 through 9"*, 1959–60, his first work featuring stenciled superimposed numbers. In the course of 1960 and 1961, Johns will execute a number of paintings and drawings employing this motif.

Uses acrylic for the first time in *Two Flags*,[5] which is also the first work in which Johns employs a double motif.

January 16–[March]: Johns's first solo show in Paris, "Jasper Johns," at the Galerie Rive Droite (23, Faubourg Saint-Honoré), features nine paintings of flags, numbers, and targets, including *Flag on Orange Field*, 1957, *White Numbers*, 1958 (LC# 53), and *0–9*, 1958. It goes virtually unnoticed except for a few short reviews.

[c. January 30]: Writer Nicolas Calas brings Marcel Duchamp to visit Johns's and Robert Rauschenberg's studios.[6] Not long after, Johns reads Robert Lebel's *Marcel Duchamp*, the first major monograph on the artist, published the same year. Also around this time, Johns begins his "Sketchbook Notes," which are similar in style to Duchamp's notes in the *Green Box*.[7]

 Despite Duchamp's importance for Johns, the two will meet, according to Johns, *no more than a dozen times*.[8]

 The first time, I saw him at a party. I did not speak to him. Then someone brought him to my studio. Once, I went to a Christmas dinner which he was at in Chinatown. Then I saw him again at a party. After that I did not see him for years. Then John Cage began to study chess with him and around that time I saw him perhaps eight or ten times. These were very modest encounters. They did not involve much exchange of ideas. There was a set of Merce Cunningham based on the Large Glass. *I saw him around that a few times.*[9]

January 30–April 19: *Target with Four Faces*, 1955, *Green Target*, 1955, and *White Numbers*, 1957, are exhibited at The Museum of Modern Art, New York, in "Recent Acquisitions," an exhibition organized by Alfred H. Barr, Jr.

March: *Arts* magazine publishes a letter to the editor by Johns, protesting critic Hilton Kramer's February

review of "Beyond Painting," the exhibition at the Alan Gallery.[10]

March 1–31: The annual exhibition organized by the Nebraska Art Association, at the University of Nebraska Art Galleries, Lincoln, Nebraska, includes *Flag on Orange Field II*, 1958.

March 21–30: "*Jasper Johns: 287ª Mostra del Naviglio*," at the Galleria d'Arte del Naviglio (Via Manzoni 45), Milan, includes, among other works, *Target with Plaster Casts*, 1955, and *0–9*, 1958. The catalogue contains an introduction by Robert Rosenblum.

May: Japanese writer Yoshiaki Tono is introduced to Johns and Robert Rauschenberg by Leo Castelli.[11] Tono will visit New York again in November 1960 and at the end of 1962.

May 4: *Time* magazine announces, "Jasper Johns, 29, is the brand-new darling of the art world's bright, brittle avant-garde. A year ago he was practically unknown; since then he has had a sellout show in Manhattan, has exhibited in Paris and Milan, was the only American to win a painting prize at the Carnegie International, and has seen three of his paintings bought for Manhattan's Museum of Modern Art."[12]

May 12–30: "Group Exhibition," at the Leo Castelli Gallery, New York, includes works by Paul Brach, Friedel Dzubas, Ludwig Sander, Cy Twombly, and Johns.

[Summer]: At his house in Southampton, the artist Larry Rivers introduces Johns to Tatyana Grosman, director of the print workshop Universal Limited Art Editions (ULAE), in Bayshore (now West Islip), New York, an hour's drive from New York City.[13]

June: Robert Rosenblum, then teaching at Princeton University, introduces Johns and Rauschenberg to Frank Stella.[14]

July 15: Frank O'Hara writes to Johns, "Having drinks with you yesterday was extremely nice....I enjoyed our conversation so much it could have gone on forever as far as I'm concerned (like two old Chinamen sitting in a mountain pass)." O'Hara goes on to suggest poets and novelists Johns may enjoy reading— among them Gary Snyder and Philip Whalen ("both marvellous"), Michael McClure, Gregory Corso, Jack Kerouac, "Bill Burroughs' *Naked Lunch*" ("remarkable"), Alain Robbe-Grillet and Nathalie Sarraute (among "the most interesting French novelists as is oft claimed on their dust jackets"), Peter Orlovsky, John Ashbery, William Carlos Williams ("all the books of poems of WCW have great great great things. in them"), Laura Riding, Jane Bowles, and "I think everyone should read all of Samuel Beckett."[15]

August 8–9: Goes with O'Hara and Vincent Warren to a weekend party at the home of the poet Kenneth Koch and his wife Janice in Southampton.[16] Parts of O'Hara's poem "Joe's Jacket," written on August 10, 1959, seem to be based on this expedition:

Water Mill, Long Island, 1959. Back row: Maxine Groffsky, Mary Abbott, Johns, Joe Hazan, Roland Pease. Middle: Rauschenberg, Stephen Rivers, Herbert Machiz, Sondra Dee, Jane Freilicher, Tibor di Nagy, John Myers. Bottom: Larry Rivers, Grace Hartigan. Photograph: John Gruen.

Entraining to Southampton in the parlor car
with Jap and Vincent, I
see life as a penetrable landscape lit from above
like it was in my Barbizonian kiddy days
when automobiles
were owned by the same people for years and
the Alfa Romeo
was only a rumor under the leaves beside
the viaduct [17]

August 27: Alfred H. Barr, Jr., of The Museum of Modern Art, writes to Johns, "I am sending you an advance copy of our new Bulletin on paintings and sculptures added to our collection during 1958. A friend…asked me whether there was any special significance in my having reproduced your three pictures in one cut instead of individually. I…intended to emphasize the fact that we had acquired three.…As you know, the Museum and I myself have been under some criticism for having bought three works by one artist and he rather little known. I think the Bulletin emphasizes rather than soft pedals this controversial action." [18]

[September]: The first issue of the Milan art magazine *Azimuth*, edited by Piero Manzoni and Enrico Castellani, reproduces *Target with Plaster Casts*, 1955, on its first page.

October 4 and 6–10: At 8:30 P.M., artist Allan Kaprow's *18 Happenings in 6 Parts* takes place at the Reuben Gallery (61 Fourth Avenue), New York. Johns and Robert Rauschenberg participate for one night, substituting for Red Grooms and Lester Johnson. Their role is to leave their seats in the audience and paint onstage, each using a single color on opposite sides of the same unprimed canvas.[19]

> *Kaprow picked Bob Rauschenberg and me from his audience and asked that we work on opposite sides of a suspended piece of muslin. One of us was told to paint circles and the other straight lines. With a brush, I nervously drew unsteady verticals on my side of the cloth and, as Bob's circles bled through the material, I was again impressed by his brilliance. He, having discarded his brush, simply dipped the top of a jar into paint and then printed it onto the fabric.[20]*

October 6–17: Leo Castelli moves his gallery from the fourth floor to the second floor of 4 East 77th Street. The opening exhibition in the new space is a group show of works by Norman Bluhm, Paul Brach, Nassos Daphnis, Gabriel Kohn, Robert Rauschenberg, Ludwig Sander, Sal Scarpitta, Frank Stella, Cy Twombly, and Johns—*Black Target*, 1959.

October 20–November 7: "Work in Three Dimensions," an exhibition at the Leo Castelli Gallery, includes sculptures by Johns dating from 1958: *Flashlight I, Flashlight II, Flashlight III,* and *Light Bulb I.*

November 24: David H. Van Hook, from the Columbia Museum of Art, in Columbia, South Carolina, writes to Castelli, "On a recent sojourn South Mr. Jasper Johns…agreed to a showing of his paintings at this museum provided the dates and the idea were agreeable to you. Such a showing of his paintings in his home state has long been overdue." [21]

November 26–December 27: "Out of the Ordinary," an exhibition at the Contemporary Arts Museum, Houston, includes the painting *Flag*, 1958. The catalogue introduction is by Harold Rosenberg.

Between December 4 and 11: Attends a performance of Red Grooms's *Burning Building* on the top floor of the "Delancey Street Museum," Grooms's building at 148 Delancey Street.[22]

[December 8, 1959–January 8, 1960]: "School of New York: Some Younger Artists," an exhibition at the Stable Gallery, New York, includes works by eleven artists including Johns. The exhibition is timed to coincide with the publication of a book of the same name, edited by B. H. Friedman and including a text on Johns by Ben Heller.

December 9, 1959–January 31, 1960: The "1959 Annual Exhibition of Contemporary American Painting," at the Whitney Museum of American Art (then at 22 West 54th Street), New York, includes *Two Flags*, 1959.

December 15, 1959–February 14, 1960: "*L'Exposition Internationale du Surréalisme: 1959–1960*" takes place at the Galerie Daniel Cordier (8, rue de Miromesnil), Paris. It is organized by André Breton and Marcel Duchamp. José Pierre, who coordinates the exhibition, has written to Johns, "We would like [to include in the exhibition] a work of an erotic nature (it was Marcel Duchamp who suggested that we invite you)." [23] The Johns work included is *Target with Plaster Casts*, 1955.

December 16, 1959–February 17, 1960: "Sixteen Americans," an exhibition at The Museum of Modern Art, curated by Dorothy C. Miller, includes the paintings *Flag*, 1954–55, *White Flag*, 1955, *Target with*

Four Faces, 1955, *Green Target*, 1955, *Gray Alphabets*, 1956, *White Target*, 1958, *Tennyson*, 1958, *White Numbers*, 1958 (LC# 53), *Numbers in Color*, 1958–59, and *Black Target*, 1959. The catalogue, edited by Miller, contains statements by the artists and others.

[December 25]: Duchamp and his wife, Teeny Duchamp, visit Johns and Robert Rauschenberg on Front Street, and they have dinner together in Chinatown.

> *We went out to dinner in Chinatown and Duchamp had, either that day, or the day before, come from taping a[n]…interview….He said he was not happy with the way he had dealt with the questions that this man had raised….and he said, "Well, this man wanted to know why I stopped painting."…And he had said [it was] because of dealers and money and various reasons. Largely moralistic reasons. And then he looked up and said, "But you know, it wasn't like that. It's like you break a leg, you didn't mean to do it." And I thought that was an incredible answer, and probably very correct. It probably wasn't a decision, it was probably something that happened to him.*[24]

1960

Rauschenberg gives Johns a group of small mimeographed maps of the United States showing the boundaries between the states. Johns uses one of these as the support for *Map* (LC# F). In 1961, Johns will paint a second *Map*, much larger and more colorful than the first one, but based on it.[25]

Makes cast-bronze sculptures,[26] among them two entitled *Painted Bronze*—one a cast of a Savarin coffee can filled with brushes, the other of two Ballantine ale cans. Both images will recur in numerous drawings and prints.

> *I was doing at that time sculptures of small objects—flashlights and light bulbs. Then I heard a story about Willem de Kooning. He was annoyed with my dealer, Leo Castelli, for some reason, and said something like, "That son-of-a-bitch; you could give him two beer cans and he could sell them."*
> *I heard this and thought, "What a sculpture—two beer cans." It seemed to me to fit in perfectly with what I was doing, so I did them and Leo sold them.*[27]

Collectors Robert and Ethel Scull commission a *Figure 5* painting from Johns, picking the number five for luck.[28]

Makes the drawing *From False Start* (LC# 115) for an auction to benefit the Living Theater.[29]

[Winter]: At Front Street, makes *Painting with Two Balls*, initiating his practice of stenciling a painting's title, his signature, and the date on the front of the canvas.[30]

February 15–March 5: "Jasper Johns," at the Leo Castelli Gallery, includes paintings executed during the previous year: *False Start*, *Device Circle*, *Thermometer*, *Shade*, *Jubilee*, *Out the Window*, *Highway*, and *Reconstruction*. Castelli will recall that *False Start* is perceived as a radical departure from earlier works: "Alfred Barr almost blanched…he was so disappointed. He said he didn't understand it at all."[31]

February 16: With Robert Rauschenberg and Emile de Antonio, Johns organizes a performance of the Merce Cunningham Dance Company at the Phoenix Theater, New York. It includes the New York premiere of *Summerspace*, 1958—the work that had first been performed at the Eleventh American Dance Festival in Connecticut in 1958.

> *We had the idea to do it, and we made all the arrangements, dealt with the problems of getting a theatre, covering the costs of it, and ensuring that there was an audience.*[32]

By March 1: In Sarasota, Florida.[33]

[Spring]: At Front Street, paints *Painting with Ruler and "Gray"*.

April 21: At 8 p.m., participates in a symposium moderated by Robert Goldwater at New York University's Eisner and Lubin Auditorium, on Washington Square South, Manhattan. Called "Art 1960," it features artists whose work had been included in "Sixteen Americans": Alfred Leslie, Robert Mallary, Louise Nevelson, Robert Rauschenberg, Richard Stankiewicz, and Frank Stella.[34]

May 3–June 15: "Recent Paintings by Jasper Johns," an exhibition at the Seminar Gallery, University Gallery, University of Minneapolis, includes, among other works, *Device Circle* and *Shade*, both 1959.

May 31–June 25: "Summary, 1959–1960: Bluhm, Bontecou, Daphnis, Higgins, Johns, Kohn, Langlais, Rauschenberg, Sander, Scarpitta, Stella, Twombly, Tworkov," an exhibition at the Leo Castelli Gallery, includes *Painting with Two Balls*, 1960.

[Summer]: In Nags Head, North Carolina, paints a Sculp-metal *Flag, 0 through 9* (LC# 103), and *Figure 5*. While in North Carolina, obtains a driver's license.[35]

July 15: Leo Castelli writes to Johns announcing his arrival at Nags Head on the 25th.[36]

July 29: Castelli writes to Walter Hopps, then running the Ferus Gallery, Los Angeles, "I have just visited Jasper Johns in his summer vacation place in North Carolina, and we picked together a number of paintings and objects that we felt would be appropriate for your show. The distinctive characteristic of the choice is the idea that the paintings as well as the sculpture have in common an object quality. A list is enclosed showing the ones I would send you." Castelli's list includes the paintings *Thermometer*, 1959, *Study for "Painting with a Ball"*, 1958, *Coat Hanger*, 1959, *Target*, 1958 (Sculp-metal), *Flag*, 1960 (Sculp-metal), and *Painting with Ruler and "Gray"*, 1960, as well as the sculptures *Light Bulb I*, 1958, and *Light Bulb II*, 1958.[37]

August 7: Tatyana Grosman writes to Johns, inviting him to collaborate with ULAE: "I have been following your work for some time. I would like very much to stimulate your interest in working lithography on stone. Your work would lend itself beautifully to this medium.

"Please contact me. I am frequently in the city and can meet with you at your convenience. However if you are passing by on your way out to Southampton it would be nice if you came to the studio.

"I think we met last year at Larry Rivers's at Southampton at the time when I published his portfolio with O'Hara."[38]

August 12: From Kill Devil Hills, North Carolina, sends postcard to Grosman to say he will be in New York in September, when she can give him a call.[39]

The artist Larry Rivers will encourage Johns to accept Grosman's invitation, telling him, according to Riva Castleman, that "prints helped pay the rent."[40]

[Late summer–fall]: At Front Street, paints *Disappearance I*, *Map*, *White Flag*, *Small False Start*, *Figure 3*, and probably *0 through 9* (LC# HH).

[September]: Visits ULAE, in West Islip. Grosman subsequently arranges for three lithographic stones to be delivered to Johns's studio. On the first stone he draws a zero, which will later result in the *0–9* portfolio, published in 1963. He uses the second stone to make *Target* (plate 73), his first published lithograph. Johns never uses the third stone. Impressed by the stones' weight, he decides that he'll find it easier to work in West Islip.[41]

September 6–30: "Jasper Johns—Kurt Schwitters," an exhibition at the Ferus Gallery (723 North La Cienega Boulevard), Los Angeles. Organized by Walter Hopps, the show was initially to include

works by Joseph Cornell as well as by Schwitters and Johns.[42]

September 22: John Richard Craft, director of the Columbia Museum of Art, writes to Castelli, "I talked today by phone with Jasper Johns. This was really on a totally different subject; but in the course of things we also reviewed our plans for his exhibition here at the Columbia Museum—returning to the scene of some of his student exhibits and the arena where he put on shows for the armed forces during his tour of duty....I realize that Jap may be a little hardpressed for paintings, but I know that he is madly at work on a number of things."[43]

September 24–October 22: *Target with Four Faces*, 1955, is exhibited in "New Forms—New Media, II," at the Martha Jackson Gallery (32 East 69th Street), New York.

September 25: *Two Flags*, 1959, is reproduced, upside-down, on the cover of *Art International*.

[Late September–early October]: Johns's first lithograph, *Target*, is published by ULAE in an edition of 30.[44] Johns continues to draw and proof lithographs, completing four probably before the end of September: *Coat Hanger I*, *0 through 9*, *Flag I*, and *Flag II*.

[October]: A group exhibition at the Barone Gallery (1018 Madison Avenue, Penthouse), New York, includes works by Grace Hartigan, Rivers, and Adja Yunkers, as well as the Johns lithographs so far completed.

October 26–December 3: "The Mysterious Sign," an exhibition at the Institute of Contemporary Arts, London, includes *White Numbers*, 1957.

[Late October–late November]: Visits Robert Rauschenberg in Treasure Island, Florida. On October 27, Johns writes to tell Tatyana Grosman that he expects to return to New York on December 10.[45]

October 31: Grosman replies to Johns, "Mr. [William] Lieberman [of The Museum of Modern Art] said that he is looking for funds to purchase all four of your lithographs (the number ones which I left in his office).

"I think the embossed Coat Hanger is fascinating. I would like to have a bigger edition, about 15 impressions of it.

"Your stone the 'Alphabet' is covered and waiting for you. The drawing 'The Alphabet' is hanging on a wall and gives us great pleasure....Maurice [Grosman, Tatyana's husband and partner in ULAE]

likes me to tell you that we got very used to you and he misses you very much."[46]

November 28–January 14, 1961: The "International Surrealist Exhibition," at the D'Arcy Galleries (1091 Madison Avenue), New York, includes *Target with Plaster Casts*, 1955.

[Early December]: In South Carolina for the opening of his solo exhibition at the Columbia Museum of Art.

December 7–January 22, 1961: "Annual Exhibition 1960: Contemporary Sculpture and Drawings," at the Whitney Museum of American Art, includes the drawing *Target*, 1960 (LC# 99).

December 7–29: "Jasper Johns 1955–1960," at the Columbia Museum of Art, includes eighteen paintings and five lithographs. The paintings are *Figure 5*, 1955, *Target with Four Faces*, 1955, *Gray Alphabets*, 1956, *Gray Target*, 1957, *Tennyson*, 1958, *Flag*, 1958, *Flag on Orange Field II*, 1958, *Target*, 1958 (LC# 39), *White Numbers*, 1958 (LC# 186), *False Start*, 1959, *Jubilee*, 1959, *Highway*, 1959, *White Numbers*, 1959, *Figure 4*, 1959 (LC# 57), *Figure 0*, 1959 (LC# 82), *Small Numbers in Color*, 1959, *Figure 5*, 1960, and *Painting with Two Balls*, 1960. There is a catalogue, with text by Robert Rosenblum.

According to writer Leonard Lyons, on the occasion of this first major show in Johns's home state, a "lady said, in audible tones: 'My, that's a beautiful painting.' The next lady commented to her: 'Oh, are you a relative too?'"[47]

December 23: In *Scrap*, a New York journal edited by Sidney Geist, Johns publishes a review of George Heard Hamilton's translation of *The Bride Stripped Bare by Her Bachelors, Even: A Typographic Version by Richard Hamilton of Marcel Duchamp's Green Box*. Around this time he also buys a copy of the 1934 edition of the *Green Box* from Duchamp, who brings it to Front Street and inscribes on it "To Jasper Johns, Sybille des cibles, Affectueusement, Marcel 1960."[48]

December 30: John Richard Craft writes to Castelli of the Columbia Museum of Art exhibition: "Taciturn as Jasper is, I hope that he also filled you in with what a thoroughly satisfying opening we enjoyed to his exhibit. Volumes of people have been attracted, shocked and thrilled with his vision of art; and I sincerely hope that we have contributed to the appreciation of Jasper within the confines of his own native state."[49]

With Tatyana Grosman at ULAE, West Islip, N.Y., June 30, 1962.
Photograph: Hans Namuth. © Hans Namuth 1990.

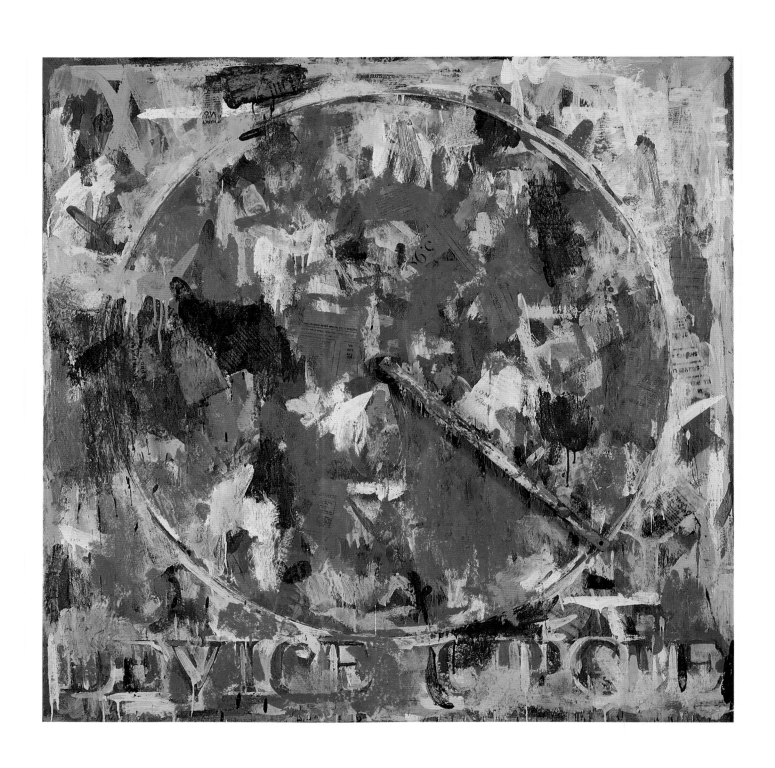

49. **Device Circle**. 1959
Encaustic and collage on canvas with wood
40 x 40″ (101.6 x 101.6 cm)
Collection Denise and Andrew Saul

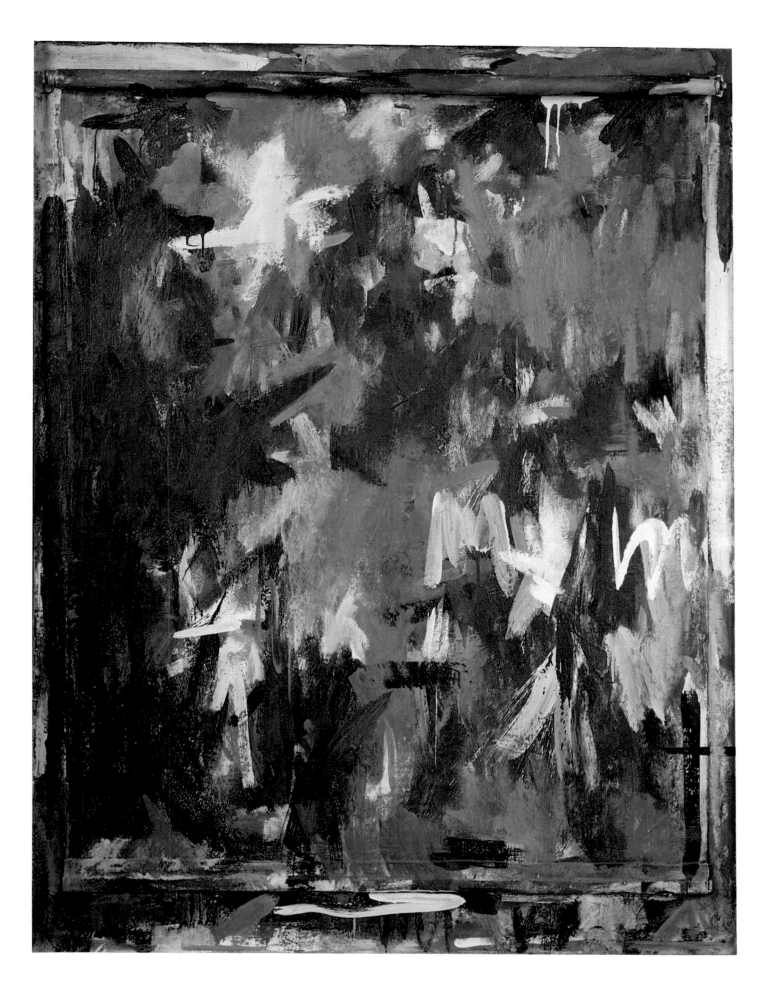

50. **Shade**. 1959
Encaustic on canvas with objects
52 x 39″ (132 x 99 cm)
The State Russian Museum, St. Petersburg

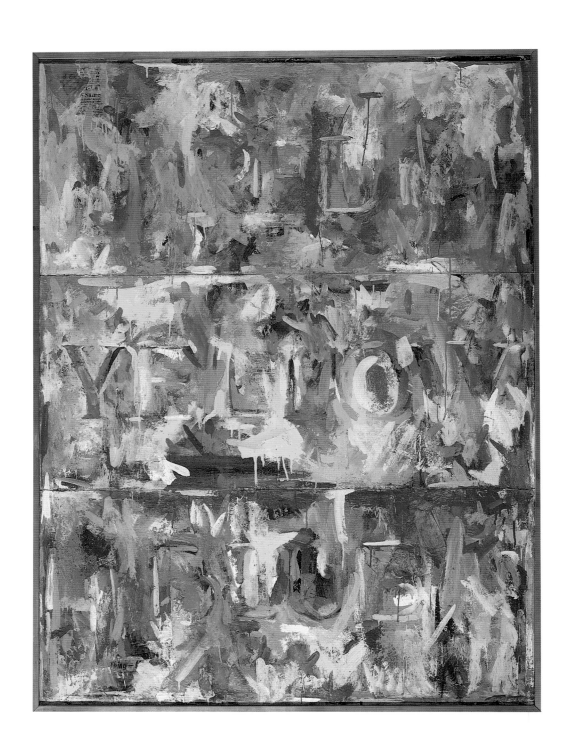

51. **Out the Window**. 1959
Encaustic and collage on canvas
54 ½ x 40 ⅛″ (138.4 x 101.9 cm)
Collection David Geffen, Los Angeles

52. **Highway**. 1959
Encaustic and collage on canvas
75 x 61″ (190.5 x 154.9 cm)
Private collection

53. **Jubilee**. 1959
Oil and collage on canvas
60 x 44″ (152.4 x 111.8 cm)
Collection Michael and Judy Ovitz,
Los Angeles

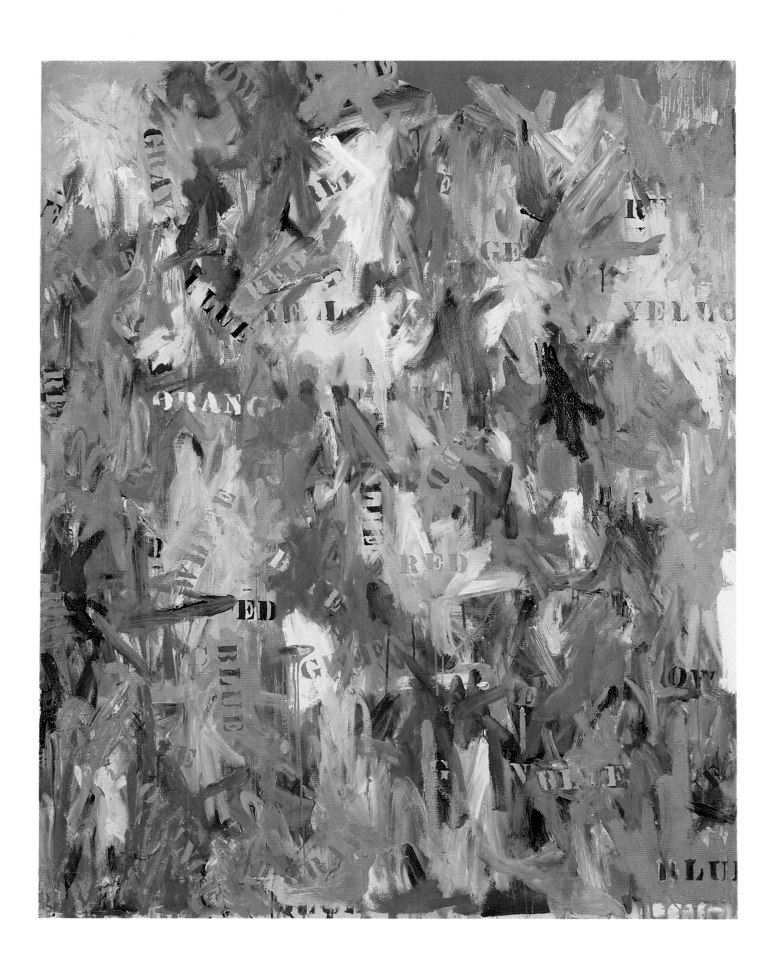

54. **False Start**. 1959
Oil on canvas
67 ¼ x 54" (170.8 x 137.2 cm)
Private collection

55. **Three Flags**. 1959
Graphite pencil on paper
14 ½ x 20″ (36.8 x 50.8 cm)
The Board of Trustees of the Victoria and
Albert Museum, London

56. **Flag**. 1959
Graphite pencil and graphite wash on paper
12 x 16″ (30.4 x 40.6 cm)
Mildred and Herbert Lee Collection

176

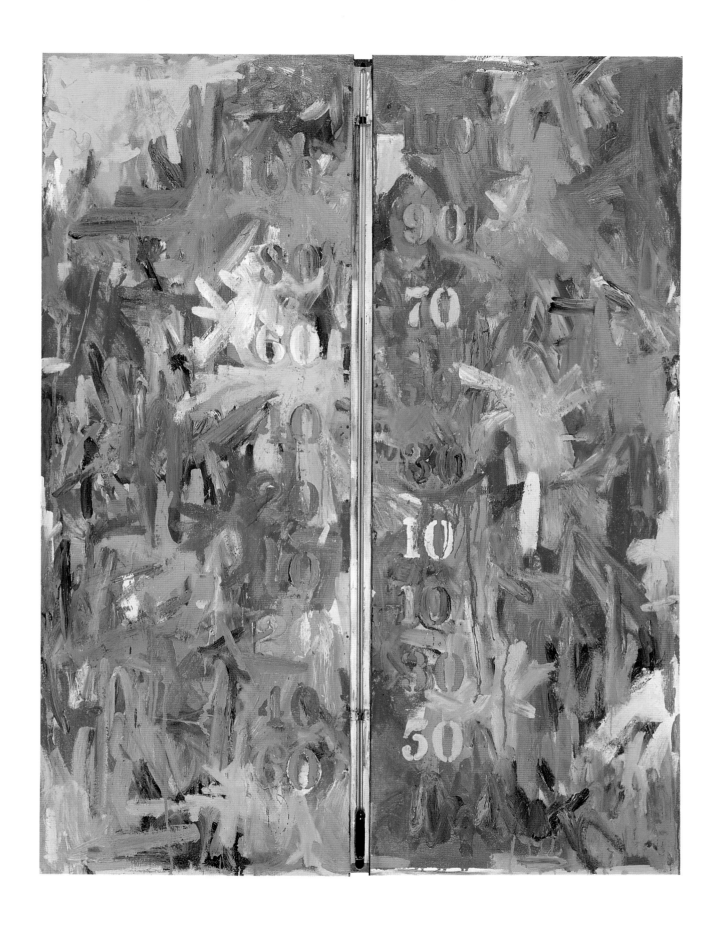

57. Thermometer. 1959
Oil on canvas with thermometer
51 ¾ x 38 ½″ (131.4 x 97.8 cm)
Seattle Art Museum, fractional interest gift
of Bagley and Virginia Wright, and
collection Bagley and Virginia Wright

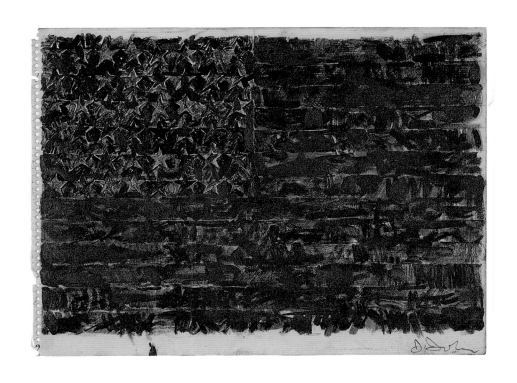

58. **Flag**. 1959
Graphite wash on paper
12 x 16″ (30.5 x 40.6 cm)
Private collection

59. **Flag**. 1960
Sculp-metal and collage on canvas
13 x 19¾ x 1½″ (33 x 50.1 x 3.8 cm)
Collection Robert Rauschenberg

60. **Black Target**. 1959
Encaustic and collage on canvas
54 x 54″ (137.1 x 137.1 cm)
Destroyed by fire in 1961

61. **Figure 5**. 1960
Encaustic and newsprint on canvas
72 ¹⁄₁₆ x 54 ⅛″ (183 x 137.5 cm)
Musée national d'art moderne, Centre Georges
Pompidou, Paris. Gift of the Scaler Foundation, 1975

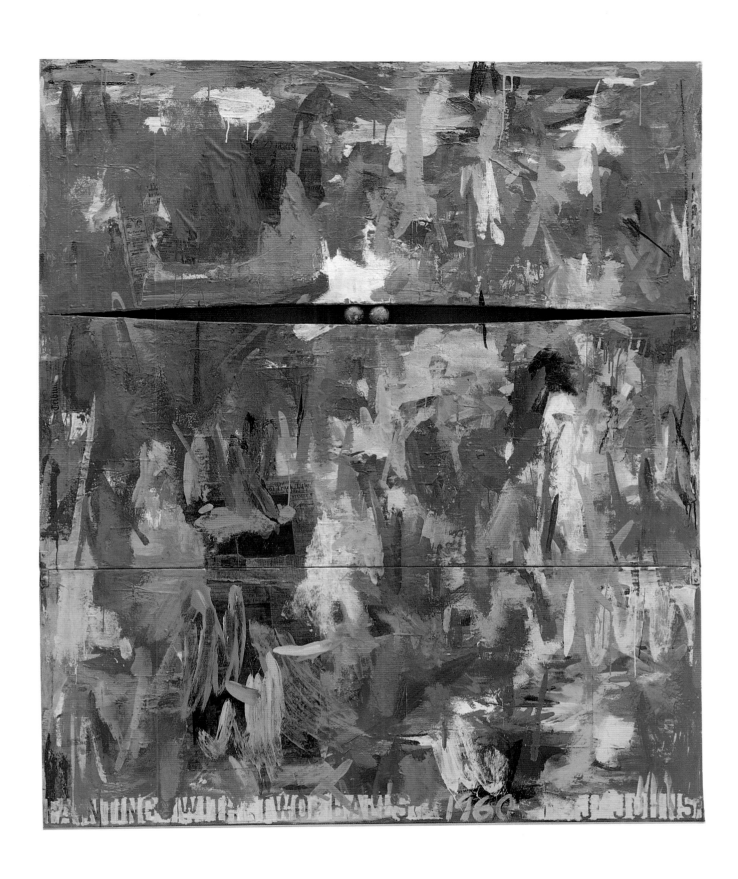

62. **Painting with Two Balls**. 1960
Encaustic and collage on canvas
with objects (three panels)
65 x 54″ (165.1 x 137.2 cm)
Collection the artist

63. **0 through 9**. 1960
Charcoal on paper
28⅞ x 22⅞″ (73.3 x 58.1 cm)
Collection the artist

64. **Night Driver**. 1960
Charcoal, pastel, and collage on paper
51 x 42″ (129.5 x 106.7 cm)
Robert and Jane Meyerhoff,
Phoenix, Maryland

65. 0 through 9. 1960
Oil on canvas
72 x 54″ (182.8 x 137.1 cm)
Collection The Fukuoka City Bank, Ltd.

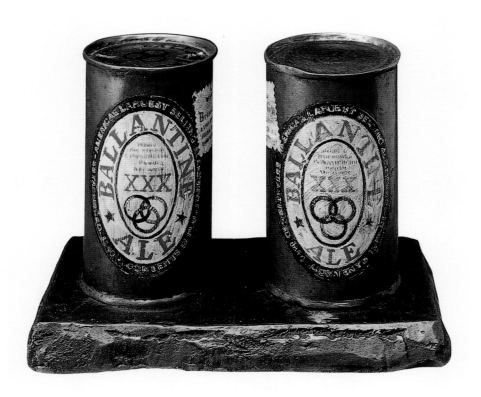

66. **Painted Bronze**. 1960
Oil on bronze
Overall: 5 ½ x 8 x 4 ¾″ (14 x 20.3 x 12 cm);
two cans: each 4 ¾ x 2 ¹¹⁄₁₆″ diameter
(12 x 6.8 cm diameter); base: ¾ x 8 x 4 ¾″
(2 x 20.3 x 12 cm)
Museum Ludwig, Ludwig Donation,
Cologne

67. **Light Bulb**. 1960
Bronze
4 ¼ x 6 x 4″ (10.8 x 15.2 x 10.2 cm)
Collection Irving Blum, New York

68. **Light Bulb**. 1960
Oil on bronze
4 ¼ x 6 x 4″ (10.8 x 15.2 x 10.2 cm)
Collection the artist

69. **Painted Bronze**. 1960
Oil on bronze
13 ½ x 8″ diameter (34.3 x 20.3 cm diameter)
Collection the artist

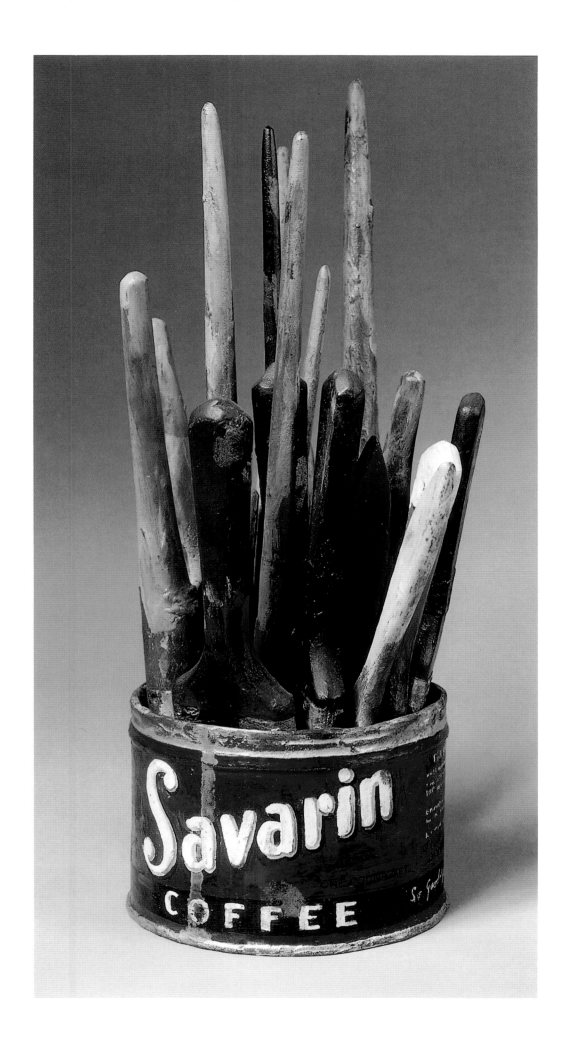

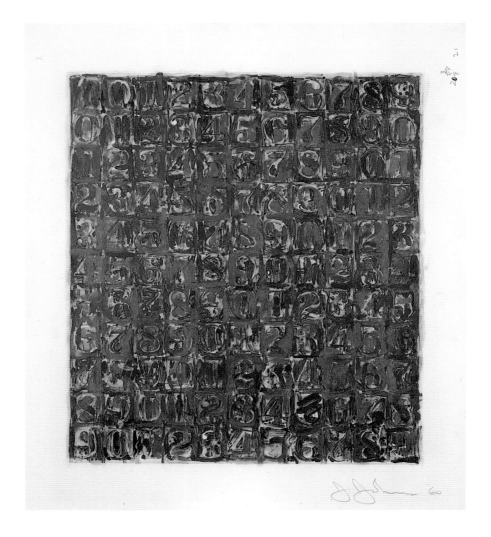

70. **Three Flags**. 1960
Charcoal and graphite pencil on
three layers of board
11 7/8 x 16 3/4" (30.2 x 42.5 cm) sight
Private collection

71. **Numbers**. 1960
Graphite wash on paper
21 x 18" (53.3 x 45.7 cm)
Private collection, Boston

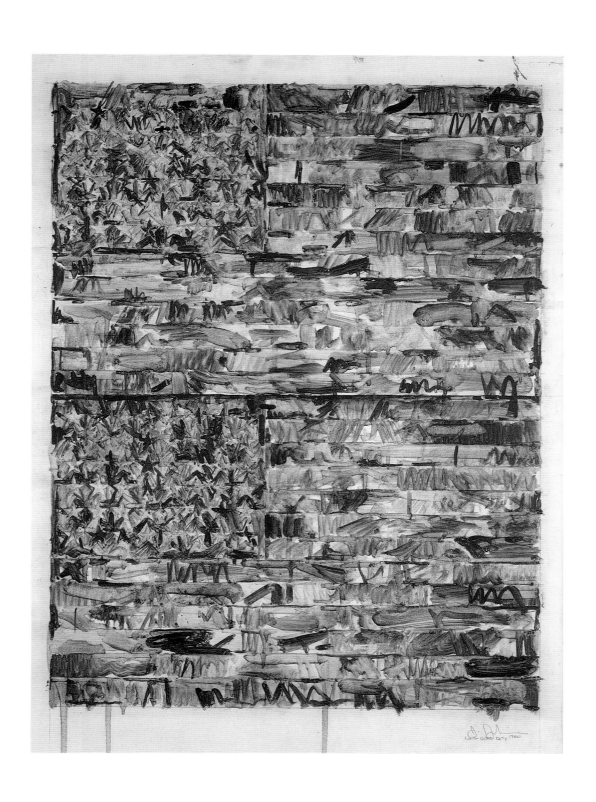

72. **Two Flags**. 1960
Graphite wash on paper
29 ½ x 21 ¾″ (74.9 x 55.2 cm)
Collection the artist

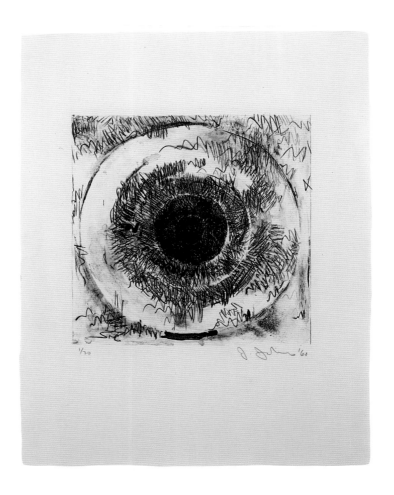

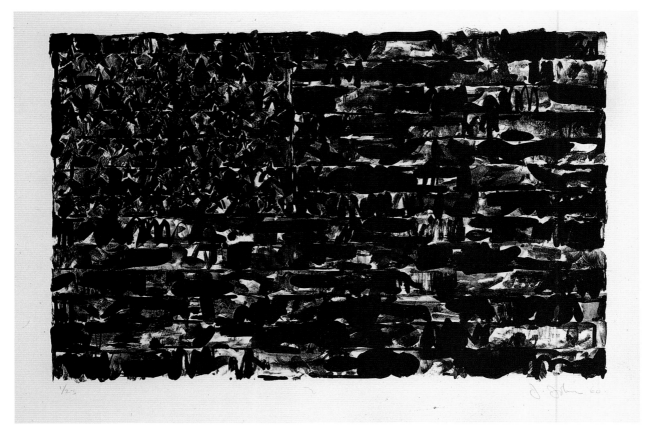

73. **Target**
West Islip, N.Y.: Universal Limited
Art Editions, 1960
Lithograph
22 ⅝ x 17 ⅝″ (57.5 x 44.7 cm)
The Museum of Modern Art, New York.
Gift of Mr. and Mrs. Armand P. Bartos

74. **Flag I**
West Islip, N.Y.: Universal Limited
Art Editions, 1960
Lithograph
22 ¼ x 30″ (56.5 x 76.2 cm)
The Museum of Modern Art, New York.
Gift of Mr. and Mrs. Armand P. Bartos

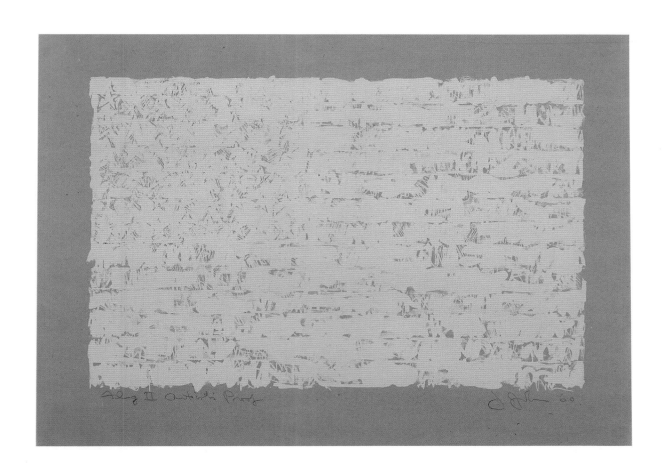

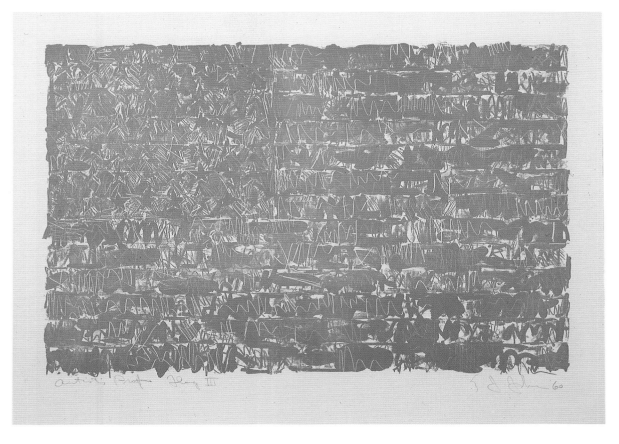

75. **Flag II**
West Islip, N.Y.: Universal Limited
Art Editions, 1960
Lithograph
23 ⅞ x 32 ¹⁄₁₆″ (60.7 x 81.5 cm)
The Museum of Modern Art, New York.
Gift of Leo and Jean Christophe Castelli
in memory of Toiny Castelli

76. **Flag III**
West Islip, N.Y.: Universal Limited
Art Editions, 1960
Lithograph
22 ⁷⁄₁₆ x 30 ⅛″ (57 x 76.5 cm)
The Museum of Modern Art, New York.
Gift of the Celeste and Armand Bartos
Foundation

Between *Thermometer* of 1959 and *Water Freezes* of 1961, a new emotional tone intervened in Johns's work, chill, dark, and bleak. Titles of negation, melancholy, or bitterness (*No, Liar, In Memory of My Feelings—Frank O'Hara*) underlined the altered mood. Even the labels of standard colors inscribed in the pictures—red, yellow, blue—often seemed to take on a distressed life, as Johns made them slide out of register, fall down, and echo in broken refractions. Gray, formerly the guise of impassive neutrality, became an expressive cast of gloom and morbidity. This was now an art under pressure, and imagery of imprinting and smearing, along with thinned-out passages of staining paint and crusts of scraped residue, gave it a more troubled material and psychological life. The small *Liar* is a telling example, where stamping into the paint—and the drips below— gives the title's accusatory sting a physical affect of frozen violence. In an interview in 1963, Johns suggested that where his earlier work was more "intellectual," the viewer of his recent work "responds directly to the physical situation," with the effect that paintings are "more related to feeling or…emotional or erotic content."[1]

The increasing instances of mirroring in works such as *Liar* may reflect the influence of Johns's printmaking activities on his thinking, and the inside-out fold of the canvas in *Disappearance II*, like the split title in *Fool's House* (which would come together if the surface were rolled around a cylinder), shows a growing complexity in his notions of an implied space beyond the picture plane. In other, quasi-narrative assemblages of the period (*Fool's House*, for example, and *In Memory of My Feelings—Frank O'Hara*), the appearance of hinged sections, diagrammatic instructions, signs, and labels may also reflect the influence of Marcel Duchamp, and particularly of the older artist's notes, then recently published in translation, for the "engineering" of *The Bride Stripped Bare by Her Bachelors, Even (The Large Glass)*, of 1915–23. Parallel with such "mechanical" indices, though, Johns made the body an explicit subject by imprinting his hands, arms, face, and feet in several drawings, lithographs, and paintings. The body prints in the (unprecedentedly large) *Diver* images evoke the extreme reach of a solitary figure virtually crucified in space, and the outstretched arm in *Periscope (Hart Crane)*, associated through the

work's title with the poet Crane's suicide by drowning, seems to reach with a thwarted desperation. The *Study for Skin* drawings, which Johns made by pressing his oiled features against paper and then affixing charcoal to the stain, were created in connection with his project for a flattened sculpture made from a distended latex cast of a head.[2] All these applications of his own body were symptomatic of the more exposed, emotional, and presumably autobiographical aspect of Johns's art in this period; by recovering the psychological charge of the encased body fragments in the early *Target* constructions, they announced an imagery of combined morbidity and sensuality that was to become central to his work.[3]

In 1961, Johns began working in a newly acquired home in Edisto Beach, a sparsely populated locale near Charleston, South Carolina. Soon, in an art-supply store in Charleston, he found sheets of translucent plastic material on which he began a new series of ink drawings, exploiting the rich patterning that resulted when ink puddled and dried on the nonabsorbent surface. He also developed an important new motif, the map of the United States. In 1960, Robert Rauschenberg had given him a small black-and-white map showing only the boundary contours of the central forty-eight states, without their names or any other geographical indications. This image, as Johns elaborated it into three major paintings and numerous smaller works, became a far more complex American sign than the flag. It encoded the fragmented political and geographic realities of the nation into a skein of contours and names that Johns painted—in contrast to the labored exactitudes of his earlier years—with an active and often seemingly reckless array of colors and gestural brushstrokes. The first of the three large *Map* paintings was especially brightly colored and agitated in its execution. The last of them, however, from 1963, was painted in heavily grayed-down hues, and the signature affixed to it gives a rare explicit indication of where the artist was emotionally at the time; it was signed "JOHNS '63 HELL." At the same time, the scale of the large *Map* paintings—a monumentality even more evident in the elaborate, self-summarizing *Diver* painting—in itself suggests an increased rhetorical range, and a newly expansive set of ambitions.

—KV

Chronology

1961

[Winter]: Robert Rauschenberg moves from 128 Front Street to a studio on Broadway.[1] The Swedish artist Öyvind Fahlström takes over Rauschenberg's studio.[2]

[January]: Paints a small *Green Target* and *Water Freezes* at the Front Street studio.

In Edisto Beach, S.C., 1965. Photograph: Ugo Mulas. © Ugo Mulas Estate. All rights reserved.

[c. January 15]: Buys a house in Edisto Beach, on Edisto Island, south of Charleston, South Carolina, where *except during the resort season, there are only four families living....My place is on the beach...forty miles to the nearest movie.*[3]

> *It was I guess December or January....It was very cold. And I went inside this house, which had been locked up all winter....The house was not very attractive; everything was pink inside. And I went to the kitchen and opened the cabinet below the sink and there was half a bottle of bourbon, and I said, "I'll buy the house."*[4]

Until 1966, Johns will live mostly in Edisto Beach from spring to fall of each year, then spend the winter in New York. He will later allow that this departure from New York working conditions, especially in terms of the light, *has probably affected the texture and color quality of my work.*[5] His working habits also change: *Before, I used to work on a picture at a time....Since [1964], I work on a couple of pictures at once, because of living here [Edisto Beach] and frequently being in New York.*[6]

[Late January]: Johns installs his upcoming show at the Leo Castelli Gallery, New York. As he is working, *A critic came in and started asking me what things were. He paid no attention to what I said. He said, what do you call these? and I said sculpture. He said why do you call them sculpture when they are just casts? I said they weren't casts, that some had been made from scratch, and others had been casts that were broken and reworked. He said yes, they're casts, not sculpture.* Johns will connect this episode to the idea for his 1961 work *The Critic Sees.*[7]

January 31–February 18: "Jasper Johns: Drawings, Sculptures & Lithographs," at the Leo Castelli Gallery, includes forty-five works.

Before February 18: Meets artist Andy Warhol and Ted Carey at the Leo Castelli Gallery, probably through Ivan C. Karp, the gallery's director. Warhol acquires the drawing *Light Bulb*, 1958 (plate 42),[8] and Carey acquires the drawing *Numbers*, 1960 (LC# 113). Johns will later describe this first meeting with Warhol: *We were introduced, and I said, "Oh, I know your work."...I was talking about his commercial work, which was what I knew, because at that time I did display work. Bob Rauschenberg and I were working together, and one of the jobs that we had gotten was to interpret some of Andy's shoe drawings in a kind of three-dimensional window display. It was at I. Miller, I think. And so I told Andy this, and he said, "Why didn't they ask me to do it?"*[9]

[Late winter–early spring]: In Edisto Beach, paints *Figure 3* and eight works each titled *0 through 9*, seven of which will be included in Johns's upcoming exhibition in Paris.

In Edisto Beach, 1965. Photograph: Ugo Mulas. © Ugo Mulas Estate. All rights reserved.

March 3: *Black Target*, 1959 (plate 60), which is in the collection of Governor and Mrs. Nelson A. Rockefeller, is destroyed by fire at the Governor's Mansion in Albany, along with numerous other works.[10]

March 10–April 17: "*Bewogen/Beweging*," an exhibition at the Stedelijk Museum, Amsterdam, includes the painting *Thermometer*, 1959. The show will travel to Sweden and Denmark.[11]

April 24: Johns is still in Edisto Beach.[12]

May 18: At Marcel Duchamp's request, contributes a *Flag* drawing to a sale to benefit the American Chess Foundation, held at Parke-Bernet Galleries, New York.[13]

By May 20: In New York.[14]

[Early June]: To Paris, for an exhibition of his work at the Galerie Rive Droite. This is Johns's first trip abroad; Leo Castelli accompanies him. It is probably during this trip that he acquires Duchamp's *Female Fig Leaf* (from the bronze edition issued by the Galerie Rive Droite), an imprint of which he will include in the paintings *No*, 1961, *Field Painting*, 1963–64, and *Arrive/Depart*, 1963–64, by heating it and then pressing it onto the painted surface.[15]

June 12: First performance of Merce Cunningham's *Suite de Danses*, 1961, a work for television directed by Jean Mercure and filmed for Société Radio-Canada, Montreal, with music by Serge Garrant. Johns has designed the costumes.

June 13–July 12: "*Jasper Johns: Peintures et Sculptures et Dessins et Lithos*," at the Galerie Rive Droite, includes seven *0 through 9* paintings of 1961, sculptures including the two *Painted Bronze* works (the Savarin can and the ale cans) and the bronze *Light Bulb*, 1960, and the drawing *0 through 9* of 1961 (plate 86).

June 19–July 8: "Vanguard American Painting," an exhibition in Vienna, organized by the United States Information Agency, includes the paintings *Gray Rectangles*, 1957, *False Start*, 1959, and *Reconstruction*, 1959. Over the next year, the exhibition will travel to Austria, Yugoslavia, England, and West Germany.[16]

June 20: At 9 P.M., David Tudor plays John Cage's *Variations II* at the Théâtre de l'Ambassade des États-Unis (41, rue du Faubourg Saint-Honoré), Paris. Rauschenberg and the artists Niki de Saint Phalle and Jean Tinguely participate in the performance. Johns contributes a large target made of flowers (documented in *Floral Design*, a drawing with collage that includes the program of the event, the bill for

Performance by David Tudor, Robert Rauschenberg, Niki de Saint Phalle, and Jean Tinguely, with contributions from Johns, at Théâtre de l'Ambassade des États Unis, Paris, June 20, 1961. Photographs: Harry Shunk.

the flowers, and the florist's card) and a sign/painting, *Entr'acte*, which he has made at the Paris studio of his friend Fance Franck (formerly Stevenson). As *Entr'acte* is brought onstage, the house lights are turned up for fifteen minutes, but the performance continues; the work's presence, then, implies an intermission that is not fully realized.[17] The event has been arranged by Darthea Speyer, who is highly criticized for it by U.S. Information Service officials and is forbidden to organize anything similar again under any circumstance.[18]

June 21: At dawn, Tudor sends a telegram to Cage at Wesleyan University, Connecticut: "You had a wonderful concert tonight with me Jasper Johns Niki de Saint Phalle Robert Rauschenberg Jean Tinguely at the American Embassy, David."[19]

June 26: Helps install Saint Phalle's show at Galerie J— her first solo exhibition, organized by Pierre Restany.

With Niki de Saint Phalle at the opening of her exhibition at Galerie J, Paris, June 28, 1961. Photograph: Harry Shunk.

June 28: Attends the opening of the Saint Phalle show, where visitors are invited to shoot at the paintings. Among the works exhibited is *Jasper Johns's Shot*, 1961, which uses images borrowed from Johns's work—the target and the coat hanger. Dinner follows, at La Coupole.

By July 6: Back in New York.[20]

Late July: Lithographs by Johns are shown in an exhibition at the Hyannis Festival, which also includes ULAE lithographs by Helen Frankenthaler, Fritz Glarner, Robert Goodnough, Grace Hartigan, Robert Motherwell, and Larry Rivers. The show will later travel to New York.[21]

[Late July–September]: In Edisto Beach, paints *Map*, *By the Sea*, and *Target*.[22]

[End of July]–October 10: Pierre Restany includes *Entr'acte* and *Painted Bronze* (the Savarin can) in the exhibition *"Le Nouveau Réalisme à Paris et à New York,"* at the Galerie Rive Droite, Paris. Also in the show are works by Arman, Lee Bontecou, César, John Chamberlain, Chryssa, Raymond Hains, Yves Klein, Robert Rauschenberg, Niki de Saint Phalle, Richard Stankiewicz, and Jean Tinguely. Restany contributes a catalogue essay, *"La Réalité dépasse la fiction,"* dated June 1960.

[Late summer]: Johns goes to Connecticut to attend performances of Merce Cunningham's. Around this time, his relationship with Rauschenberg breaks up.[23]

September 15: Writes to Tatyana Grosman from Edisto Beach that he hopes to return to New York in early October, and that he wants to finish the *0–9* portfolio before the lithographic stone rots away.[24]

September 25: Tatyana Grosman replies to Johns, "I am very anxious to do the portfolio finally. Now is the right moment to do this project. It would be also very interesting to start to build up color lithographs.

"Bob Blackburn and another very good printer will concentrate on the proofing of the 'Alphabet.'

"When you arrive we should have a final proof."[25]

September 29–November 5: The American section of the *"Deuxième Biennale de Paris: Manifestation Biennale et Internationale des Jeunes Artistes,"* at the Musée d'Art Moderne de la Ville de Paris, includes the painting *o through 9*, 1961 (LC# 138), and the drawing *0–9*, 1961 (plate 86). It is organized by Darthea Speyer.

[Fall]: At his Front Street studio, Johns makes a group of predominantly gray paintings: *Fountain Pen*, *Liar*, *In Memory of My Feelings—Frank O'Hara*, *Disappearance II*, *No*, *Good Time Charley*, and *Painting Bitten by a Man*. With this group of paintings—and already in *By the Sea*—Johns's titles change in nature, becoming more personal and less strictly descriptive. At the same time, the works increasingly feature domestic or studio objects attached to their surfaces.[26]

On seeing *Good Time Charley*, Ileana Sonnabend points out to Johns its similarity to John Frederick Peto's *The Cup We All Race 4*, c. 1900. Johns's painting *4 the News*, completed in 1962, derives its title from the Peto work.[27]

[October–December]: While preparing his essay "Jasper Johns: The First Seven Years of His Art," Leo Steinberg pays several visits to Johns's Front Street studio: "There were several long meetings with Jasper, talking hours on end; because, whenever one of my questions got an elliptical answer, and I felt unsure of its meaning, I would keep questioning his answer and not let go until that answer was clarified. Didn't matter to either of us how long it took."[28]

October 2–November 12: "The Art of Assemblage," an exhibition organized by William C. Seitz at The Museum of Modern Art, includes *Book*, 1957. The show will travel to Dallas and San Francisco.[29]

October 13–December: "American Abstract Expressionists and Imagists, 1961," at the Solomon R.

Guggenheim Museum, New York, includes *Figure 5*, 1960 (plate 61).

October 27, 1961–January 7, 1962: "The 1961 Pittsburgh International Exhibition of Contemporary Painting and Sculpture," an exhibition curated by Gordon Bailey Washburn in the Department of Fine Arts, Carnegie Institute, Pittsburgh, includes *By the Sea*, 1961. There is a catalogue with an introduction by Washburn.

December 8, 1961–January 10, 1962: The paintings *In Memory of My Feelings—Frank O'Hara*, *No*, *Good Time Charley*, and *Liar* are shown in a group exhibition at the Leo Castelli Gallery.

1962

During the course of the year, completes the following paintings at Front Street: *0–9*, 1959–62; *Iron*; *Device*, 1961–62; *Device*, 1962; *4 the News*; *Fool's House*; *M*; *Portrait—Viola Farber*, 1961–62; *Zone*; *Paregoric as Directed Dr. Wilder*; *Alphabets*; *Passage*; *Gray Painting with Spoon*; a small *Map* in oil on paper; *Map* (plate 96); *Figure 2*; *Diver*; and *Slow Field*. In Edisto Beach, paints another *Two Flags*.

Before Johns paints *Fool's House*, David Hayes introduces him to the writings of Ludwig Wittgenstein. He reads the *Philosophical Investigations* and borrows the *Tractatus Logico Philosophicus* from Hayes. He will later read all of Wittgenstein's published writings, as well as a number of books about the philosopher.[30]

Fool's House is the first work in which Johns splits the stenciled title, so that it runs off the right side of the canvas and then picks up again on the left, suggesting a cylindrical space.[31]

Begins using plastic in addition to paper as a support for his drawings, as in *Disappearance II*, 1962, and *Device*, 1962.[32]

Robert Rauschenberg paints *Trophy V (For Jasper Johns)*.

In the five prints completed at ULAE in 1962—*Painting with Two Balls I*, *Painting with Two Balls II*, *False Start I*, *False Start II*, and *Device*—Johns further explores the possibilities of lithography, experimenting with different colors and more complex compositions. The Museum of Modern Art begins acquiring the first impression of every edition that ULAE publishes, using a series of grants from the Celeste and Armand Bartos Foundation.

Johns travels to London, where he visits Madame Tussaud's Wax Museum. In 1964, he will relate this visit to the idea of using a leg cast in *Watchman*, 1964:

When I visited the Wax Museum in London two years ago, I realized that human skin is strange. I have been thinking for two years of how to use it in my works. At first I planned to use a child's leg and place a chair at the bottom of the canvas in the ordinary way. Then I intended to use a woman's leg. But eventually, after a flight from Honolulu to Tokyo, I changed the plan again into what you see now.[33]

January 14–February 24: "Abstract Drawings and Watercolors," an exhibition at the Museo de Bellas Artes, Caracas, Venezuela, that is organized by the International Program of The Museum of Modern Art, New York, and curated by Dore Ashton, includes three drawings by Johns: *Study for "Painting with a Ball"*, 1958, *Tennyson*, 1958, and *Thermometer*, 1960. The show will travel to Brazil, Argentina, Uruguay, Chile, Peru, and Ecuador.[34]

January 26: Tatyana Grosman writes to Johns, "I feel that we are building the [*0–9*] portfolio like a cathedral. I would like also to see the 'Alphabet' done, especially after seeing yours in the studio, which is beautiful!"[35]

March 17–May 6: "*4 Amerikanare: Jasper Johns, Alfred Leslie, Robert Rauschenberg, Richard Stankiewicz*," an exhibition organized by Pontus Hulten, is installed

At Front Street, New York, 1962. Photograph: Edward Meneeley.

at the Moderna Museet, Stockholm, before traveling to the Netherlands and Switzerland.[36]

April 3–May 13: "1961," at the Dallas Museum for Contemporary Arts, Dallas, Texas, includes *Portrait—Viola Farber*, 1961–62.

May: Leo Steinberg's article on Johns appears in the Milan journal *Metro*.[37]

I was impressed with Leo Steinberg's comments on my work; it seemed to me that he tried to deal directly with the work and not put his own map of preconceptions over it. He saw the work as something new, and then tried to change himself in relation to it, which is very hard to do.[38]

May 5–27: The "*XVIIIᵉ Salon de Mai*," at the Musée d'Art Moderne de la Ville de Paris, Paris, includes *Slow Field*, 1962.

May 6: Makes *Study for Skin*, a series of four drawings, by pressing his lubricated face on paper and then rubbing charcoal on the paper to render the oiled surface visible. All four works are inscribed "6 May '62" at the lower right, perhaps the first instance in which Johns inscribes the day, month, and year on a work, a practice he will adopt more consistently beginning in 1973. (See drawing LC# D-103, which is inscribed "3 May '73.") *Study for Skin* is originally intended as a group of studies for a work, never fully realized, involving a flattened mask of an entire head, for which Johns has used the artist Jim Dine as the model.[39]

At ULAE, West Islip, N.Y., June 30, 1962. Photograph: Hans Namuth. © Hans Namuth 1990.

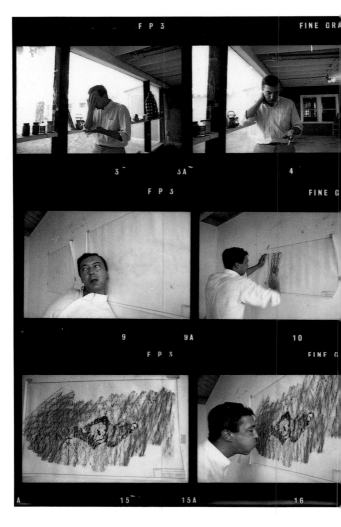

May 26–June 30: "Drawings: Lee Bontecou, Jasper Johns, Roy Lichtenstein, Robert Moskowitz, Robert Rauschenberg, Frank Stella, Jack Tworkov," at the Leo Castelli Gallery.

Summer: Stays with Dine in East Hampton.[40] According to Dine, they see each other often during 1962: "My work shows it, obviously, and his does too… compare my *Black Garden Tools* to his *Fool's House*."[41]

August: With the initial idea of promoting a Broadway season of the Merce Cunningham Dance Company, Johns, John Cage, theatrical producer Lewis Lloyd, and lawyer Alfred Geller form the nucleus of what will become the Foundation for Contemporary Performance Arts, created early in 1963 to help fund new work in dance, music, and theater.[42]

September 22–October 13: "Group Exhibition: Chamberlain, Higgins, Johns, Klapheck, Rauschenberg, Scarpitta, Stella, Tinguely, Tworkov," at the Leo Castelli Gallery.

October 2: Ileana Sonnabend writes to Castelli from Paris, regarding preparations for forthcoming shows of works by Johns and Rauschenberg there: "People are excited here about [Rauschenberg's] show and Jap's and

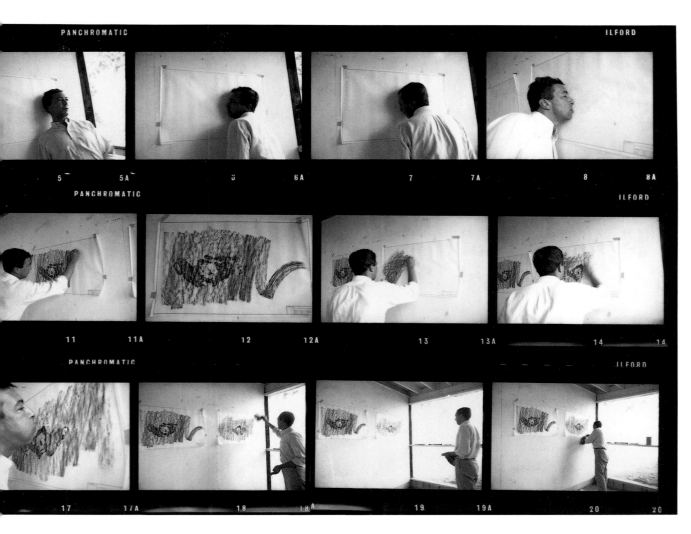

are expecting great things.... I hope that our selection will be great. If you have any ideas about this, write me *please*. I am concerned about your choice: I don't want a patchy show. People are ready for a controversy and they should be able to see the best."[43]

October 6–November 11: "Third International Biennial of Prints in Tokyo 1962," at the National Museum of Modern Art, Tokyo. William S. Lieberman selects three Johns prints from 1960 as part of the U.S. submission.[44]

[November]: The curator Henry Geldzahler takes Johns to visit Andy Warhol's studio.[45] Warhol will recall, "Henry brought Jasper to see me. Jasper was very quiet. I showed him my things and that was that. Of course, I thought it was terrific that Rauschenberg and Johns had both come up; I admired them so much. After Jasper had gone, David Bourdon said, 'Well, Henry was trying to be the helpful connection, but Jasper didn't look too thrilled to be here.'"[46]

November 5–January 6, 1963: "Lettering by Hand," an exhibition at The Museum of Modern Art, curated by Mildred Constantine, includes the paintings

Colored Alphabet, 1959, *White Numbers*, 1957, and the drawing *o through 9*, 1960 (plate 63). Beginning in 1965, the show will travel to Puerto Rico, Argentina, Brazil, Peru, Chile, and Venezuela.[47]

November 9: John Richard Craft, director of the Columbia Museum of Art in South Carolina, writes to Johns, "Dr. Cam McLain just gave the Museum the pen and ink drawing 'Idiot' [1952] which Dana bought from you through Becky Gresham's shop about five years ago.

"Personally, I want to keep this for our Graphics Gallery, believing that it is an extremely handsome example of draftsmanship from an early 'Johns' period. Van Hook, however, says that you are trying to reclaim as many of these early works as possible and thinks that we should give you a chance to trade something of recent vintage for it."[48]

November 11: At Front Street, completes the painting *Figure 2*, which is immediately shipped to Paris for the show organized by Ileana Sonnabend. Leo Castelli will later write to Sonnabend, "You should realize that getting you Jasper's 'No. 2' in one day—Jasper finished it on Sunday the 11th—was a feat which required on our part something like eight hours of work and

worry. We were as proud of it as Churchill must have been when the Normandy invasion came off according to plan."[49]

[Early November–December]: At Front Street, paints *Diver* (plate 98), his largest work to date, after the drawing of the same title (plate 101), which he has begun earlier but will not finish until 1963.[50]

November 15–December 31: At newly acquired premises still bearing the name Galerie Marcelle Dupuis (37, quai des Grands Augustins), Ileana Sonnabend hosts Johns's third solo exhibition in Paris. It includes the paintings *White Flag*, 1955, *Flag on Orange Field II*, 1958, *Target*, 1958 (LC# 39), *Flag*, 1958, *Jubilee*, 1959, *Figure 8*, 1959 (LC# 72), *Painting with Ruler and "Gray"*, 1960, *Good Time Charley*, 1961, *0–9*, 1959–62, *Gray Painting with Spoon*, 1962, *Figure 2*, 1962, and *Device*, 1962.

November 18: Sonnabend writes to Castelli, "Jap's opening was a great success. A lot of people came, drank champagne, admired what they could see of the show—some said it was the first time they saw Jap this way, i.e. could follow his development....

Unfortunately, very few visitors came since. It seems that collectors have stopped collecting in Europe (over $1,000, I mean)....
I spent $1,500 on publicity and might do more—$600 of announcements and there you are! Not a chance in the world to come out even."[51]

November 19–December 15: "Jasper Johns: Retrospective Exhibition," at the Everett Ellin Gallery, Los Angeles—the inaugural show in this gallery's new quarters—includes ten paintings and four drawings by Johns, dating from 1957 to 1962. In the following year it will travel in California.[52]

[December]: An article in *Art in America* magazine, "Folklore of the Banal," by Dorothy Gees Seckler, identifies Johns as the mentor of the emerging generation of artists that includes Roy Lichtenstein, Andy Warhol, Wayne Thiebaud, James Rosenquist, and Robert Indiana, particularly for Johns's "way of presenting commonplace objects without implying any judgements as to their beauty, desirability or morality."[53]

December 12–February 3, 1963: "Annual Exhibition 1962: Contemporary Sculpture and Drawings," at the Whitney Museum of American Art, New York, includes *Folly Beach*, 1962.

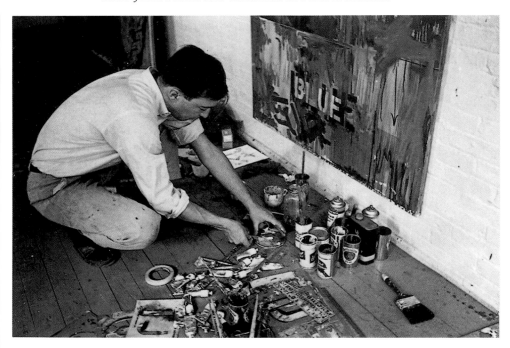

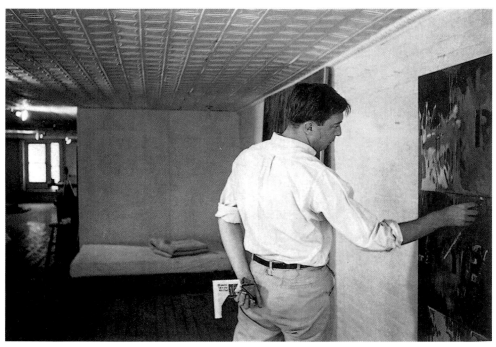

At Front Street, working on *Land's End*, 1963. Photographs: Paul Katz.

1963

During this year, at Front Street, finishes the drawing *Diver* begun the previous year, and paints *Land's End*, a Sculp-metal *Numbers*, and *Map*. In Edisto Beach, paints *Periscope (Hart Crane)*. Also this year, paints small-scale works of numbers, *Figure 2* and *Figure 1*.

Publication of Leo Steinberg's book *Jasper Johns*, the first monograph on his work—a revised version of the article Steinberg published in *Metro* in 1962.

Frank Stella completes the diptych *Jasper's Dilemma*, 1962–63, featuring two juxtaposed images of concentric squares, one in colors, the other in black, gray, and white.

January: Creation of the Foundation for Contemporary Performance Arts, with offices at 30 East 60th Street, New York. Its founding directors are Johns, Elaine de Kooning, John Cage, David Hayes, Lewis Lloyd, and Alfred Geller.[54] According to its Certificate of Incorporation, the Foundation aims "to cultivate, promote, foster, sponsor, develop and encourage understanding of, public interest in and support of performances of a contemporary nature in the fields of music, dance, and drama." The Foundation will later expand to encompass the visual arts as well.

January 12–February 7: "Jasper Johns," at the Leo Castelli Gallery, includes the paintings *Map*, 1961, *By the Sea*, 1961, *Fool's House*, 1962, *Zone*, 1962, *Passage*, 1962, *Out the Window II*, 1962, and *Diver*, 1962.

February 18: *Newsweek* magazine announces, "Jasper Johns at 32 is probably the most influential younger painter in the world."[55]

February 23–25: At the Allan Stone Gallery, New York, Johns installs an exhibition of works donated by over seventy artists to benefit the Foundation for Contemporary Performance Arts. He himself contributes a *Map* from 1962 (plate 96).[56] According to *The New Yorker*, "With the exception of Richard Lippold's delicate wire 'Variations Within a Sphere,' which Lippold himself came in to hang, Johns installed every painting and sculpture in the show. The job took him all of Saturday night, all day Sunday, and most of Monday. Pictures kept turning up until the last moment. 'Jim Rosenquist's large canvas came in on Monday afternoon, wet,' [Johns] said."[57]

February 25–March 2: The exhibition at the Allan Stone Gallery. *Dance Magazine* mentions that the foundation's first project is a mid-April Broadway

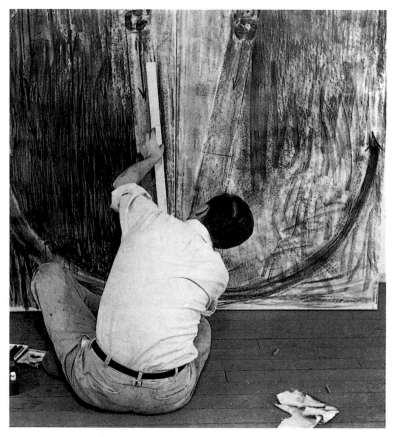

At Front Street, working on *Diver*, 1963. Photograph: Paul Katz.

program by the Merce Cunningham Dance Company "to the tune of $80,000."[58] This plan is not realized, however. Of the money collected, some will be used in 1964 to fund a world tour of the Merce Cunningham Dance Company.[59]

Johns buys Robert Morris's *Metered Bulb*, 1963, from the exhibition.[60]

March 14–June [12]: "Six Painters and the Object," an exhibition, curated by Lawrence Alloway, at the Solomon R. Guggenheim Museum, includes works by Jim Dine, Roy Lichtenstein, Robert Rauschenberg, James Rosenquist, and Andy Warhol, as well as Johns's *Tango*, 1955, *Green Target*, 1955, *White Flag*, 1955–58, *Numbers in Color*, 1958–59, and *False Start*, 1959.

March 29: Attends the opening of Rauschenberg's retrospective at the Jewish Museum, New York. A few days later, Alfred H. Barr, Jr., of The Museum of Modern Art, asks his opinion as to which Rauschenberg work the Museum should buy; Johns suggests *Rebus*, 1955. (Barr does not follow his advice.)[61]

April 3–June 2: "Ascendancy of American Painting," an exhibition at the Columbia Museum of Art, includes the painting *Reconstruction*, 1959.

April 18–June 2: "Popular Image Exhibition," curated by Alice Denney, at the Washington Gallery of Modern Art, Washington, D.C., includes the paintings

Flag above White, 1955, and *Flag on Orange Field*, 1957. Billy Klüver produces an hour-long l.p. of interviews, conducted in March of that year, with the eleven artists in the show, which later in the year will travel to London.[62] There is a catalogue with an introduction by Alan R. Solomon.

May 3–June 10: *"Schrift en beeld,"* an exhibition at the Stedelijk Museum, Amsterdam, includes the painting *Jubilee*, 1959, the drawing *Gray Alphabets*, 1960 (LC# 98), and a 1962 lithograph. The show will shortly travel to West Germany.[63]

May 9–July 27: Works at ULAE almost daily on the lithographs for the portfolio *0–9*. Conceived in 1960, the portfolio comprises ten lithographs, one for each numeral, made by reworking the same stone. Simultaneously, Johns works on lithographs employing imprints of body parts, such as *Hand*, in which he experiments with soap and oil on stone (May 12); the first state of *Skin with O'Hara Poem* (June 21)—the poem was added later, in 1965; *Pinion*, completed in 1966 (proofed on July 7); and *Hatteras* (July 17).[64]

May 20–June 30: "Group Drawing Exhibition: Bontecou, Daphnis, Johns, Lichtenstein, Moskowitz, Rauschenberg, Stella, Tworkov, van de Wiele," at the Leo Castelli Gallery.

June: Excerpts from Johns's sketchbook notes are published, for the first time, by Yoshiaki Tono in the Japanese magazine *Mizue*.[65]

June 9–September 13: Johns is represented in the "Fifth International Exhibition of Graphic Art," at the Gallery of Modern Art, Ljubljana, Yugoslavia.

June 14: Leo Castelli presents President John F. Kennedy with a bronze *Flag* of 1960: "It is my pleasure to offer you and Mrs. Kennedy this flag of ours rendered in bronze by Jasper Johns. It is one of four casts and was done in 1960. Both Jasper Johns and I are happy that we can thus express to you our gratitude and admiration."[66]

> *Once, I made a kind of sculpture of a flag in bronze: it was an edition of three, I think. One of them was given on some occasion to President Kennedy. I became very upset that this was happening. It was given on Flag Day!...It seemed to me to be such a terrible thing to happen. I complained bitterly to my very good friend, John Cage. He said, "Don't let it worry you. Just consider it a pun on your work!"*[67]

June 21: Castelli writes to the architect Philip Johnson, who is designing the New York State Theater for Lincoln Center, Manhattan, and wants to commission

works for it: "Thank you so much for the plans of your theater. I shall pass them on to Jasper and Lee [Bontecou].

"To recapitulate previous conversations, it is our understanding that a total sum of $30,000.00 will be paid for the following works to be placed in the theater:

"Jasper Johns: painting
"Lee Bontecou: relief
"Edward Higgins: freestanding sculpture."[68]

[Summer]: At Front Street, Johns makes *Numbers* in Sculp-metal on canvas, a prototype for the larger version he plans for the New York State Theater commission. He will also use this work as the model for the two *Numbers* works of 1963–68, both cast in aluminum.

[End of August–September]: Moves to the penthouse of 340 Riverside Drive (at 106th Street), where he lives and works when in New York during most of the rest of the 1960s.[69]

September 7–29: "Pop Art USA," an exhibition, curated by John Coplans, at the Oakland Art Museum, Oakland, California (copresented by the Oakland Art Museum and the California College of Arts and Crafts), includes the sculpture *Flashlight I*, 1958.

October 1: Birth of Jean Christophe, son of Leo and his wife Toiny (Antoinette) Castelli. Johns will later become the child's godfather.

October 2: Philip Johnson writes to Johns at Riverside Drive about the *Numbers* planned for the New York State Theater: "I have figured the size of the picture and just to repeat, the present proportion [of the prototype work] is 44 x 58. The new would be 108 high and 81.931 wide. You might want to adjust this to 82. [The final dimensions will turn out to be 110 x 85 inches.]

"Anyhow, I am crazy about your approach. This is going to be the subtlest monument of our time."[70]

Johns probably begins the *Numbers* commission around this time, though he does not complete it until sometime in the first few months of 1964. Because of the painting's large size, he works in an uptown warehouse rented specially for the purpose.[71] This will be his largest version of the motif. It is also the Johns work that comprises the largest number of panels—a total of 121, with one numeral on each.

October 29–November 23: Visits the exhibition "Florine Stettheimer: Her Family, Her Friends," at the Durlacher Brothers Gallery, New York.[72]

At Riverside Drive, New York, 1965. Photograph: Ugo Mulas. © Ugo Mulas Estate. All rights reserved.

December 11, 1963–February 2, 1964: "Annual Exhibition 1963: Contemporary American Painting," at the Whitney Museum of American Art, includes *Map*, 1963.

December 12, 1963–February 5, 1964: "Black and White," an exhibition at the Jewish Museum, includes the paintings *Reconstruction*, 1959, and *Shade*, 1959. There is a catalogue with an introduction by Ben Heller.

December 19: The artist Dan Flavin completes *Pink out of a Corner—To Jasper Johns*, a work made from a pink fluorescent light tube in a metal fixture (96 x 6 x 5⅜ inches), now in the collection of The Museum of Modern Art.[73]

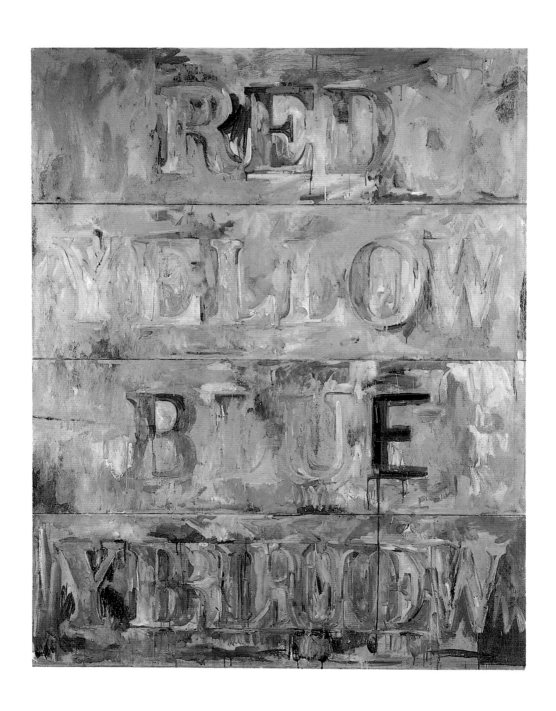

77. **By the Sea**. 1961
Encaustic on canvas (four panels)
72 x 54½″ (182.9 x 138.4 cm)
Private collection

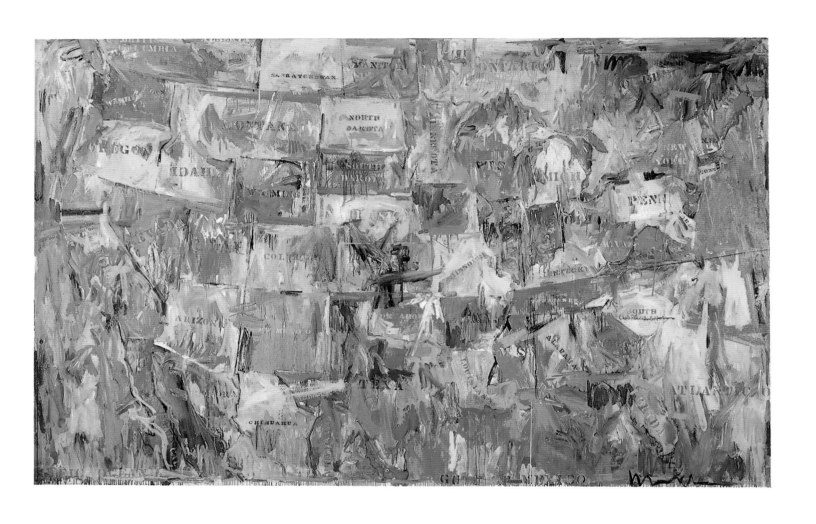

78. **Map**. 1961
Oil on canvas
6′ 6″ x 10′ 3 ⅛″ (198.1 x 312.7 cm)
The Museum of Modern Art, New York.
Gift of Mr. and Mrs. Robert C. Scull

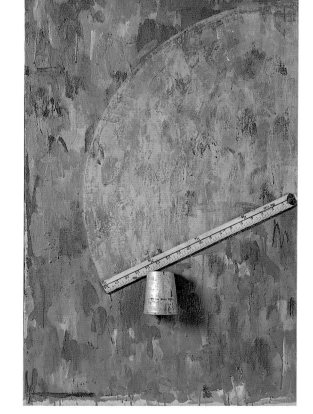

79. **Disappearance II**. 1961
Encaustic and collage on canvas
40 x 40″ (101.6 x 101.6 cm)
The Museum of Modern Art, Toyama

80. **Good Time Charley**. 1961
Encaustic on canvas with objects
38 x 24 x 4½″ (96.5 x 61 x 11.4 cm)
Private collection, Miami

81. **No**. 1961
Encaustic, collage, and Sculp-metal
on canvas with objects
68 x 40″ (172.7 x 101.6 cm)
Collection the artist

82. **Painting Bitten
by a Man**. 1961
Encaustic on canvas mounted
on type plate
9 ½ x 6⅞″ (24.1 x 17.5 cm)
Collection the artist

83. **Water Freezes**. 1961
Encaustic on canvas with thermometer
31 x 25 ¼″ (78.7 x 64.1 cm)
Courtesy Galerie Bonnier, Geneva

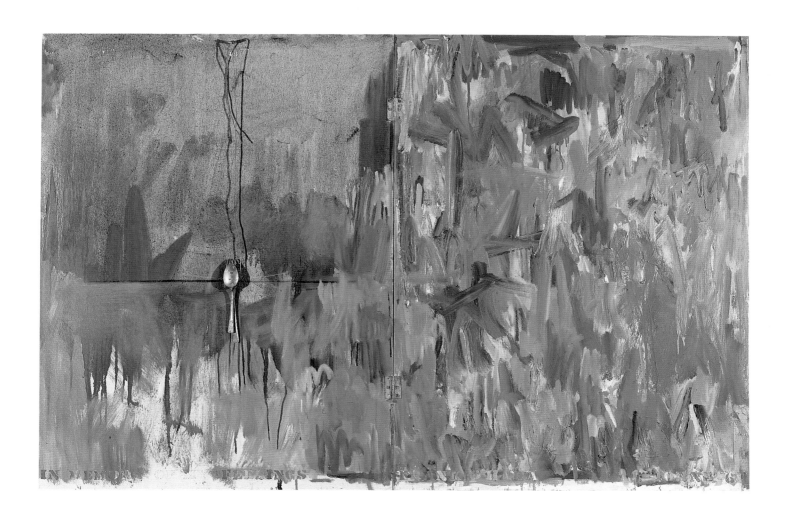

84. **In Memory of My Feelings—
Frank O'Hara**. 1961
Oil on canvas with objects (two panels)
40 x 60″ (101.6 x 152.4 cm)
Museum of Contemporary Art, Chicago.
Partial gift of Apollo Plastics Corporation

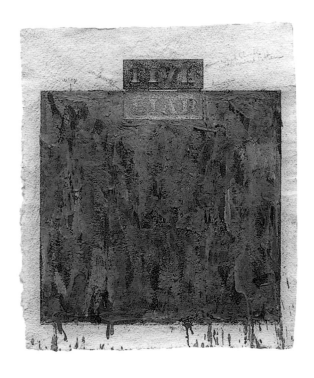

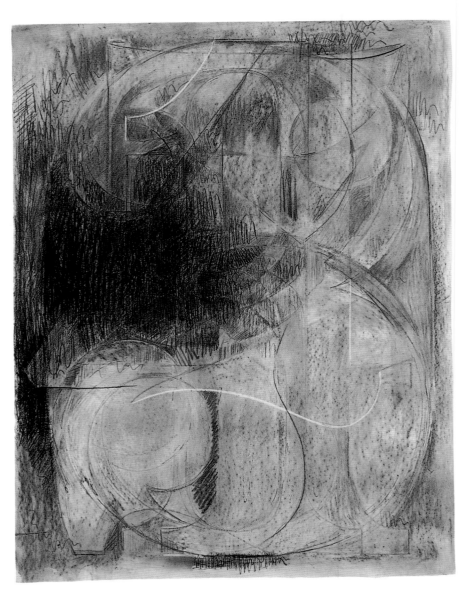

85. **Liar**. 1961
Encaustic, Sculp-metal, and
graphite pencil on paper
21 ¼ x 17″ (54 x 43.2 cm)
Collection Gail and Tony Ganz,
Los Angeles

86. **0 through 9**. 1961
Charcoal and pastel on paper
54 ⅛ x 41 ⅝″ (137.5 x 105.7 cm)

Collection David Geffen, Los Angeles

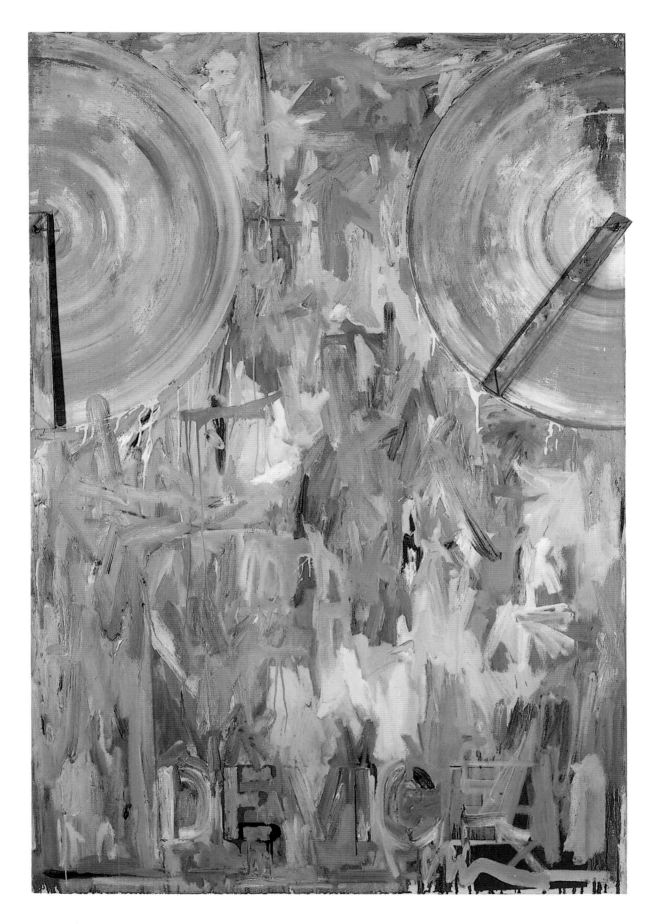

87. **Device**. 1961–62
Oil on canvas with wood
72 1/16 x 48 3/4 x 4 1/2″ (183 x 123.8 x 11.4 cm)
Dallas Museum of Art, gift of The Art Museum League, Margaret J.
and George V. Charlton, Mr. and Mrs. James B. Francis, Dr. and
Mrs. Ralph Greenlee, Jr., Mr. and Mrs. James H.W. Jacks, Mr. and
Mrs. Irvin L. Levy, Mrs. John W. O'Boyle, and Dr. Joanne Stroud
in honor of Mrs. Eugene McDermott

209

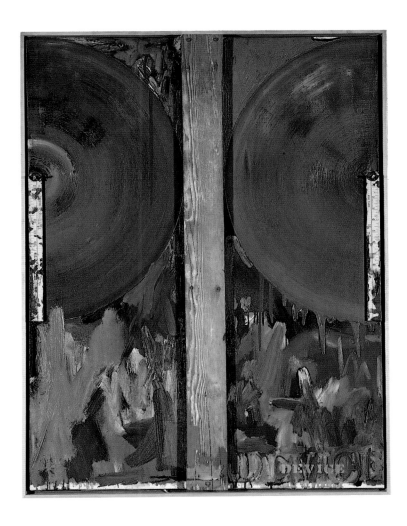

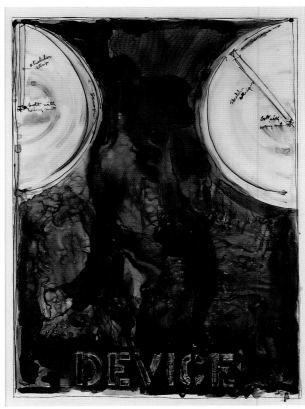

88. **Device**. 1962
Oil on canvas with wood
40 x 30″ (101.6 x 76.2 cm)
The Baltimore Museum of Art:
Purchased with funds provided
by The Dexter M. Ferry, Jr.,
Trustee Corporation Fund, and
by Edith Ferry Hooper, 1976

89. **Device**. 1962
Ink on plastic
24 x 18″ (60.9 x 45.7 cm)
Courtesy Leo Castelli Gallery, New York

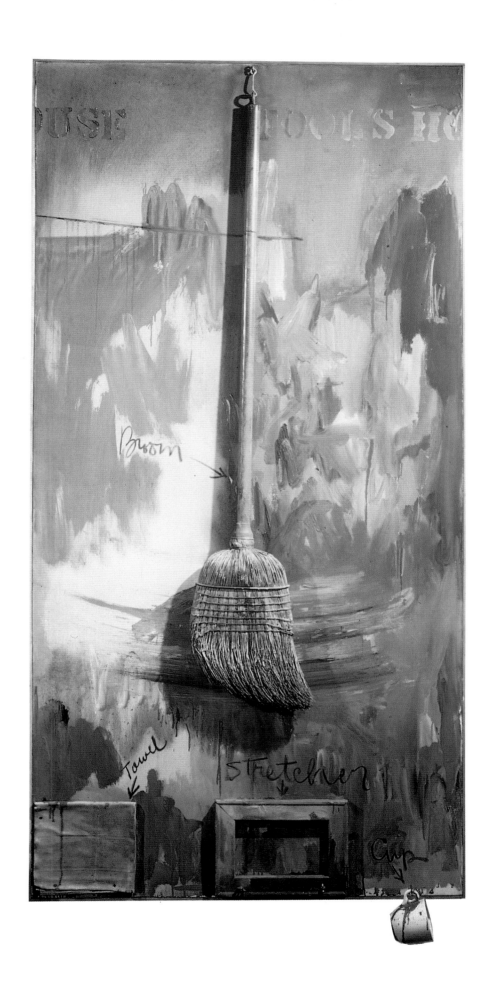

90. **Fool's House**. 1962
Oil on canvas with objects
72 x 36″ (182.9 x 91.4 cm)
Collection Jean Christophe Castelli

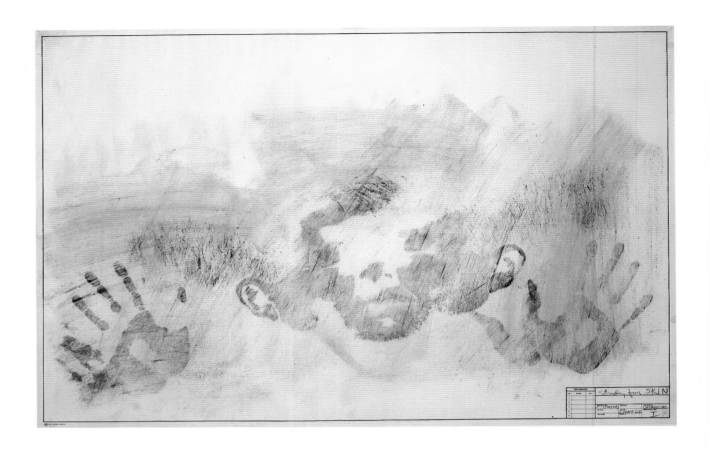

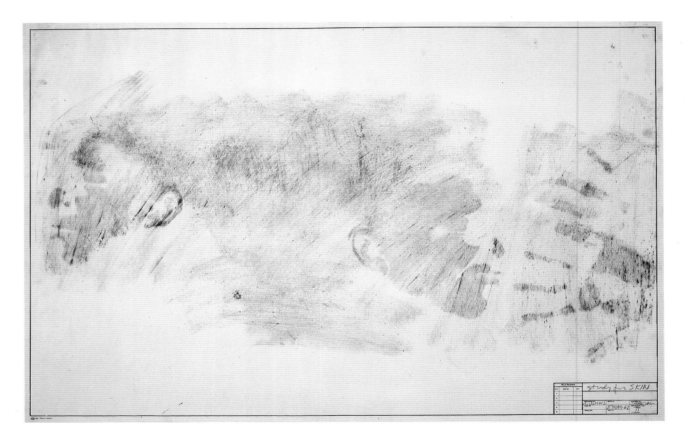

91. **Study for Skin I**. 1962
Charcoal on drafting paper
22 x 34″ (55.9 x 86.4 cm)
Collection the artist

92. **Study for Skin II**. 1962
Charcoal on drafting paper
22 x 34″ (55.9 x 86.4 cm)
Collection the artist

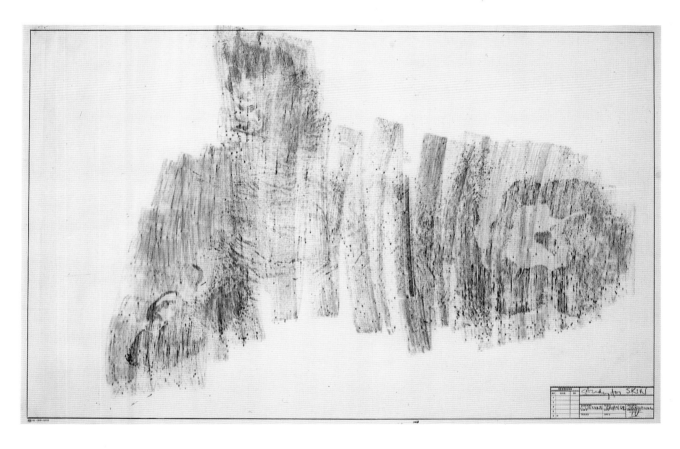

93. **Study for Skin III**. 1962
Charcoal on drafting paper
22 x 34″ (55.9 x 86.4 cm)
Collection the artist

94. **Study for Skin IV**. 1962
Charcoal on drafting paper
22 x 34″ (55.9 x 86.4 cm)
Collection the artist

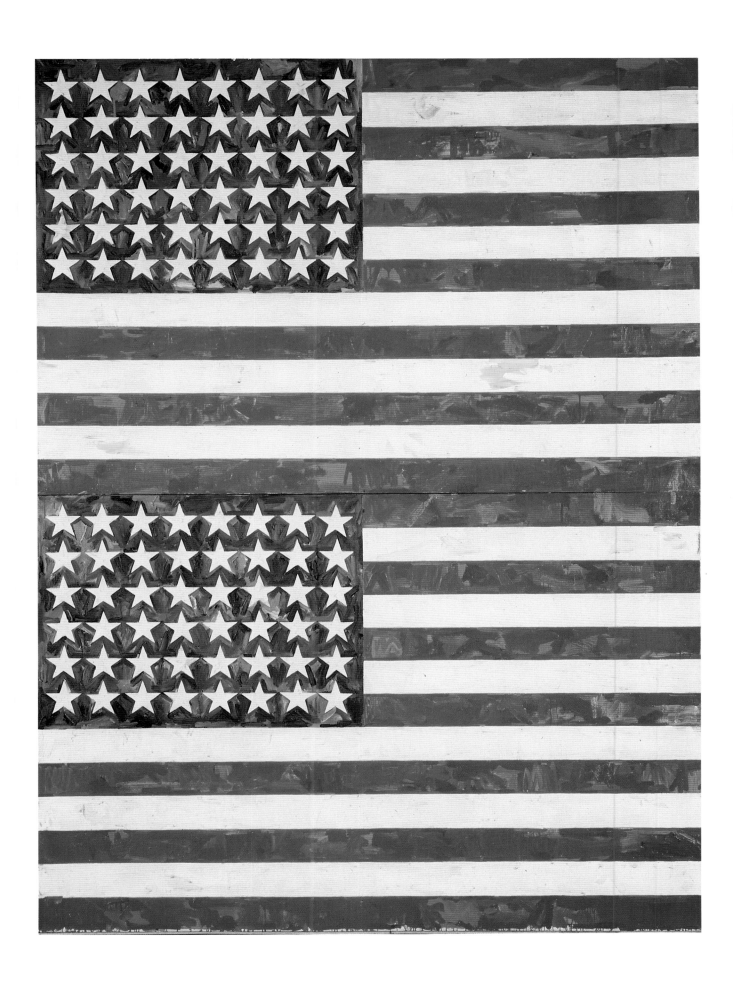

95. **Two Flags**. 1962
Oil on canvas (two panels)
98 x 72″ (248.9 x 182.8 cm)
Collection Norman and Irma Braman

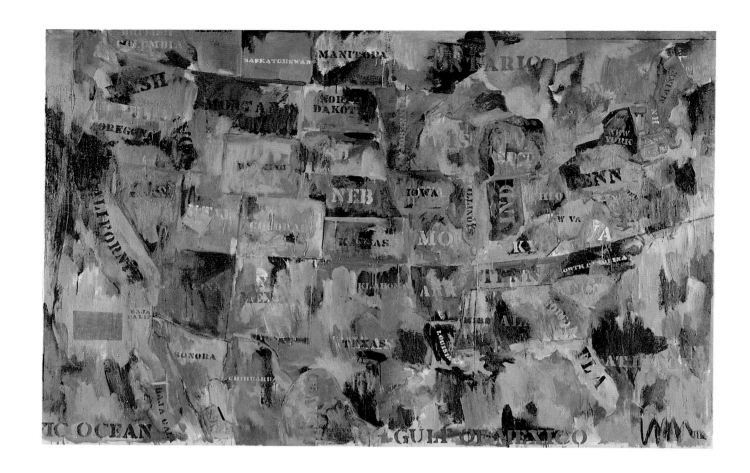

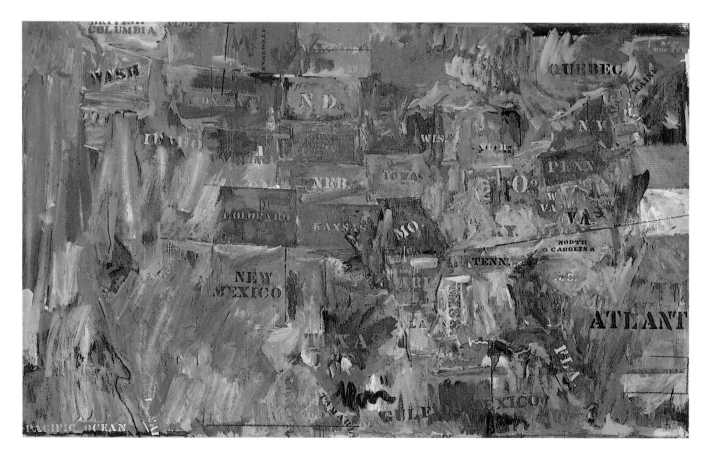

96. **Map**. 1962
Encaustic and collage on canvas
60 x 93″ (152.4 x 236.2 cm)
The Museum of Contemporary Art,
Los Angeles. Gift of
Marcia Simon Weisman

97. **Map**. 1963
Encaustic and collage on canvas
60 x 93″ (152.4 x 236.2 cm)
Private collection

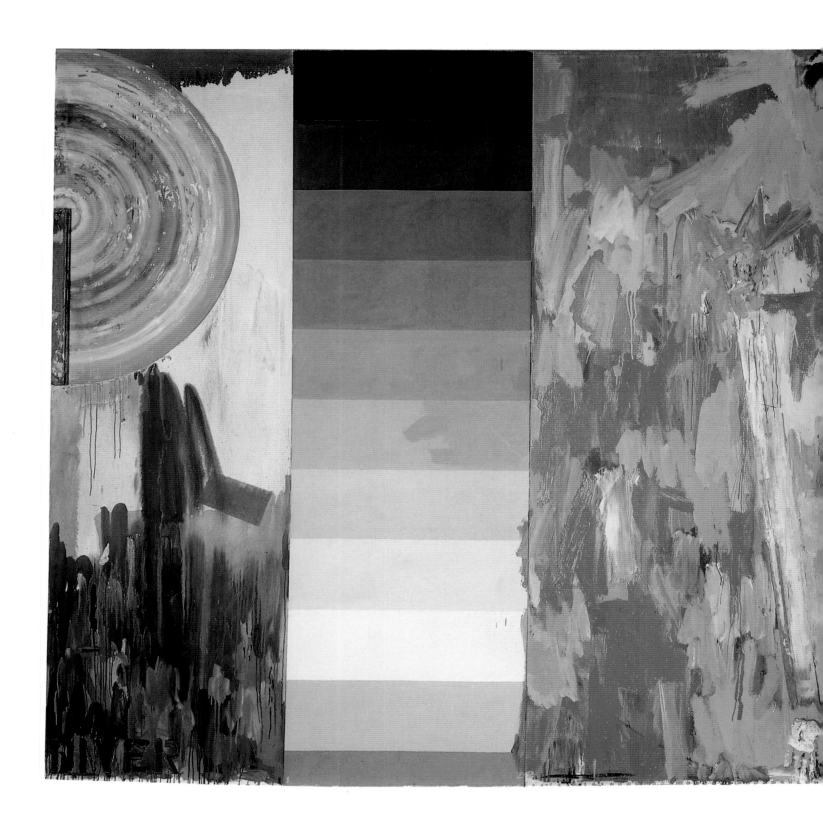

98. **Diver.** 1962
Oil on canvas with objects (five panels)
7′ 6″ x 14′ 2″ (228.6 x 431.8 cm)
Collection Norman and Irma Braman

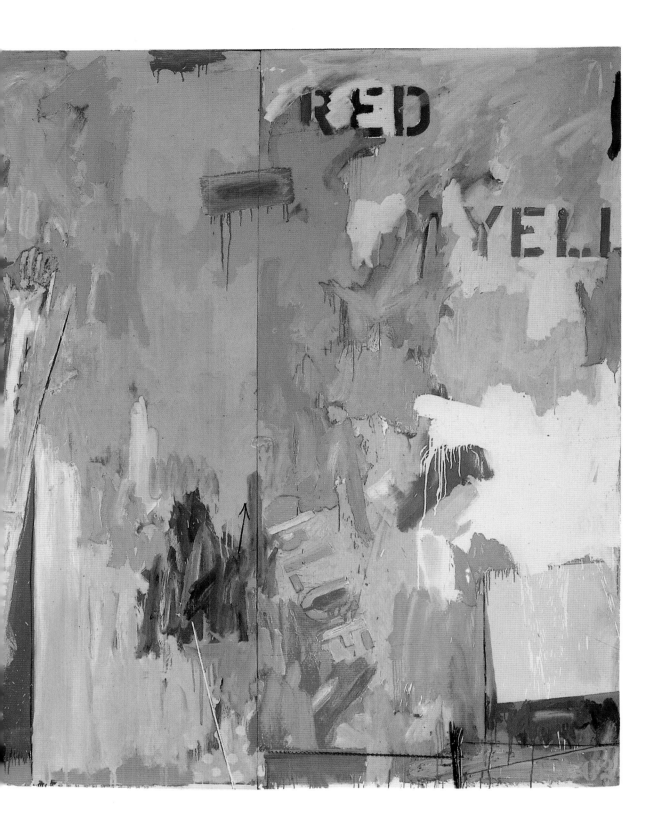

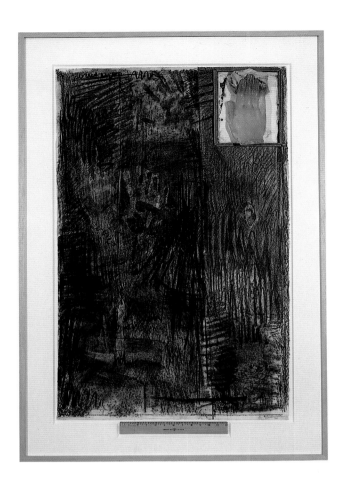

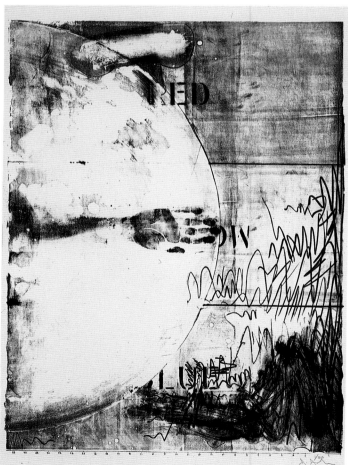

99. Wilderness II. 1963
Charcoal, pastel, and collage on paper with objects
50 x 34 ⅜″ (127 x 87.3 cm) including frame
Collection the artist

100. Hatteras
West Islip, N.Y.: Universal Limited Art
Editions, 1963
Lithograph
41 ⅜ x 29 ½″ (105.1 x 74.9 cm)
The Museum of Modern Art, New York. Gift
of the Celeste and Armand Bartos Foundation

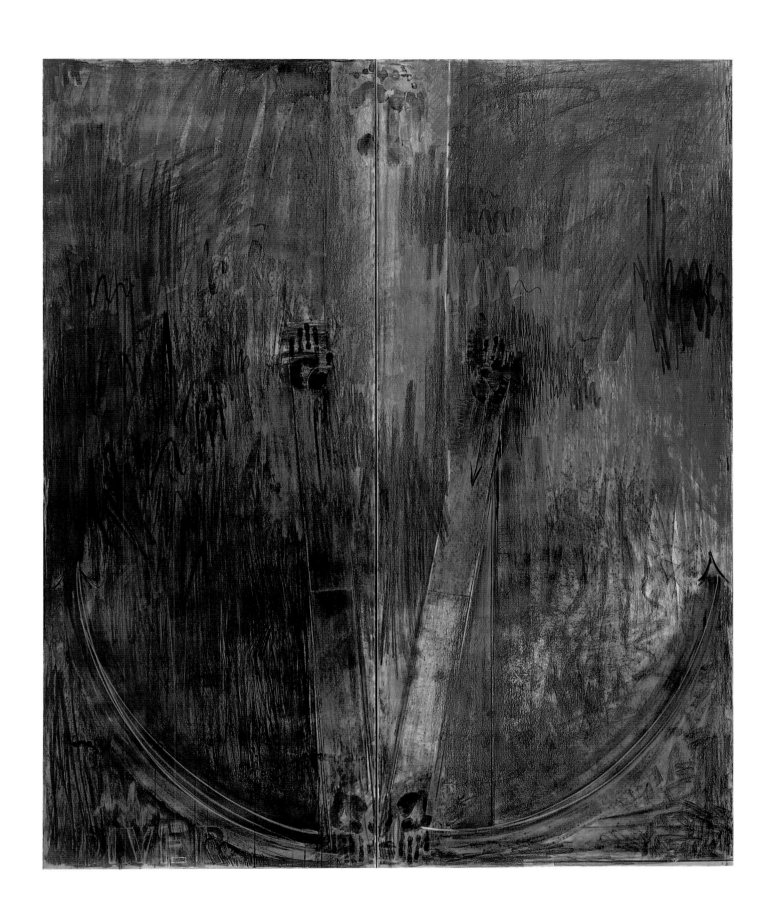

101. **Diver**. 1963
Charcoal, pastel, and watercolor (?) on
paper mounted on canvas (two panels)
86 ½ x 71 ¾" (219.7 x 182.2 cm)
Collection Sally Ganz, New York

219

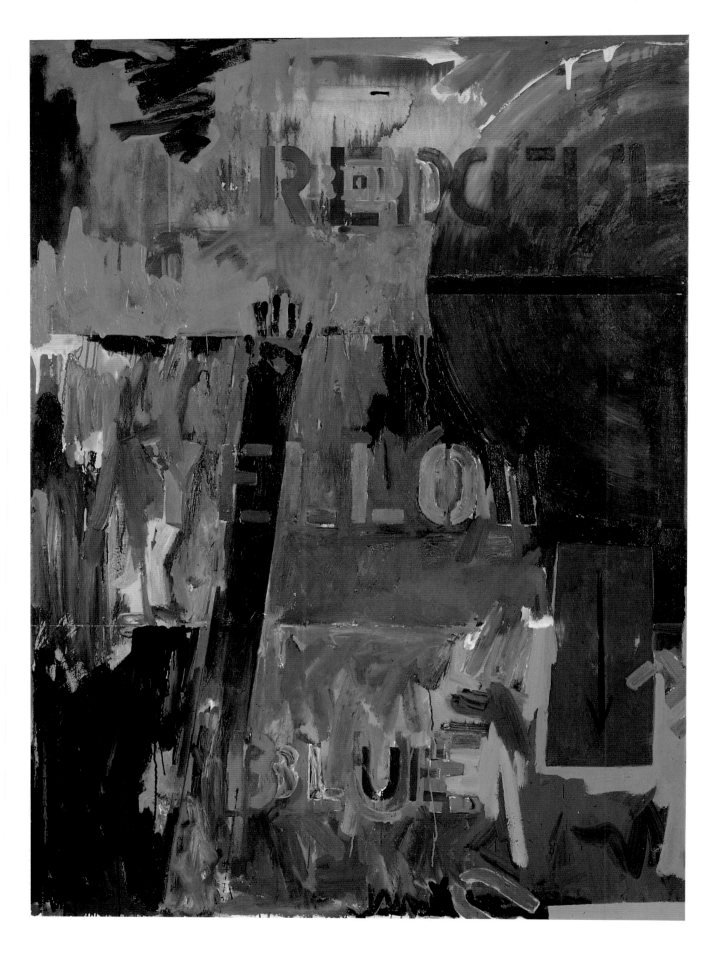

102. **Land's End**. 1963
Oil on canvas with wood
67 x 48¼″ (170.2 x 122.6 cm)
San Francisco Museum of Modern Art.
Gift of Mr. and Mrs. Harry W. Anderson

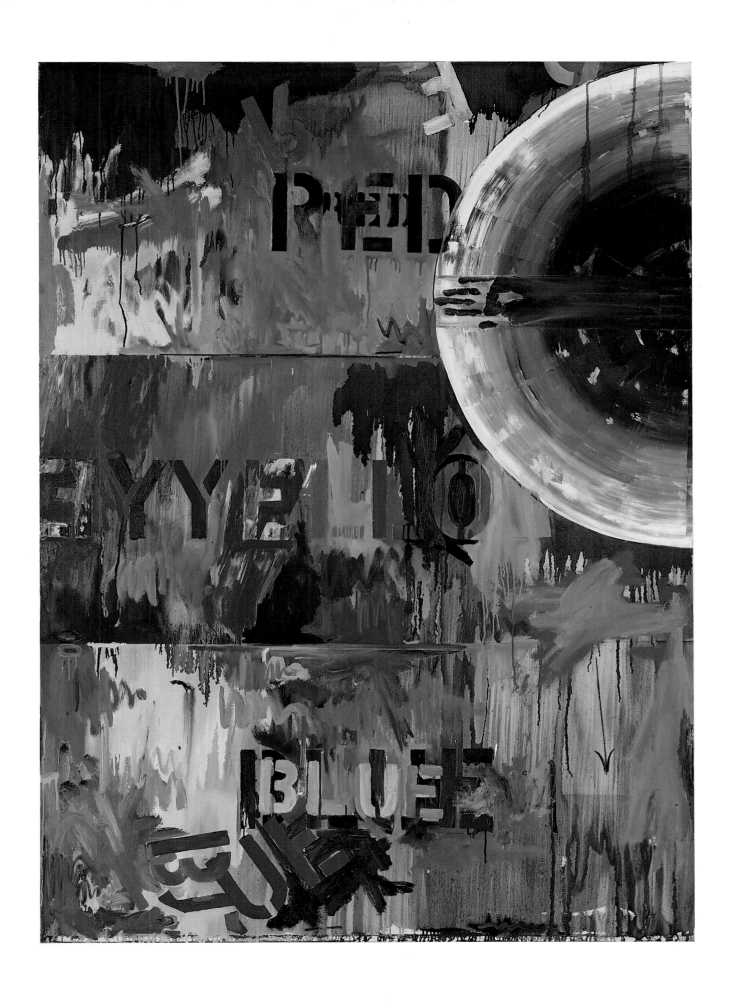

103. **Periscope (Hart Crane)**. 1963
Oil on canvas
67 x 48″ (170.2 x 121.9 cm)
Collection the artist

From the mid-1960s to the early 1970s, Johns's work became more unsettled and eclectic. His production of paintings slowed while his printmaking flourished, and he became more experimental, using screen-prints, photo reproductions, neon, and metal, as well as more familiar studio materials. Oscillating between modes of bright graphic power and more hermetic rumination, he explored altered formats and variable scales, and produced some of the biggest works of his career—both spare abstractions and packed, complex constructions with multiple references. *Arrive/Depart*, still dominantly made in the painterly style of the early 1960s, inaugurated some of the new elements in play: Johns's first use both of the human skull motif, printed directly onto the canvas (Johns used an actual skull), and of the screenprint technique, with the screen, given to him by Andy Warhol, reproducing a label that warned "Glass—Handle with Care—Thank You."[1] These two signs, mingling morbidity and Pop in a way that colored the title's meaning, announced the onset of a new polyphony in his production; and *Field Painting*, with its central rift, hinged letters "printing" on either side, electrification, and attached painter's paraphernalia, amplified that tendency.

A trip to Japan in 1964 provided the occasion to advance this assemblage aesthetic. Two *Souvenir* pictures (including Johns's first likenesses of himself) and *Watchman* (using a partial body cast for the first time since the early target pictures) were paralleled by a Duchampian set of self-questioning sketchbook notes, including a rumination over the differences between a "watchman" and a "spy" in regard to modes of visual attentiveness.[2] The huge programmatic "manifesto" (and self-conscious homage to Marcel Duchamp) that followed, *According to What*, reprised elements of *Arrive/Depart*, *Field Painting*, and *Watchman*, and deployed an insistently broad variety of modes of representation. Johns's commentaries make it clear that he wanted this big picture to remain without a consistent central reference point according to which its parts could be connected; hence its questioning title.[3] The resulting disjunctiveness sets the assemblage apart from Robert Rauschenberg's earlier "combine" works, which were typically orchestrated into a more fluid pictoriality. Johns's next comparably large canvas, however—the six-panel *Untitled* of 1964–65 (plate 106)—has a more unified

rhetoric of billboard scale, implied dynamism, and bright, flat fields of primary hue that seems responsive to the Pop and hard-edged abstract painting of the 1960s.

In the later 1960s, working simultaneously with clusters of related ideas regarding layering and ratios of proportion and scale, Johns carried some projects over a number of years. *Voice*, uncharacteristically somber and reticent for this phase of his work, occupied him from 1964 to 1967; he worked on *Voice 2* from late 1967 to 1971, and held other works still longer, making them parts of even later composites. Screenprinting became an important part of his repertoire of procedures: the three panels of *Voice 2* (originally conceived as modules capable of several different configurations) show a variety of surface textural effects that stem from pushing paint through screens,[4] and the basic structural element of the spare *Studio II* was a screen window from the Edisto Beach house, printed repeatedly against the canvas. The device of fork and spoon, extracted from *Voice* via photo-screenprint, reappeared in sections of *Voice 2* as well as in *Wall Piece*, and also spurred a series of works called *Screen Piece*, in which the photo-enlargement of the implements became part of the subject. Johns employed an even more pumped-up scale for the dislocated and slipping letters of *Voice 2*, and for the lithographic series of numbers made around the same time.

In 1967, a painted flagstone pattern glimpsed on a Harlem wall gave Johns a new motif, more abstract and more random in structure than the found schemas and maps of previous years. The first such image he reconstructed from memory, it became the focus for experiments in the systematic inversions, reversals, and overlaps of patterns—experiments that would expand in the next decade. Pressing the "stone" shapes in with paper templates also produced a new kind of surface articulation, with slick, smooth areas amid a network of interstices edged in raised paint, often in white on white. *Decoy* of 1971 was a memory construction of another order: assembling the imagery of a previous lithograph and a suite of etchings (prints that had themselves dealt with paintings and sculptures reaching back to 1959), it provided a final manifesto and valedictory for this phase of Johns's career.

—*KV*

Chronology

1964

[Winter]: At 340 Riverside Drive, completes *Arrive/Depart*, which he has begun the year before. This is the first painting in which he applies the screen-print technique, using a screen given to him by Andy Warhol.[1] This is also the first time Johns uses an image of a skull.[2]

Also at Riverside Drive, Johns paints *Field Painting*, which includes another collaboration with Billy Klüver, a red neon *R*.

Working in a rented warehouse, completes *Numbers* for the New York State Theater.

February 1–29: "Jasper Johns, Roy Lichtenstein, Robert Rauschenberg, John Chamberlain," at the Leo Castelli Gallery, New York, includes the *0–9* portfolio of lithographs.

Installation view of "Jasper Johns," the retrospective at the Jewish Museum, New York, February–April 1964. Courtesy Sonnabend Gallery, New York.

February 13–April 12: "Jasper Johns," a retrospective exhibition, curated by Alan R. Solomon, at the Jewish Museum, New York, includes 174 paintings, drawings, sculptures, and lithographs dating from 1954 to 1964. There is a catalogue, with essays by Solomon and John Cage. Versions of the show will travel to England and, in early 1965, to California.[3]

The critical reception is not unanimous. Irving Sandler hails Johns as "the most important single influence on Pop Art and other variations of Cool Art—so much so that now, at the age of 33, he finds himself in the ironic position of being an 'old master.'"[4] But Sidney Tillim writes that "it seems ridiculous to speak of the *decline* of an artist not yet thirty-five years old. Yet such is the conclusion I feel one has to draw from the Jasper Johns retrospective at the Jewish Museum."[5]

[Late March]: En route to Hawaii and Japan, travels with Lois Long and John Cage to San Francisco, where Cage is to perform with David Tudor at the San Francisco Tape Music Center. During the trip, Johns continues his practice of noting ideas and drawings for works in a sketchbook, which will serve as the basis for the paintings and drawings he will make in Japan that spring.[6]

I realized that I had had ideas I had forgotten. So I began to make some kind of notation, hoping that in a dry spell, it might jog my memory in a useful way. Gradually, some of the things became additive ideas, notes of what might go into a work, what images or thoughts might be combined.[7]

March 30, April 1, 3, 6, and 8: Cage and Tudor perform "Three Concerts with David Tudor," a program sponsored by the San Francisco Tape Music Center and Performer's Choice. During one of the performances Johns notices a spot of light on the ceiling—a reflection from the mirror in a woman's compact. This gives him the idea for the reflective light he will shortly use in the painting *Souvenir.*[8]

April 3: Inauguration of the New York State Theater, Lincoln Center, New York, where Johns's *Numbers* is installed.

Mid-April: Again with John Cage and Lois Long, to Hawaii, where Cage is to appear in the concert series of the "Festival of Music and Art of This Century," at the Honolulu Academy of Arts (April 19–26). The festival centers around the work of composer Toru Takemitsu, representing the East, and Cage, representing the West.[9]

By April 16: In Kaneohe, Hawaii, about half an hour from Honolulu.[10]

April 22–June 28: "1954–64: Painting and Sculpture of a Decade," an exhibition at the Tate Gallery, London, includes the paintings *Target with Plaster Casts*, 1955, *Flag*, 1958, *Map*, 1961, *Passage*, 1962, and *Numbers*, 1963. Organized by the Calouste Gulbenkian Foundation, the show is selected by Alan Bowness, Lawrence Gowing, and Philip James.

April 24: From Kaneohe, Johns writes to Castelli that he plans to spend a couple of days visiting the Hawaiian islands and then will go to Tokyo on April 30.[11] On the same day, from Honolulu, he sends a postcard to Tatyana and Maurice Grosman of ULAE, saying that he will leave Hawaii for Japan the following week.[12]

Late April: Castelli writes to Johns in Tokyo (care of Yoshiaki Tono): "Alfred Barr was here a few days ago and told me that they [The Museum of Modern Art] would like one of your grey paintings to have a more or less complete range of your work so far. 'Good Time Charley' is his great favorite. Would you make an exception for the Museum and what would be the price?"[13]

April 30: Flies to Tokyo, accompanied by Toru Takemitsu.[14]

[May 6]: From the Fairmont Hotel (4-Sanbancho Chiyodaku), Tokyo, writes to Castelli that he expects to get a studio the following week, with the help of Kuzuo Shimizu, of the Minami Gallery.[15]

[May 11]: Starts working in a small studio obtained for him by Shimizu near the Minami Gallery.[16] Yoshiaki Tono will write, "J.J. has begun to confine himself to a rented studio on the seventh floor of the Artists' Hall on the Ginza. He bought wax refined from honeybee hives, and looked for an old chair. He complained that all Japanese chairs were designed too nicely, and that perfectly ordinary old chairs were unavailable. Then he ordered a wooden circular cylinder with a diameter of about 15 centimeters and purchased brushes of poor quality of the type used by signboard painters, in order 'to reduce the effects of nice matière as much as possible.' I have no idea what he has in mind to achieve."[17] Here, during the following month and a half, he will make the paintings *Watchman*; *Souvenir*, in encaustic; *Souvenir 2*, in oil; and *Gastro*, as well as the drawings *Souvenir* (LC# D-53), *Handprint* (LC# D-359), two called *Watchman* (LC# TT and LC# D-360), *Untitled (Cut, Tear, Scrape, Erase)* (LC# D-170), and *No* (LC# D-48).

May 16: Leo Castelli writes to Johns (care of Tono): "I still hope that you will be back before I leave on the 9th of June, or failing that, that you will join us in Venice [where Johns will have work in the Venice Biennale] around the 15th. Now that you are used to flying it will be perhaps less difficult for you to make the decision."[18]

May 23: "At 10 a.m., c/o Toshi Ichiyanagi (Apt. 201 Green Town 2-44 Onden Shibuyaku Tokyo)," attends

In Tokyo, 1964. Photograph: Shintaro Tanaka, courtesy Bijutsu Shuppan-sha.

a concert, "Collective Music." The performers are Ichiyanagi, Tono, Takemitsu, Takehisa Kosugi, Genpei Akasegawa, Joji Yuasa, and Akira Suzuki. The program includes Cage's *Variations IV*, a piece by Ichiyanagi, a piece by Kosugi, and Takemitsu's *Time Perspective for J. Johns (May 1964)*, composed for the artist's birthday.[19]

May 24: Writes to Castelli from the Imperial Hotel, Tokyo, to say that he will return to New York in the last week of June, and will not go to Venice. Also mentions that he has just begun a new painting (probably *Watchman*), and that The Museum of Modern Art may acquire *Good Time Charley*.[20]

May 27–September 13: "American Painters as New Lithographers," an exhibition at The Museum of Modern Art, includes the Johns lithographs *0 through 9*, 1960, *Painting with Two Balls II*, 1962, *Device*, 1962, *Hatteras*, 1963, *Hand*, 1963, and the three editions of the portfolio *0–9*, 1963. Also exhibited is the stone used in the making of the portfolio *0–9*. Later in the year, the show will travel to the Netherlands.[21]

[May 29]: From Tokyo, writes to Castelli that he is making good progress on *Watchman*, for which he is also considering the title *Watchman— Ginza Light*.[22]

June 6: Castelli writes to Johns at the Imperial Hotel, "How is 'Watchman'? As it is going to remain there, have a black and white and a transparency made of it so that we can see it here at least vicariously."[23]

June 14: From the Imperial Hotel, writes to tell Tatyana and Maurice Grosman of ULAE that he now plans to return to New York in the first week of July, and could finish the beer cans lithograph then, if that is convenient for them. Beginning the next day, he is planning to take a break from nonstop work for a few days of sightseeing in Kyoto.[24]

June 15: To Kyoto. Yoshiaki Tono will write, "J.J. was taken by Toru Takemitsu to Kyoto, where, I was told, they visited Shugakuin Villa and Katsura Detached Palace, and saw movie sets for 'Seppuku' [Ritual suicide] and 'Tate' [Sword fight], as well as some maiko [apprentice geisha] in the Pontocho quarters."[25]

June 19: Tatyana Grosman writes to Johns in Tokyo, "I hope you did not go sightseeing near the area of the earthquake disaster....

"I am so pleased that you intend to work on the 'Beer Cans.' It would be just perfect if you came to work upon your arrival. [Printer] Zigmunds [Priede] will stay with us till about the first of August."[26]

June 20–October 18: As part of the exhibition "Four Germinal Painters," organized by Alan R. Solomon, the U.S. Pavilion of the XXXII Venice Biennale includes seventeen Johns paintings dating from 1957 to 1964 and three sculptures from 1960.

Robert Rauschenberg wins the Biennale's prize, of 2,000,000 lire, reserved for a non-Italian painter.[27]

June 27–October 5: Documenta III, an international exhibition in the Museum Fridericianum, Kassel, West Germany, includes the paintings *Highway*, 1959, *Periscope (Hart Crane)*, 1963, and, probably, *Fool's House*, 1962.[28]

[Early July]: Johns returns from Japan to New York, and meets the artist Mark Lancaster. At Riverside Drive, starts working on *Evian*.

July 18–19: At ULAE, in West Islip, resumes work on the lithograph *Ale Cans*.[29]

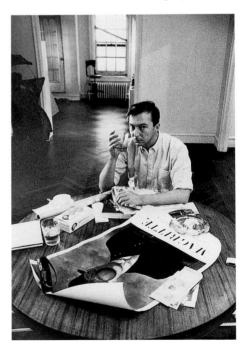

August: At Riverside Drive, works on *According to What*, his largest painting until then.[30]

August 21–23: In London with Lois Long for the weekend, on the occasion of her birthday and the start of a world tour for Merce Cunningham.[31]

During this trip, visits Windsor Castle to see Leonardo da Vinci's *Deluge* drawings: *Here was a man depicting the end of the world, and his hand was not trembling.*[32]

At Riverside Drive, New York, 1964.
Photograph: Ugo Mulas. © Ugo Mulas Estate.
All rights reserved.

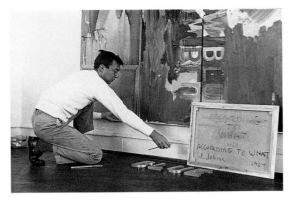

At Riverside Drive in August 1964, working on *According to What*, 1964. Photograph: Mark Lancaster.

September 12–November 15: "*I. Internationale der Zeichnung*," an exhibition at the Mathildenhöhe Darmstadt, West Germany, includes five Johns drawings dating from 1958 to 1962. There is a catalogue with essays by Heinz Winfried Sabais, Werner Hofmann, Dore Ashton, Carl Georg Heise, and Werner Haftmann.

[Fall]: In Edisto Beach, paints *Studio* (which contains an imprint of the studio's screen door) and starts the paintings *Untitled*, 1964–65, and probably *Voice*, 1964–67.

October 7–November 1: "*Premio Nacional e Internacional, Instituto Torcuato di Tella 1964*," a juried exhibition at the Centro de Artes Visuales, Instituto Torcuato di Tella, Buenos Aires, includes the paintings *Flag*, 1958, *Fool's House*, 1962, and *Arrive/Depart*, 1963–64. The jurors are Clement Greenberg, Pierre Restany, and Jorge Romero Brest.

October 21: From Edisto Beach, writes to Billy Klüver, asking him about the mechanics of a potential work including a mirror and a laser. Also states that he expects to return to New York around November 20.[33]

October 30, 1964–January 10, 1965: The 1964 "Pittsburgh International Exhibition of Contemporary Painting and Sculpture," at the Museum of Art, Carnegie Institute, Pittsburgh, includes the painting *Evian*, 1964. There is a catalogue with a foreword by Gustave von Groschwitz.

[c. November 20]: In New York. Soon after, travels to London for the openings of the exhibitions "Jasper Johns: Paintings, Drawings and Sculpture 1954–1964"—the retrospective formerly at the Jewish Museum and now at the Whitechapel Art Gallery (December 2–31), directed (in London) by Bryan Robertson—and "Jasper Johns: Lithographs," at the USIS Gallery in the American Embassy (December 1, 1964–January 8, 1965). All of Johns's lithographs to date are shown in this latter exhibition, which will travel within Great Britain.[34]

1965

During the year, in Edisto Beach, finishes painting *Untitled*, 1964–65 (plate 106), and paints *Eddingsville*, *Flags*, *Map*,[35] *Red, Yellow, Blue* (destroyed by fire in 1966), *Two Maps* (destroyed by fire in 1966), and *Untitled* (destroyed by fire in 1966). Also starts *Untitled*, 1965–67.

At Riverside Drive, paints a small *Flag*.

Contributes *Map*, 1965, to the exhibition "Drawings, 1965: Benefit for the Foundation for Contemporary Performance Arts," held simultaneously at the Leo Castelli, Tibor De Nagy, and Kornblee galleries.[36]

Acquires Magritte's *Interpretation of Dreams*, 1935.

January 14: Attends the opening of Marcel Duchamp's exhibition "Not Seen and/or Less Seen of/by Marcel Duchamp/Rrose Sélavy—1904–1964: Mary Sisler Collection," organized by the artist Richard Hamilton, at Cordier & Ekstrom Gallery (978 Madison Avenue), New York.[37]

[Before January 26]: To Pasadena, where a version of the Jewish Museum retrospective, most recently at the Whitechapel Art Gallery, is opening at the Pasadena Art Museum, directed by Walter Hopps.[38]

[February–early fall]: In Edisto Beach, with sporadic visits to New York.[39]

At Larry Rivers's house on Long Island, with, from left, Frank O'Hara, Niki de Saint Phalle (?), Jean Tinguely, and Clarisse Rivers (?), c. 1965.

March: Artists Robert Morris and Carolee Schneemann perform *Site* for the first time, at Stage 73, Surplus Dance Theater, New York. During the performance, Morris wears a rubber mask from a mold of his own face, made by Johns.[40]

March 31–April 24: "Critic's Choice: Art since World War II," at the Providence Art Club, Providence, Rhode Island, includes the painting *Out the Window II*, 1962. The artists are selected by critics Thomas B. Hess, Hilton Kramer, and Harold Rosenberg.

Interior and exterior views of Johns's studio in Edisto Beach, 1965. Photographs: Ugo Mulas. © Ugo Mulas Estate. All rights reserved.

Spring: The Swiss journal *Art and Literature* publishes an excerpt from Johns's sketchbook writings under the title "Sketchbook Notes."[41]

[April]: In Edisto Beach, the English critic David Sylvester records an interview with Johns, which is broadcast in England by the BBC on October 10, 1965.

May: John Cage, visiting Johns in Edisto Beach, gives him a copy of a book of Arnold Schoenberg's letters,[42] about which Cage is writing for *Kenyon Review*.

[May?]: Writes to Cage from Edisto Beach: Marcel Duchamp has asked Johns to donate a work to an exhibition Duchamp is organizing to benefit the American Chess Foundation, and Johns has agreed. He also thanks Cage for the Schoenberg volume, which he has been reading with interest.[43]

June: The "VI International Exhibition of Graphic Art," held at the Moderna Galerija, Ljubljana, Yugoslavia, includes twenty-five lithographs by Johns. The exhibition's international jury awards the *Prix du Musée d'Art Contemporain à Skopje* to his lithograph *Skin with O'Hara Poem*, 1963–65, which ULAE has published earlier in the year—a collaboration between Johns and Frank O'Hara.[44] (Johns and O'Hara originally planned to collaborate on a portfolio of images and poems, but Johns only responded to one of the new poems O'Hara gave him—the one used in *Skin with O'Hara Poem*.[45])

June 1–25: "Jasper Johns," an exhibition at the Minami Gallery, Tokyo, includes eighteen paintings, eleven sculptures, and four drawings, dating from 1955 to 1964. There is a catalogue with an essay by Yoshiaki Tono.

June 10: Tatyana Grosman writes to Johns, "We have sent you today the package with gum arabic etc. I have just the news that we will have zinc plates by the beginning of next week and we will ship them to you right away."[46]

July 3: Writing to Tatyana Grosman from Edisto Beach, Johns says that he is eager to receive materials from her with which to begin work on three lithographs.[47]

Mid-November–mid-December: Goes occasionally to ULAE to work on the prints *Two Maps I* and *Recent Still Life*.[48] The latter of these will be used for a poster commissioned by the Albert A. List Foundation for the exhibition "Recent Still Life," at the Museum of Art, Rhode Island School of Design (February 23–April 3, 1966).

December: "Word and Image," an exhibition at the Solomon R. Guggenheim Museum, includes seven Johns paintings dating from 1955 to 1964, and the drawing *Liar*, 1961. There is a catalogue with an introduction by Lawrence Alloway.

With Tatyana Grosman at ULAE, West Islip, N.Y., 1965. Photograph: Ugo Mulas. © Ugo Mulas Estate. All rights reserved.

December 8, 1965–January 30, 1966: The "1965 Annual Exhibition: Contemporary American Painting," at the Whitney Museum of American Art, New York, includes *Flags*, 1965.

1966

At Riverside Drive, paints *Passage II* and *Studio II*.

David Whitney starts working as Johns's assistant, a position he will keep until 1968.[49]

Tatyana Grosman applies to the National Endowment for the Arts for a grant to set up an etching workshop.[50] She also hires Donn Steward, who has trained at the Tamarind Lithography Workshop, Los Angeles, to assist printer Zigmunds Priede at ULAE.

January 8–February 2: "Jasper Johns," at the Leo Castelli Gallery, includes the paintings *According to What*, 1964, *Studio*, 1964, *Untitled*, 1964–65, and *Eddingsville*, 1965.

January 12–February 17: Works sporadically at ULAE on the lithographs *Two Maps I*, *Light Bulb* (ULAE# 24), *The Critic Smiles* (ULAE# 25), and *Two Maps II*.[51]

March 15: With Susan Sontag and Yoshiaki Tono, attends a performance of the Japanese Bunraku Puppet Theater. Teeny and Marcel Duchamp also attend, accompanied by Cage.[52]

April 10: At ULAE, resumes work on *Pinion*. He will continue to add to it and proof it on May 1 and 2.[53] This work involves the use of a photographic aluminum plate made from a detail of *Eddingsville*. It is Johns who has persuaded Tatyana Grosman to publish prints from metal plates; *Pinion* is ULAE's first such print.[54]

By June 22–June 24: In Paris.[55]

June 26, 28–30, July 1: At ULAE, works on the lithographs *Voice* and *Passage II*. He will still be working on *Passage II* on October 6, when he will visit ULAE with Susan Sontag.[56]

June 28–August 21: "The Object Transformed," an exhibition at The Museum of Modern Art, organized by Mildred Constantine and Arthur Drexler, includes *Book*, 1957. There is a catalogue with an introduction by Constantine and Drexler.

July 17–18: At ULAE, with Mark Lancaster.[57]

July 25: Frank O'Hara dies in an accident on a beach on Fire Island, New York, at age forty.[58]

In Edisto Beach in 1965, working on *Map*, 1965. Photograph: Ugo Mulas. © Ugo Mulas Estate. All rights reserved.

[Summer]: At Edisto Beach, paints *Flag* (LC# zz) and *Untitled* (window), both destroyed by fire a few months later.

October 6–November 13: "The Drawings of Jasper Johns," at the Art Hall, Museum of Natural History, Washington, D.C., includes forty drawings dating from 1955 to 1966. There is a catalogue with an introduction by Stefan Munsing.

[Before October 14]: To Japan, for the opening of "Two Decades of American Painting," an exhibition, selected by Waldo Rasmussen, at the National Museum of Modern Art, Tokyo (October 14–November 27). The exhibition includes Johns's *White Flag*, 1955, *Target*, 1958 (LC# 39), *Map*, 1961, and *Periscope (Hart Crane)*, 1963. Circulated by The Museum of Modern Art, the show will travel in Japan, India, and Australia.[59]

October 16: Writes to Leo Castelli from the Hotel New Japan, Tokyo, with his impressions of "Two Decades of American Painting." He also says that he intends to make a piece to go into Shuzo Takiguchi's book "for" Marcel Duchamp.[60]

October 20: Participates in the panel discussion "Where Is Contemporary Art Going?" at the Asahi Shimbum Hall, Tokyo. Other panelists are Clement Greenberg, Tomio Miki, Louise Nevelson, Ad Reinhardt, James Rosenquist, and Yoshiaki Tono.

November 7: Alan R. Solomon's film *USA Artists: Jasper Johns* is broadcast on the South Carolina Educational Television network. Produced by National Educational Television, the film includes an interview with Johns by Solomon, and shows Johns working on the paintings *Targets*, 1966, and *Passage II*, 1966.

November 12: From the Ginza Tokyu Hotel (5-5 Ginza-Higashi, Chuoku), Tokyo, writes to Castelli that he will return sometime in the following month, possibly via Cambodia, India, Paris, and London.[61]

November 14: While Johns is in Japan, his house and studio in Edisto Beach are destroyed by fire. A number of his works are lost: *Red, Yellow, Blue* (acrylic and collage on canvas, 48 x 48"); *Two Maps* (plastic paint on paper, 14 x 10"); *Untitled* (painted ruler, two circles), 1965 (oil on canvas, 20 x 20"); *Flag*, 1966 (encaustic and collage on canvas, 48 x 60"); *Untitled* (window), 1966 (oil on canvas, 72 x 48"); *Figure 1* (Sculp-metal and collage, no date or measurements provided); and "several drawings," "sketchbooks," and

In Edisto Beach, 1965. Photograph: Ugo Mulas.

three lithographs (*0 through 9*, unique proof; *Coat Hanger*, unique proof; and *Flag*, unique proof).

Also destroyed by the fire are works Johns owns by other artists: a large drawing, a small painting, and a lithograph entitled *Accident*, all by Robert Rauschenberg; an untitled lithograph by Bridget Riley; a small painting on paper and figure drawings by Jack Tworkov; Robert Moskowitz's drawing *Window Shade*; a screenprint and a "toothbrush painting" by Mark Lancaster; two drawings by Lois Long, *Thistle* and *Lepiota Procera*; a small black stripe painting by Frank Stella; a drawing by Larry Poons; John Chamberlain's wall sculpture *Major Hoople*; and a Duchamp etching of a coffee grinder.[62]

[Late November]: Returns to New York.

December 8: John Cage writes to Ileana Sonnabend: "Have now finished the nine to ten thousand words on World Improvement. And Jap says he'll read it and make a world map. Hope that project goes ahead."[63]

December 16, 1966–February 5, 1967: "Annual Exhibition 1966: Contemporary Sculpture and Prints," at the Whitney Museum of American Art, includes *Pinion*.

1967

January 18: From Cincinnati, Cage writes to Johns on Riverside Drive: "I spoke to Bucky [Buckminster Fuller] in Colorado; he agrees that you may use the map—he's delighted. But [would] like a letter addressed to him at Box 909, Carbondale, Illinois."[64] Cage is referring to a commission from Alan Solomon for a painting to be exhibited at the Expo 67 world's fair in Montreal, in the United States Pavilion— a geodesic dome designed by Fuller. Johns plans to base a painting on a world map conceived by Fuller.

In Edisto Beach, 1965. Photograph: Ugo Mulas.

[Late January–mid-April]: Paints the first version of *Map (Based on Buckminster Fuller's Dymaxion Air Ocean World)*. It is the largest painting in Johns's oeuvre, measuring over fifteen by thirty-three feet. Johns must work on it in parts in David Whitney's loft, at 343 Canal Street, where he can look at it from no more than twelve feet away, preventing an overall view. The painting is composed of twenty-two triangular panels, mimicking the divisions in Fuller's map. Fuller's design is transferred to the painting with the help of a projector.[65]

February 4–26: "Tenth Anniversary Exhibition," at the Leo Castelli Gallery, includes works by Richard Artschwager, Lee Bontecou, John Chamberlain, Nassos Daphnis, Edward Higgins, Johns, Donald Judd, Roy Lichtenstein, Robert Morris, Larry Poons, Robert Rauschenberg, James Rosenquist, Sal Scarpitta, Frank Stella, Cy Twombly, and Andy Warhol.

Before February 8: In New York, works on the lithograph stone for an edition of *0 through 9*. The stone is sent to ULAE on February 8, and the proofs are brought to New York for Johns's approval on March 1.[66]

February 24–April 19: "30th Biennial Exhibition of Contemporary American Painting," at the Corcoran Gallery of Art, Washington, D.C., includes the paintings *Eddingsville*, 1965, *Flags*, 1965, and *Targets*, 1966.

Late winter or early spring: Is appointed artistic advisor of the Merce Cunningham Dance Company.[67]

> *Merce is my favorite artist in any field. Sometimes I'm pleased by the complexity of a work I paint. By the fourth day I realize it's simple. Nothing Merce does is simple. Everything has a fascinating richness and multiplicity of direction.*[68]

Spring: Awarded the major prize at the "VII International Exhibition of Graphic Art," Ljubljana, Yugoslavia.

April: Meets Roberta Bernstein, who will work for him in 1968 and 1969, cataloguing his prints and works by other artists in his collection. Bernstein's 1975 doctoral dissertation, "'Things the Mind Already Knows': Jasper Johns' Painting and Sculptures 1954–1974" (later revised and published as *Jasper Johns' Paintings and Sculptures 1954–1974: "The Changing Focus of the Eye"*), will long remain the most thorough study of Johns's oeuvre of that period.

April–May: At Riverside Drive, resumes work on the painting *Voice*, 1964–67.[69]

Map (Based on Buckminster Fuller's Dymaxion Air Ocean World) in progress in David Whitney's studio on Canal Street, New York, 1967. Photograph: Rudolph Burckhardt.

April 17, 19: At ULAE, works on the lithograph *Voice*, 1966–67.[70] For this print, a photographic plate is made showing the fork and spoon that hang along the right edge of the *Voice* painting of 1964–67. Before the plate is made, Johns writes an instruction on the photograph for the printer: "fork should be 7″ long." This notation, along with the image of the fork and spoon, will appear in a number of oil paintings realized in the fall of 1967 and in 1968.[71]

April 22–30: "Benefit Exhibition and Sale of Paintings, Sculpture and Graphics," at the Carpenter Center for the Visual Arts, Harvard University, Cambridge, Massachusetts. Johns donates the *0 through 9* lithographs completed earlier in the year, produced in an edition of fifty, to this sale to benefit the Committee to Rescue Italian Art (CRIA), formed to coordinate emergency work in the museums and libraries of Florence, which has been hit by flooding.

April 28–October 27: "American Painting Now," an exhibition, curated by Alan R. Solomon, in the United States Pavilion at Expo 67, Montreal, includes Johns's *Map (Based on Buckminster Fuller's Dymaxion Air Ocean World)*. Later in the year, the show will travel to Massachusetts.[72]

The painting is exhibited vertically in Fuller's dome. (In subsequent years, it is generally shown horizontally.) When Johns sees it installed, he decides to rework it, a process, completed four years later, that will radically alter the painting's appearance.

> *When I finished the painting, I sent it up to Montreal. Then I went to the fair to look at it. It was the first time I had seen the painting put together. I didn't like it. It just looked like a map to me. When*

U.S. Pavilion, Expo 67, Montreal, 1967. Photograph: Harry Shunk.

dimensional, life-size version of Leonardo's *Last Supper* in wax, exhibited in a trailer truck": *My favorite artist in my favorite medium!*[77]

July 25: First performance of Merce Cunningham's *Scramble*, 1967, at the Ravinia Festival, Chicago, with music by Toshi Ichiyanagi (*Activities for Orchestra*) and set and costume design by Frank Stella (invited by Johns). This is the first dance produced by the company since Johns became artistic advisor.

Before August 6: Buys a Manhattan building formerly owned by the Providential Loan Society of New York, at 225 East Houston Street, on the corner of Essex Street: "The one-story-and-mezzanine building has a room 50 feet square and 35 feet high that will be Mr. Johns's studio. The structure was bought through [Jack H.] Klein, Mr. Klein will also supervise the building's renovation."[78]

Mid-August: Tatyana and Maurice Grosman visit Johns in North Carolina, bringing the edition of *Watchman* for him to sign.[79]

September: The painting *Voice*, of 1964–67, is included in a group exhibition at the Leo Castelli Gallery.[80]

[September or October]: Moves from 340 Riverside Drive to the Chelsea Hotel, at 222 West 23rd Street, where he will live while the Houston Street building is being renovated to become his studio and residence. During the months of renovation, Johns works in David Whitney's loft on Canal Street.

September–early December: Works on and off at ULAE. On September 7 and 8, Johns works on the lithographs *Numbers*, *Targets*, and *Flags*, and on the etching *Figure 4*. At ULAE again on September 12–16, he signs the lithograph *Voice*, and continues to work on the *Numbers*, *Targets*, and *Flags* lithographs, among others. (Cy Twombly is also there, working on his own lithographs and etchings.) At ULAE on September 30 and October 1, Johns completes the lithograph *Numbers* and the etchings *Target*, *Light Bulb*, and *Figure 4*. At ULAE on November 24, he signs *1st Etchings* portfolios. On November 25 and again on December 3 at ULAE, he works on the lithograph *Target*, made to benefit the Foundation for Contemporary Performance Arts. Johns signs the edition at the Chelsea Hotel on December 6.[81]

September 22, 1967–January 8, 1968: The *'IX Bienal Internacional de São Paulo*," in São Paulo, Brazil. The paintings *Three Flags*, 1958, *Map*, 1962, and *Double White Map*, 1965, are included in "Environment U.S.A.: 1957–1967," the American submission to the

I got the painting back—by then I had moved into a very large space down on Houston Street…— I could have it all together and look at it as one thing. I completely repainted it.[73]

May 17: At ULAE, Johns experiments for the first time with etching.[74]

June 16–25: Goes daily to ULAE, resuming work on the lithograph *Voice* and working on the lithographs *Watchman*, *Target*, *Targets*, *Flags*, and probably *Numbers*. Simultaneously, works on his first etchings, including *Light Bulb*, *Target I*, and the *1st Etchings* portfolio.

June 26–July 22: "Jasper Johns 0–9," at the Minami Gallery, Tokyo, includes thirty lithographs dating from 1960 to 1967. There is a catalogue with texts by Robert Rosenblum, Toru Takemitsu, and Shuzo Takiguchi.

June 28–[late August]: In North Carolina.[75] At Nags Head, makes studies for the illustrations for The Museum of Modern Art's posthumous Frank O'Hara book, *In Memory of My Feelings*.[76]

July 6: In a shopping center in Norfolk, Virginia, on the way back to Nags Head, Johns sees "a three-

show, curated by William C. Seitz. Johns is among the ten artists who are awarded the exhibition prize, the *Prêmio Bienal de São Paulo*.

[Early fall]: At Canal Street, finishes painting *Untitled*, 1965–67, and paints *Flag* and *Harlem Light*.[82] In the left-hand panel of *Harlem Light* Johns introduces a flagstonelike image that will recur in his later work.

> *The flagstone motif came from a painted wall I saw in Harlem. I was on my way to the airport, and once I saw it I said, "Let's put that in my next painting." But when I came to try to find it, I couldn't, even after driving around Harlem for an hour. It wasn't there. So I had to remember or reinvent it. And in a sense, I continued to remember and reinvent it in a number of subsequent works.*[83]

After *Harlem Light*, Johns begins *Target*, not completed until 1969.[84]

October 27, 1967–January 7, 1968: The "1967 Pittsburgh International Exhibition of Contemporary Painting and Sculpture," at the Museum of Art, Carnegie Institute, Pittsburgh, Pennsylvania, includes *Eddingsville*, 1965. There is a catalogue with a foreword by Gustave von Groschwitz.

November: In David Whitney's Canal Street studio, paints *Screen Piece*, the first of five paintings

At the Canal Street studio, working on *Harlem Light*, 1967.

bearing this title. Possibly also makes *Figure 4* around this time.[85]

At the Chelsea Hotel, reads Wittgenstein's *Zettel* and Ted Berrigan's *Sonnets*.[86]

November 9–December 17: "*Kompas III*," an exhibition at the Stedelijk van Abbemuseum, Eindhoven, the Netherlands, includes the paintings *Flag on Orange Field*, 1957, *Gray Target*, 1958, *Reconstruction*, 1959, and *Arrive/Depart*, 1963–64. There is a catalogue with an introduction by Jean Leering. The exhibition will travel to West Germany.[87]

December 13, 1967–February 4, 1968: "1967 Annual Exhibition of Contemporary American Painting," at the Whitney Museum of American Art (now at 945 Madison Avenue), includes the painting *Voice*, 1964–67.

1968

Partly for the benefit of the Merce Cunningham Dance Company, designs a poster derived from the painting *Target with Four Faces* (the faces this time are Cunningham's) and publishes the image as a screenprint.[88]

[January–February]: At Canal Street, paints *Screen Piece 2*, *Screen Piece 3*, and *Wall Piece*.

> *In [*Screen Piece 3*] I included the title page of Ted Berrigan's* The Sonnets, *which I like. I was talking to the poet Anne Waldman the other day, trying to get her to explain to me how those sonnets were written. She gave me a few clues, but she didn't seem to think there was any systematic order. He used the same lines over and over, and in some of the poems the lines were shuffled about in an entertaining way so that they read backwards instead of forwards.*[89]

At the Canal Street studio, 1967.

[February or March]: Moves from the Chelsea Hotel to 225 East Houston Street.

A journalist will later write, "At the corner of Houston and Essex Streets is a large building that is something of a neighborhood landmark. It is a 19th-century yellow-brick cube standing on a molded base, with enormous windows and a corniced roof. When its lights are on at night, rows of house plants inside cast intricate shapes on the frosted glass, and it is altogether an eccentric and inspiring sight in this Lower East Side wasteland. Formerly the Provident Loan Society, this is the bank Jasper Johns bought in 1967. Then, it was actually a pawnshop (among whose now-illustrious clients, in the 1940s, were Barnett and Annalee Newman)."[90]

February 8: At ULAE, works on the dots of the lithograph *Flags*, 1967–68, and completes the edition of *Targets* lithographs, 1967–68. Johns will finish the *Flags* lithograph on February 15. This year he will return to ULAE on June 19 and 21, when he will work on *White Target*, 1967–68, and on November 10, probably to work on the same lithograph. *White Target* will be completed in New York on December 18.[91]

February 21–March 6: "Contemporary Graphics Published by Universal Limited Art Editions," an exhibition at Dayton's Gallery 12, Minneapolis, includes thirty-seven prints by Johns.

February 24–March 16: "Jasper Johns," an exhibition at the Leo Castelli Gallery, includes *Studio II*, 1966, *Harlem Light*, 1967, *Screen Piece*, 1967, *Screen Piece 2*, 1968, *Screen Piece 3*, 1968, and *Wall Piece*, 1968.

March 3: After a few weeks spent working on the set for Merce Cunningham's *Walkaround Time*—a set based on Marcel Duchamp's *Bride Stripped Bare by Her Bachelors, Even (The Large Glass)*—Johns, accompanied by Roberta Bernstein, picks up Duchamp at 28 West 10th Street and brings him to Canal Street to see the set before the performance, which is to take place in Buffalo, New York, on March 10.

According to Bernstein, "D[uchamp] liked the set very much. He asked J[ohns] how it was done and what Merce was going to do with it, etc. J asked for suggestions and D said he thought some of the pieces should be suspended from the ceiling. Then J asked D about crediting and D thought J's name should be clearly mentioned since the idea was J's and he had done so much work on it."[92]

March 9: First performance of Cunningham's *Rainforest*, 1968, at the "Second Buffalo Festival of the Arts Today," State University College, Buffalo, with music by David Tudor (*Rainforest*), set design by Andy Warhol, and costume design by Johns. Warhol wants the dancers to be nude; Cunningham rejects this suggestion. Instead, Johns makes cuts in the dancers' leotards and tights, and ties knots where the cuts are.

March 10: First performance of Cunningham's *Walkaround Time*, also at the Buffalo Festival, with music by David Behrman (*…for nearly an hour…*). The set, after Duchamp's *Large Glass*, and costume design are both by Johns.

We went up to Buffalo for the premiere, and they were arranging the bows that were to be taken; and I said that I didn't want to be on stage for a bow. Marcel said he would be. He and I were in the audience; and, when the time came for him to go up, I offered to help him, which help he shrugged off, saying, "Aren't you coming?" And I said, "No," and he turned and he said: "I'm just as frightened as you are." [93]

[Mid-March–early May]: At the invitation of Kenneth Tyler, of the Gemini G.E.L. lithography workshop, spends seven weeks in Los Angeles, at the Château Marmont, to work at Gemini for the first time.[94]

Ken Tyler asked me to come to Gemini several times. All of my [printed] work that I had done before I came here was done at Tatyana Grosman's shop, and I wanted to see what another printing situation was

Working on the set of Merce Cunningham's *Walkaround Time*, 1968. Photograph: Oscar Bailey, courtesy Cunningham Dance Foundation, Inc.

like....Gemini, for instance, is much bigger than Tatyana Grosman's. One's contact with the printers at Gemini, however, is rather close....I would say there is a different tempo because of the different numbers of people at the two different places. Consequently, one's thought is altered a little bit.[95]

At Gemini, Johns works on a number of larger-scale prints, completing *Gray Alphabets* and the ten single *Figure* lithographs from the *Black Numeral Series.* Also in the Gemini workshop, using rubber stamps rather than stencils, he makes three oil paintings, all the same size and all with the same title: *White Alphabets.*[96]

This year Johns will return to Los Angeles by July 3, making sporadic visits to the city until August 10 to work at Gemini G.E.L. on the lithographs of the *Color Numeral Series.*[97] He is back by November 30, working at Gemini probably on *Alphabet,* 1968–69 (ULAE# 69 and 70), and the lithograph *No,* 1968–69.[98]

March 27–June 9: "Dada, Surrealism and Their Heritage," an exhibition, curated by William S. Rubin, at The Museum of Modern Art, includes *Target with Four Faces,* 1955, *Target with Plaster Casts,* 1955, and a bronze *Light Bulb* of 1960. Later in the year the show will travel to California and Illinois.[99]

[May]: "Jasper Johns: Figures 0–9," an exhibition at Gemini G.E.L. There is a catalogue with an essay by Henry Hopkins.

[May–December]: At Houston Street, works on the repainting of *Map (Based on Buckminster Fuller's Dymaxion Air Ocean World),* and paints *Screen Piece 4* and *Screen Piece 5,* both in oil and the same size.

June 22–October 20: The XXXIV Venice Biennale includes the painting *Diver,* 1962.

June 27–October 6: The Documenta IV exhibition, in the Museum Fridericianum in Kassel, West Germany, includes the paintings *Flag on Orange Field,* 1957, *Studio,* 1964, *Eddingsville,* 1965, and *Wall Piece,* 1968. In addition, thirty-one lithographs are shown in Kassel as part of the exhibition "Jasper Johns: Lithographer," curated by William S. Lieberman and Riva Castleman and circulated by the International Program of The Museum of Modern Art, New York. Over the next two years, this lithograph exhibition will travel to Denmark, Switzerland, Yugoslavia, Czechoslovakia, Poland, and Romania.[100]

July 3–September 8: "The Art of the Real: USA 1948–1968," an exhibition at The Museum of Modern

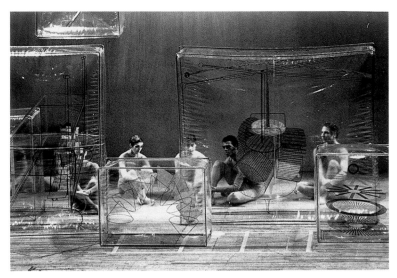

Merce Cunningham, *Walkaround Time,* performance view in Buffalo, N.Y., 1968. Photograph: Oscar Bailey, courtesy Cunningham Dance Foundation, Inc.

Art, curated by E. C. Goosen, includes the paintings *Flag,* 1954–55, and *White Numbers,* 1957. Over the next year (and without *Flag*), the exhibition will travel to France, Switzerland, and England.[101]

October 2: Death of Duchamp, at age eighty-one. Johns writes an obituary for *Artforum* magazine: *The art community feels Duchamp's presence and his absence. He has changed the condition of being here.*[102]

1969

At Houston Street, completes the painting *Target,* 1967–69. Also works on the middle, flagstone panels of *Untitled,* 1972, on *Voice 2,* and probably on *Map (Based on Buckminster Fuller's Dymaxion Air Ocean World).*

Max Kozloff's monograph on Johns is published.[103]

Meets Hiroshi Kawanishi, later of Simca Print Artists, Tokyo, who is working at the Whitney Museum of American Art.[104]

By January 21–April: In Los Angeles periodically, finishing the prints begun at Gemini G.E.L. the previous year. Also makes models from which molds are cast for five lead reliefs: *High School Days, The Critic Smiles, Flag, Light Bulb,* and *Bread.*[105] Johns will return to Los Angeles by May 6, when he will work at Gemini until May 14.[106]

[February]: In Saint Martin for two weeks. Johns will return to Saint Martin in December, and again in February or March of 1970.[107]

March 4: First performance of Merce Cunningham's *Canfield,* 1969, at Nazareth College, Rochester, New York, with music by Pauline Oliveros (*In Memoriam: Nikola Tesla, Cosmic Engineer*), set design by Robert

At East Houston Street, New York, June 30, 1969, working on *Untitled*, completed in 1972. Photograph: Hans Namuth. © Hans Namuth 1990.

At East Houston Street, June 30, 1969, working on *Voice 2*, 1968–71. Photograph: Hans Namuth. © Hans Namuth 1990.

Morris (invited by Johns; Morris's designs were not used at this first performance), and costume design by Johns.

> *It was often very simple. Just hard work. For instance, I asked Bob Morris to do something, and he had an idea but no interest in doing it. So he told me what was to be done, and who else was there to do it except me?* [108]

March 18–April 27: "New York: The Second Breakthrough, 1959–1964," an exhibition at the Art Gallery, University of California, Irvine, California, includes the paintings *Highway*, 1959, *Disappearance II*, 1961, and *Out the Window II*, 1962. There is a catalogue with an essay by Alan R. Solomon.

[April]: "Jasper Johns: Lead Reliefs," an exhibition at Gemini G.E.L. There is a catalogue with an essay by Solomon.

April 15: First New York performance of Cunningham's *Canfield*, with costumes by Johns, at the Brooklyn Academy of Music, this time with Morris's set but without music.

May: Receives an honorary degree, Doctor of Humane Letters, from the University of South Carolina, Columbia, for his work in the field of art.

May 10–29: "Jasper Johns: Lead Reliefs," at Castelli Graphics (4 East 77th Street), New York.

July: Publishes "Thoughts on Duchamp" in *Art in America*. [109]

After July 4: To Nags Head, North Carolina, where he makes the drawings *Studio*, *Untitled 1*, and *Flag*. [110]

July 6–August 6: "Jasper Johns: The Graphic Work," an exhibition at the Marion Koogler McNay Art Institute, San Antonio, Texas, includes eighty-eight lithographs, ten etchings, two screenprints, and seven embossed prints and lead reliefs. There is a catalogue with text by John Palmer Leeper. Over the next six months, the show will travel to Texas, New Mexico, and Iowa. [111]

July 8–September 3: "Pop Art," an exhibition at the Hayward Gallery, London, organized by the Arts Council of Great Britain, includes five Johns sculptures, dating from 1958 to 1964, and five lead reliefs of 1969. There is a catalogue by John Russell and Suzi Gablik.

September: Visits the Barnes Collection in Merion, Pennsylvania, with friends including Roberta Bernstein, who will write, "I visited the Barnes Collection with Johns twice (...: he had visited it several times before) and he was most interested in the Cézannes." The group also visit the Philadelphia Museum of Art, where Anne d'Harnoncourt takes them to see Marcel Duchamp's *Étant Donnés...*. [112]

October 18, 1969–February 1, 1970: "New York Painting and Sculpture 1940–1970," an exhibition at the Metropolitan Museum of Art, New York, organized by Henry Geldzahler, includes eleven paintings and twenty-nine drawings dating from 1955 to 1969.

November 4: In New York, signs *Untitled, Second State* (ULAE# 79). Johns will sign *Untitled, Second State* (plate 142) at ULAE on December 5, when he will also sign *1st Etchings, 2nd State*. And on December 18 in New York, he will sign the etching *Target II*, 1967–69. [113]

December 12–13: "Art for the Moratorium," an exhibition of artist-donated works to benefit the Vietnam Moratorium Committee, at the Leo Castelli Gallery. Johns contributes an edition of 300 signed posters, showing a photographic reproduction of the green-orange-and-black flag from the painting *Flags*, 1965. [114]

December 15, 1969–February 1, 1970: "Prints by Four New York Painters: Helen Frankenthaler, Jasper Johns, Robert Motherwell, Barnett Newman," curated by John McKendry, the second of two exhibitions of contemporary prints at the Metropolitan Museum of Art, includes forty-two prints by Johns dating from 1960 to 1969.

December 16, 1969–February 1, 1970: "1969 Annual Exhibition: Contemporary American Painting," at the Whitney Museum of American Art, includes *Wall Piece*, 1968.

1970

At Houston Street, paints *4 Leo*, and works on *Map (Based on Buckminster Fuller's Dymaxion Air Ocean World)* and probably on *Untitled*, 1972, and *Voice 2*, 1968–71.

Makes a drawing, *Space*, for the cover of a book by Clark Coolidge.[115]

Employs as a studio assistant the painter Gary Stephan, who will work for him until the fall of 1971.[116] While Stephan is working for Johns, he is apparently using polyvinyl chloride in his own paintings, which prompts Johns to use the same material in the sculpture *English Light Bulb*, 1968–70.[117]

Brice Marden paints *3 Deliberate Greys for Jasper Johns* (Collection National Gallery of Canada).

Winter: Is often at ULAE. On January 14, 16, 19, and 20, Johns works there on the lithograph *Souvenir*.[118] He will return on January 22 and 26 and on February 3, 10, and 17. On March 10, he will sign the lithograph *Light Bulb* at ULAE, and on March 26, he will sign *Souvenir* there.[119]

January 5: First performance of Merce Cunningham's *Tread*, 1970, at the Brooklyn Academy of Music, with music by Christian Wolff (*For 1, 2 or 3 People*) and set design by Bruce Nauman (invited by Johns).

Bruce Nauman was asked to do a set and he said just to get ten or fifteen fans and put them along the stage to blow at the audience and have the dancers wear sweaters and leg-warmers. Well, that's fairly easy to say, then you have to dye the sweaters, color the leg-warmers—things like that.[120]

January 8: First performance of Cunningham's *Second Hand*, 1970, at the Brooklyn Academy of Music, with music by John Cage (*Cheap Imitation*) and costume design by Johns: "Johns dyed the dancers' tights and leotards and, with lighting designer Richard Nelson, chose to use a bare stage with conventional wings. At

the choreographed curtain call, the costumes' shaded hues become the color spectrum."[121]

January 10–31: "Jasper Johns Drawings," an exhibition at the Leo Castelli Gallery.

April 17–June 14: "Jasper Johns: Prints 1960–1970," at the Philadelphia Museum of Art, exhibits Johns's complete graphic oeuvre to date, from the *Target* of 1960 to the recently completed *Souvenir*. Accompanying the retrospective is an equally complete catalogue by Richard S. Field.

By May 14: Finishes a drawing to be reproduced on the cover of *North*, a book of poems by Tony Towle.[122]

May 17: In New York, receives the Creative Arts Awards Citation for Painting from Brandeis University.

May 23: Revisits the Barnes Collection, again with Roberta Bernstein, and mentions to her that one of his favorite Cézannes is *Boy with Skull*, 1896–98.[123]

June 24–October 25: The U.S. Pavilion at the XXXV Venice Biennale includes four Johns lithographs dating from 1960 to 1969.

July 28–29: At ULAE, works on the lithograph *Scott Fagan Record*, using Fagan's record "South Atlantic Blues" as a relief printing surface.[124] Johns will return to ULAE to work on *Scott Fagan Record* on August 31 and on September 3 and 5, when he will also work on *Flags II*.[125]

September 19–26: "Benefit Exhibition for Referendum '70," at the Leo Castelli Gallery, includes work by Johns, as well as by Nassos Daphnis, Dan Flavin, Donald Judd, Roy Lichtenstein, Robert Morris, Robert Rauschenberg, James Rosenquist, Frank Stella, Cy Twombly, and Andy Warhol.

With Richard Serra at East Houston Street in 1970 as Serra makes *Splash Piece: Casting*, 1969–70. Photograph: Mark Lancaster.

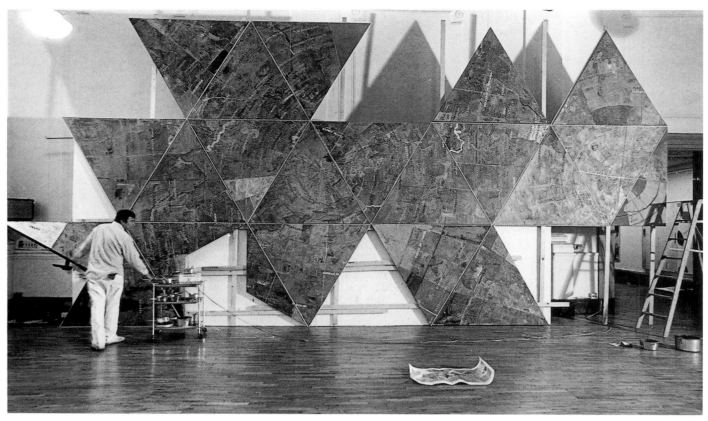

At East Houston Street, December 30, 1970, working on *Map (Based on Buckminster Fuller's Dymaxion Air Ocean World)*, 1967–71. Photograph: Hans Namuth. © Hans Namuth 1990.

October 8–November 16: "Jasper Johns: Prints," an exhibition at the John Berggruen Gallery, San Francisco, includes twenty-nine prints.

November 5–December 27: "Jasper Johns: The Graphic Work," an exhibition at the University of Iowa Museum of Art, Iowa City.

November 10: First performance of Cunningham's *Objects*, 1970, at the Brooklyn Academy of Music, with music by Alvin Lucier (*Vespers*) and set design by Neil Jenney (invited by Johns).

December 19, 1970–January 9, 1971: Solo exhibition at Castelli Graphics.

By December 20, 1970–February 28, 1971: Mostly in Los Angeles, working at Gemini G.E.L. on a series of lithographs titled *Fragments—According to What*.[126] Each of their titles—*Leg and Chair*, *Blue*, *Bent "Blue"*, *Hinged Canvas*, *Bent "U"*, *Bent Stencil*, and *Coat Hanger and Spoon*—corresponds to elements in the 1964 painting *According to What*.

December 22, 1970–May 3, 1971: "Jasper Johns: Lithographs," an exhibition at The Museum of Modern Art, curated by Riva Castleman, includes seventy lithographs dating from 1960 to 1970. There is a catalogue, its format conceived by Johns, and with text by Castleman. Over the next year and a half the

show will travel in New York State, Texas, California, Maryland, and Virginia.[127]

1971

At Houston Street, completes *Map (Based on Buckminster Fuller's Dymaxion Air Ocean World)*, 1967–71, and *Voice 2*, 1968–71, both begun in David Whitney's studio on Canal Street.

January 12–February 28: "Duchamp, Johns, Rauschenberg, Cage," an exhibition at the Contemporary Arts Center, Cincinnati, Ohio, includes twenty-three prints by Johns. There is a catalogue with an introduction by Barbara Rose.

March 9–27: "Jasper Johns," an exhibition at the Minneapolis Institute of Arts, Minneapolis, Minnesota, features the first showing of the reworked *Map (Based on Buckminster Fuller's Dymaxion Air Ocean World)*. Later in the year the exhibition will travel to Texas and New York.[128]

March 9–27: "Jasper Johns: Lithographs and Etchings Executed at Universal Limited Art Editions from 1960 through 1970," at Dayton's Gallery 12, Minneapolis, Minnesota, includes seventy prints published by ULAE.

March 15: At Hans Namuth's studio, Johns, Bill Katz, Robert Rosenblum, Lee Eastman, Tony Towle, and

Tatyana Grosman watch film made by Namuth showing Johns working on *Map (Based on Buckminster Fuller's Dymaxion Air Ocean World)*. They also see Namuth's film on Josef Albers, and his 1950 film on Jackson Pollock.[129]

April: "Jasper Johns: Fragments—According to What," an exhibition at Gemini G.E.L.

April 17–May 29: *"Jasper Johns: Graphik,"* an exhibition at the Kunsthalle Bern, Switzerland, includes 132 prints dating from 1960 to 1971. There is a catalogue with an introduction by Carlo Huber. The show will travel in West Germany, the Netherlands, and Italy.[130]

By April 27: In Los Angeles, working at Gemini G.E.L. This year Johns is probably also in Los Angeles beginning on December 6, working at Gemini until early January of 1972.[131]

May 1–29: "Jasper Johns: Fragments—According to What," an exhibition at Castelli Graphics.

May 27–June 5: "Exhibit of Graphics by Jasper Johns," curated by Sam C. C. Kimbrel, an exhibition at the Museum of the Sea, Harbour Town, Sea Pines Plantation Co., Hilton Head Island, South Carolina, includes seventy-five prints dating from 1960 to 1971.

July 10–September 5: "Jasper Johns: Graphics," curated by Joseph Randall, an exhibition at the Museum of Contemporary Art, Chicago, includes 130 prints dating from 1960 to 1970.

August 27, 30, September 3–5, 11–12: At ULAE, works on the lithograph *Decoy* and on a "black 'Flag' stone," possibly used for a *Two Flags* lithograph of 1972 (ULAE# 120 or ULAE# 121). On September 18–19, 21, 26, 30, and October 20 and 31, Johns will work at ULAE's Bay Shore extension, probably on the lithograph *Decoy*, which he will sign on November 20.[132] Before this print is completed, he will use it as the basis for two paintings made at Houston Street, both also called *Decoy* (plate 144 and LC# 345, the latter a smaller version of the former, and the same size as the print). This is a departure from Johns's working habits, since it is usually the prints that derive from paintings featuring the same motif, not the paintings that derive from prints.

As Johns works on the *Decoy* print, he is filmed for a forthcoming documentary, also called *Decoy*, being made by Blackwood Productions.

December 3: Merce Cunningham performs *Loops*, 1971, at The Museum of Modern Art, in front of *Map*

(Based on Buckminster Fuller's Dymaxion Air Ocean World), with music by Gordon Mumma (*Biophysical and Ambient Signals from FM Telemetry*) and slides by Charles Atlas projected onto the wall.[133]

December 4 or earlier: Tatyana Grosman suggests to Johns the idea of a collaboration with Samuel Beckett. Véra Lindsay will later propose to Johns that he illustrate Beckett's *Waiting for Godot*. In 1972, Lindsay will approach Beckett's literary agent about the idea, and Beckett will offer an early manuscript of the play for the project.[134] While Johns is receptive to the idea of collaborating with Beckett, he will decide he would rather work with an unpublished text.[135]

At 420 West Broadway, New York, in 1971, where the Leo Castelli Gallery moved that year. Photograph: Gerard Malanga.

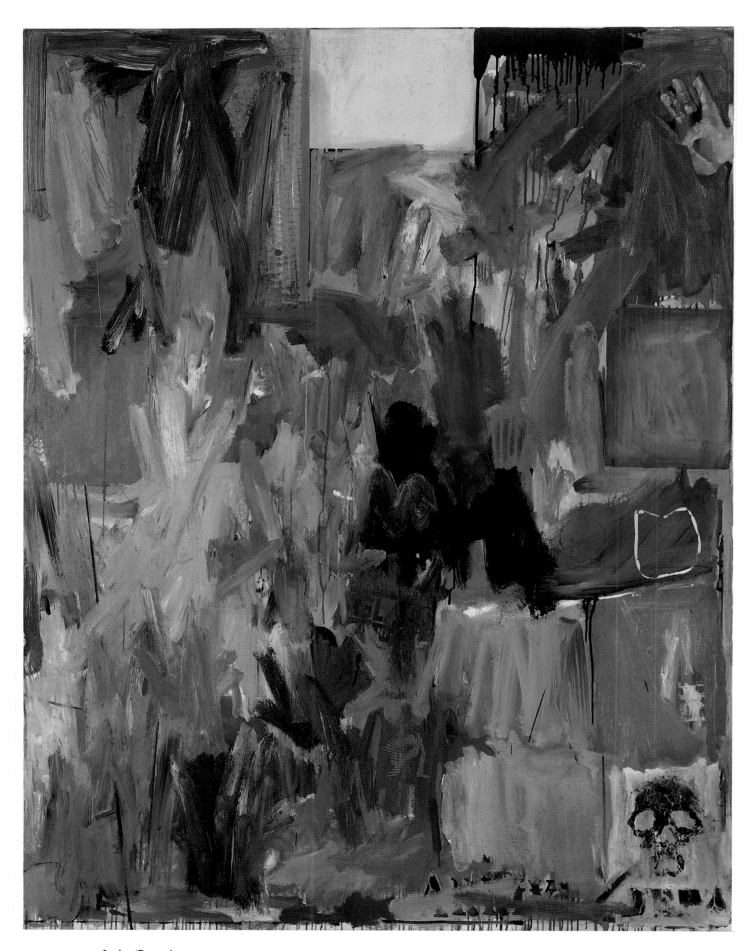

104. **Arrive/Depart**. 1963–64
Oil on canvas
68 x 51 ½″ (172.7 x 130.8 cm)
Bayerische Staatsgemäldesammlungen/
Staatsgalerie moderner Kunst, Munich

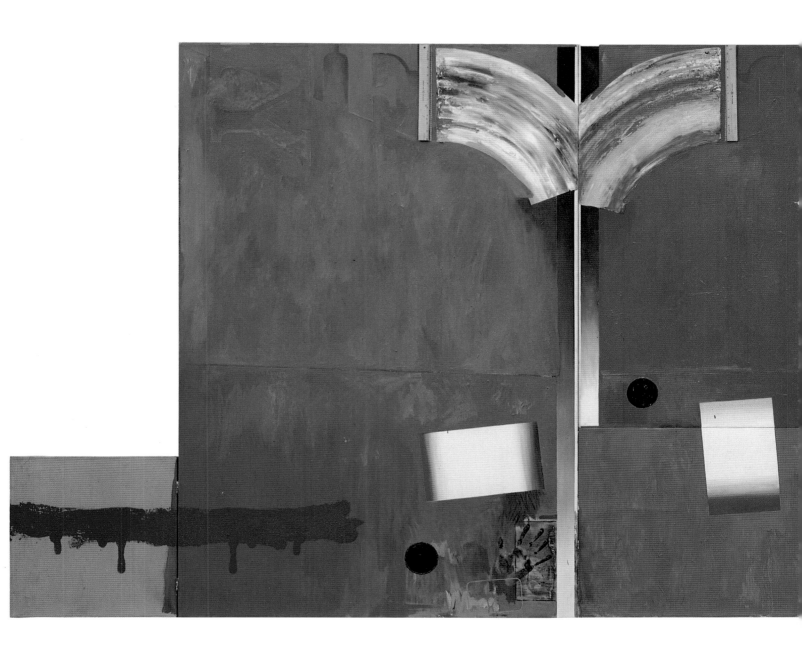

106. **Untitled**. 1964–65
Oil on canvas with objects (six panels)
6′ x 16′ (182.9 x 487.6 cm)
Stedelijk Museum, Amsterdam

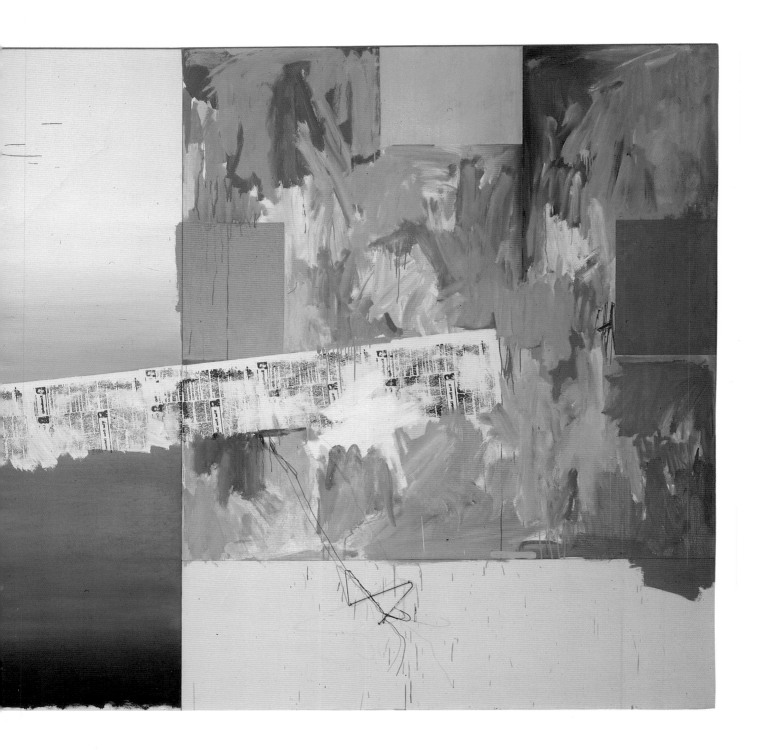

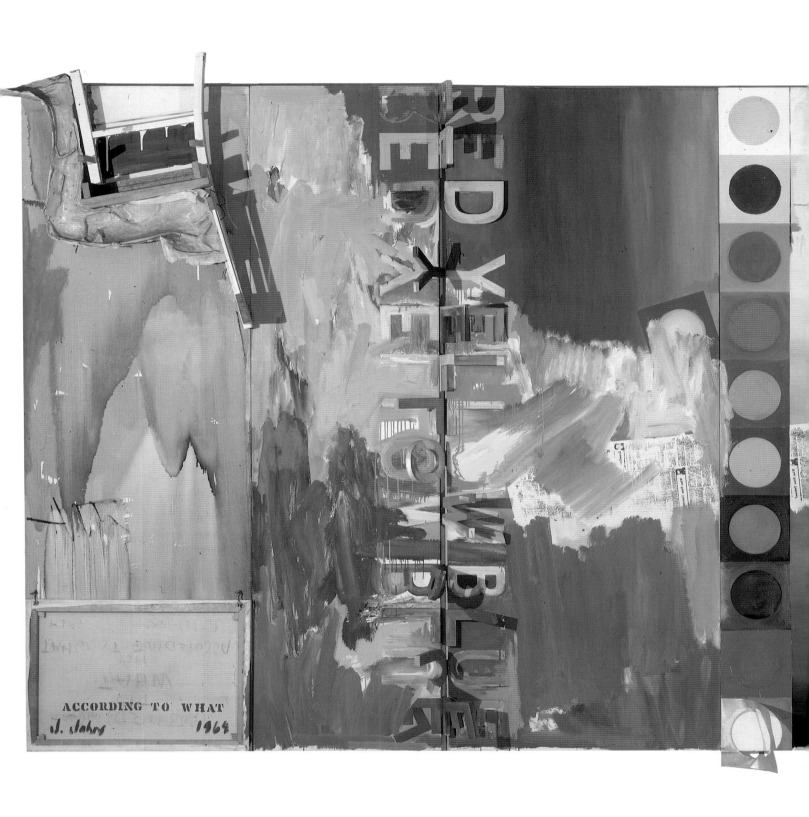

105. **According to What**. 1964
Oil on canvas with objects (six panels)
7′ 4″ x 16′ (223.5 x 487.7 cm)
Private collection

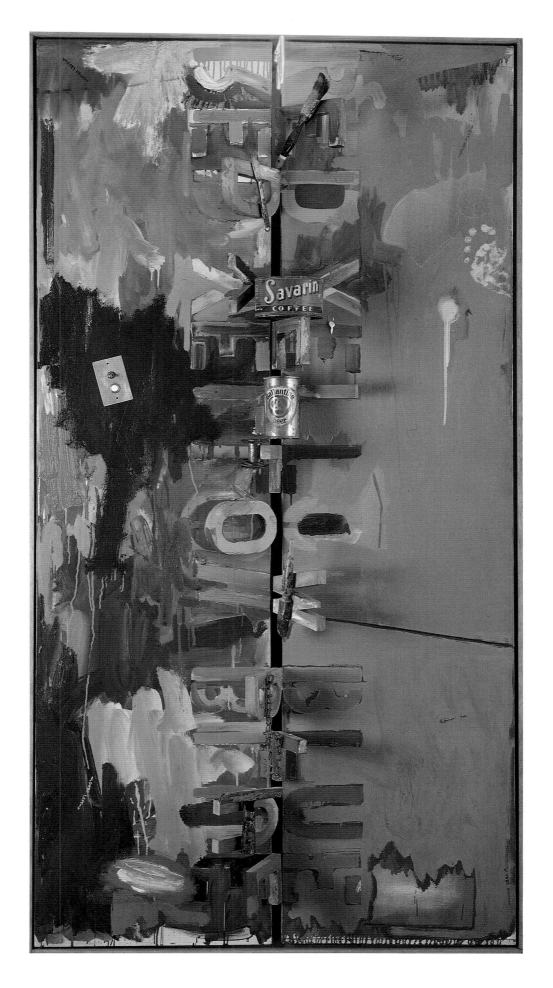

107. **Field Painting**. 1963–64
Oil on canvas with objects (two panels)
72 x 36¾" (182.9 x 93.3 cm)
Collection the artist

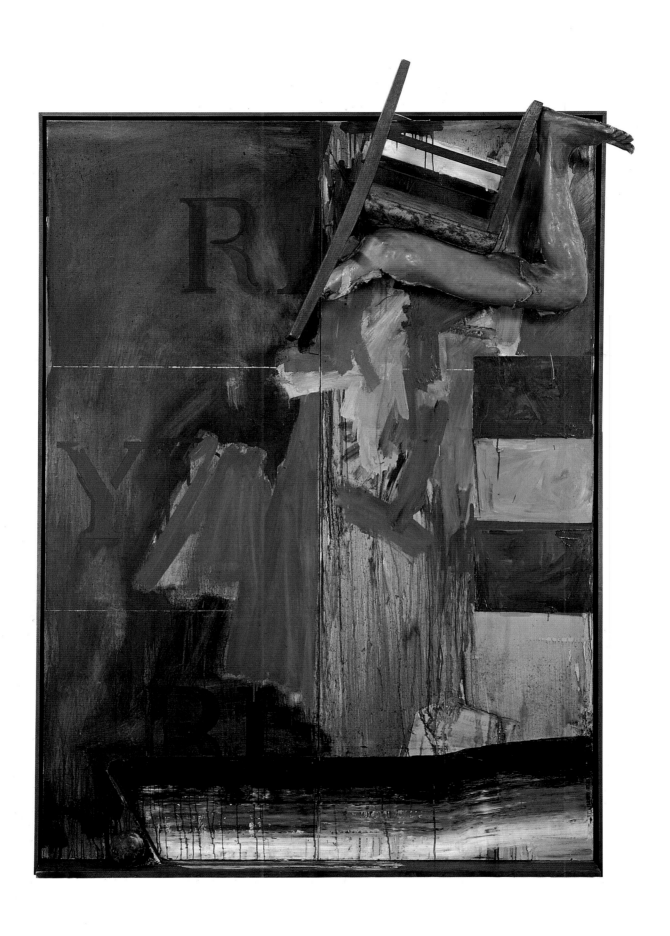

108. **Watchman**. 1964
Oil on canvas with objects (two panels)
85 x 60¼″ (215.9 x 153 cm)
The Sogetsu Art Museum, Tokyo

109. **Souvenir**. 1964
Encaustic on canvas with objects
28 ¾ x 21″ (73 x 53.3 cm)
Collection the artist

110. **Souvenir 2**. 1964
Oil and collage on canvas with objects
28 ¾ x 21″ (73 x 53.3 cm)
Collection Sally Ganz, New York

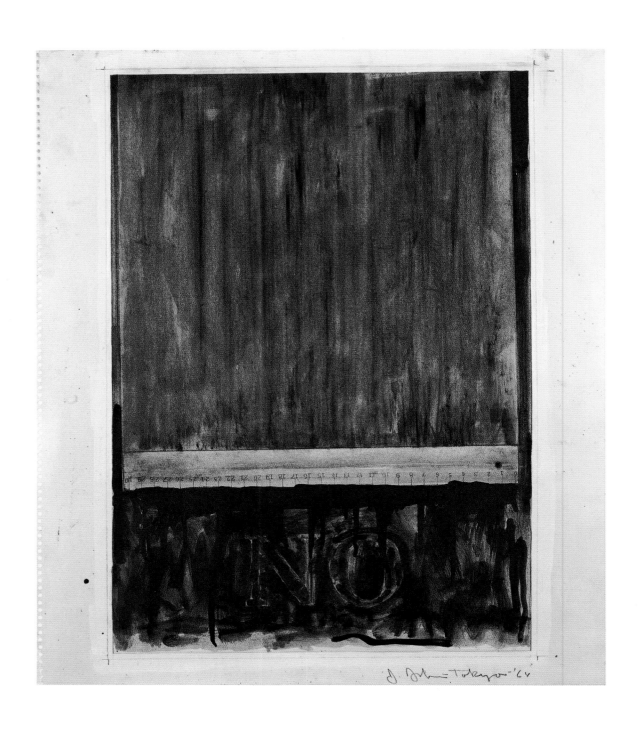

III. **No**. 1964
Graphite, charcoal, and tempera on paper
20 ¼ x 17 ½″ (51.4 x 44.5 cm)
246 Collection Sarah-Ann and Werner H. Kramarsky

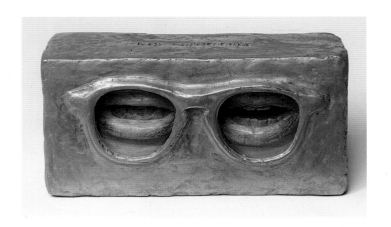

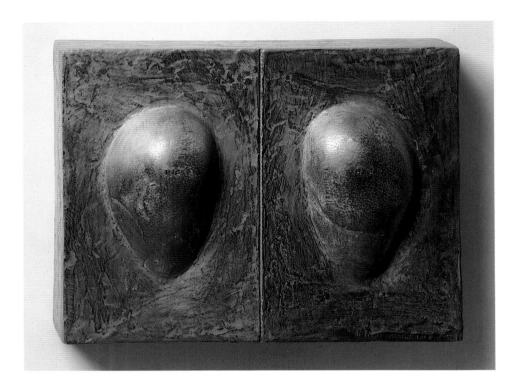

112. **The Critic Sees II**. 1964
Sculp-metal on plaster with glass
3 ¼ x 6 ¼ x 2 ⅛″ (8.2 x 15.8 x 5.3 cm)
Collection the artist

113. **Subway**. 1965
Sculp-metal on plaster and wood
7 ⅝ x 9 ⅞ x 3″ (19.4 x 25.1 x 7.6 cm)
Collection the artist

114. **High School Days**. 1964
Sculp-metal on plaster with mirror
4 ¼ x 12 x 4 ¼″ (10.8 x 30.5 x 10.8 cm)
Collection the artist

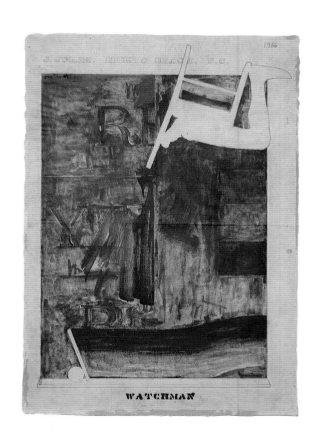

115. **Numbers**. 1966
Graphite pencil, graphite wash, and
metallic powder wash on polyester fabric
23 ⅝ x 18 ⅛″ (60 x 46 cm)
National Gallery of Art, Washington, D.C.
Gift of Leo Castelli in memory of
Toiny Castelli

116. **Watchman**. 1966
Graphite wash, metallic powder, pencil,
and pastel on paper
38 ¼ x 26 ½″ (97.2 x 67.3 cm)
The Museum of Modern Art, New York.
Gift of Mrs. Victor W. Ganz in memory
of Victor W. Ganz

117. **Studio II**. 1966
Oil on canvas
5′ 10 ⅜″ x 10′ 5 ¼″ (178.8 x 318.1 cm)
Whitney Museum of American Art.
Gift of the family of Victor W. Ganz
in his memory

118. **Passage II**. 1966
Oil on canvas with objects
59 ¾ x 62 ¼ x 13″ (151.7 x 158.1 x 33 cm)
Teheran Museum of Contemporary Art

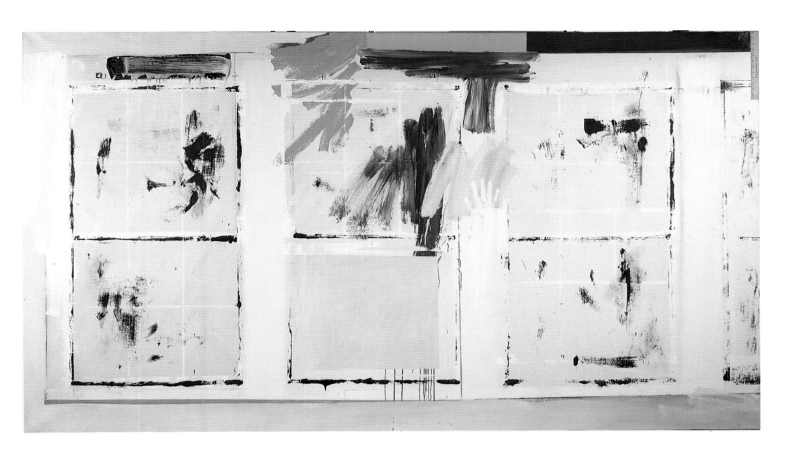

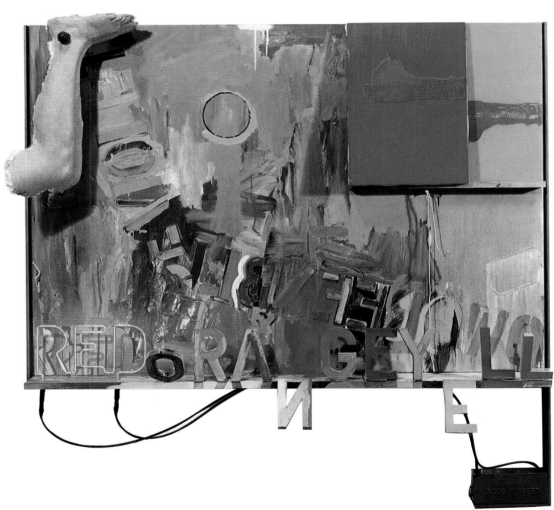

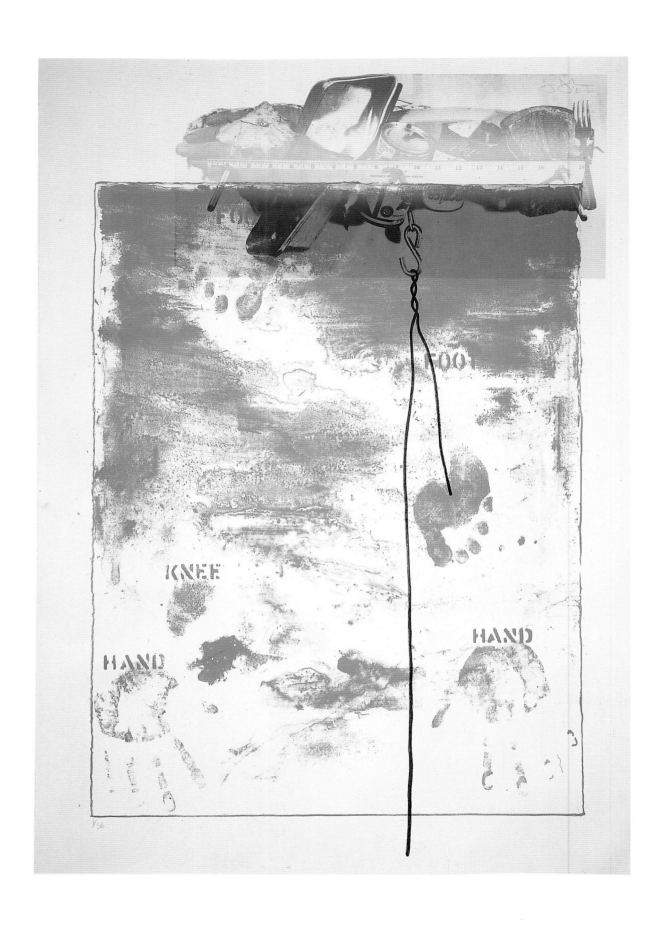

119. **Pinion**
West Islip, N.Y.: Universal Limited Art
Editions, 1963–66
Lithograph
40 1/8 x 28 1/16″ (101.9 x 71.3 cm)
The Museum of Modern Art, New York.
Gift of the Celeste and Armand Bartos
Foundation

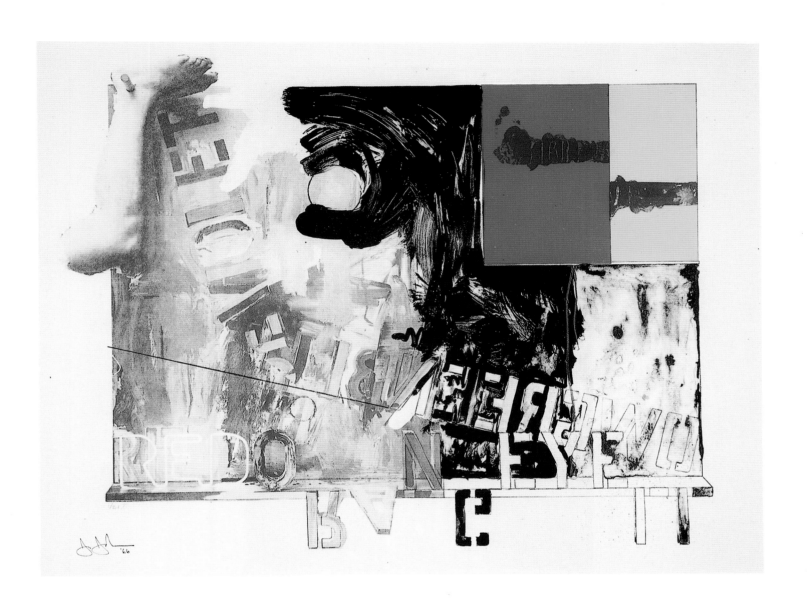

120. **Passage I**
West Islip, N.Y.: Universal Limited Art
Editions, 1966
Lithograph
28 ⅛ x 36 ⅜″ (71.4 x 92.4 cm)
The Museum of Modern Art, New York.
Gift of the Celeste and Armand Bartos
Foundation

121. **Voice**
West Islip, N.Y.: Universal Limited Art
Editions, 1966–67
Lithograph
48 3/8 x 31 11/16″ (122.9 x 80.5 cm)
The Museum of Modern Art, New York.
Gift of the Celeste and Armand Bartos
Foundation

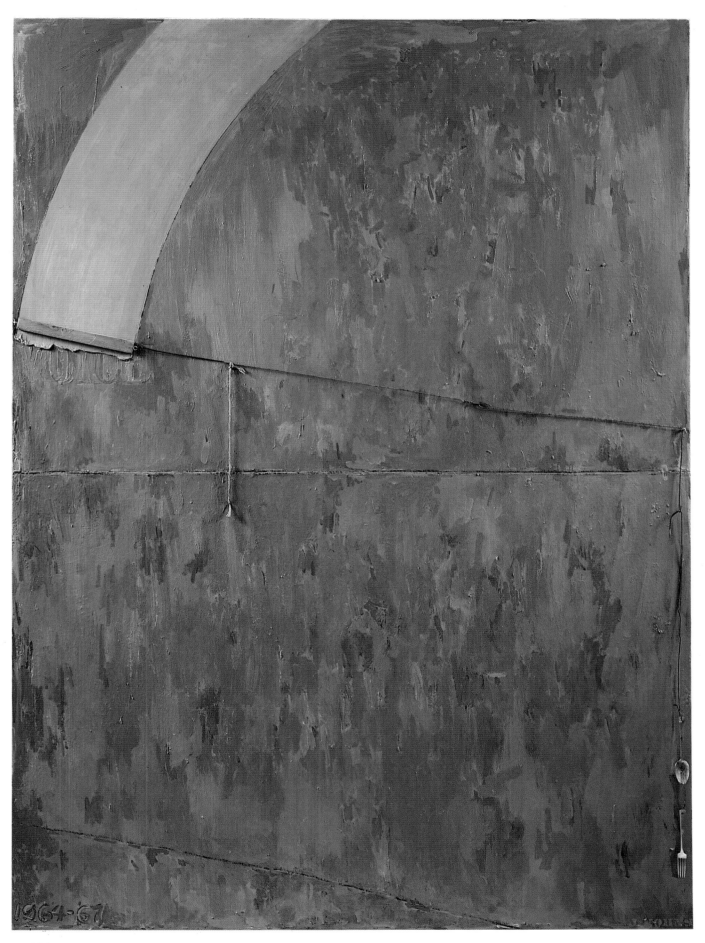

122. **Voice**. 1964–67
Oil on canvas with wood, string, wire,
and metal spoon and fork (two panels)
96 x 69 ½″ (243.8 x 176.5 cm)
The Menil Collection, Houston

123. **Harlem Light**. 1967
Oil and collage on canvas (four panels)
6' 6" x 14' 4" (198.1 x 436.8 cm)
Collection David Whitney

124. **Target with Four Faces**. 1968
Graphite pencil, pastel, charcoal, and
screenprint on paper
34 ½ x 29 ⅝" (87.6 x 75.2 cm)
Collection Jean Christophe Castelli

125. **Flags**
West Islip, N.Y.: Universal Limited Art
Editions, 1967–68
Lithograph and rubber stamp
34 ⅝ x 25 ⅞" (87.9 x 65.7 cm)
The Museum of Modern Art, New York.
Gift of the Celeste and Armand Bartos
Foundation

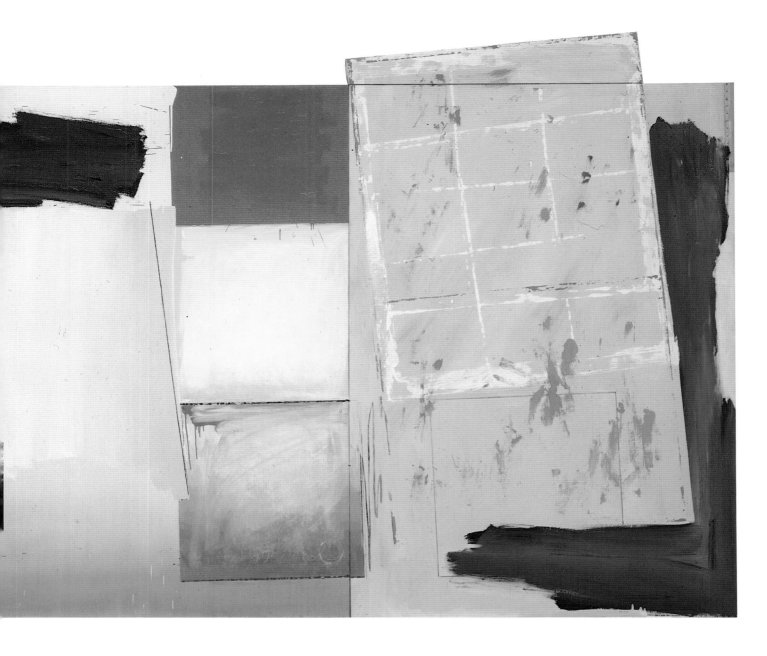

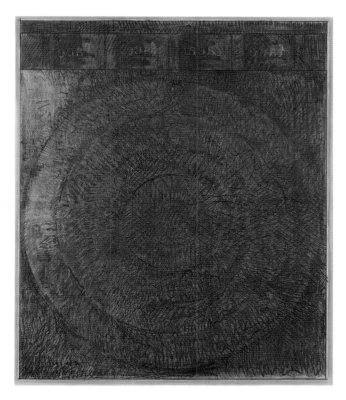

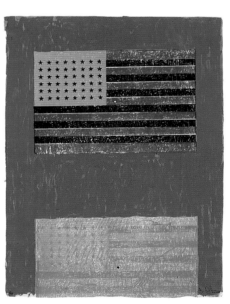

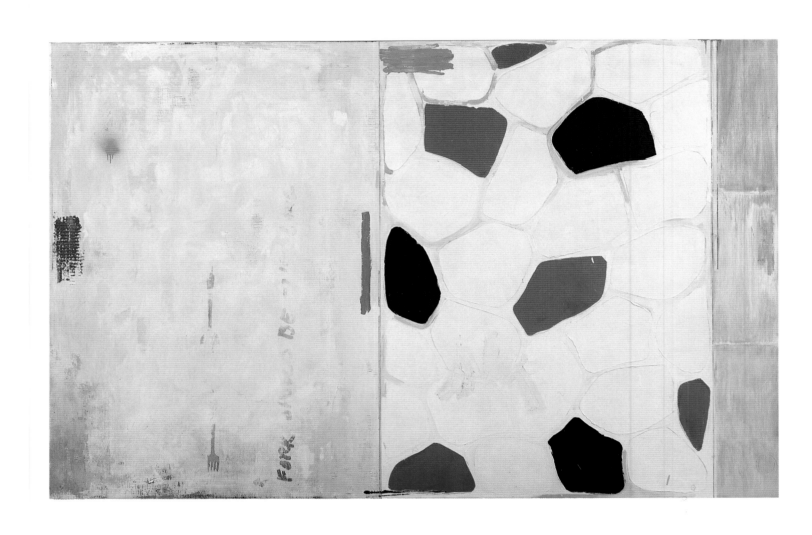

126. **Wall Piece**. 1968
Oil and collage on canvas (three panels)
72 x 110 ¼″ (182.9 x 280 cm)
Collection the artist

127. **Screen Piece 3**. 1968
Oil on canvas
72 x 50″ (182.9 x 127 cm)
Nerman Collection, Leawood, Kansas

128–37. **Figure 0**, **Figure 1**, **Figure 2**,
Figure 3, **Figure 4**, **Figure 5**, **Figure 6**,
Figure 7, **Figure 8**, and **Figure 9**
from the **Black Numeral Series**
Each Los Angeles: Gemini G.E.L., 1968
Lithograph
37 x 30″ (94 x 76.2 cm)
The Museum of Modern Art, New York.
258 John B. Turner Fund

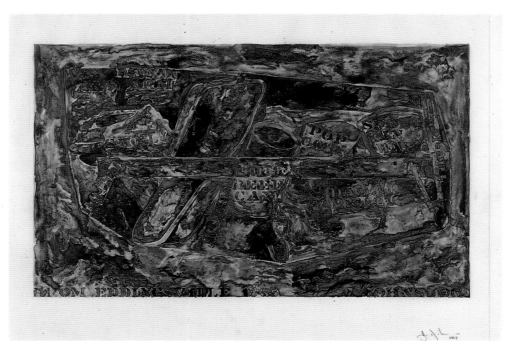

138. **Study According to What**. 1969
Graphite pencil, graphite wash, and
tempera on paper
34 ¾ x 26″ (88.3 x 66.1 cm)
The Baltimore Museum of Art: Thomas
E. Benesch Memorial Collection, 1970

139. **From Eddingsville**. 1969
Ink on plastic
18 ¾ x 28 ¾″ (47.6 x 73 cm)
Private collection

140. **Flag**. 1969
Graphite pencil and graphite wash on paper
25 ¼ x 20 ½″ (64.1 x 52.1 cm)
Private collection

141. **Scott Fagan Record**. 1969
Ink on plastic
17 ⅞ x 18″ (45.4 x 45.7 cm)
Collection David Whitney

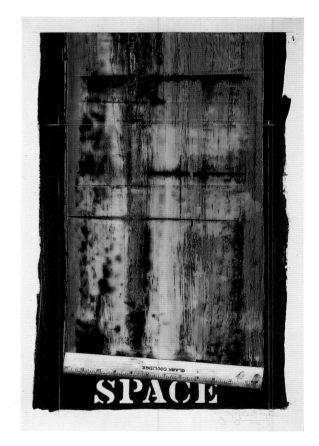

142. **Untitled, Second State**
West Islip, N.Y.: Universal Limited
Art Editions, 1969
Aquatint, etching, and photogravure
41 7/16 x 27 15/16″ (105.2 x 71 cm)
The Museum of Modern Art, New York.
Gift of the Celeste and Armand Bartos
Foundation

143. **Space**. 1970
Ink wash and screenprint on plastic
28 x 18 ½″ (71.1 x 47 cm)

Courtesy Anthony d'Offay Gallery, London

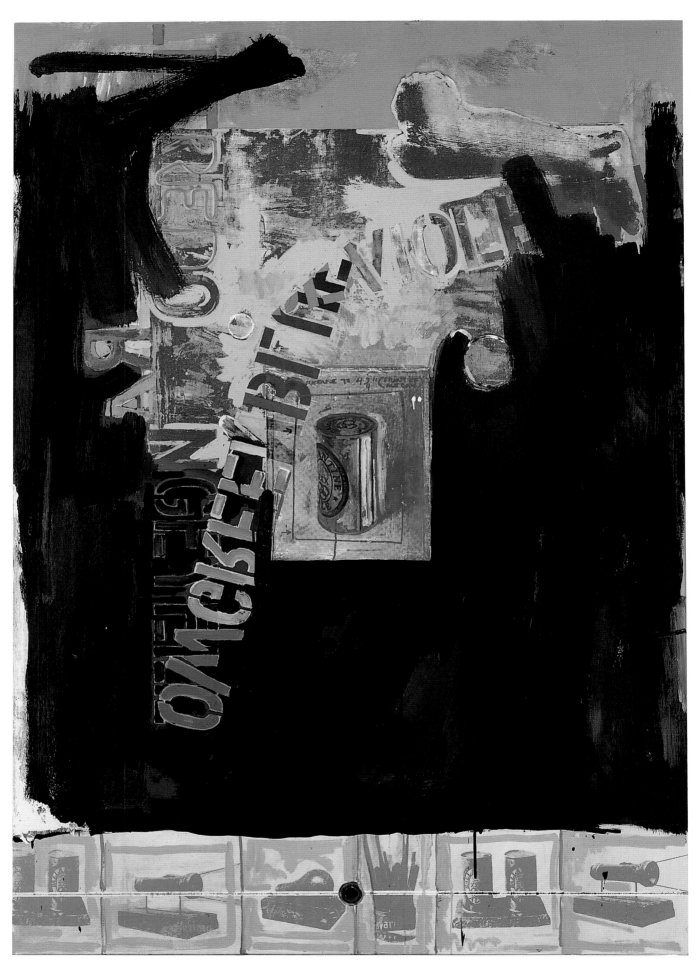

144. Decoy. 1971
Oil on canvas with brass grommet
72 x 50″ (182.9 x 127 cm)
Collection Sally Ganz, New York

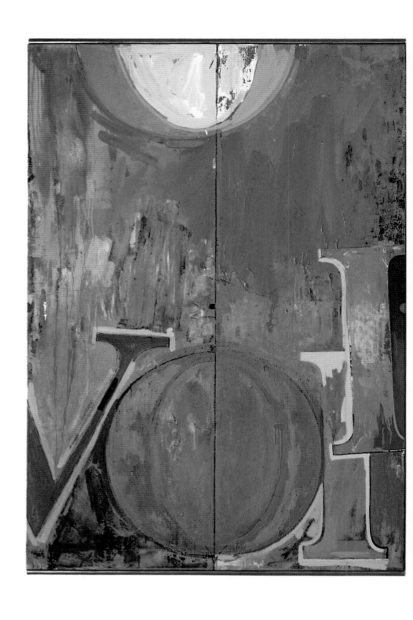

145. **Voice 2**. 1968–71
Oil and collage on canvas (three panels)
Overall: 6′ x 13′ 6″ (182.9 x 411.4 cm);
each panel: 72 x 50″ (182.9 x 127 cm);
6″ between each panel
Öffentliche Kunstsammlung Basel,

Kunstmuseum

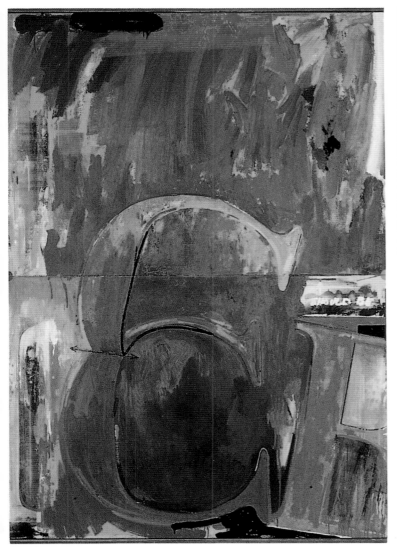
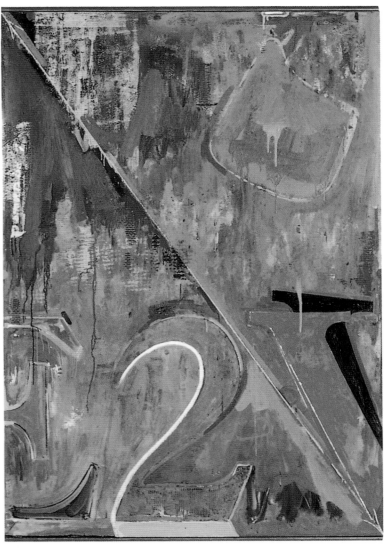

146. **Map (Based on Buckminster
Fuller's Dymaxion Air Ocean World)**.
1967–71
Encaustic and collage on canvas
(twenty-two parts)
16′ 4⅞″ x 32′ 9 ¹¹⁄₁₆″ (500 x 1000 cm)
Museum Ludwig, Cologne

Johns's progress has been recurrently punctuated by big paintings that seem to sum up a certain line of inquiry. By contrast, the large, four-panel *Untitled* of 1972 (plate 153) served as a point of departure. On the right, the first body casts in years, fragmentary, morbidly veristic, and apparently from at least two different bodies, male and female, are mounted on numbered and color-coded battens. In the middle appear two panels of flagstone pattern, one in encaustic and one in oil, in an apparent overlap such that the right half of the right-hand panel is identical with the left half of the left-hand panel; additionally, each panel replicates in 90-degree rotation a portion of the flagstone pattern in *Harlem Light*. (Johns had similarly spun the *Harlem Light* pattern in *Wall Piece*.) Finally the picture's leftmost section is covered by a wholly new motif of colored clusters of hatch marks. The totality is bolder in pictorial address but also more austere and cerebral, in a way that makes *According to What*, a similarly ambitious (and similarly disjunctive) painting of the previous decade, seem both more intimately detailed and more garrulous by contrast.

Two important print series and numerous drawings were to revisit the radically disjunctive components of this *Untitled*. The work's significance is underlined, moreover, by Johns's memory of recoiling from what he felt was the "stronger,…more subjective quality" of its body casts.[1] He continued to treat these casts and other, earlier figurative images in his graphic art; some of his most arresting *Skin* body-prints, in fact, were made in 1973 and 1975. In painting, though, for nearly a decade beginning in 1974, the abstract "cross-hatch" pattern in *Untitled* was to become his exclusive vehicle of expression. He has said he glimpsed such markings on a passing car, and knew immediately (though they only entered his art a year later) that he would use the motif. "It had," he later recalled, "all the qualities that interested me—literalness, repetitiveness, an obsessive quality, order with dumbness and the possibility of complete lack of meaning."[2] One of the things about the pattern that appealed to Johns was its malleability; he felt it could be made to be either highly sophisticated or rough and simple in the manner of street art, though he wanted to stay away from either extreme.[3] The variety of possibilities also allowed, he said, "a large range of shadings

that become emotionally interesting."[4] Crystalline shimmer, fogged uncertainty, cataclysmic fragmentation, anxious agitation, muffled quiescence—all these possibilities and more could and would be wrested from the motif according to the manner of its application.

The cluster of hatch strokes provided only a unit of surface order, which Johns then supplemented with shifting rules of patterning that were sometimes clearly demarcated and at other times only discernible by studied effort. Changes in the direction, color, and material of the hatch marks were orchestrated by gridding the pictorial field into sequences of boxes whose edges met in programmed relations of contrast, continuity, mirror reversal, and recurrence. On the variably scaled keyboard of these "mere traces,"[5] marks that often recall the fingers of a hand, Johns could compose pictures of allover optical dazzle grounded in mathematical orders that eventually reached fuguelike complexity. At their most complex, in the *Usuyuki* series of paintings and prints, these sequences were arranged according to covert topological schemas that implied curving or spiraling movements in space. Titles such as *Scent* and *Usuyuki* (which means "light snow" in Japanese) suggest respectively the sense of elusive but pervasive order and the flurrying quality of evanescence that these strategies could yield. In more splayed and enlarged form, however, the hatchings took on an expressionist energy, and *Corpse and Mirror* used their degraded replication—a "blotted" mirror reversal—to picture order's decay. Johns is rarely discussed as an abstract painter, but cross-hatch paintings such as this one, *Scent*, *Weeping Women*, and several others are among his central works, and constitute a singular chapter in the history of modern abstract art: outside the standard categories of geometric order or gestural expressionism, but partaking of aspects of both. They hold a special interest within the framework of the relationship—usually described as antithetical—between Johns's aesthetic and that of New York School painting of the early 1950s; the allover compositions of Johns's abstract painting of the 1970s would seem to represent in part a measured (in the literal sense of "quantified" or "geometricized") response to Jackson Pollock's poured paintings.

—KV

Chronology

1972

At Houston Street, finishes *Untitled* (plate 153), making it a four-panel work. The two middle panels, which Johns had worked on in 1969, show flagstones. In the leftmost panel Johns introduces the cross-hatching pattern—*slanted lines on the diagonal, a sort of cross-hatching*[1]—that will become the chief motif in his paintings from 1974 until 1982. The source for this new motif is a car painted with cross-hatching that has caught Johns's eye the previous year.

> *I was driving on Long Island when a car came toward me painted this way. I only saw it for a second, but knew immediately that I was going to use it.*[2]

The rightmost panel incorporates seven cast fragments of the human body, attached to wooden bars. Both the individual parts of this image and the image as a whole will serve as the bases for many drawings and prints in Johns's later work.

This year, also at Houston Street, finishes a *Figure 5* and a *Figure 6*, both small scale, in Sculp-metal and collage on canvas, and begun in 1964.

Earlier, Johns had been asked to create a print for an album celebrating Picasso's ninetieth birthday. *I said I wouldn't do it.... And then, of course, I stayed awake all night thinking: if I were to do it, I would do it this way.*[3] This year, using a photograph of Picasso's profile, Johns creates the lithographs *Cups 4 Picasso*, 1972, and, later, *Cup 2 Picasso*, 1973.

Hiroshi Kawanishi and Takeshi Shimada of Simca Print Artists develop an experimental project in screenprinting, working in New York with six young artists. When the project is completed, Kawanishi invites Johns to look at and comment on the results. Kawanishi will recall, "After he went through all the work, he asked me what is our plan from [*sic*] next day. I said we do not have any plan. He said let's make a print together. I almost fainted. Lucky me, I did not. We started work the next day."[4] The first published work is *Screen Piece*.[5]

Johns acquires a house and studio in Saint Martin, in the French West Indies.[6]

January 25–March 19: "1972 Annual Exhibition: Contemporary American Painting," at the Whitney Museum of American Art, New York, includes the larger of the two *Decoy* paintings of 1971.

February 1: First performance of Merce Cunningham's *Landrover*, 1972, at the Brooklyn Academy of Music, Brooklyn, New York, with music by John Cage, Gordon Mumma, and David Tudor (*52/3**), and costume design by Johns.

Merce Cunningham, *TV Rerun*, performance view, 1972. Photograph: Jack Mitchell, courtesy Cunningham Dance Foundation, Inc. © Jack Mitchell

February 2: First performance of Cunningham's *TV Rerun*, 1972, at the Brooklyn Academy of Music, with music by Mumma (*Telepos*) and set and costume design by Johns.

By February 8–February 14: In Los Angeles, working at Gemini G.E.L. Johns will return to Los Angeles by March 25, working at Gemini until March 31; he is back at Gemini again by May 16.[7]

February 21–March 11: "Jasper Johns," an exhibition at the Minami Gallery, Tokyo, includes nineteen lithographs, two screenprints, and six lead reliefs.

April 25: Awarded the Skowhegan School of Painting and Sculpture Medal for Painting, in a ceremony at the Plaza Hotel, New York. At the same event, Claes Oldenburg is awarded the Medal for Sculpture and Robert Rauschenberg the Medal for Graphics.

May 13–June 30: Represented in the "Third International Print Biennale," at the Palazzo Strozzi, Florence.

June 11–October 1: The U.S. Pavilion at the XXXVI Venice Biennale includes the Johns lithographs *Figure 3* and *Figure 9*, from the *Black Numeral Series*, 1968.

June 30–October 8: Documenta V, in Kassel, West Germany, includes the painting *Flag*, 1958, in the "Realismus" section organized by Jean-Christoph Ammann, in the Neue Galerie Schöne Aussicht.

July 6, 9–10: At ULAE, West Islip.[8] This year, Johns will work at ULAE on August 26–27; on November 28, when he will sign *Two Flags* (ULAE# 121) and *Cups 4 Picasso*;[9] and on December 10, when he will work with printers Bill Goldston, John Lund, and James Smith on *Cup 2 Picasso*. This latter image is created for the French magazine *XXe Siècle*, which will reproduce it, including the signature on the plate, in June 1973.[10]

September 14–October 15: "Jasper Johns: Decoy: The Print and the Painting," an exhibition at the Emily Lowe Gallery, Hofstra University, Hempstead, New York, curated by Robert Littman. There is a catalogue with an introduction by Roberta Bernstein.

October 4–November 26: "Johns, Stella, Warhol: Works in Series," the inaugural exhibition of the Art Museum of South Texas, Corpus Christi, curated by David Whitney, includes the paintings *Target with Four Faces*, 1955, *According to What*, 1964, *Watchman*, 1964, *Passage II*, 1966, and *Untitled*, 1972 (still in progress, according to the exhibition catalogue), and the sculptures *Flashlight II* and *III*, both 1958, the Sculp-metal *Light Bulb II* of 1958, *The Critic Smiles*, 1959, two *Light Bulb* bronzes of 1960, *Painted Bronze* (Savarin can), 1960, *Painted Bronze* (ale cans), 1960, *The Critic Sees*, 1964, *High School Days*, 1964, *Subway*, 1965, *Memory Piece (Frank O'Hara)*, 1961–70, and *English Light Bulb*, 1968–70. Johns attends the opening.[11]

October 28–November 25: "Jasper Johns: From the Robert Scull Collection," an exhibition at Castelli Graphics, New York.

1973

In Saint Martin, paints *Flags*, and makes the drawings *Skin I*, *Skin II*, *Untitled (from Untitled Painting)* (LC# D-59), and *Untitled (from Untitled Painting)* (LC# D-111).

At Houston Street, completes the painting *Figure 0*, 1964–73, begun at Riverside Drive, and begins *Scent*,

With Merce Cunningham in Stony Point, N.Y. Photograph: Yasuo Minagawa.

1973–74. *Scent* is the first of Johns's paintings to be conceived as an allover configuration of the cross-hatching motif. Cross-hatches will form the basis of increasingly complex compositions in Johns's paintings, drawings, and prints well into the 1980s.[12]

Contributes *Target* (ULAE# 126) to the portfolio *For Meyer Schapiro*, published by the Committee to Endow a Chair in Honor of Meyer Schapiro at Columbia University.[13]

Moves to a converted farmhouse in Stony Point, in upstate New York, not far from John Cage's house. Here he begins the painting *Two Flags*, 1973–77.

> *John Cage was living up there. He called me one day to say that the person he rented his house from had another little house for sale and was I interested in it. I took it. Then I started spending time there.*[14]

Mark Lancaster becomes Johns's assistant, and will work for him until the summer of 1985.

[January]: Blackwood Productions completes the film *Decoy*, narrated by Barbara Rose, which documents Johns working on the *Decoy* lithograph at ULAE in 1971.[15]

January 10–March 18: "1973 Biennial Exhibition: Contemporary American Art," an exhibition at the Whitney Museum of American Art, includes Johns's *Untitled*, 1972.

In a review of the show, Thomas B. Hess discusses the painting: "Into this metaphorical scaffolding, Johns has slotted autobiographical elements—analyses of his studio practices, glimpses of Harlem and Long Island that have haunted him, bits and pieces of four or five friends. He seems concerned with preserving memories and re-evoking lost experiences."[16]

With Judith Goldman at ULAE, West Islip, N.Y., January 26, 1973.
Photograph: Hans Namuth. © Hans Namuth 1990.

January 25: At ULAE, works on *Cup 2 Picasso*.[17]
This year Johns will also be at ULAE on June 21 and
28, working on the lithographs *Painting with a Ball*,
1972–73, and *Decoy II*.[18]

February 18–21: Tatyana Grosman visits Johns in
Saint Martin.[19]

March 4: Writes to Leo Castelli, probably from Saint
Martin, announcing his intention to visit New York
to attend a Merce Cunningham performance.[20]

May: A photograph showing a Mexican barber
painting a tree in a manner similar to Johns's cross-
hatchings is published in the magazine *National
Geographic*. Johns will later name a painting after
this image: *The Barber's Tree*, 1975.[21]

By May 3: In Saint Martin, where he makes the draw-
ing *Untitled* (LC# D-103).[22]

May 16: Is elected a member of the National Institute
of Arts and Letters. The ceremony takes place in
the Academy Auditorium, New York. Exhibitions of
works by Johns and other newly elected members are
held for the occasion.

May 25–July 22: "American Drawings 1963–1973,"
at the Whitney Museum of American Art, includes
Johns's drawings *Wilderness II*, 1963, *Target with Four
Faces*, 1968, and *Wall Piece II*, 1969.

By October 4–October 18: In Los Angeles, working
at Gemini G.E.L. on the lithograph *Four Panels from
Untitled 1972*, 1973–74.[23] Beginning by November 30,
Johns will also work at Gemini until December 3.[24]

October 18: The Taxi Rank and File Coalition forms
picket lines in front of the Parke Bernet auction
house to demonstrate against taxi-fleet owner and
art collector Robert Scull, who is auctioning Johns's
painting *Target*, 1961, and other works. They hold
placards displaying the work's estimated price. In
the same auction, *Double White Map*, 1965, sells
for $240,000, setting a record for the price paid for
an artwork by a living American artist.

Early November: To Paris, for performances of
the Merce Cunningham Dance Company. While
there, meets Samuel Beckett (through Véra Lindsay),
and proposes the idea, discussed with Lindsay
in 1972, of a collaborative project using an unpub-
lished text.

> *I told him I wanted to illustrate something new.
> He looked horrified. "A new work?" he asked me.
> "You mean you want me to write another book?"
> I said, "Don't you have some unpublished fragments,
> just some words or phrases?" At that time I was
> thinking I'd use his words inside the image, phrases
> included within the picture. "Yes," he said, "I have
> something like that but they're in French." I told him
> I don't read French. He agreed to translate them
> into English. Only later did I learn what an arduous
> process translation is for Beckett—he makes some-
> thing altogether new when he translates.*[25]

November 6: First performance of Cunningham's
Un Jour ou deux, 1973, at the Ballet de l'Opéra de
Paris, Salle Garnier, Paris, with music by John Cage
(*Etcetera*) and set and costume design by Johns
assisted by Mark Lancaster (grisaille costumes and
translucent curtains, using the full depth of the stage).

At East Houston Street, New York, June 1973. Photograph: Nancy Crampton.

1974

In Stony Point, paints *Target* (LC# 250), makes the drawings *Ale Cans I, Ale Cans II,* and *Ale Cans III,* and begins the drawing *Ale Cans IV,* 1974–75.

At Houston Street, finishes painting *Scent,* 1973–74.

During the year, also paints a small *Target* (LC# 240) and the first *Corpse and Mirror.*[26]

During a long stay in Saint Martin, begins to receive Samuel Beckett's English versions of the five texts later included in their book.

> *Finally, [Beckett] sent me two or three beautifully polished pieces; they were finished works and not fragments at all. Then I coaxed another one out of him. In the end he sent me five pieces. I decided to print both the French and the English in order to make the book longer and so that people who know both languages could compare the texts. I did etchings of the numerals and derived the other images from two patterns I've been working with in the last few years—a wall of flagstones and slanted lines on the diagonal, a sort of cross-hatching.*[27]

During 1974 and 1975, Johns will go to France several times, for stays of ten days to two weeks, to work

Merce Cunningham, *Un Jour ou deux,* performance view, November 1973. Photograph: © François Hers/VIVA, courtesy Cunningham Dance Foundation, Inc.

on the etchings and book design for the Beckett collaboration.[28] During these visits he meets Beckett at least three or four times.[29]

In Paris, Johns works at the print workshop Atelier Crommelynck, which is run by printer Aldo Crommelynck. It is at Crommelynck's that he sees Picasso's etching *Weeping Woman,* 1937, after which

With Samuel Beckett. Photograph: Robert Doisneau. © Robert Doisneau/Rapho.

he will name a painting of 1975, *Weeping Women*. Nearly two decades later, asked about the origin of the "shroudlike effect" in recent work, Johns will say, *That started in some untitled etchings I did in Paris, and then appeared again in* Perilous Night [1982]. *I may have been triggered by a print of Picasso's that hung in Aldo Crommelynck's room, where we often had lunch—a print of a weeping woman with a handkerchief. In her hand? Between her teeth? Such things are represented, but they're thin somehow. They are… like collage, because they have no great depth.*[30]

Contributes *M.D.*, a die-cut stencil, to a portfolio of seven prints commemorating collaborations with the Merce Cunningham Dance Company to benefit the Cunningham Dance Foundation. The other contributors are John Cage, Robert Morris, Bruce Nauman, Robert Rauschenberg, Frank Stella, and Andy Warhol.

By February 15–February 18: In Los Angeles, working at Gemini G.E.L. This year Johns will return to Gemini in April, to work on *Four Panels from Untitled 1972*, and in June (he is back in Los Angeles by June 3),[31] when *Four Panels from Untitled 1972* will be completed.[32]

March: "New Series of Lithographs by Jasper Johns," an exhibition at Gemini G.E.L.

April 6–June 16: "American Pop Art," an exhibition at the Whitney Museum of American Art, includes nine paintings by Johns: *Tango*, 1955, *Target with Four Faces*, 1955, *Target with Plaster Casts*, 1955, *Gray Flag*, 1957, *Alley Oop*, 1958, *Three Flags*, 1958, *White Numbers*, 1959, *Studio II*, 1966, and *Harlem Light*, 1967.

September: In Paris,[33] where he visits "*Cézanne dans les Musées Nationaux*," an exhibition at the Orangerie des Tuileries (July 19–October 14).

By September 7: In Oxford, England, for the opening of "Jasper Johns Drawings," an exhibition at the Museum of Modern Art (September 7–October 13).[34] Organized by the Arts Council of Great Britain, the show includes 111 drawings dating from 1954 to 1973. Over the next six months, it will travel within England.[35] There is a catalogue with a preface by Robin Campbell and Norbert Lynton.

September 21–October 5: "Jasper Johns: Four Panel Prints," at Castelli Graphics.

November 20–December 29: "Poets of the Cities: New York and San Francisco, 1950–1965," an exhibition directed by Neil A. Chassman at the Dallas Museum of Fine Arts, Dallas, Texas, includes the paintings *Flag above White with Collage*, 1955,

With Aldo Crommelynck, Paris, 1975. Photograph: Robert Doisneau. © Robert Doisneau/Rapho.

Painting with Ruler and "Gray", 1960, *Map*, 1961, and *Land's End*, 1963, and the sculpture *Painted Bronze* (ale cans), 1960. Over the next six months, the show will travel to California and Connecticut.[36]

1975

In Stony Point, completes the paintings *Corpse and Mirror II*, 1974–75, *Untitled* (LC# 244), *The Barber's Tree*, *The Dutch Wives*, and *Weeping Women*. (From 1975 until 1984, virtually all of Johns's paintings are produced in Stony Point.) He also completes the drawings *Ale Cans IV*, 1974–75, and *Untitled* (LC# D-81).

In Saint Martin, makes the drawings *Untitled*, 1974–75 (LC# D-72), *Ale Cans V*, and *Ale Cans VI*. *Corpse*, 1974–75 (plate 161), begun here, will be finished in Stony Point.

February 14: First public performance of Merce Cunningham's *Westbeth*, 1974, at the Merce Cunningham Studio in Manhattan, with music by John Cage and costume design by Mark Lancaster from a design by Johns (for the earlier Cunningham piece *Un Jour ou deux*). Initially conceived for video, *Westbeth* has been taped at the Merce Cunningham Studio in the fall of 1974, under the direction of Charles Atlas and Cunningham.

March 6–19: In Los Angeles, at Gemini G.E.L., Johns completes work on the lithograph *Four Panels from Untitled 1972 (Grays and Black)*.[37] He is back in Los Angeles by May 13, working at Gemini until May 16.[38]

[Late June]: In Paris, probably working at Atelier Crommelynck.[39]

September 1–2: In West Islip, working at ULAE.[40]

1976

In Stony Point, paints *End Paper* and begins the third and largest painting titled *Corpse and Mirror*, 1976–77. He also completes the drawings *Corpse and Mirror*, 1975–76 (LC# D-73), and *Untitled (From Untitled 1972)* (LC# D-83).

In Saint Martin, finishes another *Corpse and Mirror* drawing, 1975–76 (LC# D-75).

In Paris, makes the drawing *Figure 4 (Study for Figure 4 for "Fizzles")*.

Petersburg Press publishes *Foirades/Fizzles*, a book of five texts by Samuel Beckett and thirty-three etchings by Johns, printed by Atelier Crommelynck. The book is protected in a lithograph-lined box.[41]

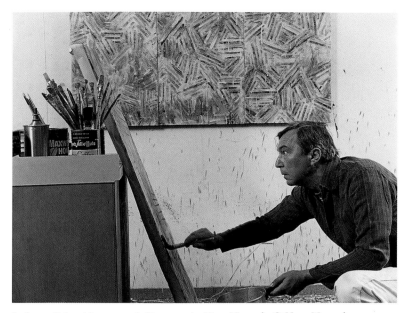

In Stony Point, May 11, 1976. Photograph: Hans Namuth. © Hans Namuth 1990.

Visits Matthias Grünewald's Isenheim Altarpiece, c. 1512–16, in Colmar, France, near Strasbourg, for the first time.[42]

> *It's very impressive, very big, it seems to explode through the space. It has a quality that is very glamorous, sort of like a movie.*[43]

January 21–March 9: "Drawing Now: 1955–1975," at The Museum of Modern Art, curated by Bernice Rose, includes fourteen Johns drawings from 1958 to 1975. Over the next year and a half, the show will travel (though not all works are shown in all venues) to Switzerland, West Germany, Austria, Norway, and Israel.[44]

January 23–March 21: "Twentieth Century American Drawings: Three Avant-Garde Generations," organized by Diane Waldman at the Solomon R. Guggenheim Museum, New York, includes twelve Johns drawings dating from 1955 to 1973.

January 24–February 14: "Jasper Johns," an exhibition at the Leo Castelli Gallery, includes seven paintings: *Scent*, 1973–74, *Corpse and Mirror*, 1974, *Corpse and Mirror II*, 1974–75, *The Barber's Tree*, 1975, *The Dutch Wives*, 1975, *Weeping Women*, 1975, and *Untitled*, 1975 (LC# 244). This is Johns's last exhibition at 4 East 77th Street, where his new work has been shown since 1958.

February 12: Death of Maurice Grosman, cofounder of ULAE.

March: Johns's painting *Untitled*, 1975 (LC# 244), is reproduced on the cover of *Art in America*.

At Simca Print Artists, New York, January 28, 1976. Photograph: Hans Namuth. © Hans Namuth 1990.

March 13–May 9: "Seventy-Second American Exhibition," at the Art Institute of Chicago, juried by Henry Hopkins, Ellen Johnson, and Thomas M. Messer, includes the paintings *Scent*, 1973–74, *Corpse and Mirror II*, 1974–75, *The Dutch Wives*, 1975, and *Weeping Women*, 1975.

March 16–September 26: "200 Years of American Sculpture," an exhibition at the Whitney Museum of American Art, includes *Painted Bronze*, 1960 (Savarin can), and *Painted Bronze*, 1960 (1964 cast).

April 30: Writes to Carolyn Lanchner, curator at The Museum of Modern Art, confirming that the Museum's *Flag* painting was his first *Flag* painting, and suggesting 1955 as the correct date, although the painting was probably begun in 1954. Johns goes on to note that the painting was severely damaged during a party at his studio. Newspapers bearing a later date were used in the repairs made at the time.[45]

May 13–July 6: "Jasper Johns: MATRIX 20," an exhibition at the Wadsworth Atheneum, Hartford,

Connecticut, includes twelve prints. There is a catalogue with an essay by Richard S. Field.

By May 18–May 20: In Los Angeles, working at Gemini G.E.L. This year Johns will return to Los Angeles by July 21, working at Gemini until July 30; by October 4, working at Gemini until October 11; and by November 23, working at Gemini until December 2.[46]

Between June 16 and 21: Visits the Basel International Art Fair.

> *[I] found the fair very amusing. At one time, I witnessed a gallery owner fetching one of my works from his storage and showing it to a visitor. I walked on immediately, because I didn't want to know how the business continued. Although I did have fun, I believe that one visit to a fair is enough for one artist's lifetime.*[47]

1977

In Stony Point, finishes painting *Corpse and Mirror*, 1976–77, and *Two Flags*, 1973–77.

Joan Mondale, wife of the vice-president of the United States, invites Johns and other artists to offer suggestions regarding federal arts policy. *They should use the lottery system. If we, the society, knew what we wanted, then we could pay for it, subsidize it. But we don't.*[48]

Acquires Marcel Duchamp's *Female Fig Leaf*, 1950 (galvanized plaster, formerly Mary and William Sisler Collection).

January: "Jasper Johns: 6 Lithographs (after 'Untitled 1975')," 1976," an exhibition at Gemini G.E.L. There is a catalogue with an essay by Barbara Rose.

January–February: Makes the drawings *Target with Four Faces*, *0–9*, *Three Flags*, *Two Flags*, *The Critic Smiles*, *Land's End*, *Periscope (Hart Crane)*, and *Savarin*, all in ink on plastic.

April 26: Receives the Skowhegan Medal for Graphics, awarded by the Skowhegan School of Painting and Sculpture. The medal is presented by architect Philip Johnson at Skowhegan's 31st Awards Dinner, which is held at the Plaza Hotel, New York.

June 1–September 19: "Paris—New York," an exhibition at the Centre National d'Art et de Culture Georges Pompidou, Paris, includes *Target with Plaster Casts*, 1955, *Flag*, 1958, and a *Painted Bronze* of 1960 (probably the Savarin can).

June 24–October 2: Documenta VI, in the Museum Fridericianum, Kassel, includes the paintings *Corpse and Mirror II*, 1974–75, *End Paper*, 1976, *Corpse and Mirror*, 1976–77, and six drawings dating from 1960 to 1977.

By July 2: In Saint Martin, where he makes *Periscope*, 1977 (LC# D-122).

By September 6–September 9: In Los Angeles, working at Gemini G.E.L.[49]

October 7, 1977–January 2, 1978: "Cézanne: The Late Work," an exhibition at The Museum of Modern Art. Visiting the show, Johns sees Cézanne's *Bathers*, 1900–1906, a painting in the collection of the National Gallery of Art, London.

Before the end of the year, Johns will use a postcard of *Bathers* to make the drawing *Tracing* (LC# D-163), his first tracing from another artist's work.[50] In 1978 he will make another *Tracing* (plate 171) from Jacques Villon's 1930 etching of Marcel Duchamp's *Bride*, 1912.

October 10–November 20: "Foirades/Fizzles (Five Stories by Samuel Beckett, Thirty-Three Etchings by Jasper Johns)," an exhibition at the Whitney Museum of American Art.

October 15–November 12: "Jasper Johns: Prints," an exhibition at Castelli Graphics.

October 17, 1977–January 22, 1978: "Jasper Johns," an exhibition at the Whitney Museum of American Art, curated by David Whitney, includes 165 paintings, sculptures, drawings, and prints. Over the next year, the exhibition will travel to West Germany, France, England, Japan, and San Francisco.[51] There is a catalogue with an essay by the novelist Michael Crichton.

> The museum asked me what I felt about the catalogue, and I said I would like someone who was a writer rather than an art critic. People who are used to studying my work have such a layered kind of knowledge about it. There are so many references they make that I thought it might be more interesting to have someone outside that kind of training, or business, to see if such a person could see anything in my work.[52]

October 24: *Newsweek* magazine features a photograph of Johns on the cover. The caption reads, "Jasper Johns: Super Artist."

November 15, 1977–January 7, 1978: "Jasper Johns Screenprints," an exhibition at Brooke Alexander, Inc., New York. There is a catalogue with an introduction

by Richard S. Field. Over the next three and a half years the exhibition will travel throughout the U.S.[53]

December 4, 1977–January 29, 1978: "An Artist Collects," an exhibition of drawings in Johns's collection, at the Columbia Museum of Art, Columbia, South Carolina. The exhibition will travel within South Carolina.[54]

1978

Completes two *Numbers* reliefs, both dated 1963–78 and both based on casts of the painting *Numbers*, 1963. They are mostly done at the Modern Art Foundry, Long Island City, New York.[55]

In Stony Point, paints *Céline* and finishes the first *Usuyuki* paintings (plates 167 and 168), which were begun in 1977.

> I think it has to do with a Japanese play or novel, and the character, the heroine of it, that is her name. And I think it was suggested that it's a kind of sentimental story that has to do with the—what do you call it?—the fleeting quality of beauty in the world, I believe. At any rate, I read this and the name stuck in my head. And then when, I think, Madame Mukai was here once, and Hiroshi [Kawanishi] was here, and I had just read this, I'd been in St. Martin and read it, and I came back and I had dinner with them one night and I said, "Hiroshi, if I said to you, 'usuyuki,' what would it mean?" And he said, "I think—very poetic—a little snow." So I kept on and made my pictures using that title.[56]

Creates his first monotypes, working at ULAE and using the Savarin-can image (ULAE# S16–S19).

Katrina Martin makes a film, *Silkscreens*, that documents printers from Simca Print Artists working on the print *The Dutch Wives*, for which twenty-seven screens are used. The filming takes five days.[57]

The Venice Biennale exhibition "From Nature to Art, from Art to Nature. Six Stations for Art-nature, The Nature of Art: 1. Great Abstraction/Great Realism" includes *Flag above White*, 1955, and *Double White Map*, 1965.

By February 10–February 11: In Cologne for the opening of the retrospective of his work that opened at the Whitney Museum of American Art the preceding fall and has now traveled to the Kunsthalle Köln.

By March 1: In Los Angeles, working at Gemini G.E.L. This year, Johns will return to Los Angeles and to Gemini by October 10, working there until

In Stony Point, August 25, 1977, working on *Numbers*, 1963–78 (LC# 252). Photograph: Hans Namuth. © Hans Namuth 1990.

October 21, and by November 13, working there until November 19.[58]

March 27–April 25: "Jasper Johns: Prints 1970–1977," an exhibition at the Center for the Arts, Wesleyan University, Middletown, Connecticut. In the accompanying publication, Richard Field catalogues the prints produced by Johns between 1970 and 1977. Over the next year and a half, the show will travel to Massachusetts, Maryland, New Hampshire, California, Ohio, Georgia, Missouri, and Rhode Island.[59]

By April 18–April 20: In Paris for the opening of his traveling retrospective at the Musée national d'art moderne, Centre Georges Pompidou.

By June 22: In London for the opening of his traveling retrospective at the Hayward Gallery.

[c. June 22]: Tells Peter Fuller, *I'm reading [Louis Ferdinand] Céline right now.*[60] It is probably around this time that Johns is working on the painting *Céline* in Stony Point.

> At one point—I don't remember exactly when—I began to read Céline....I was in some odd state of mind and it was the only writing I was able to concentrate on. There was something very special about the relationship between me and it at the time. There were Journey to the End of Night and Death on the Installment Plan and others whose titles I can't think of right now. But those two are the most astonishing. Something hallucinatory about them held my attention. I made my painting, Céline, then.[61]

By July 30–31: In Saint Martin, where he makes at least two drawings titled *Ale Cans* (LC# D-127, LC# D-128, and probably also LC# D-88).

By August 19–22: In Tokyo for the opening of his traveling retrospective at the Seibu Museum of Art. On August 22, Johns is interviewed by Yoshiaki Tono at the Hotel Okura, Tokyo.[62]

September 27: Attends the first performance of Merce Cunningham's *Exchange*, 1978, at the City Center Theater, New York, with music by David Tudor (*Weatherings [Nethograph #1*]*) and set and costume design by Johns.[63] This is Johns's last work as the Cunningham company's artistic advisor. He is not

officially replaced until 1980, when Mark Lancaster takes the appointment.

By October 19: In San Francisco for the opening of his traveling retrospective at the San Francisco Museum of Art.

October 20–November 25: "Jasper Johns: Prints and Drawings," an exhibition at the John Berggruen Gallery, San Francisco.

October 28–November 18: "Group Exhibition: Chamberlain, Johns, Kelly, Lichtenstein, Oldenburg, Rauschenberg, Rosenquist, Warhol," an exhibition at the Leo Castelli Gallery (420 West Broadway), New York.

November: In Saint Martin, where he makes the drawing *Cicada* (LC# D-95).

November 27: In absentia, receives the Mayor's Award of Honor for Arts and Culture, presented by Mayor Edward Koch and Henry Geldzahler at the Temple of Dendur, Metropolitan Museum of Art.

By December 2: In Saint Martin, where he makes the drawing *Untitled (Study for Cicada)* (LC# D-94).

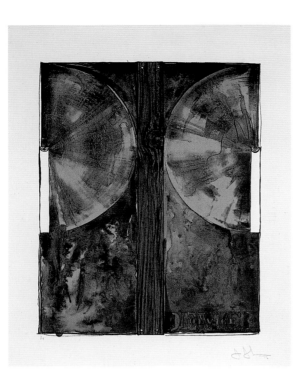

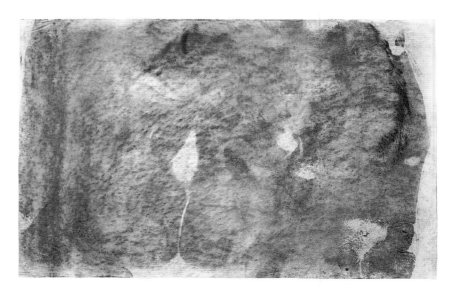

147. **Device Black State**
Los Angeles: Gemini G.E.L., 1972
Lithograph
32 ¼ x 25 ¾″ (81.9 x 65.4 cm)
Collection the artist

148. **Skin I**. 1973
Charcoal on paper
25 ½ x 40 ¼″ (64.8 x 102.2 cm)
Collection the artist

149. **Skin II**. 1973
Charcoal on paper
25 ½ x 40 ¼″ (64.8 x 102.2 cm)
Collection the artist

150. **Skin**. 1975
Charcoal and oil on paper
41 ¾ x 30 ¾″ (106 x 78.1 cm)
Collection Richard Serra and
Clara Weyergraf-Serra

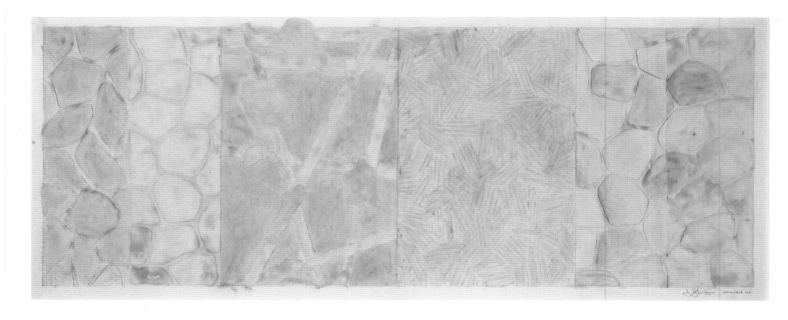

151. **Untitled (from Untitled, 1972).** 1975
Ink on plastic
20 x 42 ½″ (50.8 x 107.9 cm)
The Estate of Frederick R. Weisman,
Los Angeles, Calif.

152. **Untitled (from Untitled, 1972).** 1976
Metallic powder, clear acrylic, graphite
pencil, and collage on paper
15 ½ x 38 ½″ (39.4 x 97.8 cm) sight
Collection Joel and Anne Ehrenkranz

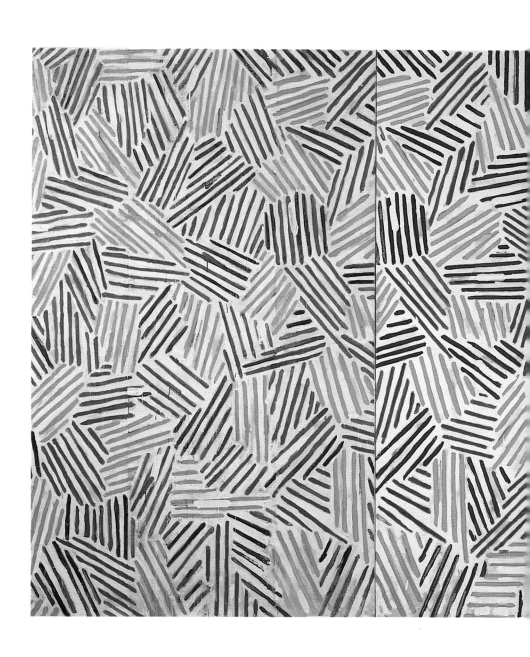

154. **Scent**. 1973–74
Oil and encaustic on canvas (three panels)
6′ x 10′ 6 ¼″ (182.9 x 320.6 cm)
Ludwig Forum für Internationale Kunst, Aachen

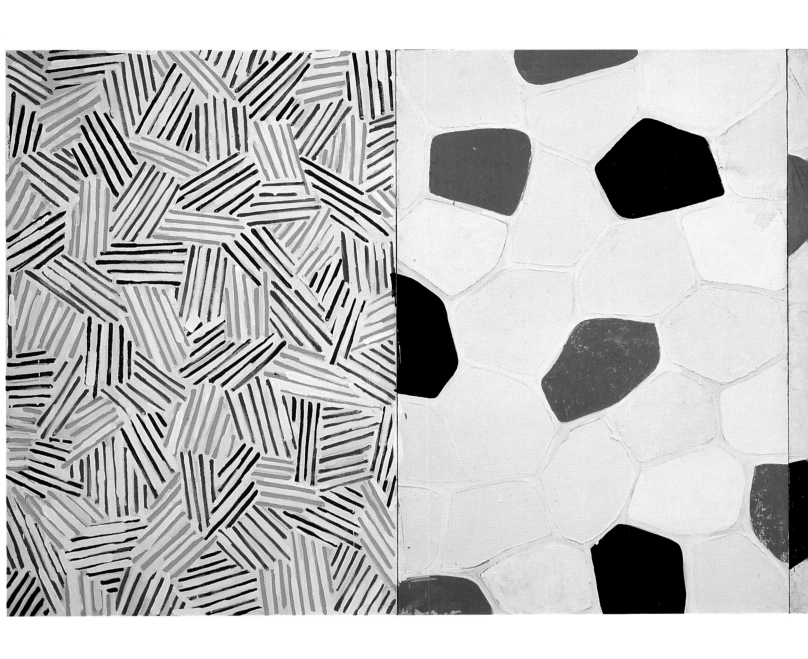

153. **Untitled**. 1972
Oil, encaustic, and collage on canvas with objects
(four panels)
6′ ¹⁄₁₆″ x 16′ 1″ (183 x 490 cm)
Museum Ludwig, Ludwig Donation, Cologne

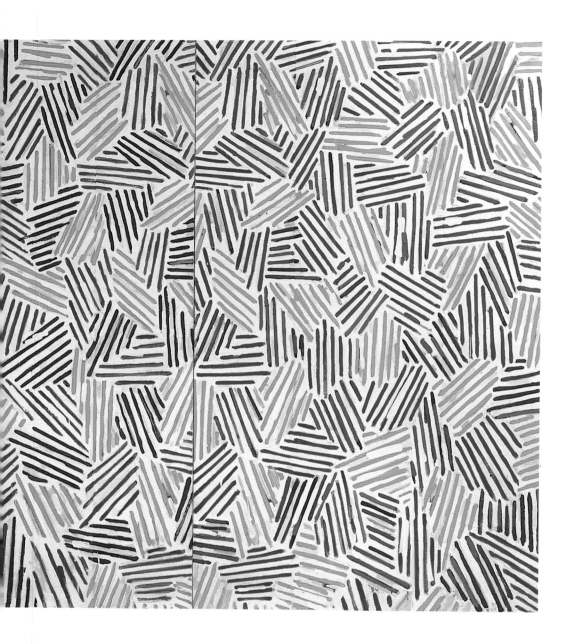

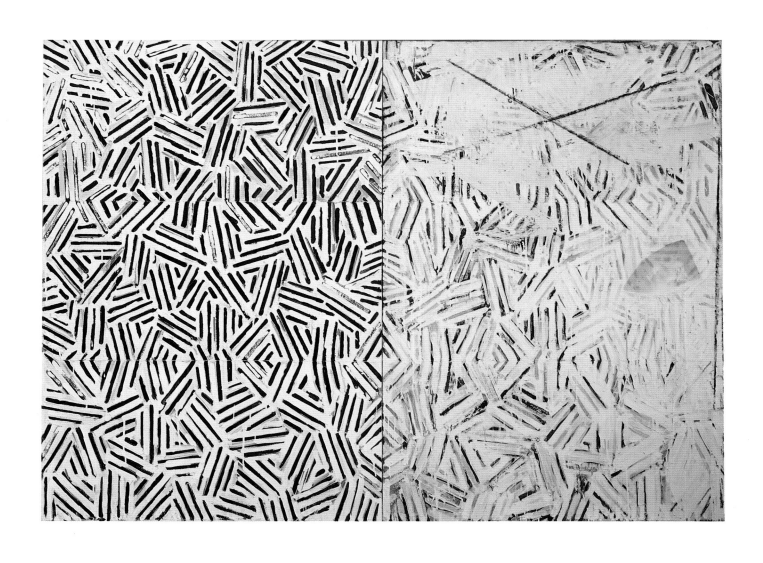

155. **Corpse and Mirror**. 1974
Oil, encaustic, and collage on canvas
(two panels)
50 x 68⅛″ (127 x 173 cm)
Collection Sally Ganz, New York

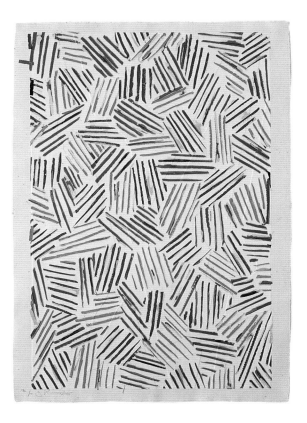

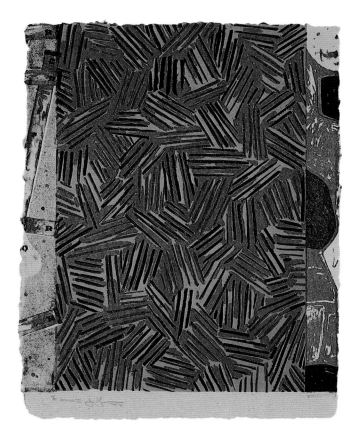

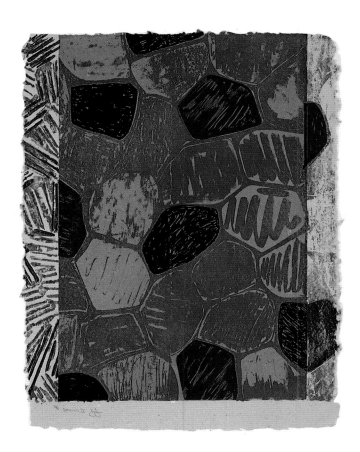

156. **Four Panels from Untitled 1972**
Los Angeles: Gemini G.E.L., 1973–74
Lithograph and embossing on four sheets
Each sheet: c. 41 ½ x 28 ⅜″ (102.8 x 72.1 cm)
The Museum of Modern Art, New York.
Jeanne C. Thayer Fund and Purchase

157. **Four Panels from Untitled 1972 (Grays and Black)**
Los Angeles: Gemini G.E.L., 1973–75
Lithograph and embossing on four sheets
Each sheet: c. 41 x 32″ (104.2 x 81.3 cm)
The Museum of Modern Art, New York.
Jeanne C. Thayer Fund

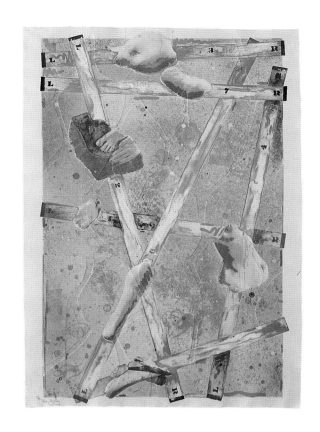

158. **Corpse and Mirror II**. 1974–75
Oil on canvas (four panels)
57 5/8 x 75 1/4″ (146.4 x 191.1 cm)
including painted frame
Collection the artist

159. **The Dutch Wives**. 1975
Encaustic and collage on canvas
(two panels)
51¾ x 71″ (131.4 x 180.3 cm)
Collection the artist

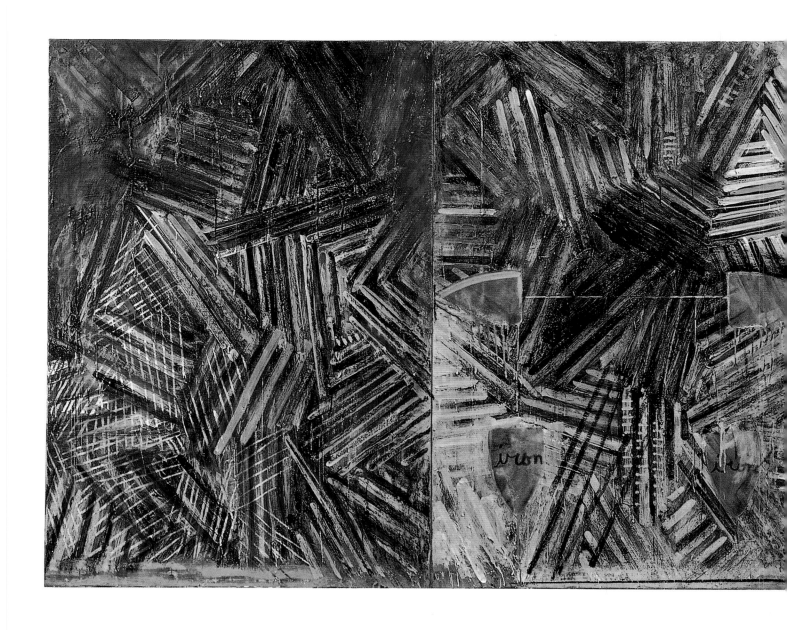

160. **Weeping Women**. 1975
Encaustic and collage on canvas
50 x 102 ¼″ (127 x 259.7 cm)
Collection David Geffen, Los Angeles

161. **Corpse**. 1974–75
Ink, Paintstik, and pastel on paper
42 ½ x 28 ½″ (108 x 72.4 cm)
Collection David Whitney

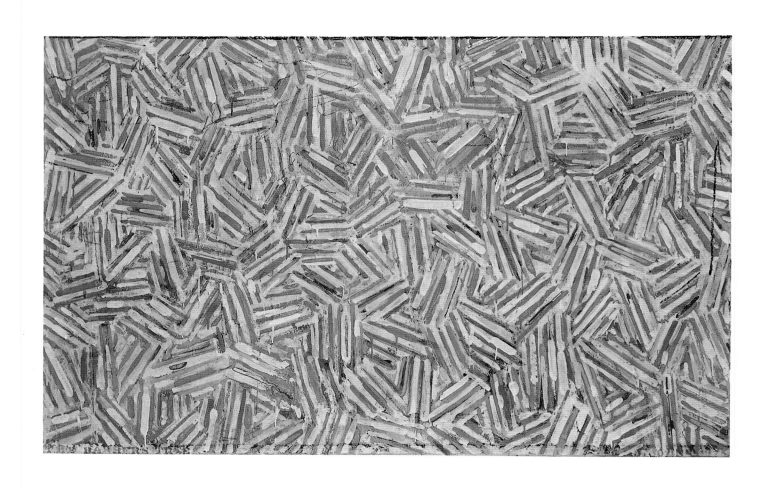

162. **The Barber's Tree**. 1975
Encaustic on canvas
34 ¼ x 54 ¼″ (87 x 137.8 cm)
Ludwig Collection

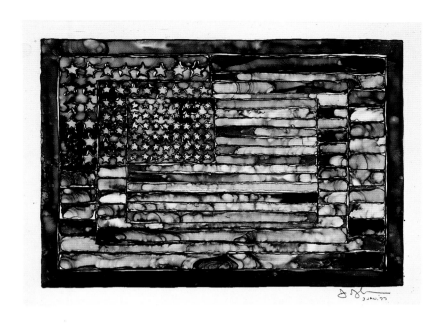

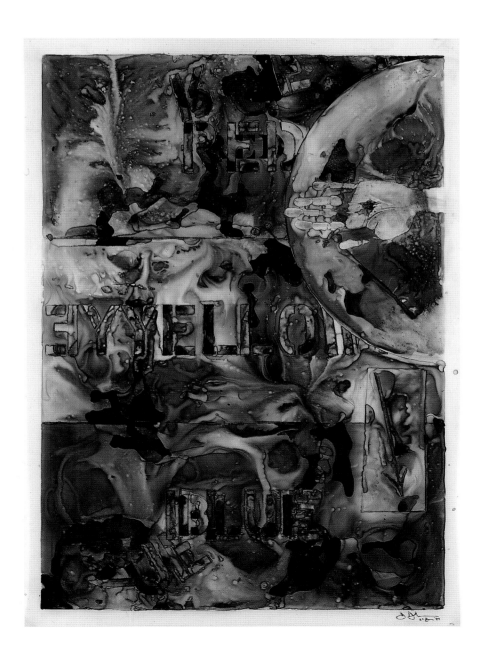

163. **Three Flags**. 1977
Ink on plastic
12 ⅛ x 18 ⅛″ (30.8 x 46 cm)
Private collection, courtesy Janie C. Lee
Master Drawings

164. **Periscope (Hart Crane)**. 1977
Ink on plastic
36 ¼ x 26 ⅛″ (92 x 66.3 cm)
Nerman Collection, Leawood, Kansas

165. **Untitled**. 1977
Ink, watercolor, and crayon on plastic
21 x 14″ (53.3 x 35.5 cm)
Collection Margo H. Leavin, Los Angeles

166. **Savarin**. 1977
Ink on plastic
36 ¼ x 26 ⅛″ (92.1 x 66.4 cm)
The Museum of Modern Art, New York.
Gift of The Lauder Foundation

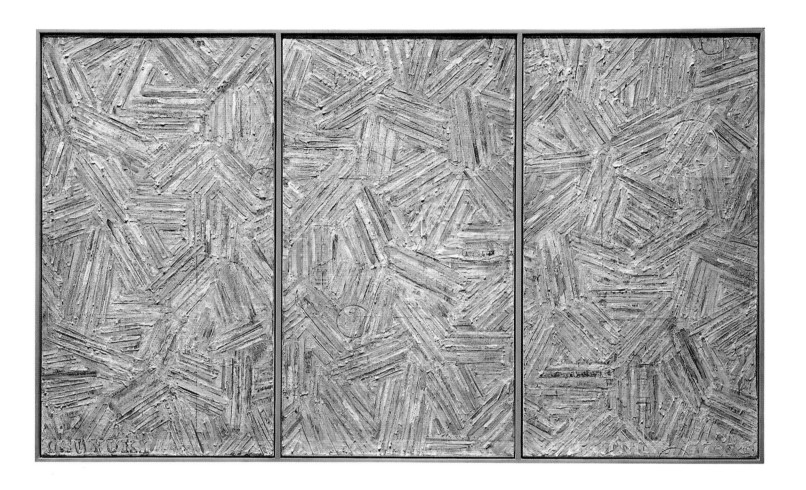

167. **Usuyuki**. 1977–78
Encaustic and collage on canvas
(three panels)
35 ⅛ x 56 ⅝″ (89.2 x 143.8 cm)
including frame
The Cleveland Museum of Art,
Leonard C. Hanna, Jr., Fund

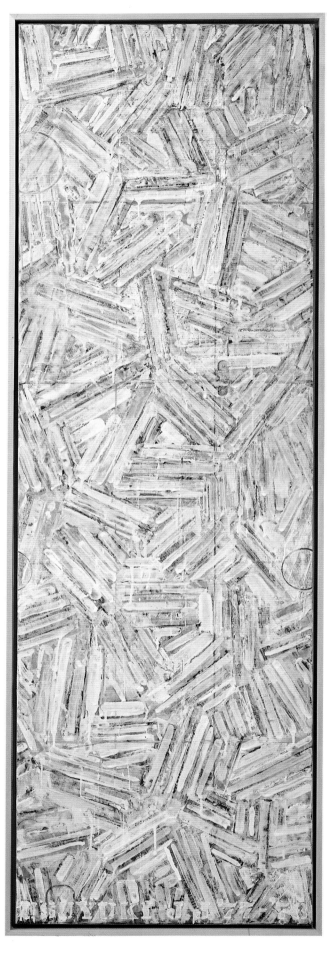

168. **Usuyuki**. 1977–78
Encaustic and collage on canvas
56 ¾ x 18″ (144.1 x 45.7 cm)
296 Collection Kenneth and Judy Dayton

169. **Ale Cans**. 1978
Ink on plastic
17 ¾ x 17 ⅜″ (45 x 44.1 cm)
Robert and Jane Meyerhoff,
Phoenix, Maryland

170. **Untitled**. 1978
Acrylic on paper
43 ¾ x 29″ (111.1 x 73.7 cm)
Collection the artist

171. **Tracing**. 1978
Ink on plastic
23 ½ x 16″ (59.6 x 40.6 cm)
Collection the artist

172. **Savarin 3 (Red)**
West Islip, N.Y.: Universal Limited
Art Editions, 1978
Lithograph
26 1/16 x 20 1/16″ (66.2 x 51 cm)
The Museum of Modern Art, New York.
Gift of Celeste Bartos

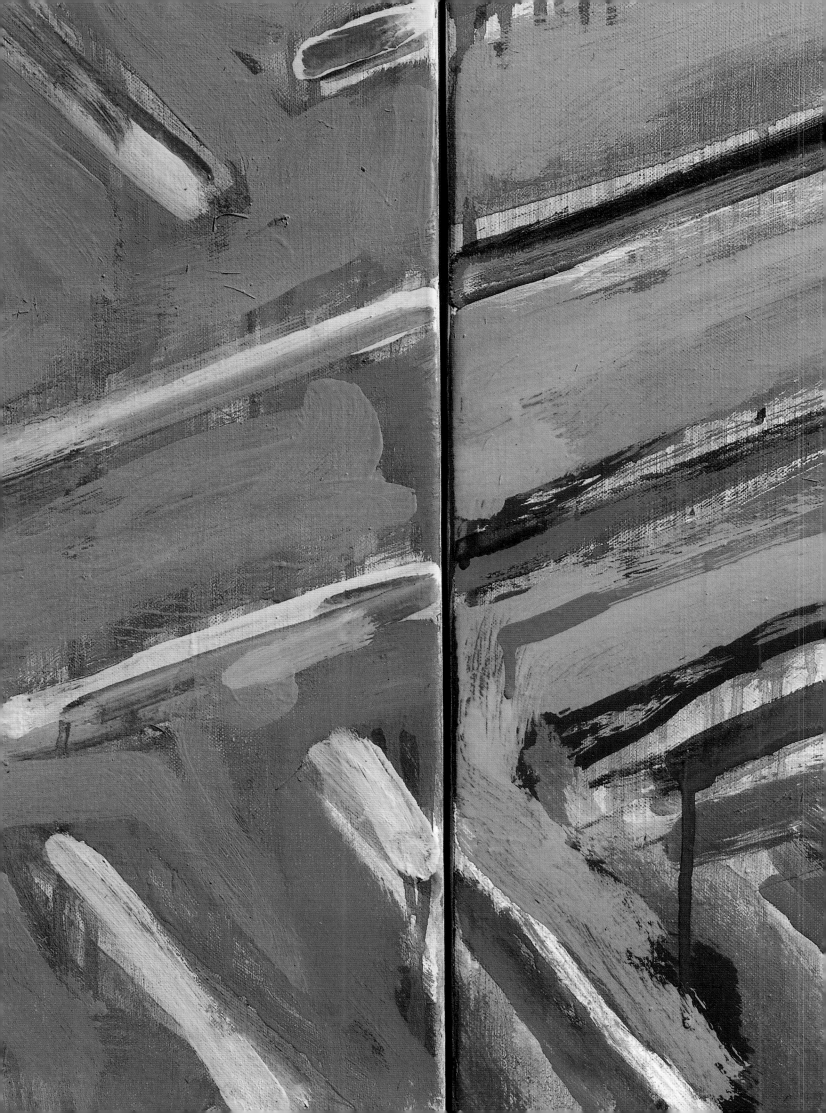

In the years following his 1977–78 traveling retrospective exhibition, Johns painted the last of the cycle of "cross-hatch" abstractions that he had begun in 1972. One has the sense that the motif's kaleidoscopic dynamism is locking up in these paintings, with intensifying rigidity and constriction—just prior (as we now know) to the breakthrough of new image content. That imagery began to return, literally, from the margins: two versions of *Dancers on a Plane* (a punning title that in part refers to the much traveled Merce Cunningham troupe, for which Johns served as artistic advisor) were framed with a frieze of forks, knives, and spoons, the first objects to attach themselves to Johns's paintings in seven years. Speaking of earlier drawings, the artist has said that this cutlery bore associations for him of "cutting, measuring, mixing, blending, consuming—creation and destruction moderated by ritualized manners."[1]

To the painted bronze frame of the second *Dancers on a Plane*, at the lower and upper center respectively, Johns added highly stylized three-dimensional signs for testicles and for a vulval opening penetrated by a phallus. These gave the painting's strong, vertical central axis, and the concentric diamond shapes formed by the mirroring along it, a new set of associations. With the larger, blunter hatching and turbulently nocturnal palette of this second *Dancers*, they also prefigured the three *Tantric Detail* canvases, which featured highly charged symbolism— a skull and genitalia—drawn from a seventeenth-century Nepalese image of life and death forces entwined in ritual copulation. The cartoonlike hairy testicles and dotted lines in these works marked not just a return to images after years of abstraction, but the first prominent instance of independent rendering—as opposed to directly transposing a found form or schema by tracing, casting, or printing—in Johns's painting.

Johns has told Michael Crichton that when he painted the first *Dancers on a Plane* he was already looking at tantric art, "thinking about issues like life and death, whether I could even survive. I was in a very gloomy mood at the time I did the picture, and I tried to make it in a stoic or heroic mood. The picture is almost uninflected in its symmetry. There is no real freedom. The picture had to be executed in very strict fashion or it would have lost its meaning."[2] In the *Tantric Detail* images and in works of the same

period referring to the cicada (a cyclically appearing locust whose complex life cycle involves seventeen years spent underground, punctuated only by a brief mating-and-dying season in the open air), the artist's familiar concerns with patterns of recurrence and transmutation through time took on a more overtly Romantic cast, as meditations on the dialogue of death and regeneration.

Johns developed the cicada theme in 1979, a year when this insect emerged, in the eastern United States, for its short dance of procreation and death. One aspect of the bug's peculiar ontogeny that seems to have attracted him was the way it split the shell of its larval body to emerge in the final, winged form of its existence. This aspect of a "second self" contained within a previous form may have resonated with Johns's interest in perceptual illusions, where two wholly opposite meanings are contained in one shape. The cicada's transformations suggested still another metaphor for the interchange of life within death and vice versa: opposite forces at work in any given moment, in any given person or organism, one or the other visible depending on one's outlook, and neither separable from, or reconcilable with, the other. On a formal level, that interest in fused dualisms is evident in the doodles at the bottom of the *Cicada* watercolor drawing, where Johns experiments with simple schemes for the eye and nose cavities of a skull, drawn from sources as diverse as the caricatures in Edgar Degas's sketchbooks and the stenciled layouts of warning signs.[3] The results, in the *Tantric Detail* canvases, yield a death's head whose eye holes and heart-shaped nasal openings are made to rhyme formally with the procreative testicles above.

References to another painter haunted by such thoughts of the dance of life and death, Edvard Munch, also began to appear in Johns's work in the late 1970s. From a late, near-death self-portrait of the Norwegian master, Johns took the title *Between the Clock and the Bed* for two large tripartite canvases painted in 1981. (The third and final one in the series would be added in 1982–83.) In contrast to the tightly swarming, kaleidoscopic structure of the *Dancers on a Plane* pictures, the hatching pattern here assumes its most open, monumentally expanded scale, just before ending its decade of dominance in the artist's concerns.

—*KV*

Chronology

At Gemini G.E.L., Los Angeles, 1979. Photograph: Sidney B. Felsen. © 1979.

1979

In Stony Point, paints *Usuyuki* (LC# 285), *Untitled* (LC# 257), *Untitled (E. G. Seidensticker)*, the first *Dancers on a Plane*, and three oils titled *Cicada*. Also makes the drawing *Study for Cicada* (LC# D-212).

> *The Cicada title has to do with the image of something bursting through its skin, which is what they do. You have all those shells where the back splits and they've emerged. And basically that kind of splitting form is what I tried to suggest.*[1]

By February 16–February 18: In Saint Martin, where he makes two *0 through 9* drawings (LC# D-129 and LC# D-131).

February 23–April 8: "36th Biennial Exhibition of Contemporary American Painting," at the Corcoran Gallery of Art, Washington, D.C., includes *Corpse*

and Mirror, 1974, *The Dutch Wives*, 1975, *Weeping Women*, 1975, *End Paper*, 1976, *Céline*, 1978, and one of the *Usuyuki* paintings of 1977–78 (LC# 254).

March–April: In Stony Point, makes the drawings *Target with Four Faces* and *Usuyuki* (LC# D-92).

March 8–April 6: "Jasper Johns: Prints, 1965–1978," an exhibition organized by John G. Powers and Ron G. Williams at Colorado State University, Fort Collins, Colorado, includes forty-one prints.

April: Accompanied by Teeny Duchamp and others, visits Matthias Grünewald's Isenheim Altarpiece in Colmar, France, for the second time.[2]

April 7–June 2: "Jasper Johns Working Proofs," an exhibition at the Kunstmuseum Basel, Basel. Over the next two years, the exhibition will travel in West Germany, Denmark, Sweden, Spain, The Netherlands, and England.[3] There is a catalogue by Christian Geelhaar.

By May 3–May 7: In Los Angeles, working at Gemini G.E.L. This year Johns will be working at Gemini by May 29, until June 1; by September 10, until September 18; by October 26, until October 31; and by November 12, until November 18.[4]

June: In Saint Martin, where he makes the drawing *Cicada* (plate 175). It is here that images from tantric art first appear in Johns's work, in a band of sketches in the drawing's lower part.[5]

July 1979–February 1980: Katrina Martin films *Hanafuda/Jasper Johns*, which shows Johns working at Simca Print Artists, New York, on four different prints, including *Cicada*, 1979, and *Usuyuki*, 1980 (ULAE# 210).[6]

[October 11]: Visits "Picasso: Oeuvres reçues," an exhibition at the Grand Palais, Paris (on view until January 7, 1980).[7]

1980

In Stony Point, makes the drawings *Two Flags*, *Untitled* (LC# D-132), *Untitled* (LC# D-147), and *Tantric Detail* (plate 182). Johns will later produce three paintings after the *Tantric Detail* drawing, the first of them, *Tantric Detail I*, later in 1980.[8] He also makes four 30-by-54-inch untitled paintings in different mediums (LC# 259, LC# 260, LC# 261,

and LC# 262), as well as the second version of *Dancers on a Plane*.

Creates a poster (ULAE# 207) for the fiftieth Anniversary of the Whitney Museum of American Art, New York.

Receives a postcard from a friend showing a reproduction of Edvard Munch's painting *Between the Clock and the Bed*, 1940–42, which depicts Munch in his bedroom; the bedspread bears a pattern similar to Johns's cross-hatchings. In Stony Point, inspired by the Munch painting, Johns makes a pastel drawing with two images (*Between the Clock and the Bed*, 1980, LC# D-134) and begins another drawing, *Between the Clock and the Bed (Six Studies)*, 1980–81. In 1981, Johns will make two large paintings on the same theme.

Is elected a foreign member of Stockholm's Académie Royale des Beaux Arts.[9]

January: In Saint Martin, makes a *0 through 9* drawing, at least two *Cicada* drawings (LC# D-98 and LC# D-99), and probably a third *Cicada* drawing (LC# D-100).

January 12: Sits for a photograph taken by the artist Lucas Samaras.

May 16–September 30: "Pablo Picasso: A Retrospective," at The Museum of Modern Art, New York. Johns visits this exhibition, which includes works—*Woman in Straw Hat* (also called *Straw Hat with*

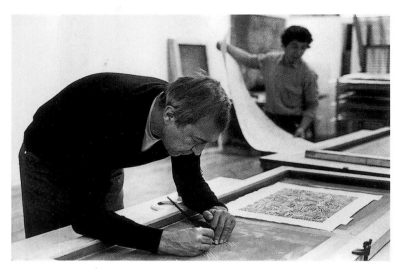

At Simca Print Artists, New York, 1980. Photograph: Katrina Martin. © Katrina Martin.

Blue Leaf, and other names), 1936 (from the collection of the Musée Picasso, Paris); *Crucifixion*, 1930; and the drawings series *Crucifixion, after Grünewald*, 1932—that relate both formally and thematically to future paintings of Johns's.[10]

Summer: Wolfgang Wittrock, a Düsseldorf-based dealer of modern drawings, sends Johns a copy of the portfolio *Grünewalds Isenheimer Altar in neun und vierzig Aufnahmen*, which features black and white reproductions of details from Grünewald's Isenheim Altarpiece, produced after the work was restored and photographed in Munich during World War I.

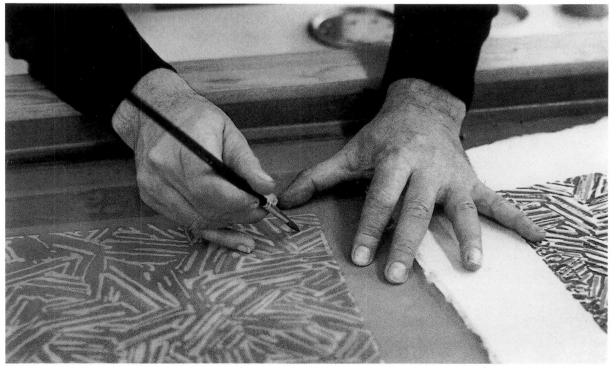

At Simca Print Artists, New York, 1980. Photograph: Katrina Martin. © Katrina Martin.

At Gemini G.E.L., Los Angeles, November 1981.
Photographs: Sidney B. Felsen. © 1981.

Shortly after, Johns begins to use tracings of images from this portfolio in his work.[11]

> Looking at [the reproduced details], I thought how moving it would be to extract the abstract quality of the work, its patterning, from the figurative meaning. So I started making these tracings. Some became illegible in terms of the figuration, while in others I could not get rid of the figure. But in all of them I was trying to uncover something else in the work, some other kind of meaning.[12]

September 26: The Whitney Museum of American Art acquires the painting *Three Flags*, 1958. The price, $1 million, is at the time the highest price ever paid for the work of a living American artist. During the 1980s, the prices of Johns's paintings will continue to escalate.[13]

By October 28–October 29: In Los Angeles, working at Gemini G.E.L. on *Cicada*, 1981 (ULAE# 219). This year Johns will return to Los Angeles to work at Gemini by December 16.[14]

November 29–December 20: "Drawings to Benefit the Foundation for Contemporary Performance Arts, Inc.," an exhibition at the Leo Castelli Gallery, New York, includes work by Johns.

December: In Saint Martin, Johns begins another *Usuyuki* drawing (LC# D-141), which he will finish the following month in Stony Point. Also this month, in New York, Johns is interviewed by Katrina Martin regarding the screenprints *Usuyuki*, 1980, *Usuyuki*, 1979–1981, *Cicada*, 1979, and *Cicada*, 1981 (ULAE# 215). Parts of this interview will be used as the soundtrack of the film *Hanafuda/Jasper Johns*, which Martin has been making since July 1979.[15]

1981

In Stony Point, completes another *Dancers on a Plane* painting, 1980–81, and paints *Tantric Detail II* and *Tantric Detail III*; the first two large-scale versions of *Between the Clock and the Bed* (plates 183 and 184, respectively in encaustic and in oil); and another *Usuyuki*, 1979–81. Drawings completed in Stony Point include *Between the Clock and the Bed (Six Studies)*, 1980–81, *Between the Clock and the Bed, Target*, 1980–81, *Untitled* (LC# D-149), and two *Usuyuki* works (LC# D-136 and LC# D-150), both begun in Saint Martin.

Using a detail from the *Crucifixion* panel of Grünewald's Isenheim Altarpiece, makes *Tracing* in ink on plastic, the first of numerous works after details of the Grünewald painting.[16] Soon after, Johns sends the drawing as a gift to Wolfgang Wittrock, who, in the summer of 1980, had given him the copy of *Grünewalds Isenheimer Altar in neun und vierzig Aufnahmen*.

January–February: Works sporadically at ULAE, West Islip.

January 10–February 7: "Jasper Johns Drawings 1970–80," an exhibition at the Leo Castelli Gallery, selected by Johns and Castelli, includes almost all the drawings Johns produced between 1970 and 1980. Later this winter the exhibition will travel to California.[17]

By February 20–February 21: In Los Angeles, working at Gemini G.E.L. This year, Johns will return to Los Angeles and to Gemini by November 20.[18] As of this writing, this is the last time Johns works at Gemini.

October 24–December 2: "Jasper Johns: Prints 1977–1981, the Complete Works," an exhibition at the Thomas Segal Gallery, Boston, Massachusetts. There is a catalogue with an essay by Judith Goldman.

November 28–December 19: "Eight Lithographs to Benefit the Foundation for Contemporary Performance Arts, Inc.," an exhibition of a portfolio of lithographs at the Leo Castelli Gallery. The portfolio, published by Gemini G.E.L., includes Johns's *Cicada*, 1981 (ULAE# 219), as well as works by Sam Francis, Philip Guston, David Hockney, Ellsworth Kelly, Bruce Nauman, Robert Rauschenberg, and Richard Serra.

December 16: Premiere of Katrina Martin's film *Hanafuda/Jasper Johns*, at the Collective for Living Cinema, New York.

In Stony Point, N.Y., 1980. Photograph: Arnold Newman. © 1986 Arnold Newman.

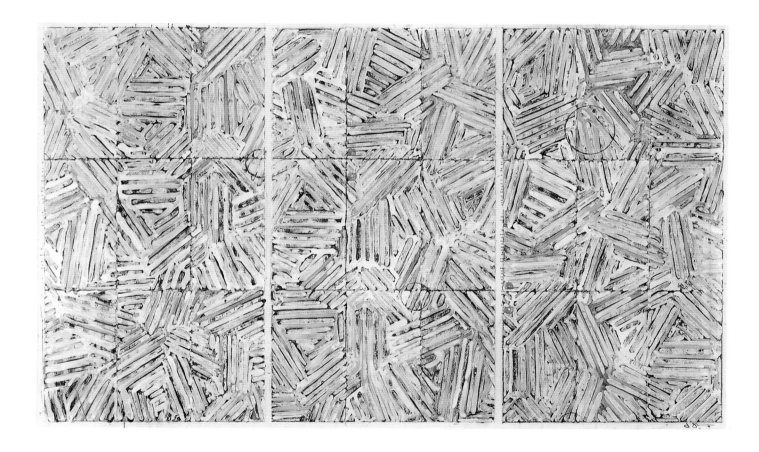

173. **Target with Four Faces**. 1979
Ink on plastic
28 ¾ x 22 ¼″ (73 x 56.5 cm)
Private collection

174. **Usuyuki**. 1979
Acrylic on plastic
33 ¾ x 51 ½″ (85.7 x 130.8 cm)

Ludwig Collection

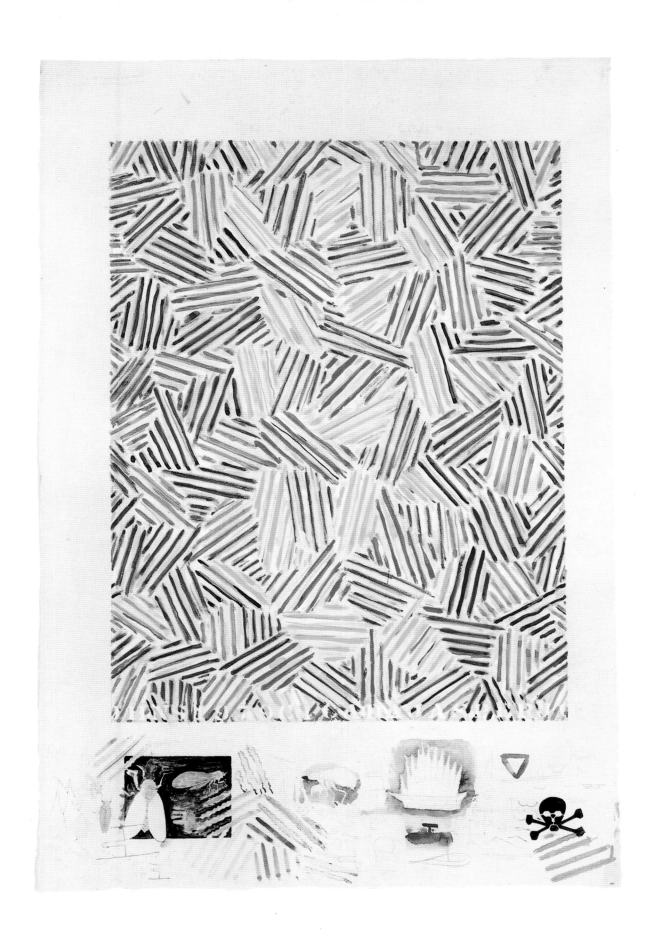

175. **Cicada**. 1979
Watercolor, crayon, and graphite
pencil on paper
43 x 28 ¾″ (109.2 x 73 cm)
Collection the artist

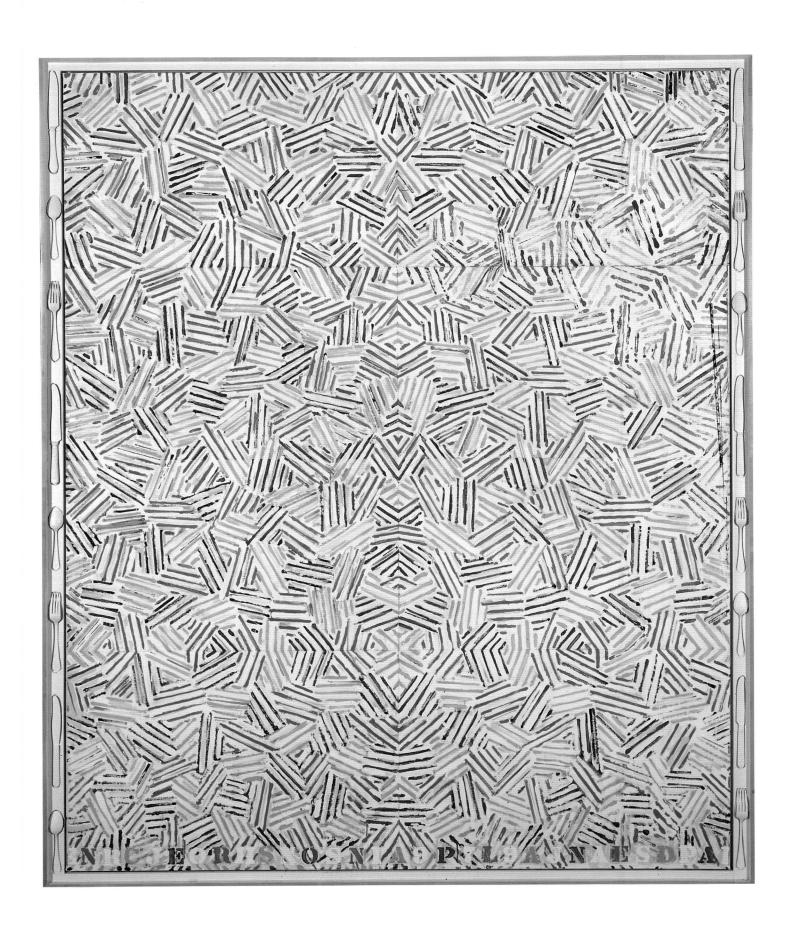

176. **Dancers on a Plane**. 1979
Oil on canvas with objects
77⅞ x 64″ (197.8 x 162.6 cm)
Collection the artist

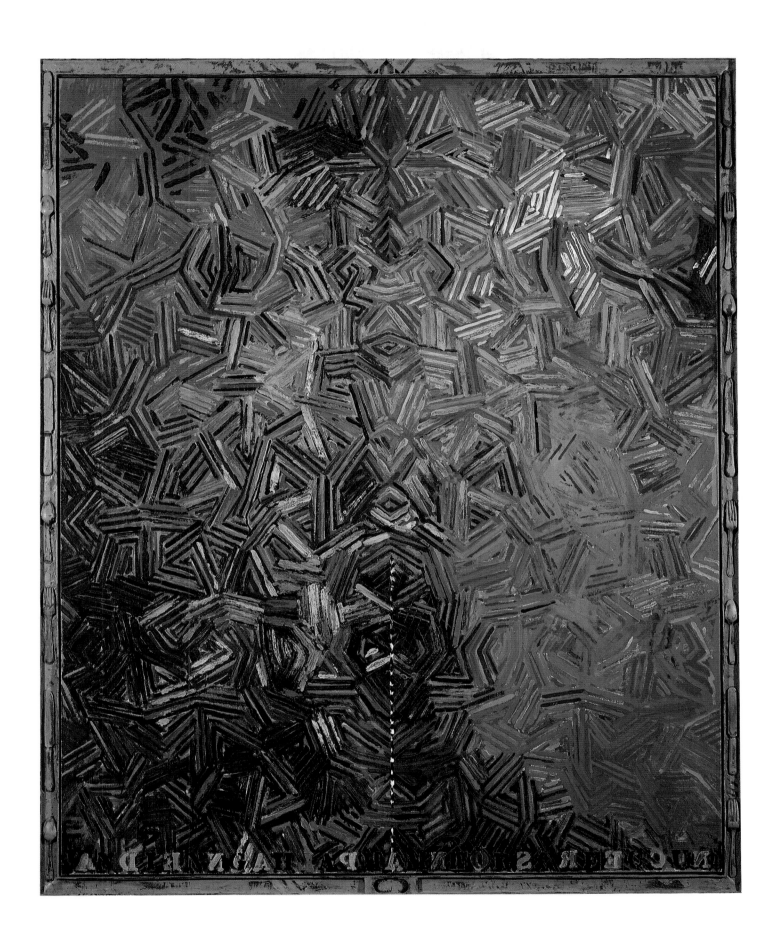

177. **Dancers on a Plane**. 1980
Oil and acrylic on canvas with
painted bronze frame
78 ⅜ x 63 ¾″ (199 x 161.9 cm)
including frame
Tate Gallery. Purchased 1981

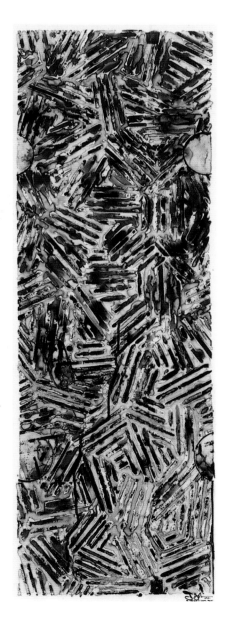

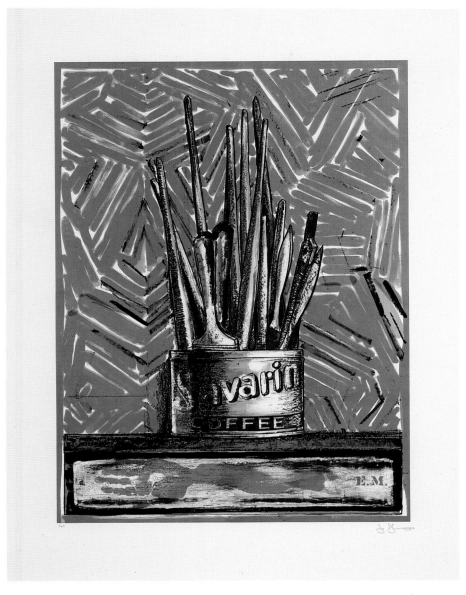

178. **Untitled**. 1980
Acrylic on plastic on canvas
30 ⅜ x 54 ⅜″ (77.1 x 138.1 cm)
Collection Michael and Judy Ovitz,
Los Angeles

179. **Target with Four Faces**. 1968–81
Pastel and charcoal on paper
41 ½ x 29 ½″ (105.4 x 74.9 cm)
Collection the artist

180. **Usuyuki**. 1981
Ink on plastic
49 x 18 ¼″ (124.4 x 46.3 cm)
Collection Peggy and Richard Danziger,
New York

181. **Savarin**
West Islip, N.Y.: Universal Limited Art
Editions, 1977–81
Lithograph
50 ¼ x 38 ⁵⁄₁₆″ (127.6 x 97.3 cm)
The Museum of Modern Art, New York.
Gift of Celeste Bartos

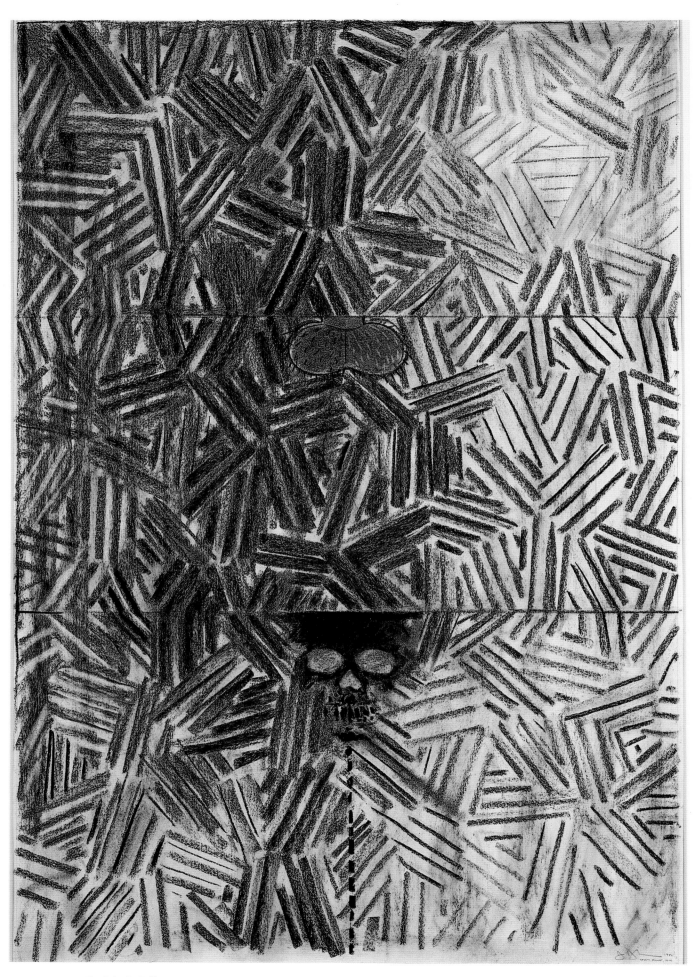

182. **Tantric Detail**. 1980
Charcoal on paper
58 x 41″ (147.3 x 104.1 cm)
Collection the artist

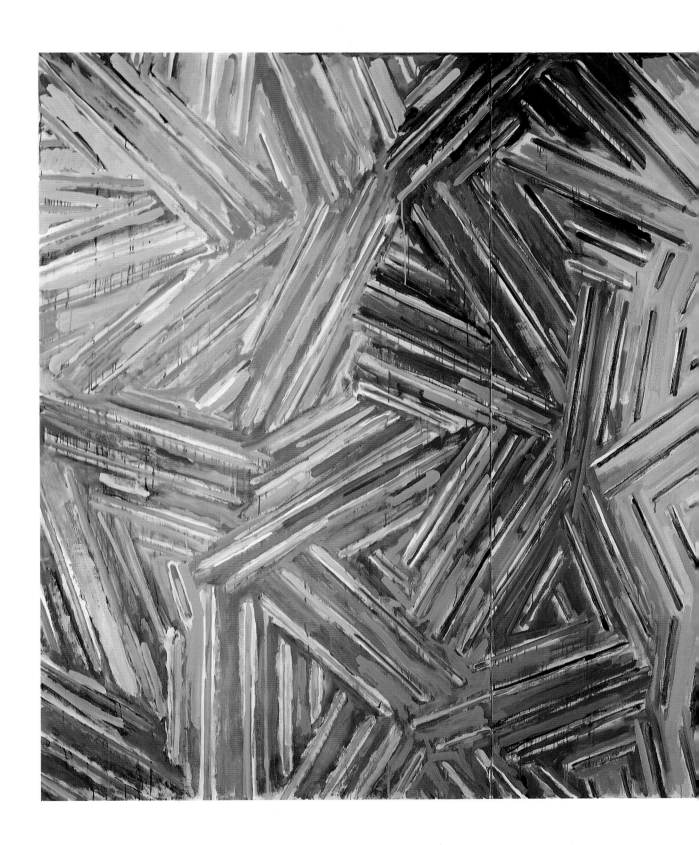

184. **Between the Clock and the Bed**. 1981
Oil on canvas (three panels)
6′ x 10′ 6 ¼″ (182.9 x 320.7 cm)
Collection the artist

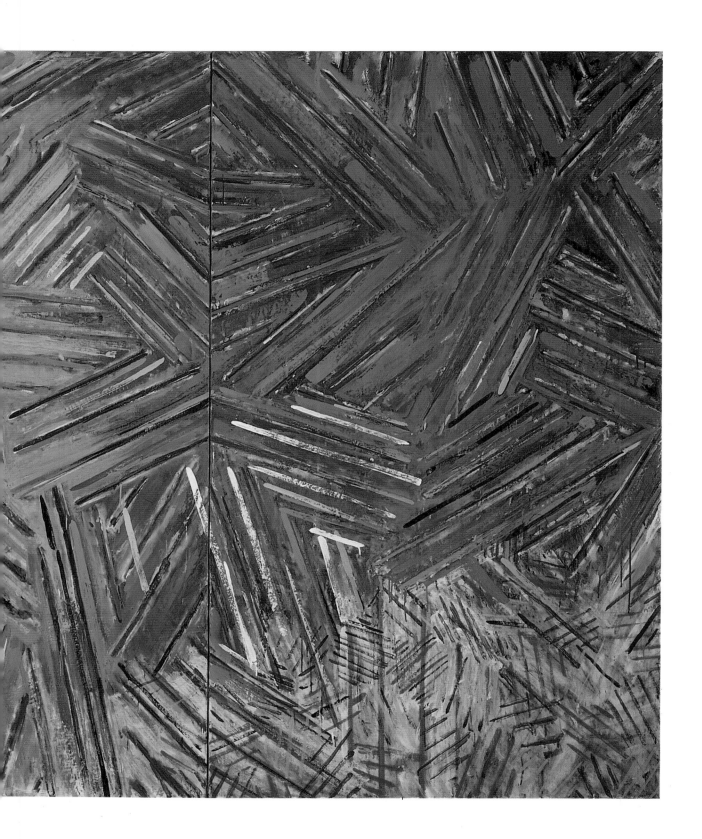

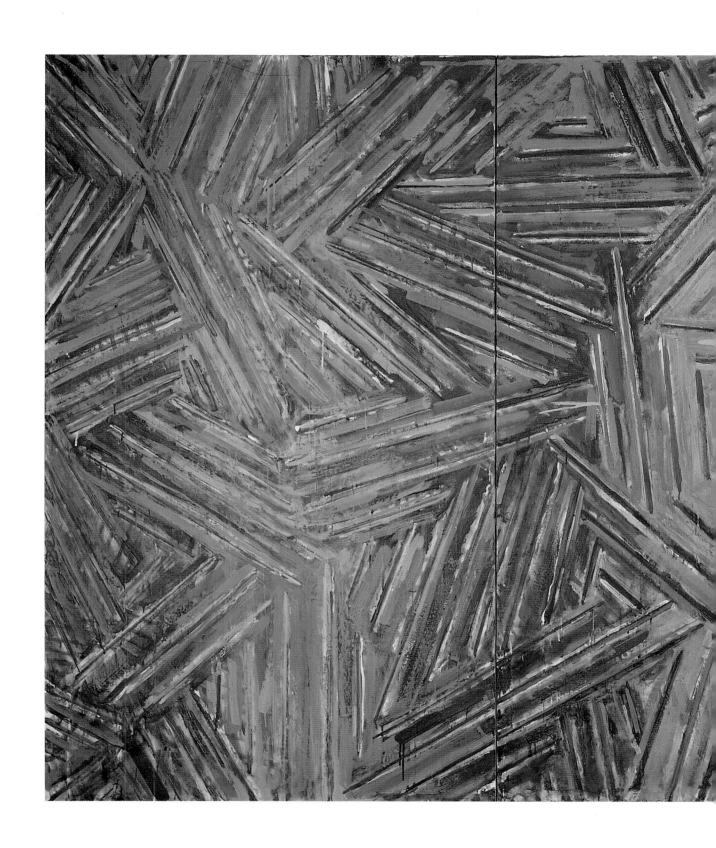

183. **Between the Clock and the Bed**. 1981
Encaustic on canvas (three panels)
6′ ⅛″ x 10′ 6 ⅜″ (183.2 x 321 cm)
The Museum of Modern Art, New York.
Gift of Agnes Gund

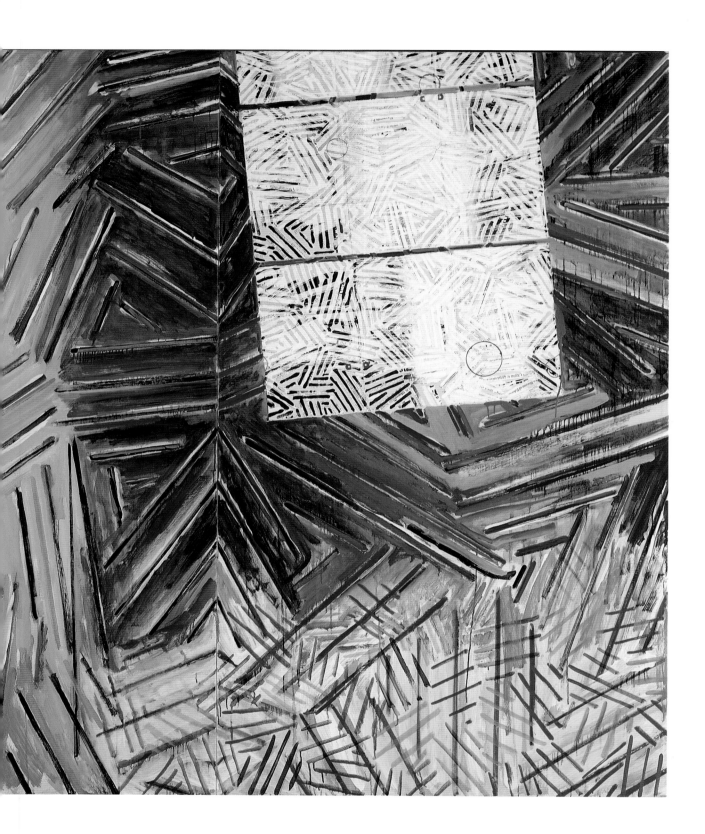

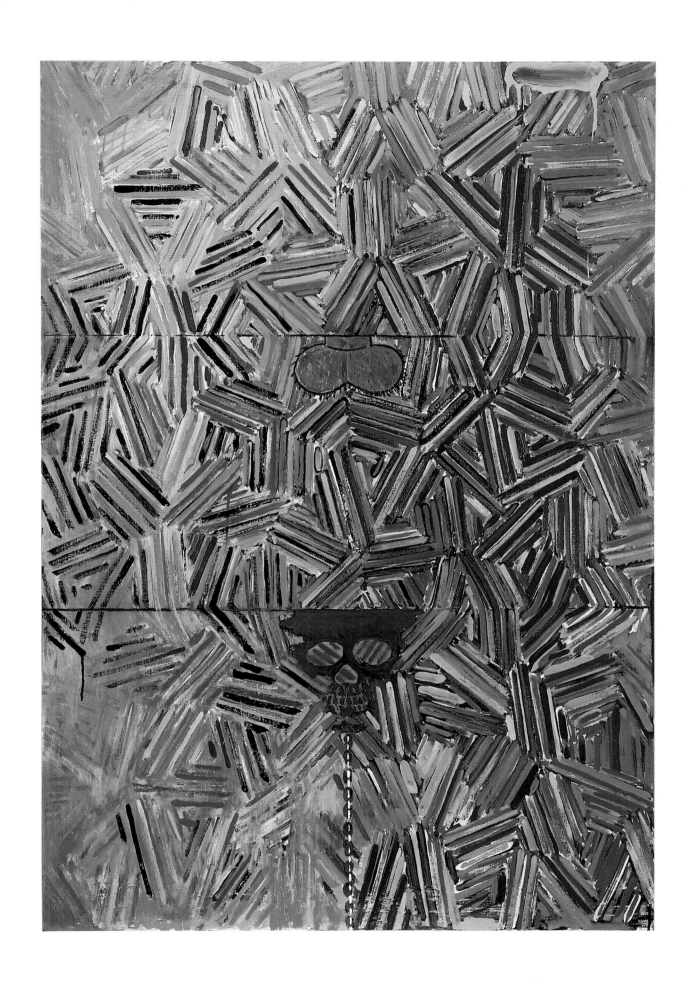

185. **Tantric Detail I**. 1980
Oil on canvas
50 ⅛ x 34 ⅛″ (127.3 x 86.7 cm)
Collection the artist

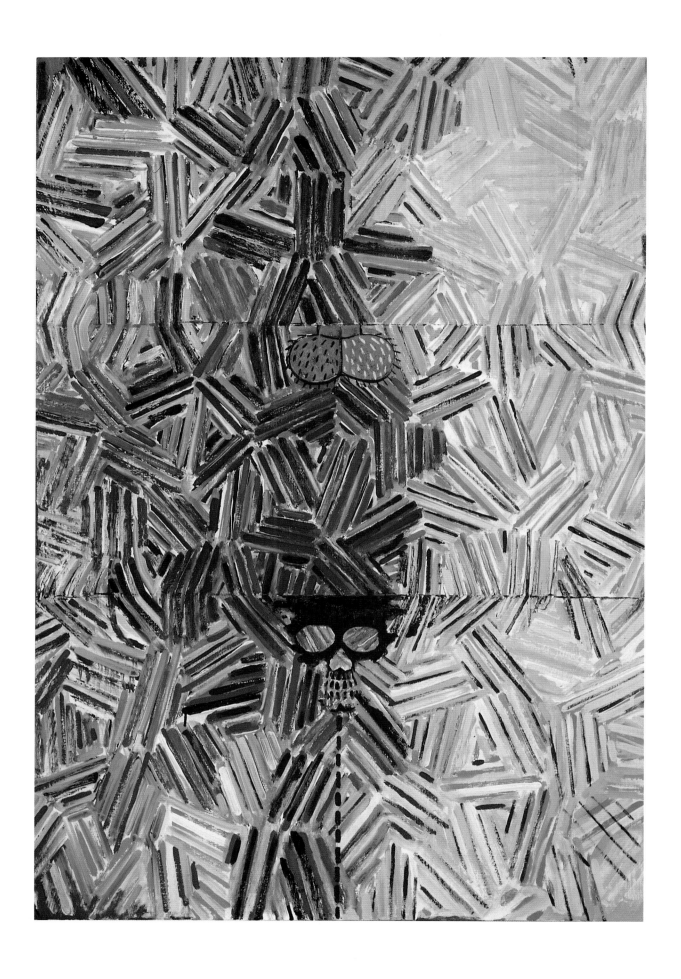

186. **Tantric Detail II**. 1981
Oil on canvas
50 x 34″ (127 x 86.4 cm)
Collection the artist

316

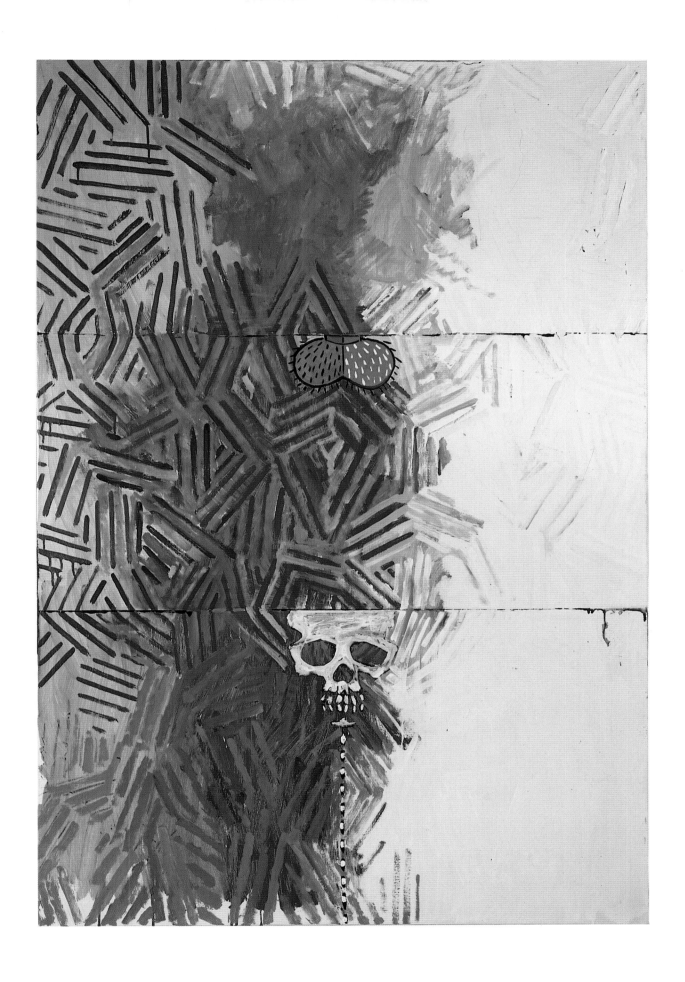

187. **Tantric Detail III**. 1981
Oil on canvas
50 x 34″ (127 x 86.4 cm)
Collection the artist

Johns's work took an unexpected turn in the early 1980s, when, simultaneous with the final prints and paintings of the cross-hatch series, he adopted what seemed an entirely un-Johnsian manner of painting and—shockingly for one who had so carefully nurtured a limited range of images for so many years—instigated a sudden proliferation of new motifs. Yet though it marked a decisive break with years of abstraction, *In the Studio* of 1982 can in some ways be seen as a reprise of *Fool's House* from twenty years earlier; and the combination of painting and cast body-parts in this work and in *Perilous Night* of 1982 might be seen as reverting to the structures of earlier works such as *Wilderness II*, 1963, *Watchman*, 1964, or even Johns's initial target constructions. The paradoxes of identity and disjunction in those former works were now to be replaced, however, by themes of ambiguity and illusion.

In formats that suggested the tackboard walls of his studio and bathroom, Johns for the first time began to paint things in nature—planks, faucets, clothing, and ceramics—that were not ready-made flat schemas. Perspectival space, previously banished from his work, made its first appearance in the "tilted" empty canvas depicted at the bottom center of *In the Studio*. (This canvas's apparent lean inward is countered by the very real lean outward of a wooden stick hinged to the bottom of the picture.) In subsequent pictures, a pictorial depth, albeit shallow and layered, would be consistently present. With a new space, there also appeared a changed notion of time: the arm casts that appear in pictures of 1982–83, though mottled with color in an unnatural camouflage under their "skin," are clearly those of a child, and—in the three different sizes in *Perilous Night*—introduce a new sense of evolution and growth.

Simultaneously, Johns also started to include "trick" images from perceptual psychology (a vase, for example, whose shaft can be read as the negative space between two facing profiles) that trap the viewer in irresolvable either-or dilemmas of interpretation. The refocus on the languages of illusion also included citations of the trompe l'oeil staples of early Cubism—fake wood-grain, and standing nails with shadows—drawn with rude simplicity. These and other trompe l'oeil devices (such as the "masking tape" that "attaches" images to the "wall"), however, are frequently contradicted by reassertions of painterly freedom, as in the inexplicably "floating" George Ohr pots, from Johns's own collection, in *Ventriloquist*, or the brushwork that allows the wall to "cover" the left edge of the framed (and reversed) copy of a Barnett Newman lithograph at the upper right of the same picture. In complex assemblages like those of the two untitled horizontal "bath" pictures of 1984 (plates 201 and 202), the layering of images—some reversed and some not—makes for a hall-of-mirrors spatial perplexity that has no stable resolution.

The new pictures bristled, too, with images of other artworks. *Racing Thoughts* included the same Newman print, here in correct orientation, and (in addition to a photo-puzzle showing Johns's dealer, Leo Castelli, in his youth) a *Mona Lisa* decal. The first of Johns's appropriations in his work of this period was the image of the two armored pikemen who flail deep in the distressed blackout on the left of *Perilous Night* (and who appear again, smaller, on the right). Abstracted via tracing from a grisaille reproduction of a detail of Matthias Grünewald's Isenheim Altarpiece, c. 1512–16, the sinuous arrangement of these faceless swooners became—like another tracing from a foul-skinned demon in the same altarpiece—a favored matrix, embedded in some of Johns's richest passages of painting. The pikemen, streaked and veiled, underlie the left half of one of the untitled 1984 "bath" pictures, and the demon, in bolder puzzle-patterning, is upside down on the left of the other. With the Swiss skull-and-crossbones placard (a three-language warning about falling ice) that Johns also began treating in this period, the Grünewald references to religious experience, and to disease, broadened and deepened the range of possible meanings in his art.

In a series of prints of 1982, Johns revisited the imagery and compositional devices—scraped half-circles, outstretched arm-prints—of pictures of the early 1960s such as *Land's End* and *Periscope (Hart Crane)*. This led in turn to several drawings and eventually to the large *Untitled (Red, Yellow, Blue)*, a three-panel picture that reformulated on a larger scale and in a more somber tone the issues of self-reference and memory implicit in *Ventriloquist* and others of the new paintings.

—*KV*

Chronology

1982

In Stony Point, paints *Untitled*, 1981–82, a *Dancers on a Plane* (LC# 272), *In the Studio*, *Perilous Night*, and a *Usuyuki*. *In the Studio* and *Perilous Night* mark a departure from the cross-hatch paintings, introducing casts of body parts and new representational elements, personal in nature, illusionistically attached to an illusionistic wall, as well as tracings of images from Matthias Grünewald's Isenheim Altarpiece.

Also in Stony Point, makes the drawings *Dancers on a Plane* and *Land's End*.

January 9–30: "Jasper Johns—Two Themes: Usuyuki & Cicada," an exhibition at Castelli Graphics, New York.

February 16–March 13: "The End Game: Opposition and Sister Squares Are Reconciled, Jasper Johns/Marcel Duchamp," an exhibition at L.A. Louver Gallery, includes twenty-seven prints by Johns.

April: In Stony Point, creates the cross-hatch drawings *Between the Clock and the Bed* (LC# D-144), *Untitled* (LC# D-155), and *Untitled* (LC# D-156).

April 9–July 11: "'60–'80: Attitudes/Concepts/Images," an exhibition at the Stedelijk Museum, Amsterdam, includes *White Numbers*, 1959, *Figure 5*, 1960, *Field Painting*, 1963–64, *Untitled*, 1964–65, the encaustic *Between the Clock and the Bed*, 1981, and a drawing of 1981. On the occasion of this exhibition, Johns is interviewed by Riki Simons in Stony Point.[1]

July 24: Tatyana Grosman dies, at the age of 78.[2] She leaves ULAE to Bill Goldston, the workshop's master printer and director, with shares in it also going to Johns, Robert Rauschenberg, and her lawyer, William Speiller.[3]

> *One of Tanya's great skills, one of the things she suffered from, was making a completely different world for each artist.... It's very hard to know what she wanted that the artists didn't want. She always acted as if she wanted more—more fancy, more severe—whatever she thought you had in mind. She didn't mind exaggerating.*[4]

August: In Stony Point, where he makes the drawing *Perilous Night* (plate 190).

November: Asked by *Artnews* magazine what artists he feels deserve more recognition, Johns names John Duff and Terry Winters.[5]

November 10, 1982–January 9, 1983: "Jasper Johns: Savarin Monotypes," an exhibition at the Whitney Museum of American Art, New York. ULAE publishes Judith Goldman's *Jasper Johns: 17 Monotypes* to coincide with this exhibition. Over the next three and a half years the exhibition will travel to Texas, Yugoslavia, Switzerland, Norway, Sweden, and England.[6]

1983

In Stony Point, completes the third large-scale *Between the Clock and the Bed*, 1982–83, and paints *Flag*, *Untitled* (LC# 282), the first (encaustic) version of *Racing Thoughts*, *Ventriloquist*, and another *Untitled* (LC# 284). Completes the drawings *Usuyuki*, 1979–83, and *Untitled* (LC# D-180). Also this year, probably also in Stony Point, after *Flag* and before *Untitled* (LC# 282), paints three smaller *Between the Clock and the Bed* canvases, in oil (LC# 279, LC# 280, and LC# 281).

The four versions of *Between the Clock and the Bed* completed in 1983—the large canvas and the three smaller ones—are among Johns's last paintings as of this writing to use the cross-hatching motif. But this year Johns also creates a series of eighteen monotypes (ULAE# S38–S55)—his largest printed works to date—after an untitled cross-hatch painting of 1979 (LC# 257), which has hung for years in his house in Stony Point. He makes these prints at ULAE, working there for the first time since Tatyana Grosman's death. For Riva Castleman, "Because of the unique procedure he followed, [the project] seemed to evolve as a sustained memorial activity."[7]

The last four paintings of 1983—*Untitled* (LC# 282), *Racing Thoughts*, *Ventriloquist,* and *Untitled* (LC# 284)—are the first "bathtub's-eye view" paintings, in Nan Rosenthal's term: they are made from the perspective of someone in a tub.[8] (At the bottom of the painting appear the faucet and sometimes other fixtures from the bathroom of Johns's house in Stony Point.) The array of new visual elements depicted in these paintings will appear repeatedly in Johns's ensuing work: the bathtub fixtures, the skull taken from a Swiss road-sign warning of avalanches, as well as several objects he owns, including pottery by George Ohr, a vase commemorating the Silver Jubilee of Queen Elizabeth II of England, his own works, prints by Barnett Newman, and a jigsaw puzzle made from a portrait of Leo Castelli.

In Stony Point, N.Y., in 1984, working on *Untitled*, 1984 (plate 202). Photographs: Mark Lancaster.

Every image or object in Racing Thoughts *was from something in the studio or the house. The portrait of Leo Castelli in the painting is a jigsaw puzzle—a Christmas present years ago from someone in the gallery.*[9]

March 23–May 22: "1983 Biennial Exhibition," at the Whitney Museum of American Art, includes *In the Studio*, 1982.

May 5: Makes the drawing *Untitled* (plate 191).

August: Makes the drawings *Untitled* (LC# D-169), *Study for Racing Thoughts* (LC# D-168), and *Untitled* (LC# D-190).

[September 28]: At ULAE, accompanied by Riva Castleman, Johns works on monotypes.

October 3–29: "Jasper Johns: Selected Prints," an exhibition at the Akira Ikeda Gallery, Tokyo, includes thirty-eight prints.

October 7: From Stony Point, Johns writes to Castleman denying rumors that he has broken a leg. He adds that the monotypes are being cleaned by Bill Goldston, and that he will soon decide on how to tear these prints' margins.[10]

November 12–December 14: "Jasper Johns: Prints," an exhibition at the Delahunty Gallery, Dallas, Texas.

December 1983–January 1984: In Saint Martin, where he makes the drawing *Untitled*, 1983–84 (LC# D-181). In this work, for the first time, he uses an illustration of 1915 by W. E. Hill, to which he will often return: "My wife and my mother-in-law."[11]

1984

In Stony Point, paints the second, oil version of *Racing Thoughts*; two untitled works (plates 202 and 201); four vertical works, also untitled, each of which sets cropped images of a *Two Flags* print and of W. E. Hill's drawing on a background showing a traced detail from the *Temptation of Saint Anthony* panel of the Isenheim Altarpiece (plates 197 and 196, LC# 292, and LC# 294); *Untitled* (LC# 296); an oil-and-encaustic-on-leather *Corpse and Mirror*; and *Untitled (Leo Castelli)*. Also in Stony Point, completes the drawings *Cicada*, 1979–84, *Between the Clock and the Bed* (LC# D-222), and a number of untitled drawings (LC# D-193, LC# D-194, LC# D-206, LC# D-197 [begun in 1980], LC# D-198 [also begun in 1980], and LC# D-213 and LC# D-214 [both begun in 1979]).

Untitled (plate 202) is the first painting to include Hill's wife-and-mother-in-law illustration.

In a drawing done in Stony Point in November of this year, *Untitled* (LC# D-223), Johns will use another well-known perceptual image, the duck/rabbit drawing published in Wittgenstein's *Philosophical Investigations*.[12]

In Saint Martin, paints *Untitled (Red, Yellow, Blue)* (plate 195), makes the drawing *Ventriloquist*, and begins two other untitled drawings (LC# D-182 and LC# D-183), both completed this year in Stony Point.

Two books on Johns and his work are published this year: David Shapiro's *Jasper Johns Drawings 1954–1984* (New York: Harry N. Abrams, Inc.) and Richard Francis's *Jasper Johns* (New York: Abbeville Press, Modern Masters Series).

The artist Steve Wolfe becomes his studio assistant (until the end of the year).[13]

January: Makes three untitled drawings (LC# D-185, LC# D-186, and LC# D-188).

January 28–February 25: "Jasper Johns: Paintings," an exhibition at the Leo Castelli Gallery, includes fourteen large-scale paintings: *Céline*, 1978; *Untitled*, 1979 (LC# 257); *Untitled (E. G. Seidensticker)*, 1979; the *Dancers on a Plane* works of both 1979 and 1980; three *Between the Clock and the Bed* works, two from 1981 and one from 1982–83; *Untitled*, 1981–82 (LC# 270); *In the Studio*, 1982; *Perilous Night*, 1982; *Untitled*, 1983 (LC# 282); *Racing Thoughts*, 1983; and *Ventriloquist*, 1983. The show takes place in Castelli's space at 142 Greene Street, which Castelli has opened (on February 19, 1980) specifically for larger-scale works. Johns's last solo exhibition at Castelli's has been in 1976, in the space on East 77th Street.

By February 14: In Saint Martin, where he makes the drawing *Untitled* (LC# D-217).

May 9: Elected a fellow of the American Academy of Arts and Sciences, Boston.

By August 21: In Stony Point, where he makes the drawing *Untitled* (LC# D-192).

September 20–December 2: "Blam! The Explosion of Pop, Minimalism and Performance 1958–1964," an exhibition at the Whitney Museum of American Art, includes *Target with Plaster Casts*, 1955, *White Flag*, 1955–58, *Gray Rectangles*, 1957, and *Flag on Orange Field II*, 1958.

October: In Saint Martin, where he makes two untitled drawings (LC# D-219 and LC# D-220).

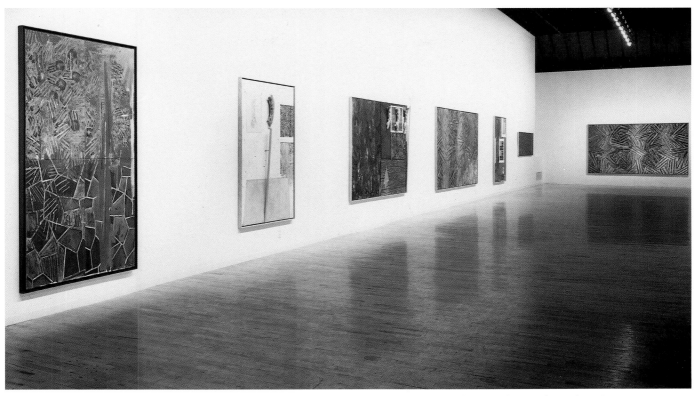

Installation view of "Jasper Johns: Paintings," at the Leo Castelli Gallery (142 Greene Street), New York, 1984. Photograph: Zindman/Fremont.

November: In Stony Point, where he makes the drawing *Untitled* (LC# D-223).

December: In Saint Martin, where he makes at least two untitled drawings (LC# D-224, LC# D-225, and probably LC# D-227).

By December 19: In Stony Point, where he makes the drawing *Untitled* (LC# D-226). This is the first work to include the image of a cartoonlike rectangular face, with eyes and mouth dispersed to the edges. Johns will later ascribe this image, which reappears in his paintings and drawings of the next ten years, to Picasso's *Woman in Straw Hat*, 1936.[14]

I was working with Picasso's Straw Hat with Blue Leaf [Woman in Straw Hat]. *He extended the woman's features to the outer edge of her face. I got the idea to push the features to the outer edge of the canvas, the canvas with features attached to it.*[15]

188. **In the Studio**. 1982
Encaustic and collage on canvas
with objects
72 x 48″ (182.9 x 121.9 cm)
Collection the artist

324

189. **Perilous Night**. 1982
Encaustic on canvas with objects
67 x 96 x 5″ (170.2 x 243.8 x 12.7 cm)
National Gallery of Art, Washington, D.C.
Robert and Jane Meyerhoff Collection

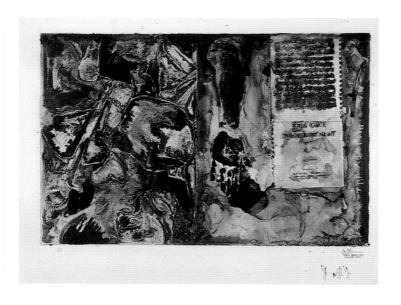

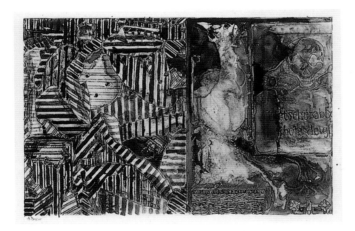

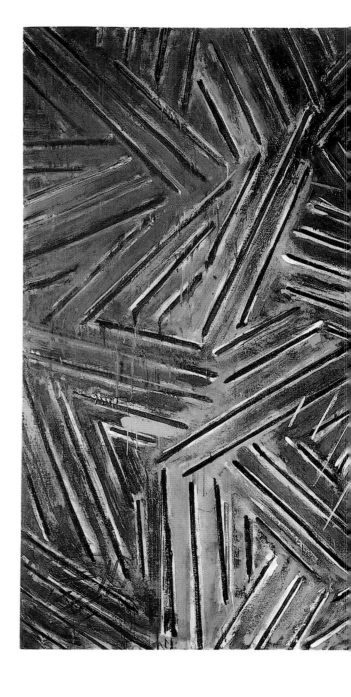

190. **Perilous Night**. 1982
Ink on plastic
31 5/8 x 40 7/8″ (80.3 x 103.8 cm) sight
The Art Institute of Chicago, through
prior gift of Mary and Leigh Block;
Harold L. Stuart Endowment, 1989

191. **Untitled**. 1983
Ink on plastic
24 3/4 x 36 1/4″ (63 x 92.1 cm)
The Museum of Modern Art, New York.
Gift of The Lauder Foundation

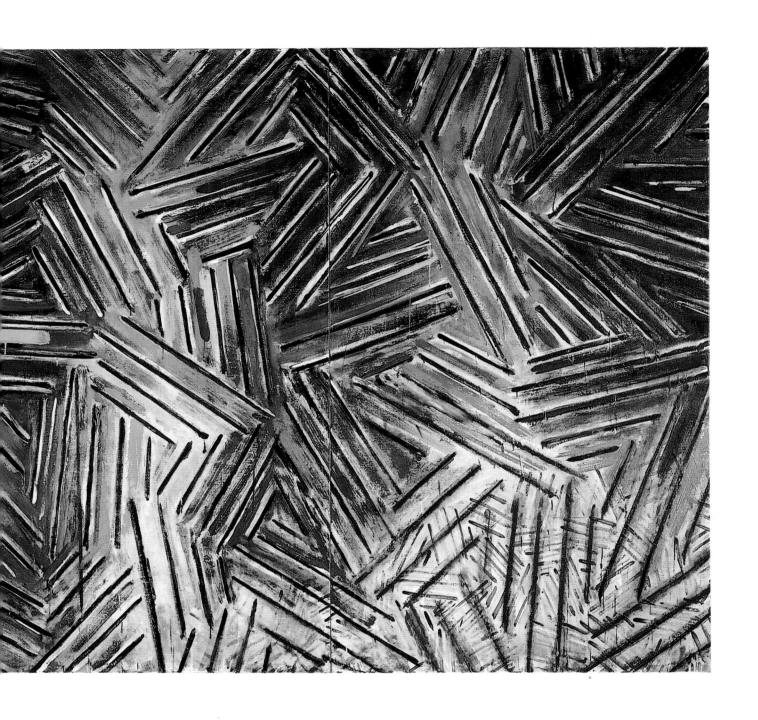

192. **Between the Clock and the Bed**. 1982–83
Encaustic on canvas (three panels)
6′ x 10′ 6 ¼″ (182.9 x 320.7 cm)
Virginia Museum of Fine Arts, Richmond.
Gift of the Sydney and Frances Lewis Foundation

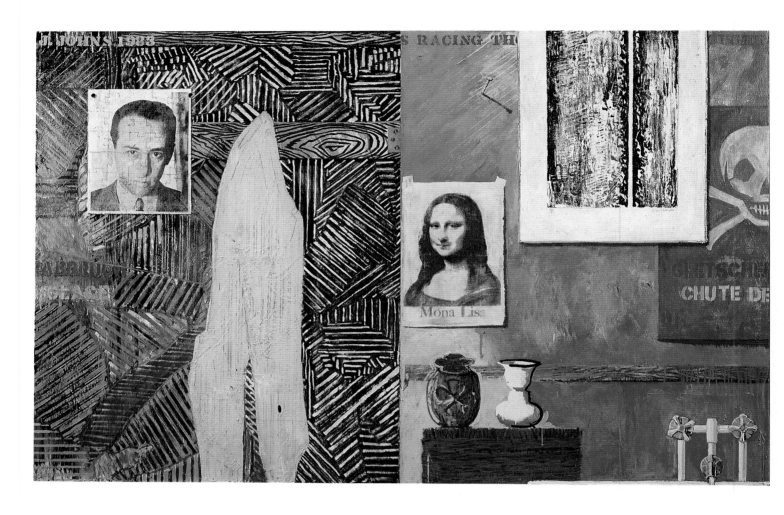

193. **Racing Thoughts**. 1983
Encaustic and collage on canvas
48 x 75 ⅛″ (121.9 x 190.8 cm)
Whitney Museum of American Art.
Purchase, with funds from the Burroughs
Wellcome Purchase Fund; Leo Castelli;
the Wilfred P. and Rose J. Cohen Purchase
Fund; the Julia B. Engel Purchase Fund;
the Equitable Life Assurance Society of
the United States Purchase Fund; the
Sondra and Charles Gilman, Jr.,
Foundation, Inc.; S. Sidney Kahn; The
Lauder Foundation, Leonard and Evelyn
Lauder Fund; the Sara Roby Foundation;
and the Painting and Sculpture Committee

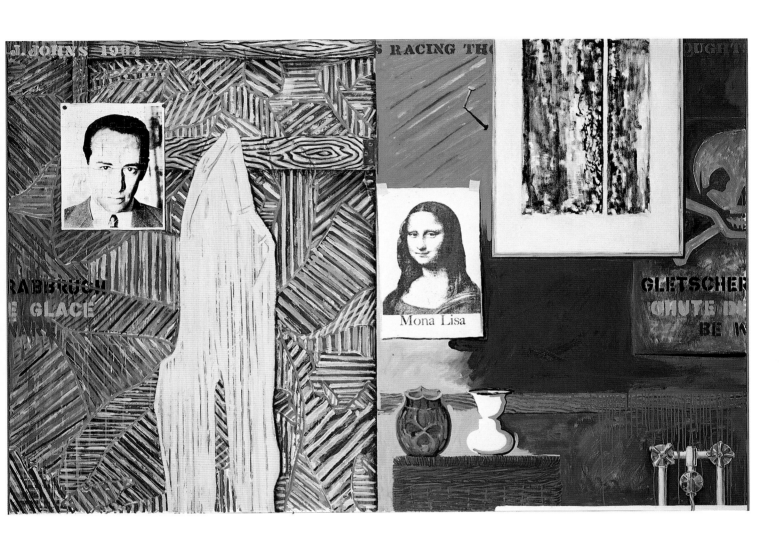

194. **Racing Thoughts**. 1984
Oil on canvas
50 x 75″ (127 x 190.5 cm)
Robert and Jane Meyerhoff,
Phoenix, Maryland

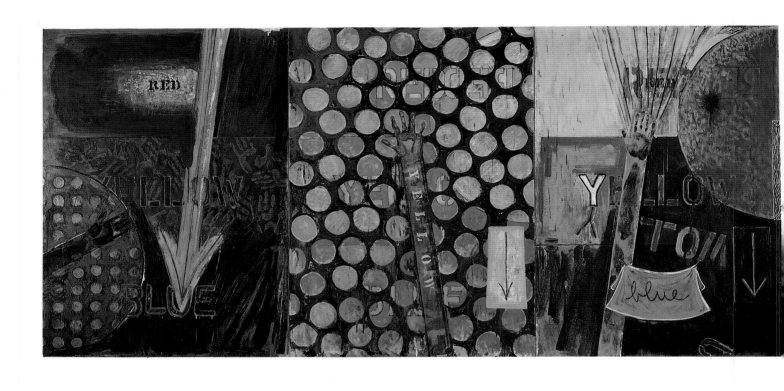

195. **Untitled (Red, Yellow, Blue)**. 1984
Encaustic on canvas (three panels)
Overall: 55 ¼ x 118 ½″ (140.3 x 300.9 cm);
each panel: 55 ¼ x 39 ½″ (140.3 x 100.3 cm)
Collection the artist

196. **Untitled**. 1984
Oil on canvas
50 x 34″ (127 x 86.3 cm)
Robert and Jane Meyerhoff,
Phoenix, Maryland

197. **Untitled**. 1984
Oil on canvas
75 x 50″ (190.5 x 127 cm)
Milwaukee Art Museum, Purchase, with
funds from FOA, CAS, and the Virginia
Booth Vogel Acquisition Fund

198. **Untitled**. 1983–84
Ink on plastic
24 x 34¾″ (60.9 x 88.2 cm)
Collection Mrs. John Hilson

199. **Untitled**. 1984
Ink on paper
42 x 31″ (106.7 x 78.7 cm) sight
Collection the artist

200. **Ventriloquist**. 1983
Encaustic on canvas
75 x 50″ (190.5 x 127 cm)
The Museum of Fine Arts, Houston;
Museum purchase with funds
provided by the Agnes Cullen Arnold
Endowment Fund

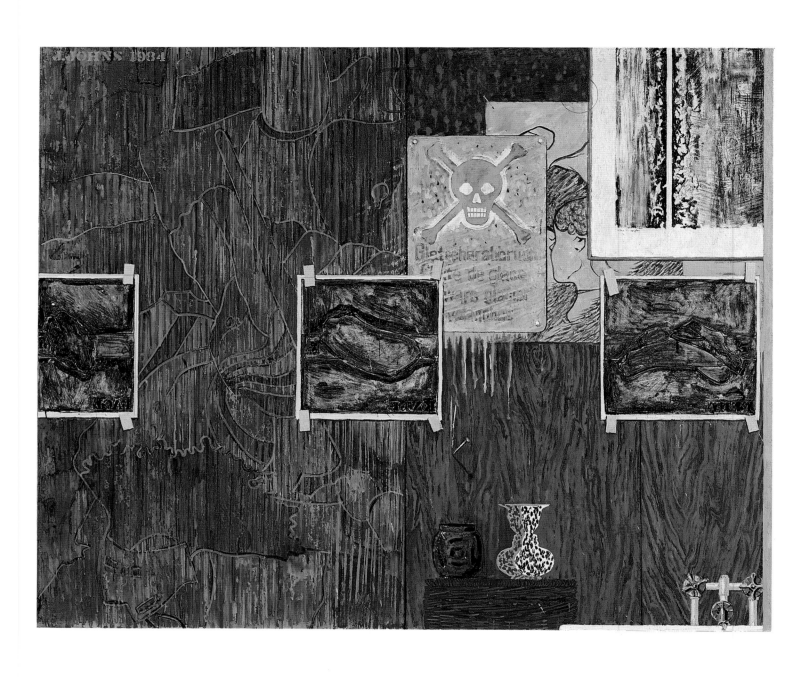

201. **Untitled**. 1984
Encaustic on canvas
63 ½ x 75″ (161.2 x 190.5 cm)
334 The Eli and Edythe L. Broad Collection

202. **Untitled**. 1984
Encaustic on canvas
50 x 75″ (127 x 190.5 cm)
Collection the artist

In the late 1980s, Picasso appeared as a presence in Johns's art in somewhat the way that Duchamp had inhabited so much of the work of the early 1960s. At the same time, the autobiographical tendency that appeared in the early 1980s intensified and, within the context of a new interest in infantile perception and representation, extended into memories of early childhood. The most immediate indication of a new phase in Johns's work, however, came in the motif of a peculiar disjointed "face." Inspired by a Picasso portrait from the 1930s in which the female sitter's eyes are displaced to the edges of opposing breast-like forms, Johns devised (first in a drawing of 1984, then in paintings from 1985 onward) an even more extreme image in which bulging eyes cleave to the corner and side of an open field containing equally exaggerated "cartoons" of nostrils and lips. These features, "projected" onto a flat rectangle from a volumetric head, were sometimes shown reprojected onto a trompe l'oeil hanging cloth; in that form the dislocated face appeared in both paintings and drawings in the company of the Picasso portrait and another "metamorphic" head, a venerable trick image from psychology that Johns first used in 1984, and that can be read as either a young woman or a crone. "Nailed up" as a trio of cloths, these mutant or mutable women may recall the three "Draft Pistons" of windblown cloth at the top of Duchamp's *The Bride Stripped Bare by Her Bachelors, Even (The Large Glass)*; a suite of ink tracings after Duchamp was one of the graphic highlights of these years. Taken together, the three images oddly commingle innocence, eroticism, and mortality, embodying the mind's power for fantasy and its vulnerability to illusion, as well as the human form's susceptibility to free change in imagination and its enchainment to fated change in physicality.

The centerpiece of the period, yet standing apart from it, was *The Seasons* of 1985–86, an ambitious cycle in which Johns assembled artifacts and seasonal symbols—nesting bird, sea horse, snowman, etc.— to represent the epochs of life. *Fool's House*, 1962, *Field Painting*, 1963–64, *Racing Thoughts*, 1983, and other previous works had brought together objects and images in implicit reference to the artist and his habitat, but now there seemed to be a narrative intent to the accumulation, an alteration of the elements from canvas to canvas to suggest not only the promises and disappointments of the general human cycle of growth and aging but the periods of Johns's own career. The self-reference is clear not only in the numerous attributes of Johns's art throughout the series, but in the locales suggested: each shadow falls on a different wall of bricks, tiles, or boards that correspond to one or another of Johns's residences.[1] The pictures owe iconography to a Picasso canvas of the 1930s showing a minotaur moving his household goods in a cart, and their "self-portrait"—Johns's shadow, which recurs in all four—was inspired by an early-1950s Picasso painting titled *The Shadow*. The displacement and splitting of Johns's shadow from picture to picture is another of the artist's codes for a changing point of view, and for time passing; the strategy is meant to suggest that the images are seen in sliding quarter-shifts, literally in rotation. The idea of implied cylindricality that had determined the split titles painted into earlier works (*Fool's House*, for example) reappears here, now more evidently attached to ideas of recurring cycles of beginnings, endings, and renewals. (Several years later, in an aquatint and etching of 1990, Johns would join all the *Seasons* compositions in a four-armed cross form that further emphasized the idea of rotation on a wheel of life.)

While *The Seasons* are densely packed and diverse, the new face motif gave rise to some of the sparest and most open paintings Johns has made, containing broad, flat fields of color unlike anything in his work since the late 1960s, and rendered with an airily clear, rejuvenated simplicity that evoked children's drawings. This "infantile" quality was something that Johns recognized and sought, and it served as an appropriate vehicle for dealing with his own earliest memories. *Montez Singing*, for example, a picture with the light, open space of a Caribbean landscape, drew its title and a miniature boating emblem from Johns's remembrance of his step-grandmother, Montez Johns, singing "Red Sails in the Sunset." Elsewhere, against the midnight-blue background of an untitled "bath" image of 1988 (plate 221), Johns introduced the motif of several small, spinning spiral galaxies, adding to the sense that he was intent not only on opening his art up to personal reference and reminiscence, but on extending its scope, pictorially and symbolically, in space as well as time.

—KV

Chronology

1985

In Stony Point, paints *Untitled* (LC# 319).

In Saint Martin, paints *Untitled (A Dream)* and *Summer*.

After *Summer* is completed but still untitled, Johns is invited to contribute illustrations to the book *Wallace Stevens Poems*, published by The Arion Press. With Stevens's poem "The Snow Man" in mind, Johns first considers making four prints on the theme of the seasons, but in the end only uses his recently finished painting as the basis for the book's frontispiece, which he titles *Summer*. He will then develop the seasons theme, however, in a series of paintings completed in 1986.[1] The paintings corresponding to the other seasons follow the structure and format of *Summer*.

> *I painted one here [in Saint Martin], at least one:* Summer, *which was the first. And that was actually influenced by this place, because when I began the painting, I didn't even have in mind that I was going to do four paintings. In a certain way,* Summer *is connected to this place in terms of its imagery. It was definitely this house. The hummingbird was in that tree, things of that sort. Sometimes I take something unfinished and bring it to New York and vice versa.*[2]

Untitled (LC# 319) and *Untitled (A Dream)* are the first paintings to include the image of a rectangular face with cartoonlike features, first used in a drawing of 1984 (LC# D-226).

The building of Johns's house in Saint Martin is completed.[3]

March: In Stony Point, executes four *Summer* drawings (LC# D-229, LC# D-230, LC# D-231, LC# D-232).

March 13–June 9: "1985 Biennial Exhibition," at the Whitney Museum of American Art, New York, includes *Racing Thoughts*, 1983, and *Untitled*, 1984 (plate 201).

April 5–May 3: "Jasper Johns: Trial Proofs and Proofs with Editions," an exhibition at Brooke Alexander, Inc., New York.

[Summer]: The artist James Meyer becomes Johns's studio assistant, working for him through 1991 and returning in the fall of 1994.[4]

July 9–August 23: "Jasper Johns: The Screenprints, 1968–1982," an exhibition at the Lorence-Monk Gallery, New York.

September: In Stony Point, where he makes a *Two Flags* drawing (LC# D-233).

September 14–October 5: "Jasper Johns: Foirades/Fizzles, Samuel Beckett," an exhibition at the Lorence-Monk Gallery.

October: Sarah Taggart starts work as Johns's assistant.

November 20, 1985–January 5, 1986: "Currents 30: Jasper Johns," an exhibition at the Saint Louis Art Museum, Saint Louis, Missouri, curated by Michael Edward Shapiro, includes three paintings and four drawings from 1983–84.

By December 16: In Stony Point, where he makes the drawing *Winter* (LC# D-234).

1986

Continuing work on the paintings of the four seasons, begins *Winter* in Saint Martin, and completes it at the Houston Street studio, which he has used mostly as office and storage space since 1974. Also at Houston Street, paints *Fall* and *Spring*. When not in Saint Martin, continues to live in Stony Point but works mainly at Houston Street, coming back and forth almost daily.

In Stony Point, makes the drawing *Study for Fall* (LC# D-248).

In Saint Martin, paints *Untitled* (LC# 306), *Flags* (LC# 308), and *Untitled* (LC# 310).

Untitled (M. T. Portrait) is also completed this year.[5]

January: Employs the image of Picasso's *Woman in Straw Hat*, 1936, for the first time, in an untitled drawing made in Saint Martin (plate 217). This image will appear repeatedly in Johns's work of 1987–91—in eight paintings, eleven drawings, and two prints.

> *It's a still life with a book and a vase. . . . It's rich in a kind of sexual suggestion, and extremely complicated on that level. And it seems so offhand. I just liked this painting, so I've been working on a number of paintings with it at once for the last year.*[6]

January–March: In Saint Martin and in Stony Point, makes drawings related to the seasons: *Winter* (LC# D-236), *Winter* (LC# D-237), *Summer* (LC# D-238), *Spring* (LC# D-239), *Fall* (LC# D-240), and *Study for Fall* (LC# D-241).

May 14–August 19: "Jasper Johns: A Print Retrospective," an exhibition at The Museum of Modern Art, New York, curated by Riva Castleman, includes around 150 prints dating from 1960 to 1985, as well as the two *Decoy* paintings of 1971 and the painting *Voice 2*, 1968–71. Over the next two years the exhibition will travel to West Germany, Spain, Austria, Texas, California, and Japan.[7]

Working from the 1983 painting *Ventriloquist*, Johns designs the exhibition poster.

May 17–June 30: "*Jasper Johns: L'Oeuvre graphique de 1960 à 1985*," an exhibition at the Fondation Maeght, Saint-Paul-de-Vence, includes ninety-five prints.

May 21: Johns receives the Gold Medal for Graphic Art from the American Academy and Institute of Arts and Letters, presented in New York by John Cage. An exhibition of works by newly elected members and award recipients, at the Art Galleries, Audubon Terrace, New York (May 21–June 15), includes thirty-three etchings from the book *Foirades/Fizzles*, 1976, by Johns and Samuel Beckett; the book *Foirades/Fizzles* itself; and the lithograph *Four Panels from Untitled 1972*, 1973–74.

May 25: Is awarded the "Wolf Prize in Arts—Painting 1986" from the Wolf Foundation, Israel.

June: Makes the drawing *Untitled* (LC# D-243), begun in Stony Point and finished in Saint Martin.

June 25–September 28: "*Arte e Scienza*; Art and Alchemy," the theme exhibition of the XLII Venice Biennale, includes the paintings *Tantric Detail I*, 1980, *Tantric Detail II*, 1981, and *Tantric Detail III*, 1981.

July: In Saint Martin, where he makes the drawing *Summer* (LC# D-242).

July 3: President Ronald Reagan presents the Medal of Liberty, designed by Johns, to twelve naturalized citizens at Governor's Island. The medal is a bronze cast from a pantographic reduction of the 1960 Sculp-metal *Flag*.

August–September: In Saint Martin, where he makes the drawing *Untitled* (LC# D-244).

October 14: Contributes the etching *Untitled*, 1981 (ULAE# 217), to "Artists for Artists: An Auction to Benefit New York Artists Housing," held at the Puck Building, New York.

November: In Saint Martin, where he makes drawings titled *Spring* (LC# D-247, LC# D-249) and also the drawing *The Seasons* (LC# D-250).

Before November 21: Finishes nine tracings from Jacques Villon's etching after Marcel Duchamp's *Bride*, eight of which are to be included in the print portfolio *The First Meeting of the Satie Society*, published by Osiris Editions, New York (plates 209–16).[8]

1987

At Houston Street, completes the painting *Two Flags on Orange*, begun in 1986.

In Saint Martin, completes the paintings *Untitled*, 1986–87 (LC# 311), and *Flags*, as well as the drawings *Untitled*, 1986–87 (LC# D-252), *Untitled*, 1986–87 (LC# D-253), and *Untitled* (LC# D-254).

In Stony Point, works on two untitled encaustic paintings in the same format (LC# 312 and plate 219) and on the drawing *Untitled* (LC# D-255).

With Leo Castelli, June 1986. Photograph: Hans Namuth.
© Hans Namuth 1986.

At 63rd Street, New York, with *The Bath*, 1988, in the background, April 18, 1988. Photograph: Hans Namuth. © Hans Namuth 1990.

January: In Saint Martin, falls off a ladder while pruning a tree and breaks his right arm.[9]

January 31–March 7: "Jasper Johns: The Seasons," an exhibition at the Leo Castelli Gallery (420 West Broadway), includes the paintings *Summer*, 1985, *Winter*, 1986, *Fall*, 1986, and *Spring*, 1986, along with related drawings and prints. There is a catalogue edited by David Whitney, with an essay by Judith Goldman.

March: Moves from the Houston Street studio to a brownstone on East 63rd Street (acquired in November 1985), at one point inhabited by Gypsy Rose Lee.[10] The first painting completed at this address will be *Two Maps*, 1989.

By March 16: In Saint Martin, where he makes the drawing *Untitled* (LC# D-256).

September 3: Death of Leo Castelli's wife, Toiny Castelli.

September 20–November 15: "Foirades/Fizzles: Echo and Allusion in the Art of Jasper Johns," an exhibition at the Grunwald Center for the Graphic Arts, Frederick S. Wight Art Gallery, University of California, Los Angeles, includes over 140 prints and trial proofs. There is a catalogue with essays by Richard S. Field, Andrew Bush, Richard Shiff, Fred Orton, James Cuno, and John Cage. Over the next year the exhibition will travel to Minnesota, Texas, Connecticut, and Georgia.[11]

Between September 22 and December 13: Attends an exhibition of Francisco de Zurbarán's work at the Metropolitan Museum of Art, where *Veil of St. Veronica* is on view.[12]

October 23–November 25: "The Drawings of Jasper Johns from the Collection of Toiny Castelli," an exhibition at Galerie Daniel Templon, Paris, includes sixteen drawings dating from 1955 to 1986. Over the next six months it will travel to California and New York.[13]

November: In Saint Martin, where he makes the drawings *Untitled* (LC# D-295) and probably *Untitled* (LC# D-294).

1988

In Saint Martin, paints *The Bath*.

In Stony Point, paints *Untitled* (plate 221) and *Untitled* (LC# 318).

All three paintings feature the image of Picasso's *Woman in Straw Hat*. Johns also uses this image for two untitled prints (ULAE# 242 and ULAE# 243) in which he experiments with carborundum, *a kind of grit, an abrasive material used for polishing and grinding, which comes in degrees of coarseness and fineness.*[14] This technique, first used by Joan Miró, has been suggested to Johns a year or two earlier by Maurice Payne, who prints these editions.

> *[Maurice Payne]'s an Englishman who lived in California for a long time. He worked solely on David Hockney's prints. Then he moved to New York and opened up his own shop. About a year ago he brought some copper plates to my house and suggested I try this technique. Only recently did I think what I was doing was appropriate.*[15]

Also in Saint Martin, makes the drawing *Sketch for Montez Singing* (LC# D-281), in which he for the first time uses the Icarus figure from Picasso's *Fall of Icarus*, 1958. Several years later Johns will return to this image in the drawings *Nothing At All Richard Dadd*, 1992, and *Untitled*, 1993–94 (plate 238), and

in the paintings *Mirror's Edge*, 1992, *Mirror's Edge 2*, 1993, *Untitled*, 1992–94 (plate 241), and *Untitled*, 1992–95 (plate 242).

Also in Stony Point, makes the drawings *Between the Clock and the Bed* and *Untitled* (LC# D-267), the latter begun in Saint Martin.

The Walker Art Center, Minneapolis, acquires over 200 prints by Johns, establishing the only complete collection of his published graphic work to that date.[16]

January: In Saint Martin, where he makes the drawing *Untitled* (LC# D-258).

February: In New York, makes the drawings *Untitled* (plate 218) and *Untitled* (LC# D-259), the latter for an upcoming benefit auction for St. Vincent's Hospital. The drawing incorporates a copy of the first page of the *New York Times* of February 14, 1988, which bears the headline "Spread of AIDS Abating, But Deaths Will Still Soar."[17]

March: In Saint Martin, where he makes the drawing *The Bath* (LC# D-261).

April: Makes two untitled drawings (LC# D-263 and LC# D-264).

May: Is awarded the Creative Arts Awards Medal for Painting by Brandeis University.[18]

[June 11–25]: In Venice for two weeks, staying at the Gritti Palace Hotel and working with curator Mark Rosenthal on the installation of his paintings in the U.S. Pavilion for the XLIII Venice Biennale.

June 26–September 25: "Jasper Johns: Work since 1974," an exhibition, curated by Rosenthal, in the Venice Biennale's U.S. Pavilion, includes thirty-four

"Jasper Johns: Work since 1974," installation view at the U.S. Pavilion, Venice Biennale, 1988. © Studio Fotografico Piermarco Menini/Michele Gregolin, Mestre, Venice.

paintings, drawings, and prints dating from 1974 to 1986. Johns is awarded the Grand Prize, the Golden Lion. Having left Venice before the Biennale's official opening, he receives news of the award while in a taxi in Basel. Organized under the auspices of the Philadelphia Museum of Art, the exhibition will later travel there.[19]

Michael Brenson writes in the *New York Times*, "The story of the 1988 Venice Biennale is Jasper Johns—the best known, most influential and probably the most complex American painter in the last 30 years. No one else in the 43d Biennale approaches him in stature.... Among American curators, critics, collectors, artists, and dealers in Venice, the respect for Johns is almost total. The assumption is that he is the greatest American artist since Jackson Pollock."[20]

In Basel, visits the exhibition *"Zeichnungen Hans Holbein d.J. aus der Sammlung I. M. Königin Elizabeth II. in Windsor Castle und aus der Öffentlichen Kunstsammlung Basel,"* at the Kunstmuseum Basel (June 12–September 4, 1988).

September: In New York, where he makes the drawing *Untitled* (LC# D-269).

October 22–November 12: "Jasper Johns, Bruce Nauman, David Salle," an exhibition at the Leo Castelli Gallery (420 West Broadway), includes two untitled paintings of 1987 (LC# 312 and plate 219) and the painting *The Bath*.

November 10: *False Start*, 1959, sells at Sotheby's at a record price for a work by a living artist.

December 8–30: "The 25th Anniversary Exhibition to Benefit the Foundation for Contemporary Performance Arts, Inc.," at the Leo Castelli Gallery (420 West Broadway) and Brooke Alexander, Inc., New York, includes the painting *Untitled*, 1988 (plate 221). Johns helps to organize the exhibition.[21]

1989

In Saint Martin, paints the first version of *Montez Singing*, in encaustic and sand, and makes the drawing *Untitled* (LC# D-300).

At 63rd Street, paints *Two Maps* and makes the drawings *Land's End* and *Two Maps*, the latter begun in Stony Point.

Produces drawings and etchings by juxtaposing the four images from the *Seasons* paintings in different configurations, such as horizontally or in cruciform shape.

Rizzoli International Publications, Inc., New York, publishes *Jasper Johns*, by Georges Boudaille.

Is elected an honorary academician of the Royal Academy of Arts, London.

January: In Saint Martin, where he makes drawings titled *The Seasons* (LC# D-270, LC# D-271, LC# D-272).

January 30: Is elected the thirty-eighth member of the South Carolina Hall of Fame. The induction ceremony takes place at Myrtle Beach Convention Center, with a tribute to Johns by Charles Wright; the unveiling by Johns's mother, Mrs. Robert E. Lee, of a portrait of Johns; and a response by Johns's sister Owen Lee, who represents him at the ceremony.

February 3–March 25: "Jasper Johns: The Maps," an exhibition at the Gagosian Gallery, New York, includes seven paintings, two drawings, and two lithographs.

February 25–April 23: *"Jasper Johns: Progressive Proofs zur Lithographie* Voice 2 *und Druckgraphik 1960–1988,"* an exhibition at the Kunstmuseum Basel. There is a catalogue with an essay by Dieter Koepplin.

March: In Saint Martin, where he makes the drawing *Montez Singing* (LC# D-282).

April: In Saint Martin, where he makes the drawings *Seasons* (LC# D-283), *The Seasons* (LC# D-276), and *Seasons* (LC# D-284).

May 17: Is elected a member of the American Academy of Arts and Letters. In connection with the ceremony, there is an exhibition of his works at the Academy Institute's Galleries, on Audubon Terrace, New York (May 18–June 11). It includes the paintings *Tantric Detail I*, *Tantric Detail II*, and *Tantric Detail III*, the *Dancers on a Plane* of 1979, and an *Untitled* of 1984 (plate 202).

Late June: In Stony Point, for the first time makes drawings by tracing the image of Hans Holbein the Younger's *Portrait of a Young Nobleman Holding a Lemur*, c. 1541, from the poster of the Basel exhibition of Holbein's drawings that Johns has visited the previous summer. The drawings are *Tracing* (LC# D-277), *Tracing* (LC# D-278), *Tracing* (LC# D-279, dated "29 June 1989"), and *Untitled* (LC# D-298). Johns will employ the same image in the drawing *Untitled (After Holbein)*, 1993; in the paintings *Untitled*, 1990 (plate 228), *After Holbein*, 1993, and *After Hans Holbein*, 1993; and in the prints each

titled *After Holbein*, 1993 (ULAE# 259, ULAE# 260, and ULAE# 261).

Riva Castleman said to me, "I wish you'd make me a picture about a person and their pet." I hadn't asked her, but when someone says something like that to you, your mind starts to work.[22]

By August 27: In Saint Martin, where he makes the drawings *Untitled* (LC# D-296) and, on September 4, *Untitled* (LC# D-297).

September 10–October 22: "Jasper Johns: Drawings and Prints from the Collection of Leo Castelli," an exhibition at the Butler Institute of American Art, Youngstown, Ohio. There is a catalogue with essays by Rebecca Mary Gerson, James Lucas, and Donald Miller.

Between September 10 and December 10: Travels to Basel to see the exhibition of Cézanne's *Bathers* at the Kunstmuseum. Two works that Johns owns are included in the exhibition: *Bather with Outstretched Arms*, c. 1883, and *Studies for Bathers*, c. 1877–80.[23]

October: In Saint Martin, where he makes the drawing *Untitled* (LC# D-299).

In late October Johns goes to London for the opening of the exhibition "Dancers on a Plane: John Cage, Merce Cunningham, Jasper Johns" (October 30–December 2), at the Anthony d'Offay Gallery, which includes six drawings and eight paintings by Johns, dating from 1979 to 1982. At the opening, on October 30, Cage reads a text, "Art Is Either a Complaint or Do Something Else: Mesostics on Statements by Jasper Johns." The show will later travel within England.[24] There is a catalogue with contributions by Susan Sontag, Richard Francis, Mark Rosenthal, David Vaughan, and David Sylvester.

With John Cage (left) and Merce Cunningham, New York, July 1989. Photograph: © Timothy Greenfield-Sanders.

203. **Untitled (A Dream)**. 1985
Oil on canvas
75 x 50″ (190.5 x 127 cm)
Robert and Jane Meyerhoff,
Phoenix, Maryland

344

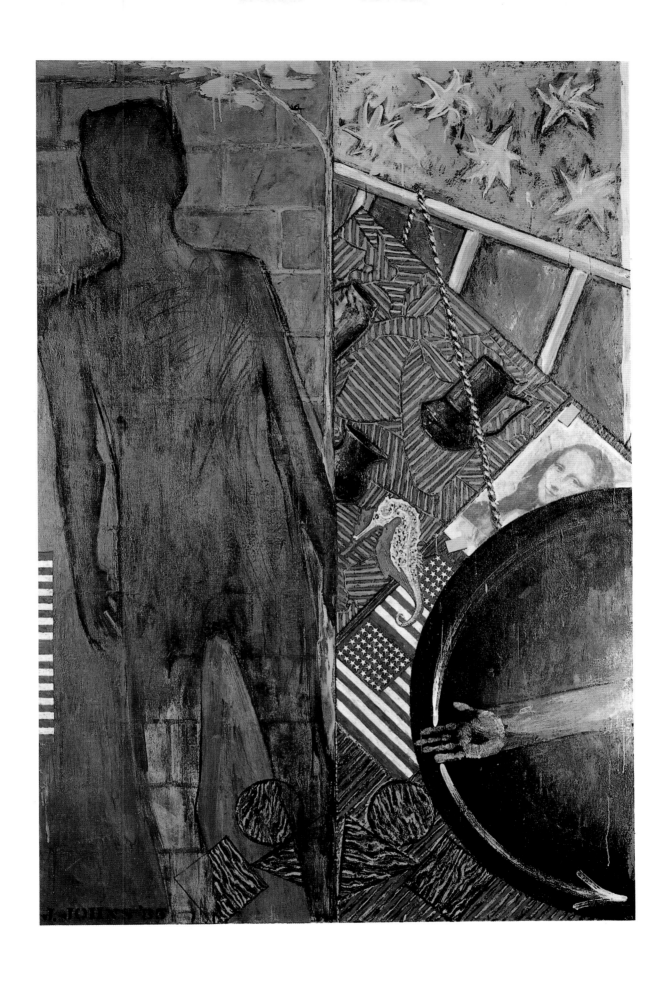

204. **Summer**. 1985
Encaustic on canvas
75 x 50″ (190.5 x 127 cm)
Collection Philip Johnson

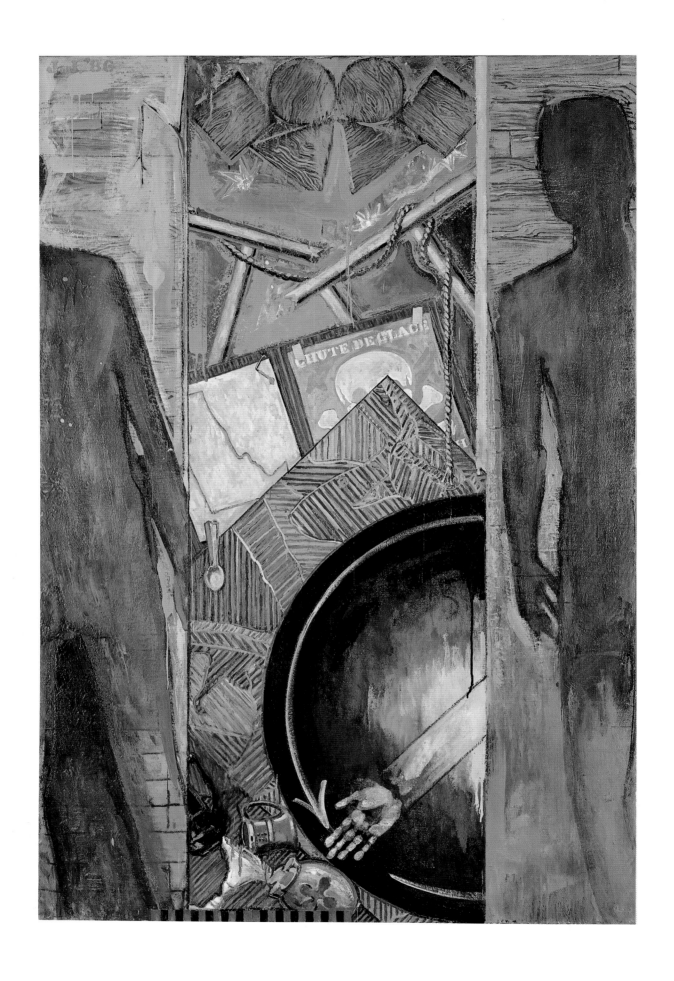

205. **Fall**. 1986
Encaustic on canvas
75 x 50″ (190.5 x 127 cm)
346 Collection the artist

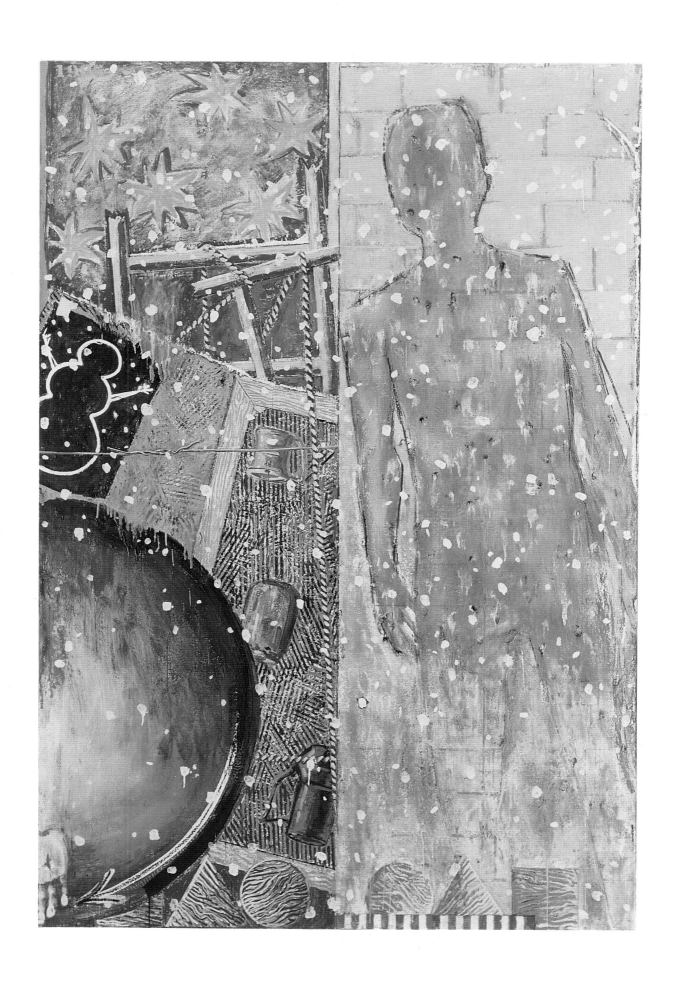

206. **Winter**. 1986
Encaustic on canvas
75 x 50″ (190.5 x 127 cm)
Private collection

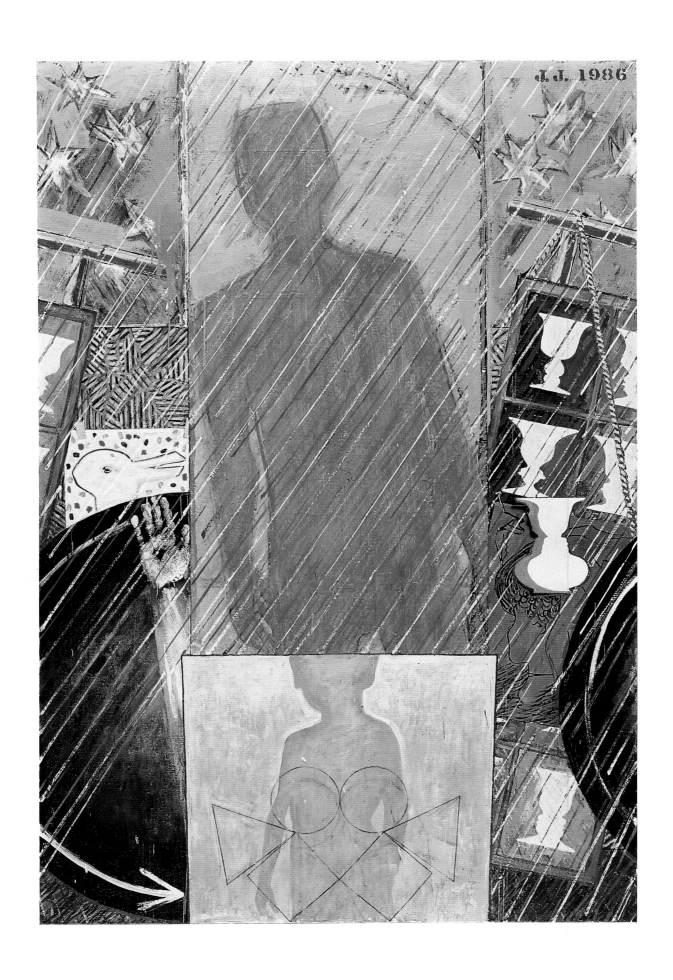

207. **Spring**. 1986
Encaustic on canvas
75 x 50″ (190.5 x 127 cm).
Robert and Jane Meyerhoff,
Phoenix, Maryland

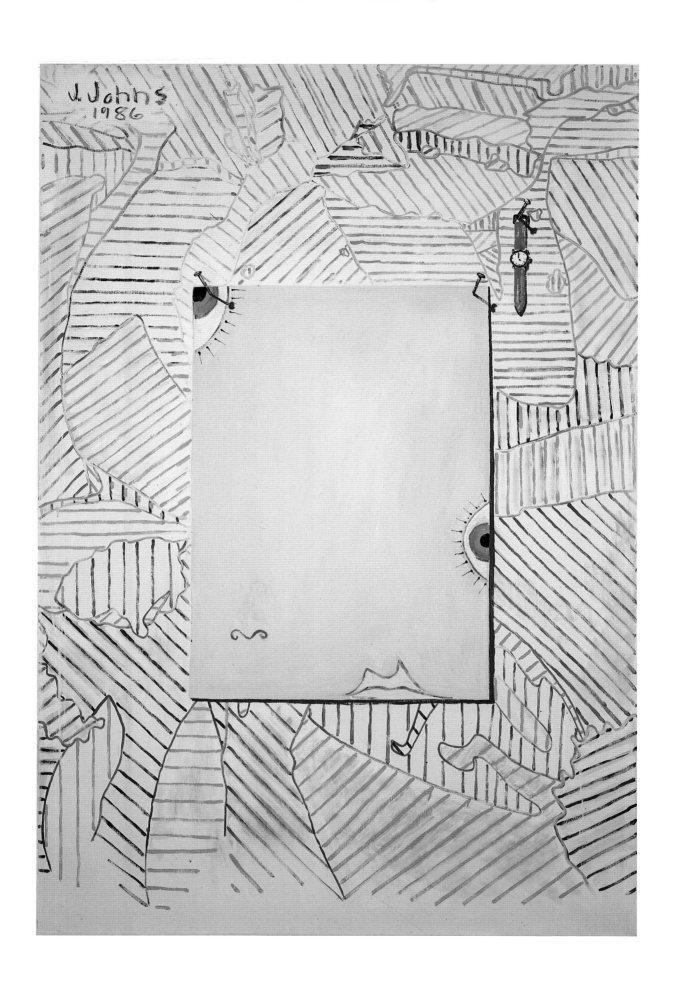

208. **Untitled (M. T. Portrait)**. 1986
Oil on canvas
75 x 50″ (190.5 x 127 cm)
Robert and Jane Meyerhoff,
Phoenix, Maryland

209. **Untitled**. 1986
Ink on plastic
26 x 18 ⅛″ (66 x 46 cm)
Collection the artist

210. **Untitled**. 1986
Ink on plastic
26 x 18 ⅛″ (66 x 46 cm)
Collection the artist

211. **Untitled**. 1986
Ink on plastic
25 ¹⁵⁄₁₆ x 18″ (65.9 x 45.7 cm)
Collection the artist

212. **Untitled**. 1986
Ink on plastic
25 ¹⁵⁄₁₆ x 18 ¼″ (65.9 x 46.3 cm)
Collection the artist

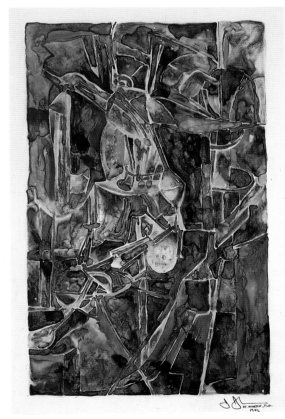

213. **Untitled**. 1986
Ink on plastic
25 7/8 x 18″ (65.7 x 45.7 cm)
Collection the artist

214. **Untitled**. 1986
Ink on plastic
25 15/16 x 18 3/16″ (65.9 x 46.1 cm)
Collection the artist

215. **Untitled**. 1986
Ink on plastic
26 x 18 1/8″ (66 x 46 cm)
Collection the artist

216. **Untitled**. 1986
Ink on plastic
25 15/16 x 18 1/4″ (65.9 x 46.3 cm)
Collection the artist

351

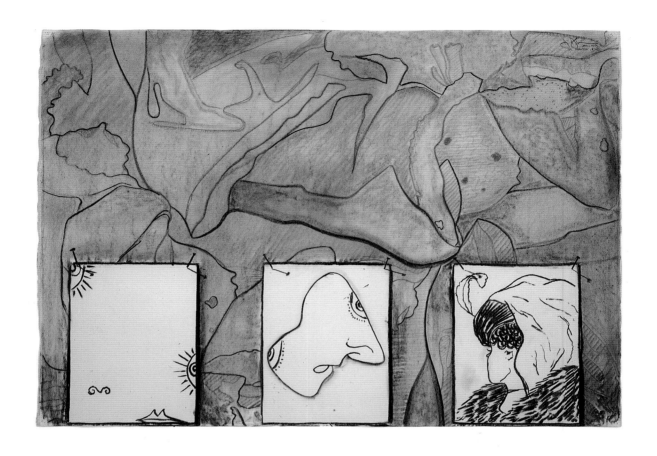

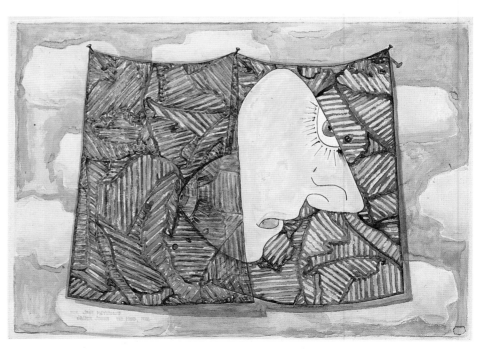

217. **Untitled**. 1986
Charcoal and pastel on paper
29 ¾ x 42″ (75.6 x 106.7 cm)
The Museum of Modern Art, New York.
Fractional gift of Agnes Gund

218. **Untitled**. 1988
Watercolor and ink on paper
27 ¾ x 38 ⅞″ (70.5 x 98.7 cm)
Robert and Jane Meyerhoff,
Phoenix, Maryland

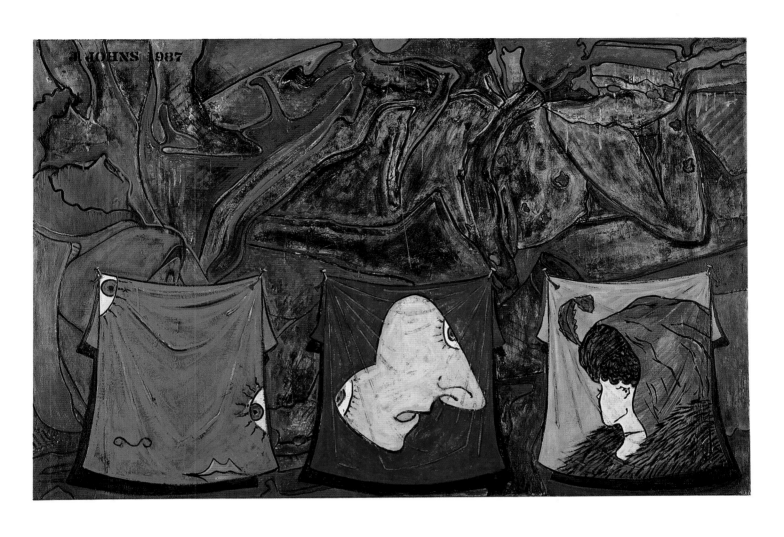

219. **Untitled**. 1987
Encaustic and collage on canvas
50 x 75″ (127 x 190.5 cm)
Robert and Jane Meyerhoff,
Phoenix, Maryland

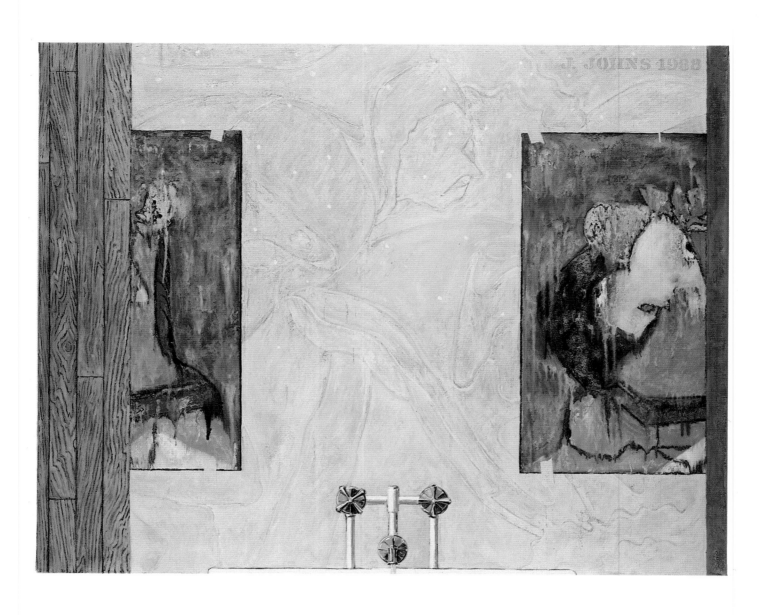

220. **The Bath**. 1988
Encaustic on canvas
48 ¼ x 60 ¼″ (122.6 x 153 cm)
Öffentliche Kunstsammlung Basel,
Kunstmuseum

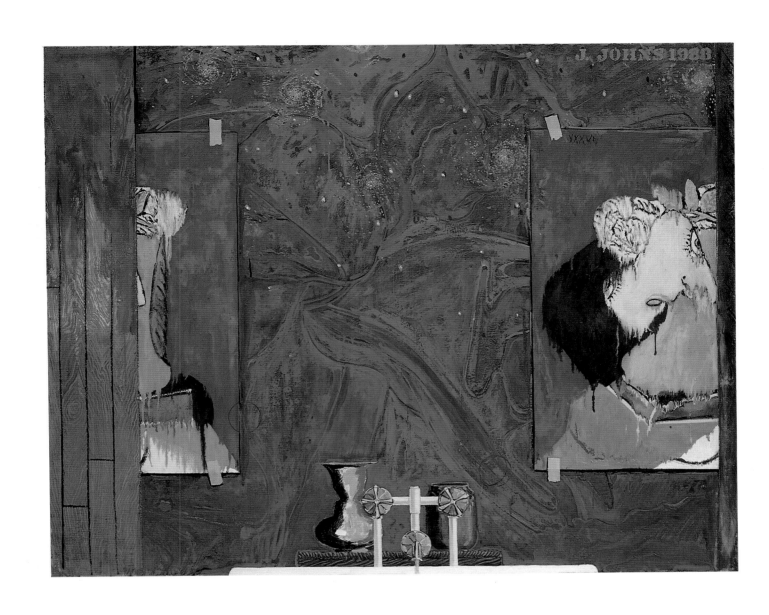

221. **Untitled.** 1988
Encaustic on canvas
48 ¼ x 60 ¼″ (122.6 x 153 cm)
Collection Joel and Anne Ehrenkranz

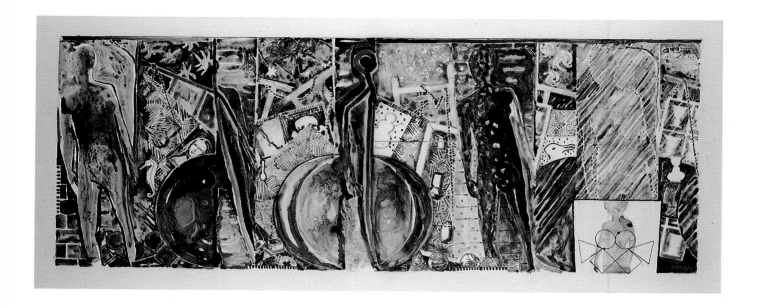

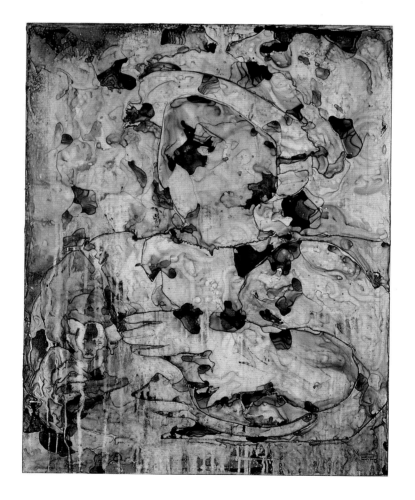

222. **The Seasons**. 1989
Ink on plastic
26 x 58″ (66 x 147.3 cm)
Collection the artist

223. **Tracing**. 1989
Ink on plastic
36 ¼ x 31″ (92.1 x 78.7 cm)
Collection Anne and Anthony d'Offay

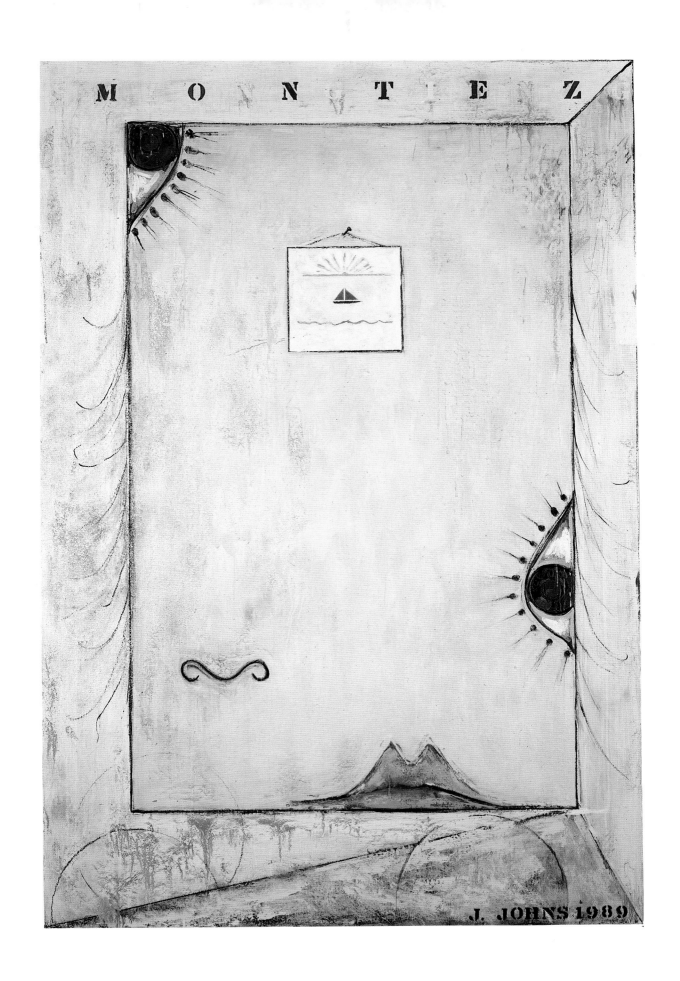

224. **Montez Singing**. 1989
Encaustic and sand on canvas
75 x 50″ (190.5 x 127 cm)
Collection Douglas S. Cramer

Johns has said that he felt as if he "aged twenty years" when he turned 60, in 1990, and he has also jokingly referred to some of the paintings from around this date as evidence of a "second childhood."[1] While certain of those works do have an insistent freshness that seems to bespeak an "innocent eye," Johns's paintings of the early 1990s also featured new surfaces toughened by sand, an enriched palette of exceptional colors (intense ochers, scarlets, greens, and purples, as well as flesh and blood), a complex sense of spatial layering, and more evidently personal themes of memory.

In keeping with the more open attention to art history that has marked the work since the early 1980s, the period saw an increase in traced imagery. Johns made a large suite of ink drawings on plastic, for example, by tracing a reproduction of a Cézanne *Bathers* composition, and he based several paintings and drawings on a tracing from a poster of Hans Holbein's *Portrait of a Young Nobleman Holding a Lemur*. The paintings based on the Holbein include some of the most aggressive hues and boldest puzzle-patterning anywhere in Johns's work. Most intriguing among the images based on tracings, however, is one that appears first in *Green Angel* of 1990, and in numerous works since, for which the artist has declined to identify his source. Johns had become dissatisfied with interpretations of earlier paintings in which critics depended heavily on a priori information to "see" motifs like the Grünewald details that were otherwise virtually indecipherable. In the face of such fresh evidence that knowing often replaces looking, he decided to force less prejudiced attention on the transformed motif as an image in its own right, independent of its original source.[2]

Mapped out (as in *Green Angel*) in picture-puzzle segments with separate colors and/or fields of diagonal striping, this unidentified motif typically imposes a dominant, organically irregular horizontal shape over the midline of a broad-based and complexly patterned vertical form, in a configuration that some have likened to a *pietà*. But Johns has also inverted the image, reversed it, and/or rotated it ninety degrees. He has typically joined it with the features of the "face" he developed in the late 1980s, which combines something "adult" in its difficulties and complexities with something "infantile" in its cartoon clarity.[3]

While developing that dislocated face, Johns had remembered a magazine illustration he had seen over thirty years before—a drawing of similarly disoriented features, made by a disturbed child.[4] Recovering the original illustration, in which a suckling infant's vision sets detached breasts, eyes, and nose free-floating in a rectangular field, Johns made it the central element in three identically sized untitled paintings of 1991 and 1991–94, in white, ocher, and purple respectively (plates 229–31). In parallel with these "regressions" to primal ways of seeing, the artist's attention to his own childhood also intensified, with renderings of an old family photograph and other indices of nostalgia.

In the two versions of *Mirror's Edge*, Johns revived the format of the studio wall with its trompe l'oeil panels of "taped" or "tacked" images, which here introduced more new imagery: a "blueprint" plan, reconstructed from memory, of the two floors of his grandfather's house, where he spent his earliest remembered years; a "photograph" of a spiral galaxy in deep space; and a globe-headed stick man derived from the figure of Icarus in a Picasso mural of the 1950s. In 1992–95, when Johns conceived a closely related pair of exceptionally large untitled canvases (plates 241 and 242), these elements, plus the unidentified traced motif, the cruciform shape from the 1990 etching *The Seasons*, and the linear contours of the Grünewald soldier, were all "laid over" the reversed imagery of the three-part *Untitled (Red, Yellow, Blue)* of 1984. Looking back beyond earlier "tackboard" pictures such as *Racing Thoughts*, 1983, to previous milestone works such as *According to What* of 1964, or the large, four-panel *Untitled* of 1972, these grand, summary pieces seem newly dematerialized, more truly synthetic in their weaving together of disparate motifs, and more complexly sophisticated in their painterly illusions. Symphonic in their orchestrations and dreamlike in the variety of their floating juxtapositions, they reformulate and synthesize the conundrums of picture-making and the concerns with time, memory, personal history, and art history that have absorbed Johns throughout his life as an artist. In characteristic fashion, they have also begun to serve as points of departure for a new cycle of work, including the 1995 lithograph on which—with its bold enlargement of the spiraling galaxy motif—the endpapers of the present volume are based.

—*KV*

Chronology

1990

In Saint Martin, completes the second, oil version of *Montez Singing*, 1989–90, and paints *Green Angel* and four untitled works (plate 228, LC# 326, LC# 327, and plate 225).

In Stony Point, paints *Untitled* (LC# 329) and makes the drawing *Untitled* (LC# D-331).

At 63rd Street, makes the drawing *Untitled* (LC# D-336) as a study for a poster for the Leo Castelli Gallery.

Also paints *Untitled* (LC# 324) and *Untitled* (LC# 328).[1]

In *Green Angel*, followed by three other paintings and sixteen of the drawings produced in 1990, Johns introduces a new image, probably a tracing from one or more artworks, that he has not identified.[2]

> *From my point of view, my perception is altered by knowing what it is, even though what it is is not what interests me....So when I made this picture I decided I wasn't going to say what it was.*[3]

Release of the film *Jasper Johns: Take an Object*, produced and directed by Hans Namuth and Judith Wechsler.

Revisits Grünewald's Isenheim Altarpiece in Colmar, with collectors Robert and Jane Meyerhoff.[4]

Donates the edition of the lithograph *Untitled*, 1990 (ULAE# 252), to benefit Harvey Gantt's campaign against Jesse Helms for a North Carolina seat in the United States Senate.

February 18–May 13: "Jasper Johns: Printed Symbols," an exhibition at the Walker Art Center, Minneapolis. There is a catalogue with a foreword by Martin Friedman, an introduction by Elizabeth Armstrong, essays by Robert Rosenblum, Charles Haxthausen, and James Cuno, and an interview with Johns by Katrina Martin. Over the next year and a half, the exhibition will travel to Texas, California, Canada, Missouri, Florida, and Colorado.[5]

February 27: Writes to Douglas W. Druick, curator at the Art Institute of Chicago, expressing satisfaction that his drawing *Perilous Night*, 1982 (plate 190), is at the Art Institute. Also confides that he has reused the three stick figures from this drawing in the fourth version of his etching *The Seasons*, 1990 (plate 227).[6] These stick figures will later reappear in two *Perilous*

At 63rd Street, New York, 1990. Photograph: Cori Wells Braun. © Cori Wells Braun.

In Stony Point, N.Y., working on *Untitled*, 1990 (LC# D-329), September 1990. Photograph: Thomas Hoepker. © Thomas Hoepker/Magnum Photos.

Night drawings of 1990 (LC# D-307 and LC# D-308) and an untitled drawing of 1992 (LC# D-346), as well as in the paintings *Mirror's Edge*, 1992, *Mirror's Edge 2*, 1993, *Untitled*, 1992–94 (plate 241), and *Untitled*, 1992–95 (plate 242).

March: Resumes work on the painting *Untitled*, 1987–91 (LC# 313), begun in Saint Martin.

April: In Saint Martin, executes the drawing *Perilous Night* (LC# D-307) and a number of untitled drawings predominantly employing the unidentified image used in *Green Angel* (LC# D-304, LC# D-305, LC# D-306, LC# D-309, and LC# D-314).

May 3–26: Contributes the lithograph *Bent "Blue"*, 1971 (ULAE# 97), to "Art against AIDS: On the Road," an exhibition to benefit the American Foundation for AIDS Research (AMFAR).

May 15–July 29: "The Drawings of Jasper Johns," an exhibition at the National Gallery of Art, Washington, D.C., curated by Nan Rosenthal and Ruth E. Fine, includes 114 drawings dating from 1954 to 1989. There is a catalogue by Rosenthal and Fine, with Marla Prather and Amy Mizrahi Zorn. Over the next year, the exhibition will travel to Switzerland, England, and New York.[7]

June: Makes the drawing *Untitled* (LC# D-315).

September 10: In Washington, D.C., receives the National Medal of the Arts, presented by President George Bush.

November 27, 1990–January 11, 1991: "Jasper Johns: New Drawings and Watercolours," an exhibition at the Anthony d'Offay Gallery, London, includes, among other works, twelve drawings reproduced in a 1991 calendar published by the gallery. As their main motif, these drawings feature the rectangular faces already used in other paintings and drawings.

1991

In Saint Martin, paints four untitled works (LC# 332, LC# 335, plate 230, and LC# 337).

Also paints three more untitled works during this year (plate 232, LC# 333, and plate 229).[8]

Untitled (plate 229) and *Untitled* (plate 230) are the first two of three 60-by-40-inch paintings that include an image of a child's drawing used as an illustration in Bruno Bettelheim's article "Schizo-phrenic Art: A Case Study," published in 1952 in the magazine *Scientific American*.[9]

In five other untitled paintings of this year (LC# 332, LC# 333, LC# 335, LC# 337, and LC# 349), Johns continues to use the unidentified image he introduced in 1990.

Makes a drawing (LC# D-337) for the poster of the twentieth annual *Festival d'Automne à Paris*. The drawing is one of the first to depict a folded-over sheet of paper, an image that will reappear in later paintings and drawings. (See also the folded sheet depicted in the drawing *Perilous Night*, 1990, LC# D-308.)

There is a drawing of flags from 1969 [Two Flags, LC# D-37] in which a corner has been bent back, something like this. But it began again when I made a poster for the Festival d'Automne in Paris last year. Someone had given me a Piranesi [the engraving Del Castello Dell'Acqua Giulia, 1761], and I was taken by his representation of folded paper, curling paper, so I used something like that in the poster. I have used it a couple of times since.[10]

February: At 63rd Street, completes the painting *Untitled* (LC# 313), begun in Saint Martin in 1987.

February 16–March 9: "Jasper Johns Paintings and Drawings," an exhibition at the Leo Castelli Gallery (420 West Broadway), New York, includes *Untitled (A Dream)*, 1985, *Untitled (M. T. Portrait)*, 1986, *Untitled*, 1986 (LC# 306), *Untitled*, 1986–87 (LC# 311), *Montez Singing*, 1989, *Montez Singing*, 1989–90, *Green Angel*, 1990, *Untitled*, 1990 (LC# 328), *Untitled*, 1990 (LC# 329), *Untitled*, 1990 (plate 225), *Untitled*, 1987–91 (LC# 313), *Untitled*, 1991 (plate 232), and *Untitled*, 1991 (LC# 332).

March 2–April 14: "Retrospective of Jasper Johns Prints from the Leo Castelli Collection," an exhibition at the Visual Arts Center, Brenau College, Gainesville, Georgia. The exhibition will travel until early 1992, visiting Israel and Belgium.[11]

At 63rd Street, 1992. Photograph: Jim Arkatov.

March 20–May 4: One of Johns's sketchbooks, dated c. 1970s–1980s, is shown in "Artists' Sketchbooks," the inaugural exhibition of the Matthew Marks Gallery, New York.

April 2–June 16: The "1991 Biennial Exhibition" at the Whitney Museum of American Art, New York, includes two of the untitled paintings of 1990 (LC# 328 and plate 225).

May: In Saint Martin, paints *Untitled* (LC# 349).

September: In New York, where he makes the drawing *Untitled* (LC# D-343).

November 9, 1991–January 4, 1992: "Jasper Johns: The Seasons (Prints and Related Works)," an exhibition at Brooke Alexander Editions, New York, includes fifty-seven works, including all published prints relating to *The Seasons*, along with selected proofs and working materials. There is a catalogue with an essay by Roberta Bernstein. Over the next year and a half the exhibition will travel to California and Spain.[12]

Johns makes a lithograph especially for the exhibition: *Summer*, published by ULAE (ULAE# 254).[13]

1992

At 63rd Street, makes four untitled paintings (LC# 339, LC# 340, LC# 350, LC# 351) and the drawing *Untitled* (LC# D-349). Johns also makes *Target*, which is based on his earlier *Black Target*, 1959, the work destroyed by fire in 1961 in the Governor's Mansion in Albany.[14]

In Saint Martin, completes the drawing *Untitled*, 1991–92, begun in New York.

This year Johns also makes the first version of *Mirror's Edge*, in oil. The painting contains a swirling pattern, a new element in his visual repertory, that also appears in the drawings *Untitled* (LC# D-345) and *Nothing At All Richard Dadd*, and in two untitled prints (ULAE# 256 and ULAE# 257). Beginning in 1993, it will appear in a number of paintings, drawings, and prints.[15]

That's based on a photograph of a spiral galaxy. As I worked on copper plates for my "Seasons" etchings, some of the stars turned into small spirals. More recently, I've worked with the galaxy image on a larger scale.[16]

Another element included in *Mirror's Edge* is the floor plan of Johns's grandfather's house in Allendale, South Carolina, where he spent part of his childhood. Other works featuring the floor plan are the

In Saint Martin,
December 1992.
Photograph: Jack Shear.

drawing *Nothing At All Richard Dadd*, 1992, and the paintings *Mirror's Edge 2*, 1993, *Untitled*, 1992–94 (plate 241), and *Untitled*, 1992–95 (plate 242).

Acquires a building adjacent to the 63rd Street studio.[17]

Rizzoli International Publications, Inc., publishes *Jasper Johns*, with text by Roberta Bernstein, in its Rizzoli Art series.[18]

January 16–August 9: "Jasper Johns, Richard Serra and Willem de Kooning: Works Loaned by the Artists in Honor of Neil and Angelica Rudenstine," an exhibition at the Arthur M. Sackler Museum, Harvard University Art Museums, Cambridge, Massachusetts, includes the paintings *The Dutch Wives*, 1975, the *Dancers on a Plane* of 1979, *Tantric Detail I*, 1980, *Tantric Detail II*, 1981, *Tantric Detail III*, 1981, three untitled works from 1984 (LC# 292, 294, and 295), and an untitled work from 1990 (LC# 330).

January 21–March 14: "Jasper Johns: According to What & Watchman," an exhibition at the Gagosian Gallery, New York, includes eleven works, among them the paintings *Watchman* and *According to What*, both 1964. There is a catalogue with an essay by Francis M. Naumann.

April 11–May 16: "Jasper Johns, Brice Marden, Terry Winters: Drawings," an exhibition at the Margo

Leavin Gallery, Los Angeles, includes eighteen drawings by Johns, dating from 1977 to 1992.

July 4–September 30: "*Jasper Johns: gravures et dessins de la collection Castelli, 1960–1991; Portraits de l'artiste par Hans Namuth, 1962–1989*," an exhibition at the Fondation Vincent van Gogh, Palais de Luppé, Arles, organized by Yolande Clergue. Later in the year the show will travel to Denmark.[19] There is a catalogue with preface by Marcelin Pleynet and essays by Michel Butor and Kathleen Slavin.

August 12: Death of John Cage, at the age of seventy-nine. Cage had written of Johns in 1964, "How lucky to be alive the same time he is! It could have been otherwise."[20]

December 4, 1992–March 7, 1993: "Hand-Painted Pop: American Art in Transition, 1955–62," an exhibition, curated by Paul Schimmel and Donna De Salvo, at the Museum of Contemporary Art, Los Angeles, includes fifteen paintings by Johns, dating from 1955 to 1962. Over the next year, the exhibition will travel to Illinois and New York.[21]

December 27: Johns's mother, Jeanette Riley Lee, dies in her home in Edisto Beach, at the age of eighty-seven. The burial takes place at the Cemetery Cave, United Methodist Church, Barnwell, South Carolina.

1993

Using the poster of Holbein's *Portrait of a Young Noble-man Holding a Lemur*, c. 1541, paints *After Hans Holbein* and *After Holbein*. Also paints *Mirror's Edge 2*.

Makes the lithograph *After Holbein* (ULAE# 261), to be published by the Association of Artists against Torture, Zurich, and printed by ULAE.[22]

Includes a portrait of his grandfather's family in an untitled drawing (plate 239).

January: In Saint Martin, where he makes the drawing *Untitled (After Holbein)*.

January 8–February 6: "Jasper Johns: 35 Years with Leo Castelli," an exhibition at the Leo Castelli Gallery (420 West Broadway), includes fourteen paintings dating from 1954–55 to 1992: *Flag*, 1954–55, *Target with Plaster Casts*, 1955, *Highway*, 1959, *By the Sea*, 1961, *Studio*, 1964, *Harlem Light*, 1967, *Corpse and Mirror*, 1974, *Weeping Women*, 1975, *Perilous Night*, 1982, *Racing Thoughts*, 1983, *Fall*, 1986, *Untitled*, 1987 (LC# 312), *Untitled*, 1990 (plate 225), and *Mirror's Edge*, 1992. There is a catalogue "scrapbook" documenting the years 1958–93, edited by Susan Brundage and containing an essay by Judith Goldman.

Between May 2 and August 15: Visits "Great French Paintings from the Barnes Foundation," an exhibition at the National Gallery, Washington, D.C. In 1994 Johns will make a series of drawings by tracing a poster from the show.[23]

October: In Tokyo, receives the Japan Art Association's Praemium Imperiale for painting, awarded annually for lifetime achievement in the arts. The other winners are conductor Mstislav Rostropovich, choreographer Maurice Béjart, sculptor Max Bill, and architect Kenzo Tange.

October 22, 1993–February 20, 1994: "Jasper Johns: Love and Death," an exhibition at the National Museum of American Art, Smithsonian Institution, Washington, D.C., includes the three *Tantric Detail* paintings, four prints, and three drawings.

[Fall]: Interviewed by Bryan Robertson and Tim Marlow, remarks, *I recently encountered the poems of Paul Celan, and I'm in love with them. I'm often surprised that when you fall in love with something it almost shocks you that you never knew it before.*[24]

December 9, 1993–January 8, 1994: Assists in the organization of "30th Anniversary Exhibition of Drawings," a benefit for the Foundation for Contemporary Performance Arts, held at the Leo Castelli Gallery (420 West Broadway).

1994

At 63rd Street, completes *Untitled*, 1991–94 (plate 231), the last of the three 60-by-40-inch paintings using the illustration from Bruno Bettelheim's article, and paints a small *Flag* in acrylic on canvas.

In Saint Martin, completes the painting *Untitled*, 1992–94 (plate 241), and paints *Untitled* (LC# 359), both in encaustic. Also makes the drawing *Untitled*, 1993–94 (plate 238), begun in New York.

Also paints *Untitled* (LC# 358), in oil.[25]

Makes seven *Flag* drawings over proofs of an unpublished lithograph, *Flag*, 1972.[26] Also makes the six drawings each titled *Tracing after Cézanne*, using a poster reproduction of Cézanne's *Nudes in Landscape*, 1900–1905, from the exhibition "Great French Paintings from the Barnes Foundation," at the National Gallery, Washington, D.C., in 1993.[27]

Makes an untitled lithograph, published by ULAE, to benefit the American Center, Paris, for the opening of its new building in June.[28]

Harry N. Abrams, Inc., New York, in association with the Whitney Museum of American Art, publishes *Jasper Johns*, by Michael Crichton, an expanded edition of their 1977 publication.

Figuring Jasper Johns, by Fred Orton, is published by Reaktion Books, Ltd., London.

May 20–June 18: "Jasper Johns' Prints from the Private Collection of Leo Castelli," an exhibition at the Leo Castelli Gallery (578 Broadway). The show is organized to coincide with the publication of *The Prints of Jasper Johns, 1960–1993: A Catalogue Raisonné*, published by ULAE, with an introduction by Richard S. Field.

August 14: Receives the Edward MacDowell Medal from the MacDowell Colony, Peterborough, New Hampshire. Kirk Varnedoe is the keynote speaker, and receives the medal on his behalf.

September: Acquires a house in Sharon, Connecticut.[29]

November 5, 1994–March 26, 1995: "Duchamp's Leg," an exhibition at the Walker Art Center, Minneapolis, Minnesota, includes Johns's *Painting Bitten by a Man*, 1961, the painting *Flags*, 1965, the sculpture *Subway*, 1965, the set for *Walkaround Time*, 1968, the lead relief *Light Bulb*, 1969, seven prints from the

series *Fragment—According to What*, 1971, and the lithograph *Fool's House*, 1972. At the end of 1995, the exhibition will travel to Florida.[30]

1995

At 63rd Street, completes the oil painting *Untitled* (plate 242), begun in 1992, and a *Usuyuki* watercolor.

In Saint Martin, paints *Untitled* (LC# 361), in encaustic, and *Untitled* (LC# 364), in oil.

In Sharon, paints *Untitled* (LC# 362), in acrylic over a mezzotint on paper mounted on canvas.

January 21–February 25: "On Target," an exhibition at the Horodner Romley Gallery, New York, which has commissioned nine artists to create a work that takes Johns's *Target* print of 1970 (ULAE# 89) as its point of departure. Participating artists are Janine Antoni, John Baldessari, David Diao, David Humphrey, Fabian Marcaccio, Tom Nozkowski, Kay Rosen, Jessica Stockholder, and Jack Whitten.

January 31–April 23: "Great French Paintings from the Barnes Foundation," the exhibition of the Barnes Collection that Johns has seen in 1993 in Washington, D.C., is now at the Philadelphia Museum of Art, where Johns revisits it.[31]

September: Acquires Cézanne's drawing *Self-Portrait*, c. 1880.[32]

November 21: Goes to the Philadelphia Museum of Art to see "Constantin Brancusi, 1876–1957." While there, arranges to see Marcel Duchamp's *Study for Étant Donnés...*, c. 1947.[33]

In Saint Martin, December 1992. Photograph: Jack Shear.

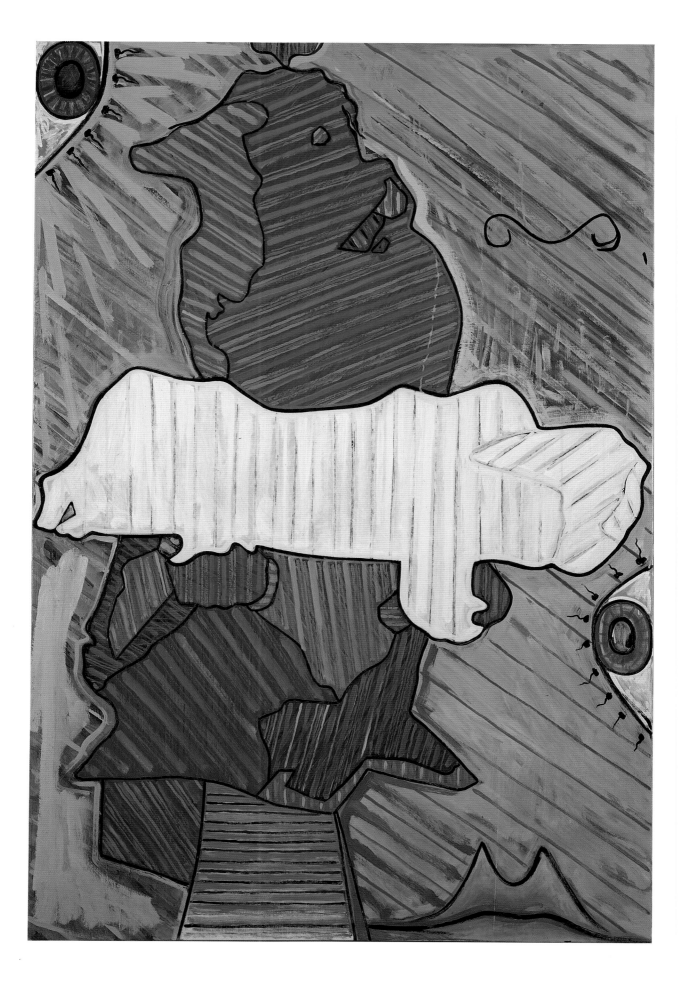

225. **Untitled**. 1990
Oil on canvas
75 x 50″ (190.5 x 127 cm)
Collection the artist

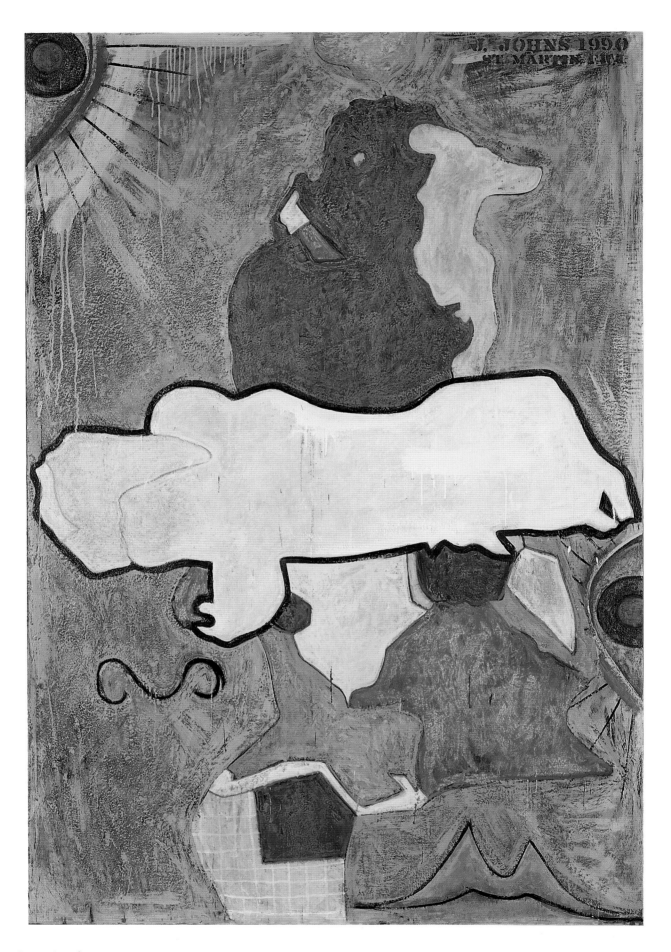

226. **Green Angel**. 1990
Encaustic and sand on canvas
75 ⅛ x 50 ³⁄₁₆″ (190.8 x 127.4 cm)
Collection Walker Art Center, Minneapolis.
Anonymous gift in honor of Martin and
Mildred Friedman, 1990

227. **The Seasons**
West Islip, N.Y.: Universal Limited Art
Editions, 1990
Aquatint, lift ground aquatint, etching,
and soft ground etching
50 ⅜ x 44 ⁹⁄₁₆″ (127.9 x 113.2 cm)
The Museum of Modern Art, New York.

Gift of Emily Fisher Landau

228. **Untitled**. 1990
Encaustic on canvas
32 ½ x 25 ⅝″ (82.5 x 65 cm)
Private collection

229. **Untitled**. 1991
Oil on canvas
60 x 40″ (152.4 x 101.6 cm)
Collection the artist

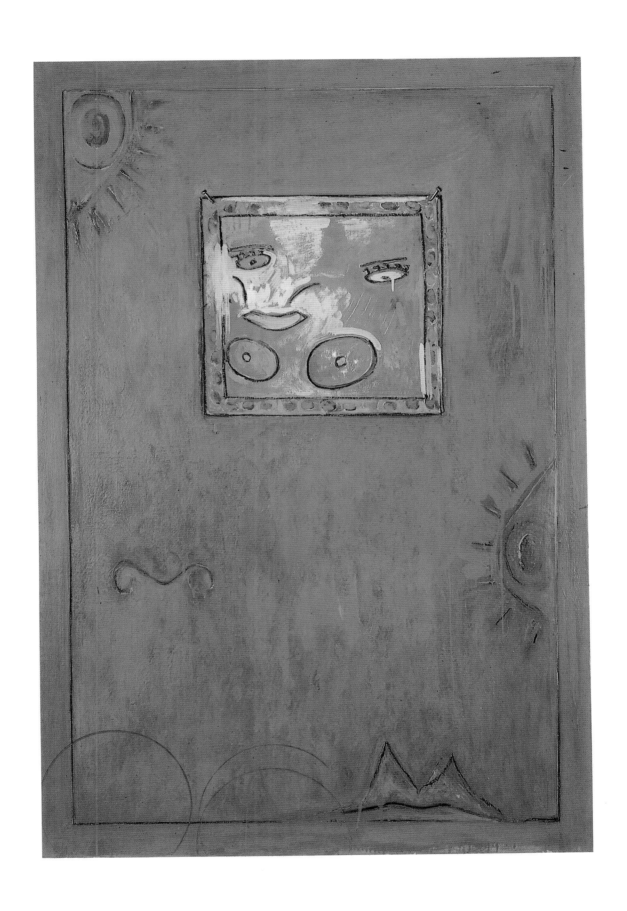

230. **Untitled**. 1991
Encaustic on canvas
60 x 40″ (152.4 x 101.6 cm)
Collection the artist

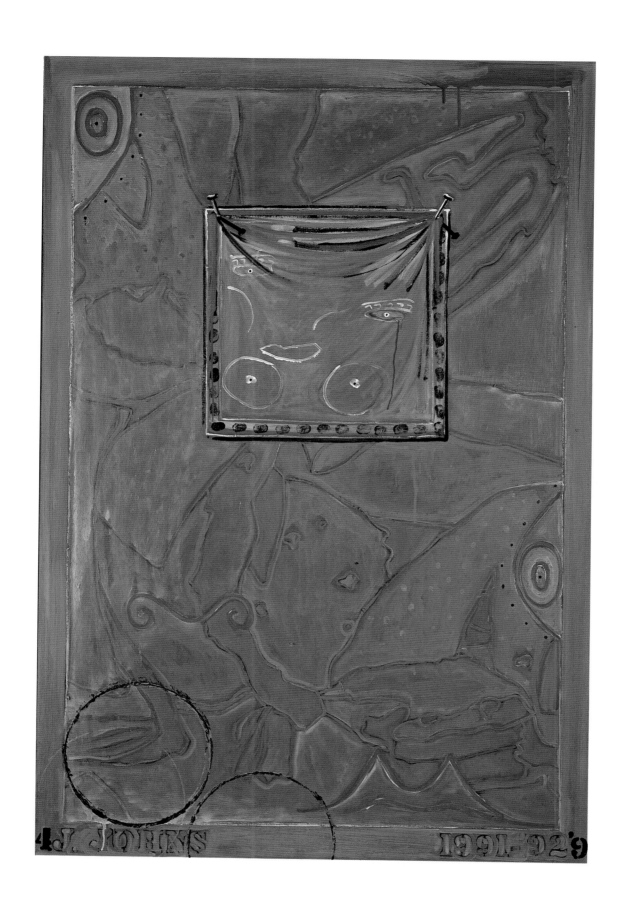

231. **Untitled**. 1991–94
Oil on canvas
60 ¼ x 40″ (153 x 101.6 cm)
372 Collection the artist

232. **Untitled.** 1991
Oil on canvas
48 ¼ x 60 ¼" (122.6 x 153 cm)
Collection Mr. and Mrs. S. I. Newhouse

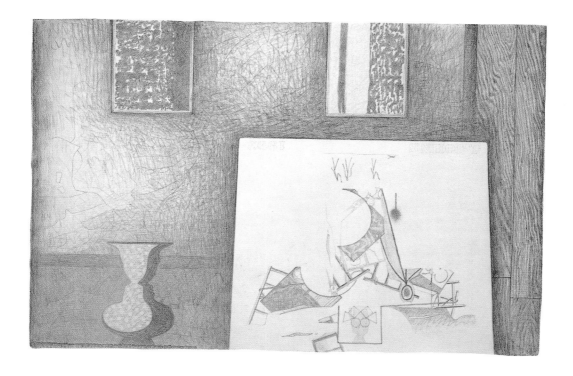

233. **Untitled**. 1991
Ink on plastic
34 x 45″ (86.4 x 114.3 cm)
Collection Sarah-Ann and
Werner H. Kramarsky

234. **Untitled**. 1992
Graphite pencil on paper
27 ¼ x 41 ¼″ (69.2 x 104.7 cm)
Private collection, courtesy
Matthew Marks Gallery, New York

235. Nothing At All Richard Dadd. 1992
Graphite pencil on paper
41 ¼ x 27 ½" (104.7 x 69.8 cm)
Collection the artist

236. **Mirror's Edge**. 1992
Oil on canvas
66 x 44″ (167.6 x 111.8 cm)
Collection Mr. and Mrs. S. I. Newhouse

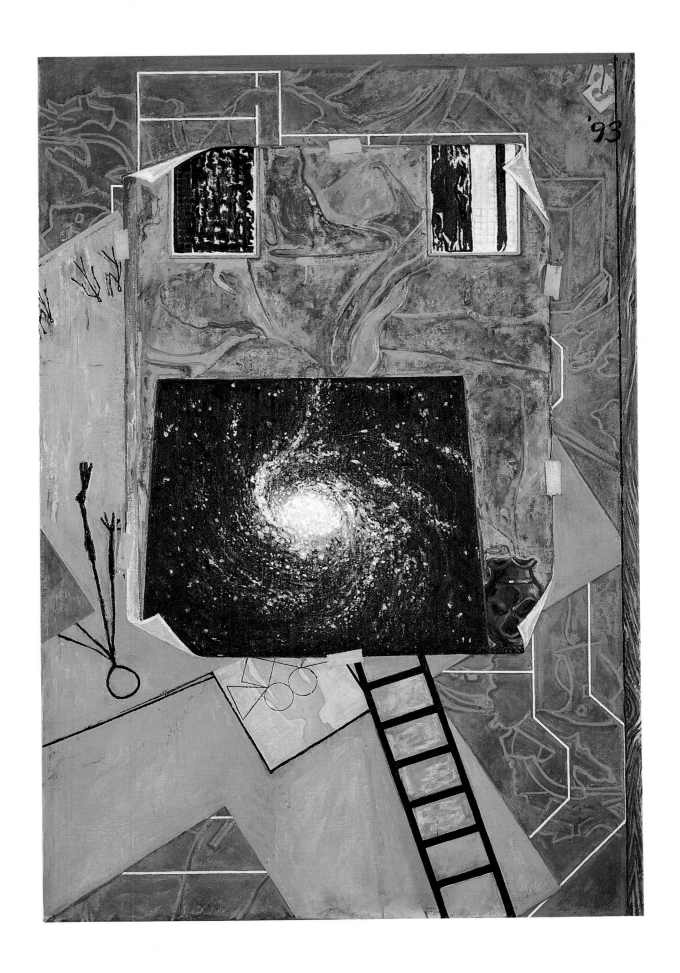

237. **Mirror's Edge 2**. 1993
Encaustic on canvas
66 x 44″ (167.6 x 111.7 cm)
Robert and Jane Meyerhoff,
Phoenix, Maryland

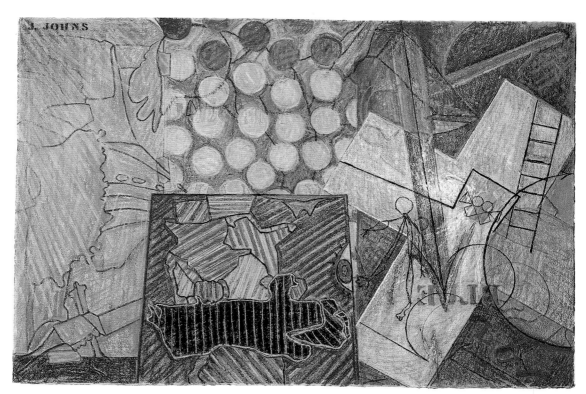

238. **Untitled.** 1993–94
Pastel, charcoal, and pencil
on paper
27 ⅝ x 40 ¾″ (70.1 x 103.5 cm
Private collection

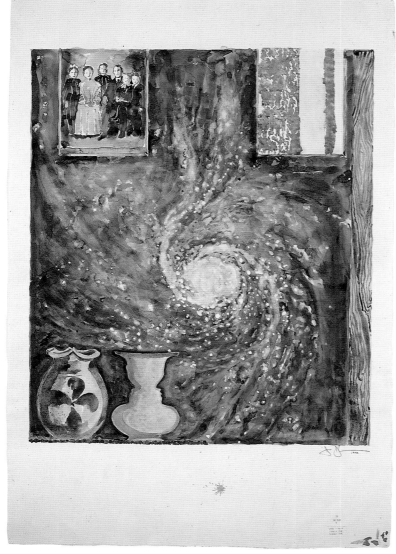

239. **Untitled.** 1993
Watercolor on paper
40 ⅞ x 27 ⅝″ (103.8 x 70.2 cm)
Private collection

240. **Untitled.** 1994
Pastel and charcoal on paper
27 ¼ x 13 ¾″ (69.2 x 34.9 cm)
Collection Kenneth and Judy Dayton

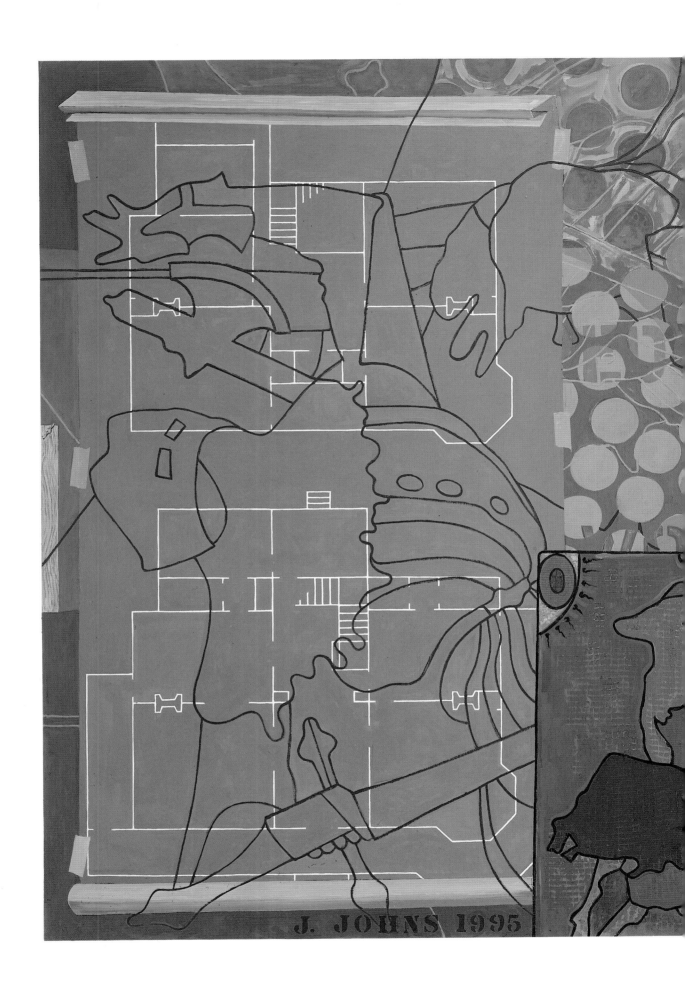

242. **Untitled**. 1992–95
Oil on canvas
78 x 118″ (198.1 x 299.7 cm)
The Museum of Modern Art, New York.
Promised gift of Agnes Gund

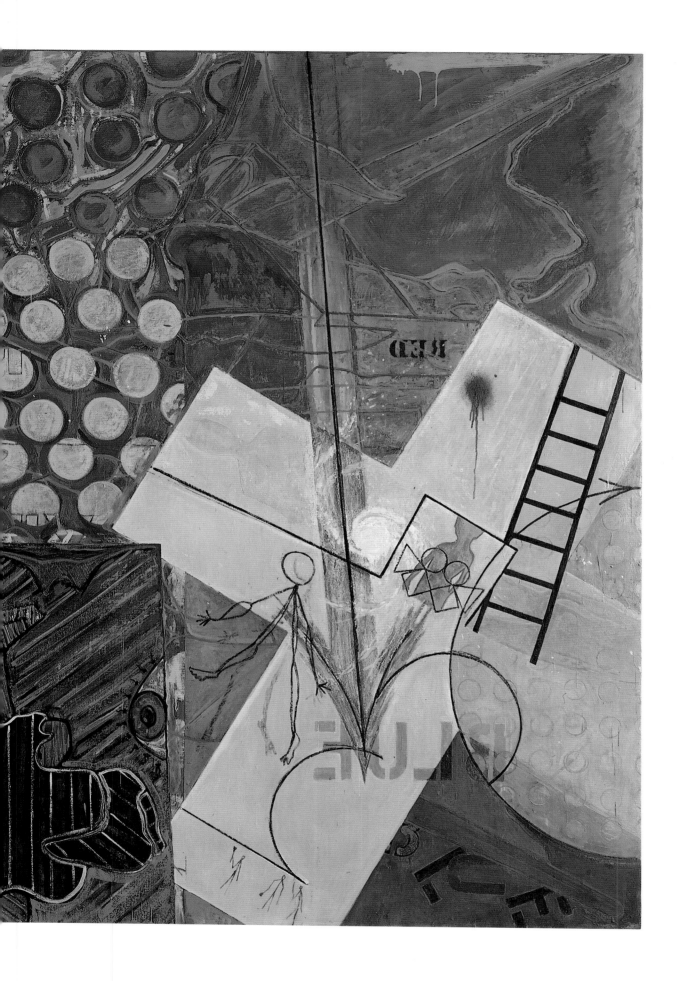

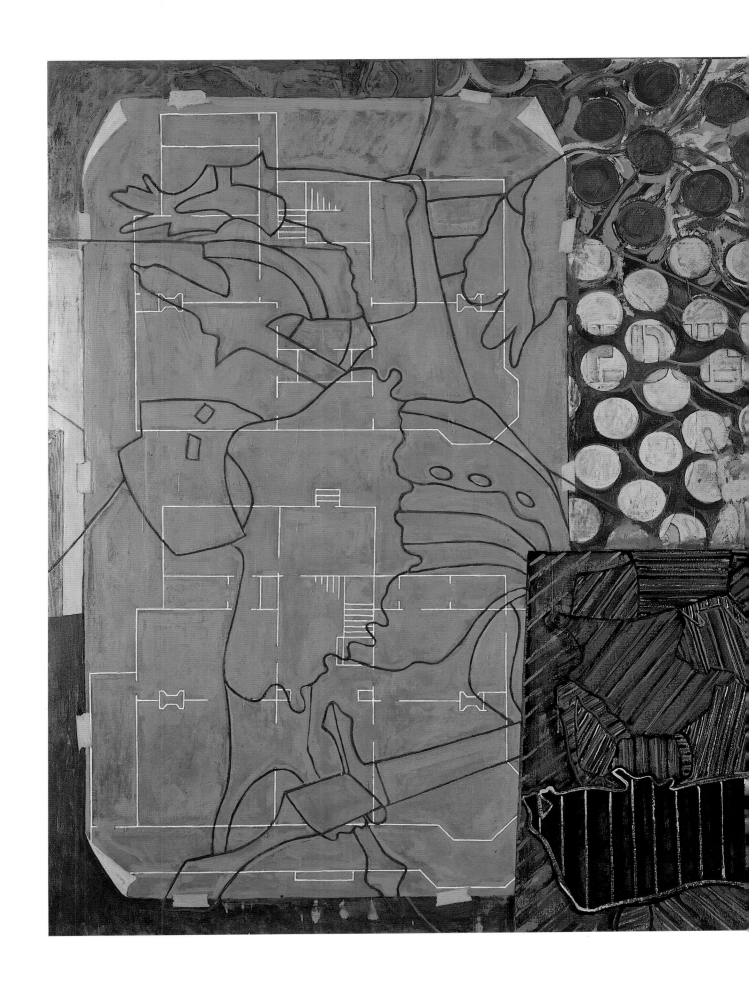

241. **Untitled**. 1992–94
Encaustic on canvas
78 x 118″ (198.1 x 299.7 cm)
Collection the artist

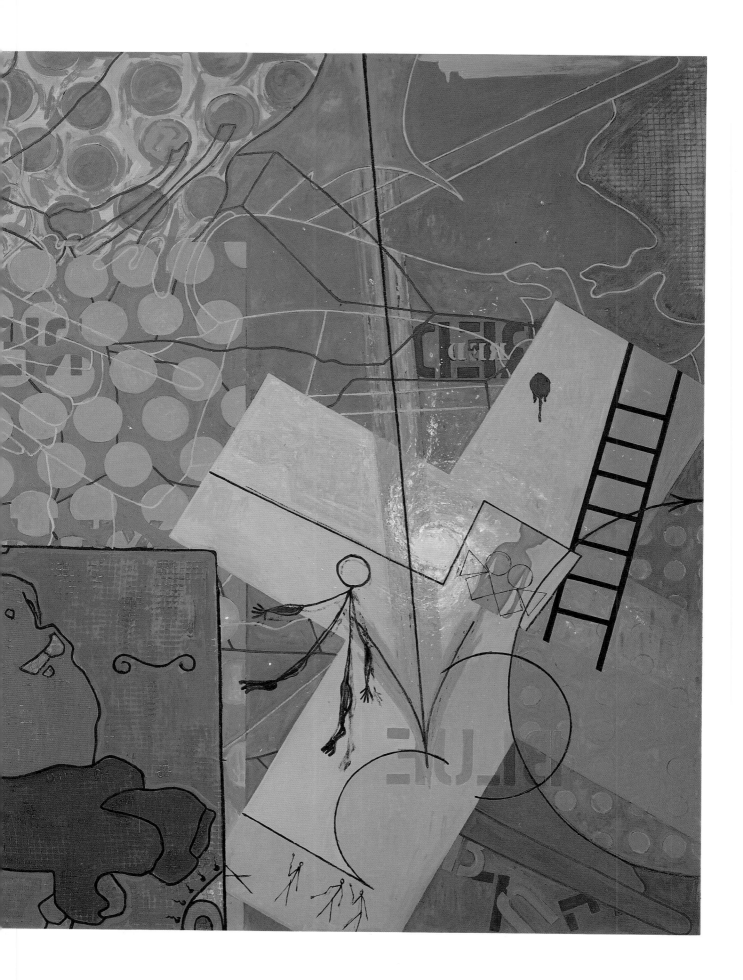

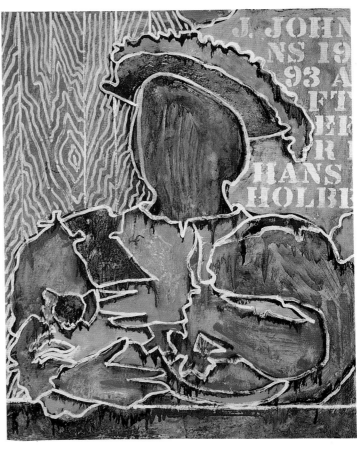

243. **After Holbein**. 1993
Encaustic on canvas
32 9/16 x 25 5/8″ (82.7 x 65.1 cm)
Private collection

244. **After Hans Holbein**. 1993
Encaustic on canvas
32 9/16 x 25 5/8″ (82.7 x 65.1 cm)
Private collection

245. **Tracing after Cézanne**. 1994
Ink on plastic
18 ¾ x 30 ⅜" (47.6 x 77.2 cm)
Collection the artist

246. **Tracing after Cézanne**. 1994
Ink on plastic
20 ¹⁄₁₆ x 28" (50.9 x 71.1 cm)
Collection the artist

247. **Tracing after Cézanne**. 1994
Ink on plastic
18 ⅛ x 28 ⅜" (46 x 72 cm)
Collection the artist

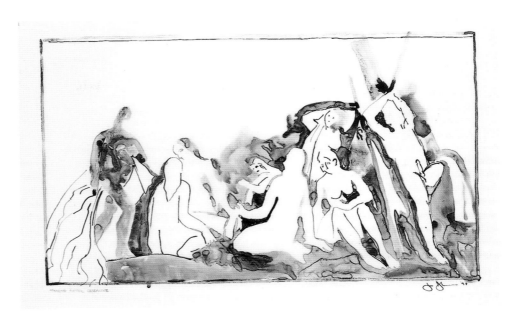

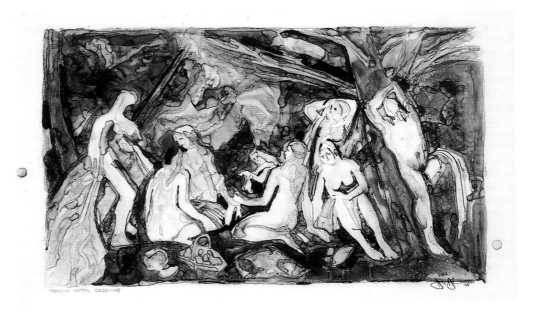

248. **Tracing after Cézanne**. 1994
Ink on plastic
17 9/16 x 28 3/16" (44.6 x 71.5 cm)
Collection the artist

249. **Tracing after Cézanne**. 1994
Ink on plastic
18 1/8 x 29 7/16" (46 x 74.7 cm)
Collection the artist

250. **Tracing after Cézanne**. 1994
Ink on plastic
18 x 28 1/8" (45.7 x 71.4 cm)
Collection the artist

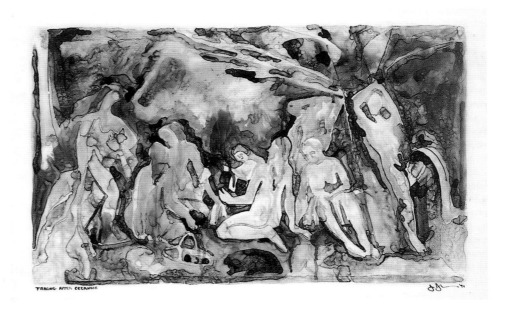

Notes to the Chronology

1930–1958

Introduction

1. "I was working in a bookstore, and you had little rectangular pads of paper to write orders on. I used to fold these sheets and then tear them, so that when they were opened the tears made a symmetrical design. This collage was a collection of torn sheets. The idea was to make something symmetrical that didn't appear to be symmetrical." Jasper Johns, quoted in Michael Crichton, *Jasper Johns* (first published 1977, revised and expanded edition New York: Harry N. Abrams, Inc., in association with the Whitney Museum of American Art, 1994), p. 76 (note 1).

2. Johns, in an interview with David Sylvester, recorded in the spring of 1965 and first broadcast, in England by the BBC, on October 10, 1965. Published as "Interview with Jasper Johns" in *Jasper Johns Drawings*, exh. cat. (London: Arts Council of Great Britain, 1974), p. 7.

3. Johns, quoted in Walter Hopps, "An Interview with Jasper Johns," *Artforum* 3 no. 6 (March 1965): 34.

4. Johns, in an interview with Billy Klüver, published as a 33 ⅓ r.p.m. record included in the catalogue *The Popular Image* (Washington, D.C.: Washington Gallery of Modern Art, 1963). Extracts from this interview appear in Klüver, *On Record: 11 Artists 1963, Interviews with Billy Klüver* (New York: Experiments in Art and Technology, 1981), where the quotation cited appears on p. 12.

5. Johns, quoted in April Bernard and Mimi Thompson, "Johns on….," *Vanity Fair* 47 no. 3 (February 1984): 65.

Chronology

1. Jasper Johns, written response to questions from Lilian Tone, December 15, 1995.

2. Notes from interview with Mary F. Young (Johns's cousin), January 25, 1967 (interviewer unknown). In Jasper Johns Vertical File, South Carolina State Library, Columbia, S.C. Johns's parents had married on September 9, 1927.

3. Jasper Johns, quoted in Sylvia L. McKenzie, "Jasper Johns Art Hailed Worldwide," *Charleston (S.C.) News and Courier*, October 10, 1965, p. 13-B.

4. Johns's other grandparents had died before he was born. His paternal grandmother was Evaline (or Evalina) Johns, née Wilson; his maternal grandparents were Richard Wilson Riley and Meta Dowling Simms. See W. H. Manning, Jr., "A History of Barnwell County," *Barnwell (S.C.) People Sentinel*, October 27, 1966, p. B1.

5. Mary F. Young, interview in South Carolina State Library.

6. Johns, quoted in Roberta Brandes Gratz, "After the Flag," *New York Post*, December 30, 1970, p. 25.

7. Johns, quoted in Barbaralee Diamonstein, *Inside the Art World: Conversations with Barbaralee Diamonstein* (New York: Rizzoli International Publications, 1994), p. 119.

8. Johns, quoted in Jo Ann Lewis, "Jasper Johns, Personally Speaking," *Washington Post*, May 16, 1990, p. F6. See also Diamonstein, *Inside the Art World*, p. 114.

9. Johns, quoted in D. R. Rickborn, "Art's Fair-Haired Boy: Allendale's Jasper Johns Wins Fame with Flags," *The State* (Columbia, S.C.), January 15, 1961, p. 20.

10. Manning, "A History of Barnwell County," p. 1. Johns's mother was probably living in Williston, S.C., at the time; Johns, in conversation with Tone, February 28, 1996.

11. Johns, quoted in Grace Glueck, "'Once Established,' Says Johns, 'Ideas Can Be Discarded,'" *New York Times*, October 16, 1977, p. 31.

12. Johns, quoted in Ruth E. Fine and Nan Rosenthal, "Interview with Jasper Johns," in Nan Rosenthal and Ruth E. Fine, with Marla Prather and Amy Mizrahi Zorn, *The Drawings of Jasper Johns*, exh. cat. (Washington, D.C.: National Gallery of Art, and New York and London: Thames and Hudson, 1990), p. 71. The date of 1935 for this incident is an estimated one.

13. Johns, quoted in Lewis, "Jasper Johns, Personally Speaking," p. F6.

14. Mary F. Young, interview in South Carolina State Library.

15. Johns, response to Tone, December 15, 1995.

16. Mary F. Young, interview in South Carolina State Library.

17. See John Cage, "Jasper Johns: Stories and Ideas," in Alan R. Solomon, *Jasper Johns: Paintings, Drawings and Sculptures 1954–1964*, exh. cat. (New York: The Jewish Museum, 1964), p. 23.

18. William I. Johns death certificate, Office of Vital Records, Columbia, S.C.

19. Allendale County Probate Court, Allendale, S.C.

20. Johns, response to Tone, December 15, 1995.

21. Mary F. Young, interview in South Carolina State Library.

22. Johns, quoted in Deborah Solomon, "The Unflagging Artistry of Jasper Johns," *New York Times Magazine*, June 19, 1988, p. 23.

23. Johns, response to Tone, December 15, 1995.

24. Mary F. Young, interview in South Carolina State Library. According to the South Carolina Department of Education, during

the school year 1944–45 nine students were enrolled in Climax. Information on the school prior to 1944 was not available. Johns, in conversation with Tone, February 28, 1996, recalled about twelve students being enrolled in the school.

25. Johns, quoted in Paul Taylor, "Jasper Johns," *Interview*, July 1990, p. 100. Johns, in conversation with Tone, February 28, 1996, has said that this happened sometime between 1942 and 1944.

26. Information provided by the University of South Carolina, Columbia.

27. "Allendale Artist: Paints What He Likes—Happens to Like Flags!," *Augusta (Ga.) Chronicle*, April 6, 1958.

28. Cage, "Jasper Johns: Stories and Ideas," p. 23.

29. Information provided by the University of South Carolina, Columbia.

30. Catharine Phillips Rembert (1905–90) had studied at various schools in New York, including Parsons School of Design. She had also studied with Hans Hofmann in Provincetown, Mass., and at the California School of Fine Arts, San Francisco. See Adger Brown, "Bundle of Happy Contradictions," *The State and the Columbia Record*, April 11, 1965, p. 16-D. See also *Catharine Rembert, Augusta Wittkowsky: Concentric Circles* (Columbia: McKissick Museum, University of South Carolina, 1989).

31. Catharine Phillips Rembert, quoted by Tom Johnson in his notes of an interview with her in c. 1989, Catharine Rembert file, The South Caroliniana Library, Columbia.

32. Rembert, quoted in Will Lester, "Jasper Johns' Story: An Inspiration to Dreamers," *The Record*, January 30, 1978.

33. Ibid. According to Johns, in conversation with Tone, February 28, 1996, the money was replaced by a loan from an uncle.

34. See Jerry Tallmer, "A Broom and a Cup and Paint," *New York Post*, October 15, 1977, p. 20.

35. Johns, response to Tone, December 15, 1995.

36. All these moves took place within a year. Johns, in conversation with Tone, February 28, 1996.

37. Johns, quoted in Mark Stevens with Cathleen McGuigan, "Super Artist: Jasper Johns, Today's Master," *Newsweek* 90 no. 17 (October 24, 1977): 73, 77. The date of 1949 for this event is an estimated one.

38. Johns, in an unpublished interview with David Bourdon, October 11, 1977. Courtesy David Bourdon.

39. Office of the University Registrar, New School for Social Research, New York.

40. See Diamonstein, *Inside the Art World*, p. 114.

41. Johns, quoted in Tallmer, "A Broom and a Cup and Paint," p. 20. In conversation with Tone, June 14, 1996, Johns amended this quotation: the school head was actually a woman.

42. See [Sarah Taggart], ["Chronology"], in *Dancers on a Plane: Cage, Cunningham, Johns* (first published 1989, reprint and enlarged ed. New York: Alfred A. Knopf, with Anthony d'Offay Gallery, London, 1990), p. 159, and Anna Brooke, "Chronology," in Richard Francis, *Jasper Johns* (New York: Abbeville Press, Modern Masters Series, 1984), p. 117.

43. See Roberta Bernstein, "'Seeing a Thing Can Sometimes Trigger the Mind to Make Another Thing,'" in the present volume, p. 71 (note 60).

44. Johns, in the unpublished interview with Bourdon.

45. In ibid., Johns mentions that he had seen Pollock's painting on glass at Betty Parsons. This exhibition included *Number 29, 1950*, Pollock's only painting on glass.

46. Ibid.

47. National Personnel Records Center, St. Louis, Mo.

48. See Bourdon, "Jasper Johns: 'I Never Sensed Myself as Being Static,'" *The Village Voice*, October 31, 1977, p. 75.

49. "Art & the Armed Forces," *Columbia Museum of Art News* II no. 8 (November 1951): 2.

50. "Art & the Armed Forces," *Columbia Museum of Art News* II no. 9 (December 1951): 2.

51. Ibid.

52. "Works of Two Major Artists to Be Shown at Museum," *The State* (Columbia, S.C.), December 4, 1960, p. 8D.

53. "Fort Jackson Gallery," *Columbia Museum of Art News* III no. 2 (February 1952): 2.

54. Bruno Bettelheim's "Schizophrenic Art: A Case Study" was published in *Scientific American* vol. 186 (April 1952): 31–34. "The Baby Drinking the Mother's Milk from the Breast" appeared there as fig. 10. The works by Johns that use this drawing include untitled paintings of 1991 (plates 229 and 230), 1991–94 (plate 231), and 1992 (LC# 350 and 351), and three untitled mezzotints completed in 1995 (ULAE# 264, 265, and 266). See also Michael Crichton, *Jasper Johns* (first published 1977, revised and expanded edition New York: Harry N. Abrams, Inc., Publishers, in association with the Whitney Museum of American Art, 1994), p. 80 (note 103).

55. Johns, in the unpublished interview with Bourdon.

56. See Bourdon, "Jasper Johns: 'I Never Sensed Myself as Being Static,'" p. 75.

57. Johns, quoted in Diamonstein, *Inside the Art World*, p. 115.

58. Yoshiaki Tono, ["Jasper Johns in Tokyo"], *Bijutsu Techô* (Tokyo), August 1964, p. 5. Translated from the Japanese by Tadatoshi Higashizono. Tono's original refers to a record by Pierre Boulez; in conversation with Tone, June 14, 1996, Johns amended this reference to Edgard Varèse.

59. National Personnel Records Center, St. Louis, Mo.

60. Johns, quoted in Diamonstein, *Inside the Art World*, p. 116.

61. Ibid.

62. See [Taggart], ["Chronology"], p. 159.

63. Johns, quoted in Glueck, "'Once Established,' Says Johns, 'Ideas Can Be Discarded,'" p. 31.

64. See [Taggart], ["Chronology"], p. 159.

65. See Diamonstein, *Inside the Art World*, p. 116, and Calvin Tomkins, *Off the Wall: Robert Rauschenberg and the Art World of Our Time* (Garden City, N.Y.: Doubleday & Company, Inc., 1980), pp. 109–10. See also Barbara Rose, *An Interview with Robert Rauschenberg* (New York: Random House, Inc., 1987), p. 47.

66. Johns, quoted in Stevens with McGuigan, "Super Artist," p. 77.

67. See Tomkins, *Off the Wall*, p. 111, where these works are described as lead drawings of potatoes, and Rosenthal and Fine, p. 86. Both Robert Rauschenberg and John Cage greatly admired these drawings.

68. Johns, in conversation with Tone, February 28, 1996.

69. See Diamonstein, *Inside the Art World*, p. 116, and Tomkins, *Off the Wall*, pp. 109–10.

70. See [Taggart], ["Chronology"], p. 159.

71. David Vaughan, "The Fabric of Friendship: Jasper Johns in Conversation with David Vaughan," in *Dancers on a Plane*, p. 137, and [Taggart], ["Chronology"], p. 159.

72. Rachel Rosenthal, quoted in an unpublished interview with Tomkins, June 2, 1978. Courtesy Calvin Tomkins.

73. Johns, quoted in Crichton, *Jasper Johns*, p. 76 (note 1). Johns has said he is not sure if this work was made at East 8th Street or in the studio he took later in 1954, at 278 Pearl Street. Johns, in conversation with Tone, December 15, 1995.

74. Bernstein, *Jasper Johns' Paintings and Sculptures 1954–1974: "The Changing Focus of the Eye"* (Ann Arbor: UMI Research Press, 1985), pp. 4, 44, 92.

75. Johns has said he first saw works by Joseph Cornell and René Magritte at about the same time. See Bernstein, "An Interview with Jasper Johns," in *Fragments: Incompletion and Discontinuity*, ed. Lawrence D. Kritzman, *New York Literary Forum* vol. 8–9 (1981): 287. During 1954, works by Cornell were included in at least two New York exhibitions: the "Third Annual Exhibition of Painting and Sculpture," at the Stable Gallery (January 27–February 20), and the 1954 Annual Exhibition at the Whitney Museum of American Art (March 17–April 18). See Bernstein, *Jasper Johns' Paintings and Sculptures*, p. 19, for a discussion of Magritte and Cornell as reference points for Johns's work of this period.

76. Rosenthal, quoted in the unpublished interview with Tomkins. Tomkins's notes from this interview also record that there was "no furniture in their lofts—just a wooden platform used for sleeping, eating, sitting. Bob and Jap used to come up to Rachel's to take baths."

77. Ibid.

78. Ibid.

79. See Crichton, *Jasper Johns*, pp. 26 and 76 (note 4), and Bernstein, *Jasper Johns' Paintings and Sculptures*, p. 217 (note 20).

80. See Crichton, *Jasper Johns*, p. 29. The few surviving examples of Johns's paintings from before 1955 were all by this point in the possession of others: *Untitled*, 1954 (plate 1), *Untitled*, 1954 (plate 5), *Star*, 1954, and *Construction with Toy Piano*, 1954. Besides the two drawings dated 1952, *Idiot* and *Tattooed Torso*, another work appears catalogued in the inventory of the Leo Castelli Gallery: *Untitled*, 1951, "board: 19 1/2 x 7 1/2", site: 18 1/2 x 6 1/8", LC# II." Its current location is unknown. On occasion, Johns acquired and destroyed early work. See Bernstein, *Jasper Johns' Paintings and Sculptures*, p. 5, and Stevens with McGuigan, "Super Artist," p. 77. He recalls one such instance when an early work was acquired by the Leo Castelli Gallery. Johns, in conversation with Tone, February 28, 1996.

81. Rosenthal, quoted in the unpublished interview with Tomkins.

82. Johns, quoted in Vivien Raynor, "Jasper Johns: 'I have attempted to develop my thinking in such a way that the work I've done is not me,'" *Artnews* 72 no. 3 (March 1973): 22.

83. See Bernstein, *Jasper Johns' Paintings and Sculptures*, p. 153. Johns has mentioned his *Flag* dream on numerous occasions since 1963. See Lil Picard, "Jasper Johns," *Das Kunstwerk* 17 no. 5 (November 1963): 6; the interview with Alan Solomon in the film *U.S.A. Artists: Jasper Johns*, 1966; Gratz, "After the Flag," p. 25; the interview with Emile de Antonio in the film *Painters Painting*, 1972; the unpublished interview with Yoshiaki Tono, 1975; Glueck, "'Once Established,' Says Johns, 'Ideas Can Be Discarded,'" p. 31; Roberta J. M. Olson, "Jasper Johns: Getting Rid of Ideas," *Soho Weekly News* 5 no. 5 (November 3, 1977): 25; Peter Fuller, "Jasper Johns Interviewed I," *Art Monthly* no. 18 (July–August 1978): 10; and Deborah Solomon, "The Unflagging Artistry of Jasper Johns," p. 63.

84. Johns, quoted in Emile de Antonio and Mitch Tuchman, *Painters Painting: A Candid History of the Modern Art Scene 1940–1970* (New York: Abbeville Press, 1984), p. 97.

85. Fairfield Porter, "Third Annual," *Artnews* 53 no. 9 (January 1955): 48.

86. *Flag* was dated 1954 (the date Johns inscribed on the painting's back) by The Museum of Modern Art until 1976, when a visitor pointed out that it contained collaged newspaper dating from 1955 and 1956. The presence of newsprint dating from 1956, though, is due to an accident during a party in Johns's studio: *Flag* was hanging on a temporary wall that fell, damaging the painting. When Johns repaired it he used current newspapers. See Milton Esterow, "The Second Time Around," *Artnews* 92 no. 6 (Summer 1993): 149; Bernstein, *Jasper Johns' Paintings and Sculptures*, p. 215 (note 1); and Joan Carpenter, "The Infra-Iconography

of Jasper Johns," *Art Journal* 36 no. 3 (Spring 1977): 224.

87. Marian Sarach, in conversation with Tone, September 12, 1995.

88. Initially, *Short Circuit* was also to include works by Ray Johnson and Stan Vanderbeek. On June 8, 1965, Leo Castelli discovered that the Johns painting had been stolen from the work. See Crichton, *Jasper Johns*, pp. 76–77 (note 23). It was replaced by a flag painting by Elaine Sturtevant, painted in the manner of Johns's work.

89. Chronologies generally record Rauschenberg moving to Pearl Street from his Fulton Street studio around December 1954–January 1955. See Walter Hopps, *Robert Rauschenberg*, exh. cat. (Washington, D.C.: National Collection of Fine Arts, Smithsonian Institution, 1976), p. 34; Hopps, *Robert Rauschenberg: The Early 1950s*, exh. cat. (Houston: The Menil Collection and Houston Fine Art Press, 1991), p. 227; and Kirk Varnedoe, "Inscriptions in Arcadia," *Cy Twombly: A Retrospective*, exh. cat. (New York: The Museum of Modern Art, 1994), p. 61 (note 89). According to Tomkins's *Off the Wall*, however (p. 118), Rauschenberg moved to Pearl Street when Rachel Rosenthal's father died, which, according to Rosenthal, happened in the summer of 1955. Johns has confirmed this in his response to Tone, December 15, 1995.

90. Rauschenberg, quoted in Tomkins, *Off the Wall*, p. 118.

91. Johns, quoted in Dodie Kazanjian, "Cube Roots," *Vogue* no. 179 (September 1989): 729.

92. According to Rosenthal, in the unpublished interview with Tomkins. See also Alan R. Solomon, *Jasper Johns*, exh. cat. (New York: The Jewish Museum, 1964), p. 8.

93. Rauschenberg, quoted by Rosenthal in the unpublished interview with Tomkins.

94. See Vaughan, "The Fabric of Friendship," p. 137; Andy Warhol and Paul Hackett, *Popism: The Warhol '60s* (New York and London: Harcourt Brace Jovanovich, 1980), p. 4; and David Revill, *The Roaring Silence. John Cage: A Life* (New York: Arcade Publishing, 1992), p. 184.

95. Cage, quoted in Mary Lynn Kotz, *Rauschenberg, Art and Life* (New York: Harry N. Abrams, Inc., 1990), p. 89.

96. Johns, quoted in D. K. [Donald Key], "Johns Adds Plaster Casts to Focus Target Paintings," *Milwaukee Journal*, June 19, 1960, p. 6.

97. Johns, quoted in Joseph E. Young, "Jasper Johns: An Appraisal," *Art International* 13 no. 7 (September 1969): 51.

98. Gene Moore and Jay Hyams, *My Time at Tiffany's* (New York: St. Martin's Press, 1990), p. 70.

99. Ibid., p. 227.

100. Ibid., pp. 80, 227.

101. See Olson, "Jasper Johns: Getting Rid of Ideas," p. 25. Johns, in conversation with Tone, February 28, 1996, said that although this exhibition was probably not the first time he saw Guston's work, it left a strong impression.

102. Johns, in conversation with Tone, February 28, 1996. Johns is uncertain of the exact date, but 1957 is his best estimate.

103. See Ann Hindry, "Conversation with Jasper Johns/*Conversation avec Jasper Johns*," in English and French, *Artstudio* no. 12 (Spring 1989): 16, and Hopps, "An Interview with Jasper Johns," *Artforum* 3 no. 6 (March 1965): 34.

104. Johns, quoted in Diamonstein, *Inside the Art World*, p. 116.

105. Moore and Hyams, *My Time at Tiffany's*, p. 227.

106. According to Anne Livet, *The Works of Edward Ruscha*, exh. cat. (San Francisco: San Francisco Museum of Modern Art, 1982), p. 157, this reproduction in *Print* made a strong impact on Ruscha, who credits "Johns's flags and targets as the reason for his becoming an artist."

107. See Bernstein, *Jasper Johns' Paintings and Sculptures*, pp. 219–20 (note 55), and Johns's account of how *Green Target* came to be in the show in Diamonstein, *Inside the Art World*, p. 117.

108. Leo Castelli's appointment book for this date.

109. Ibid., and Tomkins, *Off the Wall*, p. 141.

110. Tomkins, *Off the Wall*, p. 142.

111. Information relating to date provided by Allendale County Probate Court. Information relating to place provided by Johns in conversation with Tone, February 28, 1996.

112. Although Susan Hapgood, in *Neo-Dada: Redefining Art, 1958–62*, exh. cat. (New York: The American Federation of Arts, 1994), p. 58 (note 1), dates the first use of the term "Neo-Dada" to 1958, it appears in Robert Rosenblum, "Castelli Group," *Arts* 31 no. 8 (May 1957): 53. In a later instance, Rosenblum warned against the danger of thoughtlessly identifying Johns with Dada, advising that "such facile categorization needs considerable refining. To be sure, Johns is indebted to Duchamp (if hardly to other, more orthodox Dadaists), whose unbalancing assaults on preconceptions were often materialized in terms of a comparably scrupulous craftsmanship, yet he is far more closely related to the American Abstract Expressionists." Rosenblum, "Jasper Johns," *Art International* 4 no. 7 (September 25, 1960): 77.

113. Robert Motherwell, ed., *The Dada Painters and Poets: An Anthology* (New York: Wittenborn, Schultz, Inc., 1951).

114. Johns has said that he was unfamiliar with Marcel Duchamp's work until after his first solo exhibition, in 1958. See, among others, Bernstein, *Jasper Johns' Paintings and Sculptures*, p. 221 (note 2); Francis Naumann, *Jasper Johns: According to What & Watchman* (New York: Gagosian Gallery, 1992), pp. 17–18; Crichton, *Jasper Johns*, p. 78 (note 42); and Hindry, "Conversation with Jasper Johns," p. 6. Johns has also said, however, "I first went to see [Duchamp's] work in the Arensberg Collection when someone referred to me as 'neo-Dada,' and I did not know what Dada was." See Fuller, "Jasper Johns

Interviewed I," p. 10. This statement suggests that Johns's trip to Philadelphia may have taken place shortly after the publication of Rosenblum's 1957 review.

115. Castelli's appointment book.

116. Johns, in conversation with Tone, June 14, 1996.

117. For the Duchamp works in Johns's collection in 1970, see Bernstein, *Jasper Johns' Paintings and Sculptures*, pp. 224–25 (note 8).

118. Johns, response to Tone, December 15, 1995.

119. Johns, quoted in Fuller, "Jasper Johns Interviewed I," p. 8.

120. Tomkins, *Off the Wall*, p. 144.

121. Billy Klüver and Julie Martin, unpublished interview with Jasper Johns, February 26, 1991.

122. Dorothy Miller, quoted in Lynn Zelevansky, "Dorothy Miller's 'Americans,' 1942–63," *Studies in Modern Art* no. 4 (1994): 81.

123. Tomkins, *Off the Wall*, p. 144.

124. Rickborn, "Art's Fair-Haired Boy," p. 20.

125. Letter from Castelli to Alfred H. Barr, Jr., February 17, 1958, Leo Castelli Gallery Archives.

126. See Zelevansky, "Dorothy Miller's 'Americans,'" p. 104 (note 157).

127. Lil Picard, "Jasper Johns," *Das Kunstwerk* 17 no. 5 (November 1963): 6. Translation from the German by Henry F. Odell, in the Leo Castelli Gallery Archives.

128. See Bernstein, *Jasper Johns' Paintings and Sculptures*, pp. 39–40, for a discussion of the difference in style involved in the use of encaustic or oil.

129. "Targets and Flags," *Newsweek* 51 no. 13 (March 31, 1958): 96.

130. Moore and Hyams, *My Time at Tiffany's*, p. 227, and letter from Katherine Knauer, Tiffany's, to The Museum of Modern Art, August 1, 1995.

131. See Revill, *The Roaring Silence*, p. 191, and Hopps, *Robert Rauschenberg*, p. 34.

132. See Vaughan, "The Fabric of Friendship," pp. 137–38, and Cunningham Dance Foundation, Inc., unpublished chronology.

133. A drawing of *Tennyson* appears on the September 20 page of Castelli's appointment book, suggesting that it was completed by then.

134. Leo Castelli Gallery Archives.

135. See Howard Devree, "Art: Pittsburgh Bicentennial Show. Eight Awards Made in Category of Painting," *New York Times*, December 4, 1958, p. 36.

1959–1960

Introduction

1. See Michael Crichton, *Jasper Johns* (first published 1977, revised and expanded edition New York: Harry N. Abrams, Inc., in association with the Whitney Museum of American Art, 1994), p. 39.

2. Roberta Bernstein, *Jasper Johns* (New York: Rizzoli International Publications, Inc., 1992), p. [2].

Chronology

1. Roberta Bernstein, *Jasper Johns' Paintings and Sculptures 1954–1974: "The Changing Focus of the Eye"* (Ann Arbor: UMI Research Press, 1985), p. 45.

2. See Harold Rosenberg, "The Art World: Twenty Years of Jasper Johns," *The New Yorker* 53 no. 45 (December 26, 1977): 44. Johns later made two paintings, along with drawings and prints, entitled *Device*.

3. See Michael Crichton, *Jasper Johns* (first published 1977, revised and expanded edition New York: Harry N. Abrams, Inc., in association with the Whitney Museum of American Art, 1994), p. 47. This tripartite structure will underlie many paintings produced after 1962, such as *Out the Window II*, 1962, *Passage*, 1962, *Periscope (Hart Crane)*, 1963, *Land's End*, 1963, and *Watchman*, 1964.

4. See Bernstein, *Jasper Johns' Paintings and Sculptures*, p. 222 (note 23).

5. Paintings that Johns completed in the 1960s using acrylic paint include *0–9*, 1959–62, *0 through 9*, 1961 (LC# 134), *Red, Yellow, Blue*, 1965 (destroyed by fire in 1966), *Two Maps*, 1965 (destroyed by fire in 1966), and *Green Map above White*, 1966–67.

6. See Bernstein, *Jasper Johns' Paintings and Sculptures*, p. 60, for a discussion of the date of Johns's first meeting with Marcel Duchamp.

7. Ibid., p. 61. See also Richard Francis, *Jasper Johns* (New York: Abbeville Press, Modern Masters Series, 1984), p. 21.

8. Johns, quoted in Edmund White, "Enigmas and Double Visions," *Horizon* 20 no. 2 (October 1977): 54. See also Barbaralee Diamonstein, *Inside the Art World: Conversations with Barbaralee Diamonstein* (New York: Rizzoli International Publications, Inc., 1994), p. 118.

9. Johns, quoted in Peter Fuller, "Jasper Johns Interviewed I," *Art Monthly* no. 18 (July–August 1978): 10.

10. Johns, "Collage," *Arts* 33 no. 6 (March 1959): 7. The Hilton Kramer review had appeared under the title "Month in Review" in *Arts* 33 no. 5 (February 1959): 49.

11. Yoshiaki Tono, letter to Leo Castelli, November 2, 1959, in the Leo Castelli Gallery Archives, New York.

12. "His Heart Belongs to Dada," *Time* 73 (May 4, 1959): 58.

13. See the draft of a letter from Tatyana Grosman to Johns, August 7, 1960, ULAE Archives, West Islip, N.Y. Tatyana and Maurice Grosman had opened their workshop on November 16, 1955. Initially named Limited Art Editions, the company was reregistered as Universal Limited Art Editions seven months later. See Esther Sparks, *Universal Limited Art Editions. A History and Catalogue: The First Twenty-Five Years* (Chicago: Art Institute of Chicago, and New York: Harry N. Abrams, Inc., 1989), p. 18.

14. See William S. Rubin, *Frank Stella* (New York: The Museum of Modern Art, 1970), p. 155.

15. Courtesy Maureen O'Hara. For excerpts from the text of this letter see Marjorie Perloff, *Frank O'Hara: Poet among Painters* (New York: George Braziller, 1977), pp. 45, 203 (notes 41–44).

16. See Brad Gooch, *City Poet: The Life and Times of Frank O'Hara* (New York: Alfred A. Knopf, 1993), pp. 329–32.

17. Excerpt reprinted by permission of Maureen O'Hara. See Perloff, p. 149, and *The Collected Poems of Frank O'Hara* (Berkeley: University of California Press, 1995), p. 329. Other poems of O'Hara's also refer to Johns: "What Appears to Be Yours," of December 13, 1960; "Dear Jap," of April 10, 1963; "Poem (The Cambodian Grass Is Crushed)," of June 17, 1963; and "Bathroom," of June 20, 1963. Johns for his part has made a number of works that refer to O'Hara: *In Memory of My Feelings—Frank O'Hara*, 1961, *4 the News*, 1962, *Memory Piece (Frank O'Hara)*, 1961–70 (LC# S-19), *Memory Piece (Frank O'Hara)*, 1961 (LC# 170), and *Skin with O'Hara Poem*, 1963–65. See Fred Orton, "Present, the Scene of...Selves, the Occasion of...Ruses," in *Foirades/Fizzles: Echo and Allusion in the Art of Jasper Johns*, exh. cat. (Los Angeles: The Grunwald Center for the Graphic Arts, Wight Art Gallery, University of California, 1987), pp. 178–79, 190 (notes 32, 33), 191 (notes 34, 37).

18. Alfred H. Barr, Jr., quoted in Crichton, *Jasper Johns*, p. 77 (note 33). Barr is referring to "Painting and Sculpture Acquisitions," *The Museum of Modern Art Bulletin* (January 1–December 31, 1958), p. 21.

19. See Michael Kirby, ed., *Happenings: An Illustrated Anthology* (New York: E. P. Dutton & Co., Inc., 1965), p. 81.

20. Johns, quoted in David Vaughan, "The Fabric of Friendship: Jasper Johns in Conversation with David Vaughan," in *Dancers on a Plane: Cage, Cunningham, Johns* (first published 1989, reprint and enlarged ed. New York: Alfred A. Knopf, in association with Anthony d'Offay Gallery, London, 1990), p. 139.

21. David H. Van Hook, letter to Castelli, November 24, 1959, Leo Castelli Gallery Archives.

22. See Vaughan, "The Fabric of Friendship," p. 139, and Kirby, *Happenings*, p. 124.

23. José Pierre, letter to Johns, n.d., Leo Castelli Archives. On September 10, 1959, Castelli replied, "As for Jasper Johns, we decided to send his target with plaster casts of parts of the human body: we think that it probably is the piece that Marcel Duchamp had in mind when he invited Jasper Johns to participate in the show" (Leo Castelli Archives).

24. Johns, in an unpublished interview with Yoshiaki Tono, 1975. Courtesy Yoshiaki Tono.

25. For details regarding this first map painting, see David Shapiro, "Imago Mundi," *Artnews* 70 no. 6 (October 1971): 66; John Cage, "Jasper Johns: Stories and Ideas," in Alan R. Solomon, *Jasper Johns: Paintings, Drawings and Sculptures 1954–1964*, exh. cat. (New York: The Jewish Museum, 1964), p. 22; Bernstein, *Jasper Johns'*

Paintings and Sculptures, p. 27; and Crichton, *Jasper Johns*, p. 44.

26. Some of the bronze sculptures made in 1960—*Light Bulb*, *Flashlight*, *Painted Bronze* (ale cans), *Painted Bronze* (Savarin can), *Flag*, and *Bronze*—were cast at the Modern Art Foundry, Long Island City, New York. See Wendy Weitman, "Jasper Johns: Ale Cans and Art," *Studies in Modern Art* no. 1 (1991): 40, 62 (note 4).

27. Johns, quoted in Bernstein, *Jasper Johns' Paintings and Sculptures*, p. 54.

28. Ibid., pp. 23, 220 (note 60); and Deborah Solomon, "The Unflagging Artistry of Jasper Johns," *The New York Times Magazine*, June 19, 1988, p. 64.

29. Nan Rosenthal and Ruth E. Fine, with Marla Prather and Amy Mizrahi Zorn, *The Drawings of Jasper Johns*, exh. cat. (Washington, D.C.: National Gallery of Art, and New York and London: Thames and Hudson, 1990), p. 158.

30. See Bernstein, *Jasper Johns' Paintings and Sculptures*, pp. 48–49. *Painting with Two Balls* cannot have been completed before February 28, 1960, the date of newsprint pasted on the painting's surface.

31. Castelli, quoted in Crichton, *Jasper Johns*, p. 39.

32. Johns, quoted in Vaughan, "The Fabric of Friendship," p. 137.

33. There is a postcard from Johns in Sarasota to Leo Castelli, dated March 1, 1960, in the Leo Castelli Gallery Archives.

34. Press release, The Museum of Modern Art Collection Files, Department of Painting and Sculpture.

35. See Fine and Rosenthal, "Interview with Jasper Johns," in Rosenthal and Fine, *The Drawings of Jasper Johns*, p. 82. In the same interview, Johns mentions that *Night Driver*, 1960, is "inexplicably associated" in his mind with his getting his license. In conversation with Lilian Tone on February 28, 1996, Johns said that *Night Driver* was probably made at Front Street.

36. "For the time being, I deposited $500.00 in your account, and very shortly I shall take care of the other $500.00 for the month of August. Most likely I shall fly to Norfolk on Monday the 25th on the late afternoon plane which should get me there around 5:45, but I shall confirm this. In the meantime, love to both of you." Castelli, letter to Johns, July 15, 1960, Leo Castelli Gallery Archives.

37. Castelli, letter to Walter Hopps, July 29, 1960, Leo Castelli Gallery Archives.

38. Tatyana Grosman, draft of letter to Johns, August 7, 1960, ULAE Archives. The drafts of letters from Grosman to Johns are quoted here without their occasional spelling and grammatical errors, under the presumption that they were corrected in their final versions.

39. Johns, postcard to Grosman, August 12, 1960, ULAE Archives.

40. Riva Castleman, *Jasper Johns: A Print Retrospective*, exh. cat. (New York: The Museum of Modern Art, 1986), p. 12.

41. See Sparks, *Universal Limited Art Editions*, p. 123.

42. In a letter to Castelli, Hopps explained why he had reconsidered the plan: "The number of first rate Schwitters items available to us has turned out to be considerably greater than we anticipated—virtually enough for a one-man show. Secondly, it appears that currently Cornell has certain adverse feelings to being shown with others." Hopps, letter to Castelli, May 28, 1960, Leo Castelli Gallery Archives.

43. John Richard Craft, letter to Castelli, September 22, 1960, Leo Castelli Gallery Archives.

44. The Barone Gallery, New York, bought five of these on October 12, 1960, according to ULAE documentation notebooks. Robert Blackburn, who had trained in France, was the printer of these first lithographs. He printed Johns's work until 1962, when he was succeeded at ULAE by Zigmunds Priede.

45. Johns, letter to Grosman, October 27, 1960, ULAE Archives.

46. Grosman, draft of letter to Johns, October 31, 1960, ULAE Archives.

47. Leonard Lyons, "Art Note: Jasper Johns," *Washington, D.C., Evening Star* (March 3, 1964), p. A-11.

48. Johns, in conversation with Tone, June 14, 1996. The inscription can be translated, "To Jasper Johns, sibyl of targets, affectionately, Marcel 1960."

49. Craft, letter to Castelli, December 31, 1960, Leo Castelli Gallery Archives.

1961–1963

Introduction

1. Johns, in an interview with Billy Klüver, published as a 33⅓ r.p.m. record included in the catalogue *The Popular Image* (Washington, D.C.: Washington Gallery of Modern Art, 1963). Extracts from this interview appear in Klüver, *On Record: 11 Artists 1963, Interviews with Billy Klüver* (New York: Experiments in Art and Technology, 1981), where the quotation cited appears on p. 13.

2. See Kirk Varnedoe, "Introduction: A Sense of Life," in the present volume, p. 37 (note 56).

3. A note of the macabre was explicit in a painting of this period never completed, the vestiges of which now underlie *In Memory of My Feelings—Frank O'Hara*; these vestiges, now invisible to the general viewer, include a skull and the words "Dead Man." My thanks to Stefan Edlis and Gail Neeson for sharing with me the infra-red photographs of these details; see also Fred Orton, *Figuring Jasper Johns* (Cambridge, Mass.: Harvard University Press, 1994), pp. 64 and 65, which includes both a photograph and a quotation from Johns's sketchbook notes: "A Dead Man. Take a skull. Cover it with paint. Rub it against canvas. Skull against canvas." And see also the companion volume to this catalogue, *Jasper Johns: Writings, Sketchbook Notes, Interviews*.

Chronology

1. Walter Hopps, *Robert Rauschenberg*, exh. cat. (Washington, D.C.: National Collection of Fine Arts, Smithsonian Institution, 1976), p. 37.

2. Johns, written response to questions from Lilian Tone, December 15, 1995.

3. Johns, quoted in Jay Nash and James Holmstrand, "Zeroing In on Jasper Johns," *Literary Times* (Chicago) 3 no. 7 (September 1964): 1. See also D. R. Rickborn, "Art's Fair-Haired Boy: Allendale's Jasper Johns Wins Fame with Flags," *The State* (Columbia, S.C.), January 15, 1961, p. 21.

4. Johns, quoted in Douglas M. Davis, "An Exciting New Focus in TV: The Daring of the Postwar Arts," *The National Observer*, August 15, 1966, p. 20.

5. Johns, quoted in Sylvia L. McKenzie, "Jasper Johns Art Hailed Worldwide," *Charleston (S.C.) News and Courier*, October 10, 1965, p. 13-B.

6. Johns, speaking in Alan R. Solomon's film *USA Artists: Jasper Johns*, 1966.

7. Johns, quoted in Michael Crichton, *Jasper Johns* (first published 1977, revised and expanded edition New York: Harry N. Abrams, Inc., in association with the Whitney Museum of American Art, 1994), p. 46.

8. See David Bourdon, *Warhol* (New York: Harry N. Abrams, 1989), p. 80.

9. Johns, quoted in Paul Taylor, "Jasper Johns," *Interview*, July 1990, p. 122. See also Ann Hindry, "Conversation with Jasper Johns/ *Conversation avec Jasper Johns*," in English and French, *Artstudio* no. 12 (Spring 1989): 10.

10. See Layhmond Robinson, "A Gallery of Art Lost in Mansion," *New York Times*, March 4, 1961, p. 12L. A "List of Damaged Art Works" published alongside this article lists three categories: "Destroyed Paintings," "Damaged Sculpture," and "Damaged Paintings." *Black Target*, by "Jasper Jonas," is listed in this latter category.

11. "*Bewogen/Beweging*" traveled to the Moderna Museet, Stockholm (May 17–September 3, 1961), and the Louisiana Museum, Humlebaek, outside Copenhagen (September–October, 1961).

12. Johns wrote to Tatyana Grosman from Edisto Beach on this date; the letter is in the ULAE Archives.

13. The catalogue, *Contemporary Modern Paintings, Drawings, Collages, Objets-peinture, Sculpture: Property of The American Chess Foundation Donated for Benefit of Its Artists' Fund and from Other Owners* (New York: Parke-Bernet Galleries, 1961), lists sale number 2031, lot 31, as "*The Flag*, liquid graphite, 11½ x 15½ inches. Donated by the artist, courtesy of the Leo Castelli Gallery." I thank Francis Naumann for bringing this to my attention.

14. Leo Castelli's appointment book.

15. See Roberta Bernstein, *Jasper Johns' Paintings and Sculptures 1954–1974: "The Changing Focus of the Eye"* (Ann Arbor: UMI Research Press, 1985), pp. 67, 76.

16. "Vanguard American Painting" was curated by H. Harvard Arnason, of the Solomon R. Guggenheim Museum, New York, and Jerome A. Donson, Traveling Curator. The Viennese venue is not named in the documentation available. The exhibition traveled to the Salzburg Zwerglgarten, Salzburg (under the title "*Amerikanische Maler der Gegenwart*") (July 10–August 3, 1961); Belgrade (September 15–30, 1961); Skopje (October 14–29, 1961); Zagreb (November 9–20, 1961); Maribor (November 25–December 4, 1961); Ljubljana (December 11, 1961–January 7, 1962); Rijeka (January 13–31, 1962); the USIS Gallery, American Embassy, London (February 28–March 30, 1962); and Darmstadt (April 14–May 13, 1962).

17. Johns, response to Tone, December 15, 1995. Niki de Saint Phalle describes the performance and the role of each participant in Pontus Hulten, *Niki de Saint Phalle*, exh. cat. (Bonn: Kunst-und Ausstellungshalle der Bundesrepublik Deutschland, and Stuttgart: G. Hatje, 1992), p. 162. See also Calvin Tomkins, *The Bride and the Bachelors: The Heretical Courtship in Modern Art* (New York: The Viking Press, 1965), p. 228; and Hopps, *Robert Rauschenberg*, p. 38.

18. Darthea Speyer, letter to Tone, June 14, 1995.

19. David Tudor, telegram to John Cage, June 21, 1961, John Cage Archive, Northwestern University Music Library, Evanston, Ill.

20. Castelli's appointment book.

21. Tatyana Grosman wrote a letter to Johns about the Hyannis Festival: "The show was held in a large hall of the armory. In an adjoining room our lithographs were exhibited accompanied by smaller pieces of sculpture: Archipenko, Braque, Butler, Laurens, Lipchitz, Giacometti, Richier. I liked this room very much. ¶The public, about 2,000 visitors, mostly vacationers, was very interested in the lithographs. The exhibition was only 5 days, too short time." Grosman, letter to Johns, August 9, 1961, ULAE Archives. The show traveled to the Kornblee Gallery, New York (November 28–December 30, 1961).

22. "By The Sea 6 x 55¼"" is written on the page for August 2, 1961, in Castelli's appointment book, suggesting that the painting was completed by then.

23. Tomkins writes that Johns and Rauschenberg went to Connecticut College in the summer of 1962 to work with Merce Cunningham, who was there under the college's residency program in dance. "By the time the summer ended they were no longer together. The break was bitter and excruciatingly painful, not only for them but for their closest associates—Cage and Cunningham and a few others—who felt that they, too, had lost something of great value." Tomkins, *Off the Wall: Robert Rauschenberg and the Art World of Our Time* (Garden City, N.Y.: Doubleday & Company, Inc., 1980), p. 198. According to David Vaughan, however, archivist of the Cunningham Dance Foundation (in conversation with Tone, September 6, 1995), the

last summer Cunningham spent as a resident at Connecticut College was 1961. (He had also gone in the summers of 1958, 1959, and 1960.) This suggests that the year Tomkins is referring to was actually 1961. Johns, in conversation with Tone on February 28, 1996, confirmed that he went to Connecticut College in the summer of 1961 to attend performances there. See also Mary Lynn Kotz, *Rauschenberg, Art and Life* (New York: Harry N. Abrams, 1990), p. 98.

24. Johns, letter to Tatyana Grosman, September 15, 1961, ULAE Archives. Cited in Esther Sparks, *Universal Limited Art Editions. A History and Catalogue: The First Twenty-Five Years* (Chicago: Art Institute of Chicago, and New York: Harry N. Abrams, Inc., 1989), p. 125.

25. Tatyana Grosman, letter to Johns, September 25, 1961, ULAE Archives.

26. See Crichton, *Jasper Johns*, pp. 46–48, and Bernstein, *Jasper Johns' Paintings and Sculptures*, pp. 75 and 81.

27. Bernstein, *Jasper Johns' Paintings and Sculptures*, p. 87.

28. Leo Steinberg, "Back Talk from Leo Steinberg," in Susan Brundage, ed., *Jasper Johns—35 Years—Leo Castelli*, exh. cat. (New York: Harry N. Abrams, Inc., 1993), n.p. Steinberg further states here that his dialogue with Johns in the 1961 article is a collage of Johns's statements during their conversations. Johns saw and approved the "made-up" answers that Steinberg had provided.

29. "The Art of Assemblage" traveled to the Dallas Museum for Contemporary Arts, Dallas, Tex. (January 9–February 11, 1962) and the San Francisco Museum of Art, San Francisco, Calif. (March 5–April 15, 1962).

30. See Bernstein, *Jasper Johns' Paintings and Sculptures*, p. 92. The *Tractatus* was available to Johns in English translations by C. K. Ogden, 1922, and by D. F. Pears and B. F. McGuinness, 1961; the *Philosophical Investigations* in a translation by G. E. M. Anscombe and R. Rhees, 1953. According to Richard Francis, "Johns had systematically read Wittgenstein through the summer of 1961." Francis, *Jasper Johns* (New York: Abbeville Press, Modern Masters Series, 1984), p. 50. Regarding the impact of Wittgenstein's writings on Johns's work, see also Rosalind Krauss, "Jasper Johns," *Lugano Review* 1 no. 2 (1965): 84–113; Peter Higginson, "Jasper Johns and the Influence of Ludwig Wittgenstein," M.A. thesis, University of British Columbia, 1974; and Higginson, "Jasper's Non-Dilemma: A Wittgensteinian Approach," *New Lugano Review* no. 10 (1976): 53–60.

31. See Crichton, *Jasper Johns*, p. 55.

32. On Johns's use of Mylar, see Ruth E. Fine and Nan Rosenthal, "Interview with Jasper Johns," in Nan Rosenthal and Ruth E. Fine, with Marla Prather and Amy Mizrahi Zorn, *The Drawings of Jasper Johns*, exh. cat. (Washington, D.C.: National Gallery of Art, and New York and London: Thames and Hudson, 1990), p. 73.

33. Johns, quoted in Yoshiaki Tono, ["Jasper Johns in Tokyo"], *Bijutsu Techô* (Tokyo), August

1964, p. 7. Translated from the Japanese by Tadatoshi Higashizono.

34. "Abstract Drawings and Watercolors" traveled to the Museu de Arte Moderna, Rio de Janeiro (March 29–April 22, 1962); the Museu de Arte Moderna de São Paulo (May 8–31, 1962); the Museo de Arte Moderno, Buenos Aires (July 1–22, 1962); the Salón Municipal de Exposiciones de Montevideo (August 3–19, 1962); the Reifschneider Gallery, Santiago (September 24–October 6, 1962); the Instituto de Arte Contemporaneo, Lima (October 23–November 3, 1962); the Casa de la Cultura Ecuatoriana, Guayaquil (November 10–16, 1962); and the Museo de Arte Colonial, Quito (November 23–30, 1962).

35. Tatyana Grosman, letter to Johns, January 26, 1962, ULAE Archives.

36. "*4 Amerikanare*" traveled to the Stedelijk Museum, Amsterdam (opening June 18, 1962), and the Kunsthalle Bern (July 7–September 2, 1962). Billy Klüver, who was in charge of assembling the works coming from the U.S. for the show, made a blue neon letter *A* for Johns's *Zone*, mounting the electronics behind the painting. According to Klüver, this is the first portable neon sign ever made. See "Technology and the Arts: Engineer Billy Klüver Exercises His Technological Talents to Help Artists Design Their Work," *Reporter* 15 no. 2 (March–April 1966): 18.

37. Leo Steinberg, "Jasper Johns," *Metro* (Milan) no. 4–5 (May 1962): 87–109.

38. Johns, quoted in April Bernard and Mimi Thompson, "Johns on…," *Vanity Fair* 47 no. 2 (February 1984): 65.

39. See Crichton, *Jasper Johns*, pp. 47, 78 (note 64).

40. See David Shapiro, *Jim Dine: Painting What One Is* (New York: Harry N. Abrams, Inc., 1981), p. 207.

41. Dine, quoted in Graham W. J. Beal, *Jim Dine: Five Themes*, exh. cat. (Minneapolis: Walker Art Center, and New York: Abbeville Press, 1984), p. 18.

42. See "Artists for Artists," *The New Yorker*, March 9, 1963, p. 32.

43. Ileana Sonnabend, letter to Castelli, October 2, 1962, Leo Castelli Gallery Archives.

44. The "Third International Biennial of Prints" traveled to the Municipal Museum of Art, Osaka (January 6–February 17, 1963).

45. David Bourdon, *Warhol* (New York: Harry N. Abrams, Inc., 1989), p. 134.

46. Andy Warhol and Pat Hackett, *Popism: The Warhol '60s* (New York and London: Harcourt Brace Jovanovich, 1980), p. 23. Johns had visited Warhol's studio earlier, brought by Emile de Antonio; Johns, in conversation with Tone, February 28, 1996, and quoted in Paul Taylor, "Jasper Johns," *Interview*, July 1990, p. 122.

47. "Lettering by Hand" traveled to the University of Puerto Rico, Rio Piedras (May 12–30, 1965); the Instituto Torcuato di Tella, Buenos Aires (July 14–August 1, 1965); the Museo de Artes Plasticos, La Plata (August 7–25, 1965);

the Instituto Brasil-Estados Unidos, Rio de Janeiro (December 8–20, 1965); the Museo de Arte, Lima (opening April 27, 1966); the Museo de Arte Contemporaneo, Santiago (December 2, 1966–January 20, 1967); and the Museo de Bellas Artes, Caracas (May 14–June 4, 1967).

48. John Richard Craft, letter to Johns, November 9, 1962, Columbia Museum of Art Archives.

49. Castelli, letter to Ileana Sonnabend, December 1, 1962, Leo Castelli Gallery Archives.

50. Castelli wrote to Sonnabend in Paris, "[Restany] got very enthusiastic about only two of the Americans: Oldenburg and Lichtenstein. But his great god now is Jasper. I took him to the Tremaines where he saw the 'White Flag,' 'Tango' and 'Three Flags.' He then went to Jap's studio where he was terribly impressed by a new large 15 foot painting (in four panels) which is not quite finished called 'Diver.'" Castelli, letter to Sonnabend, November 17, 1962, Leo Castelli Gallery Archives.

51. Sonnabend, letter to Castelli, November 18, 1962, Leo Castelli Gallery Archives.

52. "Jasper Johns: Retrospective Exhibition" traveled to the Richmond Art Center, Richmond, Calif. (February 19–March 19, 1963).

53. Dorothy Gees Seckler, "Folklore of the Banal," *Art in America* 50 no. 4 (Winter 1962): 58. *Painted Bronze* (ale cans) was reproduced with the essay (p. 59).

54. See Roland F. Pease, Jr., "Avant-Garde Artists Band Together to Assist Dance, Music, Theater," *Art Voices*, February 1963, p. 22.

55. "Seven New Shows: Subtle…Simple… Sure…Surprising," *Newsweek* 61 no. 7 (February 18, 1963): 65.

56. L.J., "Paintings for Sale: Profits for Performers," *Dance Magazine* 37 no. 3 (March 1963): 44.

57. "Artists for Artists," *The New Yorker*, March 9, 1963, p. 32.

58. L.J., "Paintings for Sale," p. 44.

59. See David Vaughan, "The Fabric of Friendship: Jasper Johns in Conversation with David Vaughan," in *Dancers on a Plane: Cage, Cunningham, Johns* (first published 1989, reprint and enlarged ed. New York: Alfred A. Knopf, with Anthony d'Offay Gallery, London, 1990), pp. 139–40.

60. Johns, in conversation with Tone, February 28, 1996.

61. Tomkins, *Off the Wall*, p. 209. According to Bernstein, *Jasper Johns' Paintings and Sculptures*, p. 221 (note 14), the title of *Rebus* was suggested by Johns, and reflects "the focus on the interplay of words and images in the painting and its importance in both artists' works at the time."

62. "Popular Image Exhibition" traveled to the Institute of Contemporary Arts, London (October 24–November 23, 1963).

63. "*Schrift en beeld*" traveled to the Staatliche Kunsthalle, Baden-Baden (June 14–August 4, 1963).

64. The staff of ULAE often keep a diary, which is stored in the ULAE Archives. The diary for this period provides detailed notes on every step in the complex development of the *0–9* portfolio and on the other lithographs that Johns was working on at the same time.

65. Yoshiaki Tono, "Statements by Contemporary Artists," *Mizue* (Tokyo) no. 700 (June 1963): [6], 18–19.

66. Castelli, letter to President John F. Kennedy, June 14, 1963, Leo Castelli Gallery Archives. A week later Castelli received a reply from the White House, signed by Evelyn Lincoln: "The President asked me to thank you…for bringing him and Mrs. Kennedy the flag produced in bronze by Jasper Johns. They were particularly pleased by this symbolic gift and wanted you to know how much they appreciated your thoughtfulness." Lincoln, letter to Castelli, June 21, 1963, Leo Castelli Gallery Archives.

67. Johns, quoted in Peter Fuller, "Jasper Johns Interviewed I," *Art Monthly* no. 18 (July–August 1978): 12.

68. Castelli, letter to Philip Johnson, June 21, 1963, Leo Castelli Gallery Archives.

69. For descriptions of the apartment see Holmstrand and Nash, "Zeroing In on Jasper Johns," p. 1, and Barbara Poses Kafka, "Artists Eat," *Art in America* 53 no. 6 (December 1965–January 1966): 88.

70. Philip Johnson, letter to Johns, October 2, 1963, Leo Castelli Gallery Archives.

71. Johns, response to Tono, December 15, 1995.

72. See Elisabeth Sussman, "Florine Stettheimer: A 1990s Perspective," in Elisabeth Sussman with Barbara J. Bloemink and a contribution by Linda Nochlin, *Florine Stettheimer: Manhattan Fantastica*, exh. cat. (New York: Whitney Museum of American Art, 1995), pp. 62, 67 (note 2).

73. The date is inscribed on the work.

1964–1971

Introduction

1. Johns had painted a skull earlier, in a never completed work whose traces can now be found underneath *In Memory of My Feelings—Frank O'Hara*; see "1961–63, Introduction," p. 388 (note 3) above. He had also used screenprinting in a drawing; see Roberta Bernstein, *Jasper Johns' Paintings and Sculptures 1954–1974: "The Changing Focus of the Eye"* (Ann Arbor: UMI Research Press, 1985), pp. 97, 98.

2. The note on the watchman and the spy was published, in Japanese, in Yoshiaki Tono, "[Jasper Johns in Tokyo]," *Bijutsu Techô* (Tokyo), August 1964, pp. 272–73, and in Johns, "Sketchbook Notes," *Art and Literature* (Lausanne) no. 4 (Spring 1965): 185, 187, 192. See also this catalogue's companion volume, *Jasper Johns: Writings, Sketchbook Notes, Interviews.*

3. See John Coplans, "Fragments according to Johns: An Interview with Jasper Johns,"

The Print Collector's Newsletter 3 no. 2 (May–June 1972): 30–31.

4. Michael Crichton provides a diagram to demonstrate the conceptual circular arrangement represented by the three panels of *Voice 2*; see Crichton, *Jasper Johns* (first published 1977, revised and expanded edition New York: Harry N. Abrams, Inc., in association with the Whitney Museum of American Art, 1994), p. 56. Johns has stated that "much of the paint in *Voice 2* was applied through screens of different sorts. The patterns of the screens consisted of various sizes and distributions of dots and, in some cases, squares." Johns, quoted in Christian Geelhaar, *Jasper Johns Working Proofs* (London: Petersburg Press, 1980), pp. 38–39.

Chronology

1. See Paul Taylor, "Jasper Johns," *Interview*, July 1990, p. 122; Roberta Bernstein, *Jasper Johns' Paintings and Sculptures 1954–1974: "The Changing Focus of the Eye"* (Ann Arbor: UMI Research Press, 1985), p. 230 (note 25); and David Bourdon, *Warhol* (New York: Harry N. Abrams, 1989), p. 123 (note 9). Bernstein also points out (pp. 97, 98) that Johns had previously used a silk screen in a drawing—for the red Coca-Cola sign in *Untitled (Coca-Cola)*, 1963 (LC# 184).

2. Bernstein, *Jasper Johns' Paintings and Sculptures*, p. 111. Johns had previously used the image of a skull in *In Memory of My Feelings—Frank O'Hara*, 1961, but had painted it over in the work's final version.

3. A 108-work version of "Jasper Johns" traveled to the Whitechapel Art Gallery, London (December 2–31, 1964). The version at the Pasadena Art Museum, Pasadena, Calif. (January 26–February 28, 1965), contained 131 works, including several recently completed paintings.

4. Irving Sandler, "In the Art Galleries," *New York Post*, March 1, 1964, p. 14.

5. Sidney Tillim, "Ten Years of Jasper Johns," *Arts* 38 no. 7 (April 1964): 22.

6. See Francis M. Naumann, *Jasper Johns: According to What & Watchman*, exh. cat. (New York: Gagosian Gallery, 1992), p. 11.

7. Johns, quoted in Ruth E. Fine and Nan Rosenthal, "Interview with Jasper Johns," in Nan Rosenthal and Ruth E. Fine, with Marla Prather and Amy Mizrahi Zorn, *The Drawings of Jasper Johns*, exh. cat. (Washington, D.C.: National Gallery of Art, and New York and London: Thames and Hudson, 1990), p. 73.

8. See Michael Crichton, *Jasper Johns* (first published 1977, revised and expanded edition New York: Harry N. Abrams, Inc., in association with the Whitney Museum of American Art, 1994), pp. 48–49, and Charlotte Willard, "Eye to I," *Art in America* 54 no. 2 (March–April 1966): 57.

9. See Alfred Frankenstein, "A Concert in the Stars," *San Francisco Sunday Chronicle*, April 5, 1964, p. 29.

10. Johns wrote to Leo Castelli from Kaneohe on this date; the letter is in the Leo Castelli Gallery Archives.

11. Johns, letter to Castelli, April 24, 1964, Leo Castelli Gallery Archives.

12. Johns, postcard to Tatyana and Maurice Grosman, April 24, 1964, ULAE Archives.

13. Castelli, letter to Johns, April 1964, Leo Castelli Gallery Archives.

14. Yoshiaki Tono provides a detailed account of Johns's stay in Tokyo in his ["Jasper Johns in Tokyo"], in Japanese, *Bijutsu Techô* (Tokyo), August 1964, pp. 5–8.

15. Johns, letter to Castelli, [May 6, 1964], Leo Castelli Gallery Archives.

16. Johns, letter to Castelli, [May 8, 1964], Leo Castelli Gallery Archives.

17. Tono, ["Jasper Johns in Tokyo"], p. 6.

18. Castelli, letter to Johns, May [16], 1964, Leo Castelli Gallery Archives.

19. In the John Cage Archive, Northwestern University Music Library, Evanston, Ill., there is both a copy of the program for the event and a letter from Johns to Cage of May 24, 1964, describing it.

20. Johns, letter to Castelli [May 24, 1964], Leo Castelli Gallery Archives.

21. "American Painters as New Lithographers" traveled to the Stedelijk Museum, Amsterdam (September 25–November 2, 1964).

22. Johns, letter to Castelli, [May 24, 1964], Leo Castelli Gallery Archives. Bernstein has noted that *Watchman* is the first painting since 1955 in which Johns used a cast; see *Jasper Johns' Paintings and Sculptures*, p. 233 (note 3). See also John Coplans, "Fragments according to Johns: An Interview with Jasper Johns," *The Print Collector's Newsletter* 3 no. 2 (May–June 1972): 30. On the model for the leg cast in *Watchman*, see Richard S. Field, *Jasper Johns: Prints 1960–1970*, exh. cat. (Philadelphia: Philadelphia Museum of Art, 1970), cat. 60, n.p., and Bernstein, p. 233 (note 3).

23. Castelli, letter to Johns, June 6, 1964, Leo Castelli Gallery Archives.

24. Johns, letter to Tatyana and Maurice Grosman, June 14, 1964, ULAE Archives.

25. Tono, ["Jasper Johns in Tokyo"], p. 3.

26. Tatyana Grosman, letter to Johns, June 19, 1964, ULAE Archives.

27. "Prize Winners at the XXXII Venice Biennale," *Art International* 8 no. 7 (September 25, 1964): 44.

28. Although *Flag on Orange Field*, 1957, is listed in the catalogue, *Fool's House* was probably sent instead: see Castelli, letter to Johns, April 22, 1964, Leo Castelli Gallery Archives.

29. ULAE diary.

30. A series of photographs by Mark Lancaster show Johns working on *According to What*, and are dated "August 1964." On the use of Olga Klüver's leg for the cast in *According to What*, see Field, *Jasper Johns: Prints 1960–1970*, n.p., and Bernstein, *Jasper Johns' Paintings and Sculptures*, p. 234 (note 18).

31. Lois Long, in conversation with Lilian Tone, October 25, 1995. See also an undated

note by Johns addressed, probably, to Cage, in the John Cage Archive, announcing their arrival in London on August 21.

32. Johns, quoted in Max Kozloff, *Jasper Johns* (New York: Harry N. Abrams, Inc., 1969), p. 38, and Bernstein, *Jasper Johns' Paintings and Sculptures*, p. 60.

33. Johns, letter to Billy Klüver, October 21, 1964. Courtesy Billy Klüver.

34. "Jasper Johns: Lithographs" traveled to the University of Newcastle-upon-Tyne (January 20–February 6, 1965); the Ashmolean Museum, Oxford (February 15–March 3, 1965); and Morton House, Edinburgh (August 24–September 11, 1965).

35. Johns has said he does not remember where he made the *Flags* and *Map* of 1965, or where he made *Numbers* (LC# 207) and *Double White Map* (LC# 199) of the same year. Johns, in conversation with Tone, December 15, 1995. Photographs taken by Ugo Mulas in 1965, however, show Johns working on *Flags* and *Map* in the Edisto Beach studio.

36. Rosenthal and Fine, *The Drawings of Jasper Johns*, p. 112.

37. See Anna Brooke, "Chronology," in Richard Francis, *Jasper Johns* (New York: Abbeville Press, Modern Masters Series, 1984), p. 118.

38. See ibid., p. 118.

39. See Alan R. Solomon's film *USA Artists: Jasper Johns*, 1966. There is in the John Cage Archive a letter from Johns, in Edisto Beach, to Cage, dated February 12, 1965.

40. See Kimberly Paice, "Catalogue," in *Robert Morris: The Mind/Body Problem*, exh. cat. (New York: Solomon R. Guggenheim Museum, 1994), p. 168.

41. Johns, "Sketchbook Notes," *Art and Literature* (Lausanne) 4 (Spring 1965): 185–92.

42. Arnold Schoenberg, *Letters*, selected and edited by Erwin Stein (New York: St. Martin's Press, 1965).

43. Johns, letter to Cage, [May] 1965, John Cage Archive. The benefit exhibition, "Hommage à Caïssa," was held at Cordier & Ekstrom Gallery, New York (February 8–26, 1966).

44. See Zoran Krzisnik, letter to Johns, June 22, 1965, ULAE Archives.

45. See Ann Hindry, "Conversation with Jasper Johns/*Conversation avec Jasper Johns*," in English and French, *Artstudio* no. 12 (Spring 1989): 10. See also Riva Castleman, *Jasper Johns: A Print Retrospective*, exh. cat. (New York: The Museum of Modern Art, 1986), p. 20.

46. Tatyana Grosman, letter to Johns, June 10, 1965, ULAE Archives.

47. Johns, letter to Tatyana Grosman, July 3, 1965, ULAE Archives.

48. ULAE diary.

49. Brooke, "Chronology," p. 118.

50. Castleman, *Jasper Johns: A Print Retrospective*, pp. 26–27.

51. ULAE diary. The edition of *Two Maps I* is signed on February 21, *Light Bulb* and *The Critic Smiles* on March 1, *Two Maps II* on April 24.

52. Jennifer Gough-Cooper and Jacques Caumont, *Ephemerides on and about Marcel Duchamp and Rrose Sélavy, 1887–1968* (Milan: Bompiani, 1993), n.p.

53. ULAE diary.

54. Esther Sparks, *Universal Limited Art Editions. A History and Catalogue: The First Twenty-Five Years* (Chicago: Art Institute of Chicago, and New York: Harry N. Abrams, Inc., 1989), p. 134.

55. Leo Castelli's appointment book.

56. ULAE diary. Johns approves the proofs of *Passage II* on January 19, 1967, in New York, and the edition is signed on January 30.

57. ULAE diary.

58. See Brad Gooch, *City Poet: The Life and Times of Frank O'Hara* (New York: Alfred A. Knopf, 1993), pp. 455–66.

59. "Two Decades of American Painting" traveled to the National Museum of Modern Art, Kyoto (December 10, 1966–January 22, 1967); the Lalit Kala Gallery, Rabindra Bhavan, New Delhi (March 28–April 16, 1967); the National Gallery of Victoria, Melbourne (June 6–July 8, 1967); and the Art Gallery of New South Wales, Sydney (July 17–August 20, 1967).

60. Johns, letter to Castelli, October 16, 1966, Leo Castelli Gallery Archives. The work Johns made for Shuzo Takiguchi was *Summer Critic*, 1966 (ULAE# 40), a silk screen on colored acetate set into embossed paper (13 1/16 x 10 1/2"). Takiguchi's book was *To and from Rrose Sélavy, Selected Words of Marcel Duchamp, with Special Contributions: A Self-Portrait in Profile by Marcel Duchamp and Works by Shusaku Arakawa, Jasper Johns and Jean Tinguely* (Tokyo: Rrose Sélavy, 1968).

61. Johns, letter to Castelli, November 12, 1966, Leo Castelli Gallery Archives.

62. A record of the insurance claim for Johns's losses is in the Leo Castelli Gallery Archives.

63. Cage, letter to Ileana Sonnabend, December 8, 1966, John Cage Archive.

64. Cage, letter to Johns, January 18, 1967, John Cage Archive.

65. See Bernstein, *Jasper Johns' Paintings and Sculptures*, p. 30; Milton Esterow, "The Second Time Around," *Artnews* 92 no. 6 (Summer 1993): 149; and Hans Namuth's and Judith Wechsler's film *Jasper Johns: Take an Object. A Portrait: 1972–1990*, 1990.

66. ULAE diary.

67. Johns has said, "I wasn't asked to be Artistic Advisor to the Company until 1967, and I was reluctant. In the theatre, there is something about the setting up and taking down of things that I dislike. But when I thought of the people who might be available to do the work that I was being invited to do, I decided I might do it in ways that would offend me less when I went to see the performance. It was a poor way to make a decision, an arrogant way, but that was my feeling." Johns, quoted in David Vaughan, "The Fabric of Friendship: Jasper Johns in Conversation with David Vaughan,"

in *Dancers on a Plane: Cage, Cunningham, Johns* (first published 1989, reprint and enlarged ed. New York: Alfred A. Knopf, with Anthony d'Offay Gallery, London, 1990), p. 140. Johns later invited Frank Stella, Andy Warhol, Bruce Nauman, Robert Morris, and others to design sets for the company.

68. Johns, quoted in Hubert Saal, "Merce," *Newsweek*, May 27, 1968, p. 88.

69. Bernstein, *Jasper Johns' Paintings and Sculptures*, p. 236 (note 17).

70. ULAE diary.

71. See Castleman, *Jasper Johns: A Print Retrospective*, p. 23, and Crichton, *Jasper Johns*, p. 54.

72. "American Painting Now" traveled to the Horticultural Hall, Boston, Mass. (December 15, 1967–January 10, 1968).

73. Johns, quoted in Esterow, "The Second Time Around," p. 149. For a description of the painting's appearance when first exhibited, see Bernstein, *Jasper Johns' Paintings and Sculptures*, p. 30.

74. Bernstein, "Johns and Beckett: Foirades/Fizzles," *The Print Collector's Newsletter* VII no. 5 (November–December 1976): 143, 145 (note 9).

75. ULAE diary.

76. See the inscription on drawings LC# D-201 and LC# D-199.

77. Johns, quoted in Bernstein, *Jasper Johns' Paintings and Sculptures*, p. 224 (note 3).

78. Thomas W. Ennis, "Bowery Hotel Where Derelicts Slept Being Converted to Artist Studios," *New York Times*, August 6, 1967, section 8, pp. 1, 6.

79. ULAE diary.

80. Bernstein, *Jasper Johns' Paintings and Sculptures*, p. 236 (note 17).

81. Information for all these dates comes from the ULAE diary.

82. In her unpublished journal, Bernstein notes seeing Johns working on *Harlem Light* on October 15, 1967. See Bernstein, *Jasper Johns' Paintings and Sculptures*, p. 235 (note 11).

83. Johns, quoted in Bryan Robertson and Tim Marlow, "The Private World of Jasper Johns," *Tate: The Art Magazine* no. 1 (Winter 1993): 46. See also Crichton, *Jasper Johns*, pp. 52–53; Bernstein, *Jasper Johns' Paintings and Sculptures*, pp. 128–29, 235–36 (note 11); and *Art Now: New York* 1 no. 4 (April 1969): n.p.

84. A photograph taken by Ugo Mulas in 1967, in David Whitney's Canal Street studio, shows *Untitled*, 1965–67, hanging on the wall while Johns works on *Harlem Light*. Another photograph by Mulas shows Johns working on *Target*, with *Harlem Light* hanging on another wall; on the wall facing *Harlem Light* are three vertical blank canvases of the same size, possibly to be used for the first three *Screen Piece* paintings or for *Voice 2*.

85. According to Bernstein, Johns also began *Voice 2* in the Canal Street studio around this time—in December of 1967. The painting is dated 1968–71 in the artist's records, however. See Bernstein, *Jasper Johns' Paintings and Sculptures*, pp. 134, 236 (note 21).

86. Ibid., pp. 92, 132, 236 (note 15).

87. *"Kompas III,"* coorganized by the Stedelijk van Abbemuseum and the Kaiser-Wilhelm-Museum, Krefeld, West Germany, traveled to the Frankfurter Kunstverein, Frankfurt, West Germany (December 30, 1967–February 11, 1968).

88. See Field, *Jasper Johns: Prints 1960–1970*, cat. 92 (n.p.); Bernstein, *Jasper Johns' Paintings and Sculptures*, p. 20; and [Sarah Taggart], ["Chronology"], in *Dancers on a Plane*, p. 160.

89. Johns, quoted in April Bernard and Mimi Thompson, "Johns on…," *Vanity Fair* 47 no. 2 (February 1984): 65.

90. Vivien Raynor, "Jasper Johns: 'I have attempted to develop my thinking in such a way that the work I've done is not me,'" *Artnews* 72 no. 3 (March 1973): 20.

91. ULAE diary.

92. Bernstein, *Jasper Johns' Paintings and Sculptures*, p. 68. See also Gough-Cooper and Caumont, *Ephemerides*, n.p., and Johns, quoted in James Klosty, ed., *Merce Cunningham* (New York: E. P. Dutton & Co., Inc., 1975), p. 85.

93. Johns, quoted in Vaughan, "The Fabric of Friendship," p. 141.

94. See Brooke, "Chronology," p. 118; also Leo Castelli's appointment book.

95. Johns, quoted in Joseph E. Young, "Jasper Johns: An Appraisal," *Art International* 13 no. 7 (September 1969): 51.

96. Johns, in conversation with Tone, November 15, 1995. For a description of these paintings, see Bernstein, *Jasper Johns' Paintings and Sculptures*, p. 24.

97. Nancy Ervin, of Gemini G.E.L., letter to Tone, January 6, 1996. See also [Taggart], ["Chronology"], p. 161, and Young, "Jasper Johns: An Appraisal," p. 53.

98. Ervin, letter to Tone.

99. "Dada, Surrealism and Their Heritage" traveled to the Los Angeles County Museum of Art, Los Angeles, Calif. (July 16–September 8, 1968) and the Art Institute of Chicago, Chicago, Ill. (October 19–December 8, 1968).

100. "Jasper Johns: Lithographer" traveled to the Louisiana Museum, Humlebaek, near Copenhagen (November 20, 1968–January 12, 1969); the Kunstmuseum Basel (February 1–March 9, 1969); the Moderna Galerija, Ljubljana (for the "Eighth International Exhibition of Graphic Art") (June 7–August 31, 1969); the Muzej Savremene Umetnosti Beograd, Belgrade (September 5–28, 1969); the Národní galerie v Praze, Prague (October 23–December 23, 1969); the Museum Sztuki w Lodzi, Lodz (February 28–March 31, 1970); and the Ateneul Român, Bucharest (July–August, 1970).

101. "The Art of the Real" traveled to the Grand Palais, Paris (November–December, 1968); the Kunsthaus Zürich (January–February, 1969); and the Tate Gallery, London (April–June, 1969).

102. Johns, "Marcel Duchamp (1887–1968)," *Artforum* 7 no. 3 (November 1968): 6.

103. Max Kozloff, *Jasper Johns* (New York: Harry N. Abrams, Inc., 1969).

104. Hiroshi Kawanishi, letter to Tone, October 14, 1995. The son of a Tokyo art dealer, Kawanishi moved back to Japan in 1970. That same year, with screen printer Takeshi Shimada, he established the print workshop Simca Print Artists.

105. See [Taggart], ["Chronology"], p. 161, and Brooke, "Chronology," p. 118.

106. Ervin, letter to Tone, January 6, 1996.

107. ULAE diary, complemented by information provided by Bernstein, recorded in her unpublished journal.

108. Johns, quoted in Hindry, "Conversation with Jasper Johns," pp. 8, 10. See also Johns, quoted in Klosty, *Merce Cunningham*, p. 85.

109. Johns, "Thoughts on Duchamp," in Cleve Gray, ed., "Feature: Marcel Duchamp 1887–1968," *Art in America* 57 no. 4 (July–August 1969): 31.

110. Johns was in Nags Head by July 23, when he sent a postcard, now in the ULAE archives, from there to Tatyana Grosman.

111. "Jasper Johns: The Graphic Work" traveled to the Pollock Galleries, Southern Methodist University, Dallas, Tex. (September 14–October 12, 1969); the University Art Museum, University of New Mexico, Albuquerque, N.M. (October 27–November 23, 1969); and the Des Moines Art Center, Des Moines, Iowa (December 6, 1969–January 4, 1970).

112. Bernstein, *Jasper Johns' Paintings and Sculptures*, p. 69, and information provided by Bernstein, recorded in her unpublished journal.

113. ULAE diary.

114. Bernstein, *Jasper Johns' Paintings and Sculptures*, p. 15.

115. Clark Coolidge, *Space* (New York: Harper & Row, 1970).

116. Gary Stephan, in conversation with Tone, October 13, 1995.

117. See Bernstein, *Jasper Johns' Paintings and Sculptures*, p. 223 (note 4).

118. See Field, "The Making of 'Souvenir,'" *The Print Collector's Newsletter* 1 no. 2 (May–June 1970), pp. 29–31, and Field, "Souvenir: Theme and Execution," in *Jasper Johns: Prints 1960–1970*, n.p.

119. ULAE diary.

120. Johns, quoted in Hindry, "Conversation with Jasper Johns," p. 10.

121. The Cunningham Dance Foundation's press release for *Second Hand* in its 1972 season.

122. ULAE Archives. The book was Tony Towle's *North* (New York: Columbia University Press, 1970).

123. Bernstein, *Jasper Johns' Paintings and Sculptures*, p. 111.

124. ULAE diary. See also Field, *Jasper Johns: Prints, 1970–77*, exh. cat. (Middletown, Conn.: Wesleyan University, 1978), p. 68.

125. ULAE diary. Johns met Scott Fagan, a guitarist and singer, later that year, on December 17, in New York. Towle records in the ULAE diary, "In the city. Went to Jasper's; while we were there Scott Fagan came by with a friend, meeting Jasper for the first time."

126. Ervin, letter to Tone, January 6, 1996. See Coplans, "Fragments according to Johns," pp. 29–32.

127. "Jasper Johns: Lithographs" traveled to the Albright-Knox Art Gallery, Buffalo, N.Y. (July 15–August 31, 1971); the Tyler Museum of Art, Tyler, Tex. (September 20–October 31, 1971); the San Francisco Museum of Art, San Francisco, Calif. (November 22, 1971–January 2, 1972); The Baltimore Museum of Art, Baltimore, Md. (January 24–March 5, 1972); The Virginia Museum of Fine Arts, Richmond, Va. (March 17–April 16, 1972); and The Museum of Fine Arts, Houston, Tex. (May 15–[June 25], 1972).

128. "Jasper Johns" traveled to the Marion Koogler McNay Art Institute, San Antonio, Tex., and The Museum of Modern Art, New York (October 11, 1971–February 13, 1972).

129. ULAE diary.

130. *"Jasper Johns: Graphik"* traveled to the Städtisches Museum Mönchengladbach; the Hannover Kunstverein; the Stedelijk Museum, Amsterdam; and the Castello Sforzesco, Milan.

131. Ervin, letter to Tone, January 6, 1996.

132. ULAE diary. The diary for November 20 mentions a work it calls *Passage III*—probably *Decoy*, which Johns made by reworking the stone for *Passage I*, 1966, rotating the image ninety degrees and obscuring some details. See Sparks, *Universal Limited Art Editions*, p. 139; Bernstein, *Jasper Johns' Paintings and Sculptures*, pp. 126–27, 235 (note 4); Bernstein and Robert Littman, *Jasper Johns. Decoy: The Print and the Painting*, exh. cat. (Hempstead, N.Y.: Emily Lowe Gallery, Hofstra University, 1972); and Castleman, p. 26.

133. Cunningham Dance Foundation, Inc., unpublished chronology, n.p.

134. The entry of the ULAE diary for December 4, 1971, reads, "We [Johns, Tatyana Grosman, Bill Goldston, Towle, and possibly others] had a brief discussion about the Samuel Beckett project." See also Bernstein, "Johns and Beckett: Foirades/Fizzles," p. 142.

135. Johns has discussed this exchange in a number of interviews. See Edmund White, "Jasper Johns and Samuel Beckett," *Christopher Street* (October 1977): 20–24; Hindry, "Conversation with Jasper Johns," pp. 6–25; and Robertson and Marlow, "The Private World of Jasper Johns," pp. 40–47. Johns has said, in an interview with Mark Rosenthal, that before the idea for the book was proposed to him, Tatyana Grosman had coincidentally mentioned to him that some of his images reminded her of Beckett. See Mark Rosenthal, *Jasper Johns: Work since 1974*, exh. cat. (Philadelphia: Philadelphia Museum of Art), 1988, p. 30.

1972–1978

Introduction

1. Jasper Johns, in an interview with Annelie Pohlen, *"Interview mit Jasper Johns,"* *Heute Kunst* (Milan) no. 22 (May–June 1978): 21. Translated from the German by Ingeborg von Zitzewitz.

2. Johns, quoted in Sarah Kent, "Jasper Johns: Strokes of Genius," *Time Out* (London), December 5–12, 1990, p. 15.

3. Footnoting her journal for July 2, 1972, Roberta Bernstein writes, "Johns said this pattern could look either very sophisticated, like a Matisse, or very simple, like street art, and that while it was probably closer to the latter, he wanted it to be neither." See Bernstein, "Johns and Beckett: Foirades/Fizzles," *The Print Collector's Newsletter* 7 no. 5 (November–December 1976): 143.

4. "They [the hatch marks] became very complex….with the possibilities of gesture and the nuances that characterise the material— colour, thickness, thinness—a large range of shadings that become emotionally interesting." Johns, in Kent, p. 15.

5. Johns, quoted in Pohlen, p. 21.

Chronology

1. Johns, quoted in Edmund White, "Jasper Johns and Samuel Beckett," *Christopher Street* 2 no. 4 (October 1977): 24. Johns has also called the motif "stripes and hatchings." See Roberta Bernstein, *Jasper Johns' Paintings and Sculptures 1954–1974: "The Changing Focus of the Eye"* (Ann Arbor: UMI Research Press, 1985), p. 136.

2. Johns, quoted in Sarah Kent, "Jasper Johns: Strokes of Genius," *Time Out* (London), December 5–12, 1990, pp. 14–15. See also Michael Crichton, *Jasper Johns* (first published 1977, revised and expanded edition New York: Harry N. Abrams, Inc., in association with the Whitney Museum of American Art, 1994), p. 57; Annelie Pohlen, "Interview mit Jasper Johns," *Heute Kunst* (Milan) no. 22 (May–June 1978): 21; and Edward J. Sozanski, "The Lure of the Impossible," *The Philadelphia Inquirer Magazine*, October 23, 1988, pp. 30–31.

3. Johns, quoted in Amei Wallach, "Jasper Johns at the Top of His Form," *New York Newsday*, October 30, 1988, p. 5.

4. Hiroshi Kawanishi, letter to Lilian Tone, October 14, 1995.

5. See Richard S. Field, *Jasper Johns: Prints, 1970–1977*, exh. cat. (Middletown, Conn.: Wesleyan University, 1978), p. 75.

6. [Sarah Taggart], ["Chronology"], in *Dancers on a Plane: Cage, Cunningham, Johns* (first published 1989, reprint and enlarged ed. New York: Alfred A. Knopf, with Anthony d'Offay Gallery, London, 1990), p. 161.

7. Nancy Ervin, of Gemini G.E.L., letter to Tone, January 16, 1996.

8. According to the ULAE diary, Johns signed "the progressives & black & color separations of 'Decoy'" on July 6 and worked on the lithograph *Decoy II*, 1971–73 (ULAE# 125), on July 9 and 10.

9. ULAE diary.

10. ULAE diary. See also *The Prints of Jasper Johns 1960–1993: A Catalogue Raisonné* (West Islip, N.Y.: Universal Limited Art Editions, Inc., 1994), cat. #123, n.p., which cites *XXe Siècle* (Paris) 35 no. 40 (June 1973): 131.

11. Leo Castelli's appointment book.

12. Regarding the painting's title as a reference to Jackson Pollock, see Rosalind Krauss, "Jasper Johns: The Functions of Irony," *October* no. 2 (Summer 1976): 97–98; David Bourdon, "Jasper Johns: 'I Never Sensed Myself as Being Static,'" *The Village Voice*, October 31, 1977, p. 75; Richard Francis, *Jasper Johns* (New York: Abbeville Press, Modern Masters Series, 1984), p. 83; Bernstein, *Jasper Johns' Paintings and Sculptures*, p. 139; James Cuno, "Voices and Mirrors/Echoes and Allusions: Jasper Johns's *Untitled, 1972*," in *Foirades/Fizzles: Echo and Allusion in the Art of Jasper Johns*, exh. cat. (Los Angeles: The Grunwald Center for the Graphic Arts, Wight Art Gallery, University of California, 1987), pp. 203, 227; Mark Rosenthal, *Jasper Johns: Work since 1974*, exh. cat. (Philadelphia: Philadelphia Museum of Art), pp. 20, 22; Georges Boudaille, *Jasper Johns* (New York: Rizzoli, 1989), p. 27; Barbara Rose, "Jasper Johns: The *Tantric Details*," *American Art* 7 no. 4 (Fall 1963): 54; and Robert Saltonstall Mattison, *Masterworks in the Robert and Jane Meyerhoff Collection* (New York: Hudson Hills Press, 1995), p. 47 (note 24).

13. Field, *Jasper Johns: Prints, 1970–1977*, p. 87.

14. Johns, quoted in Bourdon, "Jasper Johns: 'I Never Sensed Myself as Being Static,'" p. 75.

15. ULAE diary.

16. Thomas B. Hess, "Polypolyptychality," *New York* 6 no. 8 (February 19, 1973): 73.

17. ULAE diary.

18. ULAE diary. According to the diary, Johns signed *Decoy II* on September 29 in New York.

19. The ULAE diary entry for February 21 reads, "On Sunday [February 18] Tanya flew down to Saint Martin's, a small island in the West Indies, to Jasper's. I…reserved a hotel room for her & when you get there it means nothing, so she stayed at Jasper's, with Bill Katz & Louise Nevelson."

20. Johns, letter to Leo Castelli, March 4, 1973, Leo Castelli Gallery Archives.

21. See Crichton, *Jasper Johns*, pp. 59–60, citing *National Geographic* no. 143 (May 1973): 668.

22. This is the first drawing since 1962 inscribed with its day, month, and year of completion: "St. Martin 3 May '73."

23. See *Jasper Johns: Lithographs 1973–75* (Los Angeles: Gemini G.E.L., 1975), n.p. Precise dates are specified in Ervin, letter to Tone.

24. Ervin, letter to Tone.

25. Johns, quoted in White, "Jasper Johns and Samuel Beckett," pp. 20, 24.

26. In conversation with Tone on December 15, 1995, Johns did not remember where these works were made.

27. Johns, quoted in White, "Jasper Johns and Samuel Beckett," p. 24.

28. Aldo Crommelynck, in conversation with Tone, October 20, 1995.

29. Bernstein, "Johns and Beckett: Foirades/Fizzles," *The Print Collector's Newsletter* VII no. 5 (November–December 1976): 142.

30. Johns, quoted in Mark Rosenthal, *Artists at Gemini G.E.L.: Celebrating the 25th Year* (New York: Harry N. Abrams, Inc., in association with Gemini G.E.L., Los Angeles, 1993), p. 66.

31. Ervin, letter to Tone.

32. *Jasper Johns: Lithographs 1973–75*, n.p.

33. A photograph dated September 1974 in *Kusuo Shimizu & Minami Gallery*, exh. cat. (Tokyo: Minami Gallery and Bijutsu Shupan-Sha, 1985), shows Johns, the art dealer Kuzuo Shimizu, and the artist Sam Francis in Paris.

34. [Taggart], ["Chronology"], p. 161.

35. "Jasper Johns Drawings" traveled to the Mappin Art Gallery, Sheffield (October 19– November 17, 1974); the Herbert Art Gallery, Coventry (November 30–December 29, 1974); the Walker Art Gallery, Liverpool (January 4– February 2, 1975); the City Art Gallery, Leeds (February 8–March 9, 1975); and the Serpentine Gallery, London (March 20–April 20, 1975).

36. "Poets of the Cities" traveled to the San Francisco Museum of Art, San Francisco, Calif. (January 21–March 23, 1975), and the Wadsworth Atheneum, Hartford, Conn. (April 23–June 1, 1975).

37. See *Jasper Johns: Lithographs 1973–75*, n.p., and Anna Brooke, "Chronology," in Richard Francis, *Jasper Johns* (New York: Abbeville Press, Modern Masters Series, 1984), p. 118.

38. Ervin, letter to Tone.

39. Leo Castelli appointment book.

40. ULAE diary.

41. [Taggart], ["Chronology"], p. 161.

42. See Nan Rosenthal, "Drawing as Rereading," in Nan Rosenthal and Ruth E. Fine, with Marla Prather and Amy Mizrahi Zorn, *The Drawings of Jasper Johns*, exh. cat. (Washington, D.C.: National Gallery of Art, and New York and London: Thames and Hudson, 1990), p. 36.

43. Johns, quoted in Crichton, *Jasper Johns*, p. 64.

44. Under the auspices of The Museum of Modern Art's International Program, "Drawing Now: 1955–1975" traveled to the Kunsthaus Zürich, Zurich (October 10–November 14, 1976); the Staatliche Kunsthalle, Baden-Baden (November 25, 1976–January 16, 1977); the Graphische Sammlung Albertina, Vienna (January 28–March 6, 1977); the Sonja Henie-Niels Onstad Foundations, Oslo (March 17– April 24, 1977); and the Tel Aviv Museum, Tel Aviv (May 12–July 2, 1977).

45. See above, "1930–1958, Chronology," p. 385 (note 86) above.

46. Ervin, letter to Tone.

47. Johns, quoted in Irene Vischer-Honegger, "*Ich bringe nichts mehr in meinen Kopf,*" *Bilanz* (Zurich), June 1988, p. 96. Translated from the German by Ingeborg von Zitzewitz.

48. Johns, quoted in White, "Enigmas and Double Visions," *Horizon* 20 no. 2 (October 1977): 55.

49. Ervin, letter to Tone.

50. See Bernstein, "'Seeing a Thing Can Sometimes Trigger the Mind to Make Another Thing,'" in the present volume, p. 63.

51. "Jasper Johns" traveled to the Kunsthalle Köln (in an exhibition organized by the Museum Ludwig), Cologne (February 10–March 27, 1978); the Musée national d'art moderne, Centre Georges Pompidou, Paris (April 19–June 4, 1978); the Hayward Gallery, London (June 22–July 30, 1978); the Seibu Museum of Art, Tokyo (August 19–September 26, 1978); and the San Francisco Museum of Art, San Francisco, Calif. (October 19–December 19, 1978).

52. Johns, quoted in Peter Fuller, "Jasper Johns Interviewed I," *Art Monthly* no. 18 (July–August 1978): 6.

53. "Jasper Johns Screenprints" traveled to the Akron Art Museum, Akron, Ohio (December 9, 1978–January 21, 1979); the Seattle Art Museum, Seattle, Wash. (February 1–March 18, 1979); the Centre for the Arts, Simon Fraser Gallery, Burnaby, British Columbia (April 2–May 13, 1979); the Phoenix Art Museum, Phoenix, Ariz. (May 27–July 8, 1979); the Portland Art Museum, Portland, Oreg. (July 23–September 16, 1979); the San José Museum of Art, San José, Calif. (October 1–November 11, 1979); the Tucson Museum of Art, Tucson, Ariz. (December 8, 1979–January 13, 1980); the Roswell Museum and Art Center, Roswell, N.M. (January 29–March 2, 1980); the University Art Gallery, University of Texas, Arlington (March 17–April 27, 1980); the Arkansas Arts Center, Little Rock (May 12–June 22, 1980); the Tyler Museum of Art, Tyler, Tex. (August 1–24, 1980); the Center for the Visual Arts Gallery, Illinois State University, Normal (September 22–November 9, 1980); The Toledo Museum of Art, Toledo, Ohio (November 24, 1980–January 4, 1981); the J. B. Speed Art Museum, Louisville, Ky. (January 19–March 1, 1981); and the Springfield Art Museum, Springfield, Mo. (March 16–April 26, 1981).

54. "An Artist Collects" traveled to the Gibbes Gallery of Art, Charleston (February 7–March 26, 1978), and to the Greenville County Museum of Art, Greenville (April 5–May 31, 1978).

55. Johns, in conversation with Tone, December 15, 1995, said they were mostly done in a foundry in Long Island City where Jacques Lipchitz used to work.

56. Johns, quoted in Katrina Martin, "An Interview with Jasper Johns about Silkscreening," in *Jasper Johns: Printed Symbols* (Minneapolis: Walker Art Center, 1990), p. 60.

57. Martin, letter to Audrey Isselbacher, September 14, 1981, Department of Prints and Illustrated Books, The Museum of Modern Art.

58. Ervin, letter to Tone.

59. "Jasper Johns: Prints 1970–1977" traveled to the Museum of Fine Arts, Springfield, Mass. (May 20–June 25, 1978); The Baltimore Museum of Art, Md. (July 11–August 20, 1978); Dartmouth College Museum and Galleries, Hopkins Center, Hanover, N.H. (September 8–October 15, 1978); the University Art Museum, University of California, Berkeley (November 3–December 15, 1978); the Cincinnati Art Museum,

Ohio (January 5–February 16, 1979); the Georgia Museum of Art, University of Georgia, Athens (March 9–April 20, 1979); the Saint Louis Art Museum, Saint Louis, Mo. (May 11–June 22, 1979); the Newport Harbor Art Museum, Newport, Calif. (July 13–September 9, 1979); and the Rhode Island School of Design, Providence, R.I. (October 3–November 18, 1979).

60. Johns, quoted in Fuller, "Jasper Johns Interviewed Part II," *Art Monthly* no. 19 (September 1978): 5.

61. Johns, quoted in Ann Hindry, "Conversation with Jasper Johns/*Conversation avec Jasper Johns*," in English and French, *Artstudio* no. 12 (Spring 1989): 8.

62. The interview was published, in Japanese, in *Sekai* magazine (Tokyo) in December 1978.

63. See Christian Geelhaar, "Interview with Jasper Johns," in *Jasper Johns: Working Proofs* (Basel: Kunstmuseum Basel, and London: Petersburg Press, 1980), pp. 48, 56 (note 4).

1979–1981

Introduction

1. Johns, in an interview with Ruth E. Fine and Nan Rosenthal, "Interview with Jasper Johns," in Nan Rosenthal and Ruth E. Fine, with Marla Prather and Amy Mizrahi Zorn, *The Drawings of Jasper Johns*, exh. cat. (Washington, D.C.: National Gallery of Art, and New York and London: Thames and Hudson, 1990), p. 82.

2. Johns, quoted in Michael Crichton, *Jasper Johns* (first published 1977, revised and expanded edition New York: Harry N. Abrams, Inc., in association with the Whitney Museum of American Art, 1994), p. 62.

3. In the lower margin of the 1979 *Cicada* watercolor (plate 175), Johns experiments with schematic renderings of a skull. From these and other indications in an untitled drawing of 1982 (LC# D-173), it is clear that he was informed in these schematizations by at least two sources. First, in his sketchbook Johns copied Edgar Degas's caricatural renderings of the heads of the German leader Otto von Bismarck and the French leader Adolphe Thiers; see pp. 227 and 228 of Degas's notebook no. 34, in Theodore Reff, *The Notebooks of Edgar Degas: A Catalogue of the Thirty-Eight Notebooks in the Bibliothèque Nationale and Other Collections* (Oxford: Clarendon/Oxford University Press, 1976), 2:n.p. Degas's schema for Thiers's round head, in which the features below the round glasses are indicated only by an *X*, may have seemed to Johns to connect with the graphic schema of a stenciled skull-and-crossbones warning sign shown in a newspaper photo pasted onto one of his sketchbook pages. The latter photo, which shows Pope John Paul II walking out of the gates of a former Nazi concentration camp, was published in the *New York Times* on June 8, 1979, alongside an article entitled "Pope Prays at Auschwitz: 'Only Peace!'" Johns inscribed this headline next to his rendering of the skull in the margin of *Cicada*.

Chronology

1. Johns, quoted in Katrina Martin, "An Interview with Jasper Johns about Silkscreening," in *Jasper Johns: Printed Symbols*, exh. cat. (Minneapolis: Walker Art Center, 1990), p. 60.

2. Ruth E. Fine and Nan Rosenthal, "Interview with Jasper Johns," in Nan Rosenthal and Ruth E. Fine, with Marla Prather and Amy Mizrahi Zorn, *The Drawings of Jasper Johns*, exh. cat. (Washington, D.C.: National Gallery of Art, and New York and London: Thames and Hudson, 1990), p. 82. See also Robert Saltonstall Mattison, *Masterworks in the Robert and Jane Meyerhoff Collection: Jasper Johns, Robert Rauschenberg, Roy Lichtenstein, Ellsworth Kelly, Frank Stella* (New York: Hudson Hills Press, 1995), p. 27.

3. "Jasper Johns Working Proofs" traveled to the Staatliche Graphische Sammlung, Munich (June 19–August 5, 1979); the Städtische Galerie im Städelschen Kunstinstitut, Frankfurt am Main (September 13–November 11, 1979); the Kunstmuseum mit Sammlung Sprengel, Hannover (November 25, 1979–January 6, 1980); Den Kongelige Kobberstiksamling, Statens Museum for Kunst København, Copenhagen (January 19–March 16, 1980); the Moderna Museet, Stockholm (March 29–May 11, 1980); the Centre Cultural de la Caixa de Pensiones, Barcelona (October 2–November 2, 1980); the Provinciaal Museum Begijnhof, Hasselt (November 21, 1980–January 4, 1981); and the Tate Gallery, London (February 4–March 22, 1981).

4. Letter from Nancy Ervin, of Gemini G.E.L., to Lilian Tone, January 16, 1996.

5. See Roberta Bernstein, "'Seeing a Thing Can Sometimes Trigger the Mind to Make Another Thing,'" in the present volume, p. 51.

6. Per Martin, letter to Audrey Isselbacher of The Museum of Modern Art, September 14, 1981, Department of Prints and Illustrated Books, The Museum of Modern Art. See also [Sarah Taggart], ["Chronology"], in *Dancers on a Plane: Cage, Cunningham, Johns* (first published 1989, reprint and enlarged ed. New York: Alfred A. Knopf, with Anthony d'Offay Gallery, London, 1990), p. 161.

7. See Paul Chutkow, "Picasso Genius Unveiled in 'Artistic Event of Decade,'" *The State* (Columbia, S.C.), October 12, 1979, p. unknown, and Mark Rosenthal, *Jasper Johns: Work since 1974*, exh. cat. (Philadelphia: Philadelphia Museum of Art, 1988), p. 107 (note 61). Mattison has remarked that it was in this exhibition that Johns first saw Picasso's *Woman in Straw Hat*, 1936, which he would later use in his work. Mattison, p. 36.

8. See Michael Crichton, *Jasper Johns* (first published 1977, revised and expanded edition New York: Harry N. Abrams, Inc., in association with the Whitney Museum of American Art, 1994), p. 63.

9. [Taggart], ["Chronology"], p. 161.

10. See Nan Rosenthal, "Drawing as Rereading," in Rosenthal and Fine, p. 45 (note 38).

11. See ibid. According to Rosenthal, imagery from the Isenheim Altarpiece appears

in more than seventy of Johns's works from between 1981 and 1989. See ibid., p. 34. The portfolio, produced by Ostar Hagen, was made in Munich in 1919.

12. Johns, quoted in Richard Cork, "The Liberated Millionaire Is Not Flagging," *The Times* (London), November 30, 1990, p. 21.

13. In November 1986, *Out the Window*, 1959, was sold at auction for $3.63 million, the highest price paid at auction for the work of a living artist. In May 1988, *Diver*, 1962, was sold for $4.18 million, once again a record; and in November 1988, *False Start*, 1959, was sold for $17 million—another record.

14. Ervin, letter to Tone.

15. The interview was published as Martin, "An Interview with Jasper Johns about Silkscreening," pp. 51–61.

16. Rosenthal, "Drawing as Rereading," p. 36.

17. See [Taggart], ["Chronology"], p. 161. "Jasper Johns Drawings 1970–80" traveled to the Margo Leavin Gallery, Los Angeles (February 21–March 28, 1981).

18. Ervin, letter to Tone.

1982–1984

Chronology

1. See Riki Simons, "*Gesprek met Jasper Johns: Dat ik totaal niet begrepen word, is interessant,*" *NRC Handelsblad* (Rotterdam), April 23, 1982, p. CS3.

2. See Esther Sparks, *Universal Limited Art Editions. A History and Catalogue: The First Twenty-Five Years* (Chicago: Art Institute of Chicago, and New York: Harry N. Abrams, Inc., 1989), p. 15.

3. See Riva Castleman, *Seven Master Printmakers* (New York: The Museum of Modern Art, 1991), p. 86.

4. Johns, quoted in Sparks, *Universal Limited Art Editions*, p. 9.

5. See Grace Glueck, "The Artists' Artists," *Artnews* 81 no. 9 (November 1982): 94–95.

6. "Jasper Johns: Savarin Monotypes" traveled to the Dallas Museum of Art, Dallas, Tex. (March 31–May 20, 1984); the Moderna Galerija, Ljubljana, Yugoslavia (June 1–30, 1984); the Kunstmuseum Basel, Basel (September 14–November 10, 1985); the Sonja Henie and Niels Onstad Foundations, Oslo (December 1985–January 1986); the Heland Thordén Wetterling Galeries, Stockholm (February–March 1986); and the Tate Gallery, London (May 28–August 31, 1986).

7. Castleman, *Seven Master Printmakers*, p. 86.

8. Ruth E. Fine and Nan Rosenthal, "Interview with Jasper Johns," in Nan Rosenthal and Ruth E. Fine, with Marla Prather and Amy Mizrahi Zorn, *The Drawings of Jasper Johns*, exh. cat. (Washington, D.C.: National Gallery of Art, and New York and London: Thames and Hudson, 1990), p. 82.

9. Johns, quoted in April Bernard and Mimi Thompson, "Johns on…," *Vanity Fair* 47 no. 2 (February 1984): 65.

10. Johns, letter to Castleman, October 7, 1983, Artist File, Department of Prints and Illustrated Books, The Museum of Modern Art.

11. W. E. Hill's drawing was published in *Puck* (London) no. 78 (November 6, 1915): 11, with the caption "My wife and my mother-in-law/They are both in this picture—find them." See Nan Rosenthal, "Drawing as Rereading," in Rosenthal and Fine, p. 45 (note 27).

12. See Michael Crichton, *Jasper Johns* (first published 1977, revised and expanded edition New York: Harry N. Abrams, Inc., in association with the Whitney Museum of American Art, 1994), p. 66.

13. Steve Wolfe, in conversation with Lilian Tone, October 13, 1995.

14. See Crichton, *Jasper Johns*, pp. 70–71.

15. Johns, quoted in Robert Saltonstall Mattison, *Masterworks in the Robert and Jane Meyerhoff Collection: Jasper Johns, Robert Rauschenberg, Roy Lichtenstein, Ellsworth Kelly, Frank Stella* (New York: Hudson Hills Press, 1995), p. 36.

1985–1989

Introduction

1. Michael Crichton writes, "The four shadows are cast on four different walls, each referring to one of Johns' residences: *Summer* has bricks from his Stony Point [N.Y.] house, glazed green; *Winter* has tiles from the courtyard of his new house in New York; *Fall* has boards from his residence on Houston Street; and *Spring* has tiles from his house in St. Martin." See Crichton, *Jasper Johns* (first published 1977, revised and expanded edition New York: Harry N. Abrams, Inc., in association with the Whitney Museum of American Art, 1994), p. 69.

Chronology

1. See Roberta Bernstein, "Jasper Johns's *The Seasons*: Records of Time," in *Jasper Johns: The Seasons* (New York: Brooke Alexander Editions, 1991), pp. 9–13. See also Michael Crichton, *Jasper Johns* (first published 1977, revised and expanded edition New York: Harry N. Abrams, Inc., in association with the Whitney Museum of American Art, 1994), pp. 68–69, and Bernstein, "'Winter' by Jasper Johns," *Sotheby's Preview* (New York) 7 no. 6 (November 1995): 12–14.

2. Johns, quoted in Ann Hindry, "Conversation with Jasper Johns/*Conversation avec Jasper Johns,*" in English and French, *Artstudio* no. 12 (Spring 1989): 13.

3. See Crichton, *Jasper Johns*, p. 21.

4. James Meyer, conversation with Lilian Tone, October 16, 1995.

5. In conversation with Tone, December 15, 1995, Johns did not recall where this work was made.

6. Johns, quoted in Amei Wallach, "Jasper Johns at the Top of His Form," *New York Newsday*, October 30, 1988, p. 20.

7. "Jasper Johns: A Print Retrospective" traveled to the Schirn Kunsthalle, Frankfurt

(November 22, 1986–January 25, 1987); the Centro de Arte Reina Sofía, Madrid (February 9–April 5, 1987); the Wiener Secession, Vienna (May 7–June 8, 1987); the Fort Worth Art Museum, Fort Worth, Tex. (July 4–August 30, 1987); the Los Angeles County Museum of Art, Los Angeles, Calif. (October 1–December 6, 1987); the Hara Museum ARC, Shibukawa-shi (May 29–July 17, 1988); the National Museum of Art, Osaka (July 23–September 6, 1988); and the Kitakyushu Municipal Museum of Art (September 12–October 10, 1988).

8. According to Johns's records, the drawings were sent to ULAE on November 21, 1986, where photogravure plates were made and proofed in December, and sent to Osiris in January 1987.

9. Wallach, "Jasper Johns at the Top of His Form," p. 4.

10. See Michael Pye, "Behind Veils, The Elusive Heart," *The Independent* (London), November 18, 1990, p. 21.

11. "Foirades/Fizzles: Echo and Allusion in the Art of Jasper Johns" traveled to the Walker Art Center, Minneapolis, Minn. (December 6, 1987–January 31, 1988); the Archer M. Huntington Gallery, University of Texas, Austin, Tex. (February 15–March 28, 1988); the Yale University Art Gallery, New Haven, Conn. (April 12–May 31, 1988); and the High Museum of Art, Atlanta, Ga. (September 6–November 27, 1988).

12. See Bernstein, "'Seeing a Thing Can Sometimes Trigger the Mind to Make Another Thing,'" in the present volume, p. 61.

13. "The Drawings of Jasper Johns from the Collection of Toiny Castelli" traveled to the Museum of Contemporary Art, Los Angeles, Calif. (February 16–March 20, 1988), and The Museum of Modern Art, New York (April 1–May 15, 1988).

14. Johns, quoted in Wallach, "Jasper Johns: On Target," *Elle* (November 1988): 156.

15. Johns, quoted in John Yau, "Jasper Johns. Proofs Positive: The Master Works," *Artnews* 87 no. 7 (September 1988): 104–5.

16. [Sarah Taggart], ["Chronology"], in *Dancers on a Plane: Cage, Cunningham, Johns* (first published 1989, reprint and enlarged ed. New York: Alfred A. Knopf, with Anthony d'Offay Gallery, London, 1990), p. 162.

17. See Nan Rosenthal and Ruth E. Fine, with Marla Prather and Amy Mizrahi Zorn, *The Drawings of Jasper Johns*, exh. cat. (Washington, D.C.: National Gallery of Art, and New York and London: Thames and Hudson, 1990), p. 300. Johns's drawing was lot seven in "Contemporary Art: A Benefit Auction for the Supportive Care Program of St. Vincent's Hospital and Medical Center of New York," held at Sotheby's, New York, on May 2, 1988. See Rosenthal, "Drawing as Rereading," in Rosenthal and Fine, p. 45 (note 43).

18. See [Taggart], ["Chronology"], p. 162, and Wallach, "Jasper Johns at the Top of His Form," p. 4.

19. See [Taggart], ["Chronology"], p. 162, and Edward J. Sozanski, "The Lure of the

Impossible," *The Philadelphia Inquirer Magazine*, October 23, 1988, p. 25. "Jasper Johns: Work since 1974" was installed at the Philadelphia Museum of Art from October 23, 1988, to January 8, 1989.

20. Michael Brenson, "Jasper Johns Shows the Flag in Venice," *New York Times*, July 3, 1988, p. H27.

21. See [Taggart], ["Chronology"], p. 162.

22. Johns, quoted in Crichton, *Jasper Johns*, p. 72.

23. Bernstein, "'Seeing a Thing Can Sometimes Trigger the Mind to Make Another Thing,'" p. 63.

24. "Dancers on a Plane: John Cage, Merce Cunningham, Jasper Johns" traveled to the Tate Gallery Liverpool, Liverpool (January 31–March 25, 1990).

1990–1995

Introduction

1. Johns, quoted in Amei Wallach, "An American Icon: Jasper Johns and His Visual Guessing Games," *New York Newsday*, February 28, 1991, Part II p. 65.

2. Johns discusses this decision in an unpublished interview with Wallach, conducted on February 22, 1991. See the companion volume to this catalogue, *Jasper Johns: Writings, Sketchbook Notes, Interviews*.

3. Johns has described the works featuring this face as "infantile—images of faces where features seem to float about. One tends to associate it with Picassoesque distortion. So there's a conflation of infantile and adult, if you rank Picasso as an adult." Johns, quoted in Paul Clements, "The Artist Speaks," *Museum & Arts Washington* 6 no. 3 (May/June 1990): 117.

4. See Roberta Bernstein, "Seeing a Thing Can Sometimes Trigger the Mind to Make Another Thing," in the present volume, p. 60. The article in question was Bruno Bettelheim, "Schizophrenic Art: A Case Study," *Scientific American* vol. 186 (April 1952): 31–34.

Chronology

1. In conversation with Lilian Tone, December 15, 1995, Johns did not recall where these works were made.

2. See Jill Johnston, "Trafficking with X," *Art in America* 79 no. 3 (March 1991): 102–11, 164–65.

3. Johns, quoted in Michael Crichton, *Jasper Johns* (first published 1977, revised and expanded edition New York: Harry N. Abrams, Inc., in association with the Whitney Museum of American Art, 1994), p. 72.

4. See Robert Saltonstall Mattison, *Masterworks in the Robert and Jane Meyerhoff Collection: Jasper Johns, Robert Rauschenberg, Roy Lichtenstein, Ellsworth Kelly, Frank Stella* (New York: Hudson Hills Press, 1995), p. 27.

5. "Jasper Johns: Printed Symbols" traveled to The Museum of Fine Arts, Houston, Tex. (June 17–August 19, 1990); The Fine Arts Museums of San Francisco, San Francisco, Calif. (September 15–November 18, 1990); the

Musée des beaux-arts de Montréal, Montreal (December 14, 1990–March 10, 1991); the Saint Louis Art Museum, Saint Louis, Mo. (April 6–June 2, 1991); the Center for the Fine Arts, Miami, Fla. (June 22–August 18, 1991); and The Denver Art Museum, Denver, Colo. (September 14–November 10, 1991). This last stop replaced the stop at the Brooklyn Museum, New York, that was originally planned and is listed in the exhibition's catalogue.

6. Johns, letter to Douglas W. Druick, February 27, 1990, Art Institute of Chicago Archives.

7. "The Drawings of Jasper Johns" traveled to the Kunstmuseum Basel, Basel (August 18–October 28, 1990); the Hayward Gallery, London (November 29, 1990–February 3, 1991); and the Whitney Museum of American Art, New York (February 20–April 7, 1991).

8. In conversation with Tone, December 15, 1995, Johns did not recall where these works were made.

9. Bruno Bettelheim, "Schizophrenic Art: A Case Study," *Scientific American* vol. 186 (April 1952): 31–34.

10. Johns, quoted in Mark Rosenthal, *Artists at Gemini G.E.L.: Celebrating the 25th Year* (New York: Harry N. Abrams, Inc., in association with Gemini G.E.L., Los Angeles, 1993), p. 58.

11. "Retrospective of Jasper Johns Prints from the Leo Castelli Collection" traveled to the Helena Rubenstein Pavillion for Contemporary Art, Tel Aviv Museum of Art, Tel Aviv (October 3–November 25, 1991), and the Galerie Isy Brachot, Brussels (December 4, 1991–January 1992), where it was held to coincide with "Jasper Johns," an exhibition of Johns's paintings and drawings (December 11, 1991–February 1, 1992).

12. "Jasper Johns: The Seasons (Prints and Related Works)" traveled to the San Diego Museum of Art, San Diego, Calif. (June 27–August 9, 1992); the Galeria Weber, Alexander y Cobo, Madrid (September 17–November 14, 1992); the Fundación Municipal de Cultura, Gijón (January 1993); the Fundación Luis Cernuda, Seville (February 1993); the Casa de la Parra, Xunta, Santiago de Compostela (March 1993); and the Fundació Pilar i Joan Miró a Mallorca, Palma de Mallorca (May 1993).

13. See unpublished chronology by Sarah Taggart, Johns's assistant.

14. See Joe Martin Hill's unpublished M.A. thesis "The Targets of Jasper Johns, 1955–74: A History and Biography," Institute of Fine Arts, New York University, January 1995, pp. 102–3.

15. See "Jasper Johns: Works on Paper," *Grand Street* (New York) 54 (Fall 1995): 71–80.

16. Johns, quoted in Mark Rosenthal, *Artists at Gemini G.E.L.*, p. 63. According to Mattison, *Masterworks in the Meyerhoff Collection*, p. 48 (note 88), this galaxy image is reproduced in Timothy Ferris, *Galaxies* (San Francisco: Sierra Book Club, 1980), p. 82.

17. Taggart, unpublished chronology.

18. Ibid.

19. "Jasper Johns: gravures et dessins de la collection Castelli, 1960–1991; Portraits de l'artiste par Hans Namuth, 1962–1989" traveled to the Louisiana Museum, Humlebaek (October 21, 1992–January 17, 1993).

20. John Cage, "Jasper Johns: Stories and Ideas," in Alan R. Solomon, *Jasper Johns: Paintings, Drawings and Sculptures 1954–1964*, exh. cat. (New York: The Jewish Museum, 1964), p. 23.

21. "Hand-Painted Pop" traveled to the Museum of Contemporary Art, Chicago, Ill. (April 3–June 20, 1993), and the Whitney Museum of American Art, New York (July 16–October 3, 1993).

22. Taggart, unpublished chronology.

23. See Roberta Bernstein, "'Seeing a Thing Can Sometimes Trigger the Mind to Make Another Thing,'" in the present volume, p. 66.

24. Johns, quoted in Bryan Robertson and Tim Marlow, "The Private World of Jasper Johns," *Tate: The Art Magazine* (London) no. 1 (Winter 1993): 47.

25. In conversation with Tone, December 15, 1995, Johns did not recall where this work was made.

26. Taggart, unpublished chronology.

27. Bernstein, "'Seeing a Thing Can Sometimes Trigger the Mind to Make Another Thing,'" p. 63.

28. Taggart, unpublished chronology.

29. Ibid.

30. "Duchamp's Leg" traveled to the Center for Fine Arts, Miami, Fla. (December 2, 1995–March 3, 1996).

31. Bernstein, "'Seeing a Thing Can Sometimes Trigger the Mind to Make Another Thing,'" p. 74 (note 131).

32. Ibid., pp. 64, 74 (note 139).

33. Tom Loughman, of the Philadelphia Museum of Art, in conversation with Tone, December 22, 1995. This study, in textured wax and black ink on yellow-toned paper and cut gelatin silver photographs, mounted on board, 17 by 12 ½ inches, was on loan to the Philadelphia Museum of Art from Madame Marcel Duchamp.

Selected Bibliography

COMPILED BY CHRISTEL HOLLEVOET

This catalogue is accompanied by an electronic publication containing a complete bibliography and exhibition history. It can be obtained through The Museum of Modern Art's web site, at www.moma.org/johns.biblio.html, or through The Museum of Modern Art Bookstore.

Entries marked with an asterisk include interviews and statements in the artist's own words.

Writings by Johns
In chronological order.

"Collage" (letter to the editor). *Arts* 33 no. 6 (March 1959): 7.

["Statement"]. In *Sixteen Americans*, ed. Dorothy C. Miller, exh. cat., p. 22. New York: The Museum of Modern Art, 1959.

"Duchamp." *Scrap* no. 2 (December 23, 1960): [4].

Letter to the editor. *Portable Gallery Bulletin* no. 3 [December 1962]: n.p.

Sketchbook notes. In ["Statements by Contemporary Artists"], ed. Yoshiaki Tono. *Mizue* (Tokyo) no. 700 (June 1963): [6], 18–19. In Japanese.

"Sketchbook notes." *Art and Literature* (Lausanne) vol. 4 (Spring 1965): 185–92.

Sketchbook notes. In "This Week's Cover: *White Flag*, Tokyo, 25 Oct. '66." *Asahi Magazine* (Tokyo) 8 no. 46 (November 6, 1966): 110. In English and Japanese.

Sketchbook notes. In ["Jasper Johns: The Words; The Idea of a Changing Focus"], by Jun Miyakawa. *Bijutsu Techô* (Tokyo), July 1968, pp. 60–63. Reproduced and in Japanese.

Sketchbook notes. In ["Jasper Johns: The Point 'According to What'?"], by Yoshiaki Tono. *Bijutsu Techô* (Tokyo), July 1968, pp. 64–65, 70–74. Reproduced and in Japanese.

"Marcel Duchamp (1887–1968)." *Artforum* 7 no. 3 (November 1968): 6.

"Sketchbook Notes." *Juillard* (Leeds) 3 (Winter 1968–69): 25–27. Excerpted in *Art Now: New York* 1 no. 4 (April 1969): n.p.

"Sketchbook Notes." *o to 9* (New York) no. 6 (July 1969): 1–2.

"Thoughts on Duchamp." In "Feature: Marcel Duchamp 1887–1968," ed. Cleve Gray. *Art in America* 57 no. 4 (July–August 1969): 31.

"Neue Skizzenbuch-Notizen." In *Jasper Johns Graphik*, ed. Carlo Huber, exh. cat. Bern: Klipstein und Kornfeld, 1971.

Sketchbook notes. In ["About Leg, or Duchamp and Johns II"], by Yoshiaki Tono. *Bijutsu Techô* (Tokyo) 27 no. 394 (May 1975): 196–207. Reproduced and in Japanese.

"Jasper Johns: Sketchbook Notes." *av* (Seibu Museum, Tokyo) 4 no. 10 (July 1978): n.p. (6 pages). Reproduced and in Japanese. See also "The Structure of Watchman," by Tadashi Yokoyama, in the same issue.

Statement on Willem de Kooning, dated January 1983. *Art Journal* (New York) 48 no. 3 (Fall 1989): 232.

Sketchbook notes. Reproduced in *Artists' Sketchbooks*, exh. cat. New York: Matthew Marks Gallery, 1991.

Articles
In alphabetical order by author.

Alloway, Lawrence. "The Man Who Liked Cats: The Evolution of Jasper Johns." *Arts* 44 no. 1 (September–October 1969): 40–43.

Anderson, Alexandra. "A Preview of *Foirades/Fizzles* by Samuel Beckett with Etchings by Jasper Johns." *New York Arts Journal* 1 no. 2 (September–October 1976): 41.

"Artists for Artists." *The New Yorker*, March 9, 1963, pp. 32–34.*

Atkins, Robert. "Tracking and Retracking: On Target with Jasper Johns." *Print News* (San Francisco) 8 no. 4 (Fall 1986): 4–9.

Bernard, April, and Mimi Thompson. "Johns on…." *Vanity Fair* 47 no. 2 (February 1984): 65.*

Bernstein, Roberta. "Johns & Beckett: Foirades/Fizzles." *The Print Collector's Newsletter* 7 no. 5 (November–December 1976): 141–45.*

———. "Jasper Johns and the Figure. Part One: Body Imprints." *Arts* 52 no. 2 (October 1977): 142–44.

———. "An Interview with Jasper Johns." In *Fragments: Incompletion and Discontinuity*, ed. Lawrence D. Kritzman, *New York Literary Forum* vol. 8–9 (1981): 279–90.*

———. "*Winter* by Jasper Johns." *Sotheby's Preview* (New York) 7 no. 6 (November 1995): 12–14.

Bourdon, David. "Jasper Johns: 'I Never Sensed Myself as Being Static.'" *The Village Voice*, October 31, 1977, p. 75.*

Calas, Nicolas. "ContiNuance." *Artnews* 57 no. 10 (February 1959): 36–39.

———. "Jasper Johns and the Critique of Painting." *Point of Contact* 1 no. 3 (September–October 1976): 50–57.

———. "*Jasper Johns: 'ceci n'est pas un drapeau.'*" *XXe Siècle* (Paris) 40 no. 50 (June 1978): 33–39.

Carpenter, Joan. "The Infra-Iconography of Jasper Johns." *Art Journal* (New York) 36 no. 3 (Spring 1977): 221–27.

Cato, Robert. "Sources of Inspiration." *Print* 11 no. 1 (February–March 1957): 28.

Clements, Paul. "The Artist Speaks." *Museum & Arts Washington* 6 no. 3 (May/June 1990): 76–81, 116–17.*

Coplans, John. "Fragments according to Johns: An Interview with Jasper Johns." *The Print Collector's Newsletter* 3 no. 2 (May–June 1972): 29–32.*

Cork, Richard. "The Liberated Millionaire Is Not Flagging." *The Times* (London), November 30, 1990, p. 21.*

Cuno, James. "Jasper Johns." *Print Quarterly* (London) 4 no. 1 (March 1987): 83–92.

Davvetas, Demosthène. "*Jasper Johns et sa famille d'objets.*" *Art Press* (Paris) vol. 80 (April 1984): 11–12.*

Debs, Barbara Knowles. "On the Permanence of Change." *The Print Collector's Newsletter* 17 no. 4 (September–October 1986): 117–23.

Domecq, Jean-Philippe. "*Jasper Johns ou l'Art sur l'art.*" *Esprit* (Paris) no. 219 (March 1996): 115–30.

Dorfles, Gillo. "Jasper Johns and the Hand-made Ready-made Object." *Metro* (Milan) no. 4/5 (May 1962): 80–81.

Dubreuil-Blondin, Nicole. "*Autour d'un drapeau de Jasper Johns.*" *Vie des Arts* (Montreal) 20 no. 81 (Winter 1975–76): 51–53.

Esterow, Milton. "The Second Time Around." *Artnews* 92 no. 6 (Summer 1993): 148–49.*

Feinstein, Roni. "New Thoughts for Jasper Johns' Sculpture." *Arts* 54 no. 8 (April 1980): 139–45.

——— "Jasper Johns's *Untitled* (1972) and Marcel Duchamp's *Bride*." *Arts* 57 no. 1 (September 1982): 86–93.

Ferrier, Jean-Louis. "*Jasper Johns, l'incendie de l'Amérique.*" *XXe Siècle* (Paris) 35 no. 40 (June 1973): 131–37.

Field, Richard S. "The Making of 'Souvenir.'" *The Print Collector's Newsletter* 1 no. 2 (May–June 1970): 29–31.

——— "Jasper Johns' Flags." *The Print Collector's Newsletter* 7 no. 3 (July–August 1976): 69–77.

——— "Jasper Johns Screenprints." *Dialogue*, December 1978, pp. 10–12.

Fisher, Philip. "Jasper Johns: Strategies for Making and Effacing Art." *Critical Inquiry* 16 no. 2 (Winter 1990): 313–54.

Francis, Richard. "Disclosures." *Art in America* 72 no. 8 (September 1984): 196–203.

Fuller, Peter. "Jasper Johns Interviewed I." *Art Monthly* (London) no. 18 (July–August 1978): 6–12.* "Jasper Johns Interviewed, Part II." *Art Monthly* no. 19 (September 1978): 5–7.*

Gablik, Suzi. "Jasper Johns's Pictures of the World." *Art in America* 6 no. 1 (January–February 1978): 62–69.

Gay, Morris. "A Major Modern Artist Who Puts Ideas into Action." *Palo Alto Times*, October 23, 1978, section II, p. 11.*

Glueck, Grace. "Art Notes: No Business like No Business." *New York Times*, January 16, 1966, section II, p. 26.*

——— "'Once Established,' Says Johns, 'Ideas Can Be Discarded.'" *New York Times*, October 16, 1977, section 2, pp. 1, 31.*

———— "The 20th-Century Artists Most Admired by Other Artists." *Artnews* 76 no. 9 (November 1977): 87, 89.*

Goldman, Judith. "*Les saisons.*" *Artstudio* (Paris) no. 12 (Spring 1989): 110–19.

Gottlieb, Carla. "The Pregnant Woman, the Flag, the Eye: Three New Themes in Twentieth Century Art." *The Journal of Aesthetics and Art Criticism* (Cleveland) 21 no. 2 (Winter 1962): 177–87.

Gratz, Roberta Brandes. "Daily Closeup: After the Flag." *New York Post*, December 30, 1970, p. 25.*

Green, Blake. "That Enigmatic Father of Pop Art." *San Francisco Chronicle*, October 23, 1978, p. 17.*

Greenberg, Clement. "After Abstract Expressionism." *Art International* (Lugano) 6 no. 8 (October 25, 1962): 24–32.

Harris, Kay. "Five Young Artists." *Charm* 90 no. 2 (April 1959): 84–85.

Haryu, Ishiro. ["The Destiny of the Person Who Sees"]. *Sekai* (Tokyo) 263 (October 1967): 239–42. In Japanese.

Henning, Edward B. "*Reconstruction*: A Painting by Jasper Johns." *Cleveland Museum of Art Bulletin* 60 no. 8 (October 1973): 235–41.

Herrmann, Rolf-Dieter. "Johns the Pessimist." *Artforum* 16 no. 2 (October 1977): 26–33. See also "Correction," *Artforum* 16 no. 4 (December 1977): 12.

———— "Jasper Johns' Ambiguity: Exploring the Hermeneutical Implications." *Arts* 52 no. 3 (November 1977): 124–29.

Hess, Thomas B. "On the Scent of Jasper Johns." *New York Magazine* 9 no. 6 (February 9, 1976): 65–67.

———— "Jasper Johns, Tell a Vision." *New York Magazine* 10 no. 45 (November 7, 1977): 109–11.

Higginson, Peter. "Jasper's Non-Dilemma: A Wittgensteinian Approach." *New Lugano Review* no. 10 (1976): 53–60.

Hindry, Ann. "Conversation with Jasper Johns/ *Conversation avec Jasper Johns.*" *Artstudio* (Paris) no. 12 (Spring 1989): 6–25.* In English and French.

Hirsch, Faye. "Master of the Reflected Life: The Allegories of Jasper Johns." *Arts* 65 no. 4 (December 1990): 38–41.

"His Heart Belongs to Dada." *Time* 73 (May 4, 1959): 58.*

Hobhouse, Janet. "Jasper Johns: The Passionless Subject Passionately Painted." *Artnews* 76 no. 10 (December 1977): 46–49.

Holert, Tom. "*Geographic der Intention. Jasper Johns' Map (Based on Buckminster Fuller's Dymaxion Airocean World), 1967–1971.*" *Wallraf-Richartz Jahrbuch* (Cologne) vol. 50 (1989): 271–305.

Hopps, Walter. "An Interview with Jasper Johns." *Artforum* 3 no. 6 (March 1965): 32–36.*

———— "Jasper Johns: *Fragments—According to What.*" *Print Review* (New York) no. 1 (March 1973): 41–50.

Hughes, Robert. "Jasper Johns' Elusive Bull's Eye." *Horizon* (Tuscaloosa, Ala.) 14 no. 3 (Summer 1972): 20–29.

Jespersen, Gunnar. "*Møde med Jasper Johns.*" *Berlingske Tidende* (Copenhagen), February 23, 1969, p. 14.

Jodidio, Philip. "*Jasper Johns: La Tradition repensée.*" *Connaissance des Arts* (Paris) no. 314 (April 1978): 66–73.

"Johns, Jasper." *Current Biography* 48 no. 5 (May 1987): 18–21.

Johnson, Ellen H. "Jim Dine and Jasper Johns: Art about Art." *Art and Literature* (Lausanne) vol. 6 (Autumn 1965): 128–40.

Johnson, Philip. "Young Artists at the Fair and at Lincoln Center." *Art in America* 52 no. 4 (August 1964): 112–25.

Johnston, Jill. "Tracking the Shadow." *Art in America* 75 no. 10 (October 1987): 128–43.

———— "Jasper Johns' Artful Dodging." *Artnews* 87 no. 9 (November 1988): 156–59.

———— "Trafficking with X." *Art in America* 79 no. 3 (March 1991): 102–11, 164–65.

Kaplan, Patricia. "On Jasper Johns' *According to What.*" *Art Journal* (New York) 35 no. 3 (Spring 1976): 247–50.

Kazanjian, Dodie. "Cube Roots." *Vogue* (New York) no. 179 (September 1989): 729.*

Kent, Sarah. "Jasper Johns: Strokes of Genius." *Time Out* (London), December 5–12, 1990, pp. 14–15.*

Kerber, Bernhard. "*Jasper Johns: Übernehmen statt Entwerfen.*" *Künstler. Kritisches Lexikon der Gegenwartskunst* (Münich) no. 25 (1994): 3–13.

Key, Donald ("D.K."). "Johns Adds Plaster Casts to Focus Target Paintings." *Milwaukee Journal*, June 19, 1960, pt. 5, p. 6.*

Kozloff, Max. "Johns and Duchamp." *Art International* (Lugano) 8 no. 2 (March 20, 1964): 42–45.

———— "Art and the New York Avant-Garde." *Partisan Review* 31 no. 4 (Fall 1964): 535–54.

———— "Jasper Johns: The 'Colors,' the 'Maps,' the 'Devices'." *Artforum* 6 no. 3 (November 1967): 26–31.

———— "The Division and Mockery of the Self." *Studio International* (London) 179 no. 918 (January 1970): 9–15.

Krauss, Rosalind. "Jasper Johns." *Lugano Review* 1 no. 2 (II/1965): 84–113.

———— "Jasper Johns: The Functions of Irony." *October* (Cambridge, Mass.) 2 (Summer 1976): 91–99.

Kuspit, Donald B. "Personal Signs: Jasper Johns." *Art in America* 69 no. 6 (Summer 1981): 111–13.

Lang, Luc. "*La Peinture inutile.*" *Artstudio* (Paris) no. 12 (Spring 1989): 48–57.

Levinger, Esther. "Jasper Johns' Painted Words." *Visible Language* (Cleveland) 23 no. 2/3 (Spring–Summer 1989): 281–95.

Lewis, Jo Ann. "Jasper Johns, Personally Speaking." *The Washington Post*, May 16, 1990, pp. F1, F6.*

Love, Joseph. ["Too Many Footprints"]. *Bijutsu Techô* (Tokyo) 24 no. 354 (April 1972): 305–10. In Japanese. See also pp. 285–304.

Marin, Louis. "*De la citation. Notes à partir de quelques oeuvres de Jasper Johns.*" *Artstudio* (Paris) no. 12 (Spring 1989): 120–32.

Marzorati, Gerald. "Lasting Impressions: A Johns Print Retrospective." *Vanity Fair* 49 no. 5 (May 1986): 116–17.*

Masheck, Joseph. "Jasper Johns Returns." *Art in America* 64 no. 2 (March–April 1976): 65–67.

McKenzie, Sylvia L. "Jasper Johns Art Hailed Worldwide." *The Charleston, S.C., News and Courier*, October 10, 1965, p. 13-B.*

Michelson, Annette. "The Imaginary Object: Recent Prints by Jasper Johns." *Artist's Proof* (New York) vol. 8 (1968): 44–49.

Minemura, Toshiaki. ["Jasper Johns Painting"]. *Mizue* (Tokyo) no. 858 (September 1976): 34–36, 41–45. In Japanese.

Mitsuda, Yuri. ["Jasper Johns: The Face of American Contemporary Art"]. *Bijutsu Techô* (Tokyo) 42 no. 622 (April 1990): 159–63. In Japanese.

Monnier, Geneviève. "*Dessins: l'équilibre de l'alternative.*" *Artstudio* (Paris) no. 12 (Spring 1989): 98–109.

Moritz, Charles, ed. "Jasper Johns." *Current Biography* 28 no. 5 (May 1967): 17–20.

Myers, John Bernard. "The Impact of Surrealism on the New York School." *Evergreen Review* 4 no. 12 (March–April 1960): 75–85.

Nash, Jay, and James Holmstrand. "Zeroing In on Jasper Johns." *Literary Times* 3 no. 7 (September 1964): 1, 9, 14.*

Naugrette, Jean-Pierre. "*La Peau de la peinture: Three Flags de Jasper Johns.*" *Revue française d'Etudes Américaines* (Paris) 15 no. 46 (November 1990): 245–52.

Nemeczek, Alfred. "*Jasper Johns, immer nur Flagge zeigen?*" *Art: Das Kunstmagazin* (Hamburg) no. 12 (December 1988): 4, 28–48.

Olson, Roberta J. M. "Jasper Johns: Getting Rid of Ideas." *Soho Weekly News* 5 no. 5 (November 3, 1977): 24–25.*

Orton, Fred. "On Being Bent 'Blue' (Second State): An Introduction to Jacques Derrida/ A Footnote on Jasper Johns." *Oxford Art Journal* (Oxford, England) 12 no. 1 (1989): 35–46.

Orton, Fred, and Charles Harrison. "Jasper Johns: 'Meaning What You See.'" *Art History* (London) 7 no. 1 (March 1984): 76–101.

"Painting and Sculpture Acquisitions." *Museum of Modern Art Bulletin*, January 1–December 31, 1958, p. 21.

Payant, René. "*De l'iconologie revisitée. Les questions d'un cas (Jasper Johns).*" *Trois* (Montreal) 2 no. 1 (Autumn 1986): 18–34.

———— "*Collage at large: le texte déchaîné.*" *Artstudio* (Paris) no. 12 (Spring 1989): 84–97.

Perrone, Jeff. "Jasper Johns' New Paintings." *Artforum* 14 no. 8 (April 1976): 48–51.

———— "The Purloined Image." *Arts* 53 no. 8 (April 1979): 135–39.

Picard, Lil. "Jasper Johns." *Das Kunstwerk* (Stuttgart) 17 no. 5 (November 1963): 6–12.* In German.

"Pictures from Modern Masters to Aid Music and Dance." *Artnews* 61 no. 10 (February 1963): 44.*

Pohlen, Annelie. *"Interview mit Jasper Johns."* *Heute Kunst* (Milan) no. 22 (May–June 1978): 21–22.*

Porter, Fairfield ("F.P."). "Jasper Johns." *Artnews* 56 no. 9 (January 1958): 5, 20.

———— "The Education of Jasper Johns." *Artnews* 62 no. 10 (February 1964): 44–45, 61–62.

Prinz, Jessica. *"Foirades/Fizzles/Beckett/Johns."* *Contemporary Literature* (University of Wisconsin Press) 21 no. 3 (Summer 1980): 480–510.

Pye, Michael. "Behind Veils, the Elusive Heart." *The Independent* (London), November 18, 1990, pp. 21–22.*

Raynor, Vivien. "Jasper Johns: 'I have attempted to develop my thinking in such a way that the work I've done is not me.'" *Artnews* 72 no. 3 (March 1973): 20–22.*

Restany, Pierre. "Jasper Johns and the Metaphysic of the Commonplace." *Cimaise* (Paris) 8 no. 55 (September–October 1961): 90–97.

Rickborn, D. R. "Art's Fair-Haired Boy: Allendale's Jasper Johns Wins Fame with Flags." *The State Magazine* (Columbia, S.C.), January 15, 1961, pp. 20–21.*

Robertson, Bryan, and Tim Marlow. "The Private World of Jasper Johns." *Tate: The Art Magazine* (London) issue 1 (Winter 1993): 40–47.*

Rose, Barbara. "The Graphic Work of Jasper Johns: Part I." *Artforum* 8 no. 7 (March 1970): 39–45. "The Graphic Work of Jasper Johns: Part II." *Artforum* 9 no. 1 (September 1970): 65–74.

———— "Decoys and Doubles: Jasper Johns and the Modernist Mind." *Arts* 50 no. 9 (May 1976): 68–73.

———— "Jasper Johns: Pictures and Concepts." *Arts* 52 no. 3 (November 1977): 148–53.

———— "To Know Jasper Johns." *Vogue* (New York) 167 no. 11 (November 1977): 280–85, 323.

———— "Jasper Johns: The Seasons." *Vogue* (New York) 177 no. 1 (January 1987): 192–99, 259–60.

———— "Jasper Johns: This Is Not a Drawing." *The Journal of Art* 4 no. 4 (April 1991): 16–17.

———— "Jasper Johns—The *Tantric Details*." *American Art* 7 no. 4 (Fall 1993): 47–71.

Rosenberg, Harold. "Jasper Johns: Things the Mind Already Knows." *Vogue* (New York) 143 no. 3 (February 1, 1964): 175–77, 201, 203.*

———— "The Art World: Twenty Years of Jasper Johns." *The New Yorker* 53 no. 45 (December 26, 1977): 42–45.

Rosenblum, Robert. "Jasper Johns." *Art International* (Lugano) 4 no. 7 (September 25, 1960): 74–77.

———— *"Les Oeuvres récentes de Jasper Johns."* *XXe Siècle* (Paris) 24 no. 18, supplement (February 1962): n.p.

Rosenthal, Mark, David Vaughan, et al. "Cage, Cunningham & Johns: Participation and Collaboration." *Journal of Art* 2 no. 2 (November 1989): 12–14.

Rothfuss, Joan. "'Foirades/Fizzles': Jasper Johns's Ambiguous Object." *Burlington Magazine* (London) 135 no. 1081 (April 1993): 269–75.

Rougé, Bertrand. *"Le Visage de l'angoisse."* *Artstudio* (Paris) no. 12 (Spring 1989): 68–83.

Rubin, Joan. "Retrospective: Jasper Johns at the Whitney." *Lofty Times* no. 5 (November 1, 1977): 22.*

Ruhrberg, Karl. *"So ist es—Ist es so? Jasper Johns oder Kunst als Denkspiel."* *Die Kunst* (Munich) no. 7 (July 1988): 536–43.

Russell, John. "Jasper Johns." *Connaissance des Arts* (Paris) no. 233 (July 1971): 48–53. In French.

———— "Jasper Johns." *Réalités* (Paris) no. 251 (October 1971): 70–74. In English.

Schefer, Jean-Louis. *"Jasper Johns, quelle critique?"* *Artstudio* (Paris) no. 12 (Spring 1989): 38–47.

Shapiro, David. "Imago Mundi." *Artnews* 70 no. 6 (October 1971): 40–41, 66–68.*

Shestack, Alan. "Jasper Johns: Reflections." *The Print Collector's Newsletter* 8 no. 6 (January–February 1978): 172–74.

Simons, Riki. *"Gesprek met Jasper Johns: Dat ik totaal niet begrepen word, is interessant."* *NRC Handelsblad* (Rotterdam), April 23, 1982, p. cs3.*

Smith, Philip. "Jasper Johns." *Interview* 7 no. 12 (December 1977): 36–37.*

Solomon, Alan R. "The New Art." *Art International* (Lugano) 7 no. 7 (September 25, 1963): 37–41.

———— "The New American Art." *Art International* (Lugano) 8 no. 2 (March 1964): 50–55.

———— "Americans in Venice." *The Art Gallery* (Ivoryton, Conn.), June 1964, pp. 14–21.

Solomon, Deborah. "The Unflagging Artistry of Jasper Johns." *New York Times Magazine*, June 19, 1988, pp. 20–23, 63–65.*

Sozanski, Edward J. "The Lure of the Impossible." *The Philadelphia Inquirer Magazine*, October 23, 1988, pp. 25–31.*

Steinberg, Leo. "Contemporary Art and the Plight of Its Public." *Harper's Magazine* 224 no. 1342 (March 1962): 31–39.

———— "Jasper Johns." *Metro* (Milan) no. 4/5 (May 1962): 87–109.

Stevens, Mark, with Cathleen McGuigan. "Super Artist: Jasper Johns, Today's Master." *Newsweek* 90 no. 17 (October 24, 1977): 66–79.*

Sugimoto, [Hidetaro]. ["Jasper Johns at Night"]. *av* (Seibu Museum, Tokyo) 4 no. 10 (July 1, 1978): n.p. In Japanese.

Swartz, Mark. "Jasper Johns's Zen Consciousness." *Chicago Art Journal* 4 no. 1 (Spring 1994): 14–23.

Sweet, David. "Johns's Expressionism." *Artscribe* (London) no. 12 (June 1978): 41–45.

Swenson, Gene R. "What Is Pop Art? Part II." *Artnews* 62 no. 10 (February 1964): 43, 66–67.*

Sylvester, David. *"Entretien avec Jasper Johns."* *Artstudio* (Paris) no. 12 (Spring 1989): 26–37.*

Tallmer, Jerry. "A Broom and a Cup and Paint." *New York Post*, October 15, 1977, p. 20.*

Tani, Arata. ["Jasper Johns' Technique"]. *Mizue* (Tokyo) no. 883 (October 1978): 50–52, 61–63. In Japanese.

Taylor, Paul. "Jasper Johns." *Interview* 20 no. 7 (July 1990): 96–100, 122–23. Also published in German, as Taylor. *"Ein Ami Zeigt Flagge."* *Zeit Magazin* no. 44 (October 26, 1990): 104–14.*

Tillim, Sidney. "Ten Years of Jasper Johns." *Arts* 38 no. 7 (April 1964): 22–26.

Tono, Yoshiaki. ["Jasper Johns or the Metaphysics of Vulgarity"]. *Mizue* (Tokyo) no. 685 (April 1962): 24–40. In Japanese.

———— ["Jasper Johns in Tokyo."] *Bijutsu Techô* (Tokyo), August 1964, pp. 5–8.* In Japanese.

———— ["American Pop Art…and After"]. *Mizue* (Tokyo) 2 no. 839 (February 1975): 5–29. In Japanese.

———— ["Painting Records a Concept"]. *Sekai* (Tokyo), December 1978, pp. 126–44.* In Japanese.

———— ["Jasper Johns in Venice"]. *Mizue* (Tokyo) no. 948 (Autumn 1988): 3–19. In Japanese.

Tono, Yoshiaki, and Keiji Nakamura. ["Special Feature: Jasper Johns, from Pop Art to Art"]. *Bijutsu Techô* (Tokyo) 30 no. 438 (September 1978): 43–127. In Japanese.

Tracy, Robert. *"Interview: Le duo Johns-Cunningham."* *Vogue* (Paris), September 1990, p. 42.*

"Trend to the Anti-Art: Targets and Flags." *Newsweek* 51 no. 13 (March 31, 1958): 96.*

Verdier, Jean-Émile. *"Le Modèle du moulage dans la fabrication de l'oeuvre de Jasper Johns."* *Artstudio* (Paris) no. 12 (Spring 1989): 58–67.

Vischer-Honegger, Irene. *"Ich bringe nichts mehr in meinen Kopf."* *Bilanz* (Zurich), June 1988, pp. 94–96.*

Wallach, Amei. "Jasper Johns, Enigma." *New York Newsday*, October 2, 1977, section II, pp. 4–5, 14.*

———— "Jasper Johns at the Top of His Form." *New York Newsday*, October 30, 1988, section II, pp. 4, 20.*

———— "Jasper Johns: On Target." *Elle*, November 1988, pp. 152, 154, 156.*

———— "Jasper Johns and His Visual Guessing Games." *New York Newsday*, February 28, 1991, II:57, 64–65.*

Weatherby, W. J. "The Enigma of Jasper Johns." *The Guardian* (London), November 29, 1990, p. 29.*

Weinberg, Jonathan. "It's in the Can: Jasper Johns and the Anal Society." *Genders* (Austin) vol. 1 (March 1988): 40–56.

Weitman, Wendy. "Jasper Johns: Ale Cans and Art." *Studies in Modern Art* (The Museum of Modern Art, New York) no. 1 (1991): 39–63.

Welish, Marjorie. "Frame of Mind: Interpreting Jasper Johns." *Art Criticism* 3 no. 2 (1987): 71–87.

———— "Jasper's Patterns." *Salmagundi* no. 87 (Summer 1990): 281–302.

——— "When Is a Door Not a Door?" *Art Journal* 50 no. 1 (Spring 1991): 48–51.*

White, Edmund. "Enigmas and Double Visions." *Horizon* (London) 20 no. 2 (October 1977): 48–55.*

——— "Jasper Johns and Samuel Beckett." *Christopher Street* 2 no. 4 (October 1977): 20–24.*

Willard, Charlotte. "Eye to I." *Art in America* 54 no. 2 (March–April 1966): 57.*

Yau, John. "Target Jasper Johns." *Artforum* 24 no. 4 (December 1985): 80–84.*

——— "Jasper Johns. Proofs Positive: The Master Works." *Artnews* 87 no. 7 (September 1988): 104–6.*

——— "The Phoenix of the Self." *Artforum* 27 no. 8 (April 1989): 145–51.*

Young, Joseph E. "Jasper Johns: An Appraisal." *Art International* (Lugano) 13 no. 7 (September 1969): 50–56.*

——— "Jasper Johns Lead-Relief Prints." *Artist's Proof* (New York) 10 (1970): 36–38.

Zaya, Octavio. "Jasper Johns: El valor de la pintura." *El Europeo* no. 9 (February 1989): 58–71.

Books
In alphabetical order by author.

Beckett, Samuel, and Jasper Johns. *Foirades/Fizzles*. New York: Petersburg Press, 1976.

Bernstein, Roberta. *Jasper Johns' Paintings and Sculptures 1954–1974: "The Changing Focus of the Eye"*. Ann Arbor, Mich.: UMI Research Press, 1985.

——— *Jasper Johns*. New York: Rizzoli Art Series, 1992.

Bertozzi, Barbara. *"Le Stagioni" di Jasper Johns*. Milan: Charta, 1996.

Boudaille, Georges. *Jasper Johns*. Paris: Albin Michel, 1989, and New York: Rizzoli International Publications, Inc., 1989.

Butor, Michel. *Comment écrire pour Jasper Johns*. Paris: Éditions La Différence, 1992.

Chalumeau, Jean-Luc. *Découvrons l'art du XXe siècle: Jasper Johns*. Paris: Cercle d'art, 1995.

Diamonstein, Barbaralee. *Inside the Art World: Conversations with Barbaralee Diamonstein*.* New York: Rizzoli International Publications, Inc., 1994.

Field, Richard S. *The Prints of Jasper Johns 1960–1993: A Catalogue Raisonné*. West Islip, N.Y.: Universal Limited Art Editions, Inc., 1994.

Francis, Richard. *Jasper Johns*. New York: Abbeville Press, 1984. Also published in Japanese (Tokyo: Bijutsu Shuppan-sha, 1990).

Friedman, B. H., ed. *School of New York: Some Younger Artists*. (New York: Grove Press, Inc., Evergreen Gallery Book Number 12). With an essay by Ben Heller.

Klosty, James., ed. *Merce Cunningham*.* New York: E. P. Dutton & Co., Inc., 1975.

Kozloff, Max. *Jasper Johns*. New York: Harry N. Abrams, Inc., 1969.

——— *Jasper Johns*. New York: Abrams/Meridian Modern Artists, 1974.

Orton, Fred. *Figuring Jasper Johns*. Cambridge, Mass.: Harvard University Press, and London: Reaktion Books, Ltd, 1994.

Rosenthal, Mark. *Artists at Gemini G.E.L.: Celebrating the 25th Year*.* New York: Harry N. Abrams, Inc., in association with Gemini G.E.L., Los Angeles, 1993.

Shapiro, David. *Jasper Johns Drawings 1954–1984*. New York: Harry N. Abrams, Inc., 1984.

Sparks, Esther. *Universal Limited Art Editions. A History and Catalogue: The First Twenty-Five Years*. New York: Harry N. Abrams, Inc., and Chicago: The Art Institute of Chicago, 1989.

Steinberg, Leo. *Jasper Johns*. New York: George Wittenborn, Inc., 1963.

Tono, Yoshiaki. [*Jasper Johns And/Or*].* Tokyo: Bijutsu Shuppan-sha, 1979. In Japanese.

——— [*Jasper Johns—A Source for American Art*].* Tokyo: Bijutsu Shuppan-sha, 1986. In Japanese.

——— [*Chatting with Artists*]. Tokyo: Iwanami-Shoten, 1984. In Japanese.

Tsujii, Takashi (pen name of Seiji Tsutsumi), and Mamoru Yonekura. [*Contemporary Great Masters 13: Jasper Johns*]. Tokyo: Kodansha, Ltd., 1993. In Japanese.

Films
In alphabetical order, by director.

Blackwood, Michael, director. *Jasper Johns Decoy*, a 16-mm. film in color, 18 minutes 20 seconds, 1971. Produced by Blackwood Productions, Inc.

Caplan, Elliot, director. *Cage/Cunningham*, a 16-mm. film in color, 95 minutes, 1991.* Produced by the Cunningham Dance Foundation/La Sept.

De Antonio, Emile, director and producer, with Mary Lampson. *Painters Painting*, a 16-mm. film in color and black and white, 116 minutes, 1972.* Produced by Turin Film Corporation. The interview seen in this film was published in Emile de Antonio and Mitch Tuchman, *Painters Painting: A Candid History of the Modern Art Scene 1940–1970* (New York: Abbeville Press, 1984), pp. 86–87, 96–100, 102.

Martin, Katrina, director. *Silkscreens*, a 16-mm. film in color, 20 minutes, 1978.

——— , director and producer. *Hanafuda/Jasper Johns*, a 16-mm. film in color, 35 minutes, 1980.* The interview from which the film's soundtrack is excerpted was published as Martin, "An Interview with Jasper Johns about Silkscreening (New York City, December 1980)," in *Jasper Johns: Printed Symbols*, exh. cat. (Minneapolis: Walker Art Center, 1990), pp. 51–61.

Namuth, Hans, director and producer, with Judith Wechsler. *Jasper Johns: Take an Object. A Portrait: 1972–1990*, a 16-mm. film in color, 26 minutes, 1990.* Produced by Museum at Large, Ltd.

Slate, Lane, director and producer, and Alan R. Solomon, writer. *U.S.A. Artists 8: Jasper Johns*, a film in black and white, 30 minutes, 1966.* Produced by the National Educational Television Network and Radio Center.

Tejada-Flores, Rick, director. *Jasper Johns: Ideas in Paint*, a film in color, 60 minutes, 1989.* Documentary produced by WHYY, Inc., Philadelphia, in association with WNET, New York, for the American Masters series on PBS.

Exhibition Catalogues
In chronological order by year and in alphabetical order, by each exhibition's initiating institution, within each year. Unless otherwise noted, the catalogue is published by the exhibition's initiating institution. Cities to which the exhibition traveled are listed in parentheses after the initiating institution. If an institution hosting a traveling exhibition published its own catalogue for the show, it is listed at the end of the entry.

1959
Galleria del Naviglio, Milan. *Jasper Johns: 287a Mostra del Naviglio* (Milan: Carlo Cardazzo). Brochure. Text by Robert Rosenblum.

Museum of Modern Art, The, New York. *Sixteen Americans*, ed. Dorothy C. Miller.*

1960
Columbia Museum of Art, Columbia, S.C. *Jasper Johns 1955–1960*. Brochure. Text by Robert Rosenblum.

1962
Everett Ellin Gallery, Los Angeles, Calif. (Richmond, Calif.) *Jasper Johns: Retrospective Exhibition*. Brochure. Text by Everett Ellin.

Moderna Museet, Stockholm. (Amsterdam. Bern.) *4 Amerikanare: Jasper Johns, Alfred Leslie, Robert Rauschenberg, Richard Stankiewicz*, ed. K. G. [Pontus] Hultén. The Kunsthalle Bern published its own catalogue, with differing contents.

1963
Washington Gallery of Modern Art, Washington, D.C. (London.) *The Popular Image Exhibition*.* With an essay by Alan R. Solomon. The catalogue comes with a 33⅓-rpm record of interviews with the show's artists, including Johns, recorded and edited by Billy Klüver in March 1963. The ICA, London, published its own catalogue, with differing contents.

1964
Galleria dell'Ariete, Milan. *Quattro americani*. Text by Gillo Dorfles.

Jewish Museum, The, New York. (London.) *Jasper Johns*, by Alan R. Solomon. With essays by Solomon and by John Cage. The Whitechapel Gallery, London, published its own edition of the catalogue.

Venice Biennale. *USA: XXXII International Biennial of Art Venice 1964*, by Alan R. Solomon (New York: The Jewish Museum, 1964). With preface and essays by Solomon. In Italian and English.

1965

Minami Gallery, Tokyo. *Jasper Johns*. With an essay by Yoshiaki Tono. In Japanese.

Moderna Galerija, Ljubljana. *6th International Exhibition of Graphic Art*. With a text by William S. Lieberman and Riva Castleman. In English and Slovene.

Morton House, Edinburgh. (London. Newcastle-upon-Tyne. Oxford.) *Jasper Johns: Lithographs* (Edinburgh: Traverse Theater Club Art Gallery, 1965). With a text by Sean Hignett. The USIS, American Embassy, London, was the initiating institution, but did not publish a catalogue.

1966

Museum of Natural History, Art Hall, Washington, D.C. *The Drawings of Jasper Johns* (Washington, D.C.: National Collection of Fine Arts, Smithsonian Institution). Brochure. Text by Stefan Munsing.

1967

Leo Castelli Gallery, New York. *Leo Castelli: Ten Years*. With statements by various authors.

Minami Gallery, Tokyo. *Jasper Johns: 0–9*. With essays by Robert Rosenblum and Shuzo Takiguchi. In Japanese.

1968

Dayton's Gallery 12, Minneapolis, Minn. *Contemporary Graphics Published by Universal Limited Art Editions*, by Harmony Clover.

Gemini G.E.L., Los Angeles, Calif. *Jasper Johns: Figures 0 to 9*, by Henry Hopkins. Folder containing ten loose cards and a foldout.

Museum Fridericianum, Kassel. (Kassel's 1968 Documenta exhibition included a show of Johns's ULAE prints, which traveled to Humlebaek, Basel, Ljubljana, Belgrade, Prague, Lodz, and Bucharest.) *4. Documenta* (Kassel: Druck + Verlag GmbH Der Documenta-Rat). The Kunstmuseum Basel; Moderna Galerija, Ljubljana; Muzej Savremene Umetnosti Beograd, Belgrade; Národni Galerie v Praze, Prague; Museum Sztuki w Łodzi, Lodz; and Athaneul Roman, Bucharest, published their own catalogues, with differing contents.

1969

Castelli Graphics, New York. *Jasper Johns: Lead Reliefs*, by Alan R. Solomon (Los Angeles: Gemini G.E.L.). Folder containing six loose cards and a foldout.

Marion Koogler McNay Art Institute, San Antonio, Tex. (Dallas, Tex. Albuquerque, N.M. Des Moines, Iowa.) *Jasper Johns: The Graphic Work*. With a text by John Palmer Leeper.

1970

John Berggruen Gallery, San Francisco, Calif. *Jasper Johns: Prints*. Foldout.

Museum of Modern Art, The, New York, 1970–71. (Buffalo, N.Y. Tyler, Tex. San Francisco, Calif. Baltimore, Md. Richmond, Va. Houston, Tex.) *Jasper Johns: Lithographs*, by Riva Castleman. Brochure in newspaper format, conceived by Johns, with text by Castleman. The Museum of Fine Arts, Houston, published its own brochure.

Philadelphia Museum of Art, Philadelphia, Pa. *Jasper Johns: Prints 1960–1970*, by Richard S. Field.

1971

Betty Gold Fine Modern Prints, Los Angeles, Calif. *Jasper Johns: 1st Etchings, 2nd State*, by Richard S. Field.

Contemporary Arts Center, Cincinnati, Ohio. *Duchamp, Johns, Rauschenberg, Cage*. With an essay by Barbara Rose.

Dayton's Gallery 12, Minneapolis, Minn. *Jasper Johns: Lithographs and Etchings Executed at Universal Limited Art Editions from 1960 through 1970*. Text by John C. Stoller.

Gemini G.E.L., Los Angeles, Calif. *Jasper Johns: Fragments—According to What/Six Lithographs*, by Walter Hopps. Folder containing six loose cards and a foldout.

Kunsthalle Bern. (Mönchengladbach. Hannover. Amsterdam. Milan.) *Jasper Johns Graphik*, ed. Carlo Huber (Bern: Klipstein und Kornfeld). With an essay by Huber, German translations of previously published essays by Alan R. Solomon and John Cage, and German translations of writings by Johns, including previously unpublished sketchbook notes. There is also a brochure, *Die Graphik Jasper Johns*. The Städtisches Museum, Mönchengladbach; Kunstverein Hannover; Stedelijk Museum, Amsterdam; and Castello Sforzesco, Milan, each published its own catalogue, with differing contents.

Museum of Modern Art, The, New York. (Eindhoven. Düsseldorf. Hannover. Stuttgart. Saint-Gall. Vienna. Grenoble. Geneva. Saint-Etienne. Marseilles.) *Technics and Creativity: Gemini G.E.L.*, by Riva Castleman. The catalogue includes a catalogue raisonné and is enclosed in a box containing a reproduction of *Target*, 1971 (ULAE # 89). The Musée Rath, Geneva, published its own catalogue, with differing contents.

Museum of the Sea, Harbour Town, Hilton Head Island, S.C. *An Exhibit of Graphics by Jasper Johns* (Hilton Head Island, S.C.: Sea Pines Plantation Co.).

1972

Art Museum of South Texas, Corpus Christi. *Johns, Stella, Warhol: Works in Series*, by David Whitney.

Emily Lowe Gallery, Hofstra University, Hempstead, N.Y. *Jasper Johns. Decoy: The Print & the Painting*. With text by Roberta Bernstein and notes by Robert R. Littman.

Minami Gallery, Tokyo. *Jasper Johns: Print Exhibition*. With an essay by Yoshiaki Tono. In Japanese.

1974

Christ-Janer Art Gallery, New Canaan, Conn. *Jasper Johns*. Brochure.

Museum of Modern Art, Oxford, England. (Sheffield. Coventry. Liverpool. Leeds. London. Tokyo. Kyoto.) *Jasper Johns Drawings*, ed. Richard Francis (London: Arts Council of Great Britain, 1974).* With David Sylvester's interview with Jasper Johns, excerpted from an interview recorded in June 1965 and broadcast on radio by the BBC, England, on October 10, 1965. To coincide with this exhibition, the Arts Council of Great Britain also published an accordion leaflet, *For Jasper Johns*, ed. Ellen H. Johnson.

1975

Gemini G.E.L., Los Angeles, Calif. *Jasper Johns: Lithographs 1973–1975*. Brochure.

Minami Gallery, Tokyo (Kyoto). *Jasper Johns Drawings*. With essays by Yoshiaki Tono and Jiro Takamatsu. In Japanese.

Sumter Gallery of Art, Sumter, S.C. *Prints by Jasper Johns* (Greenville, S.C.: Greenville Museum of Art). Brochure.

1976

Wadsworth Atheneum, Hartford, Conn. *Jasper Johns: MATRIX 20*. Brochure, with an essay by Richard S. Field.

1977

Brooke Alexander Gallery, New York, 1977–78. (Akron, Ohio. Seattle, Wash. Burnaby, B.C. Phoenix, Ariz. Portland, Oreg. San Jose, Calif. Tucson, Ariz. Roswell, N.M. Arlington, Tex. Little Rock, Ark. Tyler, Tex. Normal, Ill. Toledo, Ohio. Louisville, Ky. Springfield, Mo.) *Jasper Johns/Screenprints*. With an essay by Richard S. Field.

Gemini G.E.L., Los Angeles, Calif. *Jasper Johns: 6 Lithographs (after 'Untitled 1975'), 1976*, by Barbara Rose.

Whitney Museum of American Art, New York, 1977–78. (Cologne. Paris. London. Tokyo. San Francisco, Calif.) *Jasper Johns*, by Michael Crichton (New York: Harry N. Abrams, Inc., in association with the Whitney Museum of American Art).* There is also a brochure, *Jasper Johns* (New York: Whitney Museum of American Art, 1977). Crichton's catalogue was revised and expanded in 1994 (New York: Harry N. Abrams, in association with the Whitney Museum of American Art, 1994). The Museum Ludwig, Cologne; the Centre national d'art et de culture Georges Pompidou, MNAM, Paris; the Hayward

Gallery, London; and the Seibu Museum of Art, Seibu Department Store, Ikebukuro, Tokyo, published their own catalogues, with differing contents. The San Francisco Museum of Modern Art, San Francisco, published a brochure.

Whitney Museum of American Art, New York. *Foirades/Fizzles*. With an essay by Judith Goldman.

1978

Faith and Charity in Hope Gallery, Hope, Idaho. *Jasper Johns*, by Ed Kienholz and Sid Felsen.

Galerie Mukaï, Tokyo. *Jasper Johns Screenprints* (New York: Simca Print Artists, Inc.). With essays by Yoshiaki Tono and Sumio Kuwahara. In Japanese.

Galerie Valeur, Nagoya. *Lead Reliefs Jasper Johns*. With text by Shunkichi Baba. In Japanese.

Minami Gallery, Tokyo. *Samuel Beckett, Foirades/Fizzles, and Jasper Johns, Gravures/Etchings*. Brochure. With an essay by Yoshiaki Tono. In Japanese.

Wesleyan University, Davison Art Center, Middletown, Conn. (Springfield, Mass. Baltimore, Md. Hanover, N.H. Berkeley, Calif. Cincinnati, Ohio. Athens, Ga. Saint Louis, Mo. Newport Beach, Calif. Providence, R.I.) *Jasper Johns: Prints 1970–1977*, by Richard S. Field (Middletown, Conn.: Wesleyan University Press, and London: Petersburg Press, 1978).

1979

Colorado State University, Student Center Gallery, Fort Collins. *Jasper Johns Prints 1965–1978*, by John G. Powers and Ron G. Williams.

Galerie Valeur, Nagoya. *Jasper Johns: Prints & Drawings*.

Kunstmuseum Basel. (Munich. Frankfurt am Main. Hannover. Copenhagen. Stockholm. Barcelona. Hasselt. London.) *Jasper Johns: Working Proofs*, by Christian Geelhaar.* In German. There is also an English-language edition (London: Petersburg Press, 1980). Den Kongelige Kobberstiksamling Statens Museum for Kunst, Copenhagen; the Moderna Museet, Stockholm; and the Centre Cultural de la Caixa de Pensiones, Barcelona, published their own catalogues, with differing contents; the Tate Gallery, London, published a brochure.

1980

Satani Gallery, Tokyo. *Jasper Johns Copper Prints*. With a text by Kazuhiko Satani. In Japanese.

1981

Thomas Segal Gallery, Boston, Mass. *Jasper Johns: Prints 1977–1981*, by Judith Goldman.

1982

McKissick Museums, University of South Carolina, Columbia. *Jasper Johns…Public and Private*, by Lynn Robertson Myers.

Whitney Museum of American Art, New York. (Ljubljana. Basel. Oslo. Stockholm. London.) *Jasper Johns: 17 Monotypes*, by Judith Goldman (West Islip, N.Y.: Universal Limited Art Editions). A book coinciding with the exhibition "Jasper Johns: Savarin Monotypes." The Kunstmuseum Basel published a brochure.

1983

Akira Ikeda Gallery, Tokyo. *Jasper Johns: Selected Prints*.

1984

National Gallery of Art, Washington, D.C., 1984–85. *Gemini G.E.L.: Art and Collaboration*, by Ruth E. Fine (Washington, D.C.: National Gallery of Art, and New York: Abbeville Press, 1984). With essays by Bruce Davis and Fine.

1985

Saint Louis Art Museum, Saint Louis, Mo., 1985–86. *Currents 30: Jasper Johns*. Text by Michael Edward Shapiro.

1986

Fondation Maeght, Saint-Paul-de-Vence. *Jasper Johns: L'Oeuvre graphique de 1960 à 1985*. With an essay by Judith Goldman.

Museum of Modern Art, The, New York. (Frankfurt. Madrid. Vienna. Fort Worth, Tex. Los Angeles, Calif. Shibukawa. Osaka. Kitakyushu-shi.) *Jasper Johns: A Print Retrospective*, by Riva Castleman (New York: The Museum of Modern Art, and Boston: New York Graphic Society Books/Little, Brown and Company). Also published in French, as Castleman, *Jasper Johns: L'Oeuvre gravé* (Münich: Schirmer/Mosel Verlag, 1986). The Schirn Kunsthalle, Frankfurt; the Centro Reina Sofía, Madrid; the Wiener Secession, Vienna; and the Hara Museum ARC, Shibukawa, published their own catalogues, with differing contents.

1987

Leo Castelli Gallery, New York. *Jasper Johns: The Seasons*, ed. David Whitney. With an essay by Judith Goldman.

Greenville County Museum of Art, Greenville, S.C. (Longwood, N.C. Hickory, N.C. Williamsburg, Va. Columbia, S.C. Athens, Ga.) *Jasper Johns Prints*. With a text by Thomas W. Styron.

Neuberger Museum, State University of New York at Purchase, 1987–88. *Jasper Johns: Numerals in Prints*. Brochure. With an essay by Anne Ocone.

Satani Gallery, Tokyo. *Jasper Johns: 1960s Prints*. With an essay by Tatsumi Shinoda. In Japanese and English.

Wight Art Gallery, The Grunwald Center for the Graphic Arts, University of California, Los Angeles, Calif., 1987. (Minneapolis, Minn. Austin, Tex. New Haven, Conn. Atlanta, Ga.) *Foirades/Fizzles: Echo and Allusion in the Art of*

Jasper Johns, ed. James Cuno. With essays by Andrew Bush, Riva Castleman, Cuno, Richard S. Field, Fred Orton, and Richard Shiff.

1988

Caffè Galleria Dante, Umag, Yugoslavia. *Jasper Johns: Godisja Doba–The Seasons* (New York: Castelli Graphics). In Slovene and English. With a preface by Zvonko Makovic.

Lorence Monk Gallery, New York, 1987–88. *Jasper Johns: Lead Reliefs*. With an essay by John Yau.

Philadelphia Museum of Art, 1988–89. *Jasper Johns: Work since 1974*, by Mark Rosenthal (Philadelphia: Philadelphia Museum of Art, and London and New York: Thames and Hudson, 1988, 1990). Also published in an English and Italian edition, as *Jasper Johns: Work since 1974: 43rd Venice Biennale* (Philadelphia: Philadelphia Museum of Art). See also the Venice Biennale catalogue for that year (Venice: Edizioni La Biennale di Venezia/Fabbri Editori).

1989

Butler Institute of American Art, Youngstown, Ohio. *Jasper Johns: Drawings & Prints from the Collection of Leo Castelli*. Brochure. With essays by Rebecca Mary Gerson, James Lucas, and Donald Miller.

Anthony d'Offay Gallery, London. (Liverpool.) *Dancers on a Plane: Cage, Cunningham, Johns*. With essays by Susan Sontag, Richard Francis, and Mark Rosenthal. The book was published in an expanded edition (New York: Alfred Knopf, and London: Thames and Hudson, with Anthony d'Offay Gallery, 1990) including an interview with Johns by David Vaughan.* There was also a German edition, *Freundschaften: Cage, Cunningham, Johns* (Bonn: Edition Cantz, 1991). The Tate Gallery, Liverpool, published its own catalogue.

Gagosian Gallery, New York. *Jasper Johns: The Maps*. With an essay by Roberta Bernstein (excerpted from her 1985 book *Jasper Johns' Paintings and Sculptures 1954–1974: "The Changing Focus of the Eye"*).

Kunstmuseum Basel. *Jasper Johns: Progressive Proofs zur Lithographie Voice 2 und Druckgraphik 1960–1988*. Brochure. With text by Dieter Koepplin.

McKissick Museum, University of South Carolina, Columbia, S.C. *Paintings by Jasper Johns*. With a text by Bradford R. Collins.

San Jose Museum of Art, San Jose, Calif., 1989–1990. *Jasper Johns and Robert Rauschenberg: Selections from the Anderson Collection*. Brochure. With an essay by James Cuno.

1990

Anthony d'Offay Gallery, London, 1990–91. *Jasper Johns: New Drawings and Watercolours*. Calendar published to coincide with an exhibition of the same title.

Cleveland Center for Contemporary Art, Ohio. *Jasper Johns: Drawings & Prints from the Collection of Leo Castelli.* Foldout, with an essay by Pamela Runyon Esch.

Galerie Humanité, Tokyo. (Nagoya.) *Jasper Johns: Prints. 60s, 70s and Foirades/Fizzles.* With an essay by Akira Tatehata. In Japanese, with English translation on loose leaf.

Isetan Museum of Art, Tokyo. (Niigata. Urawa. Matsudo. Shizuoka.) *The Jasper Johns Prints Exhibition,* by Shigeo Chiba (Tokyo: Japan Art & Culture Association/Nihon Keizai Shimbum, Inc.). With an essay by Neal Benezra in Japanese and in English, and an essay by Chiba in Japanese.

National Gallery of Art, Washington, D.C. (Basel. London. New York.) *The Drawings of Jasper Johns,* by Nan Rosenthal and Ruth E. Fine, with Marla Prather and Amy Mizrahi Zorn (Washington, D.C.: National Gallery of Art, in association with Thames and Hudson, 1990).* With essays by Rosenthal and Fine, and an interview with Johns by Fine and Rosenthal. There is also a brochure with an essay by Rosenthal. The Kunstmuseum Basel and the Hayward Gallery, London, published their own brochures.

Seibu Department Store, Shibuya Branch, Tokyo. *Prints Exhibition 1960–1989: Jasper Johns* (Tokyo: Seibu Museum).

Walker Art Center, Minneapolis, Minn. (Houston, Tex. San Francisco, Calif. Montreal, Que. Saint Louis, Mo. Miami, Fla. Denver, Colo.) *Jasper Johns: Printed Symbols.** With an introduction by Elizabeth Armstrong and essays by James Cuno, Charles W. Haxthausen, Robert Rosenblum, and John Yau, and an interview with Johns by Katrina Martin. The Montreal Museum of Fine Arts published a French translation of the catalogue.

1991

Brooke Alexander Editions, New York, 1991–92. (San Diego, Calif. Madrid. Gijon. Seville. Santiago de Compostela. Palma de Mallorca.) *Jasper Johns: The Seasons,* by Roberta Bernstein.

Brenau College, Simmons Visual Arts Center, Gainesville, Ga. (Tel Aviv. Brussels.) *Retrospective of Jasper Johns Prints from the Leo Castelli Collection.* The Tel Aviv Museum of Art and the Galerie Isy Brachot, Brussels, each published its own catalogue, with differing contents.

Gana Art Gallery, Seoul. *Jasper Johns: Recent Paintings and Drawings.*

Heland Wetterling Gallery, Stockholm. *Jasper Johns.* With a text by David Sylvester.

1992

Dolenjski Muzej-Galerija, Novo Mesto, Llubljana. *2. Bienale Slovenske Grafike Otocec/ 2nd Biennial of Slovene Graphic Arts Otocec 1992: Johnny Friedlaender—Jasper Johns* (Ljubljana: Narodna in univerzitetna knjiznica). With an essay by Kathleen Slavin. In Slovene and English.

Fondation Vincent Van Gogh, Palais de Luppé, Arles. (Humlebaek.) *Jasper Johns: Gravures et dessins de la Collection Castelli 1960–1991/ Portraits de l'artiste par Hans Namuth.* With texts by Marcelin Pleynet, Michel Butor, and Kathleen Slavin. In French and English. The Louisiana Museum, Humlebaek, published its own catalogue, with differing contents.

Gagosian Gallery, New York. *Jasper Johns: According to What & Watchman,* by Francis M. Naumann.

Margo Leavin Gallery, Los Angeles. *Jasper Johns, Brice Marden, Terry Winters: Drawings,* by Jeremy Gilbert-Rolfe.

Milwaukee Art Museum, Wisconsin. (Chapel Hill, N.C. Lethbridge, Alta. Albany, N.Y.) *Jasper Johns: Prints and Multiples,* by Sue Taylor.

1993

Newport Harbor Art Museum, Newport Beach, Calif. *Artists at Gemini G.E.L.: Celebrating the 25th Year,* by Mark Rosenthal (New York: Harry N. Abrams, Inc., in association with Gemini G.E.L., Los Angeles, 1993).* Prepared in conjunction with the exhibition "Both Art and Life: Gemini G.E.L. at 25," 1992. With an introduction by Michael Botwinick and an interview with Johns.

Leo Castelli Gallery, New York. *Jasper Johns— 35 Years—Leo Castelli,* ed. Susan Brundage (New York: Harry N. Abrams, Inc.). With an essay by Judith Goldman.

University of Missouri Gallery of Art, Kansas City, Mo., 1993–94. (Augusta, Ga.) *Jasper Johns: Collecting Prints* (Kansas City: University of Missouri). With a preface by Craig Allen Subler (curator) and an essay by Melinda Rountree.

1996

Anthony d'Offay Gallery, London. *Jasper Johns Flags 1955–1994.* With an introduction by Anne Seymour and an essay by David Sylvester.

Menil Collection, Houston, Tex. (Leeds.) *Jasper Johns: The Sculptures,* by Fred Orton (Leeds: The Centre for the Study of Sculpture at the Henry Moore Institute).

Index of Illustrations

Photograph Credits

The following list applies to photographs for which a separate acknowledgment is due, and is keyed to page numbers. For clarity, illustrations may also be identified by plate (pl.) and figure (fig.) numbers.

© Addison Gallery of American Art, Phillips Academy, Andover, Massachusetts. All rights reserved: 153, pl. 35.
Michael Agee: 86, fig. 59.
David Allison, New York: 92; 190; 336; 352, pl. 217.
Arion Press, San Francisco: 88, fig. 65.
Art Resource, New York/Tate Gallery, London: 80, fig. 28; 91, fig. 83.
Artothek: photograph by Joachim Blauel, 240.
Photograph by Bayer & Mitko, 222.
© 1996 The Barnes Foundation: 79, figs. 23 and 26.
© Primula Bosshard, Fribourg: 358.
Rudolph Burckhardt, New York: 44, fig. 3; 159, pl. 42.
C & M Arts, New York: 254–55, pl. 123.
Leo Castelli Photo Archives: 28, fig. 13; 43; 61; 62, figs. 15 and 16; 63; 66; 100, fig. 12; 141; 179; 211; 290–91, pl. 160; 306, pl. 174; 310, pl. 178; 357.
Photographs by Eric Pollitzer, 48, fig. 7; 292.
Photograph by Glenn Steigelman, 314.
Photographs by Dorothy Zeidman: 53; 150, pl. 29; 210, pl. 89; 255, pl. 124; 312.
City Light Studio, Miami: 204, pl. 80.
© The Art Institute of Chicago. All rights reserved: 288; © 1996, 326, pl. 190.
Christie's, New York: 170; 206, pl. 83; 216–17.
© 1995 The Cleveland Museum of Art: 295.
Bevan Davies, New York: 306, pl. 173.
Des Moines Art Center: photograph by Craig Anderson, 154.
Fondation Edelman, Musée d'Art Contemporain, Lausanne: 347.
© The Equitable Life Assurance Society of the U.S.: 107, fig. 25.
Gagosian Gallery, New York: 109, fig. 28; 208, pl. 86; 241; 244.

Gamma One Conversions: 31; 130, pl. 2; 142, pls. 17 and 18; 158, pl. 41; 182, pl. 64; 281; 297, pl. 169; 352, pl. 218.
Rick Gardner, Houston: 293, pl. 163.
© Anne Gold, Aachen: 268; 284.
© President and Fellows, Harvard College, Harvard University Art Museums: 289.
Harvard University Art Museums: 81, fig. 38.
Greg Heins, Boston: 186, pl. 71.
© The Estate of Eva Hesse, courtesy Robert Miller Gallery: 103, fig. 16.
Hickey-Robertson, Houston: 82, fig. 42.
Hirshhorn Museum and Sculpture Garden: photograph by Lee Stalsworth, 105, fig. 21. 133.
George Hixson, Houston: 160, pl. 44; 161, pl. 47; 184, pl. 68; 247, pl. 114.
Jacqueline Hyde, Paris: 89, fig. 72.
© Paul Klee Stiftung, Bern: photograph by Kurt Blum, 91, fig. 84.
Arxiu MAS, Barcelona: 89, fig. 71.
McKee Gallery, New York: photograph by Mates, 108, fig. 27. Photograph by Steven Sloman, 108, fig. 26.
The Menil Collection, Houston: © Hickey-Robertson, 95, fig. 6; 130, pl. 1; 132; 143; 253.
© 1996 The Metropolitan Museum of Art, New York: 86, fig. 60; 87, fig. 63.
Milwaukee Art Museum: Efraim Lev-er, 331.
© Munch Museum: 84, fig. 50.
© The Museum of Modern Art, New York: 294, pl. 166. Photographs by Kate Keller, 46; 49; 136; 139; 203; 250; 313; 326, pl. 191. Photographs by Kate Keller and Erik Landsberg, cover; 2; 8; 12; 13; 23, fig. 4; 24; 28, fig. 12; 38; 80, fig. 30; 88, fig. 66; 90, fig. 75; 99, fig. 11; 101; 111; 135; 142, pl. 16; 150, pl. 28; 159, pl. 43; 187; 188, pls. 73 and 74; 189, pls. 75 and 76; 206, pl. 82; 212–13, pls. 91–94; 218, pl. 100; 245, pl. 109; 252; 255, pl. 125; 258–59, pls. 128–37; 261, pl. 141; 262, pl. 142; 280, pls. 148 and 149; 286–87, pls. 156 and 157; 291, pl. 161; 299; 311, pl. 181; 332, pl. 199; 368; 380. Photographs by James Mathews, 22; 251. Photograph by Mali Olatunji, 248, pl. 116. Photographs by Soichi Sunami, 78, fig. 21; 83, fig. 46; 84, fig. 49; 94, fig. 2.
© National Gallery of Art, London: 79, fig. 25.
National Gallery of Art, Washington, D. C.: © 1996, 109, fig. 29. Photograph by Dean Beasom, 248, pl. 115. Photographs by Richard Carafelli, 138; 205. Photographs by Bob Grove, 116; 243; 300; 318. © 1994 photographs by Edward Owen, 23, fig. 5; 325; 349.
National Museum of American Art, Smithsonian Institution, Washington, D.C.: 26; 221.
© The Nelson Gallery Foundation. All reproduction rights reserved. The Nelson-Atkins Museum of Art, Kansas City: photograph by Robert Newcombe, 293, pl. 164.
The New Yorker Magazine, Inc.: © 1960, 1988, 93. © 1962, 1990, 113.

Jeffrey Nintzel Photography, New Hampshire: 172.
Nippon Television Network Corporation, Tokyo: 33.
Öffentliche Kunstsammlung Basel: photographs by Martin Bühler, 134, pl. 6; 264–65; 354.
Pace Wildenstein, New York: 104, fig. 18; 110.
Douglas M. Parker, Glendale, California: 334.
Philadelphia Museum of Art: 25, fig. 8; 161, pl. 48; 181; 185, pl. 69; 247, pl. 112 and 113; 324.
Photographs by Graydon Wood, 80, fig. 29; 81, fig. 37; 86, fig. 58; 162.
Estate of Pablo Picasso: 90, fig. 79.
Eric Pollitzer: 27; 83, figs. 47 and 48; 103, fig. 17; 105, fig. 22; 245, pl. 110; 249, pl. 118; 263; 285.
© R.N.M., Paris: 90, figs. 76–78.
© Rheinisches Bildarchiv, Cologne: 25, fig. 9; 45, fig. 4; 147; 156; 184, pl. 66; 266–67; 283.
Rose Art Museum, Brandeis University: photograph by Harry Bartlett, 145, pl. 22.
Lynn Rosenthal: 80, fig. 31.
Royal Collection Enterprises, Photographic Services: 78, fig. 20.
S.A.D.E. Archives, Milan: 81, figs. 34 and 35.
San Francisco Museum of Modern Art: photographs by Ben Blackwell, 220; 256.
Photograph by Don Myer, 95, fig. 5.
Marc Schuman, Glenwood Springs, Colorado: 155; 260, pl. 139; 261, pl. 140.
© Seattle Art Museum: photograph by Paul Macapia, 177.
© Shelburne Museum: 87, fig. 62.
© 1989 Steven Sloman, New York: 219.
© Sotheby's, Inc.: 131; 173–75; 178, pl. 58; 207; 257; 348.
Jim Strong, Inc., New York: 45, fig. 5; 83, fig. 45; 151, pl. 31; 369; 378, pl. 239.
Tate Gallery: photograph by John Webb, 309.
Telimage, Paris: 89, fig. 74.
UNESCO/R. Lesage: 91, fig. 82.
© Malcolm Varon, New York: 184, pl. 67; © 1995, 282, pl. 152; 355.
Virginia Museum of Fine Arts: photograph by Katharine Wetzel, 326–27, pl. 192.
Walker Art Center, Minneapolis: 296.
© Whitney Museum of American Art, New York: 95, fig. 4. Photographs by Geoffrey Clements, 32; 99, fig. 10; 151, pl. 30; 328.
John D. Woolf, Cambridge, Massachusetts: 144, pl. 21; 148; 176, pl. 56.
© Dorothy Zeidman: 28, fig. 14; 29; 78, fig. 22; 79, fig. 24; 80, fig. 32; 81, fig. 36; 83, fig. 44; 85, figs. 55 and 56; 87, fig. 64; 88, figs. 67 and 68; 91, fig. 81; 134, pl. 7; 160, pl. 46; 182, pl. 63; 280, pl. 147; 307; 310, pl. 179; 335; 344–46; 371–72; 374, pl. 234; 378, pl. 238; 379; 382–83, pls. 245–50. © 1989, 218, pl. 99; 356, pl. 222. © 1990, 366. © 1991, 298; 350–51, pls. 209–16; 370; 375. © 1994, 14; 330, pl. 195; 377; 378, pl. 240.
Octave Zimmerman, Colmar: 85, figs. 53 and 54.

Lenders to the Exhibition

Ludwig Forum für Internationale Kunst, Aachen
Stedelijk Museum, Amsterdam
The Baltimore Museum of Art
Öffentliche Kunstsammlung Basel, Kunstmuseum
Albright-Knox Art Gallery, Buffalo, New York
The Art Institute of Chicago
Museum of Contemporary Art, Chicago
The Cleveland Museum of Art
Museum Ludwig, Cologne
Dallas Museum of Art
Des Moines Art Center
Modern Art Museum of Fort Worth
The Menil Collection, Houston
The Museum of Fine Arts, Houston
Victoria and Albert Museum, London
Tate Gallery, London
The Museum of Contemporary Art, Los Angeles
Walker Art Center, Minneapolis
Bayerische Staatsgemäldesammlungen/
 Staatsgalerie moderner Kunst, Munich
The Museum of Modern Art, New York
Whitney Museum of American Art, New York
Musée national d'art moderne,
 Centre Georges Pompidou, Paris
Virginia Museum of Fine Arts, Richmond
The State Russian Museum, St. Petersburg
Seattle Art Museum
The Sogetsu Art Museum, Tokyo
The Museum of Modern Art, Toyama
Rose Art Museum, Brandeis University,
 Waltham, Massachusetts
Hirshhorn Museum and Sculpture Garden,
 Smithsonian Institution, Washington, D.C.
National Gallery of Art, Washington, D.C.

Irving Blum
Norman and Irma Braman
Jean Christophe Castelli
Leo Castelli
Douglas S. Cramer
Peggy and Richard Danziger
Kenneth and Judy Dayton
Anne and Anthony d'Offay
Mr. and Mrs. Barney A. Ebsworth
Joel and Anne Ehrenkranz
Gail and Tony Ganz
Sally Ganz
David Geffen
Mrs. John Hilson
Jasper Johns
Philip Johnson
Sarah-Ann and Werner H. Kramarsky
Margo H. Leavin
Mildred and Herbert Lee Collection
Ludwig Collection
Margulies Family Collection
Robert and Jane Meyerhoff
Nerman Collection
Mr. and Mrs. S. I. Newhouse
Michael and Judy Ovitz
Robert Rauschenberg
Jane and Robert Rosenblum
Denise and Andrew Saul
Richard Serra and Clara Weyergraf-Serra
Sonnabend Collection
Mrs. Lester Trimble
David Whitney

Anonymous lenders

Galerie Bonnier, Geneva
Leo Castelli Gallery, New York
Anthony d'Offay Gallery, London

The Fukuoka City Bank